W9-CJD-075

NICOLAS POUSSIN

NICOLAS POUSSIN

FRIENDSHIP AND THE LOVE OF PAINTING

ELIZABETH CROPPER AND

CHARLES DEMPSEY

PRINCETON UNIVERSITY PRESS

Published by Princeton University Press, 41 William Street, Princeton, New Jersey 08540
In the United Kingdom: Princeton University Press, Chichester, West Sussex

Library of Congress Cataloging-in-Publication Data
Cropper, Elizabeth
Nicolas Poussin : friendship and the love of painting / by
Elizabeth Cropper and Charles Dempsey.
p. cm.
Includes bibliographical references and index.
ISBN 0-691-04449-X (CL : acid-free paper)
1. Poussin, Nicolas, 1594?–1665—Criticism and interpretation. 2. Poussin, Nicolas,
1594?–1665—Friends and associates. I. Dempsey, Charles. II. Title.
ND553.P8C76 1996
759.4—dc20 95-5243

Publication of this book has been aided by a grant from the Millard Meiss Publication Fund
of the College Art Association of America

MM

This book has been composed in Garamond #3
by The Composing Room of Michigan, Inc.

Princeton University Press books are printed on acid-free paper and meet the guidelines for
permanence and durability of the Committee on Production Guidelines for Book Longevity of
the Council on Library Resources.

Printed in the United States of America
by Princeton Academic Press

10 9 8 7 6 5 4 3 2 1

EDITED BY TIMOTHY WARDELL
DESIGNED BY LAURY A. EGAN

For Adam and Kayoko

CONTENTS

LIST OF ILLUSTRATIONS

PREFACE

IN ONE SENSE this book has had a long gestation, beginning with the authors' Ph.D. dissertations on Nicolas Poussin (1963) and Pietro Testa (1972), and developing over continuous years of thinking, teaching, and writing about Poussin in particular and the art of the seventeenth century in general. However, although our professional relationship has always been collaborative in the best sense, each of us ever ready to discuss and read the work of the other, we can neither of us recall exactly when the idea of writing a book about Poussin together first took coherent shape. Once the decision was made, however, we were greatly encouraged by the enthusiastic prompting of two friends and colleagues at Johns Hopkins, Michael Fried and Herbert Kessler, each of whom has read significant parts of this book and given us the benefit of wise and critical counsel. We are also grateful for the support of two other friends, the late Louis Marin and the late Rensselaer W. Lee, both greatly missed in more ways than we can acknowledge.

Invitations to lecture on different aspects of the material presented in this book have made it possible for us to benefit greatly from discussions with diverse colleagues and students. In particular we would like to thank Cambridge University, where Elizabeth Cropper was Slade Professor in 1992–1993 and devoted a part of her lectures to Poussin; the École des Hautes Études en Sciences Sociales in Paris, where, as Directeur d'études associé, she gave three seminars on Poussin in 1991–1992; the Bibliotheca Hertziana in Rome, where she and Charles Dempsey read papers on Poussin at a colloquium entitled *Der Künstler über sich in seinem Werk* in 1989; the British Museum in London, where Elizabeth Cropper gave a paper on Vincenzo Giustiniani at a symposium on Cassiano dal Pozzo's Paper Museum, co-sponsored by the Warburg Institute of the University of London in 1989; the Institute for Advanced Study in Princeton, where both authors read papers on Poussin in 1989; the Biblioteca Vaticana, where both lectured on Poussin at a symposium on Time in the Eternal City, jointly sponsored with the Smithsonian Institution in 1988; Princeton University, where Charles Dempsey presented a paper on Poussin at the symposium held in Memory of Rensselaer W. Lee in 1986; Columbia University, where Elizabeth Cropper lectured on Poussin at the symposium held in Memory of Milton Lewine in 1980; Brown University, where Charles Dempsey contributed a paper on Poussin to a symposium on City and Country in the Renaissance in 1980; the American Institute of Classical Archaeology, where Charles Dempsey lectured on the Fogg *Birth of Bacchus* at a symposium on Dionysus held in conjunction with the annual meetings in 1979; and finally The Johns Hopkins University, where Elizabeth Cropper read a paper on Poussin at the symposium held in memory of Louis Marin co-sponsored by the Humanities Center and Departments of French and the History of Art in 1993, and where Charles Dempsey read another at a

symposium on Apollo and Dionysus, sponsored by the Classics Department in the same year. Other institutions that have provided us with lively and stimulating audiences are Bowdoin College, Emory University, the Kimbell Art Museum, the Studio School in New York, the University of Delaware, the University of North Carolina at Chapel Hill, the University of Texas at Austin, the University of Vermont, and The Johns Hopkins Center for Italian Studies at the Villa Spelman in Florence. All of these opportunities have improved the book, not least through starting conversations with many whose own interests are outside the specific field of the seventeenth century, but whose warm response to Poussin's paintings sustained our sense of the need for a more critical interpretation of his work.

In addition to The Johns Hopkins University, which provided us each with leaves at different points during our research and writing of this book, we are also grateful to the Institute for Advanced Study, where we both held Visiting Memberships in the Fall semester of 1989, and where significant parts of it were first written. The resources of the Center for Advanced Study in the Visual Arts at the National Gallery of Art in Washington, D.C., where Elizabeth Cropper began her appointment as Andrew W. Mellon Professor in 1994, proved indispensable in the final stages.

In a book by two authors, and one so long in the making, we have incurred more than the usual number of debts and cannot hope to acknowledge them all here. We would, however, like to record our special gratitude to Sherry Babbitt, Barbara Burns, Martino Capucci, Gérard Defaux, Diane DeGrazia, Anne D'Harnoncourt, Marc Fumaroli, Creighton Gilbert, David Jaffé, Irving Lavin, George Marcus, Jennifer Montagu, Ann Percy, Giovanna Perini, Joseph Rishel, Pierre Rosenberg, Eric Schleier, Innis Shoemaker, Francesco Solinas, Richard Spear, Timothy Standring, Peter Sutton, Richard Verdi, Matthias Winner, and Richard Wollheim. It has been a pleasure to work with Elizabeth Powers and Timothy Wardell of Princeton University Press. Very special thanks are due to Pauline Thayer Maguire, Lauren Freeman, and Morton Steen Hansen for their hard work checking the manuscript and to Pauline Maguire especially for her help with photographs.

Material included in the chapters of this book originally appeared in greatly abbreviated form in the following: 1) "The Greek Style and the Prehistory of Neoclassicism," in Elizabeth Cropper, *Pietro Testa 1612–1650: Prints and Drawings* (exhibition catalogue, Philadelphia Museum of Art), Philadelphia, 1988, pp. xxxvii–lxv; 2) "Vincenzo Giustiniani's *Galleria*: The Pygmalion Effect," in *Cassiano dal Pozzo's Paper Museum* (*Quaderni Puteani*, 3), 2 vols., Milan, 1992, 2, pp. 101–126; 3) "Poussin's *Sacrament of Confirmation*, the Scholarship of *Roma sotterranea* and Dal Pozzo's *Museum chartaceum*," in *Cassiano dal Pozzo: Atti del Seminario Internazionale di Studi* (Istituto Universitario Suor Orsola Benincasa, Napoli), ed. Francesco Solinas, Rome, 1989, pp. 101–118; 4) "Poussin and Leonardo: Evidence from the Zaccolini MSS," *Art Bulletin* 62, 1980, pp. 570–583; 5) "Painting and Possession: Poussin's Portrait for Chantelou and the *Essais* of Montaigne," in *Der Künstler über sich in seinem Werk* (Internationales Symposium der Bibliotheca Hertziana, Rome, 1989), ed. Matthias Winner,

Weinheim, 1992, pp. 485–509; 6) "*Mavors armipotens*: The Poetics of Self-Representation in Poussin's *Mars and Venus*," in *Der Künstler über sich in seinem Werk* (Internationales Symposium der Bibliotheca Hertziana, Rome, 1989), ed. Matthias Winner, Weinheim, 1992, pp. 435–452; and 7) "Marino's *Strage degli Innocenti*: Poussin, Rubens, and Guido Reni," *Studi Secenteschi* 33, 1992, pp. 435–452. Though each of these studies was produced by a single author, their rewriting, revision, and incorporation in this book was a thoroughly joint undertaking. Sections of chapters five and eight are also scheduled to appear in the *Actes* of the Poussin Colloquium, which was held in October of 1994 in connection with the great Poussin exhibition in Paris.

The manuscript of this book was completed at the Villa Spelman in Florence in April of 1994, and the final version, incorporating our responses to specific questions asked in two very helpful readers' reports, was returned to the Press just one month before the opening of that glorious exhibition at the Grand Palais. Together with other important, supplementary displays of Poussin's work at the Louvre, in Chantilly, and in Bayonne, as well as the more general thematic exhibitions at the Villa Medici and the Palazzo Barberini in Rome, the exhibition at the Grand Palais will be a point of departure for research for years to come. We do not wish to make our long book even longer by taking up the new problems raised by these exhibitions, or by drawing attention to the ways in which our discussions of, say, Vincenzo Giustiniani and Cassiano dal Pozzo have been supported by works on display, many of them newly cleaned. The effective date of completion for this book remains April of 1994.

However, one or two brief comments on specific points we do raise in the book are in order. First, the Berlin *Self-Portrait*, discussed in chapter four, is published for the first time after cleaning in the catalogue of the exhibition at the Grand Palais. Secondly, in the course of debates at the colloquia in Paris and Rome (and following recent publications), the question of dating the Chantilly *Massacre of the Innocents* has become even more a matter for discussion, and the extremely early date of 1624 has even been put forward. We stand by our proposal of a date in the early 1630s for all the reasons given in chapter seven, although it is also clear that the early work of Poussin remains an area of confusion and still requires much clarification. Thirdly, it is our hope that the argument in chapter five that the scene depicted in the Louvre *Healing of the Blind* should be identified with Christ's miracle at Capernaum will lead eventually to a change in the title of that work, however difficult that may be in light of the significance of "*Les aveugles de Jéricho*" in the tradition of French scholarship. Finally, the catalogue of the exhibition at the Grand Palais reports that technical examination assisted by microscope and television scanner of the Boston *Mars and Venus*, the principal subject of chapter six, has discovered nothing—nothing, that is, that would indicate any alteration to our argument. These specific points aside, however, the Paris exhibition has again drawn general attention to Nicolas Poussin's greatness as a painter, and it has been our hope to contribute in some small measure to the understanding and appreciation of that greatness.

November 1994

NICOLAS POUSSIN

INTRODUCTION

IN THE DECADES since the near legendary exhibition devoted to Poussin at the Louvre in 1960, which was followed soon after by the publication of Anthony Blunt's indispensable catalogue and monograph in 1966 and 1967, there has been no lack of continuing study of Poussin's life and works. Important new paintings have come to light, and significant effort has been devoted to questions of documentation, attribution, and dating—especially of Poussin's earlier works, which remain controversial. Alternative catalogues of Poussin's paintings have been published, by Jacques Thuillier among others; Thuillier has also contributed a detailed biography of the artist; and Alain Mérot has published the latest monographic overview of Poussin's career and artistic production. As of this writing, an ambitious exhibition is in preparation in Paris, as well as a second exhibition in London, in commemoration of the four-hundredth anniversary of Poussin's birth in 1594. International colloquia are being planned in Paris and Rome, where many of the problems raised by the exhibition and the ongoing scholarship will be discussed, and where new contributions to knowledge will certainly be made. A reassessment of Poussin's drawings is being undertaken, as well as a new edition of his letters.

No one whose memory extends earlier than 1960 can be unaware or unappreciative of the enormous progress that has been made in the intervening years. However, in light of the work that has been done, and continues to be done, this has not seemed to us the moment to write yet another monograph with catalogue raisonné of Poussin's paintings. We think it might perhaps be more useful to attempt a broad critical engagement with some central issues raised by his art, exemplified by a limited number of carefully chosen works. The course of research moves at a relatively rapid pace, each year seeing publication of new works, attributions and iconographical contributions, new documents, inventories, and all sorts of data about the artist, his patrons, his friends and rivals. By gradual accumulation the steady increase of detailed knowledge forces adjustments in the state of the question, but an actual change in the state of the question itself generally occurs at a relatively glacial rate. In writing this book, we have been prompted to think again about the extent to which appreciation and understanding of Poussin's work really have been altered since the 1960 exhibition. If the labors of scholarship can be said to have continuity at all, then it would seem that at least the broad outlines of the new research and criticism which will be prompted by the 1994 exhibition should be discernible in the general features of past work. It is not altogether clear to us that Poussin studies have in fact taken directions substantially different from those that were already emerging in the 1960s.

Blunt's all but comprehensive bibliography of studies and notices about Poussin

written between 1627 and 1966 included 137 entries for 1960 alone, and the forth-coming exhibitions will surely stimulate a similar number. The *Actes* of the colloquium held in conjunction with the 1960 exhibition published many new documents relevant to Poussin's social and intellectual existence in Paris and Rome, new attributions and chronological researches, new critical and historical analyses, as well as a few brilliant combinations of all these things. The year 1960 also saw the publication of Georg Kauffman's *Poussin-Studien* (in which Poussin's self-portraits and his study of the an-cient statues in Rome were treated in close detail), Luigi Salerno's publication of the inventories of the Giustiniani collection, Francis Haskell's, Sheila Rinehart's, and Cor-nelius Vermeule's pioneering investigations of Cassiano dal Pozzo's *Museo Cartaceo*, or "Paper Museum," and Erwin Panofsky's close iconographic and critical reading of Poussin's *Bacchus and Erigone* in Stockholm, which he retitled *Bacchus-Apollo.* In addi-tion, the exhibition of that year demanded a great deal of rethinking on the part of all who saw it. During its course Blunt rewrote his 1958 Mellon Lectures, to produce what is the most important and original book on Poussin to date. Denis Mahon rethought Poussin's chronology in his *Poussiniana*, challenging many of Blunt's conclusions, only to arrive at the realization that, in the aftermath of so much detailed study and re-search, there had risen the need to return to fundamental issues of quality and aesthetic value. His "A Plea for Poussin as a Painter" appeared in 1965. In the same year Walter Friedlaender, whose monograph of 1914 Blunt had called the foundation of modern Poussin studies, published an even more passionate defense of Poussin's paintings in *Nicolas Poussin: A New Approach.* Each of these studies, part of what Friedlaender called a "Poussin renaissance," opened up entirely new directions that are still being followed today, and all have stimulated the work we present here.

Since that remarkably productive phase of intensely original scholarship, chrono-logical and attributional questions have, as we have indicated, continued to be debated, and there have been contributions and refinements to the iconographical readings of individual works—particularly in relation to Poussin's personal philosophy, a question that greatly preoccupied Blunt. The old and—in 1994—regrettable question of Pous-sin's "nationality" has been taken up again. Several distinguished contributions to the study of Poussin as a painter have been made, among them Kurt Badt's closely ob-served analysis of Poussin's colorism and working procedure, Louis Marin's intensely focused semiological and phenomenological studies of the logic of Poussin's visual arguments (which Oskar Bätschmann has taken up in a more Hegelian form), and Marc Fumaroli's literary and historical researches into the different poetic and rhetorical aims and strategies open to, and hotly contested by Poussin's contemporaries in the Rome of Urban VIII. In fundamental ways, however, all these studies have contributed to a deepening of historical and critical understanding of issues that were raised more than thirty years ago (especially by Panofsky), and they are concerned with essential prob-lems to which we also intend to return in this book.

Central to the state of the question regarding Poussin's art is the problem of

bringing together in a critical engagement with his paintings the two terms so uneasily combined in the very name of art history itself (which some would regard as an oxymoron), namely "art" and "history." Our own ideal and hope would be the achievement of a genuinely historical criticism, one that is critically revealing to present sensibilities, and is at the same time historically probable, attempting on the one hand to shed real light on the expressive content of unique works of art, and on the other to do justice to the actual concerns of the artist and his audience. Works of art have a multiple existence, both in history and in the experiences of the present as this itself evolves over time. They address each new viewer freshly and directly, so that, to paraphrase Alberti, the sentiments and desires, as well as the particular real and imaginative appearances of people and cultures from the past, are kept alive and perpetually renewed in an art that never loses the force and passion of life. The interpretation of works of art, whether in poetry, music, or painting, means working simultaneously on at least two primary levels, on the one hand that of history and its conventions and traditions (which determine expectations), and on the other that of the individual expression of unique works (the pleasure of which often results from confounding expectations).

This overarching problem continues to dominate discussion of Poussin's work, even as it continues to preoccupy art-historical thinking more generally. It is the central problem Blunt felt himself compelled to confront in his monograph, and about which he clearly felt defensive. He had at first planned, as he wrote, "to produce a straightforward monograph on Poussin as a painter."[1] However, he found that it was necessary first to understand "the intellectual climate in which [Poussin] worked and the ideas . . . in which he believed and which affected his method of work as well as his paintings." He hoped someday to be able to write a book in which all this historical matter could be taken for granted, so that "Poussin's supreme merits as a painter can be made the principal theme." He never wrote that book, and perhaps could not have. The quality of Poussin's art, and on a deeper level his own response to it, was not something he could easily resolve within himself. Blunt was one of that small group of Englishmen (Denis Mahon was another) who pioneered in the recovery of the positive values of Italian "Baroque" art from the anathema that had been pronounced upon it by John Ruskin in England, and from the opprobrium into which it had fallen in the general climate of nineteenth-century anti-clericalism and political liberalism in Europe. In consequence, as late as 1953, in his Pelican volume on French art and architecture, Blunt had expressed the sentiment that the "classical" Poussin could not be considered in the first rank of painters because of a certain coldness and intellectual reserve in his art, in contrast to the "Baroque" virtuosity and intuitive flair of, say, a Van Dyck.[2] Only a few years earlier Mahon had passed a similar judgment on the late style of Guercino, which he claimed had been adversely affected by the precepts of a "classical" theory that led him to abandon the natural painterly, instinctive exuberance of his youthful works.[3]

Despite Mahon's plea in 1965 for a renewed appreciation of Poussin as a painter, Blunt's turning away from this problem to that of Poussin's intellectual context and philosophy has endured in the literature. He himself realized that he was "running counter to many deeply ingrained beliefs" in his decision to investigate the importance for Poussin of such matters as the relation of theory to practice, poetry to painting, or indeed of broader questions of antiquarian lore, Stoic ethics, and *Libertin* philosophical views of religion and the natural world—all of them pertinent to concerns the artist expressed in his paintings (and not only in terms of subject matter). Blunt was referring in particular to the convictions of the formalists of his day, both among painters and critics, for whom Poussin held a kind of fatal fascination that denied other kinds of meaning in his work. However, formalism is only one leg of the tripod supporting the modernist aesthetic which was then still at its height, the other two being idealism and classicism. On the one hand Blunt revolutionized Poussin studies by following on Friedlaender's and Grautoff's earlier historical insights, and by defying the more familiar formalist expectations of monographic writing, the most extreme representative of which, for his generation, was Roger Fry. On the other, although acutely sensible of the choice he had made to take up questions of history rather than art in the strictest sense, and feeling unable to bring the two together coherently in a single book (while insisting on taking the one for granted when treating the other), Blunt shared the modernist prejudice that artistic thinking (which was universally condemned as empty "theory") bore only an adventitious relation to actual practice. Mahon shared the same prejudice, although for him (and perhaps more consistently as a champion of the Italian Baroque) the problem lay not so much with formalism as with the concept of classicism, which, as we have indicated with respect to Guercino, he identified with the vain, debilitating, and ultimately irrelevant activities of theoretical and academic speculation. However, no matter which leg of the modernist tripod was found to be infirm, the stability of the whole with respect to a critical understanding of earlier historical styles was threatened.

In writing about Poussin's theories of art, Blunt accepted Friedlaender's not very well thought-through (but often quoted) statement that, in Blunt's paraphrase, "generally speaking, indeed, seventeenth-century artists were not given to speculation on philosophical subjects—even on aesthetics—for it is a well known fact that far fewer treatises on the arts were produced in this century than in either the sixteenth or the eighteenth."[4] In going on to attempt a distinction between the art of Poussin and that of Rubens and Bernini in particular, Blunt sought to emphasize his sense of the difference between an idea of learning (affecting Poussin's intellectual climate) and one derived from a genuine philosophy or aesthetics (affecting his art). Perhaps because his terms were misconceived, he was never really able to put his own understanding of Poussin's theory and practice together, thereby overcoming the modernist prejudices once and for all. We shall be suggesting in this book that the question for Poussin had to do not so much with learning versus aesthetics as it did with a concept of aesthetics

that was itself centered on knowledge and experience (*esperienza* in Italian also carrying the meaning of "experiment").

That it continues to prove difficult to integrate knowledge about Poussin as an artist in his own time, and as a critical thinker about the art of both the past and present that he saw in Rome—knowledge derived not only from written texts but also from close analysis of his own choices as a painter—into a critical assessment of his work as a whole also has much to do with his own critical fortune in the traditions of France. The issue of classicism and its continuing legacy in modernist aesthetics is vital to these traditions, and it is especially complex in that Poussin himself was instrumental in the discovery of certain of the fundamental concepts that were to be assimilated into neoclassical criticism as it later evolved in the eighteenth and nineteenth centuries. The initial emergence and definition of a truly neoclassic aesthetic and its deployment in art at the hands of Nicolas Poussin and his friends François Duquesnoy and Pietro Testa is therefore the subject of the first chapter of this book, which is quite broadly conceived and which carries implications that are developed throughout our later chapters. This occurred when all three artists were working with intimate knowledge of the collection of ancient statues owned by the Marchese Vincenzo Giustiniani, for whom each of them worked, and accordingly the Marchese's own aesthetic ideas are further examined in chapter two. These ideas, it will be suggested, are continuous with the broader philosophy of the Marchese, who in his life enacted the new ideal of gentle comportment first defined in the writings of Stefano Guazzo and Michel de Montaigne. Such an idea was based in the cultivation of one's natural inclination, good taste, and *honnêteté*; and this in turn strikes a second primary theme of our book, which again is developed in the later chapters.

To take up the first question, that of Poussin's classicism, let us exemplify one aspect of the problem of the later, French modernist classical interpretation of Poussin's own art with a quotation from Maurice Denis, writing in 1905: "Poussin would not oppose style and nature; in the mind of the painter they should merge. . . . All the classical masterpieces are simultaneously ideally beautiful and full of the *natural*. . . . Damn the pedants who have taught us to distinguish prose and poetry in our pictorial language."[5] Denis is, of course, writing about Cézanne, the "Poussin of still-life and green landscape."[6] In discussing this passage Richard Shiff has called attention to the importance of the concept of a "natural," and even "spontaneous classic" at the beginning of this century. For many French critics Poussin provided the model for such an idea of natural classicism, which they opposed to the arid academic classicism of his imitators, whose intuitive spontanteity had withered (as for Mahon had Guercino's) in the dry soil of theoretical precepts and learning. For these critics it was to be by returning again to Poussin, and studying and learning from his paintings, that the problem of how to revive painting through a reinvigorated academic imitation could be negotiated. The role that Poussin, or rather the legend of Poussin, played in changing the course of painting at the beginning of this century is not our subject. However,

the effects of that legend are of the greatest significance for a modern understanding of Poussin, and they still need to be acknowledged. As Blunt saw with regard to Roger Fry, Poussin's art, like Cézanne's, was appropriated by formalist critics for whom a theory of the classic was, despite occasional claims to the contrary, still associated with the planarity and essential abstraction of Wölfflin's "classic" style. Had Poussin not been associated with Cézanne in this way, then for them he would have run the risk of being identified with the very sterile academicism he was seen to have fathered, albeit unwittingly. It is precisely because the dialectical opposition of originality to imitation was resolved in the particular case of Cézanne through reference to Poussin's "spontaneous" classicism that examination of this critical moment helps unmask the very historical contingency of the solution and its influence. The strong "misreadings" of Poussin, furthermore, by nineteenth- and early twentieth-century critics challenge us as historians to question our own assumptions, and to represent more accurately Poussin's particular historical and artistic situation, as opposed to that which has been assigned him by modernist concepts of formalism and classicism, which often enough are contradictory among themselves.

Poussin provided the French model for a revival of painting because he combined the study of nature and the art of antiquity in an original way that simultaneously revivified the past and signified a "living" tradition. As such, he assumed a role similar to that of Raphael for Vasari and Annibale Carracci for Bellori (and no doubt for Poussin himself); both were understood to have brought naturalism and idealism, the fresh study of both nature and the traditions of art, back into alignment with one another. Poussin, as Shiff puts it, was "the recognized master of two true 'sources,' antique art and nature."[7] Remaking Poussin after nature, as Cézanne was seen to have done, was the equivalent of remaking the true idea of art vested in the antique after nature. The difference in the equation between Italian seventeenth- and French nineteenth-century criticism is in the latter's emphasis, not on the traditions of ancient *and* Italian art, but exclusively on the antique as the true "classic." The example repeatedly cited for Poussin's "return to ancient art" is the story told by both Bellori and Félibien of how the young painter on his arrival in Rome had made diligent copies of the antique statues, specifically measuring the Belvedere *Antinous* in order to learn the secrets of its proportions. However simple it may appear, the story was capacious enough in its potential implications to absorb the widest range of interpretations, becoming a critical touchstone. It might signify the "French" Poussin's resistance to contemporary Italian art, and his ability to imitate without copying. It might be held up precisely as an example of the dangers of servile copying. Or it might be cited as the means by which Poussin's originality found its expression.

The historical Poussin held only a tangential interest for early twentieth-century formalist critics seeking to come to grips with the originality of Cézanne. But Poussin as a painter mattered deeply to them, and the issues they raised continue to provide important signposts to problematic areas that might otherwise pass unnoticed. One

reason the story of Poussin's study of antiquity became such a fertile topos for criticism is that its meaning, in fact, is not that easy to understand. Had not other artists, and many of them, copied the ancient statues? What was so special about measuring the *Antinous*? What was it about Poussin's way of studying ancient art that made Paul Mantz say, in 1858, that "This vigorous return to antique art constitutes the better part of Poussin's originality"?[8] To what was Raymond Bouyer responding in 1893 when he wrote of Poussin that "We forget too often that this *genius* . . . far from tyrannizing art, rehabilitated nature, and with his heart brought to life the icy convention of the Bolognese [academics]"?[9] What *was* the difference between the academic Poussin's and, say, the Bolognese "academic" Domenichino's idea of antiquity? Our first two chapters take up some of these questions. In the first the story of Poussin's study of the proportions of the *Antinous* is examined in detail, with specific reference to Passeri's report that the great sculptor François Duquesnoy and Poussin together newly deduced the principles of "Greek" style, and that Poussin in particular set himself against the "Latin style." Their absolutely original attempt to distinguish Greek from Roman stylistic manners, which without doubt differentiates their study of antique form, as well as that of their young follower Pietro Testa, from that made by the Bolognese or any artists who had gone before them, was, it is argued here, derived from a new conception of the aesthetic force of the surface contours and proportions of "Greek" sculpture, which they argued established the emotional *disposition* of the viewer, and led them to a new theory of the *expression* latent in forms in and of themselves.

Since Blunt and Friedlaender wrote, a growing number of scholars, among whom we count ourselves, has been attempting a broad redefinition, initially arising in the study of the Carracci and their followers, of what theoretical thinking about art, as incorporated in academic teaching and in critical conversations among artists, actually meant to painters of the sixteenth and seventeenth centuries. As a result, though we are aware that there is still controversy, we hope that a clearer idea is beginning to emerge of the role of practical criticism, and of the mutually sustaining relation between theory and practice in the formation of individual styles (as well as in the making of particular works of art, and with respect to their particular audiences). Far better understood than it was in 1960 is the way in which the general late sixteenth-century critical crux of idealistic versus naturalistic imitation (exemplified by Vasari as Michelangelo versus Titian) came to be set in the context of a theoretical, but by no means idle debate about the relative values of imitating art on the one hand and nature on the other; and how this crux found a resolution in the Carracci Academy—only to be immediately reformulated and polemicized all over again, in very different terms, in early seventeenth-century Rome (exemplified by Bellori as the Cavaliere d'Arpino versus Caravaggio). To date, however, Poussin has tended to be excluded from this discourse, except insofar as his work contributed to the translation of the Italian critical debate into French in the latter part of the century.

Our understanding of the importance of theory (and even anti-theory) to the

practice of art, or what we would prefer to call an actively engaged critical self-awareness among artists of the seventeenth century, from the Carracci and their school to Poussin, Pietro Testa, and Dufresnoy, and certainly not excluding Bernini, Rubens, or even Friedlaender's "Bohemian" Caravaggio, is not founded only on published treatises or a conception of "high" theory alone. Critical and historical analysis of the works themselves, assisted by close attention to the language and terms of critical discussion preserved, not only in contemporary published treatises and histories (many of which were written by artists), but also in manuscripts, annotations, and letters, has fundamental bearing on the ways in which seventeenth-century art was in fact viewed—whether or not single paintings are described in terms of the convenient, but anachronistic stylistic shorthand as being "classical" or "baroque." As a result of close reading of the paintings in conjunction with the historical record, fewer and fewer scholars continue to find persuasive the repetition of Friedlaender's assertion that the seventeenth century was a time relatively free of critical thinking on the part of artists. Moreover, several manuscripts written by artists close to Poussin, which were unknown to Friedlaender and Blunt—among them Matteo Zaccolini's texts on optics, Pietro Testa's on ideal painting, and Orfeo Boselli's on sculpture, all of which are utilized in this book—help confirm this conclusion, even though in themselves they are not essential to it.

The challenge of coming to terms with the historical Poussin on the one hand, and with the "Poussins" he painted on the other, in fact resembles in many ways that confronting the scholar who intends (to take but one other seventeenth-century example) to consider the character and art of Caravaggio, about whom we also know a great deal, but who also has become increasingly isolated critically from his contemporaries in modern scholarship. That Caravaggio may in part have calculated, and even tried to control the perception of himself as an anti-social outsider (and of his sociopathic tendencies there is indeed no room for doubt), and therefore as an original whose own style, or anti-style based in a concept of realism that presented itself in polemical engagement against the traditions of past art, is now recognized to a degree. Poussin, on the other hand, remains very much the figurehead of a modernist notion of classicism that is presumed to be objectively based and eternally remote from the contingencies of relativistic stylistic choices and alternatives. Yet Poussin was himself among the most perspicacious of all interpreters of Caravaggio's polemical attack on the traditions of art, clearly perceiving that in so doing Caravaggio had intended to "destroy painting" itself. Himself an outsider and a latecomer, Poussin had had to master the traditions and canons of ancient and modern art upon his arrival in Italy, and to this his paintings of the 1620s and 1630s stand witness. In the late 1640s and 1650s, as the Bolognese domination of painting in Rome began to wane (in some part as a consequence of Poussin's own earlier achievement), he overtly undertook a coming to terms with the great tradition of modern Italian art a second time. In so doing, and related to the intensely focused experience of painting the two series of the *Seven Sacraments*, he

took Raphael, and especially the Raphael of the Madonnas, as his guide in an effort that entailed nothing less than a reformulation of the notion of easel painting, or *tableau* as such (especially of religious subjects).

Nevertheless, Nicolas Poussin, himself more than any other French artist having been identified as the French "classic" (or "surrogate ancient" in Michael Fried's happy phrase), has been perceived in curious isolation as the *fons et origo* of a permanent concept of style and national expression, and isolated by his very canonical status and the idea of aesthetic objectivity assigned to it. As had earlier been the case with the Carracci, it seems that an insistence on his greatness as a painter still requires denying the aesthetic significance of his critical thinking in its proper historical context—that taking up the purportedly adventitious questions raised by his "theories" must necessarily entail the loss of an essential engagement with the works of art he made. Where Blunt detected a commitment to reason within Poussin's paintings, he also found an intellectual reserve and diminished aesthetic value, a sacrifice on the artist's part of "certain opposite qualities," among them "spontaneity of design, freedom of handling, richness of colour, beauty of *matière*," and an "inhibiting of the free working of his imagination."[10] The modernist dilemma of reconciling the demands of history with those of art, which Blunt felt unable to resolve, remains powerfully in force.

In the chapters that follow we have sought to come to grips with this dilemma, which we see as presenting the greatest single challenge to scholarship on Poussin, not so much by theorizing it as by taking up some basic questions that have been considered in various methodological contexts, among them the familiar and well-tested techniques of stylistic and iconographic analysis. Rather than seeking only to identify Poussin's particular visual or literary sources in this attempt, however, we have tried to move beyond this necessary but historically and critically preliminary foundation to a broader consideration of his more abstract thematic concepts. Indeed, by moving to the broader thematics of both style and subject we hope to be able to bring the two terms, which formalist criticism has always found difficulty in bringing together, into expressive interaction with one another.

Close reading of works of art in terms of their own critical engagement with the traditions of art and literature, following on the example of literary criticism, requires a revision of the very concept of Poussin's "sources," whether in art or in poetry. Poussin and his contemporaries did not look to the great masters of the past as "sources of inspiration," nor did they submit themselves to their "influence." Instead, they saw them as exemplifying in their works a knowledge and mastery of various critical concepts of expression, as well as different natural and artistic perfections in a distinctly modern tradition. In their eyes Guercino's natural inclination had led him to study Titian's and Ludovico Carracci's methods of chiaroscuro in order to learn the optical secrets of their expressive movements and contrasts, and he then adapted the knowledge he had thus gained as the foundation for his own highly dramatic energies. Guido Reni's knowledge and understanding of Raphael's sovereign proportions was seen as the

critical point of departure for his own concept of grace, and Domenichino's mastery of the *affetti*, or representation of the human passions and affections, was seen to derive from his study and knowledge of Raphael's narrative clarity, to which Guido was temperamentally indifferent. In the case of Poussin, in our first chapter we shall be examining the way in which he in turn developed his own concept of expressive tenderness on the basis of close study of Titian's *Worship of Venus* in the Ludovisi collection, and how he and his friends Duquesnoy and Testa went on to arrive at a critical, and for the first time a truly psychological (as well as neoclassical) theory of aesthetic *expression* in art, which they sharply distinguished from representation of the *affetti*, through careful measurement and analysis of the proportions and surface contours of the "Greek" statues in Roman collections. On the basis of the knowledge they had gained from such studies, as we shall see, they succeeded in overtly thematizing various concepts of expressiveness in their art. These concepts—among them tenderness, blossoming youth, virility, or declining strength—can be perceived to share a ground overlapping that of subject matter, which in its turn provides the point of departure for treating such expressive and abstract themes (the eternal themes of art and poetry) as youthful love, sexual desire, friendship, heroic virtue, terror and pity, or loss and death.

Theoretical support for such analysis, which helps to move beyond the impasse created by the artificial oppositions of style to content or iconography, of practice to theory, of aesthetic essence to intellectual context, and of art to history, has been provided by literary criticism. Recent theories about beholding and reception, as well as estrangement or belatedness (which are especially useful in considering not only the position of foreign artists like Poussin, but also the Italian artists contemporary with him, who all worked in acutely "anxious" awareness of the stupendous achievements of the great masters of the sixteenth century), we would insist are also historical to the core. Such methodological concepts have won gradual acceptance through their historical and critical usefulness. They permit a far more precise understanding of the specific visual problematics posed by period styles in their own unique contexts, rather than forcing them into the conceptual straitjackets imposed by an abstract critical idealism, whether or not invoking such later and alien descriptive metaphors as "classicism," "eclecticism," or "historicism." Especially useful has been the theoretical concept of intertextuality, which has clearly exposed the limitations of seeking to identify only particular literary (as well as formal and stylistic) "sources." Such a limited, and minimally enlightening activity in fact coincides with recent caricatures of the iconological methods of Erwin Panofsky, which pretend that these methods consist of no more than the assembling of a standard repertory of myths, histories, and cross-references, assisted by handbooks like those written by Cartari or Ripa—whose own purposes in writing them are thereby misrepresented. However, two of Panofsky's finest essays, to which we shall turn in both the fifth and last chapters, were devoted to Poussin's *Arcadian Shepherds* (which Félibien called a "pensée morale"), for which there is no known literary "source," and hence no readily identifiable "subject." Panofsky's real contribution was

to identify Poussin's theme, a meditation on the tragedy of lost love and death, by locating the artist's *pensée* within its proper genre of the elegiac pastoral, the setting for which is Virgil's poetic fiction of Arcadia as the synecdoche for both the theme and its genre. His demonstration has lain the foundation for all continuing work on the painting, including Louis Marin's highly challenging interpretations adducing the historical phenomenon of the logic of Port Royal, for which he also built on theoretical concepts developed by Benveniste and Merleau-Ponty.

We further suggest in this book that the familiar literary and historical subjects chosen by Poussin were also conceived by him as matters for critical interpretation on the part of both the painter and the viewer, for whom the painting initiates a kind of dialogue. An example is the *Rebecca and Eliezer* for Pointel, who in requesting the work from Poussin did not specify a subject but instead asked for the artist's *pensée* about a theme, that of different female beauties, and that he express this in rivalry with the concept of beauty expressed by Guido Reni. Or again, we shall consider the *conférence* led by the painter Sebastien Bourdon at the Académie Royale in 1667, just two years after Poussin's death, when the academicians debated at length whether Poussin's *Christ Healing the Blind* represents the miracle at Jericho or instead, as is certainly true, the miracle at Capernaum. Though this might seem to suggest that their primary interest was iconographical, the academicians do not dwell on Poussin's *subject* alone, but move on quickly to broader questions of his *theme* and its expression. As we shall see, Poussin's theme is that of sight itself, and sight conceived not only as a theme inherent in the Biblical subject, but also as inherent to Poussin's handling of the painterly means of light and color, which give sight to the viewer and hence themselves participate in the broader thematics suggested by Christ's giving sight to the blind. In both the *Rebecca and Eliezer* and the *Christ Healing the Blind* questions of style and subject, art and history, become jointly implicated in the broader thematics of painterly expression, and can no longer usefully be considered separately or in opposition to one another.

The question of Poussin's genres, especially in relation to the poetic thought of his contemporaries, has been taken up in several recent essays in historical criticism written by Marc Fumaroli. Following upon our investigation of Poussin's neoclassic study of the principles of "Greek" style, Fumaroli has suggested that this is also related to the ambitions of the new *ars musica*, with its exploration of the harmonic principles of the ancient Greek modes, and to Urban VIII's advocacy of a new *ars poetica*, self-consciously formed on Greek models such as the Pindaric ode, both of which hence also manifest neoclassic ambitions. Fumaroli has also drawn attention to the new social and courtly ideal of civil conversation that had been developed late in the sixteenth century, notably by writers such as Stefano Guazzo and Michel de Montaigne, according to whom works of art provided an occasion for sprightly response and conversation among sophisticated and lettered gentlemen in their moments of leisure. In responding to the work of art—whether presented in the form of a painting, a poem, or a letter—the

reader/viewer does not play a passive or solitary role, and the accumulated response to such works of art is also the extended cultural and social experience of all who have seen and conversed about the themes and expression of art itself. In fact, not only does the kind of conversation held in the Académie Royale by Bourdon and his fellows about Poussin's *Christ Healing the Blind* represent in an institutional setting a dialogue between the painting and its viewers (while Poussin's friend Félibien later organized his *Entretiens* in the form of a conversation between *amateurs* in dialogue with paintings), but also it had been Poussin himself who wrote to Chantelou in 1639 that it is necessary for him to engage paintings in just such dialogues, considering carefully the theme of each painting and its expression: "Lisez l'histoire et le tableau, afin de connaître si chaque chose est appropriée au sujet." Indeed, in recent years it has come to be acknowledged among art historians that, no matter whether the artist under consideration be Michelangelo, Pontormo, the Carracci, or Poussin, the issue of sociability—the artist's intellectual and physical context as well as his working conditions (to put it another way, the full cultural and social environment within which he practiced his art)—is no longer, as it was for Blunt, something necessarily at odds on materialist grounds with an understanding of the work of art itself. Nor are such considerations restricted only to the history of patronage, collecting, or provenance.

One of the chief aims of the present volume is to explore how what we know of Poussin's social and intellectual life might be brought to bear directly on the explication, understanding, and appreciation of his painting and the concerns that went into its production and final appearance. And this brings us to our second primary theme, which is that of Poussin's conception of himself in relation, not just to his paintings, but also to the world in which he lived as a man, to his friends and his patrons, and how he viewed his paintings as being not so much objects of possession as in open dialogue with them, as expressions of his own *honnêteté*. Taking Poussin's own statement about the allegory contained in his *Self-Portrait* for Chantelou—that the two arms embracing the personification of Painting indicate "l'amore di essa Pittura e l'amicizia"—as our point of departure (and for our title), we have associated each of the four pairs of chapters with important persons in Poussin's life. The first two sections are organized around two figures of the widest cultural influence and consequence: chapters one and two turn around the Marchese Vincenzo Giustiniani, whose personal example and whose collection of ancient art provided the foundation for Poussin's and his friend François Duquesnoy's revolutionary discovery of a new aesthetic based in "Greek" art; and chapters three and four take up the figure of Cassiano dal Pozzo, Poussin's close friend and most important Italian patron, whose position as the supervisor of Barberini scholarly patronage gave him access to all the resources of contemporary learning.

The chapters organized around Giustiniani treat first the two friends' study and analysis of the aesthetic qualities of ancient sculpture at a moment when both were working in an environment close to the Marchese and his famous collection of ancient statues, and how the fruits of that study blossomed in their work and that of another

friend, the younger Pietro Testa; and secondly of the aesthetic and social considerations that induced Giustiniani to publish his collection of statues in two splendid volumes of engravings, which he entitled the *Galleria Giustiniana*. Immensely intelligent and sophisticated, Giustiniani provides a unique point of reference for the development of questions of aesthetic knowledge gained through visual response and analysis, leading him to further consideration of comparative and provisional concepts of knowledge that are derived from the cultivation of individual tastes, natural inclinations, a certain *disinvoltura*, as well as affection and openness to every kind of experience, and civil conversation. All of these are integral components of the new social, intellectual, and highly moral notion of the *honnête homme*, whose early appearance in Italy (as his French name indicates) has tended until recently to be overshadowed by his French counterpart.

The two chapters organized around Cassiano dal Pozzo are concerned with a different kind of knowledge, one derived not from the senses or aesthetic experience but from scholarship and learning. Such learning, as we have seen, Blunt sought to differentiate from the "genuine" knowledge, or aesthetic that Poussin displayed in his art, a distinction that we suggested is misconceived. Our chapters on Dal Pozzo take up Poussin's *Seven Sacraments* and his researches into the rituals of the early Christians on the one hand, for which the essential antiquarian material had been collected in Cassiano's "Paper Museum"; and on the other they examine Poussin's study of Leonardo da Vinci's optical observations and theories as these had been transmitted to the seventeenth century, and again collected by Cassiano with a view to eventual publication (in which Poussin collaborated). As chapters devoted to the kind of knowledge gained by scholarly analysis, systematic cataloguing, and publication, these two also bear the closest resemblance to the familiar forms and methods of iconographical research, and of investigation into the concepts informing Renaissance "art theory." It should for that reason be kept in mind that the conversations that occurred in Cassiano's household, in and around his collections and *Museo Cartaceo*, were themselves encyclopaedic and academic in the special sense that Fumaroli has defined the social ritual and concept of civil conversation as "une encyclopédie orale et vivante."[11] In the ideal artists' studio invented and drawn by Poussin (discussed in chapter four) each artist—each investigator—makes his own observations, notwithstanding the fact that such analysis may repeat earlier and published experiments, and furthermore takes place within circumscribed laboratory conditions. Poussin himself, as we know, preferred to conduct his own academy, not in the workshop or atelier, but in daily conversations that occurred during his walks along the Pincio. Like the experience of travel for Vincenzo Giustiniani, the activity of painting for Poussin was neither a purely theoretical nor a simply practical part of his life, but an extension of his whole life and his continuing prudent search for wisdom and truth as an *honnête homme*. The sections devoted to Giustiniani and Dal Pozzo are therefore conceived as foils to one another. Although they introduce two different concepts of knowledge, we must insist that these are not concepts that we

would wish to see placed in mechanical opposition to one another. They are rather, historically as well as conceptually, two parts to an integrated whole, or two sides of the same question. The two sections serve as an introduction to questions of the overlapping thematics of subject and style that we take up in the second half of the book.

The third section of our book introduces a third patron and friend, Paul Fréart de Chantelou, but specifically it is organized around the writer Montaigne, Poussin's constant intellectual companion, who through the *Essais* taught him about friendship itself, and about the sublimation of passion in art—both lessons that Poussin sought to transmit to Chantelou in his letters and in painting. The fourth and final section, entitled "Poussin and the Poets," considers the ways in which the artist united intellectual friendship with personal affection and shared sentiment. Giovanni Battista Marino, author of the *Adone* and the *Strage degli Innocenti*—which states the theme treated in chapter seven—was Poussin's first Italian friend, who was responsible for bringing him from Paris to Rome. Cardinal Camillo Massimi, for whom Poussin painted the sublime Arcadian vision of the *Apollo and Daphne*—the subject of chapter eight—was the closest friend of the artist's old age, and this his last work. However, the most important question raised in this section concerns what a detailed examination of two quite different, but central themes in painting of the seicento—the revolting horror exemplified by the story of the Massacre of the Innocents, and the poetic landscape of Arcadia—can reveal about Poussin's own, particular interpretive genius.

Within each chapter of this book we will encounter many others who shared Poussin's journey of discovery and whom he counted as his friends: among them, Duquesnoy, Testa, Sandrart, Domenichino, Zaccolini, Pointel, and the family of Jean Dughet. Others, like Guido Reni and Caravaggio, are figures with whom Poussin conducted his own critical dialogue. Aside from the examples of Giustiniani and Dal Pozzo, however, Montaigne's own instance of *honnêteté* was so vital to Poussin that he is given an importance equal to that of the artist's own contemporaries, and placed in a kind of direct dialogue with him. By so doing, it is not at all our intention to question the importance of the other writers, patrons, or friends whom Blunt identified in an analysis of what he chose to characterize as the intellectual climate informing Poussin's philosophy. Nevertheless, taking Poussin's own association of himself with Montaigne as our point of departure, we have chosen to emphasize this particular relationship because it seems, as it developed over time, especially formative of Poussin's concept of himself and his work.

In attempting to move beyond technical problems of dating and chronology to the "meaning" of Poussin's paintings, Walter Friedlaender expressed his ambition to establish what he called a chronology of content (or what we have been calling themes), that in turn "would demonstrate the internal development of Poussin's style."[12] That it is possible even to think of such a chronology, in which the accumulated meaning of a long lifetime of painting bears an intimate relationship to the artist's personal develop-

ment as a man as well as a painter, is something new in the history of art. In Poussin's case, of course, such a possibility appears in greater relief because of the way in which he himself structured the market for his work. Too often seen as incidental, Poussin's deliberate distancing of himself from those upon whose purses he relied should instead be recognized as a new way of working and as a new self-conception of himself as a person, in which his own intentions outweigh the desires or will of a patron.

Philosophical arguments against the idea, or even the possibility of intentionality in art should not be confused with the history of expressed intention. Poussin's chronology of intention, especially when, as in the case of the *Sacraments* or the two *Self-Portraits*, he undertook to rethink his own purposes, is clearly to be distinguished from modernist concepts of self-expression. This is especially true when his intentions are considered in relation to Montaigne's morality and scepticism. Poussin's paintings, for all their expression of his evolving sensibilities and meditations upon the great and abiding themes of poetry and life, are no more frank and uncensored than is Montaigne's own book of essays, which Montaigne disingenuously claimed to be simply a series of confessions, "consubstantial with its author."[13]

Montaigne's importance for Poussin goes well beyond the part he played in the development of the practice of "civil conversation" to which we have referred. He came to provide a particular example for the painter by claiming to make of all his work a portrait of himself, assuring his readers (whom he defined, as Poussin indeed always tried to do in practice, as his friends), that "I am myself the matter of my book."[14] In the recognition that he could not sustain this theme of self-representation unaltered, for his feelings and opinions were themselves subject to change, he acknowledged that he did not portray being but passing, and with no contradiction to the truth. "If my mind could gain a firm footing," he writes in the essay *Du repentir*, "I would not make essays, I would make decisions; but it is ever in apprenticeship and on trial."[15] It is in such utter identification of the author with his work that the author himself comes into being and, in the particular historical examples of Montaigne and Poussin, that the distinction between history and art which so preoccupied Blunt, whether to consider the philosophy of the maker or the expression of his work, is collapsed: "He who touches the one, touches the other."[16]

Not surprisingly, it is in the *Self-Portrait* for his friend Chantelou that Poussin most directly established an argument that his paintings could be viewed as essays, as timebound expressions of what and who he was at that moment, not as he was yesterday or might be tomorrow. In his maturity Poussin was in a position to represent not only subjects from Montaigne (as in the *Death of Eudamidas*), but broader themes that even included (through the many devices treated in chapters five and six) the phenomenon of the essay, or trial of judgment, itself. Contrary, once again, to the entrenched idealist construction of Poussin as a classical painter of formally absolute truths, which in turn his critics at the turn of the century decried as icy academicism, we have tried to recover a historical sense of Poussin's dedication to questions of becoming rather than

being, of the *honnête homme*'s search for human understanding rather than perfection. He was surely one of the first painters (the example of Michelangelo also comes to mind) to contemplate directly the possibility of failure, and who continued in his old age to hope to paint a more perfect work before death overwhelmed him. Not wishing to frame Poussin in the image of the philosopher-painter struggling as the bearer of absolute truth within the constraints of an absolutist world, we would prefer to think of him, the great painter of nature, history, and poetry, no less than philosophy, as echoing the words of Montaigne: "Je n'enseigne poinct, je raconte."[17] And this was clearly understood by Bernini when he called Poussin a "gran' favoleggiatore." *teller of tales*

Poussin did not arrive at such self-awareness, and at the ability to express the provisional truths of his perpetually expanding knowledge and experience of the world all at once. At the same time, his extraordinary expression in visual form of the theme of sexual and artistic desire in the early *Mars and Venus* and its original pendant, the *Venus and Mercury* (the subject of chapter six), establishes how Poussin was already representing himself in his painting, with specific reference to Montaigne's *Essais*, very shortly after his arrival in Rome. His mode in this case is poetic rather than narrative, historical, or discursive in the manner of the essay. Nevertheless, as Friedlaender intuited, what links all Poussin's paintings in the end is the extraordinary sense they convey of an individual sensibility, of a sustained self-awareness that never ceases to speak to the individual beholder through the paintings of its own developing confidence and maturity, expressing a precocious concept of the man within the work that no other contemporary artist of Poussin's ambition (however much artists like Salvator Rosa, Pietro Testa, and even Caravaggio might have tried) was able to define and to represent in so disciplined and sustained a production.

So much is made of the fact that Poussin was already thirty when he arrived in Rome that we tend to overlook the equally remarkable fact that almost all of his forty years of painting occurred in the same place. However perspicuous, Friedlaender's account of Poussin's "chronology of content," moving, as he saw it, between periods of a "predilection for humanistic subjects, for fables and poetry, for Bacchanales and Old Testament scenes, for devotional subjects, and finally for the vagueness and poetic revival of Poussin's old age," touches on Poussin's intense relationship with the actual poetry of his time and place very little. In our last two chapters we take up two very different aspects of Poussin's relationship to poets and poetry, one from the early years of his career in Rome, and the other the epitome of his late mythological landscapes. The shift from one to the other is hardly towards vagueness, but is rather revelatory of the extent to which Poussin's poetic inventiveness developed.

In the *Massacre of the Innocents* his interpretation of visual and poetic "texts" was original, and quite distinct from that of such contemporaries as Reni and Rubens; but it remains comparable to theirs nonetheless, and not just because all three artists took the same passages from Marino's *Strage degli Innocenti* as their point of departure and as a challenge. By the time Poussin came to paint the *Birth of Bacchus*, now in The Fogg

Museum of Art, and especially the *Landscape with Apollo and Daphne*, his last painting and the last great Arcadian vision of his career, Poussin had arrived at an understanding of poetic and mythological truth, and an ability to express in paint his feeling about it that none of his contemporaries could match, and which no one could follow.

That we should conclude with an observation about Poussin's enduring theme of the sentiment of Arcadia seems right, for it is in his late works that Poussin succeeded in articulating without any hint of struggle or study that affective sensibility which had prompted his early study of "Greek" style, and to which Vincenzo Giustiniani also gave expression in the cultivation of his own taste. The means through which he did so was knowledge of the ancient culture of nature that he had come to understand in Cassiano dal Pozzo's house. Not all our eight chapters take the same form, and their argumentation is not always the same in terms of questions asked, or, therefore, in the methods chosen for working toward answers. Following Montaigne, Poussin expressly intended that, like speech itself, painting should belong partly to the painter and partly to the beholder. In conversations such as these, Montaigne had written, "As among tennis players, the receiver moves and makes himself ready according to the motion of the striker and the nature of the stroke."[18]

I

VINCENZO
GIUSTINIANI

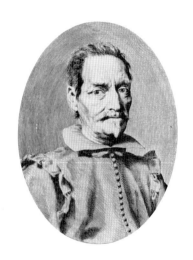

CHAPTER ONE

THE GREEK STYLE,

THE EXQUISITE TASTE, AND

THE PREHISTORY OF

NEOCLASSICISM

WHEN THE YOUNG ARTIST Pietro Testa from Lucca, still in his mid-teens and in search of a teacher, first arrived in Rome around 1628, he gained entry into the studio of the Bolognese artist Domenichino. Domenichino was to leave the city permanently for Naples in 1631, but before doing so he set Testa to copying the great works of art in Rome, as he had himself done as a young man and as artists had been doing for the whole of the preceding century. These were notably the paintings of Raphael and Polidoro da Caravaggio, together with the ancient statues and relief sculptures that could be found everywhere in the city. According to Testa's principal biographer, Giovanni Battista Passeri, who had also studied with Domenichino, Testa especially delighted in the "taste expressed in the ancient statues"—what we would call their style—and gave himself over to close and accurate study of them.[1]

While Testa was drawing in the Colosseum, on the Palatine, and after the statues in the Campidoglio, he was befriended by the German artist Joachim von Sandrart (who later wrote a short biography of Testa).[2] Sandrart had come to Rome in 1629 and, after working with Domenichino, was to be commissioned by the Marchese Vincenzo Giustiniani (who was, as we shall see, a profoundly knowledgable collector and patron of the arts) to engrave the ancient statues in his extraordinary collection. Sandrart in turn employed Testa to make drawings for these engravings, which eventually appeared as the two sumptuous volumes to be discussed in chapter two, entitled the *Galleria Giustiniana*. It was through this project that the young artist fell in with a remarkable group of foreign draughtsmen and printmakers who were all working under Sandrart's direction. These included Cornelis Bloemaert, Renier Persin, Theodor Matham, Michael Natalis, Claude Mellan, François Perrier (who in 1638 published one of the very earliest illustrated volumes expressly restricted to the finest ancient sculpture preserved

in Rome), together with the great Flemish sculptor François Duquesnoy, who had come to Rome in 1618 and was acquiring a high reputation as a connoisseur and restorer of ancient statuary. It was then too, if not earlier when studying with Domenichino, that Testa no doubt consolidated his friendship with Nicolas Poussin. The Frenchman had arrived in Rome in 1624, and he too had frequented Domenichino's studio to draw from the nude; he had also drawn after the statues in the Campidoglio and the gardens of Rome, and he had studied and measured a number of these ancient statues with Duquesnoy, with whom he shared rooms in 1625–26.³ Before the end of the decade all three artists, Poussin, Duquesnoy, and Testa, were employed by the great antiquarian scholar Cassiano dal Pozzo, secretary to Cardinal Francesco Barberini (the nephew of Urban VIII), in making drawings for his *Museo Cartaceo*, or "Paper Museum," of all the surviving antiquities of Rome.⁴ Like Testa, Duquesnoy worked on the *Galleria Giustiniana*, and both he and Poussin contributed works of their own to the Marchese's collection.

Together with the painter Andrea Sacchi, who had trained with Domenichino's Bolognese friend Francesco Albani (who earlier in his career had worked with Domenichino painting frescoes for Giustiniani's villa at Bassano di Sutri, and whose initial style, like Domenichino's, had been formed on the model of Annibale Carracci's later, more "classical" manner), Poussin, Duquesnoy, and Testa have been seen—and correctly so—as the principal later practitioners of a restrained, "classical" style that scholars have defined in an opposing relationship to the "baroque" style that dominates the century.⁵ The practical usefulness to art historians of the paired concepts of "classic" and "baroque," grounded especially in the stylistic antinomies set forth in Heinrich Wölfflin's great *Kunstgeschichtliche Grundbegriffe* of 1915, has been incalculable.⁶ It is important, nevertheless, to keep in mind that neither term has any part to play in artistic discourse of the seventeenth century. Scholars have long known that the word "baroque" was not applied to the visual arts before the end of the eighteenth century, when it appeared as a form of abuse (meaning the superlative form of "bizarre"), and that it was not used as a stylistic term until 1855, when it was so applied by Jacob Burckhardt and Wilhelm Luebke.⁷ In the same way, the concept of the "classic" in a stylistic rather than canonical sense was invented by Friedrich Schlegel in 1797, while its derivative "classicism" belongs entirely to the nineteenth century, occurring first in Italy in 1818, in Germany in 1820, in France in 1822, in Russia in 1830, and in England in 1831.⁸

The concepts of "classic" and "baroque" are themselves products of the Romantic movement, and they are indeed fundamental to that movement's attempt to define itself with respect to the tension then so acutely felt between the demands of reason and feeling. (It is significant that the earliest definitions of "classicism" do not oppose it to a concept of "baroque," but rather contrast it to "romanticism.") Since Wölfflin, scholars have come to depend on the generic opposition of classic to baroque as a convenient point of stylistic reference. However, precisely because the two terms are not histori-

cally founded in seventeenth-century criticism and practice, it has also proved difficult to apply them to particular historical situations.[9] Just what was the "taste expressed in the ancient statues" to which the young Testa responded so deeply? How does the "classicism" defined by Poussin and Duquesnoy in the 1620s, in the formation of which the Italians Testa and Sacchi were both participants and beneficiaries, differ from the "classicism" developed two decades earlier in Annibale Carracci's late style and directly adapted into the art of his students Domenichino and Albani, with whom Testa and Sacchi had their respective beginnings? And how, for that matter, does the "classicism" of either moment differ from that of Raphael and Polidoro, whose paintings the young Testa and generations of earlier artists in Rome, Albani and Domenichino among them, had sedulously copied as students?

The notion of "classic" style, both in its present-day usage and in its historical development as a critical term, has always carried with it a reference to Greek art of the fifth century B.C., which is taken as a benchmark or canon against which all later styles based in whatsoever idea of antiquity are explicitly or implicitly measured.[10] It is universally agreed that the establishment of this canon was the achievement of Johann Joachim Winckelmann, who in 1763 published his *Geschichte der Kunst des Altertums* (in which, however, the words "classic" and "classical" do not appear), the first comprehensive historical account of the stylistic development of the art of antiquity, including Egyptian and Etruscan as well as Greek and Roman.[11] By applying historical method to the study of ancient art, Winckelmann was able to perceive an organic development from youth to decay in its products, distinguishable into five periods: 1) an archaic, pre-Phidian style, 2) the High or Sublime Style of Phidias himself, 3) the Beautiful Style prevailing from Praxiteles to Lysippus, 4) the Imitative, or Eclectic Style of the Romans, and finally 5) a period of decay. On this basis he was able to claim and indeed insist (with the help of ethical, political, religious, and geographical arguments) that Greek sculpture of the finest period referred to a permanent standard of the very highest excellence.[12]

In the Renaissance no such clear distinction had been made between Greek and Roman art, much less a qualitative estimation of their respective merits (which were generally thought to be much the same), and the products of both cultures—meaning in fact what had survived in Italy—were generically referred to as the "antique." Winckelmann redefined the aesthetic and moral legacy of the whole of antiquity, and from his redefinition emerged the style of later eighteenth-century art that today is called Neoclassicism (again an *ex post facto* coinage of the mid-nineteenth century).

A fundamental aspect of Neoclassic style is its reference to a Greek canon, together with its historical awareness, indeed historical self-consciousness. This is not to say that all art of this period is explicitly Greek in derivation but rather that its point of reference, its touchstone of absolute value, had changed. Just as Winckelmann had argued that the stylistic development he had discovered in antiquity was repeated in the Renaissance—an archaic style before Raphael, a High Style in Leonardo and the

mature Raphael, a Beautiful Style in Correggio, an Eclectic Style in the Carracci and their followers, and a period of decay initiated in the time of Carlo Maratta—so too did artists rethink and reinterpret on that basis the values inherent in various historical models, among them the art of Etruria, ancient Rome, and the Renaissance. Already in 1755, in his *Gedanken über die Nachahmung der griechischen Werke in der Malerei und Bildhauerkunst*, Winckelmann had discovered a "Greek taste" evident in the works of Raphael and Correggio; and it was from his reconception of the standard of canonical excellence—an Ideal defined with reference to Greek art of the fifth century in particular and not to antiquity in general—that the seed of a true idea of classicism was sown. And so we find, not long after Winckelmann's claim that Raphael, Andrea del Sarto, and Leonardo were the modern counterparts of Phidias, Polyclitus, and Polygnotus, respectively, that the painter Anton Raphael Mengs (whose *Parnassus* of 1761, the initial manifesto of a Neoclassical style, was conceived with Winckelmann's conceptual collaboration) refers in his critical writings to the styles of Raphael and Correggio as "Greek."[13] The designation today seems historically inapt, and yet it is perfectly comprehensible if we but translate "Greek" as "classical." Along the same lines, when we find Mengs' friend Ireneo Affò in 1794 characterizing Correggio's paintings in the Camera di San Paolo in Parma as the earliest manifestation of his "Greek" manner, we have no difficulty in understanding him to be referring to Correggio's initial adoption of what is now agreed to be a recognizably High Renaissance "classical" style.[14]

THUS FAR we have found nothing remarkable about the moment of Pietro Testa's beginnings in Rome, his early acquaintance with Poussin and Duquesnoy, and the three artists' initial employment by Vincenzo Giustiniani and Cassiano dal Pozzo. After all, the story of the Renaissance itself begins with Brunelleschi's and Donatello's close study of the architecture and statues of ancient Rome, and at least since the pontificate of Leo X (1513–21) young artists had felt themselves obliged to study in what has been called the "great free academy" of Rome,[15] copying Polidoro's paintings on the palace facades of the city, Michelangelo's Sistine Chapel, and Raphael's frescoes in the Farnesina and in the Vatican. Passeri, however, does report something very remarkable in his life of Duquesnoy:

> His understanding contained within itself the most exquisite subtleties, and always fastened upon the best and choicest perfections, and he had a talent that was so refined that by his very selections of the best he made known the profundity of his knowledge. . . . He wished to show himself a rigorous imitator of the Greek style, which he called the true mistress of perfect procedure in art because it held within itself at one and the same time grandeur, nobility, majesty, and loveliness [*grandezza, nobiltà, maestà, e leggiadria*], all qualities difficult to unite together in a single compound, and this feeling was increased in him by the observations of

Poussin, who desired altogether to vilify the Latin style for reasons I shall report in my account of his life.[16]

This passage has always proved baffling, since Passeri unfortunately did not keep his promise to say more in his life of Poussin, and especially since, as Blunt observes in his monograph on the painter, "The distinction between Greek and Roman art was hardly noticed till the time of Winckelmann." Even so, Blunt acknowledges that Passeri's "passage is in itself enough to prove that [Poussin] considered the distinction between Greek and Roman art a matter of fundamental importance." After all, Passeri himself was born a century before Winckelmann, was an exact contemporary of Testa, and had known Poussin ever since all three artists had frequented the studio of Domenichino in the latter 1620s. Moreover, as Blunt observed, "Poussin's classical works of the 1640's and later have a solemnity and a grandeur which are strangely akin in feeling to Greek sculpture of the fifth century B.C."[17] Similar classical qualities have also been observed in Duquesnoy's sculpture, especially in his masterpiece, the *Sta. Susanna* in the church of Santa Maria di Loreto in Rome, which could justly be considered his canon (fig. 1). Of this statue Nava Cellini writes that to contemporary viewers such as Passeri and Bellori the "influences of the 'Greek manner' were immediately discernible," but instead of pursuing this important point she argues the frustratingly conventional proposition that Duquesnoy's sculpture, for all its classicism, is highly original and unmistakably of the seventeenth century.[18] No one would disagree, but at the same time the measure of Duquesnoy's originality and character as a seventeenth-century sculptor is to be found in his conception of the values inherent in Greek art. Nor does Blunt have more to say about Poussin's Hellenism.

What has always fascinated scholars, on the other hand, is the quality and depth of Poussin's antiquarian knowledge. His friend and biographer Bellori, for example, notices in Poussin's *Moses Striking the Rock* (now in the Duke of Sutherland's collection, on loan to the National Galleries of Scotland) a woman "with the hairstyle and trappings of Egypt, whence the Israelites had fled."[19] Poussin himself wrote a letter explaining that he had painted into his *Holy Family in Egypt*, now in St. Petersburg (fig. 2), many different things illustrating "the natural and moral history of Egypt and Ethiopia"—appropriately and accurately costumed Egyptian priests with shaven heads and tambourines, for example, sparrow-hawks on staffs, a birdhouse for the sacred ibis, and the coffin of Serapis—all taken from the Nilotic landscape represented on the mosaic floor of the ancient Temple of Fortune at Palestrina, then the site of a Barberini villa (fig. 3).[20] Similarly, Blunt comments that one of the women in Poussin's *Rebecca and Eliezer at the Well* (pl. VI) wears a Greek dress called a peplos, as does a woman in his drawing of *Moses and the Daughters of Jethro* (now in the Louvre).[21] As we shall consider in more detail in chapter three, the principal figure in *Diogenes Throwing Down His Cup* (fig. 71) appears with the *baculum* and *duplex pannum*, or staff and single cloak (folded double in winter), that the ancient authors attribute to the Cynic philosopher

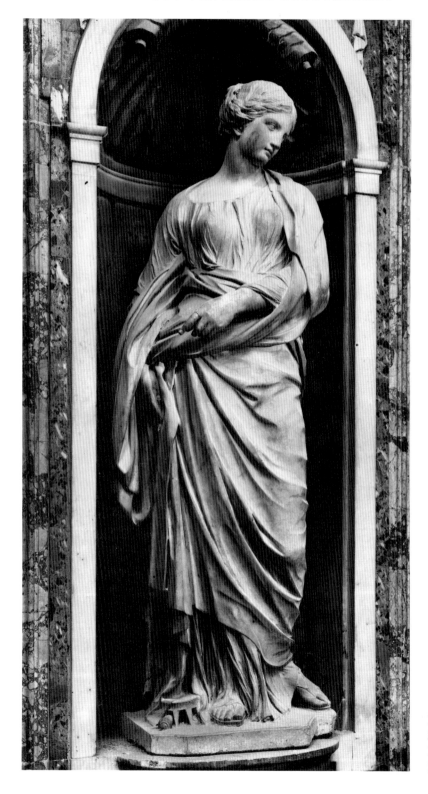

1. François
Duquesnoy, *Santa
Susanna,* Santa
Maria di Loreto,
Rome

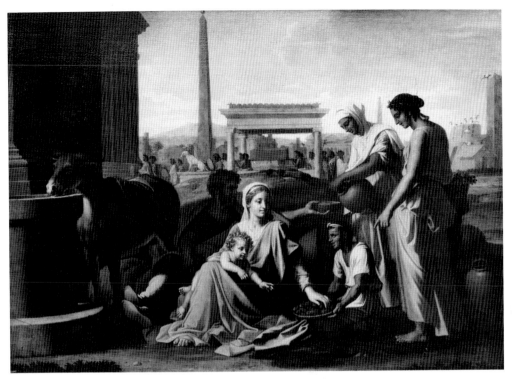

2. Nicolas Poussin, *The Holy Family in Egypt,* State Hermitage Museum, St. Petersburg

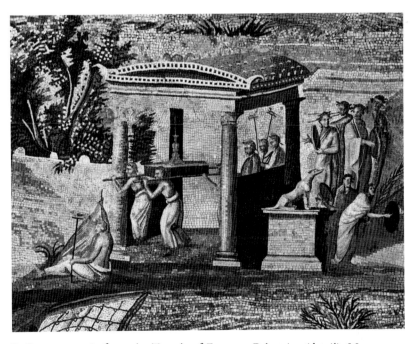

3. Roman mosaic from the Temple of Fortune, Palestrina (detail), Museo Archeologico Nazionale, Palestrina

(figs. 70 and 73).[22] In the same manner, the man receiving the sacrament in Poussin's *Confirmation* (pl. II), the primary subject of chapter three, wears the richly dyed robe and *latus clavus* of a Roman senator (fig. 74), while one of his daughters wears a stola.[23]

In a similar way Poussin's young friend Testa, in his etching entitled *Il Liceo della Pittura* (fig. 4), represented gathered around the central figure of Minerva (adapted from the famous *Minerva Giustiniana*, fig. 33)[24] figures intended to allegorize the origins and historical development of religion in human society: an obelisk with hieroglyphs to show that religion first arose in Egypt; a Greek priestess wearing the peplos; a Roman pontifex with robe drawn over his head in order to preside over the sacrifice taking place behind him; a Jewish high priest wearing the twin-peaked miter and twelve-jeweled breastplate of his office; and a Christian bishop. Especially interesting is the soldier who stands just to the right of the central group and listens to Aristotle lecture beneath a statue personifying Public Happiness. His long hair, tightly bound by a fillet and falling in neat, curly strands over his shoulders, clearly indicates that Testa's model was either the archaic Greek statue type called a kouros or an Etruscan derivative, as indeed does his stiff-legged pose, one foot set straight before the other (fig. 5). It is a moot point whether Testa chose the kouros type simply as a model of Greek costume and bearing (which is itself highly significant) or also as an appropriately archaic exemplar in allusion to Aristotle's notion that the political foundations

4. Pietro Testa, *Il Liceo della Pittura*, etching, Bibliothèque Nationale de France, Paris

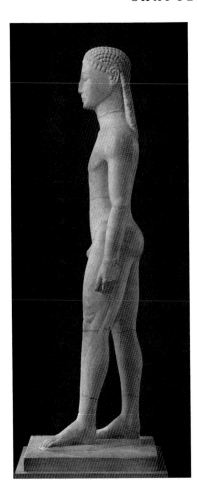

5. *Kouros,* The Metropolitan Museum
of Art, New York

to public happiness first arose in the primitive social units of the family, the soldiery, and the chieftainry.[25] Similar examples could be produced almost infinitely, but the essential point is that a consciousness of historical and chronological periods in antiquity without doubt existed in the minds of Poussin, Testa, and Duquesnoy. As it would be for Winckelmann, such historical awareness was a necessary precondition for their discovery of different stylistic moments in ancient art. If one is able to establish on sound historical and iconographical grounds that different statues represent Egyptian, Greek, and Roman personages, it is then possible to see each statue in rough chronological relation to the others and to begin to distinguish them according to changing technical and expressive criteria.

So far our examples give evidence of the considerable expertise of Poussin and Testa, and reveal much about the iconographic content of their works. The origins of their expertise are easily discovered in the compilation of Cassiano dal Pozzo's *Museo Cartaceo,* on which both artists are known to have worked (though the extent of their

participation, Poussin's especially, has yet to be established with certainty). Part of the purpose of the Paper Museum, as will be discussed further in chapter three, was to record all that survived of the ancient world in Rome, whether relief sculptures, religious implements, oil lamps, or Etruscan vases. Cassiano's conception was itself the product of the kind of investigation into the physical remains of Early Christian Rome that had been carried out in the previous generation by the great Church historian Cardinal Cesare Baronio and other scholars connected with the Oratory of Saint Philip Neri. Their goal was to compile all the material data necessary for a historical and indeed anthropological—but not necessarily artistic—understanding of the past and its different moments. Poussin's and Testa's own historical orientation began in their work with Cassiano and for his project. However, for these draughtsmen who had also drawn from the ancient statues as part of their own artistic education, it seems to have been but a short step to move from the ability to identify on the basis of historical evidence a particular ancient costume or artifact—an Egyptian sistrum, a Greek helmet, a Roman harness, or an Early Christian lamp—to a consequent ability to distinguish on critical grounds the objects themselves and the monuments on which they appeared as possessing different stylistic qualities and different values with respect to an abstract ideal of perfection.

That this is in fact what happened is indicated by Passeri's report that Poussin and Duquesnoy sought rigorously to imitate the Greek style, finding it much superior to the Roman. It is not easy to pinpoint the particular circumstances of their discovery, which certainly took place when the two young artists were living and working together around 1626, and which was well advanced by the time Duquesnoy received the commission for the *Sta. Susanna* in 1629. It would be difficult to believe, however, that it was not then recognized, confirmed, and encouraged by the taste of their second major early patron, Vincenzo Giustiniani.

Giustiniani, descended from a great Genoese family, had in fact been born on the Greek island of Chios, where his father was military governor under Turkish suzerainty. As we shall see in the next chapter, his project for having his own collection of ancient statues engraved, and indeed for forming the collection in the first place, had a very different purpose from Cassiano's *Museo Cartaceo*. Whereas Cassiano determined to catalogue and arrange thematically all available examples of antique religious and social customs, Giustiniani's intent was to publish in as beautiful a way as possible statues that he had himself assembled for their exemplary beauty and excellence. Giustiniani's response to sculpture, and especially ancient sculpture, is illustrated in an extraordinary way by the following famous passage from one of his letters to his friend Theodor Ameyden:

> It is necessary that the sculptor not only have knowledge equal to the painter in drawing perfectly, on the basis of experience acquired from the good ancient and modern statues and bas-reliefs, but also that he be superior to him in knowing how to give a beautiful posture to his figures. This means that they be well placed

on the base and of such grace and liveliness that they overcome the limits imposed by the stone, as can be seen in certain ancient statues. It is especially true of the Pighini *Adonis* [i.e., the Vatican *Meleager*],[26] which is a full-length standing statue, but so well proportioned in every part, of such exquisite workmanship, and with so many signs of indescribable vivacity, that in comparison to other works it seems to breathe. Yet it is of marble like the others, and in particular Michelangelo's *Risen Christ* in the church of Santa Maria sopra Minerva [in Rome], which is extremely beautiful and made with industry and diligence, but seems a mere statue. It does not have the liveliness and spirit of the *Adonis*, from which one may conclude that this particular consists of a grace given by nature, without which it is unattainable by art.[27]

It is not difficult to establish what particular statues Poussin and Duquesnoy especially admired. These in turn form the basis for understanding their conception of Greek style. Duquesnoy's *Sta. Susanna*, as all his biographers agree, was predicated on long and intense study of the Capitoline *Urania* (fig. 6) and Cesi *Juno* (fig. 7).[28] According to Bellori, he made copies of the Belvedere *Torso* (fig. 8) and the *Laocoon* (fig. 9), while he and Poussin together measured the Belvedere *Antinous* (figs. 10 and 11).[29] Indeed, the painter Charles Le Brun, who had known Poussin in Paris and who accompanied him on his return to Rome in 1642, describes the figures depicted in Poussin's *Israelites Gathering Manna* (completed for Paul Fréart de Chantelou in 1639, pl. I) as referring in their proportions and contours, *although not in their specific poses*, to a virtual compendium of famous ancient statues.[30] He observes that the elderly man standing to the left and the sick man next to him follow the proportions and contour (*taille*) of the father in the *Laocoon* group, which are certainly not those of an ailing man but at the same time of one past the full vigor of mature manhood; the breast-feeding woman and her suckling mother both combine a masculine yet delicate beauty that is appropriate to well-born women of middle age and is modeled on the Medici *Niobe* (now in the Uffizi, fig. 12);[31] the old man lying on the ground just beyond refers in the perfection of his lean and desiccated proportions to the Borghese (Pseudo-) *Seneca* (fig. 13), while the solid proportions and vigor of the young man who sustains him depend upon the Belvedere *Antinous* (fig. 10); the two youths battling over scraps of fallen manna mirror, respectively, the tender age of the younger son in the *Laocoon* group (fig. 9) and the more fully formed strength of one of the Medici *Wrestlers* (now in the Uffizi);[32] the kneeling woman with her back turned resembles in her elegantly gracious limbs and svelte contours the *Diane Chasseresse* (now in the Louvre);[33] the young man with a basket next to her, whose beauty is more delicate than that rendered in the *Antinous*, resembles instead the Belvedere *Apollo* (now in the Vatican); and finally, the woman holding up her robe to catch the manna as it falls exemplifies the proportion and contours of the Medici *Venus* (now in the Uffizi, fig. 14),[34] while the kneeling man in front of her derives from the *Hercules-Commodus* (now in the Vatican).[35]

Many more examples of ancient statues admired by Poussin and Duquesnoy could

6. *Urania,* Musei Capitolini, Rome

7. *Cesi Juno,* Musei Capitolini, Rome

easily be adduced. The list certainly would include those statues engraved and published in the *Segmenta nobilium signorum et statuarii* (1638) and *Icones et segmenta* (1645) by their friend François Perrier, who had worked with Duquesnoy and Testa on the Giustiniani project.[36] In fact we are here dealing with the initial formation of a selected canon of *admiranda* in Roman collections that was to serve as the basis, as Francis Haskell and Nicholas Penny have documented, of taste for two centuries to come. To be sure, some of these statues, such as the *Laocoon* or the Belvedere *Torso* and *Apollo*, had long been singled out as exemplary, as was the more recently discovered Niobid group

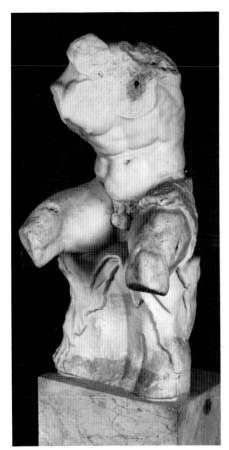

8. *Torso Belvedere,* Musei Vaticani, The Vatican

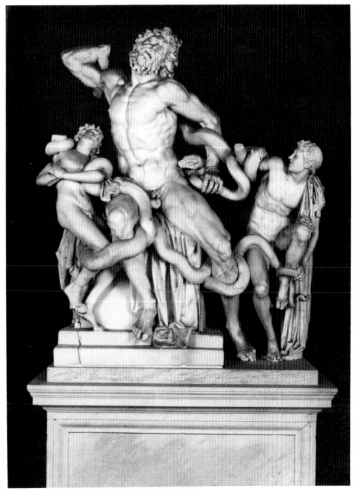

9. *Laocoon,* Musei Vaticani, The Vatican

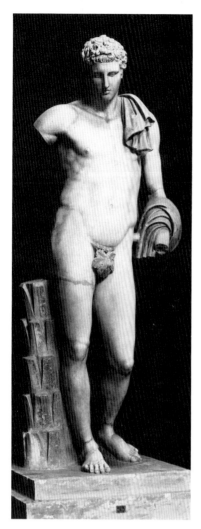

10. *Antinous Belvedere,* Musei
Vaticani, The Vatican

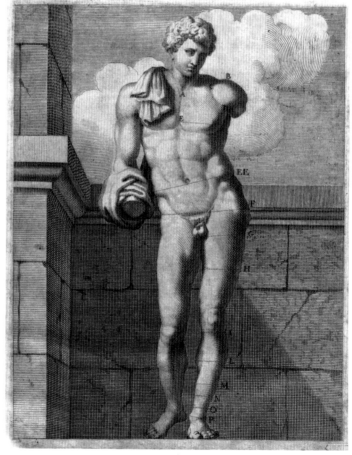

11. After Nicolas Poussin, *Antinous Belvedere,* engraving from G. P.
Bellori, *Le Vite de'pittori, scultori, ed architetti moderni,* Rome, 1672

13. (Pseudo-) *Seneca*, Musée du Louvre, Paris

12. *Medici Niobe*, Galleria degli Uffizi, Florence

14. *Medici Venus,* Galleria degli Uffizi, Florence

then displayed in the gardens of the Villa Medici in Rome. However, it is with Poussin's and Duquesnoy's fresh study of the ancient statues already existing in Rome—further spurred on not only by Giustiniani's collection but also by the stupendous finds made during the building of the Villa Ludovisi from 1621 to 1623—that the canon was extended and deepened and a different and new set of critical criteria applied. These new criteria identify the effects of different proportions and contours with such expressive and psychologically determined qualities as strength, delicacy, tenderness, and vigor.

Not long after Poussin's death in 1665, an expression of these criteria indeed crops up in the lectures of the Académie Royale in Paris, where they are identified as originating in Greek art; and different expressive qualities are moreover identified with the different styles characteristic of various Greek cities. In 1669, for example, the sculptor Michel Anguier spoke on the Farnese *Hercules* (now in the Museo Nazionale in

Naples),[37] which he identified as being by the Athenian sculptor Glycon, and in the following year he lectured on the *Laocoon* (fig. 9), which he said was sculptured by the Rhodian sculptors Hagesandrus, Polidorus, and Athenodorus.[38] Anguier, like Le Brun and Félibien, had known Poussin in Rome in the early 1640s, and like them was a powerful agent, both in his criticism and in his own sculpture, for transmitting the master's ideas to the artists of the French Academy. Although the texts of his lectures have been lost, his ideas were referred to in a lecture on proportions given by the French etcher and art historian Henri Testelin on October 2, 1678:

> One could, if it please your lordship, give an account in regard to this point [of the necessity for stronger contours in statues intended to be seen in full daylight] of what has been said about sculpture on previous occasions. It has been said, in speaking of the great Belvedere *Torso*, that one can distinguish four different manners among excellent sculptors. The first is called the strong and powerfully expressed, such as was followed by Michelangelo, the Carracci, and the whole of the Bolognese school, and this manner was attributed to the city of Athens. The second, weak and effeminate, which was followed by Étienne Delaulne, [Pierre] del Franqueville, [Germain] Pilon, and also Giovanni da Bologna, was considered to come from Corinth. The third, filled with tenderness and the various graces, especially regarding delicate details, was said to be followed by Apelles, Phidias, and Praxiteles in their design. This manner was highly esteemed, and was said to come from Rhodes. But the fourth is both sweet and correct, and indicates great contours, smoothly flowing, natural and fluent. This manner derives from the Peloponnesian city of Sicyon, the birthplace of Herodotus, the sculptor of the Belvedere *Torso* [sic]. It achieved perfection through selecting and joining to-gether those things that were most perfect in each of the other styles. It is also thought that this rare sculptor is the author of the small female torso that all scholars recognize as surpassing all the other antiques in its beauty.[39]

It is of course significant that Anguier, Testelin, and the French savants not only possessed an idea of Greek style but also distinguished this style into different manners and forms of expression associated with different Greek cities; moreover, they generalized these manners into principles applicable to the best modern artists. In both respects they anticipate Winckelmann's more historically detailed conceptions, and they furthermore indicate their critical heritage by applying to Greek art the concept of regional (but not chronological) style that had first been developed in the Carracci Academy, where the modern Italian schools were classified as Roman, Florentine, Venetian, Lombard, and ultimately Bolognese, in which the best of the others was unified. Moreover, the conception by the Carracci of regional Italian styles had itself already been identified by Agucchi as deriving from literary accounts of the different manners that had sprung up in the various Greek cities of antiquity.[40] So too, in 1668, does Le Brun anticipate, on grounds that had already been stated by Rubens earlier in the

century, the moral and geographical arguments of Winckelmann, who famously maintained that the climate of Greece produced superior physical specimens than existed in the modern world. In a remarkable response to Philippe de Champaigne's reproaching of Poussin for following the proportions and draperies of the ancient statues too closely, Le Brun asserted that on the contrary Poussin had been led through such imitation to a more perfect idea of nature itself:

> For in truth the Greeks had great advantages over us because their country ordinarily produced better formed people than ours, furnishing them with better models . . . and, for greater ease in observing their beauties, they incessantly had before their eyes young slaves who were nearly completely nude, as well as robust and well-made athletes whose appearance in their frequent spectacles gave ample material for study and examples of perfection to these excellent sculptors.[41]

DUQUESNOY'S FRIEND and pupil, the sculptor Orfeo Boselli, writing in Rome some time around 1657, observes that just as there are many who hate to admit that anything antique is marvelous, so there are others who study the remains of antiquity uncritically, failing to distinguish the good from the bad.[42] There are those who can tell good from bad, he continues, but only Duquesnoy could discriminate the good from the best. As we shall see, Boselli also stresses the importance of proportion and contour as criteria central to Duquesnoy's criticism. Passeri too, in the passage already quoted above, remarks upon the refinement of Duquesnoy's judgment (which undoubtedly was sharpened by his experience as a restorer of ancient statues), reporting that Duquesnoy found in the Greek style three related abstract qualities, grandeur, nobility, and majesty, as well as a fourth, *leggiadria*, or a lively grace, which is not easily combined with the gravity and weightiness implied by the others. Giustiniani was deeply impressed with the grace and sense of breath in the *Meleager* (fig. 15), in contrast to which the undoubtedly majestic *Risen Christ* of Michelangelo (fig. 16) to him seemed merely a statue. The comparison recalls Testelin's observation that the powerful "Athenian" style of Michelangelo and the Carracci is less perfect than the "Sicyonian" style of the Belvedere *Torso*, in which grandeur of contour is yet smoothly flowing and natural, producing a sweeter expressive effect. Le Brun, as well as Poussin's friend and biographer André Félibien, also refers particularly to the proportions and contours Poussin derived from "the most beautiful ancient statues," and they moreover make it plain that the artist consulted not one canon but several, which he distinguished according to affective qualities appropriate to different ages and sexes.[43]

Boselli too, in his unpublished treatise on sculpture, recommends particular canons according to age and sex, indicating some by now familiar examples and others less so:[44] for old men (*vecchi*), the *Laocoon*, the Belvedere *Torso*, and the *Nile*[45] and *Tiber*[46] (now respectively in the Vatican and the Louvre); for powerful old men (*vecchi robusti*), the Farnese *Hercules*; for men in their full maturity (*virili*) the men in the group

15. *Meleager,* Musei Vaticani, The Vatican

16. Michelangelo, *Risen Christ,* Sta. Maria sopra Minerva, Rome

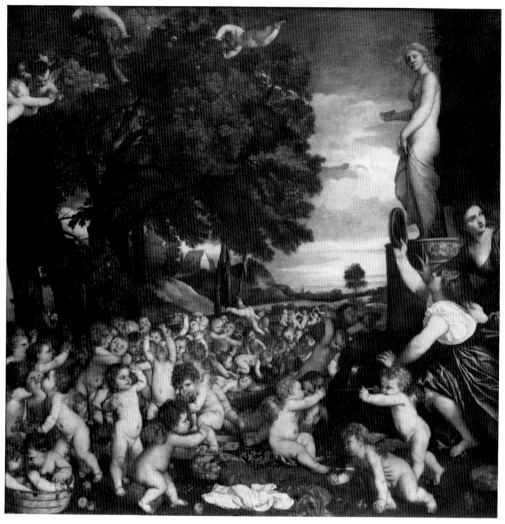

17. Titian, *The Worship of Venus,* Museo del Prado, Madrid

of the *Farnese Bull* (now in the Museo Nazionale in Naples);[47] for young men (*giovani*), the *Meleager*; for strong young men (*giovani robusti*), the bronze *Hercules* on the Capitoline;[48] for delicate youths (*giovani dilicati*), the sons in the *Laocoon* group and the Belvedere *Antinous*; for clothed women (*donne vestite*), the Cesi *Juno*, the Capitoline *Urania*, and the Farnese *Flora* (now in the Museo Nazionale in Naples);[49] for women (*donne*), the Medici *Venus* and the women from the Medici *Niobid* group; and for children (*putti*), either the ancient canon represented by the Capitoline *Ercole di selce* (the flint Hercules) or the modern and more tender canon discovered by Duquesnoy and Poussin on the basis of their study of Titian's *Worship of Venus* (fig. 17) in the Ludovisi Collection (now in the Prado).[50] "The marvelous in art," Boselli writes, "derives from a perfect understanding of all the beauties pertaining to our condition, from the least to

[handwritten marginal note: based on Venetian Greek statues, text: Philostratus (Greek)! Ch]

the best, and since the ancients availed themselves of this sort of imitation their works are therefore most marvelous." He continues:

> Who will ever find a more beautiful youth than the Belvedere *Antinous*? a more beautiful woman than the Medici *Venus*? a stronger old man than the Farnese *Hercules*? a more beautiful horse than that [of Marcus Aurelius] on the Capitoline? a more robust youth than the Borghese *Gladiator*? more grave propriety than in the *River Gods* [the *Nile* and *Tiber*]? more tenderness than in the *Fauns* and *Orestes and Pylades* of the Ludovisi? more masterfulness than in the Orsini *Pasquino*? an excellence greater than in the Colonna *Deification of Homer*? more expression than in the *Laocoon* group? greater softness than in the Caetani *Graces*? more decorum than in the histories on the Capitoline, the Arch of Constantine, and the Trajanic and Antonine columns? greater artifice than in the *Ara {di Bacco}* owned by Martino Longhi? a more beautiful head and drapery than in the Cesi *Juno*?[51]

Although it is clear that not all the examples cited in the above list are Greek—notably the Antonine reliefs on the Capitoline and the sculptures on the Arch of Constantine and the Columns of Trajan and Antoninus—the other statues mentioned could be so considered, many of them being signed in Greek, and all of them indeed being called Greek by Winckelmann and attributed accordingly until quite recent times.[52] But in what does their Greekness consist? Boselli confirms Le Brun's account of the qualities that Poussin perceived in the ancient statues and imitated in *The Israelites Gathering Manna*. They are psychological and expressly aesthetic qualities dependent upon physical proportion and contour. "The less the contour is pronounced," he writes, "the more Greek will the style be," for "since the human body is spherical it does not love straight lines: for it is beautifully graded, and where the contour recedes it meets with one that swells, and this law must not be broken [by the modern sculptor]."[53] This manner, Boselli writes, was taught him by Duquesnoy,

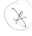

> who before having [students] copy a head taught [them] what its form was, whether round, square, or oval, and how with almost invisible lines to divide the form in half and then mark with a cross the intersections of the ends of the forehead, nose, and chin, teaching more how to seek out the whole than the parts. He showed with facility in what consisted Beauty, *Disegno*, Contour in the Greek style, Proportion, and Attitude. He convinced us of the need for diligence, and even more of the importance of contour, and to put the whole and the parts together.[54]

The purpose of such study was to acquire a grand manner, defined not according to its grandeur, nobility, and majesty alone but by its *leggiadria*, the exquisite loveliness and tenderness produced by the softness of its all but imperceptible gradations in contour:

The grand manner, accordingly, and the exquisite taste appear in making the work with sweetness and tenderness, which consists in knowing how to hide the bones, nerves, veins, and muscles; in keeping one's eye to the whole and not the parts—something so difficult that only to the ancients was conceded the great marvel of seeing a figure consummately beautiful, with everything and with nothing being there; of seeing a mind that had regard for the bones and a hand that worked in flesh. This tenderness of manner not only was practiced in the Apollos, Antinouses, Bacchuses, Fauns, and other youths of natural stature, but also in the great River Gods and even in stupendous colossi. The more they remove the grander the style becomes, for by so much the more does a sense of flesh increase as the hollows become less deep; and they substitute for the muscles something that seems a vein. It is an artifice beyond the supreme, and of surpassing difficulty.[55]

It will be apparent from this extraordinary statement that Boselli is characterizing an entirely new and refined conception of the grand manner, one evolved on the basis of Duquesnoy's and Poussin's early study of the ancient statues in Rome. It is a conception based not so much in power and epic scale as it is in an ennobled idea of the "exquisite taste." The point of emphasis is not on grandeur alone (and, although each undertook a few large commissions, both Poussin and Duquesnoy preferred smaller formats in which to express concepts of unquestioned nobility). It also stresses surface tenderness and finesse, whether in sculpturing young boys or colossi. Grandeur of style and conception—or, as Winckelmann would later name the foremost general characteristic of Greek art, "a noble simplicity and a quiet grandeur, in posture as well as in expression"[56]—consists in the mastery of all perfections. For this reason Testelin placed the strong and powerfully expressed "Athenian" style followed by Michelangelo and the Bolognese in the second rank, beneath the perfected "Sicyonian" style that also contained fluency, tenderness, and grace. For the same reason Giustiniani found *The Risen Christ* merely a statue in comparison to the ineffable liveliness and grace of the Pighini *Meleager*.[57]

Duquesnoy had characterized the qualities of exquisite surface as inherent in Greek handling of proportion and contour, and it is precisely this tenderness and "Greekness" of manner, a certain *leggiadria*, that Michelangelo was felt to lack. Moreover, the unified perfections of the new grand manner and the exquisite taste (or what came to be called in French criticism the *grand goût*) are affective in their very nature. As such, they differ fundamentally from the concept of unified perfections that had been emphasized by the Carracci in their reform of painting more than thirty years earlier.[58] Such perfections had been defined as deriving from the selective study of nature and the traditions of art, and referred to the rendering of such qualities as light and shadow, color, *disegno*, and proportion as these things could be deduced from nature and as they had each been individually perfected in the work of the great Renaissance

artists. The chiaroscuro of Titian and the coloring of Correggio, for example, could be joined with Michelangelo's *disegno* and Raphael's perfect symmetry and proportions. Such natural perfections could then be used for affective purposes to move the soul of the viewer within the context of a rhetorical argument or poetic invention, but affective qualities were not inherent in them by definition. For Poussin and Duquesnoy, on the other hand, the essence of a Greek proportion or contour, whether derived from *Laocoon* or one of his young sons, provoked in itself a sympathetic response embodied in the very figures of declining age or supple youth. It was itself affective, the embodiment of *expression* (italicized as the French term which they conceived and used), itself inherently expressive, the psychological foundation of style itself.

The concept of surface thus paradoxically includes stylistic and critical essence. As Félibien wrote, the ancients "gave their figures proportions in conformity with their character and rendered their gods with contours more fluent, more elegant, and of greater taste than those of ordinary men."[59] The point is perhaps more easily made if we compare the works of Poussin, Duquesnoy, or Testa with those of Annibale Carracci and Domenichino, the "classical" painters of the earlier generation. Both Annibale and Domenichino made use of the resonant effects of chiaroscuro, while Poussin painted in a brighter key, producing effects that recall Duquesnoy's admonition to his students that they should not hide behind the effects of shadow—"because in the end shadows are shadows, and whoever achieves shadow flees from the light."[60] Such statements by Duquesnoy, together with his well-known insistence that draperies be arranged in simple folds that reveal the form beneath, have been interpreted as expressing his opposition to the extravagantly "baroque" effects of Bernini, whose draperies are conceived independently of the forms they conceal and are deeply undercut, producing richly decorative chiaroscuro patterns and—in the view of his "Greek" critics—a glossy emotionalism fatally linked (despite Bernini's own close study and even restoration of the same ancient statues) to the splendor of his materials more than to the effects of life.[61]

Such understanding of Duquesnoy's criticism is true, but stresses its negative side. Duquesnoy intended to express a positive artistic conviction, one also upheld by the painter Sacchi in his debate with Pietro da Cortona in the Accademia di San Luca: that the true perfection of art, the consummate beauty of surface that carries the tenderness of life and flesh, which is the essence of the Greek sculptors' art, can only be seen in the full light of day. Thus it is that Bellori writes of Sacchi, "His contours are graded by a certain tenderness of shadows and lights, without strong contrasts, . . . and he unites with the beauty of the airs of his heads both grace and a noble manner of arranging fabrics and clothing, which he composed with an unaffected purity of folds over the nude body."[62] In this conviction painters like Sacchi and Poussin avoided the chiaroscuro and coloristic effects not only of painters such as Pietro da Cortona, but also Annibale Carracci and Domenichino, whose works they deeply admired.

It is obvious that Duquesnoy's *Sta. Susanna* (fig. 1) and the magnificent woman

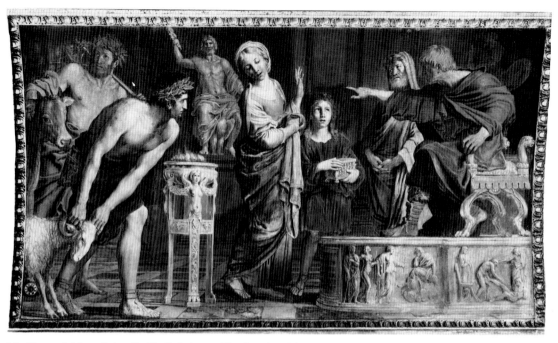

18. Domenichino, *Saint Cecilia Refusing to Worship the Idols,* Polet chapel, San Luigi dei Francesi, Rome

contemplating the tomb in Poussin's *Arcadian Shepherds* (pl. VIII) are portrayed with ideal features and simply massed drapery as well as particular costumes and hairstyles that are recognizably Greek. Both in fact take the Capitoline *Urania* and the Cesi *Juno* as points of departure. It is equally obvious that the heroine of Domenichino's profoundly antiquarian frescoes devoted to the life of Saint Cecilia in San Luigi dei Francesi in Rome instead responds to an ideal that cannot be called Greek at all, but is more generically and Latinly antique, compounded out of both the remains of Roman antiquity itself and the paintings of Raphael (fig. 18). The proportions of Domenichino's figures are discernibly squarer, calling to mind such models as the figures sculptured on the Column of Trajan as well as those painted by Raphael in the Loggia of Psyche in the Farnesina. They are deduced from a study of the natural perfections rendered in canonical models, rather than from analysis of those models according to expressive type or psychological idea. Because of this, Domenichino's rendering of the dramatic structure of his story—notably his handling of the *affetti*, or the affections expressed by the figures (for which he was preeminently famous)—follows from his disposition of the actors as participants in a great and solemn event, all carrying stamped upon their faces and in their gestures a sign of inner character.

Poussin, as is seen from Le Brun's perceptive description of *The Israelites Gathering Manna* (pl. I), not only represented or depicted the affections imprinted on the faces of the individual Israelites, but also embodied expression in their very forms. The pathos

of their individual characters is expressed in their bodies, conceived and defined by the perfected and abstract norms of tender infancy, blossoming youth, virile manhood, ripe female beauty, matronly nobility, advancing years, and desiccated old age and senescence. The proportions and contours appropriate to the character of each figure as representative of one or another universal human condition directly evoke a sympathetic response from the viewer that fits the particular part each plays in the story. Such a response, as conceived by Poussin, is in essence psychological, and on an instinctive level precedes rational analysis and reading of a dramatic narrative as orchestrated by the portrayal of the *affetti*, or passions. The *affetti* portray feelings, they dramatize or emblematize them, but they do not embody *expression*. *Expression* is rather, to use the term employed by Poussin in his letter on the Greek modes, a means by which the painter is able to predetermine the *disposition* of the beholder, to establish a primary response that is anterior to the secondary act of reading the actual subject of a work of art.[63] The two stages of response are not antithetical but aligned to one another, and Poussin also emphasized the importance of analyzing or "reading" a subject, as a means of rational confirmation of the viewer's preconditioned response. Examples of the kind of detailed analysis he required indeed survive, as we shall see in our examination in chapter four of the important debate over Poussin's own *Christ Healing the Blind*, in the many close critical readings recorded in the *conférences* of the French Academy.

As a new concept, *expression* derives its power from a prior, instinctive, virtually empathetic identification on the part of the beholder with the pure forms and character of the figures represented. Thus, in Poussin's *Massacre of the Innocents* in Chantilly (pl. XII), as well as in Testa's painting of the same subject in the Galleria Spada (fig. 148), both of which we will be examining in closer detail in chapter seven, we see the perfected forms of an infant Eros, a womanly Niobid, and a powerful, brutal gladiator. We need no exegete to tell us what we can already sense, and, on that basis, recoiling as we must at the sight of tenderness and nobility overwhelmed by brute strength, we thereby identify with the morally right conclusion. Initial, instinctive response, the viewer's *disposition* as determined by the artist, is then immediately confirmed by considered rational recollection of the story of the Massacre of the Innocents, its meaning, and the traditions of its retelling in art.

From this moment a rationalist Italian theory of the *affetti* begins to be replaced by the critical (and more truly aesthetic) concept called *expression* by the French. The distinction between the two, enunciated by De Piles in an important early attempt to differentiate *expression* and *passion* in art, is a subtle one, but it is also fundamental. "Every species of object requires a different mark of distinction," De Piles wrote, "Stone, water, trees, fur, feathers, and indeed every animal requires different touches in order to express the spirit of its character. The nude human figure too has its marks of distinction; some artists, in order to imitate flesh, give their contours an inflection that carries this spirit, while others, so as to imitate the antique, preserve in their contours the regularity of statues, fearing that they might lose something of their beauty."[64] And, he continues:

One further sees, in the drawings of the great masters, that in order to express the *passions* of the soul [the *affetti* or *moti*] they mastered certain strokes that show the *expression* of their idea even more vividly than their paintings. The word *expression*, when speaking of painting, is commonly confused with the word *passion*. They differ, nevertheless, in that *expression* is a general term which signifies the representation of an object according to the character of its nature, and according to the turn that the painter has designed to give it for the convenience of his work. And *passion*, in terms of painting, is a movement of the body accompanied by certain features of the face that mark an agitation of the soul. Accordingly, every *passion* is an *expression*, but every *expression* is not a *passion*. From this we must conclude that there is no object in a painting which does not possess its own *expression*.[65]

The concept of *expression*, as we have suggested, is at heart psychological in that it is based upon an emerging awareness on the part of Poussin and Duquesnoy of pure and unmediated sensory response to forms in and of themselves. At the same time it is intensely moral, simultaneously identifying the perfected forms of nature and antiquity not only with expression at its most intense, but also with a beauty that in its irresistible perfection embodies the very idea of truth itself. For Poussin the paradox inherent in the equation of beauty with truth was not an issue, and, as we have already remarked, instinctive response to the pathos of forms, predisposing the viewer to an automatic and correct understanding of the forces deployed in the narrative structure of a work of art, was necessarily followed by rational analysis and confirmation. It was only in the next century that, as Michael Fried has exhaustively documented, the natural tension between internal psychological response as governed by *expression* and externally organized dramatic narrative as disposed by the *passions* was to become problematized in the critical opposition of Absorption to Theatricality.[66] It was Poussin and Duquesnoy, however, who first conceived this distinction on the basis of their study and articulation of the values inherent in the contours and proportions of "Greek" form, and with the resulting fundamental change in emphasis a truly classical criticism in the modern sense, a criticism based not in reason alone (whatever its apologists might claim) but also in the paired concepts of an ideal beauty derived from Greek models and an instinctive moral response to the forms in which such beauty is embodied, begins its slow road to ascendancy over an earlier criticism of natural perfection based in a concept of the rational workings of universal laws of nature deduced from the art of antiquity in general as well as from the masters of the High Renaissance.

ALTHOUGH the young and virtually untrained Pietro Testa had initially been set by Domenichino to draw after the ancient statues, his own conception of ancient style was grounded in his early acquaintance with Duquesnoy and Poussin (as well as his youthful employment by Vincenzo Giustiniani and Cassiano dal Pozzo) rather than in the

imitation of Domenichino's own system of proportions. That Testa's figures, his use of classical models, and his modes of invention and expression, are much closer to Poussin's and Duquesnoy's than they are to those of the older master is telling. Indeed a number of his drawings (including the wonderful study at Rugby School for *The Prophecy of Basilides*) show Testa following the same method for establishing proportion that Boselli reports Duquesnoy used to teach his students, with almost invisible lines dividing the form in half and tiny crosses marking the principal intersections of the various parts.[67] As Passeri reports, it was from such study and from his "natural good taste" that Testa acquired his own *leggiadra maniera*, "such that he gained among the youths who were studying at the time an aura of great reputation, and was called *Il Lucchesino, esquesito disegnatore*."[68]

Testa was not himself one of the originators of the grand and exquisite style, but it was his good fortune to be present in Rome in the days of its inception by Poussin and Duquesnoy (whose foreign origins—like Giustiniani's—one can only feel must have freed these extraordinary intelligences to rethink issues of both ancient and modern style that native artists had taken as a matter of course). Testa's particular genius was to understand their conceptualization of an aesthetic basis for stylistic expression, and to be one of the first to explore the values they defined in inventions of his own devising. And his work, so deeply affected by theirs, stylistically documents what we have been saying about the revolutionary nature of Poussin's and Duquesnoy's insights. Thus, the irresistible infant loves swarming in giddy profusion in his *Venus and Adonis* or *Garden of Venus* (fig. 19), who reappear as angelic cherubs in *The Dream of Joseph*, dedicated to Cassiano dal Pozzo (fig. 20), are perfect models of the *putto moderno* that Bellori and Passeri report Poussin and Duquesnoy created on the basis of their close study of Titian's *Worship of Venus*. Bellori writes of the *putto moderno* that it was based on the appearance of a baby in its first year of life, and that it was conceived by Poussin and Duquesnoy in order to express the quality of tenderness.[69]

It has recently been shown by Anthony Colantuono, with reference to Boselli's treatise, how the proportions of these modern, tender infants were analyzed by Poussin and Duquesnoy as being different from those of the *putto antico*, and how *putti moderni* are also younger in age, being really impossibly young and too immaturely formed to be physically capable of the actions they are called upon to perform in art.[70] Colantuono also showed how for Poussin and Duquesnoy the ancient *putto*, derived from infants in their second year, was governed by what they called the *amabile proportione* (lovable proportion), denoting, and indeed literally embodying the aesthetic of *dolcezza*, or sweetness of expression. By contrast, the proportions of the modern *putto* signified, even while they simultaneously gave kinetic form and expression to, the quality of absolute *tenerezza*, or the ineffable tenderness of the newborn. Bellori found in the *putto moderno* the origin of what he called "the manner followed today," but warned that it had an inherent defect, for infants so young possessed neither the strength to pull on the bowstring nor the awareness to assume the role of mourners on tombs.[71]

In Bellori's view, imitators of Poussin and Duquesnoy who lacked their superior

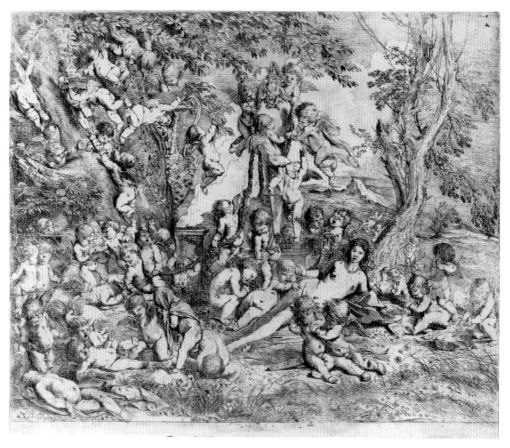

19. Pietro Testa, *Garden of Venus,* etching, Collection of Her Majesty Queen Elizabeth II, Royal Library, Windsor Castle

gifts and fine judgment often fell into clumsiness when attempting the *putto moderno*, an awkwardness that the inherent defect of the form only made more painfully evident: "Hoping to do better, it is easy to tinker and fall into excess, and so they have magnified this defect, making it palpable by swelling the cheeks, hands, feet, enlarging the head and bloating the belly in an ugly way, a vice that has insinuated itself into painting [as well as sculpture]."[72] As examples of the tender infant in the perfection of its contours and proportion, one need only cite the exquisite reliefs of heartbreakingly vulnerable babes sculptured by Duquesnoy, for which he is preeminently famous, in contrast to the creamily bloated cherubs favored by Bernini and his followers, with which the church of St. Peter's is filled. More instructive, perhaps, is the contrast between the resilient bellies and limbs of the putti painted by Poussin in such works as the Barberini *Infant Bacchanales* or the *Bacchanal before a Herm* in the National Gallery in London (fig. 21) to the obese and shapeless *erotes* depicted in the *Venus and Adonis* in the Kimbell Art Museum. This painting has recently been hopefully reattributed to

20. Pietro Testa, *The Dream of Joseph,* etching, Bibliothèque Nationale de France, Paris

Poussin, but should perhaps be reconsidered. It had been ascribed by Blunt to the "Master of the Clumsy Children," a designation that had been suggested to him by Ellis Waterhouse, undoubtedly with Bellori's criticism of the imitators of Duquesnoy's and Poussin's *putti moderni* in mind.[73] Testa's cherubic babes, on the other hand, like

21. Nicolas Poussin, *Bacchanal before a Herm,* National Gallery, London

those appearing in unquestioned works by Poussin, are not merely iconographic representations of the tender loves, but in fact embody tenderness itself, a tenderness that is appropriate to the feelings as well as the themes of love they celebrate, and that is bodied forth in the softly swelling contours of their cheeks, bellies, and thighs.

Testa also made the identification of passion with fleshly existence iconographically explicit in a number of his etchings, most movingly perhaps in the allegories of *Summer* (fig. 22) and *Winter* (fig. 23). In both prints he adopted the famous Platonic metaphor of the winged soul (for Testa the soul of the artist) struggling to escape from the mortal bondage of time and its entrapment in the elemental coil of bodily existence. For Plato the descent of the soul into matter meant its imprisonment in the passions of the sublunar world, from which escape was possible only through death or the exercise of virtue. In *Summer* the youthful soul of the artist hovers near death, assaulted by the elements and the passions directed against him, while in *Winter* his aging soul struggles upward toward its desired immortality, aided by Virtue, in an attempt to rise above the passions that still threaten, in the forms of Envy and Drunkenness, to pull him down.[74] Fleshly existence itself, in other words, signified for Testa

22. Pietro Testa, *Summer,* etching, Nationalmuseum, Stockholm

23. Pietro Testa, *Winter,* etching, Nationalmuseum, Stockholm

the embodiment of the passions, and the pathos of human existence is expressed in the tender vulnerability of the artist's youthful soul and in the declining strength of his aging soul, respectively embodied with the proportions and contours of the *Antinous* and the *Laocoon*.

Similar allegories of the passions together with the fleshly expression of their different natures occur throughout Testa's work, as in *Altro diletto ch'imparar non trovo* (fig. 24). In his etching of *The Triumph of Painting on Parnassus* (fig. 25), Testa's invention called for the personification of the affections so as to indicate the particular and supreme (merit of Painting herself, which is to express the passions). As the cartouches placed along the lower edge of the etching state, she expresses the affections (AFFECTVS EXPRIMIT) and therefore merits a triumphal arch (ARCVM MER-ETVR) and exaltation on Parnassus (PARNASO TRIVMPHAT). The affections are personified in the forms of a pair of lovers in the left background (tender infant loves at their feet) who signify Pleasure; in the figure wrestling with a serpent, derived from the *Laocoon*—long considered to be the *exemplum doloris* par excellence—who hence is to be identified as Pain, the opposite of Pleasure; in the heroically proportioned man thrust-

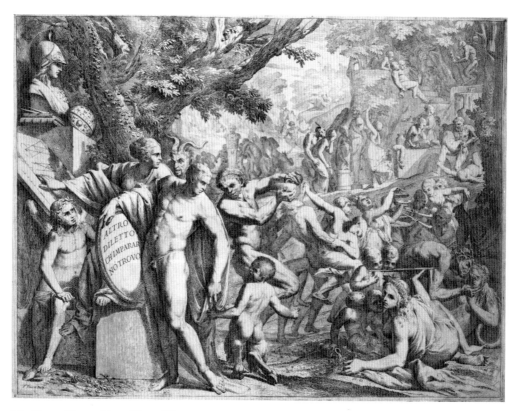

24. Pietro Testa, *Altro diletto ch'imparar non provo,* etching, The National Gallery of Scotland, Edinburgh

ing his arm into a lion's maw and in the emaciated old man behind him, who signify respectively Magnanimity and Pusillanimity; and in the lean, snake-encircled woman being crushed under the wheels of Painting's chariot, who represents Envy.[75] But it is not the ability of Painting to allegorize the passions that earns her a triumph on Parnassus, but rather her ability to *express* them bodily in living flesh (in Testa's inscription, AFFECTVS *EXPRIMIT*). This Testa accomplished by endowing the young lovers with the youthful proportions and soft contours of the *Antinous*, Pain with the forms of the aging *Laocoon*, Magnanimity with those of the virile Belvedere *Torso*, and Pusillanimity with the desiccated formal attributes of the old Borghese (Pseudo-) *Seneca*. In the same way the Muses opposite are distinguished expressively, with the leading Muse endowed with the nobility and grandeur of the Cesi *Juno*, for example, and the Muse seen in profile behind her figured with the more youthful proportions of the Medici *Venus*. As the one embodies a regal and matronly dignity appropriate to Melpomene, the Muse of Tragedy, and the other a more delicately voluptuous ideal appropriate to Erato, the Muse of Love Poetry, so too does the young hero of *The Triumph of the Virtuous Artist on Parnassus* (fig. 26) embody the very essence of hopeful youth by incarnating the proportions and contours of the *Antinous*, while the figure of Time at his feet, formed on the model of the *Laocoon*, expresses pain and defeat not merely because he is

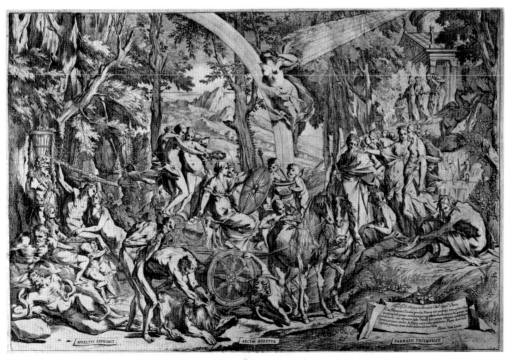

25. Pietro Testa, *Triumph of Painting*, etching, Bibliothèque Nationale de France, Paris

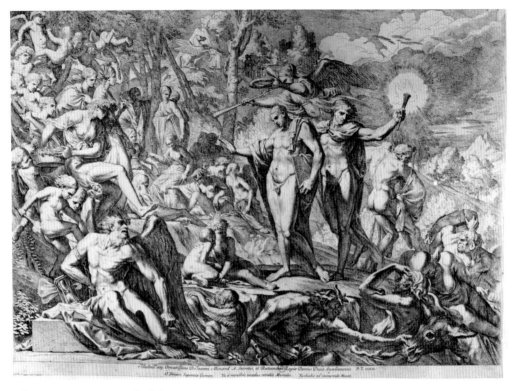

26. Pietro Testa, *Triumph of the Virtuous Artist on Parnassus,* etching, Bibliothèque Nationale de France, Paris

allegorically bound but also because his body is that of a man beyond the fullness of adult strength, a body beginning to decline with advancing age.

In this mode of artistic thinking we can discern the workings of a revised concept of artistic value, one based in an emerging criticism of purely visual expression founded in an idea of psychological response to form. This concept is not yet the pure Aesthetic conceived by Alexander Gottlieb Baumgarten and Immanuel Kant a century later, for the methods followed by Testa and his early mentors are profoundly rational and moral, but one rooted in an emerging idea of taste (meaning the exercise of a judgment of sense, or aesthetic judgment, as Aristotle had defined it) that has long been seen as paving the way for their discoveries.[76]

In the same sense the acutely rational analysis of ideal qualities undertaken by Poussin, Duquesnoy, and Testa in those exhilarating days of drawing and study in the gardens of Rome during the 1620s paved the way for Winckelmann's concept of Greek style, even though it cannot be said to be identical to it. Yet they set the criteria that were to be developed in the French Academy and transmitted to Winckelmann more than a century later in their very concept of the Greek in art, in their definition of a Greek grand manner possessing both nobility and a *leggiadria* bestowed through the

workings of a refined and exquisite taste, in their derivation of the principles of Greek proportion through exact measurement, in their responses to the indescribably subtle and life-simulating modulations of a Greek contour, and in their identification of a Greek ideal with expressive and poetic qualities that are simultaneously psychological and highly moral. How this was done is still not well understood. As Jacques Thuillier observed some thirty years ago, the painters, sculptors, and critics of the French Academy, such as Poussin's friends Le Brun, Anguier, and Félibien, were not mere epigones of the Italians but developers of highly original channels of thought. The measure of their originality and its basis in ideas first articulated and given form in those early years of intense study and creative activity in the sculpture collections in Rome in the 1620s is still uncharted.[77]

The reasons for this are not hard to discover. They are based to a great extent in a modern aversion to the kind of theoretical reasoning and study that so deeply engrossed Poussin, Duquesnoy, and Testa, together with a modern mistrust and even fear of emotional content in art. Even Francis Haskell and Nicholas Penny, for example, in *Taste and the Antique*, their excellent and (as this chapter testifies) indispensable book on the collecting and appreciation of ancient art, find themselves constantly embarrassed when the actual expression of taste, as distinguished from its material consequences in the purchasing and formation of collections of art, arises in the writings of seventeenth- and eighteenth-century critics and travelers. The plates of Gérard Audran's *Les proportions du corps humain mesurés sur les plus belles figures de l'antiquité*, published in Paris in 1683, are characterized as "somewhat pedantic," although in spirit and content they follow upon the measurements of the ancient statues made by Duquesnoy and Poussin in their attempts to understand the subtleties of Greek proportion and contour half a century earlier.[78] Ironic disapproval greets the "irresistible urge to rhapsodise" over the familiar canon of ancient statues from which, as Montesquieu is quoted, "'the Moderns have built up their system of proportions, and . . . which have virtually given us the arts.'"[79] And yet the system of proportions deduced by Poussin and Duquesnoy in their studies of those statues was conceived with an excitement of discovery and purpose that was scarcely pedantic but instead inherently and aesthetically affective, rhapsodic in its true meaning of exalted expression. Nevertheless, the abbé Raguenet is found to have extolled the expression inherent in the ancient statues "in melodramatic prose" and not without "a touch of the absurd" in the following passage from *Les monumens de Rome* of 1700:

Life, Death, Agony, the suspension of Life, the image of Death—all that is nothing; but states which are neither Life, nor Death, nor Agony, such as the Niobe who is neither alive nor dead nor dying but turned to stone. Two kinds of Sleep—natural sleep, as in the Faun in the Palazzo Barberini and drunken sleep as in the Ludovisi Silenus. Reverie—as in the figure which one sees on the Palatine [the Farnese *Agrippina*]. Lassitude—as in the Farnese Hercules. Agony—as

in the Seneca in the Villa Borghese. Finally, the very moment from Life to Death, the instant of the last breath, as in the Myrmillo [*Dying Gladiator*].[80]

Neither melodrama nor absurdity seems self-evidently apparent in these words, unless one were to find the pathos of the works of art themselves melodramatic and absurd, as well as any attempt to describe their effects. What appears instead is the critical application of an important theory of expression that had taken root in the thought of the artists of the French Academy, and that is itself a response to expressive qualities in art that does not differ in kind (or perceptiveness) from Boselli's discernment in the *Laocoon* of piety mixed with agony, or Winckelmann's perception that the agony expressed in the statue follows not only from facial expression but also from the very forms of the body.

Winckelmann's famous poetic passages on the Belvedere *Torso*, *Apollo*, and *Laocoon* are also received by Haskell and Penny with uneasiness, although his methods are described in a fine, if sardonic paragraph:

> His generalisations about the treatment of gods and heroes in sculpture are always based on the scrutiny of separate parts of individual works, and this technique . . . further sharpened in his readers that alertness to minute particulars which art historians today are taught to believe was first propagated by [Giovanni] Morelli a century later. Winckelmann's observations on the size of nipples and knees; his fastidious anxiety about the depth of the *Venus de' Medici*'s navel; the enormous importance he attached to the scarcely detectable flaring of the *Apollo*'s nostrils—are all highly characteristic: "he catches the thread of a whole sequence of laws in some hollowing of the hand, or dividing of the hair" [Pater]. We sense his influence immediately when we read in Goethe of a group of German art students discussing the *Apollo*'s ears, or when we hear a French connoisseur pointing out that the merit of the Capitoline [sic] *Antinous* was demonstrated by the fact that the undercutting of the testicles was so fine that a piece of paper slipped between them and the thigh would be held in place, or, later, when—as described by an indignant traveller—"so many people who know nothing at all of muscles and veins" [Galiffe] are to be found holding forth for hours about the surface of the [Belvedere] *Torso*.[81]

We in turn can sense the influence upon Winckelmann of a method and a critical vocabulary that had earlier been developed for describing the qualities of the Greek style—the analysis of the statues and their proportions part by part, the attention to the rippling contours of muscles and veins, the aesthetic of surface treatment, and above all the expressive language employed. In all these things appears the marshaling of critical criteria and aims that descend from the analyses of the ancient statues undertaken by Duquesnoy and Poussin many years earlier, applied by them in their own art, and transmitted to their followers in Rome, Paris, and ultimately Prussia.

IT IS OFTEN SAID that the classical style in seventeenth-century Rome, from its inception in the later works of Annibale Carracci to its fundamental reorientation in the art and critical thought of Duquesnoy, Poussin, Sacchi, and Testa, however sublime their individual creations may be, was nevertheless a rear-guard action that in the end suffered defeat at the hands of the dominant baroque taste expressed in the sculpture of Bernini and the paintings of Pietro da Cortona. In the short term, this may be correct, although even as a short-term proposition it is open to debate, for the reason that the values they discovered and defined in "Greek" art are, like the very concept of classicism itself, neoclassic.

Poussin shunned public commissions, and Sacchi and Duquesnoy (a man, like Testa, deeply melancholic by nature) were both notoriously slow workers, undoubtedly because of the extreme difficulty of the aims they set for themselves. However, they also had great reputations. Extremely interesting light on one of the bases for Duquesnoy's reputation, for example, is shed by the circumstances motivating the purchase in the second quarter of the seventeenth century of several of his bronzes, including a *Mercury* very possibly acquired from the Giustiniani collection (fig. 27), by Karl Eusebius von Liechtenstein (1611–1684). The surviving documentation makes it very clear that the

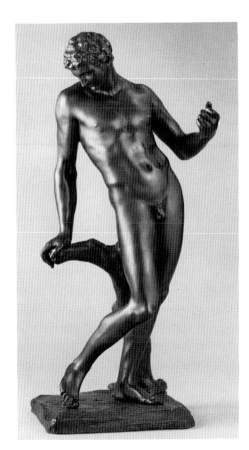

27. François Duquesnoy, *Mercury,* Princely Collections of the Prince of Liechtenstein, Vaduz

prince was interested in precisely the exquisite qualities of contour and surface handling that we have been considering, and that his dominant concern was to build a collection that was based on considerations of quality, containing sculptures and paintings that constitute "a beautiful and necessary *curiosität*," and which would reveal his own capacities as a true connoisseur. The basis for such quality appears in a letter written by Johann Adam von Liechtenstein, Karl Eusebius' son, to the Florentine sculptor Massimiliano Soldani, admonishing him to take great care with the chasing of the surfaces of the bronzes to be sent him, "so that they retain their softness, and that some contour not be spoilt" (*che le cose restino morbide e che non si guasti qualche contorno*).[82]

By the end of the century Roman painting was dominated by Carlo Maratta, who had been Sacchi's pupil and whose style was formed on Sacchi's paintings in the Lateran Baptistry and such works as the astonishing portrait of *Marc'antonio Pasqualini Crowned by Apollo* now in The Metropolitan Museum in New York (fig. 28). Here the figure of the god is conceived according to an extreme, epicene interpretive idea of softly feminine expression—indeed prettiness of taste—deduced from the Belvedere *Apollo* that can only be called Neoclassic *avant la lettre*. In Maratta's lifetime, however, Italian dominance in the arts was ceding to France, where the (neo-) classical ideas and example of Poussin were to be developed and tested against the coloristic and dramatic powers of another non-Italian painter, Peter Paul Rubens.

In the long term, therefore, it is certainly not true that the idea of classical art prefigured in the discovery of the Greek style was in any sense a rear-guard action; it was in fact a new and powerful idea that still has not completely run its course. The emergence of classic taste in France, together with its identification with an idea of aesthetic purity and expressive truth (as contrasted to an idea of speciousness and theatricality identifiable in baroque taste), is fundamentally linked to the thought of Poussin. Similarly his paintings, and especially the designs he made for the decoration of the Grand Gallery in the Louvre (which were to be painted as grisailles imitating ancient relief sculpture and which possess a purity of style that might raise the envy of a John Flaxman or Bertel Thorwaldsen), provided the examples from which French Neoclassic style took its point of departure (fig. 29). Duquesnoy's *Sta. Susanna* (fig. 1) is little known except to specialists today, but for Bellori it was the canon for the modern draped figure. In the seventeenth and eighteenth centuries it was copied more than any other statue, including the most famous works by Bernini, and Wittkower was right to observe that a direct line leads from its lyrical and delicate tenderness of expression (praised by Bellori as "un aria dolce di grazia purissima," or a sweet air of purest grace)[83] to the often sentimental prettiness of what he called the "classicist Rococo."[84] Just as Cassiano dal Pozzo assembled and catalogued the remains of the Roman past, as well as the materials of natural history, in the drawings he commissioned for his *Museo Cartaceo*, so Poussin and Duquesnoy subjected the material of style and expression themselves to taxonomic analysis, redefining the criteria of excellence. In the process they not only expanded the canon of ancient exemplars but also changed the ways in

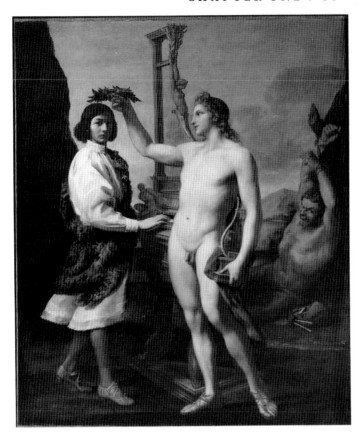

28. Andrea Sacchi,
*Marc'antonio Pasqualini
Crowned by Apollo,* The
Metropolitan Museum of
Art, New York

which they were experienced and understood. In their own art they, like their young
follower Testa, put their discoveries to the test, enriching the ancient canon with mod-
ern "Greek" exemplars. Thus, as Bellori again writes of one of the mourning infants
Duquesnoy sculptured for the tomb of Ferdinand van den Eynde in the church of Santa
Maria dell'Anima in Rome, "This is certainly the most beautiful infant that ever was
animated by Duquesnoy's chisel, and it is put forward, together with his companion
opposite, by sculptors and painters as the exemplar and idea [of tender infancy]."[85]

Pietro Testa's work is scarcely better known today than Duquesnoy's, but the
great demand for his prints, which were constantly reprinted from the day of his death
by publishers in Rome, Paris, and Amsterdam, continued until well into the eigh-
teenth century.[86] His work was much copied in the academies of Italy, France, and
England, and the classical conception of his later prints was especially emulated in
French Neoclassic painting. The powerful expression of the passions in etchings like
The Suicide of Cato and paintings like *Aeneas on the Bank of the River Styx* (fig. 30) found
its direct inheritance in Le Brun's *Treatise on the Passions,*[87] and struck deep chords in
romantic classicists such as Henry Fuseli and James Barry.[88] Similarly, Testa's series of

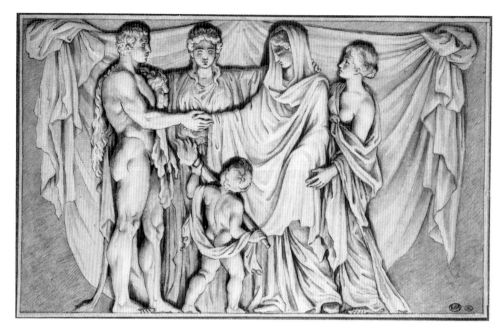

29. After Nicolas Poussin, *The Marriage of Hercules with Megara,* drawing, Département des arts graphiques, Musée du Louvre, Paris

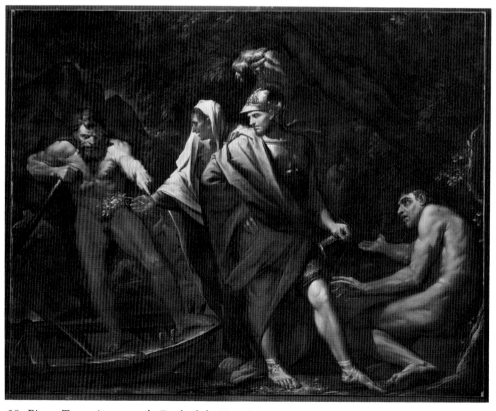

30. Pietro Testa, *Aeneas on the Bank of the River Styx,* Private Collection, New York

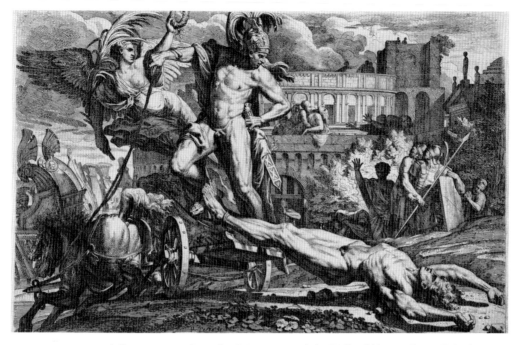

31. Pietro Testa, *Achilles Dragging the Body of Hector around the Walls of Troy,* etching, British Museum, London

etchings devoted to the *Iliad*, and notably *Achilles Dragging the Body of Hector around the Walls of Troy* (fig. 31), are profoundly neoclassic in spirit and directly affected the works of artists such as Gavin Hamilton.[89] In perhaps the finest tribute of all, many of his drawings were acquired and engraved by the French publisher François Collignon, who issued them not as finished examples of Testa's inventions (as Marcantonio had done for Raphael) but instead as samples, complete with *pentimenti*, of his draftsmanship. Testa, along with Guercino, is one of the first artists whose drawings were published in this way, and this is in itself sufficient vindication of Passeri's claims for the high regard in which connoisseurs and other artists held his drawings, earning him the name of *esquesito disegnatore*. Having witnessed and participated in the revolution in critical taste that had been brought about by Poussin and Duquesnoy, Testa worked in the new exquisiteness of manner that was the fruit of the swelling of delight that Passeri recalls was roused in the young artist when he first experienced and understood the "taste expressed in the ancient statues" while drawing as a youth in the sculpture gardens of Rome.

CHAPTER TWO

VINCENZO GIUSTINIANI'S *GALLERIA*: A TASTE FOR STYLE AND AN INCLINATION TO PLEASURE

THE PAINTERS Nicolas Poussin, Pietro Testa, and Giovanni Battista Ruggieri, the printmakers Giovanni Andrea Podestà, Claude Mellan, and Anna Maria Vaiani, and the sculptor François Duquesnoy are among the best known among a band of artists who moved easily between Cassiano dal Pozzo's palace in the via dei Chiavari and Vincenzo Giustiniani's more splendid property at S. Eustachio in the early 1630s.[1] Even if, as Poussin and Testa surely did, they stopped on the way to look at Domenichino's frescoes at S. Andrea della Valle, and stepped into the Pantheon to remember Raphael, the walk was but a short one.

How great was the philosophical or social distance between the patrons of these two households is harder to assess. Neither family was Roman, but by 1631, when Vincenzo announced his project to reproduce his collection of antiquities through the publication of an engraved portrait of himself by Mellan (fig. 32), the Giustiniani of Chios had been established in the city for just over sixty years. A member of a large Genoese family, Vincenzo's father, Giuseppe Giustiniani, had ruled Chios under Turkish feud until the Turks themselves occupied the island. At this point, in 1566, and two years after his son's birth, he moved to Rome, where, in 1586, his older son Benedetto became a Cardinal and Treasurer of the Apostolic Camera. In 1590, the family acquired the palace opposite S. Luigi de' Francesi, where the brothers lived together with their father, excluding the period Benedetto spent in Ferrara with the Pope in 1598. After Giuseppe's death in 1600 Vincenzo and Benedetto shared residency in the palace, except for the years between 1606 and 1611, when Benedetto served as Papal Legate in Bologna. Vincenzo purchased the feud of Bassano di Sutri in 1595. He set about constructing the palace there in 1603, immediately after which it was beautifully decorated with frescoes by Domenichino and Albani, among others,

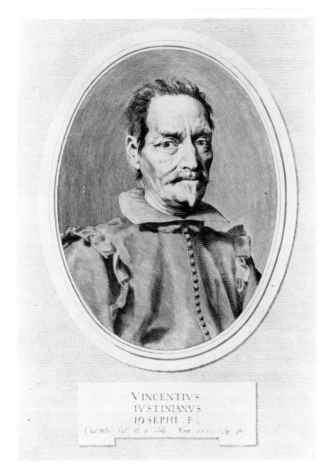

VINCENTIVS
IVSTINIANVS
IOSEPHI . F .

32. Claude Mellan, *Vincenzo Giustiniani*, engraving, *Galleria Giustiniana*, I, plate 2

and Bassano was raised to a marquisate in 1605.[2] Cassiano, on the other hand, admitted to the Sienese nobility and a member of the military order of the Knights of St. Stephen, arrived in Rome only in 1612. He had moved into his palace there as recently as 1626.[3] Both men travelled extensively outside Italy, but for very different reasons. Vincenzo, as we shall see, undertook his journey to northern Europe in 1606 as a noble gentleman seeking diversion, and as an opportunity for leisurely and extended conversation about different cultures and works of art. Cassiano's journeys, if just as full of conversations about art, were diplomatic missions undertaken as a courtier in the Barberini household.

Noble birth and a large fortune clearly set the two men apart.[4] Sixteen years after Vincenzo Giustiniani's death in 1637, Cassiano himself reflected upon their difference, and specifically in the context of their different paper projects. Writing in 1653, he recalled that the Marchese had been so rich that he was able to commission artists as famous as Lanfranco to make drawings for his prints, and that he even had the large

sheets of paper for the *Galleria* produced in the palace.[5] Engraving on a large scale was clearly beyond Cassiano's means, although in 1634 the great French antiquarian scholar Nicolas-Claude Fabri de Peiresc was still encouraging him to publish his collection in direct emulation of Vincenzo.[6] Cassiano was, of course, directly if not financially involved in various other publications illustrated with the finest engravings, among them G. B. Ferrari's *De Florum Cultura* (Rome, 1633) and *Hesperides* (Rome, 1646), both published under the patronage of the Barberini.[7] These contained plates by several of Vincenzo's artists, including the elusive Anna Maria Vaiani, and even the expensive Lanfranco.[8]

Cassiano dal Pozzo the antiquarian seems inseparable from Cassiano dal Pozzo the patron of Poussin and Testa. By contrast, Vincenzo Giustiniani's palace of art has often been presented as divided against itself. So remarkable was Giustiniani's early passion for the work of Caravaggio that his support for later arrivals on the Roman scene has been overshadowed by it. Nonetheless, his collection of modern paintings is generally recognized as having been without rival in Rome around 1630.[9] Vincenzo's vast *antiquarium*, on the other hand, distributed among his various properties, is often seen, perhaps too negatively, as making up in quantity for lack of quality.[10] Yet this collection too was fabled throughout the eighteenth century, in spite of the fact that, after deaccessioning began with the sale of pieces to the Earl of Pembroke around 1720, it could hardly be called his any more. Around 1738, for example, Pier Leone Ghezzi noted that in putting together his collection Giustiniani had not hesitated to pay one thousand scudi to the owner of a head belonging to one of his sculptures.[11]

Among Vincenzo's especially famous pieces were the *Minerva Giustiniana* (fig. 33), the *Vesta Giustiniana* (fig. 34), the *Faun Resting* (a version of the *Marble Faun*, fig. 35), and the bust of Apollo in the British Museum now known as the *Pourtalès Apollo*. Francis Haskell and Nicholas Penny are not, however, wrong in their observation that the Giustiniani brothers owned few sculptures that would later belong in the ranks of *admiranda*. As they put it, "for most visitors the collections were clearly of notable importance as an unrivalled repertoire of subjects and themes, but with only two or three exceptions the statues were not in themselves of sufficient quality to be compared with those which could be seen in the villas so far mentioned [i.e., the Medici, Borghese, and Ludovisi villas, the Vatican Belvedere, and the Palazzo Farnese]."[12]

As a consequence, Vincenzo's project to disseminate knowledge of his collection through the publication of the *Galleria Giustiniana* has tended to be considered rather simplistically as mere self-promotion on his part.[13] The *Galleria Giustiniana*'s importance as one of the very first illustrated records of a collection has been obscured by the irony of the fact that these two volumes later came to serve almost as an early sales catalogue, quite contrary to Giustiniani's intent, because they had made many of the pieces more famous than they would otherwise have been at the time the collection was finally broken up.[14] By contrast, Cassiano dal Pozzo's paper museum—which included many drawings of sculptures owned by Vincenzo—is conventionally viewed as a precursor to the encyclopedic culture of the future.[15] In short, around 1630, we are seem-

33. Anna Maria Vaiani, *Minerva Giustiniana*, engraving,
Galleria Giustiniani, I, plate 3

34. Claude Mellan, *Vesta Giustiniana*,
engraving, *Galleria Giustiniani*, I, plate
17

ingly confronted by a contrast between an enormously rich nobleman living in the Palazzo Giustiniani who was embarking upon an idle project of self-promotion on the one hand, and, on the other, a brilliant courtier of more modest means situated in the via dei Chiavari who was energetically devoted to a disinterested possession of knowledge.

This view does justice neither to Cassiano dal Pozzo, whose ambitions are discussed in the next chapter, nor to Vincenzo Giustiniani. One of the most striking negative effects of the rather narrow prevailing view is that scant attention has been paid to the *Galleria Giustiniana* itself, Vincenzo's extraordinary two-volume publication that has so much to tell about the world of collecting in which Cassiano dal Pozzo and his protegé Nicolas Poussin also lived.[16] Its relation to Giustiniani's collection, its purpose, and even its date of publication, has long remained uncertain, and it is with this aspect of his patronage, which entailed both works of antiquity and a significant group of living artists, that we will begin.

The problem of the date may be disposed of first. To the well-known testimony of Rubens, who wrote to Peiresc on September 4th, 1636, that he had seen letters from Rome reporting the very recent appearance of the *Galleria*, may now be added the evidence of a letter written by Cassiano dal Pozzo to Peiresc on April 15th, 1636, describing his meeting with Cardinal Francesco Barberini.[17] In the library the Cardinal had expressed to Cassiano a wish to send Giustiniani's "libro de' marmi" to Peiresc. This would have had to refer to Francesco Barberini's own presentation copy, however, because the Marchese did not wish to distribute the book until he had put together the second volume illustrating reliefs and busts of famous men and women. Indeed, so sought after was the first volume that Francesco Barberini had to tell Cassiano in January of 1637 that, much as he respected Rubens' desire to acquire it, even he had used up his credit soliciting copies from the Marchese.[18]

This *terminus ante quem* fits with Peiresc's letter of 9 February 1634 to Cassiano indicating that the work is still in progress, and with the fact that Joachim von Sandrart, supervisor of the whole scheme, left Rome before the Easter census of 1635.[19] Claude Mellan's portrait of Vincenzo Giustiniani, appearing immediately after Duquesnoy's frontispiece to the first volume (figs. 32 and 36), on the other hand, is inscribed with the date 1631.[20] Sandrart had made himself known to Vincenzo that year, and by Easter, 1632, he was living in Palazzo Giustiniani.[21] It may be assumed with some confidence, then, that the first volume of the *Galleria* was put together between 1631 and early in 1636. The second volume probably appeared towards the end of 1636, or early 1637. In his letter of 5 June 1636, Peiresc had written to Cardinal Francesco Barberini that the volume of bas-reliefs "will be more valuable for information on ancient history," and he urged him to encourage Vincenzo to put together the sheets already printed for a second volume. On 8 May 1637, Peiresc wrote to Cassiano that he was still awaiting a copy.[22]

One year before his death on 28 December 1637, Vincenzo had directed his nephew, Camillo Massimi, concerning the disposition and future use of the plates.[23]

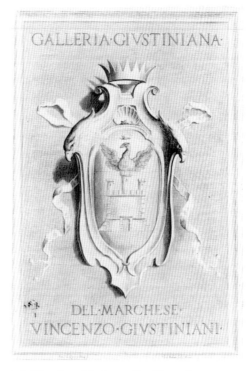

35. Michel Natalis after Giovanni Lanfranco, *Faun Resting,* engraving, *Galleria Giustiniana,* I, plate 130

36. Theodore Matham after François Duquesnoy, *Frontispiece,* engraving, *Galleria Giustiniana,* I, plate 1

37. Anonymous, *Postscript,* engraving, *Galleria Giustiniana,* I, plate 153

He requested that prints should be pulled from the plates of the *Galleria* in editions not to exceed two hundred copies, and that these prints should be sold to raise money to invest in *Monti Camerali*. The proceeds, but not the capital, were to be used for the benefit of the poorest members of his Genoese family. Vincenzo felt the need to compensate for having spent so much on both the *Galleria* and on the statues themselves— "di lunga mano con spesa continuata più che mediocre" as he put it. However, he certainly had no intention of letting any of his collection go, even after death, and to ensure that it would not be broken up and sold he bound it by an extraordinarily comprehensive *fideicommissum*.

The engraved postscript to Volume I (fig. 37) states that the prints had been collected together "in diversi tempi," but this is surely a rhetorical strategy intended to leave the impression that the publication had come about almost by accident. Rather than acknowledging his ambitions for the *Galleria*, the Marchese wanted to make it seem that the plates had been put together according to his fancy, or, as Cassiano dal Pozzo wrote in a different context, "non di proposito ma di capriccio."[24] That Bloemaert, Matham, Natalis, and Persin were all living in Palazzo Giustiniani with Sandrart from about 1633 onwards is a clear sign that prints were then being produced in an intense and systematic way.[25] A recent suggestion that the drawings were in fact made over a longer period of time, beginning in the 1620s, rests on Perrier's absence in France from 1630 to 1635.[26] But Perrier could easily have made drawings for four plates in Volume I at the end of 1635 or the beginning of 1636.[27] His drawing for the engraving of *Bacchus Seated on a Tiger* (fig. 38) almost certainly could not have been made earlier than this, for the print records an extensive reconstruction of an ancient fragment by Duquesnoy, who was introduced to the Marchese by Sandrart himself only in 1629.[28] Also significant is the recently established date of Giovanni Valesio's death in 1633, for the Bolognese draughtsman-engraver contributed at least eleven images to the first volume, and none to the second.[29] Mellan, furthermore, left Rome early in 1636, and contributed no new plates to Volume II.[30]

Concerning Vincenzo's purpose for the *Galleria* we have several testimonia. Most extensive is that of Sandart himself, whose *Teutsche Akademie* was decorated with reduced versions of images from the *Galleria* when it appeared in Nuremberg in 1675. Sandrart's recollections are often inconsistent, but in this case his vacillation over whether Vincenzo had set out to reproduce all his statues, or only the most beautiful, probably reflects the Marchese's own changing view of the publication.[31] In 1631, having no direct male heirs, Giustiniani had a *fideicommissum* drawn up in order to guarantee that his collection of paintings and sculpture would always be kept together, "per mia memoria perpetuamente." The correspondence between this date and that on Mellan's engraved portrait, marking the beginning of the project in 1631, is pointed.[32] The *Galleria* may indeed, therefore, originally have been conceived in part as a sort of vast, illustrated, and permanent catalogue, almost every plate bearing the Giustiniani stemma as a mark of ownership, just as many of the works in the collection were mounted on wooden plinths emblazoned in the same way.[33]

38. Cornelis Bloemaert after
François Perrier, *Bacchus
Seated on a Tiger* (restored by
François Duquesnoy),
engraving, *Galleria
Giustiniana*, I, plate 139

Like other "authors" of collections, Vincenzo probably felt the need to produce a "text" in the form of a visual document by which the collection could be made legible to posterity as a whole, not just through its individual parts.[34] Beginning with the Giustiniani arms and the portrait of Vincenzo himself, the published volumes provide something more like an ideal portrait of the collection at its most perfect (and therefore at its most vulnerable) than could any private inventory. Yet the sheer splendor of Vincenzo's publication sharply distinguishes it from any other early catalogue.[35] Despite the expense Vincenzo had lavished upon the publication, he was also anxious to see it out before he died, and the reduction in the number of plates projected probably coincided with the increase in the number of artists at work on the project soon after the printing of the collector's portrait in 1631.

The beautifully incised Roman inscription engraved as a postscript to Volume I (occasionally bound instead as a preface), provides a different kind of explanation (fig. 37). It states:

There having been collected various prints, made from plates engraved at different times after statues in the Galleria Giustiniana (and the drawing and engraving of which speak for themselves), it was decided to compile this book so that those who have some knowledge of ancient sculpture might see at one time how much has been done to satisfy many people who have begged for this for a long time.

In short, the volume itself constitutes a kind of collection, bringing together in a single time and place images made severally, not as a systematic catalogue, but in a way that reflects Vincenzo's taste. We are reminded of Sandrart's report that Giustiniani wanted his sculpture garden on the via Flaminia to be opened wide to *virtuosi*, providing opportunities for extraordinary pleasure for their eyes and tongues—to provide, in other words, a site for conversation.[36] According to the inscription, the quality of the prints (which were usually signed by both draughtsman and engraver, and which presented a wide range of styles in themselves) was such that, like Vincenzo's hospitable garden, the *Galleria* would speak for itself, prompting much conversation without need for an explanatory text.

In publishing the *Galleria* Vincenzo also, in Sandrart's account, created a school for carving (or *Bildhauerey*).[37] The claim was just, for even as Poussin could speak of being trained in the house of Cassiano dal Pozzo, so could those artists who worked on the *Galleria* claim to have been taught about both sculpture and engraving in Palazzo Giustiniani. The publication in turn extended the walls of this free academy far beyond Rome. To understand what it could teach, however, we need to pursue the character of the *Galleria* a bit further.

Unlike Sandrart, Vincenzo did not present his work as an *Accademia*; nor, like Cassiano, did he call it a *Museo*. He called it a *Galleria*. By the early seventeenth century *gallerie*, which originally were conceived as covered walkways or passages for the display of works of art, both ancient and modern, had become specifically associated with "Signori, e gran personaggi," as Vincenzo Scamozzi put it.[38] Another famous seventeenth-century definition of the *galleria* is Galileo's contrasting of Ariosto's *Orlando furioso* with Tasso's *Gerusalemme liberata*, according to which Tasso's poem is called "a little studio of some curious little man," filled with "little things" like flies in amber, Egyptian terracottas, and even a few sketches by Bandinelli or Parmigianino, whereas Ariosto's is like "a *guardaroba*, a *tribuna*, a royal gallery," filled with ancient statues, the best paintings, and marvelous, precious things.[39]

Galileo surely had the Tribuna in the Uffizi in mind, and such also was Giustiniani's collection. Yet the general organization of Giustiniani's possessions in a manner befitting a modern noble household could not alter the fact that, unlike the Tribuna, the physical space provided in the dark gallery in his palace, into which were packed two hundred and forty ancient sculptures in four parallel rows, was ill-suited to the installation of many pictures. As a group the sixteen or so canvases displayed there were

39. Claude Mellan, *Apollo*, engraving, *Galleria Giustiniana*, I, plate 51

40. Michael Natalis after Giovanni Lanfranco, *Apollo*, engraving, *Galleria Giustiniana*, I, plate 54

not the most distinguished, whereas over two hundred of Vincenzo's select works hung in his "Stanza grande dei quadri antichi" and two adjoining smaller rooms. The collection of sculpture, furthermore, was also far too enormous to fit into the gallery in the palace, and at least nine hundred pieces were in any case intended for display in the gardens of the villa outside the Porta del Popolo.[40] The sheer size of the family's collection made the experience of it as a whole difficult, forcing a redefinition of the relationship of gallery to collection. A walk through the pages of the paper *Galleria*, on the other hand, recreated the proper conditions of an *ambulacrum* in which each

sculpture could be admired in turn (and indoors), and various pieces could be seen "nell'istesso tempo."

The uncertain etymology of the word "gallery" is also pertinent, for not only is the gallery associated by assimilation in French, according to Littré, with the naval galley, or *galère*, but also with the printer's galley, a rectangular frame for type, and hence with the framing of a picture. This etymological turn fits the conception of the illustrations of the gallery in the *Galleria*, as a series of rectangular printed plates, each image framed for viewing. Works representing the same subject, whether Apollo (figs. 39 and 40), Hercules (figs. 41 and 42), or Venus (figs. 43 and 44), but normally displayed in different places, could be compared in a manner that the size of the

41. Claude Mellan, *Hercules,* engraving, *Galleria Giustiniana,* I, plate 11

42. Claude Mellan, *Hercules,* engraving, *Galleria Giustiniana,* I, plate 12

43. Claude Mellan, *Venus,* engraving,
Galleria Giustiniana, I, plate 39

44. Cornelis Bloemart after G. Citosibio Guidi, *Venus,* engraving, *Galleria Giustiniana,* I, plate
90

collection made impossible through memory alone. Indeed, Peiresc especially singled out the advantages of being able to see in the *Galleria Giustiniana* "an assortment of various statues of the same god, with the various attributes that they are given in various places or by different people."[41] At the conclusion of Volume II appear engravings of Giustiniani family properties in Rome—among others the palace itself (fig. 45), the villas outside the Porta del Popolo (fig. 46) and near the Lateran, as well as the feudal seat at Bassano (figs. 47 and 48)—which taken together set the scene for the itinerary. A view of Chios provided a memorial to the past.[42]

Whether or not the *Galleria* set out to be a comprehensive visual document, however, the collection it represented was not itself comprehensive in any historical or material sense. Whereas other famous noble galleries, such as those established in Mantua and Turin in the first decade of the century, included both *naturalia* and *artificialia*, Vincenzo collected works of art exclusively and selectively; and, however much the historical and documentary information his statues provided may have appealed to the scholarly interests of Peiresc or Cassiano dal Pozzo, for Vincenzo they were exemplary of his own taste, or what he called his own inclination, spurring him on to assemble them as works of art.[43] The notion that he was a discriminating collector of antiquities may seem impossibly paradoxical at first, given the prevailing conception of his collection as that of a man who came too late on the scene to be able to buy famous pieces at any price. But we should not forget that Vincenzo sought out Caravaggio

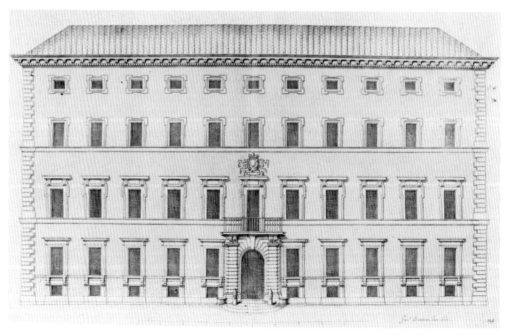

45. After Francesco Buonamici, *Palazzo Giustiniani, Rome,* engraving, *Galleria Giustiniana,* I, plate 154

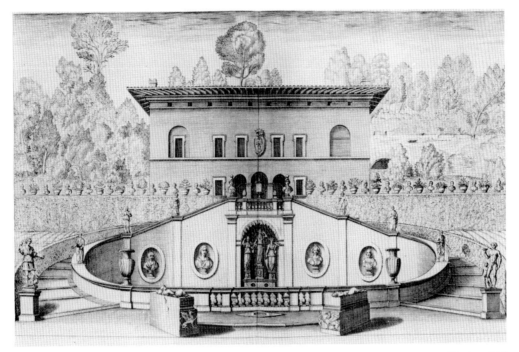

46. Anonymous, *Villa Giustiniani outside Porta del Popolo*, engraving, *Galleria Giustiniana*, II, plate 156

when other, more established, artists commanded higher prices, and that his own concept of style was both broadly based and highly developed. His collection of antiquities also included such unusual items as a bust of King Euthydemos of Bactria and was noteworthy precisely because of them.[44]

Closer to Vincenzo's idea of a gallery than those of the Gonzaga or the house of Savoy was another published *Galeria*, this a collection, not of prints, but of poems by Poussin's first Italian friend and patron, the Cavaliere Marino. Marino defended the selectivity of his *Galeria*, the collection of poems about works of art which he first published in 1619, by insisting that "it must be understood that the principal intention of the author was not to compose a universal museum about all subjects that can be represented in painting and sculpture, but to play with a few, according to the poetic motifs that came into his fantasy each day."[45] Marino, then, presents us with a choice between two possible kinds of collection: the gallery, which reflects the collector's own capricious wishes, or his taste; and the *museo universale*, which aims to be complete, as its name suggests. Among Marino's Roman contemporaries the two kinds of collection could not be better exemplified than by Vincenzo Giustiniani's noble gallery on the one hand, and by Cassiano dal Pozzo's museum, which included not only the *Museo Cartaceo*, but also live birds, paintings, and ancient inscriptions on the other. The former was assembled "di capriccio" by a man whose solution to the dispute over the question of the superiority of painting or sculpture was, as we shall see, to compare

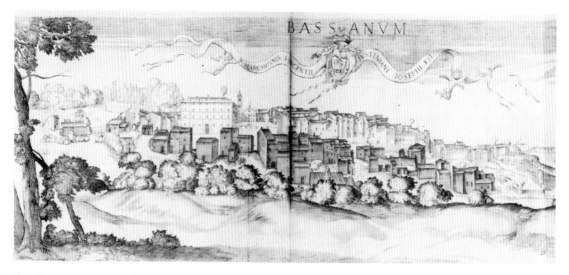

47. Anonymous, *View of Bassano,* engraving (detail), *Galleria Giustiniana,* II, plate 166

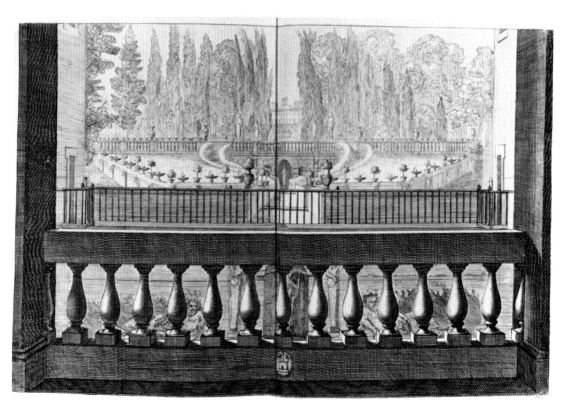

48. Anonymous, *View of the Garden at Bassano,* engraving, *Galleria Giustiniana,* II, plate 162

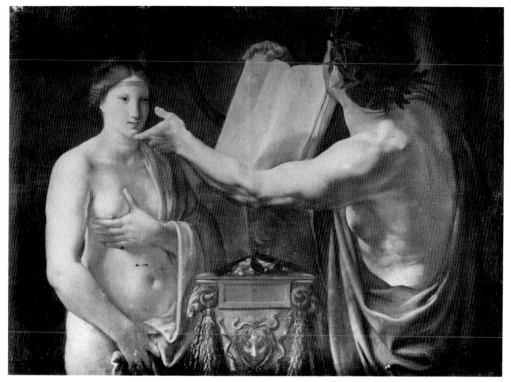

49. Angelo Caroselli, *Allegory of Sculpture (Pygmalion and Galatea),* formerly Potsdam-Sanssouci, destroyed

the problem to taking sides when watching a game between two people one does not know, on the basis only of some kind of "natural sympathy." The latter, like Cassiano's, was purposely designed "di proposito," and aimed at universal knowledge.[46]

The final testimony to Giustiniani's purpose in publishing the *Galleria* is the painting of *Pygmalion and Galatea* done for him by Angelo Caroselli, formerly in Berlin and now presumed destroyed (fig. 49).[47] The 1638 inventory describes this as a *sopraporta*, or overdoor, showing "the story of Pygmalion sacrificing to the idols in order to bring alive the statue of a woman with which he had fallen in love, made in allusion to the book of the Galleria Giustiniana; so as to say that the Signor Marchese Vincenzo Giustiniani of fond memory, by sending to the presses his ancient statues, brought them alive."[48] An artist wearing a laurel crown displays the open volume of the *Galleria* above the smouldering sacrifice, inviting us to compare the plates to the woman at the left. She is no longer a statue but flesh, brought alive by the prints, among which she resembles most closely a *Venus* drawn and engraved by Mellan (fig. 43). At the center of this marvelous effect is the altar. Similar to actual ancient examples in the *Galleria*, this bears the face of the Medusa; where she once turned figures to stone, figures petrified in stone are now brought alive, and it is we who are in turn dazzled and

84

50. Claude Mellan after
François Duquesnoy,
Mercury, engraving,
Galleria Giustiniana, I,
plate 84

petrified by the *meraviglia* of the volumes of engravings. Caroselli's witty play on the reversal of Medusa's power to create marmoreal spoils again situates the *Galleria* in the marvelous world of Marino, in whose *Galeria* of poems about paintings, sculpture, and even prints, such reversal is a central theme.[49]

Caroselli's *concetto* claims that the *Galleria Giustiniana* was not just the transparent record of a collection, but an attempt to bring the art of antiquity alive in print through the mimetic means of art itself. Better known than this aspect of the *Galleria* is Vincenzo's effort to enliven his collection of ancient statues through the commissioning of new works, some famous, such as Duquesnoy's *Mercury* (figs. 27 and 50), and some not, such as the now unknown *Amor Discovering a Sleeping Amorino* (fig. 51). As in the case of Duquesnoy's *Mercury*, which was conceived as a pendant to an ancient bronze of *Hercules*, this was done in order to complement his ancient pieces with works conceived on parallel aesthetic lines.[50] Giustiniani also commissioned extensive and cre-

51. Giovanni Luigi Valesio, *Amor Discovering a Sleeping Amorino*, engraving, *Galleria Giustiniana*, I, plate 25

ative restorations, among the most famous being Duquesnoy's restoration of the *Bacchus Seated on a Tiger* (fig. 38). In these things, however, he did nothing unusual, for all *gallerie* were expected to contain complete pieces (Bernini's restoration of the Ludovisi *Mars* is an especially familiar example); nevertheless, this is another characteristic that sets Vincenzo's collection apart from Cassiano's documentary museum.[51]

Caroselli's invention also serves as a reminder that Vincenzo Giustiniani perceived in certain ancient statues a liveliness and surface grace of contour that seemed to transcend the very limits of stone. As we have seen in the last chapter, Vincenzo felt that when compared to the indescribable lifelikeness and vivacity of the Pighini *Adonis* (i.e., the Vatican *Meleager*), Michelangelo's beautiful *Risen Christ* was but "a mere statue" (figs. 15 and 16).[52] What we might call the "Pygmalion effect" (to which the *concetto* of Caroselli's painting alludes), or the capacity to endow statues with a living grace, is also the most extraordinary characteristic of the engravings he commissioned, especially for the first volume. Sometimes the sense of lifelikeness may be attributed to a draughtsman who endowed the figures with eyes, movement, and even expression, as in plates drawn by G. Citosibio Guidi (fig. 44), Sandrart (fig. 52), and François Perrier (fig. 53),

52. Johan Comin after Joachim von Sandrart, *Polyhymnia*, engraving, *Galleria Giustiniana*, I, plate 77

53. Cornelis Bloemaert after François Perrier, *Seated Nymph*, engraving, *Galleria Giustiniana*, I, plate 142

all of which were engraved by Bloemaert. Sometimes draughtsman and engraver are the same, as in plates by Valesio (fig. 51) and by Mellan (figs. 34, 39, and 41–43). In each instance, however, the animation of the image relies on the unique qualities of the engraved line.

By the end of the sixteenth century, reproductive engraving in Italy had been revolutionized through the perfection by northern artists (especially Cornelis Cort, Hendrik Goltzius, and Egidius Sadeler) of a swelling line that was capable of expressing all the effects of movement, color, and style in the works of art they had seen in Italy.[53] Sandrart, who had studied with Sadeler in Prague in 1622, claimed that,

whereas earlier reproductive engravers had produced "mere projections of the originals" ("nur Projecta der Originalien"), Sadeler actually improved upon his painted models. As a result artists everywhere imitated his manner.[54]

After the deaths of Agostino Carracci, who had mastered the burin style of Cort and Goltzius, and of Francesco Villamena, who had perpetuated the manner of both Cort and of Agostino, the most expert practitioners of this swelling line were Northerners.[55] The three draughtsman-engravers, Mellan, Valesio, and Vaiani, were all trained in the Italian tradition, but the nine pure engravers Sandrart engaged for the *Galleria* were not. The most experienced were Cornelis Bloemaert and Theodor Matham, who came from Paris together at his request.[56] With their help, in what he calls "our Academy," Sandrart trained Renier van Persyn, who had accompanied Bloemaert and Matham from France, and Michael Natalis, who had arrived independently.[57] In this private, Giustiniani-sponsored "academy" Sandrart's team investigated the processes of reproductive engraving as truly creative imitation, finding the means for re-endowing ancient sculptures with life through recarving them on the plate. Even as Rubens, warning against conveying the effect only of marble when drawing after the ancient statues, had developed a manner of drawing in chalk that endowed his imitations of ancient sculpture with lifelike movement and a sense of living flesh, so did the artists of the *Galleria* engage in an imitative experiment that mediated between sculpture and painting.[58] The engraved line itself, sometimes on the basis of another artist's drawing, brings the marble alive, endowing it with the feel of flesh bathed in warm light. In holding up the example of Bloemart, as the most admired of his team, Sandrart described his line as *saftig*, or plump, praising him in terms that he otherwise reserved for Sadeler.[59]

As a "Lehrschule der Bildhauerey," or a school of carving, the *Galleria* was hence more than an illustrated catalogue; it was also an inventory of artistic manners by which sculptures could be made flesh. Accordingly, and in direct contrast to the *Museo Cartaceo* (for which Cassiano wanted drawings of transparent clarity, not individual stylistic idiosyncracy), it was important that Giustiniani's artists identify their own style through inscriptions on the plate. Not merely as a sign of Giustiniani's wealth, Lanfranco's contribution of six vigorous drawings (five of them reproduced by the swelling lines of Natalis), like those of his pupils Perrier and Ruggieri, was on the contrary a part of the Marchese's stylistic experiment (figs. 35 and 40 for Lanfranco; fig. 54 for Ruggieri; and fig. 53 for Perrier).[60] The Bolognese Giovanni Luigi Valesio had worked for the Giustiniani brothers before, but his participation in the project as a draughtsman-engraver also reflects his position as heir (if an inadequate one) to the luminous reproductive burin technique of Agostino Carracci.[61] Most extraordinary of all are the twenty one images drawn on the plate for Volume I by Claude Mellan, the French engraver whose style had undergone such a dramatic change since his arrival in Rome in 1624.[62] Conceived entirely in terms of light, through a pattern of curving parallel strokes of varying depth, without any outlines, and with an almost complete

54. Giovanni Battista Ruggieri,
Faun Playing a Pipe, engraving,
Galleria Giustiniana, I, plate 131

absence of cross-hatching, Mellan's engravings dissolve the hard surface of the marble, even in rendering the powerfully muscled figure of a Hercules.

The endowment of ancient sculptures with infinite softness and roundness of surface contours through engraving was to be a primary concern of later imitations of the *Galleria Giustiniana*, such as Jan De Bisschop's *Signorum veterum icones* (1669), in which ancient statues were reproduced as perfect models for types of human nature.[63] The new canon of affective models, as we saw in chapter one, was first formulated by Duquesnoy and Poussin in their search to understand the peculiar grace and beauty of Greek style. One of their conclusions, to quote Duquesnoy's pupil Orfeo Boselli once again, was that "the less the contour is pronounced the more Greek will the style be," for the human body does not love straight lines. The sweetness and tenderness of the Greek manner derived from the concealment of parts in favour of a mellifluous surface. Each printmaker represented in the *Galleria* attempted this effect in different ways, but Mellan stands out as the most "Greek" in Boselli's sense. Significantly, the only work by another contemporary artist that he reproduced in the *Galleria Giustiniana* was Duquesnoy's *Mercury*.

We have come a long way from the via dei Chiavari, it seems. Yet it would be misleading to set the aristocratic Greek taste of Vincenzo Giustiniani too far apart from the Roman erudition of Cassiano dal Pozzo. The rather different approach of the second volume of the *Galleria*, for example, which Peiresc, as a student of ancient manners and customs, found more appealing, probably reflects Cassiano's influence. The postscript to that volume emphasizes the erudition offered by the latter with regard to "the customs, rites, and deeds of the ancients." Sandrart seems to have drawn only ten plates, and the book appeared after he had left Rome. About a third of the one hundred and sixty nine plates are of portrait busts, drawn and engraved by many of the same artists who had worked on Volume I. The remainder, mostly after relief sculptures, and some even incomplete, are almost all anonymous.

Vincenzo Giustiniani's project to bring ancient statues alive and Cassiano's paper museum do, however, belong to different conceptual and even stylistic categories. And yet they were both resources for painters, especially including Poussin. Two works by Poussin, dating to the years in which Volume I of the *Galleria* was produced, may serve as examples. At the very center of *The Plague at Ashdod* of 1631, now in the Louvre (fig. 55), lies a dead mother, her breasts bare.[64] One of her two children is dead, and the other looks up pathetically at the man who stays him from her breast. This group, the emotional heart of the picture, has often been referred to Pliny's description of a painting by Aristeides, but it has been literally overlooked as an expressive form in its own right. In a complex fusion of expressive models, Poussin emblematized the woman's noble and lost struggle against death by the way in which her body takes up the pose of the *Laocoon*, the most famous *exemplum doloris* of all; but at the same time he rendered her particular pathos beautiful and affecting through giving her equal resemblance to the dead *Amazon* from the group then in the Farnese collection.[65] The entire group was drawn for Cassiano (see fig. 56), and Poussin may even have learned from him the theory that the Amazon once had a child at her swollen breast.[66] But Cassiano's anonymous drawings express the pathos neither of the statue nor of Poussin's painting. It was rather Poussin's direct encounter with the affective power of ancient Greek sculptures that enabled him to transform the Amazon into a mother.

The *Massacre of the Innocents*, now at Chantilly (pl. XI), which we will discuss at length in chapter seven, was painted for Vincenzo Giustiniani himself.[67] On this occasion Poussin derived the image of the soldier seizing the bare-breasted woman by the hair from an Amazon sarcophagus rather than from the Farnese group. The image was a famous one, even conventional, but in Poussin's day it was nonetheless closely associated with its ancient source. In his Naples *Agenda* Cassiano lists the most famous example then in the Vatican (originally from the courtyard of Saints Cosmas and Damian), and he commissioned a new drawing to add to the old one he had acquired.[68] As we have seen in chapter one, he also derived the particular, bodily expressive forms of the child, mother, and soldier from sculptures of Eros, a Niobid, and a gladiator. As we shall see in chapter seven, the *Massacre* was one of a series of four overdoors that

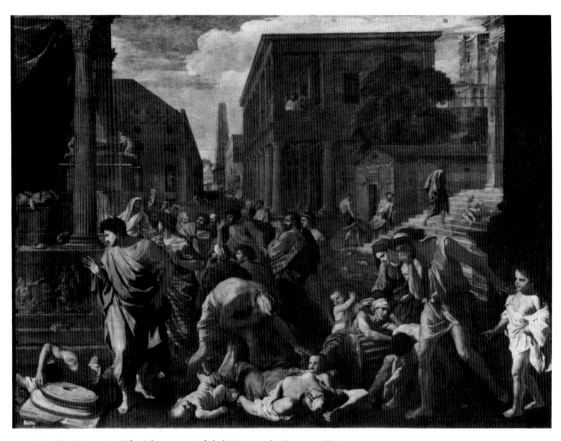

55. Nicolas Poussin, *The Plague at Ashdod,* Musée du Louvre, Paris

56. Anonymous, *Dead Amazon,* drawing from the *Museo Cartaceo,* Collection of Her Majesty Queen Elizabeth II, Royal Library, Windsor Castle

57. Giovanni Luigi Valesio, *Seated Philosopher (Diogenes)*, engraving, *Galleria Giustiniana*, I, plate 114

included Sandrart's own *Death of Seneca* (fig. 140), the *Death of Socrates* by the as-yet-unidentified "Giusto Fiammingo," (fig. 142), and the *Death of Cicero* by Perrier (fig. 141).[69] The group comprised two ancient Stoic suicides and two scenes of brutal murder at the hands of tyrants, one of a Stoic, and the other of the first Innocents to die for Christ. Displayed with them in a small room in the palace was, according to the inventory of 1638, a statuette of a seated philosopher, thought to be Diogenes, and very likely the figure reproduced for the *Galleria* by Valesio (fig. 57).[70] Remarkably, then, Poussin's first representation of early Christian history in specifically neo-Stoic terms was not painted for his erudite patron Cassiano dal Pozzo. It was produced for the Marchese Vincenzo Giustiniani, who, on his arrival in Louvain in June, 1606, had been frustrated in his hopes of meeting Justus Lipsius. The neo-Stoic philosopher had died just weeks before.[71] Much that Poussin, originally Marino's protegé, may have learned from Cassiano dal Pozzo in the early 1630s, whether about Leonardo's theories of movement, ancient music, architecture, or sculpture, he, like others, may have been encouraged to learn and to represent through the natural sympathy he felt for the taste of Vincenzo Giustiniani.

TO DEFINE Vincenzo Giustiniani's taste is more difficult than establishing its effects. If we examine his writings in detail, however, a consistent pattern emerges, and one that suggests that Vincenzo's conception of his collections and their rationale is part of a more complete, and also new conception of himself. If we see in Cassiano dal Pozzo an early prototype for the eighteenth-century encyclopaedist and member of a European republic of letters, in Vincenzo Giustiniani we equally find the prototype, and an extraordinarily sophisticated one, for the aristocratic *virtuoso* and *amateur*, blessed by position and means to be able to acquire, and then put into practice the benefits of a cosmopolitan taste, formed on what he called the cultivation of his own natural inclinations.

Despite Vincenzo's discriminating support of Caravaggio, the Giustiniani brothers have, as we have seen, sometimes too easily been dismissed as merely rich parvenus. By this reasoning, their collection, put together later than those of other noble families such as the Farnese or the Borghese, could only make up in quantity for what it lacked in quality, especially as far as antiquities were concerned. Certainly, all the many Giustiniani properties were packed with works of art, but these were not accumulated without thought. Benedetto looked for pictures to buy while he was in Bologna, and Vincenzo, on his five-month journey to northern Europe, traveling to Germany, Flanders, England, and France in the company of Bizoni and the painter Roncalli, expanded his knowledge of painting and architecture in unconventional directions.

On his return, in Francis Haskell's authoritative view, Vincenzo had acquired, with the single exception of Rubens, "the broadest and most deeply experienced artis-

tic culture of any man in Rome and indeed Europe."[72] Haskell also comments on the catholicity of Vincenzo's and Benedetto's collecting, and indeed, in addition to the Caravaggios, the brothers owned works by all the members of the Carracci family, together with at least one hundred and eighteen different identifiable artists, from Albani to Zuccaro. In the palace was exhibited everything from precious fragments of mosaic and fresco from Old Saint Peter's to more recent works by Pietro Testa and Poussin, from pictures by earlier north Italian painters such as Garofalo and Francia (whose work Benedetto was at pains to acquire in Bologna) to less well documented Northern European contemporaries such as Antonie van Os or Timan Arentsz Cracht, not to mention the better-known Calvaert, Pieter Van Laer, and Cornelis Bloemaert.[73]

Even while noting this apparent eclecticism, Haskell went on to suggest that Vincenzo's "taste" was "more clearly defined" than that of anyone else of his age. Vincenzo was almost alone, he believed, in realizing "the full implications of the artistic revolution that had occurred at the end of the sixteenth century." In Haskell's view, Vincenzo and Benedetto concentrated on collecting works by the reformers, while the older generation of Mannerists was little represented, and they also, ever open to new ideas, gave a special welcome to Northern artists in Rome among whom was Nicolas Poussin.[74] Several statistical arguments might be marshalled against this conclusion. Furthermore, despite the Giustiniani brothers' interest in modern art, they also displayed in their collection religious art from early Christian times, and they were not indifferent to works by such artists as Nosadella, Mastelletta, and Innocenzo da Imola. In addition, as Salerno recognized, in any analysis of Vincenzo's taste his passionate collecting of antiquities has to be taken into consideration, not as an alternative to his interest in painting, but as yet another expression of his curiosity, and on a level with his parallel interests in architecture and music.[75]

Despite these qualifications, Haskell was surely right to think that both the character of the Giustiniani collection and the way it was enjoyed were determined by a newly developed concept of *taste*, and by the pleasure of exercising it. By his own account Vincenzo Giustiniani's interest in works of art was, as we shall see, directed not just by a desire for ostentatious possessions, but also by his "inclination" toward certain works, determined by a sort of free and spontaneous passion. Understood in the seventeenth century as preceding the acquisition of moral habits, such natural inclinations were associated with that part of the psyche that would emerge with the passage of time as the seat of personal taste based on instinct.[76] Although, as we have seen in chapter one, it would long be insisted that such taste could be conditioned or even manipulated in the service of moral ends, those rearguard Aristotelians who defined it as potentially either a force for the good or the bad were not wrong.[77] The question for the seventeenth century, in fact, was to determine whether such instinctive good taste was the prerogative of the well-born, or whether it resulted from moral habit (a question closely bound up with the determination of whether aristocracy was inherited or earned).

Giustiniani's unique articulation of a personal preference, or inclination for admiring and wishing to acquire works of art in different media or styles distinguishes him sharply from the preponderance of critics who categorized and evaluated paintings according to, for example, historical, local, or (to cite but one other possibility) academic considerations. Such personal preference, which, as we shall see, was no different in quality from the preference he expressed for certain kinds of hunting, or music or architecture, might seem to suggest that Vincenzo's outlook was still rather closer to the courtly ideal expressed by Castiglione than it was to the natural philosophy being developed among his contemporaries in the Accademia dei Lincei.

Castiglione's definition of *sprezzatura* as a kind of effortlessness and nonchalance— a quality that could degenerate into affectation if too self-consciously pursued—had contributed to authoritative accounts of the manifestations of personal style in painting both by Ludovico Dolce (who had edited *Il Cortegiano* for publication in 1552) and by Vasari.[78] Both writers, no matter how much they disagreed over the superiority of their own local traditions, associated artistic style with the courtly bearing of those who were their patrons, and with the artist's or writer's own manners. The very same qualities that they praised, such as *disinvoltura, sprezzatura, vaghezza,* or *grazia* contributed to the rationale motivating the formation of new kinds of collections in the later sixteenth and seventeenth centuries, in which artistic styles displaying such characteristics were represented. These qualities were moreover of critical importance in contributing to the general shift in values in Italian courtly culture from those based in a concept of artistic *giudizio,* or discrimination, to one founded, as Robert Klein recognized, in a more purely aesthetic idea of *gusto,* or *buon gusto.*[79] That shift—or rather the discursive play of ideas engaged in differentiating questions of taste and judgment (for the definitions of each remained highly flexible)—would in turn be an important point of departure for discussions of taste, judgment, and *honnêteté* in seventeenth-century France. Such discussions dominated the cultural experience of the court, where Poussin would come to be seen as the ideal painter, whose *honnêteté* equalled, and even surpassed Raphael's courtly grace and *maniera* as defined by Vasari.

More helpful than Castiglione's example, therefore, to an understanding of Vincenzo Giustiniani's comportment—whether in assembling his palaces, his gardens, his printed volumes, or in his collecting and display of works of art—is Stefano Guazzo's *La conversazione civile,* which appeared in Venice in 1574, when Vincenzo was just ten years old.[80] *Il Cortegiano* had after all been published in 1528, and was written about a world that was already lost. Guazzo's dialogue, which led to renewed interest in both the *Cortegiano* and Giovanni della Casa's *Galateo,* quickly dominated the discourse of manners in Europe, especially in France, and all three Italian treatises were translated into French soon after its publication. In combination with Montaigne's portrayal of his own lived experience in the *Essais* on the one hand, and new ideal models for courtly behaviour, such as those delineated by Faret or Bardin, on the other, they provided the guidelines for the behaviour of the *honnête homme.*[81] *Honnêteté,* with its cognates of

civilité, *bienséance*, and *goût* (which also engages, therefore, questions of the *grand goût*, inclination, and the "exquisite taste" of the Greek style), made up, as we have suggested, perhaps *the* dominant cultural discourse of seventeenth-century France.[82] That even the terminology for this set of social concepts has to remain in French is a reflection of this. Correspondingly, historians of ideas have tended to write its history from the perspective of seventeenth-century France exclusively (even if Italian "sources" are recognized, along with Montaigne). Only rarely, furthermore (and partly because of the later history of the concept of classicism which we have discussed in chapter one), has the relational aspect of what Michael Moriarty has called "the *honnête* discourse of taste," its political dimension, and the manner in which aesthetic values and social relations were intertwined within it, been acknowledged.[83]

The developing discourse on taste is obviously of the greatest importance to an understanding of Poussin's relations with his French patrons, those *honnêtes hommes* (whether noble or bourgeois) whose ability to *bien juger* was sometimes in question. Poussin's relationship to the French tradition of *honnêteté* and friendship will be examined in chapter five, with particular reference to his reading of Montaigne; but it would be unfortunate to perpetuate the assumption that this tradition and discourse belong only to the *grand siècle* in France, with just a few nods to Italian parallels. It is through such assumptions that narrowly nationalistic perspectives are defended and all sense of real cultural difference, as well as community, is lost. The European boundaries of the *République des lettres* are now more clearly drawn (although the territory is still given a French name). Most aspects of late sixteenth- and seventeenth-century Italian culture that resemble the culture of *honnêteté* continue to be assigned, nevertheless, to some other historical or cultural phenomenon—usually neo-Stoicism. A *virtuoso* culture in Italy, on the other hand, which to some extent resembles that of *honnêteté*, is gradually being identified, but, in turn, without much reference to France.[84]

Such historiographical questions add significance to the role of Vincenzo Giustiniani as an Italian exponent of a series of ideas and social practices belonging to a developing Italian discourse of civil conversation and taste that has not been much attended to in the wider European context.[85] Giustiniani was an outstanding representative of the sophisticated, civilized Roman courtier in the new feudal style. He was Genoese, but foreign-born, neither attendant at a peripheral court, nor the descendant of a long-established Roman noble family. He had purchased his own feud and set himself up in the family's immense palace in Rome, where his brother's position as Treasurer of the Apostolic Camera and association with the Aldobrandini pope contributed yet more wealth and a good deal of status. In fashioning his own life as a prince who was also something of an outsider, Vincenzo undertook everything with the requisite sense of honor, ease, and grace. This involved participating in the republic of letters through the publication of his collection, as we have seen, and it implied a very high level of sociability, both in the world at large and in his own personal sphere.

Giustiniani's example is especially noteworthy because he left behind as testimony

not only the *Galleria Giustiniana* and the inventories of his collection, but also a series of writings in which his taste and sociability, his commitment to pleasure, experience, and to his own inclinations, are all outlined. From Vincenzo's "Avvertimenti per uno scalco," where he counsels the steward to make sure the taste of every guest is satisfied, to his "Dialogo fra Renzo e Aniello Napolitano sopra gli usi di Roma e di Napoli," in which the wines, cabbages, and weather of both cities are compared, these occasional pieces, which remained unpublished in his lifetime, reveal a consistent interest in comparative culture, in travel, and in philosophical questioning worthy of Montaigne.[86] Of the broadest relevance here are the instructions he offered for travel, together with the rather better known letters on hunting and the arts of music, architecture, sculpture, and painting that Giustiniani addressed to his friend Theodor Ameyden.[87]

Castiglione's courtier had been encouraged to shun the crowd, and if he chose to mix or compete with his inferiors he was to do so only under the terms of masquerade.[88] Guazzo's courtier may have been encouraged to refer to Castiglione for advice on how to deal with his prince, but in his daily life body and soul were to be nourished instead by conversation with other men of all sorts. Such conversation could only thrive, and with it civilized life, where ambition and flattery were kept at bay; exclusivity was to be avoided through careful accommodation. To make his point Guazzo insists that it would be wrong to miss the chance to take a gondola from Padua to Venice just because such boats often carry both men and women, religious and secular, soldiers and courtesans, Germans, French, Spanish, Jews, and other foreigners of different ranks. He recalls having done many things more with his body than with his soul in the company of disagreeable people so as not to be thought superior or unlikeable. But he had often rejoiced in the outcome, at his success in accommodating the wishes of others without compromising his own honor.[89] Montaigne, too, in his concern that "We are all huddled and concentrated in ourselves and our vision is reduced to the length of our nose," had insisted he knew no better school for forming one's life "than to set before it constantly the diversity of so many other lives, ideas, and customs, and to make it taste such a perpetual variety of forms of our nature."[90] In taking his trip north as far as London in 1606 Vincenzo Giustiniani comported himself in the manner of Montaigne, or more like Guazzo's ideal traveller than Castiglione's aloof courtier; unafraid, indeed eager to test his honor in conversation, he sought to learn through his ears rather than from books. This was not always easy. In England, for example, where he saw the heads of the Gunpowder conspirators still displayed on Tower Bridge as he entered the city (the head of the Jesuit Garnet still with its white beard!), and where it was unclear if his Italian innkeeper, Paolo Lucchese, was a Catholic or a heretic, Giustiniani nevertheless tried to behave honorably towards all, both Catholics and heretics alike.[91] At Hampton Court he refused to follow local custom by kissing Prince Henry's hand, though bowing to him at Nonesuch; at Greenwich, however, he declined to bow to King James, "per non soggettarsi troppo."[92] (This of course immediately brings to mind Benjamin Franklin's celebrated refusal to bow to the French monarch, and seems

more in keeping with the eighteenth century, even as it also reveals much about the concept of *honnêteté*.)

Unlike the journeys undertaken by his brother and other clerics or emissaries on bureaucratic and diplomatic missions, Vincenzo Giustiniani's seem to have had no immediate practical purpose other than the experience itself. This we infer from the undated "Istruzione per far viaggi," containing his reflections on the practical philosophy of such travel, and which complements the more direct observations preserved in his companion Bernardo Bizoni's diary of the journey of 1606.[93] Vincenzo begins his instructions by talking about life itself as a journey for which prudence must be at the helm. Such prudence may be learned through the study of philosophy or through experience in public life; the latter is always limited, however, because it provides no knowledge of the good qualities of other societies, for which travel is the only source. Having expressed in this way a sort of ethical purpose for travel, Vincenzo then insists that peregrination by land and sea should be undertaken *per mera elezione però non per necessità*—that is, out of pure choice, and not from any necessity.[94] The traveler should remember what he has seen in order to act more prudently, but the true, simple purpose of travel should be curious delight.

Based on his own experiences, Vincenzo offers much practical advice, about carrying food and sheets along, always trying to get one's own bed, about procuring horses, avoiding swollen streams during heavy rains, or about discussing religion in heretical countries. His main focus, however, is on how to get the most enjoyment out of the journey. The traveler should take along someone of slightly lower rank with whom he can converse; the painter Roncalli fitted the bill perfectly in his own case, and the pair must have resembled the elegant aristocratic traveler and his humbler draughtsman companion portrayed by Stefano della Bella in the frontispiece to his *Diverse figure e paesi* of 1649 (fig. 58).[95]

Giustiniani counsels the traveler to inquire about what is worth seeing, especially buildings that are out of the ordinary, gardens, fortresses, paintings, statues, and so on; then the whole group, never larger than six, should go see these things and "each should say what occurs to him."[96] Such conversation helps the memory of experience, making future reminiscences more satisfactory. In order to be able to do all this with as much freedom as possible, it is better to stay in inns than with one's companions. Rich friends in particular wish to provide too much hospitality, and make it difficult to go sightseeing or leave.[97] Travelling by water, as Bizoni describes the group doing near Frankfurt, between Brussels and Antwerp, and around Avignon, makes it easier for the company to talk without getting tired, but it sometimes means not being able to see things, leaving curiosity unsatisfied.[98]

Giustiniani's traveler must be open to try *everything* observantly, for each place has its own specialty, whether this be food, wine, or manufactured goods. In a passage that calls to mind the new genre of still-life painting that was gaining in popularity in his day, and which may help to explain the reasons for that popularity, Vincenzo mentions

PARIS Chez Ifrael, rüe de L'Arbre fec, au logis de Monfieur le Mercier, Orfeure de la Reyne; proche la Croix du Tiroir.

58. Stefano della Bella, frontispiece to *Diverse figure e paesi,* engraving

carp in Lake Garda, trout and grayling in Lake Maggiore, *sardoni* in Mantua; as well as the cloths, laces and tapestries of Flanders, the clocks and plasters of France, glasses, silk and fine wool socks in England, in Spain sword blades and perfumed leathers, in Germany marquetry work and other kinds of things made very diligently with iron.[99] At the same time Vincenzo warns that it is important to adapt to local manners. This means avoiding conversation altogether in Germany unless one is prepared to die from drink; and in France it means being hospitable, visiting and serving ladies, and always being ready to fight duels.[100] After experiencing all these different social customs, observing the specialties of different countries, and seeing notable works of art for pure pleasure, the traveler returns home with his memories and reflects in tranquillity on the vanity of all things as he prepares for his final journey.[101]

An ethical, and even aesthetic principle of pleasure, so crucial to the social practices of *honnêteté,* also underlies Vincenzo's approach to hunting. In his "Discorso sopra la caccia," framed as a letter to his friend Ameyden, Giustiniani claims to have been the first in his day to have hunted boar, goats, and wolves in the *campagna* on a grand scale without guns, relying instead on setters, greyhounds, and beautiful horses.[102] All this Vincenzo describes as something he had to give up in 1600, when his father's death compelled him to pay more attention to the family's financial affairs.[103]

The requirements Giustiniani spells out for hunting on the grand scale resemble

59. Jacques Callot, *Stag Hunt,* etching, National Gallery of Art, Washington, D.C.

those for travel. The hunter must have a full and open purse, a good constitution, and, most important again here, a natural inclination for it. Hunting might serve some diplomatic or business purpose, but it should really be engaged in simply "for one's own delight that evaporates as soon as the operation is over."[104] *Gentilhuomini,* such as those portrayed in Callot's famous *Stag Hunt* (fig. 59), clearly hunted for their "proprio gusto," and success that came by chance rather than design was especially pleasing.[105]

Vincenzo spoke from personal experience as a traveler and as a hunter, and this is equally true of his discussions of music and architecture, which are also the products of his cultivation of his own tastes and inclinations. His "Discorso sopra la musica" was again written in the form of a letter to Ameyden, apparently as a postscript to a response written in answer to a request from his friend about the mode and rules of conversation that is now lost.[106] Music and conversation, as he explains it, were constant companions in his household, where instead of cardplaying he encouraged musical performance, not by professionals, but by gentlemen "who took pleasure in it and had a taste for it by their natural inclination."[107] Vincenzo records that his father had sent him to music school as a child, when the compositions of Arcadelt, Lassus, Strigio, Cipriano di Rores, and Filippo di Monte were still in vogue. He then traces the major musical developments of his day, including the madrigalists already mentioned (whose importance for Caravaggio's *Luteplayer* from Vincenzo's collection [fig. 60], in which compositions by Arcadelt prominently appear, comes immediately to mind), the polyphonic music of Palestrina, the affective style of Caccini's *musica nuova,* the singing by women and eunuchs, and the *seconda pratica* of Monteverdi, which also was committed to a sweet expression of the affections.[108]

These musical developments are arranged historically, but Vincenzo presents

60. Michelangelo da Caravaggio, *Luteplayer,* State Hermitage Museum, St. Petersburg

them more in terms of taste than of chronology. Styles change, he writes, according to the tastes of the lords and grand princes who delight in them, just as such men change their manner of dressing.[109] Again, Giustiniani insists on the importance of local custom, quoting the familiar saying that the French sing, the Spanish wail, the Germans groan, and the Italians plead. He observes regional differences within Italy; every city in Sicily has its own arias, as do Genoa, Milan, Florence, Bergamo, Urbino, Ancona, Foligno, and Norcia, not to mention Rome, and many others.[110] Should Ameyden ask wherein lies musical *aria* or grace, Vincenzo could only explain this by making a familiar comparison: a very beautiful woman may have no grace at all, whereas an ugly one may possess it. Singing with grace involves long observation of the modes and rules, which can bring delight to the ears of men of ordinary judgment. However, judgment is in itself problematic, for styles differ, and so too do tastes. Certain voices please some and not others, and, in another comparison of women and art, Vincenzo points out that in Spanish and African whorehouses no woman goes

without a taker, no matter how ugly she is. In yet another, fleshly comparison, he remarks that all cuts of meat in the slaughterhouse get sold.[111]

On the variety of modes and manners ("la diversità della maniera e del modo") in ancient enharmonic music, which moved spirits to be happy or sad, to make war or obey rules (and which so interested Domenichino and Poussin), Giustiniani simply refers his reader to ancient authority (such as Pythagoras and Plato) without attempting his own explanations.[112] Only experience and practice, he concludes, can really come to terms with musical effects. As in his reflections on travel, Vincenzo was more interested in all the many examples he could think of in his own experience of the natural world than he was in any particular theory, ancient or modern. He poses a series of standard philosophical questions—such as why songs with Greek words help when hunting swordfish, and why music makes men fall asleep, why song makes silkworms produce more, why it makes children less afraid of walking in the dark, why it makes work seem easier, how it helps preachers, who rely on song rather than arguments to move the *gente bassa*, and so on—to the philosophers, wryly demonstrating at the same time how well he knows what those questions are.[113] His discourse, he is proud to say to his friend, is not based on passages stolen from other authors, but is a true story based on his own familiarity with the subject that is derived from "a conversation I have held in my house with many nobles and gentlemen, a conversation in which, among other honored exercises, music was practiced."[114]

In his third letter to Ameyden, this time on the subject of architecture, Vincenzo could again claim a great deal of practical knowledge.[115] He refers briefly to his own buildings, both completed and planned, in Rome and Bassano. He digresses at some length about his gardens, listing the names of various *viali* and *piazze* in the garden at Bassano, and giving advice about how to plant with a view to reducing maintenance and to providing a verdant prospect all year round. Vincenzo introduces ideas he had gathered in France, where he especially admired the garden of Madame de Chantelou at Chantilly, with its many mythological inventions, and found the shady *allées* particularly beautiful.[116] In Tuscany he had observed that ordered lines of evergreens (like those illustrated in Olina's *Uccelliera*, which Cassiano dal Pozzo presented to the Accademia dei Lincei in 1622 [fig. 61]) were good for catching birds.[117]

The comparative methods attained by the knowledgeable, experienced traveler are again on display in Giustiniani's discussion of architectural ornament, in which he describes the different practices of Rome and Genoa, as well as the use of different materials—whether marble, travertine, or peperino, whether tufa, brick, or various methods of incrustation with plaster, either left plain, whitewashed, or decorated with bas-reliefs and so on. This last he had admired at Nonesuch Palace in England when he visited in June of 1606.[118]

Reiterating the now familiar, and unifying theme of all his observations, Vincenzo insists that the patron of a building must have a natural inclination for his project. Another favorite topic—the importance of sociability—arises in his discussion of the

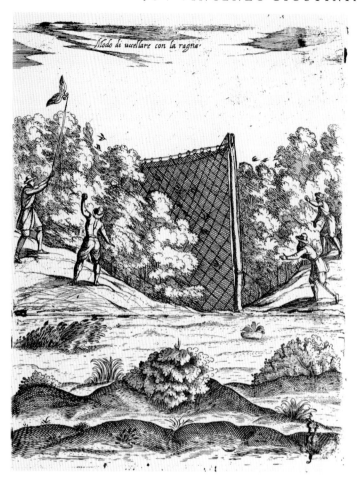

61. Antonio Tempesta,
*"Modo di uccellare con la
ragna,"* from G. P. Olina,
Uccelliera, Rome, 1622

choice of a site. This must be large and noble and set apart, but at the same time close to the piazzas where business goes on; and what is built upon it must be a civic ornament. The pleasure of looking at such buildings, is, he reminds us, shared not only by citizens but also foreign travelers on long journeys, and he again characterizes his own travels as "for my sheer satisfaction, nourished by curiosity" ("per mera mia sodisfazione, nutrita dalla curiosità").[119] As the finest example of such universally admired public buildings, Vincenzo cites St. Peter's, the ideal for all buildings, sacred or profane. If only Plato had formed his ideas so well (in a gentle dig against philosophical authority), he would not be an object of mockery in modern times.

Giustiniani's two other letters to Ameyden concern sculpture and painting, and, though better known to art historians than the other writings so far considered, they nevertheless merit a more careful consideration within the context of Giustiniani's social and aesthetic philosophy as a whole.[120] For both of these arts his experience was as an onlooker or collector rather than as a practitioner, but he felt especially close to

the practice of sculpture. He had watched so many pieces being restored, and had had to learn the techniques of the forger in order to be sure of what he was buying.[121]

In the "Discorso sopra la scultura," predictably, Giustiniani starts with classification. He lists the sculptor's various materials and their qualities, the techniques of drawing, carving, and modelling, and the instruments used in practicing them. He lays out the relative values of old and new pieces, noting that even a mediocre antiquity will always cost more than a modern piece, for the Roman soil has been sifted through and sculptures are not renewed every year, "like mushrooms or truffles."[122] Antique portraits of well-known people will always be more valuable than "teste di maniera," or pieces collected for their artistry rather than their famous identity. There are some exceptions—a statue in fine Palvacchian marble by the Cavaliere Bernini, for example, would be much more valuable than anything ancient.[123] However, his praise for the Pighini *Adonis* in comparison to Michelangelo's *Risen Christ* in Santa Maria sopra Minerva, to which we have several times referred, is a reminder that he did not consistently praise the moderns over the ancients either. What mattered most to him in sculpture of any kind was the power of lively expression.

Finally, on the perennially vexed question of whether sculpture or painting was more estimable, Vincenzo reports that in his own collection of good paintings and sculptures he has noticed that noblemen tend to reflect more on painting than on sculpture, but that people possessing good *disegno* and with practical skill hold ancient sculpture in great esteem.[124] The question for Vincenzo is, however, again really a matter of individual taste or inclination, of personal preference for one medium or the other, and to settle it he makes the extraordinary analogy of the disinterested kibbitzer at a game of cards, which we have already mentioned. Following his earlier comparison of the random choices made by patrons of the Spanish whorehouse, in which every kind of woman finds a customer, or patrons of the abattoir, where all cuts of meat get sold, Vincenzo here suggests that deciding between painting and sculpture is like watching two complete strangers gambling, and attaching oneself to one side rather than the other simply on the basis of personal inclination or affection. Or again, he adds, it is like watching a duel and hoping that the side for which one has formed an affection will win, without really knowing why.[125] Each individual will decide whether he prefers painting or sculpture on the basis of his own *genio* or inclination, "his natural sympathy, as the philosophers say," without really being able explain this intellectually. Although Vincenzo only rarely refers to authorities beyond his own experience, in this case he concludes the letter by saying that this whole question of natural sympathy has been discussed by many authors, and by Fracastoro in particular, even though its explanation remains uncertain.

Girolamo Fracastoro, the Veronese humanist, physician, and astronomer, is best known for his poem on syphilis, but it was the treatise *De sympathia et antipathia rerum* that had come to Vincenzo's mind in this case. Dedicated to Cardinal Alessandro Farnese in the Lyons edition of 1550, it served as prologue to the *De contagionibus et*

contagiosis morbis et eorum curatione libri tres. Following Galen, Fracastoro defined contagions as having to do with just such sympathies and antipathies, and it is striking that Giustiniani, the admirer of Lipsius and patron of Sandrart, Poussin, and Testa (all neo-Stoics in some way or another), seems to have been grappling with an attempt to explain individual and artistic taste in terms of natural philosophy. Fracastoro was also, however, the author of the rather better known *Naugerius.* This was a discourse on poetics, included together with the essays on natural sympathy and contagions in his *Opera omnia* of 1555, and it includes much that helps to account for Giustiniani's concept of stylistic aesthetic, if in rather different terms.[126] A somewhat fragmentary treatment of the question of poetic style, *Naugerius* is framed as the kind of Ciceronian dialogue about art that Vincenzo enjoyed; and it is notable that the Giustiniani brothers owned a portrait of the poet Navagero himself.[127]

Fracastoro makes Navagero deny the proposition that poets write only for pleasure, but his conclusion is in fact that "A poet is inspired by no other aim than simply to express himself delightfully about anything that proposes itself to him."[128] Any didactic aim is ultimately accomplished, not by sugar-coating serious subject matter, but by imitating the most beautiful elements in a style that is appropriately beautiful. What makes poetry poetry is not subject matter but *elocutio.*[129] The aim of the poet is simply to express himself well about anything that proposes itself to him. He does not explicate his subject, "but making a different idea for himself of untrammeled and universal beauty, seeks all the adornments of speech and beauties which can be given it."[130] Fracastoro's ideal is beauty of expression, not verisimilitude, not the representation of a transcendental idea; the idea itself is correspondingly beauty of expression, in which the reader delights. His most effective example concerns the question of whether or not the poet's way of teaching through beauty relies on the inclusion of material that is *extra rem,* or, more precisely, by recourse to the mythological or fabulous. In a remarkable answer to the question of the relation between substance and ornament, Fracastoro has "Navagero" redefine the notion of the "extraneous." If only the bare subject is essential, he states, then indeed all refinement will seem extraneous. For example, if a house is conceived only as a shelter from storms and cold, then all columns, peristyles, and other ornaments will seem to be additions. But if we look at things as they ought to be, in their perfection, then such ornaments will no longer seem *extra rem,* but will in fact be essential and necessary.[131] Just as nature produces perfect and ornamented things, so the additions of poets and painters are essential to the perfection of things of beauty. Only the greatest artificers understand what this perfection is, for menial artists who work under constriction or for some purpose—just like poets or orators when working for a practical end—are incapable of making ornamental beauty essential.

In his extraordinary denial of the dichotomy of substance and ornament, Fracastoro distinguishes beauty from functionalism, and in so doing makes it easier to understand how Vincenzo Giustiniani could appreciate St. Peter's, not just as the most

perfect earthly expression of the idea, but as *the idea itself* made perfect by man. And, although Fracastoro recognised only the heroic style as absolutely beautiful, he saw that poets did not always want to use it. The "simply beautiful" can mean the absolutely beautiful (like St. Peter's), but it can also mean what is beautiful in every kind of writing: universal beauty and particular beauty are not the same.[132]

Fracastoro's emphasis on beauty as the wholly pleasurable perfection and enlivening of any subject in its own way, according to the poet's own idea, helps to justify Vincenzo Giustiniani's taste for so many different styles in his collection. It also suggests a way to account for his interest in a broad range of subject matter (not yet strictly categorized as genres), an interest that he expressed in his last letter to Ameyden, the "Discorso sopra la pittura," rather more than in his collection itself.[133] Unlike the more straightforward classifications rehearsed in the letters so far discussed, the categories around which Giustiniani structures this discourse on painting seem at first not to be organized around congruent principles, and some contain artists whom we have come to think of in rather different ways.

The first four groups outlined in the *Discorso* concern copying, first through the transfer of drawings by means of punched cartoons to which the artist adds his own color; then, secondly, through the exact copying of actual paintings by means of simple observation, the use of a grid or by holding a drawing up against the light.[134] These methods were commonly practiced throughout the century, and the second may help explain why the version of Caravaggio's *Luteplayer* copied for Cardinal del Monte from Vincenzo's own original looks the way it does.[135] The third—an essential part of learning to paint—is knowing how to copy everything, especially ancient or modern sculpture or good paintings, with chalk or in pen and wash, and the fourth has to do with the portrayal of individual people, their faces, clothes, extremities, and their deportment.

The fifth category in Vincenzo's list is the portrayal of flowers and other small things, for which the painter needs to be able to manage colors and their effects, and to draw all the many different positions of small objects. To succeed in painting in color at arm's length the varied design of the many positions of small objects and the variations of light on them is very difficult, and requires extraordinary patience. It is in this context that Vincenzo makes his famous reference to Caravaggio's having said that there was as much workmanship in a good painting of flowers as in a painting of figures.[136] Such an endorsement of still-life or floral painting (as opposed to miniatures) was highly unusual, and it is less surprising that Vincenzo owned but one painting of this type upon his death in 1637.[137] Vincenzo, seeing beauty in many different subjects, valued paintings of flowers, but seems not to have found many he liked.

The character of the next two categories—knowing how to paint architecture and architectural perspective, as well as how to locate a building or an antiquity near or far in space—suggests that Vincenzo was, perhaps, singling out different parts of painting as a whole rather than classifying specific genres. Architecture and landscape might

appear in many paintings of other subjects (though Vincenzo did own a few architectural views, and a fair number of landscapes with figures by Annibale Carracci, Claude, Viola, and others). He distinguishes between views in which everything is expressed through *macchie* (literally blots, but referring to the artist's broad massing of lights and darks), and those done with diligence, in which everything is imitated. He gives Civetta (Herri met de Bles), Breughel, and Bril as examples of the latter, although, once again, these names do not appear in the inventory of his collection. As examples of the broader manner he lists Titian, Raphael, the Carracci, and Guido Reni, whose works were very well represented in the collection, though often by copies and only rarely by landscapes.[138]

The eighth category is the painting of grotesques, which Vincenzo saw as especially difficult because, in Vincenzo's words, the painter of grotesques must be "universal," yet with a "natural inclination" for this special kind of work. He must be able to draw and color in fresco, and to produce appropriate inventions befitting his patron's *gusto*. He has to be able to paint human figures, both large and small, as well as animals, plants, flowers, medallions, perspectives, and stories in *quadri riportati*; and he must be able to feign metals and paint naturalistically. Vincenzo gives no examples, but the frescoes he commissioned from Domenichino and Albani at Bassano, themselves modelled on Annibale Carracci's frescoes in the Palazzo Farnese, in which Annibale himself was generally held to have achieved this kind of universality, would all qualify, rather than the grotesques in the narrower sense also to be found at Bassano.[139]

Next comes the quality of being able to paint with *furore di disegno, e di istoria dato dalla natura*, like Polidoro da Caravaggio, and to invent battles or hunting scenes in the manner of Antonio Tempesta.[140] Vincenzo praises both artists for their work in chiaroscuro and in prints, even as he criticizes their ability to work in oil, and in this case his collection provides evidence of the basis for his opinion. In Rome he had two large overdoors in chiaroscuro by Tempesta, who also decorated the courtyard at Bassano with chiaroscuri.[141] His praise for Polidoro, shared by many contemporaries, would have been based on the famous surviving frescoes on Roman palace facades, and engravings after them.[142] The final three of Vincenzo's twelve categories form a special group. Tenth is painting "di maniera," which means that the artist, long practiced in drawing and painting, is now able to work without a model in giving form in paint to what he has stored in his imagination. Vincenzo's exemplars of such painting *di maniera* in his own lifetime are Barocci, Roncalli, Passignano, and the Cavaliere d'Arpino.[143] The eleventh category of painter keeps his objects in front of him, not merely portraying what he sees, but drawing well and with a skill in color that comes naturally, and is conceded to few. Most important in this kind of painting is the relation of color to chiaroscuro, and the distinction between light and shadow which makes everything pleasing to the eye. Among modern painters, in Vincenzo's view, especially prominent in this category were Rubens, Ribera, Honthorst, Enrico d'Anversa, and Baburen.[144] Of these painters Vincenzo's collection lacked only a Rubens, and it is interesting that

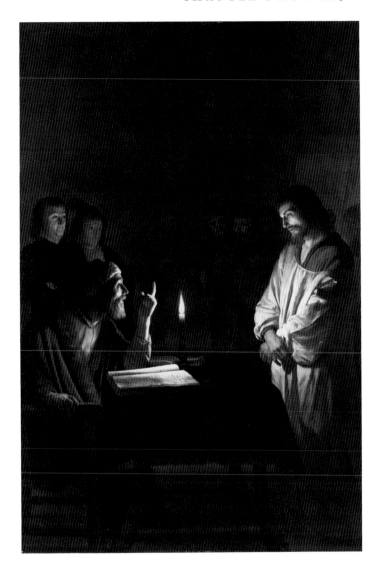

62. Gerrit van Honthorst, *Christ before Caiaphas*, National Gallery, London

he associated Rubens with the group of otherwise Caravaggist painters whose works he owned, including Honthorst's magnificent *Christ before Caiaphas*, now in the National Gallery in London (fig. 62).

Even more interesting is the way in which Vincenzo separated Caravaggio himself from this group. For the twelfth, and famous last category, the most perfect of all, comprised a combination of the tenth (painting *di maniera*) and eleventh (painting with the model before the eyes). In this, the most excellent of all, were included the world-famous painters of Vincenzo's times—Caravaggio, the Carracci, and Guido Reni. Some painters of this type, he writes, inclined more to one side or the other, toward imagination on the one hand or natural imitation on the other, but without stepping outside

either, and they always devoted themselves to good drawing, true color, and proper illumination.[145]

Giustiniani recognized in conclusion that artists excel in different ways because of their different abilities, some having been hampered by the vagaries of patronage or by material need. Excellence in a particular kind of painting, as we should by now expect, depends on each artist's *inclinazioni naturali*.[146]

VINCENZO GIUSTINIANI'S specific collecting of antiquities must be set in the context of all these other activities. As a phenomenon it needs to be reviewed in light of the evidence that his collecting of all sorts was governed not simply by a desire to possess, but by an ability to form relationships with works of art in many different modes and manners on the basis of a sort of spontaneous or disinterested passion for them, something he associated with taking sides in a duel between strangers, and which allowed him to find different beauties in many different kinds of things. His taste for style was not unique in its details, but rather in his conception of the role played by the individual taste both of the artist and the collector. The Tribuna of the Uffizi in Florence under Francesco I, for example, already included paintings by Civetta and Bril, and Cosimo II was especially fond of works by Bril and Tassi; among others he favored the Caravaggists, Artemisia Gentileschi, Honthorst, and Caracciolo.[147] But the Tribuna also contained *bizzarie*, and the historical direction of its hanging was set very early. In 1602 Grand-duke Ferdinando expanded export controls on paintings, placing special restrictions on works by Michelangelo, Raphael, Andrea del Sarto, Rosso, Leonardo, and Fra Bartolomeo among the Florentines, and by Titian, Parmigianino, Correggio, and Perugino among artists from elsewhere.[148] Florentines might develop new passions in the criticism, commissioning and collecting of contemporary art, but in their view of their own past achievement as shaped by Vasari they would never again take a disinterested position among competing historical claims involving Florentine art.

Vincenzo Giustiniani, on the other hand, was guided by his instincts, his natural inclination, and by the different cultural experiences he had actively sought, out of his own curiosity and for reasons of sheer self-satisfaction. When it came to beauty Vincenzo understood that no Spanish whore was so ugly that she would not find a taker, and he would have agreed with Montaigne that "it is likely that we know little about what beauty is in nature and in general, since to our own human beauty we give so many different forms" (to which Montaigne added a list of national preferences from the Indies to Peru, to Mexico, Italy, and Spain).[149] Vincenzo Giustiniani may have wished to impress his visitors with the transfixing power of Caravaggio's *Amor vincit Omnia*, following Joachim von Sandrart's advice that he should keep it covered until they were ready to be surprised by it, but he sought to determine neither the taste nor the judgment of others by associating his own taste with a universally valid ideal.[150]

63. *Conversatione,* woodcut from C. Ripa, *Nova Iconologia,* Padua, 1618

Like the figure of *Conversatione* in Ripa's *Iconologia* (fig. 63), who carries a caduceus made up of human tongues and myrtles and pomegranates that twine together, and who holds out a motto from *Proverbs* condemning the solitary life, Vincenzo Giustiniani personified Stefano Guazzo's ideal.[151] Whereas courtly and gallant conversation in France would soon be distinguished by the inclusion of women, Ripa insisted that conversation was most proper among men, and he chose a male personification to make this point, despite the gender of the noun.[152] In his lifetime and, through the binding trust of his extraordinary will, even beyond it, Vincenzo wanted his collections, garden, and villas to continue to bring pleasure, the pleasure of civil conversations about matters of no immediate purpose, and about matters of taste and style, to men who followed their inclinations, and with plenty of time on their hands. Among such men were many of Poussin's friends and patrons in Italy and in France. And among them too was Poussin himself, who, as we shall see in the following chapters, shared with the Marchese not only a concept and inclination toward the taste expressed in ancient statues, but also the broader social idea of disinterested self-possession and civil conversation among equal friends that characterizes the *honnête homme*.

II

CASSIANO
DAL POZZO

CHAPTER THREE

POUSSIN'S *SACRAMENT OF CONFIRMATION*, THE SCHOLARSHIP OF *ROMA SOTTERRANEA*, AND CASSIANO DAL POZZO'S *MUSEO CARTACEO*

WHEN NICOLAS POUSSIN was a young man in France he attracted the attention of the great Italian poet Giovanni Battista Marino, who was staying in Paris under the high patronage of the Italian queen of France, Marie de'Medici. Poussin had painted a series of six pictures, now lost, for a magnificent apparatus built by the Jesuits in the late summer of 1622 for the celebration of the canonization of Ignatius Loyola and Francis Xavier. It is clear from the reports of his biographers that Poussin, who had already twice been frustrated in his attempts to travel to Italy in order to improve his art, was dissatisfied with the quality of training he had received in the outdated Italian-ate manner still practiced in France. He had been taught in a late and enfeebled version of the style introduced there a century earlier by Primaticcio and Rosso Fiorentino, a now exhausted mannerist idiom that had been overthrown in Italy a generation earlier by the Carracci reform. Nevertheless Marino, who had known the Carracci and their followers well and was a highly competent judge of art, admired Poussin's paintings for the Jesuits because of their liveliness and invention. He sought Poussin out, and then gave him a room in which to paint in his own house. The poet was in poor health, and he and Poussin used to read poetry together. Marino soon became even more impressed by the young painter's promise, and especially by his ability in contriving poetic inven-tions for his pictures, as well as by his skill in representing the affections. He conceived the idea that Poussin might make drawings for his ambitious epic poem of love, the *Adone*, which received its *editio princeps*, although without illustrations, in Paris in 1623.[1] In April of the same year that Marino returned to Italy, and with his assurances

and offers of introduction (which the painter had previously lacked), Poussin at last was able to travel to Rome, where he arrived in the early months of 1624.[2]

Marino was as good as his word, and before departing Rome for his native Naples, where he died in the following year, he recommended Poussin to Marcello Sacchetti, who in turn brought him to the attention of Cardinal Francesco Barberini. Roger de Piles suggests that Marino himself also intervened with the young cardinal on Poussin's behalf, introducing him with the famous, and irresistable, declaration, "Vedrete un giovane che a una furia di diavolo."[3] Francesco Barberini was the nephew of Urban VIII, elected to the papacy less than a year earlier, in 1623, one of whose first acts (to the scandal of some) had been to promote his twenty-six year old relative to the purple. It was then that Poussin first met Cassiano dal Pozzo, whose own career had finally stabilized with his appointment to the new cardinal's household. Cassiano was to become Poussin's most important and consistent Roman patron over the next two decades. In Bellori's words, he conceived such a friendly inclination for Poussin that the artist himself used to say that he had received his real training from Cassiano dal Pozzo's *Museo Cartaceo* and his house ("[il] commendatore Cassiano dal Pozzo, il quale si rivolse verso di lui con tanta inclinazione che possiamo dire quello che Pussino stesso diceva, di essere allievo del suo museo e della sua casa").[4]

The time, however, was not yet ripe. Early in 1625 Cassiano left Rome with Francesco Barberini on an important mission which was to last until late the following year, taking him to France and Spain in connection with a diplomatic effort on the part of the papacy to mediate a truce between the two rival powers. The mission also had an important cultural agenda, for the Barberini, principally under the direction of Cardinal Francesco, were already preparing the ground for becoming one of the most ambitious and coherently organized patrons of learning and the arts ever to gain access to the power and wealth of the papacy. Cassiano was to play a crucial role in administering this cultural policy.[5] Born in Turin in 1588, he had been taken by his family at the age of eight to Pisa, where his uncle was archbishop and an important advisor to the Tuscan grand-duke, Ferdinando I de'Medici. Pisa was celebrated for its university, to which its world-famous son Galileo was summoned in 1610, and for its botanical gardens which were then an especially active center for the study of natural history. Many artists were commissioned to draw the exotic (and also familiar) plants cultivated there. Natural history became a particular interest of dal Pozzo's, and was to be well represented in many beautiful drawings for his *Museo Cartaceo*. Having moved to Rome in 1612, he became in 1622 a member of the scientific Accademia dei Lincei (to which Galileo also belonged), founded some twenty years earlier by the youthful and brilliant Federigo Cesi, whose large collection of natural history drawings Cassiano later acquired for his Paper Museum. However, though he shared with Cesi the belief that investigation and classification of the phenomena of the natural world should be supported by a comprehensive and systematic compilation of accurately observed and recorded visual records, Cassiano's interests, and the contents of his paper museum, were even more encyclopaedic in scope.

In the *Museo Cartaceo* Cassiano extended the new observational and taxonomic principles then being developed in the study of natural history—supported as far as possible by the systematic and comprehensive gathering, reproduction, and classification of its materials—to the study of human history, founded in an equally comprehensive recording and arranging of the artifacts, the costumes, and the physical remains that might shed light on the religious and social customs, the rituals and ceremonies of antiquity, early Christianity, and even the Middle Ages. Cassiano has accordingly often been called, not wrongly, the father of modern archaeology, not only because of the sheer volume of evidence and information he aspired to gather together, but also because of the interconnectedness he perceived between different kinds of material which, taken all together, might shed almost infinite new light on the cultures of the past.

The conceptualization of the Paper Museum was apparently hit upon at some moment after 1620, the date of the arrival in Rome of Cassiano's younger brother Carlo Antonio dal Pozzo (1606–1689) who was his principal collaborator and heir, and who continued to add to the museum after Cassiano's death in 1657. Cassiano's appointment to Francesco Barberini's household in 1623 gave him the means and, above all, the position to pursue the project on a scale suitable to its ambition. He began to acquire existing collections of prints and drawings of both *naturalia* and *artificialia*, to commission artists to draw more materials for the *museo*, and to carry out extended correspondence and exchanges of information with scholars throughout Italy and the whole of Europe. On his trip to France and Spain in 1625–1626 he saw many collections and made acquaintances who would be of importance for his work, both for the *museo* and for Cardinal Barberini (several of whom, incidentally, would become supporters and patrons of Poussin after his fame was established).

From the point of view of Cassiano's *museo* and the interests represented there, of special importance was his meeting the great French lawyer, scientist, and antiquarian scholar Nicolas-Claude Fabri de Peiresc. In a different vein, also important was the lively interest he took in paintings, notably the Titians in the Spanish royal collections and the Leonardos in France; in particular, his appreciative response to the *Mona Lisa* at Fontainebleau is well known. An important consequence of his interest in both science and art was his promotion of the study of Leonardo's manuscripts and optical theories. It was Cassiano who conceived the idea of publishing Leonardo's *Trattato della pittura*, which first appeared in print a quarter-century later, in 1651, with illustrations by Poussin. What is more, as we shall see in the next chapter, Cassiano owned (and later lent to Poussin) manuscripts on optics, color, and the effects of light and shade which had been composed on the basis of a close familiarity with Leonardo's writings and their later interpretation, and designed for the practical training and use of painters, by Matteo Zaccolini, the Theatine painter and a specialist in perspectival architectural projections.

Although Poussin's initial introduction to the Barberini household in 1624 seems to have immediately resulted in some work for Cassiano dal Pozzo and a commission from the cardinal himself for a painting, now lost, of *Titus' Capture of Jerusalem*, there is

no question that during their extended absence on the mission to France and Spain things were difficult for him.[6] He changed households several times, living a hand-to-mouth existence in the community of foreign artists in Rome, and selling such paintings as he could for a pittance. However, his time was not wasted. It was during these years, as we have seen, that Poussin lived and studied with the Flemish sculptor François Duquesnoy and the two studied, drew after, and measured the ancient statues in the city, developing their new theories of the secrets of Greek contours, proportions, and expressiveness. Poussin also learned to model in clay, and it was then that he studied intensively Titian's *Bacchanales* in the Villa Ludovisi and made his first attempts, in his *Children's Bacchanales*, to represent the quality of expressive tenderness he and Duquesnoy deduced from Titian's *putti moderni*. He studied anatomy at first hand in the Roman hospital with the help of the surgeon Nicolas Larcher, drew from the nude in Domenichino's studio, and initiated his studies of optics and the geometry of light with Zaccolini, who had instructed Domenichino in this knowledge.[7]

When Cardinal Barberini returned with Cassiano dal Pozzo to Rome on 17 December 1626, Poussin had made great strides, and was well prepared for the opportunities to come. He immediately received a commission from the cardinal for a *Death of Germanicus* and responded with his first mature masterpiece, one that not only demonstrated his artistic mastery, but also his historical assimilation of the forms of Roman furnishings and costumes as learned from his study of information preserved in ancient relief sculptures.[8] As he had done with Marino, he also soon became friends with Cassiano dal Pozzo, not a man blessed with the private wealth of Vincenzo Giustiniani, much less the all but limitless resources available to Cardinal Barberini, but nevertheless a shrewd collector and patron who eventually was to own some fifty paintings by Poussin or copied after him.[9]

By way of understanding the foundation for that friendship, or what Bellori, in a phrase that recalls Vincenzo Giustiniani's emphasis on instinctive sympathy, called the "natural inclination" that existed between the two men, as well as the meaning of Poussin's statement that he considered himself a pupil of Cassiano's house and the *Museo Cartaceo*, we shall now turn to Poussin's two series of paintings devoted to the seven sacraments, which have rightly been called the most important paintings with Christian subjects from Poussin's middle years. Poussin's treatment of the theme of the sacraments not only depends closely on material and interests represented in the *Museo Cartaceo*, but also provides an excellent case history for illuminating Cassiano's purpose in creating it. The first series was painted between 1636 and 1642 for Cassiano himself, by then his most important Roman patron, and the second was painted between 1644 and 1648 for his most important French patron, Paul Fréart de Chantelou, each of whom set aside a room in his house especially for their display.[10] Chantelou had learned of the great fame the Dal Pozzo *Sacraments* enjoyed in Rome, and asked Poussin to have copies made for himself. After a certain amount of shilly-shallying Poussin, maintaining that he could not find a copyist up to the job, offered to paint a second series for

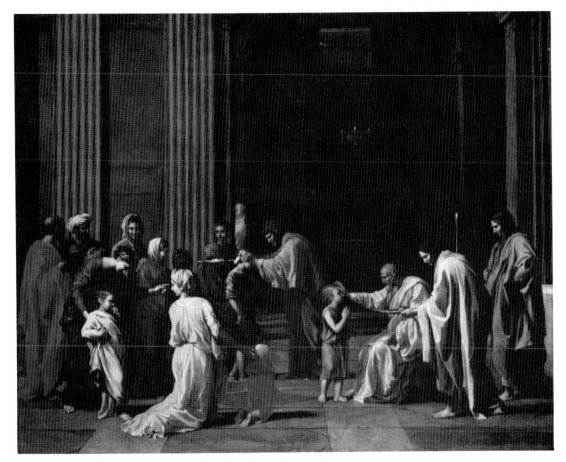

64. Nicolas Poussin, *Confirmation,* Duke of Rutland, Belvoir Castle

Chantelou. But his real reason must have been that he had not gotten the theme out of his system, something that seems evident from the fact that on the one hand he based the Chantelou *Sacraments* directly upon those he had painted for Dal Pozzo, and on the other he extended and deepened the historical precision of the individual scenes almost incalculably.

Bellori describes the first series in great detail (but only *Extreme Unction* from the second), introducing his descriptions of them by remarking that they were the most famous paintings by Poussin in Cassiano's collection, and drawing special attention to the perfection of Poussin's idea of painting, and to the fact that the figures appear "ne gli abiti apostolici della primitiva Chiesa," dressed in the Apostolic costumes of the early Christian church.[11] This is remarkable in itself, and a clear indication that Poussin's point of departure was Cassiano's interest in ancient and early Christian costume as documented in his letters and the *Museo Cartaceo*. Bellori then goes on to note the white pallium worn by the officiating bishop in the *Confirmation* (fig. 64) and the priest in a

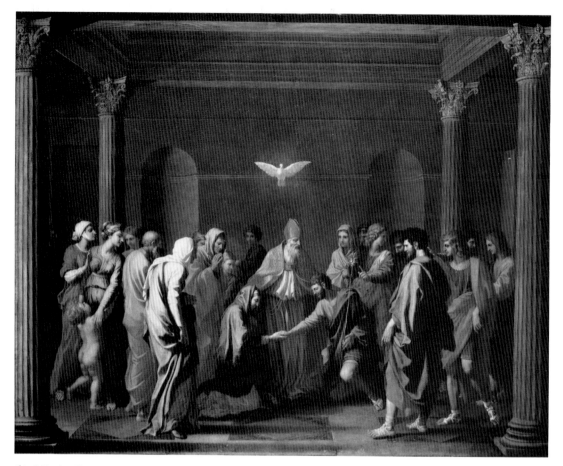

65. Nicolas Poussin, *Marriage*, Duke of Rutland, Belvoir Castle

yellow pallium, attended by a torch-bearing deacon with a red mantle in *Extreme Unction*. He also observes the Roman triclinium in *Penitence*, around which the diners in the house of Simon the Pharisee recline, as do the apostles gathered together around Christ in the representation of the last supper in the *Eucharist* (pl. III).[12] Despite the truth of Bellori's descriptions, however, the antiquarian knowledge displayed in the Dal Pozzo *Sacraments*, even as regards the portrayal of the costumes, is more generic than it is truly specific; the marriage of the Virgin shown in *Marriage* (fig. 65), for example, is staged in an exquisitely proportioned tetrastyle hall that derives from Palladio's *Quattro libri dell'architettura* (fig. 66), rather than from Poussin's direct, reconstructive observation of genuinely ancient ruins.[13]

Moreover, the series as a whole was also calculated by Poussin (as Bellori's reference to his "più perfetta idea della pittura," as well as the emphases he chose in his descriptions of the individual paintings, make clear) as a sequential display of his artistic prowess as such, setting for himself a series of the most difficult artistic prob-

66. *Tetrastyle Hall*, engraving from A. Palladio, *I quattro libri dell'architettura*, Venice, 1570

lems in order to demonstrate a seemingly effortless perfection in conquering them. Bellori's praise for the *Eucharist* (pl. III), for example, is not for Poussin's representation of the triclinium per se, but rather for his handling of light and shade, his posing the problem of three different light sources, "dupplicandosi e triplicandosi i raggi e l'ombre," the solution to which will be discussed in close detail in the next chapter.[14] Similarly, his attention is captured by the moving orchestration of the passions expressed by the figures attending the deathbed scene shown in *Extreme Unction*; while in *Baptism* (fig. 67) Bellori marvels at the way in which Poussin has indicated the apparently unrepresentable, the sound of God's voice, by having one figure look toward the dove of the Holy Ghost hovering above Christ, even as a companion points away from the dove and upward into the empty heaven in order to call to the mind of the viewer the words simultaneously uttered from above, "Behold my Son, in whom I am well pleased."[15] Also of interest, and mentioned both by Bellori and by Poussin himself in one of his letters, are the two figures attending Christ at the far right; though they appear as men, without wings, they are in fact angels, the only hint of their divine nature being the inadequate, but extraordinarily graceful gesture with which the kneeling figure supports Christ's blue robe.[16] Poussin's varied effects are indeed marvelous, but at the same time they retain a hint of the artificial, of contrivances designed by an artist still anxious to please by demonstrating inexhaustible wit and a mastery of every conceivable painterly difficulty.

In the series painted for Chantelou, on the other hand, no such trace of hesitancy remains, the historical and antiquarian materials gathered together in support of Poussin's theme are far more specific in derivation and function, and the themes chosen to exemplify each of the sacraments determine in themselves the emotional coherence and expressive means of each painting and its particular place in the series as a whole. In the *Penitence* for the second series (fig. 68), for example, Poussin retained, and refined upon, the triclinium form of the banqueting table in the house of Simon the Pharisee (which he varied in the *Eucharist* by showing, although in an incorrect form, another type of Roman dining table known from its shape as the sigma).[17] However, he set the scene in an imposing and far more convincing Roman interior, and added a wealth of subsidiary antiquarian detail, such as the small tripod serving table and variously formed ancient serving vessels. The Pharisees are not shown, as in Dal Pozzo's version, in generic Eastern costume, but now wear carefully researched head coverings into which cloths with Hebrew inscriptions are infixed.

These are without doubt intended to be the phylacteries inscribed as a "memorial between thine eyes" (Exod. 13: 9), which Christ condemned the hypocrite scribes and Pharisees for ostentatiously broadening, even as they amplified the borders of their garments (compare Simon's voluminous and magnificent robes in Poussin's painting to Christ's restrained tunic and pallium); and going on to chastize them further for taking the place of honor at feasts and rejoicing in the title of "Rabbi" (Matt. 23: 5–6): "dilatant enim phylacteria sua, et magnificant fimbrias. Amant autem primos recubitus

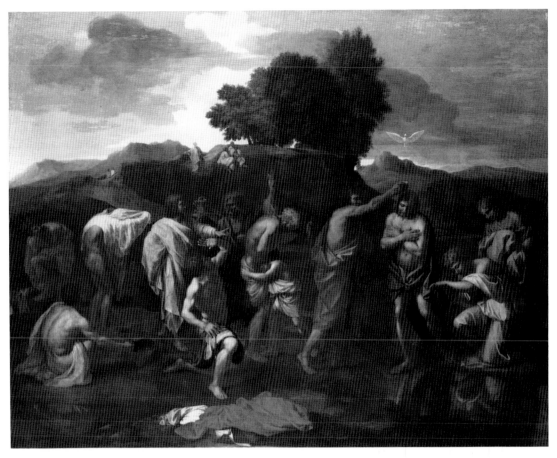

67. Nicolas Poussin, *Baptism,* National Gallery of Art, Washington, D.C.

in coenis, et primas cathedras in synagogis, et salutationes in foro, et vocari ab homi-
nibus: Rabbi."[18] The Hebrew inscribed on Poussin's phylacteries is in bad grammar,
containing a double genitive, because the texts are carefully contrived alterations of
Psalm 25: 15. Instead of reading, as it should, "Mine eyes are ever toward the Lord,"
the text has been changed to say, "Mine eyes are ever toward the letter of the law of the
Lord."[19] This new, exquisitely Pharisitical statement in turn motivates and explains
the gaze of Simon, the host at the banquet, whose fearful and perplexed eyes are fixed
directly upon Christ. His blind faith in the written law renders him unable to recog-
nize the Lord, even with eyes turned full upon him; and this in its turn renders even
more poignant Poussin's representation of the acknowledgment of Christ by a simple
woman from the city, the penitent Magdalene, who stands behind Christ (*stans retro* in
the passage from Luke [7: 38], on the basis of which scholars had decided Christ must
have dined reclining at a Roman triclinium), and who bathes Christ's feet with her
tears. As she does so, an oblivious servant boy ritually washes Simon's feet in prepara-
tion for the feast.

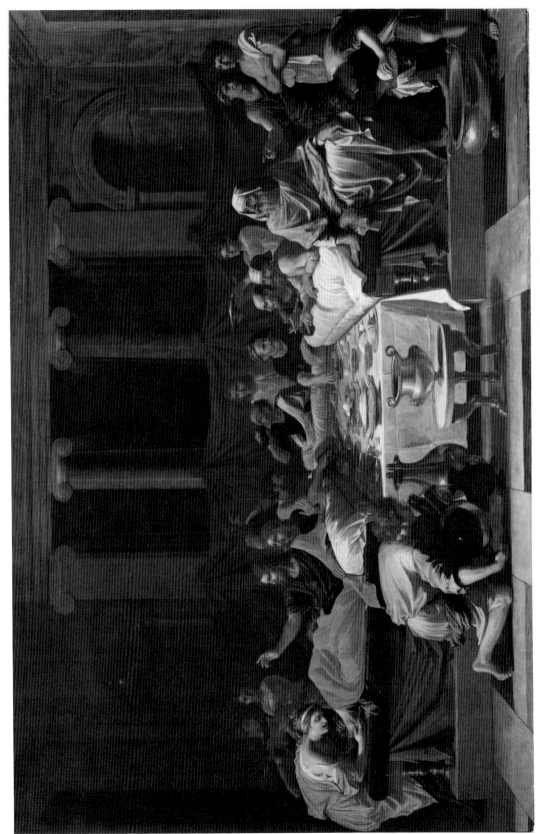

68. Nicolas Poussin, *Penitence*, Duke of Sutherland Collection, on loan to the National Gallery of Scotland, Edinburgh

In the *Baptism* for Chantelou (fig. 69) Poussin again reworked from scratch the same theme he had treated in the Dal Pozzo series, and again with a view to heightening the sense of an antique world revisited and made visible as it was, in a way that makes it seem accessible to the present while still retaining its distance and strangeness as a glimpse into the dead past. Save for the dove of the Holy Ghost, which appears almost as an afterthought, no more than an ordinary bird in the air high above Christ, there are no indications of divine intervention, no angels, and no ingenious devices drawing the viewer's attention to the voice of an invisible God. Attention is instead drawn to the groups gathered around Christ and the Baptist. On the arm of one diagonal extending from foreground to middleground appear, to the left young men disrobing in preparation for baptism, and to the right old men, women, and children. On the opposed diagonal, in the left middleground can be seen an old man in dark clothing, tugging his beard in puzzlement while two younger men to either side engage in fruitless discussion, and in the right foreground are three beautiful young men, dressed in bright robes colored with expensive dyes, their blond hair falling in ringlets about their shoulders. The first group is the Pharisees, idolaters of the word who cannot fathom the Word kneeling enfleshed before their eyes. The second group is the Sadducees, the most fully assimilated and Hellenized sect of ancient Jewry.

The second series of *Sacraments* gives clear evidence, in other words, of a mature absorption on Poussin's part, and a deeper reflection upon the historical purposes and possibilities of the materials being gathered together in Cassiano dal Pozzo's *Museo Cartaceo*. His mastery of those materials and their meaning is far greater than in the series painted for Cassiano himself. In order to arrive at an understanding of the thoroughgoing historicism of Poussin's new inventions for Chantelou, and the relationship it bears to the more tentative historical expressiveness of the series for Dal Pozzo, it is important to take into account the fact that the subjects chosen in both series to exemplify each of the sacraments do not uniformly follow the Biblical foundations laid down for each at the Council of Trent. A sacrament is a manifestation of Grace, and contemporary disputes over the validity of each of the canonical seven centered on the question of whether Biblical exegesis proved that each of them originally and in fact had been instituted by Christ in his lifetime. By exemplifying *Baptism* with the baptism of Christ, and *Eucharist* with the last supper, Poussin was on safe ground. However, by choosing to exemplify *Marriage* with the marriage of the Virgin, rather than the miracle at Cana, he was less securely based, for the churchmen gathered at Trent had rejected the former as the true foundation of the sacrament for the reason that the event preceded Christ's life on earth, and they upheld instead the miracle of the changing of water to wine as the correct basis for the sacrament of marriage.

Moreover, Poussin's representations of *Confirmation* (fig. 64 and pl. II) and *Extreme Unction* (fig. 75) do not show scenes from the Bible at all, much less from the life of Christ, but seem instead to refer to the early Church in the days of the pagan emperors. Such facts as these, combined with the extensive antiquarian learning and rather dusty

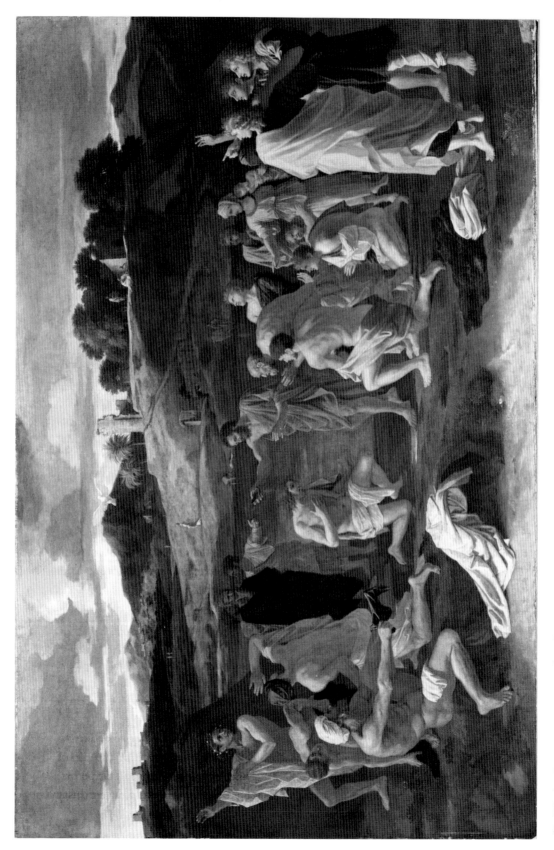

69. Nicolas Poussin, *Baptism*, Duke of Sutherland Collection, on loan to the National Gallery of Scotland, Edinburgh

Roman austerity that characterizes both series, Chantelou's in particular, has tempted surprisingly many scholars to suggest that the ideas expressed by Poussin in these paintings skirt dangerously close to unorthodox or even heretical beliefs. Anthony Blunt put forward the most influential statement of this position, writing that "Poussin was not in sympathy with the Catholicism current in the Rome of his own day." He went on to argue that the interest of Poussin's contemporaries (such as Cassiano dal Pozzo) in comparative religion suggests that for the artist, "[t]he Sacraments would have represented the basic truth which runs through all forms of religion, whether Christian or pagan, and as such would have expressed the belief in religion as above sect or creed."[20]

Yet the very fact that Poussin chose to represent seven sacraments, the canonical number powerfully upheld at the Council of Trent in response to Protestant and schismatic attacks on the validity of the Biblical foundation proposed for many of them, in itself presumes Catholic orthodoxy on his part. Moreover, the spirit of Poussin's paintings to which Blunt responded, although incontrovertibly informed by contemporary studies in comparative religion, is best understood in the context of sixteenth- and seventeenth-century Oratorian and Barberini-sponsored researches into the history and physical remains of early Christianity—or what has been known since the time of Cardinal Cesare Baronio, to that of Giovanni de Rossi, and right down to the present day as the scholarship of *Roma sotterranea*.[21] It was Blunt himself who established beyond doubt that when Poussin came to paint the sacraments he consulted the Oratorian Antonio Bosio's great book on the catacombs and rites of the early Christians, published under the very title of *Roma sotterranea*, which was the first work of scholarship ever devoted to a detailed description of the burial chambers and sepulchral imagery of the early martyrs.[22] Bosio had worked together with Baronio in the later years of the sixteenth century, and the fame and influence of his book, as well as its importance for the study of seventeenth-century art, was pointed out long ago by Emile Mâle. He observed that Bosio's *Roma sotterranea* was exemplary of that new desire for historical documentation and authentication of the story of the early Church which is most characteristically and completely displayed in the scholarship of Baronio's monumental *Annales Ecclesiasticae*.[23]

Mâle found both Baronio's and Bosio's works remarkable, as indeed they are, for the profoundly Counter-Reformatory point of view from which they were written. They were initiated from out of the Oratory of St. Philip Neri (in Baronio's case, upon Neri's direct command), again in response to Protestant doubts, and in particular to challenges from the Anglican Church regarding the legitimacy of the doctrine of the Apostolic succession. Both books were motivated by the same concern to set the story of the primitive Church, its saints, its martyrs, and its rituals, on a more secure historical foundation. They endeavor to separate fact from legend, to expunge Catholic history of fancy rather than clinging uncritically to suspect traditions, and they intend thereby to establish once and for all the history, authority, and primacy of the Church on the hard rock of documentable fact.

Bosio's book, which had long been anticipated by scholars and theologians, was still incomplete at the time of his death in September of 1629.[24] Many illustrations of catacombs, with their wall paintings, sarcophagi, religious signs and implements, had been engraved for the press, but not all, and the text still required much work. The Barberini librarian Joseph Maria Suarez, who had first met Cardinal Francesco Barberini in France at the time of his mission of 1625, convinced the cardinal to underwrite the completion and publication of Bosio's book. Suarez is best remembered today for his restoration and publication, illustrated with engravings made after drawings from Cassiano dal Pozzo's *Museo Cartaceo*, of the famous Barberini mosaic from the Temple of Fortune at Palestrina, the Nilotic landscape which, as we have seen in chapter one, gave Poussin the inspiration for the setting of his painting of the *Holy Family in Egypt* (fig. 2).[25] Suarez was also a formidable theologian, however, as well as scholar of the early Church. Among much else, he wrote on the practice of the sacraments from the very beginnings of the Church in Rome, with the highly orthodox and Counter-Reformatory intent of defending against all challengers their antiquity in the rituals of the Church from Apostolic times; and accordingly he wrote in particular on the three primary sacraments by which the faithful were initiated and sanctified—Baptism, Confirmation, and Eucharist—all of which had been practiced in the subterranean cemeteries where Christians were forced to worship in the days of Roman persecution.[26]

Suarez was an expert on ancient and medieval mosaics (and wrote a treatise on the letters represented on the togas of the saints in early mosaics and frescoes); and in connection with the extensive Barberini campaigns for restoring the early churches of Rome he was given responsibility for supervising restorations, including the apsidal mosaics of S. Teodoro and SS. Cosmas and Damian.[27] This work was undertaken hand in hand with comprehensive campaigns to survey and to produce drawings recording the mosaics and wall paintings still surviving in the ancient churches of the city, and these drawings are still of immense value for the information they give about works of art that have since been much altered, or lost altogether. Between 1630 and 1640 the keeper of Raphael's frescoes in the *Stanze*, the painter Antonio Eclissi, produced several volumes of watercolors, bearing dedications to Cardinal Francesco Barberini and preserved today in the Vatican, reproducing the decorations in mosaic and fresco of Sta. Pudenziana, Sta. Cecilia in Trastevere, S. Urbano alla Caffarella, Sta. Maria in Trastevere, S. Lorenzo fuori le mura, among many others. Ingo Herklotz has found documentation in the Barberini archives of about five hundred copies, now lost, made in the same decade by Simone Lagi and Marco Tullio Montagna of the decorations of other early churches. Many of these drawings reproduce material also found in Cassiano dal Pozzo's *Museo Cartaceo*, and Herklotz has shown that in some cases they were not drawn from the objects directly, but instead done after drawings Cassiano had supplied them.[28] So far as the publication of Bosio's *Roma sotterranea* is concerned, Cardinal Barberini assigned the Oratorian Giovanni Severano with editorial responsibility for

bringing the book to completion, and he in turn reported to Cassiano, who acted as liaison between Severano and the cardinal, as well as with other contributors to the book, and also helped him by supplying and procuring drawings for new illustrations.[29]

All this activity was taking place in the years Poussin was painting the Dal Pozzo *Sacraments* and beginning to conceive the second series for Chantelou, and at the center of it all stood Cassiano himself. Poussin's two series of the *Seven Sacraments* exemplify their sacred themes with subjects taken both from the life of Christ and from the days of the early Church. For all seven of them he adopted the same firmly historical criteria, in a painstaking way attempting to reconstruct the Roman world that existed when the events he painted actually occurred. In order to understand the importance for this artistic phenomenon of Cassiano dal Pozzo's *Museo Cartaceo* and the scholarship of *Roma sotterranea*, and also in order to get a sense of the intellectual range and context of his activities, we shall now turn to a close consideration of one of them in particular, the *Sacrament of Confirmation* from the second series for Chantelou (pl. II).

WHEN ANTHONY BLUNT wrote of the kneeling man receiving the sacrament in Poussin's *Confirmation*, he noted that his toga has a broad, flat band extending from the left shoulder across the chest. Although the form of the toga corresponds to a type found in many Roman sculptures of the late second and early third centuries, Blunt observed that, "[i]n one point, however, Poussin has blundered. He makes the toga itself of a dull red and the band of a deep purple."[30] Romans did not wear separate bands, and the color of the band painted by Poussin should be the same as that of the toga itself, since it should represent merely a part of the toga folded over. Some ancient statues showing this form of toga do indeed make the fold look like a separate garment, and Blunt suggested that this was the cause of Poussin's confusion.[31] He further made the important point that by representing such a toga and giving it Tyrrhian red and purple coloring (both called *purpureus* by the Romans), dyes only the wealthy could afford, Poussin meant to indicate that the person shown is a man of distinction; and in a footnote he added that Poussin "may have thought that this band represented the *latus clavus* or purple border used on the togas of senators and other persons of importance," an idea he then rejected as summarily as he had raised it.[32]

Blunt's rejection was too hasty. One of the most notorious controversies, lasting nearly two centuries, ever to consume the learned world concerned the precise identity of the *latus clavus*, or what we now know to be the broad purple stripe lining the tunic of Romans of senatorial rank and thus distinguishing them from their fellow citizens. Albert Rubens, the son of Peter Paul Rubens, discussed the problem at length in his famous *De re vestiaria veterum*, the second half of the title of which is *praecipue de lato clavo*.[33] In 1657 Ottavio Ferrari, who had been a collaborator and friend of Cassiano dal Pozzo, responded with his *Analecta de re vestiaria*, but this was only the latest salvo in a

dispute of long standing.[34] Among those scholars whose opinions were by this time to be counted were Baysius, Baptista Egnatius, Sigonius, Accursius, Lipsius, Lazius, Cujas, Guido Panciroli, Budaeus, Salmasius, Samoscius, Casaubon, and the great Joseph Scaliger. Many more could be listed—Jan Wouwer, for example, whose features (and also Lipsius') are familiar to us from Rubens' poignant *Four Philosophers* in the Pitti Palace—or Croquius, or Bossius Ticinensis (Matthew Bossus), the author of a slender volume entitled *De lato clavo senatorum*.

The affair indeed grew to such magnitude as to become the object of satirical comment. Joseph Addison, in his *Dialogues upon the Usefulness of Ancient Medals*, published in 1726, wrote of the three great scholars Sigonius, Scaliger, and Dacier that "These are I suppose the names of three Roman tailors: for is it possible to believe that men of learning can have any disputes of this nature? May we not as well believe that hereafter the whole of the learned world will be divided upon the make of a modern pair of breeches?"[35] Addison's query then became the basis for a famous episode in Laurence Sterne's *Tristram Shandy*. When the young Tristram's father decided the boy was old enough for breeches, he consulted Albert Rubens' *De re vestiaria veterum* for an apt antique precedent. Needless to say, nothing of breeches could he find in the pages of Rubens, but his attention was caught by the statement that in the time of Augustus almost every class distinction in clothing had been lost among the Romans, except for the *latus clavus*:

> And what was the *Latus clavus*? said my father.
> Rubenius told him, that the point was still litigating amongst the learned:
> —that Egnatius, Sigonius, Bossius Ticinensis, Baysius, Budaeus, Salmasius, Lipsius, Lazius, Isaac Casaubon, and Joseph Scaliger, all differed from each other,—and he from them: that some took it to be the button,—some the coat itself,—and others only the colour of it:—That the great Baysius, in his *Wardrobe of the Ancients*, chap. 12—honestly said he knew not what it was,—whether a fibula,—a stud,—a button,—a loop,—a buckle,—or clasps and keepers.—
> My father lost the horse, but not the saddle—They are hooks and eyes, said my father—and with hooks and eyes he ordered my breeches to be made.[36]

In the *De re vestiaria veterum* Rubens conveniently reduces the substance of all the learned opinions proposed to five basic categories: those who believed the words *latus clavus* referred: 1) to a floral or ornamental pattern woven into the fabric of the toga or tunic; 2) to a pin or brooch-like clasp used to fasten the toga to the tunic; 3) to a purple stripe lining the border of the tunic; 4) to a broad band worn over the tunic that was suspended from the shoulder and fell across the chest; and 5) to a series of studs, either round or square in shape, woven of heavy purple or gold thread and resembling in form the head of a nail or spike woven into the fabric. All were agreed that the *latus clavus* was the mark of a man of senatorial rank, distinguishing him from the class of *equites* (who wore the *angusticlavus*); and all were agreed that its color was in general purple, although it could occasionally be gold.[37]

As we have just indicated, the third opinion, that the *latus clavus* was a broad stripe lining the border of the tunic, is now known to be true. The fifth and last, which conceived it as a kind of orphrey subsequently adopted in the ecclesiastical vestments of the early Church, was the one most generally approved up to the time of Rubens' and Ferrari's dispute. The fourth theory, however, that the *latus clavus* was a broad band suspended laterally across the chest, found a powerful advocate in Jacques Cujas of Toulouse (1522–1590), the founder of the historical school of Jurisprudence and a scholar of such distinction that professors in certain German universities would doff their caps whenever his name (or that of the great Turnebus) occurred in their lectures.[38] Cujas and his supporters thought of the *latus clavus* as a kind of scapular, and argued that it had in fact survived in meaner form in the scapulars worn by certain orders of monks. They also believed that the senatorial *latus clavus* had been adopted for the vestments of deacons and bishops in the early Church.

Cujas' opinion was almost certainly shared by Cassiano dal Pozzo. Cassiano had befriended, and maintained an extensive correspondence with Ottavio Ferrari in Padua, the same Octavius Ferrarius who was Albert Rubens' opponent on the question of the *latus clavus*. He sent Ferrari notices and drawings of materials collected in his *Museo Cartaceo* while the scholar was at work on the writing of his *Analecta de re vestiaria*. Among Cassiano's papers there survives a *Nota delle figure mandate al Signor Ottavio Ferrari a Padova*, which included drawings after several miniatures in the Vatican Virgil, some figures from the Column of Trajan, and various drawings after ancient statues, all sent to Ferrari as aids to his research into the history of ancient costume. One of these was a drawing of a bronze Mercury with winged sandals, purse in hand, and wearing a *paenula*, while another showed "A marble statue, not much more than the size of an ordinary man, which is said to be the statue of a philosopher" (fig. 73).[39] Ferrari responded with the following, written in a letter to Cassiano of 19 June 1643:

> The drawings are the more pleasing to me insofar as they serve my purpose wonderfully. In the first the half-figure whom I think to be Trajan has the *paenula* which he wears half gathered up. The others have the chlamys only slightly different from the *paenula*, but still different. The second drawing of the soldier shows him with the *paenula*. I find the *paenula* of Mercury stupefying, for it differs little from the toga, which is very rare, if it is indeed antique. Above all I treasure the statue of the Cynic philosopher, which is like the fourth drawing depicting Tiberius in Cynic costume without the tunic, because it confirms me in my own opinion which is contrary to that of Salmasius, who thinks they wore at least the *subercola*, or undergarment.[40]

Ferrari's preoccupation with the *paenula* shown in the statue of a philosopher, whom he identifies as a Cynic, is especially interesting, for it directly affects our understanding of two paintings by Poussin. The statue especially excited Ferrari because it confuted the opinion of the great Saumaise (Salmasius) that the Cynic *paenula*, or pallium (a woolen cloak worn on journeys or in bad weather) must have been worn with

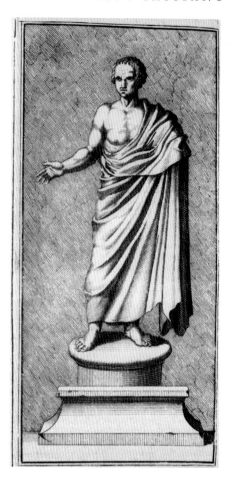

70. *A Cynic Philosopher,* engraving
from O. Ferrarius, *Analecta de re
vestiaria veterum,* Rome, 1657

some other garment: whereas in fact (as Ferrari later wrote in the *Analecta de re vestiaria,* which he illustrated with an engraving after a drawing sent him by Cassiano [Fig. 70]), Cynic philosophers went barefoot, carried only a wallet and *baculum,* or walking staff, wore a subfusc cloak without other garment of any kind, which was gathered up around the left arm and worn summer and winter, the only concession to the weather being that in summer it was worn single and in winter was doubled over the upper part of the body, for which reason the characteristic habit of the Cynics was known as the *duplex pannum* or *diploïs.* The figure of Diogenes in Poussin's great *Diogenes Breaking His Drinking Cup* (c. 1658) in the Louvre shows all these characteristics of Cynic costume with great exactitude (fig. 71).[41] So too does the principal figure in Poussin's earlier painting in the Prado (c. 1648), known only as a *Landscape with Buildings,* who also wears the subfusc *duplex pannum* and carries the *baculum,* and accordingly without question is meant to represent Diogenes (fig. 72).[42] The Prado picture, like the later *Diogenes Breaking His Drinking Cup,* illustrates a story taken from the *Lives and Opinions of*

Eminent Philosophers by Diogenes Laertius, to wit: when Diogenes was asked by a stranger why he was leaving Sparta on the road bound for Athens, he replied that he preferred the women's apartments to the men's; even Athenian effeminancy was better than Spartan manhood.[43] The painting therefore might now be given the more precise title of the *Leavetaking of Diogenes from Sparta*.

A drawing of the Cynic philosopher, possibly the same figure as that used by Ferrari for the engraving in his book, still exists in the volumes of Dal Pozzo's *Museo Cartaceo* preserved in the Royal Collections in Windsor Castle (fig. 73). Another drawing in the same book reproduces a statue of a Roman *togatus*, in which the stylization of the costume is so pronounced as to make what was in fact the fold of the toga appear to be a separate band (fig. 74). Moreover, that Cassiano and his artist understood it to be just such a band, which they misidentified as the *latus clavus*, appears from an inscription on the drawing—which in fact reads *laticlavum*.

The *Confirmation* is the second of the series of sacraments Poussin painted for Chantelou. The first in chronological order, dating to 1644, was *Extreme Unction* (fig. 75). The two moreover seem to bear a relationship to one another conceptually, for they are alone in the series in exemplifying their subjects with scenes of early Christian ritual rather than stories derived from Biblical narrative. In *Extreme Unction* the spear and shield with the Chi-Rho monogram suspended from the wall of the dying man's chamber clearly identify him as a member of the class of *equites*, the second ranking Roman class, for only *equites* were permitted to display arms in their homes.[44] There can be no doubt that by representing a dying knight Poussin intended to indicate that he was one of Constantine's officers, for, although Bosio notes that the Chi-Rho monogram can be found in the cemeteries of the martyrs as early as the periods of Hadrian, Antoninus Pius, and Diocletian, he affirms that it was only with Constantine that the emblem of the cross was adapted for official insignia and placed on armor as the emblem of *virtus exercitus*.[45] In the painting of *Confirmation* from the following year, Poussin again intended to indicate class distinction. The broad band of deep purple that crosses the breast of the toga worn by the man receiving the sacrament is unquestionably meant to represent the *latus clavus*, clearly identifying him as a man of senatorial rank—for only members of the highest Roman class were entitled to wear the *latus clavus*.

Poussin's setting is self-evidently a reconstruction of the days of the early Church, in a manner of speaking documenting the historical circumstances and antiquity of sacramental rituals in what we have already suggested is the same spirit that motivated the first explorers of *Roma sotterranea* who worked with the great Church historian Cardinal Baronio. Blunt was indeed able to show in considerable detail the extent of Poussin's historical researches for the *Confirmation*.[46] The large basin in the center of the painting appears there in reference to the early practice of baptism by total immersion, which had long been abandoned in the western Church, and it further refers to the early custom of administering baptism and confirmation on the same day, almost as part of

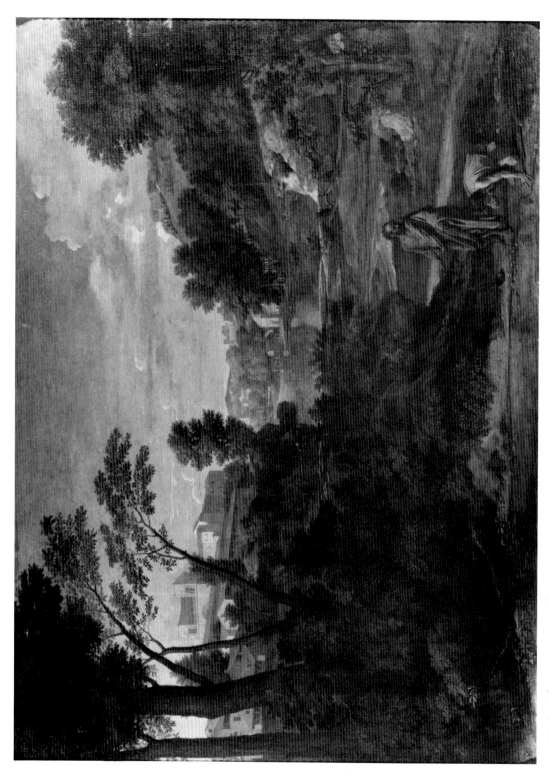

71. Nicolas Poussin, *Diogenes Throwing Down His Cup*, Museé du Louvre, Paris

72. Nicolas Poussin, *Leavetaking of Diogenes from Sparta*, Museo del Prado, Madrid

73. Anonymous, *A Cynic Philosopher,* drawing
from the *Museo Cartaceo,* Collection of Her
Majesty Queen Elizabeth II, Royal Library,
Windsor Castle

74. Anonymous, *Roman Senator Wearing the Latus
Clavus,* drawing from the *Museu Cartaceo,* Collection
of Her Majesty Queen Elizabeth II, Royal Library,
Windsor Castle

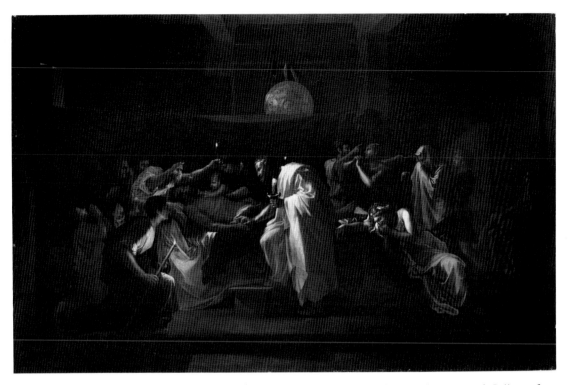

75. Nicolas Poussin, *Extreme Unction,* Duke of Sutherland Collection, on loan to the National Gallery of Scotland, Edinburgh

the same ceremony. An adult is being confirmed in order to show that these are the days of Apostolic conversion, when many Romans, including members of the patriciate, entered the Church. At the left of the painting the Paschal candle is being lit, which in the early Church occurred on Easter Eve, the time laid down as appropriate for baptism and confirmation. At the right a youth sprinkles water from a branch of hyssop, a Jewish practice adopted by the early Christians and mentioned by St. Ambrose in his discussion of the sacraments. The server kneeling in the left foreground holds the chrism, and the one standing just behind the officiating priest holds a dish in which appears a yellowish substance identified by Blunt as the milk and honey symbolizing the body of Christ and hence the hope of salvation. Next to him a third server carries a plate with the lint used to bind the foreheads of those who had been consigned with the chrism, and accordingly a deacon is shown in the center of the painting binding the forehead of a child.

To Blunt's observations we can add that the deacon's robe, like the senator's, is dyed a shade of red, signifying the fact that vestments in the early Church adapted elements from the clothing of the Roman upper classes. The officiating priest, on the

other hand, wears a robe of white linen, similar to an alb, but with part of the robe pulled up to cover his head in the manner of an ancient Roman *pontifex* performing a ritual of the highest solemnity—as may conveniently be exemplified by the figure of Augustus as *pontifex maximus* sculptured on the *Ara pacis*. His high rank moreover is established by the fact that he too wears the *latus clavus*, now in the form of its adaptation for ecclesiastical robes, which Poussin represented as a broad and beautifully embroidered gold band thrown over the shoulder. As we have seen, the argument of Cujas, Albert Rubens, and others had been that the senatorial *latus clavus* was adopted in the early Church for the vestments of deacons and bishops, and the correspondingly high rank of Poussin's priest is furthermore justified by several of the Church fathers, who wrote that only bishops were allowed to consecrate the chrism used in confirmation.

Blunt made one more essential observation, which is that the room painted by Poussin is completely enclosed, with no source of external light, and that, besides the two sarcophagi, there can be seen through the door in the extreme background the corpse of a man laid out for burial. These details suggest that Poussin intended the scene to be set in a Roman catacomb, and correspond in certain respects to several of the illustrations in Antonio Bosio's *Roma sotterranea*, which Blunt was able to show Poussin had consulted when painting the series of the *Sacraments*.[47] However, the grandiose architecture of the interior of the room, with its great columns, fluted pilasters, cut stone blocks fitted together with cement, and marble floor, all of them derived from Roman monumental building, corresponds poorly to our knowledge of what catacombs actually look like. Again, in Blunt's judgment Poussin seemed to have blundered, something he attributed to the primitive state of archaeological knowledge in the seventeenth century.

However, Blunt's leaving of the problem there was again too hasty. For if we turn to Bosio's *Roma sotterranea*, we find him writing that the catacombs, which he knew intimately and through which he had often wandered in his studies, were for the most part made up of passages and chambers roughly cut from out of the living tufa underground. There existed, however, one notable and very important exception. This was a burial place for the early martyrs which, Bosio writes, "was not excavated in the manner of other Christian cemeteries but was composed of a few subterranean rooms; it was not cut from the tufa but was comprised of rooms and vaulted, columned galleries built with cement and limestone, and it was perhaps the Baths of Novatus which afterwards was dedicated as a church."[48] The Baths of Novatus were also known by the name of his brother as the Baths of Timothy; and Bosio cites Baronio's statement that the remains of these Baths existed in a subterranean place on the Viminal which had been dedicated as a church under the titulus of Pastor, who was its first bishop. It was used as a burial place for the early martyrs, and it had a baptismal font, not surprising given the plumbing necessary for its original use as a bath, but something that also appears from several early references to baptisms *in titulum Pastoris*. The church was then re-

dedicated in the name of Sta. Pudentiana, the sister of SS. Novatus and Timothy, by their other sister, Sta. Praxedes. The churches of Sta. Pudenziana and Sta. Prassede of course still survive in the area where the Baths of Novatus or Timothy once stood, and they are among the oldest of the city of Rome.

Before its consecration as a church, however, the rooms had been the place of a cult, "suitable," in Baronio's words (which we again quote from Bosio), "for administering the sacraments"—*sacramentorum ministerio decorata*.[49] The cult was located in the house of the Roman senator Pudens, the father of SS. Novatus, Timothy, Pudentiana, and Praxedes, and it was there that the first Christians were given hospitality and a refuge for worship. In this house St. Paul, who sends greetings to Pudens in his second epistle to Timothy, was a guest, and so too was St. Peter. "It was there," Baronio writes, "that for the first time the Evangel of Christ, pronounced by Peter, became known to the Romans; moreover, it was there where Peter became known as a preacher of the Evangel to the Gentiles, since he no longer was allowed to do so among the Jews; and he was instead received by Senator Pudens, who already believed in Christ, in his own house, which was on the Viminal and where later a titulus was erected known as the *titulus Pastoris*."[50] Bosio also quotes part of an inscription commemorating Peter's mission to the Romans, then still existing in the church of Sta. Pudenziana at the altar where he had celebrated Mass. The inscription reads:

> In hac omnium ecclesiarum
> urbis vetustissima
> olim domo S. Pudentis Senatoris
> Patris SS. Novati et Timothei
> Et SS. Pudentianae
> et Praxedis virginum
> Fuit SS. Apostolorum Petri
> et Pauli hospitium primum ad
> Martyrum et Christianorum
> Baptismum, et ad missas
> sacramque synaxum
> sub altari jacent tria millia
> corpora SS. Martyrum
> et copiosus SS. Sanguis, &c.[51]

(In this, the oldest of all the city's churches, was once the house of St. Pudens the Senator, and father of SS. Novatus and Timothy, and of the virgins SS. Pudentiana and Praxedes, the first place of refuge for the Holy Apostles SS. Peter and Paul for the baptism of the Martyrs and Christians and for meeting together for Holy Mass: beneath the altar lie three thousand bodies of the Holy Martyrs and an abundance of Holy blood, etc.)

Poussin's *Confirmation*, it should now be clear, is not, as in the earlier version for Cassiano dal Pozzo, simply a generic representation of the sacrament as such, but is instead a deeply considered historical reconstruction of a particular place and event, intended to document, so to speak, the antiquity of the rite of confirmation as it actually was performed in the earliest days of the Church. The subject is the confirmation of Senator Pudens and his children. Pudens is identified by the senatorial *latus clavus* (which only adults could wear), and the teen-aged youth with a yellow robe who kneels by his side is Novatus. Timothy, already having been anointed with the chrism, is shown as the boy having his forehead bound with lint by the deacon. Praxedes, a little girl wearing an exquisite blue robe and with her hair bound in a topknot fashionable in the days of Augustus, is gently prodded forward by her nurse to a position a step behind her father. Her older sister Pudentiana, a beautiful young woman in an orange *stola*, completes the little procession. Behind her, bowing his head as he is sprinkled with water from the hyssop, appears St. Peter, easily recognizeable by his bald head and short, curly hair and beard. The administering priest, with black hair and beard, can also be identified as St. Paul.

As we have seen, the *latus clavus* indicates the high rank of the priest as well as of the senator receiving the sacrament, and scholarly opinion contemporary with Poussin had maintained that it had been adapted in the days of the early Church for the vestments of bishops. However, the baptism of Pudens occurred in the Apostolic period of the Church, and the church that was dedicated in his house was moreover the first in Rome, preceding the establishment of the See of St. Peter. (As we have seen, Bellori wrote of Dal Pozzo's *Sacraments* that there too Poussin had represented "le figure medesime ne gli abiti apostolici della primitiva Chiesa.")[52] Furthermore, in the church of Sta. Pudenziana, in the earliest of the great Christian apse mosaics to have survived (dating to c. 400, fig. 76), St. Paul appears seated on the right hand of Christ, wearing the same *latus clavus* worn by Christ himself and by the original Apostles who are also shown gathered around him. Though the *latus clavus* is correctly represented in the mosaic, as a purple band lining the tunic of Christ and the Apostles, nevertheless it is easy to see how Poussin, especially as he was working under a mistaken hypothesis inspired by the ambiguous representation of the toga on late antique statues, might have misinterpreted it as the separate band he elaborated for the costume of Senator Pudens in the *Confirmation*. It is also easy to see that he correctly understood the meaning of the *latus clavus* as designating Paul's Apostolic rank.

The mosaic also shows St. Peter on Christ's left hand. We have already mentioned the story of Peter's initial preaching of the Gospel to the Romans in the house of Pudens, a story quoted by Bosio from the pages of Baronio's *Annales Ecclesiasticae*. However, the legend that made Pudens a disciple of Peter derives from a later tradition of the Roman Church, always jealous of the dignity of its first head. There is no need to enter into the question in detail, beyond noting that the early legends are based on an attempt to explain the origins of the two ancient and neighboring churches of Sta.

76. Antonio Eclissi, *Apse Mosaic in Santa Pudenziana,* drawing from the *Museo Cartaceo,* Collection of Her Majesty Queen Elizabeth II, Royal Library, Windsor Castle

Pudenziana and Sta. Prassede. The earliest version, however, as told in the *Acts of SS. Pudentiana and Praxedes,* which was purportedly written by the very Pastor who was the first bishop of the church dedicated at the house of Pudens, had it that Pudens was a disciple of Paul in Rome, and that before his death he himself transformed his own house into the church called the *titulus Pastoris.*[53] This legend is the basis for Poussin's giving Paul priority over Peter in the *Confirmation.*

The reason Poussin chose to follow the Pauline version, however, rather than the Petrine version accepted by Baronio, again rests on the evidence gathered by the Barberini restorers and archaeologists who were exploring the Christian remains of subterranean Rome. Among the drawings of early medieval church decorations made by Antonio Eclissi for Cassiano dal Pozzo is a group after several frescoes devoted to the ministry of St. Paul, frescoes that still exist in a little oratory behind the apse of Sta. Pudenziana. They are half ruined and seem not to have been completely published to this day. The first to discuss them in modern times was Wilpert, who examined the frescoes in 1906, had them copied for his book on medieval painting, and who dated

77. Antonio Eclissi, *Fresco from the Oratory in Santa Pudenziana: St. Paul Preaching in the House of Pudens and St. Paul Baptising Timothy and Novatus,* drawing from the *Museo Cartaceo,* Collection of Her Majesty Queen Elizabeth II, Royal Library, Windsor Castle

them toward the end of the eleventh century. Dal Pozzo's drawings, included in the volumes of the *Museo Cartaceo* at Windsor Castle, were published in exemplary fashion by Charles Rufus Morey in 1915, and they have been republished by Waetzoldt.[54] Three narrative scenes remained in the seventeenth century, and survive in slightly poorer condition today, two of them in a single lunette (fig. 77). The first shows Paul preaching in the house of Pudens, who appears standing at the right with SS. Novatus, Pudentiana, and Praxedes. The second shows the baptism by total immersion of Timothy and Novatus by St. Paul, with the two virgins, one of them holding her brother's tunic, standing next to the font. In both frescoes Paul wears the toga and Apostolic *latus clavus*. At the base of the frescoes is an inscription, condemned by Morey as "thoroughly medieval and bad," which he transcribed and translated as follows:

> + PAVLVS ALENS MENTE[m] PLEBIS NATASQ[ue] PVDENTEM
> + AVXIT MACTATOS HIC VIVO FONTE RENATOS

> (Paul, giving sustenance to the spirit of his flock, and to Pudens and his daughters, blessed them that were dead and here are born again in living water.)[55]

The third fresco, much of which had already been destroyed by the seventeenth century, represents St. Paul ordaining Timothy as a Christian priest (fig. 78).

We do not know whether the frescoes of Paul's administering the sacraments to the family of Pudens were matched by a second series devoted to St. Peter. However, a

ANXII

78. Antonio Eclissi, *Fresco from the Oratory in Santa Pudenziana: St. Paul Ordaining Timothy as a Christian Priest,* drawing from the *Museo Cartaceo,* Collection of Her Majesty Queen Elizabeth II, Royal Library, Windsor Castle

fourth fresco, also copied for the *Museo Cartaceo,* survives in the oratory which shows St. Peter standing between SS. Pudentiana and Praxedes, all of them clearly identified by inscriptions. This suggests that a Petrine cycle may also have existed, which is supported by the fact that the other memorials in Sta. Pudenziana, including the inscription reproduced by Bosio and the great apse mosaic, conflate the Pauline and Petrine legends of the Senator Pudens and his family into an expression of the *concordia fratrum* existing between Peter and Paul in the great work of converting the Romans. The theme of the reconciliation of the two Apostles in Rome, as Herbert Kessler has shown, was an important concern of the fifth-century Church, for in the Bible Peter is last heard from in Jerusalem and Paul alone is reported as preaching the Gospel in the pagan capital.[56] In the apocryphal accounts, on the other hand, Peter's role is enhanced, and when Paul arrives in the city Peter is already seated at the head of a congregation; they then meet and work together in harmony. In the apse mosaic of SS. Cosmas and Damian, accordingly, the two are given equal prominence, and the same is true in the mosaic of Sta. Pudenziana, in which Paul and Peter sit on the right and left hand of Christ respectively and receive crowns from two women who have been identified either as SS. Pudenziana and Prassede or as personifications of the church of the Gentiles (crowning Paul) and the church of the Jews (crowning Peter).

Poussin's *Confirmation* provides a fascinating commentary to the ancient dispute

over the priority of the two Apostles, which lies of course at the heart of the conflicting legends regarding the conversion of the Roman senator Pudens. Unquestionably both Peter and Paul are present in the painting, which in itself means that Poussin also intended to indicate the reconciliation of the two. At the same time, St. Paul is given the dominant role, with St. Peter shown subordinately as a member of the congregation and not the leader of it (which is why he is not wearing the pallium and *latus clavus* worn by Paul as officiating priest). This suggests not only that Poussin followed the more ancient version of the legend, making Pudens the disciple of Paul, but also that for him and for Cassiano dal Pozzo the priority of Paul as the converter of the Gentiles in Rome must have appeared to be marvelously confirmed by the "archaeological" evidence of the frescoes in the oratory of Sta. Pudenziana itself. So too must the antiquity of the sacraments and their rites have seemed to be securely documented in the visible remains of the place of the original Christian cult in the city, where the Apostles for the first time preached the Gospel and thereby converted, baptized, confirmed, and ordained the Romans; a place truly, as Baronio had written, *sacramentorum ministerio decorata*.

IN THE LIGHT of Counter-Reformation concern for the primacy of the See of Peter, the dominant position given Paul over Peter in Poussin's *Confirmation* is not without its troublesome aspects. Baronio, as we have seen, when he related the legend of Senator Pudens asserted that it was in his house that the "Evangel of Christ, pronounced by Peter, first became known to the Romans." However, Baronio's knowledge of the older legend, according to which Paul converts and baptizes the Senator and his children, appears in his statement that Peter was received into the house of Pudens, *who already believed in Christ*.[57] It may perhaps, therefore, be worth adding a postscript about Poussin's *Sacrament of Ordination* for Chantelou (fig. 79), which is exemplified by the giving of the keys to Peter, but in which the relationship between Peter and Paul is again a primary theme, and in which Poussin again explored the relationship between the two saints and sought to redress the balance between them.

For St. Paul is also present in the *Ordination*.[58] Christ stands at the center of the painting, with two groups of five Apostles each arranged symmetrically to his right and left. The planar emphasis of the composition is energized by a chiastic movement into depth, with Christ again at the center: from the left-hand group of Apostles, through Christ to the pyramidal building in the right background; and from the right-hand group of Apostles, through Christ and the final two Apostles (one kneeling before Christ and the other standing just behind him) to the pilaster inscribed with the letter "E" at the left. These two Apostles stand in privileged relation to Christ. They are Peter, easily recognizable from his bald head and short beard, who kneels to receive the keys; and Paul, with his characteristic dark hair and beard, who stands behind and to Christ's right. And that he most surely is Paul appears from the following circumstances.

79. Nicolas Poussin, *Ordination*, Duke of Sutherland Collection, on loan to the National Gallery of Scotland, Edinburgh

In the *Ordination* the historical particularity of Poussin's reconstruction of the days of the early Church faced its severest test. He chose to represent the sacrament with Christ's giving of the keys to Peter, an act indicative not only of the ordaining of ministers as such, but also one profoundly significant for the establishment of the Apostolic succession and of the authority of the Roman Church, both of them doctrines of great consequence in the light of Protestant and especially Anglican challenges. The meaning of the giving of the keys is irrevocably linked to Rome and St. Peter's, the literal rock of Christ's pronouncement to Peter (the words "Tu es Petrus, et super hanc petram aedificabo ecclesiam meam" are indeed inscribed round the drum of the dome of St. Peter's itself). The historical donation of the keys, however, did not take place in Rome but, as the Bible expressly states, in Caesarea. The problem Poussin faced lay in the reconciliation of historical fact with historical significance; the former dictated a setting in Caesarea, the second in Rome.

Poussin chose Rome, the symbolic and not the historically literal setting. His approach, which Blunt again analyzed in considerable detail, was to interpret the meaning of the event by tracing it back through such closely related themes as Christ's mission to the Apostles and the *Pasce oves meas* (Raphael's design of this subject being an important predecessor of the *Ordination*) to its origins in the imagery of the early Church.[59] Thus, an important preparatory drawing, now in the Louvre (fig. 80), that Poussin made for the *Ordination* shows Christ handing Peter a scroll, not the keys, and this motif is directly derived from early Christian sarcophagus representations of the theme of the *Traditio legis*. On these sarcophagi Christ appears standing above the four rivers of Paradise flanked by the twelve Apostles. The two leading Apostles are Paul, who stands to Christ's right, and Peter, who appears to his left and receives the scroll inscribed with the legend *Dominus legem dat*. Here again Poussin was indebted to Dal Pozzo's *Museo Cartaceo*, which contained some drawings of the early Christian sarcophagi, and to Bosio's *Roma sotterranea*, in which a number of sarcophagi with the theme of the *Traditio legis* are reproduced (see fig. 81), some of them engraved after drawings that Dal Pozzo supplied to Bosio's editor Severano.[60]

As a theme the *Traditio legis* is entirely abstract in character; it does not represent events that literally took place, but instead shows the symbolic fulfillment of the prophecies of Isaiah. And as a theme it addresses problems of crucial importance to the early Church. These are the dominance of Rome, the primacy of Peter, and the Apostolic status of Paul, the converter of the Gentiles. So far as the last is concerned, Paul had not known Christ in life—and was certainly not present in Caesarea when Peter received the keys—and so his claims to Apostolic rank are tenuously based on his vision on the road to Damascus. His importance to the Roman Church was such, however, that in the days of the early Church Apostolic status was claimed for him, and accordingly, as we have seen, he and Peter appear together in many medieval church decorations, a notable example being the mosaics of SS. Cosmas and Damian, in which both of them wear the *latus clavus* to denote that they are Apostles. In the apse mosaic

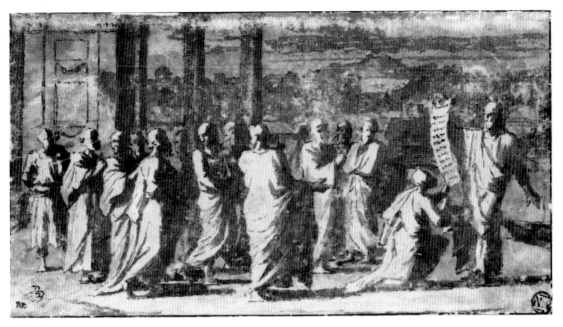

80. Nicolas Poussin, *Ordination,* drawing, Département des arts graphiques, Musée du Louvre, Paris

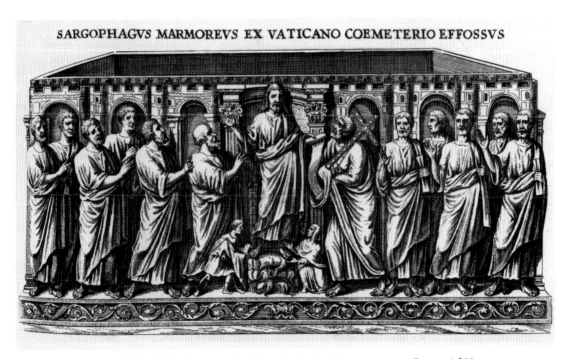

SARGOPHAGVS MARMOREVS EX VATICANO COEMETERIO EFFOSSVS

81. Sarcophagus with *Traditio legis,* engraving from A. Bosio, *Roma sotteranea,* Rome, 1659

of Sta. Pudenziana Paul also is shown, again with the *latus clavus*, again as one of the twelve Apostles, and again paired with Peter at their head. It is in precisely this role that he appears as one of the Apostles and is paired with Peter at their head in early Christian representations of the *Traditio legis*, and it is this that motivates his presence in Poussin's *Ordination*.

The significance of Poussin's interpretation of the giving of the keys to Peter is accordingly dependent upon the very early and very Roman theme of the *Traditio legis*, which defines Peter's relationship to Paul, and which dictates the presence of Paul in the painting of the *Ordination*. Moreover, that Poussin specified the setting as Rome cannot be doubted, for the architectural structures depicted in the *Ordination* are easily explained by a reading of Bosio's description of the ancient topography of the Vatican. Bosio writes that there was a triumphal gateway into the Vatican which was entered by crossing "a bridge called the Ponte Trionfale to a hill upon which there were, among other buildings, two famous temples, one dedicated to Apollo, the other to Mars."[61] In the same area could be seen "the sepulchre of Scipio Africanus, which was in the form of a pyramid, and which some say was the same pyramid that used to be visible not far distant from the Mole Adriana."[62] The primary architectural and topographical features of Poussin's painting are thus accounted for—the bridge behind Christ which crosses the river to a hill, on which may be seen two temples and a villa at its crest; the enormous circular structure shown just beyond the lower of the two temples, clearly Castel Sant'Angelo restored to its ancient form as an imperial tomb; and most conspicuously the cubical tomb at the right, the pyramidal roof of which unmistakeably proclaims it to be the tomb of Scipio Africanus as described by Bosio. The view into the distance beyond the bridge, the triumphal gateway into the Vatican which Poussin imagined on the basis of the bridge shown in Marcantonio's engraving after Raphael's *Massacre of the Innocents* (fig. 143), with Castel Sant'Angelo directly ahead and slightly to the left, leaves no doubt that the scene is taking place on the exact spot where Peter was later to be buried and his church built.

Finally, with regard to the vexed question of the pier in the foreground inscribed with the enigmatic letter "E," Blunt has suggested that the meaning of the letter may have been motivated by Plutarch's essay on the meaning of the E inscribed on the portal of the Sanctuary of Apollo at Delphi.[63] There is indeed evidence at hand to support this hypothesis, for Delphi was the site of a famous oracle, and Bosio writes that the name "Vatican" derived from the *vates*, or *vaticinii*, who occupied the hill in Roman times and were the last of the soothsayers and oracles of pre-Roman Italy.[64] However, it should be observed that the pier has something of the character of a funerary monument, and that this is entirely in keeping with its position in relation to the tomb of Scipio Africanus and with the use of the Vatican in the Roman era as a cemetery. It marks in fact the exact site of the tomb of Peter, and in this sense can be said to be Peter, the rock upon which Christ's church is to be built. The primary signification of the E can accordingly only be, as many have thought, *Ecclesia*. With one

hand Christ is shown pointing to heaven, the source of his authority, and with the other he points to the base of the pier, indicating to Peter the earthly extension of that authority, the rock of the Church of Peter.

Poussin depicted Christ in the moment of sanctioning Peter's inheritance of the law, and through him the Church, with the utterance: "Tu es Petrus et super hanc petram aedificabo ecclesiam meam. Et tibi dabo claves regni caelorum, et quodcumque ligaveris super terram, erit ligatum & in caelis; & quodcumque solveris super terram, erit solutum & in caelis" ("Thou art Peter, and upon this rock I will build my church. And I will give unto thee the keys of the kingdom of heaven, and whatsoever thou shalt bind on earth shall be bound in heaven; and whatsoever thou shalt loose on earth, shall be loosed in heaven").

In the *Confirmation* Poussin delineated Paul's historical primacy as the converter of the Gentiles in Rome, with Peter in the secondary role. In the *Ordination*, on the other hand, he redressed the balance, and by interpreting the significance of the giving of the keys through reference to the theme of the *Traditio legis*, he established Peter's primacy as inheritor of the law, and Paul's acquiescence to the dominance of Peter. In these paintings, and in the *Sacraments* as a whole, Poussin had concentrated all the gifts of acquired learning and sensibility that had been given him by the friendly inclination of the many extraordinary men he had known in Italy, from Giambattista Marino and François Duquesnoy, to Vincenzo Giustiniani and Cassiano dal Pozzo.

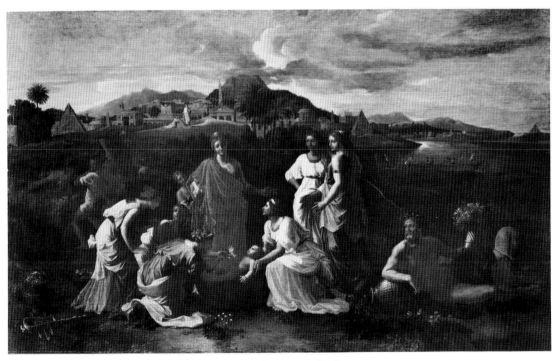

82. Nicolas Poussin, *The Finding of Moses,* Musée du Louvre, Paris

It is scarcely surprising then, given the thought and devotion Poussin had expended upon the *Sacraments* in general, and the *Ordination* in particular, that he should have reacted with anger and hurt to Chantelou's expression of dislike for the *Ordination*; and what is more to Chantelou's scarcely supportable accusation that Poussin showed more love for another French patron, Pointel, for whom he had just painted the magnificent *Finding of Moses* (fig. 82), now in the Louvre, than he did for him. In response, on 24 November 1647 Poussin wrote Chantelou his famous letter on the ancient Greek modes, reminding him how difficult it is to judge well, and pointing out that the nature of the subject determines the nature of its treatment, which in turn produces an effect upon the viewer, by determining his *disposition*.[65] "I am not a light man," he wrote, "and I do not change my affections once I have given them." The continuation of this story of thoughtlessly imperiled friendship is the subject of our fifth chapter, which treats of Poussin's *Self-Portrait*, painted for Chantelou in 1650 (pl. IV), and the artist's concern to express to his proud patron something of the true basis for friendship and love between *honnêtes hommes*, and between men of mutual inclinations. How well the lesson took can not be known. However, after Chantelou later showed the Cavaliere Bernini around his collection, in one room of which the *Seven Sacraments* were kept as objects of special pride and honor, and where they elicited due and merited praise from the great sculptor, the only comment Bernini made about Poussin's *Ordination* that Chantelou found worthy of mention in his diary was the dismissive remark that the architecture of the painting and its pyramid reminded him of Mansard roofs, or, as he put it, "les toits à la français."[66]

ON THE EXPERIENCE OF LIGHT AND COLOR: POUSSIN, PADRE ZACCOLINI, CASSIANO DAL POZZO, AND THE LEGACY OF LEONARDO

IN THE *Self-Portrait* he completed for his friend Pointel in 1649 (pl. V), Poussin represented himself holding a book.[1] In Jean Pesne's engraving after the portrait (fig. 83), which certainly was made while Poussin was still alive, the book is entitled DE LVMINE ET COLORE, and until very recently the same inscription appeared on the painting, which is now in Berlin.[2] Blunt's identification of this version as the original has received general acceptance, but, after cleaning in 1993, it appears that neither the inscription identifying the painter at the top of the canvas, nor the title on the spine of the book in this version (both of which are identical with the inscriptions in Pesne's print) were part of the original painting.[3] Another autograph version of the *Self-Portrait* Poussin sent to Pointel may come to light, but the strongest alternative candidate to date apparently does not bear the inscription on the book either.[4] The exact title and contents of this volume are therefore now in doubt, although there can be no denying that by including it Poussin intended to emphasize his own interest in the sort of knowledge (whether expressed in words or in drawings) that got bound up into books in the seventeenth century, and not just in the actual practice or craft of painting as such.

This emphasis on knowledge is established in many other ways. The artist's hand holding the chalk-holder, or *toccalapis*, for example, rests on the wrist of his other hand, which holds the book rather than being actively at work. The painter's clothing, furthermore, as both Georg Kauffmann and Matthias Winner have argued, associates Poussin with the image of Vouet designed by Van Dyck for his *Iconographie* of 1641 (fig. 84).[5] In this engraving, Poussin's predecessor at the court of Louis XIII wears similar dark robes and rests his hand on a book entitled *Trattato della nobiltà della Pittura*. This must be a copy of Romano Alberti's treatise of that title, commissioned by the Com-

83. Jean Pesne after Nicolas Poussin, *Self-Portrait,* engraving

pagnia di S. Luca and the Accademia della Pittura in Rome, and first published in 1585, and the robes worn by both Vouet and by Poussin are surely academic.[6] The characterization of Poussin as *ACADEMICVS ROMANVS PRIMVS PICTOR ORDI-NATVS LVDOVICI* in the engraved inscription behind Poussin's head in Pesne's print, and which was probably added to the Berlin *Self-portrait*, is not incorrect.

The exact date of Pesne's print remains problematic, for Mariette's inscription of 1660 on the copy in his collection is possibly incorrect, as Jacques Thuillier has pointed out. The print is dedicated to Cérisier, who had acquired the painting from the estate of his friend Pointel. We now know that the inventory of Pointel's collection taken upon his death was drawn up only on 20–22 December 1660, making it almost (but not completely) impossible for the print with its dedication to the new owner to have been made that year.[7] At the same time, at least one of Pesne's engravings after a work by Poussin, the print of Chantelou's *Ecstasy of St. Paul*, must have been issued before 1662.[8] The possibility remains, therefore, that the print after the Pointel-Cérisier *Self-Portrait* was made to commemorate Cérisier's acquisition of the work early in 1661, Mariette having simply forgotten to adjust to the new year, or else dated it to coincide with Pointel's death. Whatever the date of the print, either Jean Pesne himself added the title *De lumine et colore* to the book held by Poussin in the engraving after the Pointel-Cérisier picture, or the intervention had already been made on the original portrait itself; quite possibly the spine of the volume in the painting now in Berlin was adorned with a title after the publication of the print in order to conform to it.

The example of Van Dyck's portrait of Vouet, who died in the very year Poussin completed the *Self-Portrait* for Pointel, might seem to have been a determining factor for Poussin's inclusion of the book and choice of academic robes in any case, but it does not explain the specific title attributed to the book held by Poussin in the engraving. To account for this we have first to recognize how strong was the desire on the part of both Poussin's French patrons and members of the Académie Royale that Poussin should have written a book on painting. The newly questionable status of the inscription itself helps to point up this desire by casting in an entirely new light the important evidence provided by Jean Dughet in his letter to Chantelou of 23 January 1666, concerning his brother-in-law's intention to write a treatise.

According to Félibien, who published the letter, Chantelou had written to Dughet shortly before Poussin's death asking about the "Traité des Lumières et des Ombres" that everyone thought Poussin had written.[9] Dughet makes it clear that the original query had come from none other than Cérisier, the new owner of the Pointel portrait and the dedicatee of the engraving. Cérisier had told Chantelou about seeing a book by Poussin "dealing with lights and shadows, colors and measures." Dughet replied that there was no truth to this, but that he did have in his possession some manuscripts on light and shade that Poussin had had him copy out from an original book in the Barberini library. The author was "Padre Matheo Maestro di Prospettiva di Domenichino," that is to say the Theatine priest and painter, Padre Matteo Zaccolini, a

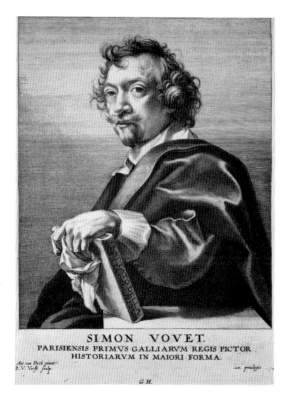

SIMON VOVET.
PARISIENSIS PRIMVS GALLIARVM REGIS PICTOR HISTORIARVM IN MAIORI FORMA.

84. Robert Van Vorst after Anthony van Dyck, *Simon Vouet*, engraving, National Gallery of Art, Washington, D.C.

specialist in the art of perspective projection. Dughet had copied out a large section of this work at Poussin's request, together with some rules of perspective by Witelo, before they went to Paris together (that is to say before late 1640). Subsequently everyone thought Poussin was the author of these manuscripts, and "all the French," continued Dughet, thought he had left some kind of treatise behind. Providing they were returned at once, Dughet was prepared to send the manuscripts to M. Roland Fréart, Sieur de Chambray, Chantelou's older brother, who also seems to have been anxious to see them.

Chambray, it will be recalled, had himself written a short treatise with the very long, but highly informative title *Idée de la perfection de la Peinture demonstrée par les principes de l'Art et par des examples conformes aux observations que Pline e Quintilien ont faites sur les plus célèbres tableaux des anciens Peintres, mis en parallel à quelques ouvrages de nos meilleurs Peintres modernes, Léonard de Vinci, Raphaël, Jules Romain et le Poussin*, published in 1662, and of which Poussin had requested Chantelou to send him a copy early in 1663.[10] In one of his last letters, dated 1 March 1665, Poussin acknowledged Chambray's book, praising its clarity and critical independence. He added a brief series of notes defining the "beautiful art" of painting: the principles of vision that anyone can learn (which notes incorporate material from Witelo); and other aspects of painting that only the painter can know, in which he offers a rather different set of parts from those put forward either by Chambray or by Franciscus Junius, Chambray's own source.[11] This letter, together with an earlier one of 29 August 1650, in which Poussin tells Chantelou that he has decided not to send to Chambray the thoughts on painting he was beginning to organize because this would be like taking coals to Newcastle ("porter de l'eau à la mer"), confirms that the notion that Poussin indeed intended to write some kind of book on painting was not entirely wishful thinking on the part of the French academic community.[12] Bellori also reports that Poussin had often talked of writing a discourse on painting, and he went so far as to publish the observations that the painter had made "in the manner of Leonardo da Vinci"; these had been disclosed to Pierre Le Maire by Camillo Massimi, who kept the original manuscript in his library.[13]

Most of the notes published by Bellori are derived from Poussin's reading of Tasso and Mascardi, and have little to do with the subject of light and color, the title attributed to the book the painter holds in the Pointel *Self-Portrait*.[14] The frontispiece to Bellori's Life of Poussin (fig. 85), however, agrees at least in part with Pesne's engraving in presenting the artist as a student of optics. Bellori's frontispiece, designed by Errard under his supervision, shows a female figure holding up a perspective diagram of a cube and a triangular pyramid, and behind her there appear a cylinder, a cone, and a cube, the latter inscribed *LVMEN ET VMBRA*.[15] Accompanying the frontispiece is an engraved portrait by Clowet, adapted from Poussin's second *Self-portrait*, which had been completed in 1650 for Chantelou (fig. 86 and pl. IV).

In this second *Self-Portrait* Poussin presents himself holding a portfolio bound with a red ribbon, and in Clowet's engraving, in a sort of conflation of the two painted

85. Charles Errard, *Frontispiece to the Life of Poussin,* from G. P. Bellori, *Le Vite de'pittori, scultori, ed architetti moderni,* Rome, 1672

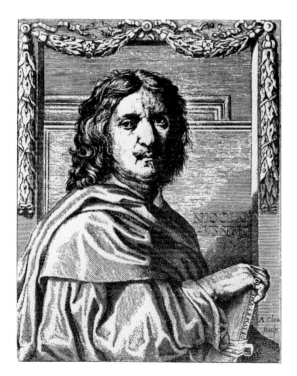

86. Albertus Clowet, engraving adapted from *Portrait of Nicolas Poussin,* frontispiece to G. P. Bellori, *Le Vite de'pittori, scultori, ed architetti moderni,* Rome 1672

versions, this portfolio was changed into a book bearing the inscription *DE. LVM. ET. VMB* on the spine. As we shall see, both plates illustrate Bellori's statement, which again coincides with Dughet's report, that Poussin had studied the manuscripts of the Theatine Matteo Zaccolini, both with regard to the diminution of forms in space and to the principles of light and shade.[16]

Once this is established, Cérisier's understanding that Poussin had made (the word is "fatto," which may well imply compilation rather than authorship) a book "dealing with lights and shadows, colors and measures" (*lumi et ombre, colori et misure*) may be seen to reflect even more accurately Poussin's study of the contents of Zaccolini's treatises. Whereas Bellori and his illustrator focused on Poussin's interest in the perspective of shadows as treated by Zaccolini in his manuscript entitled "Della descrittione dell'ombre prodotte da corpi opachi rettilinei," Cérisier, as quoted by Chantelou and Dughet, recalled the wider range of materials also treated by Zaccolini. Discussions of "colori et misure" were included in Zaccolini's manuscripts entitled "De colore," and "Prospettiva del colore," in which, as we shall see, colors were assigned measures on a perspective scale. It is also possible that the "misure" in question relate to the contents of another manuscript, entitled "Prospettiva lineale."

A remarkable drawing by Poussin, now in the Uffizi, which depicts artists at work in a specially equipped studio (fig. 87), provides a unique point of departure for determining how the painter approached the study of chiaroscuro and color in accordance with what he had learned from studying the manuscripts of Zaccolini, as reported by Dughet and Bellori. Whatever the preoccupations may have been at the French Academy in the 1650s and 1660s regarding Poussin's study of chiaroscuro, color, and perspective, perhaps leading to the imposition of the inscription on the Pointel portrait, it was through such study that Poussin himself enthusiastically embraced optical traditions that he, like many contemporaries, associated with the knowledge of Leonardo da Vinci. The drawing also helps us to understand how Poussin envisaged that the principles of optics, once learned, should ideally be taught to others and applied in paintings, and in a way that was closer to the investigative experience of Leonardo than it was to the more dogmatic and systematized procedures of the Académie.

Anthony Blunt long considered the Uffizi drawing to be a copy, but in the end— and correctly in our view—he attributed it to Poussin. At the same time, he continued to illustrate and base his discussion of its imagery on the copy in the Hermitage, because this is easier to read.[17] Some of the attempts at clarification made by the copyist, however, contradict the indications of the original drawing. Because of this, and because many details of the Uffizi study are all but lost in reproduction, it is necessary to describe the original rather carefully.[18]

A low platform with sloping sides appears to our left at the side of the studio. The rear of this platform is bounded by a high-standing screen, so folded as to form at least three angles and to enclose two major spaces. Four geometrical solids stand on the platform, beginning in the foreground with a sphere, followed by a cone, a cylinder,

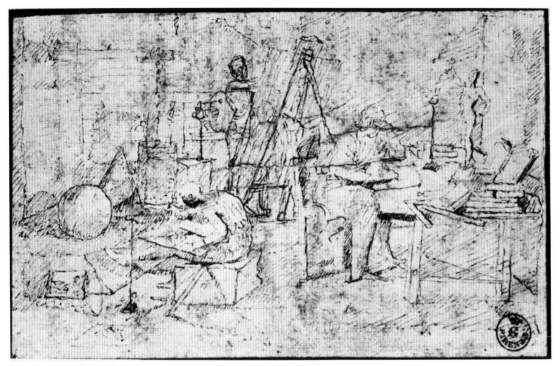

87. Nicolas Poussin, *Artists' Studio,* drawing, Gabinetto Disegni e Stampe, Gallerie degli Uffizi, Florence

and a triangular solid. The cylinder is suspended by a chain from a sort of gibbet that is attached to the first section of the screen, and it casts a circular shadow on the platform beneath. This shadow must be created by one of the two lamps that appear to be above and slightly behind the cylinder, but it is impossible to see how either of these lamps is supported, and so their exact position is unclear. A vertical stand is placed on the triangular solid, supporting what appears to be a lamp shielded on one side by a circular disc; in the copy this shield seems to have a hole in it, but this is not at all clear in the original. A student draws from these geometrical forms. He is seated on a bench that has been overturned so that the actual seat, with a small hole at its center, is turned towards us. A ruler is propped against the front edge of the stool, casting its shadow on the floor and on the vertical surface of the stool. The student rests his left leg on the sloping edge of the platform, upon which it too casts a shadow, and he places his compasses on the tablet resting on his knee. Another lamp is to his left, this time on a high stand. A piece of paper bearing a geometrical drawing lies at the foot of the lamp, and to the left, sketched in very lightly, a cone lies on its side, its surface inscribed with circular sections. Behind this is an indecipherable rectangular form that rests against the platform, marked with the numbers 4 and 8.

Another student is at work to the right. He is seated in a high-backed chair at a table, his right leg crossed over his left, and his left foot resting on a cross-bar of the

table. He rests his head on his left hand and draws with his right on a sheet of paper. The table at which he works is littered with geometrical instruments. A lamp on a stand in front of the student illuminates a statuette of a standing figure in such a way that its enlarged shadow is cast on the wall behind.

The central part of the drawing is the most difficult to read. A third figure stands at work on a large canvas that is supported by an easel set at a sharp angle to the surface. In the St. Petersburg copy the faint traces discernible in the original of the head and shoulders of a fourth figure, apparently leaning over on our side of the easel, have been strengthened, and the size and angle of the easel have been adjusted. This makes it possible to imagine that this fourth figure is looking through a hole in the shield in front of the lamp on the triangular solid. In the Uffizi drawing, however, the pen lines that delineate the easel have been drawn over the neck and shoulders of this figure, and the hatchings across the back of the canvas run over his head, thus suggesting that Poussin decided to cancel the whole figure.

Poussin's drawing, as Blunt pointed out, belongs to the relatively new tradition of the representation of artists' studios, or "academies," one of the most famous examples of which is the engraving of Bandinelli's studio by Agostino Veneziano published in 1531 (fig. 88).[19] The relationship between Poussin's and Bandinelli's studios is especially close once it is understood that, although the former has the colors of painting as its end and the latter the relief of sculpture, both are primarily dedicated to the study of chiaroscuro and shadow projection. Bandinelli makes his statement very simply. His studio is illuminated by a single, brilliant candle whose spreading light projects on the walls behind enlarged shadows of all the objects ranged on the shelves (like the statuette in Poussin's drawing), as well as those of the artists themselves. Unlike the sculptor's daughter in the ancient story, however, who discovered the art of painting by tracing the outlines of such shadows, these students do not look at the walls.[20] They work instead from statuettes placed closer to the light, which are endowed with interior modeling and relief by the play of light and dark upon them. Leonardo himself had argued that sculpture would look flat without the aid of nature in the form of chiaroscuro, and in Bandinelli's studio drawing, whether for painting or for sculpture, is seen to rely on the manipulation of chiaroscuro for the achievement of relief.[21]

Leonardo's lesson about the contribution of nature, and in particular natural light, to sculptural relief was to be of continuing interest. In the seventeenth century, for example, Pietro Accolti, the Florentine academician and author of *Lo inganno degl' occhi* (1625), introduced a section of his book entitled (like that in the Bellori portrait of Poussin) "De lumi et ombre" with a description of how Apelles destroyed the effect of a sculpture by Praxiteles by shading all the highlights and lightening all the shadows with his brush, so that the appearance of relief disappeared. Galileo proposed to make the same demonstration.[22] The continuity of this observational tradition from Leonardo to Galileo (who as a youth had studied in the Accademia del Disegno in Florence) should prepare us for Poussin's own dedication to the study of chiaroscuro for the purposes of understanding how to produce the illusion of relief and distance.

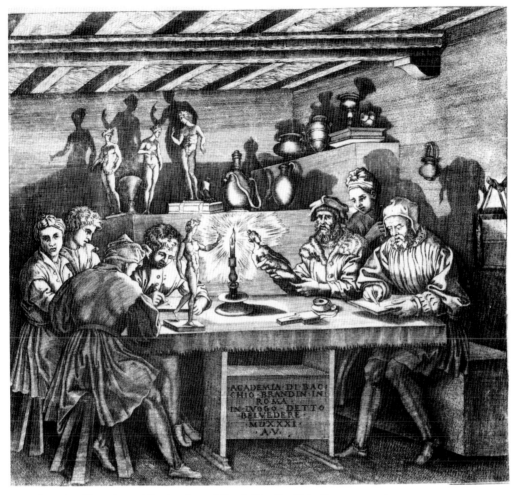

88. Agostino Veneziano, *The Academy of Baccio Bandinelli in Rome*, engraving

At the same time, the presence of the sphere, cylinder, and cone in his studio drawing may seem incongruous, evoking as they do the aesthetics of ideal form that modern criticism has attributed to Cézanne's famous dictum that nature should be treated in accordance with these geometric solids.[23] Indeed, Cézanne's own critical fortune as a painter of form rather than of color and light is closely linked with Poussin's. Theodore Reff has proposed that a taste for classicism in the early twentieth century was responsible not only for the image of Cézanne as a reformer of Impressionism, but also for the concomitant revival of critical interest in Poussin. To this taste for classicism, he suggested, is owed the first translation of Bellori's biography of the artist into French, the first edition of Poussin's correspondence, Desjardins' comparative study of Poussin, Corneille, and Pascal, and finally the pioneering studies of Magne, Grautoff, and Friedlaender, all three of which were published in 1914, and which

provided the initial basis for modern historical and critical approaches to Poussin's art.[24]

The early twentieth-century view of Poussin as the model for rational painting, as providing an example for the reform of Impressionism, has discouraged studies of the artist as himself a painter of color and light, given that color in painting has conventionally been considered to be ungovernable by theory, or not subject to reason.[25] Such a view is directly associable with earlier arguments in the French Academy between Poussinistes and Rubénistes, which were in themselves as much arguments about teaching, and about the relationship of theory to practice, as they were truly about drawing versus color, or the historical Poussin and Rubens. Especially difficult for modernist critics to understand, it seems, is the relationship between the values of chiaroscuro and color in Poussin's mature work, which at its most refined stands somewhere between the chiaroscuro painting of the Venetians and the Bolognese and the purely optical values of Impressionism.

Friedlaender and Blunt, for example, isolated moments in Poussin's career when the influence of an artist particularly associated with *colore*, namely Titian, was important for his art, but only Badt attempted a thoroughgoing analysis of the role of color and light in the whole of Poussin's oeuvre.[26] It was Badt, the Cézanne scholar, who first developed the argument that Poussin's theory of the Modes was to some extent at least a theory of color.[27] Yet despite his extraordinary interest in Poussin's color, or perhaps because of it, even Badt misread the frontispiece to Bellori's biography (fig. 85), which is so closely related to the Uffizi drawing in question. Because of the presence of the sphere, the cylinder, and the cone, Badt thought that the image was based on a misconception of Poussin's art, that he was interested in shading individual forms (haptic rather than optic) as opposed to what Badt perceived to be Poussin's true interest in the play of light and shade across forms as the foundation for color (optic rather than haptic).[28] However, as we shall see, Bellori intended to record in the frontispiece a particular aspect of Poussin's studies of chiaroscuro, one that ultimately did engage the study of the interrelationship of effects of light and shadow on groups of solids, rather than on single forms. Despite this misreading, however, Badt's distinction between Leonardo's use of chiaroscuro for modeling in haptic relief, and Poussin's more thoroughgoing employment of an optical structure based on chiaroscuro is an important one.

It is in fact, as we have suggested, the arrangement of geometrical solids in the Uffizi drawing, to which Bellori's frontispiece also alludes, that makes possible the precise connection of Poussin's study of chiaroscuro with the similar studies by Padre Zaccolini, who is known to have given Domenichino instruction in optics. This connection helps in turn to clarify Poussin's interest in Leonardo's investigation of the subject, of which Zaccolini was one of the most devoted students in seventeenth-century Rome, and whose writings, like those of Leonardo, were conserved and promoted by Cassiano dal Pozzo.

Both Bellori and, earlier, Cassiano dal Pozzo report that in some cases Zaccolini wrote in reverse script, mastered by him in the course of his Leonardo studies. Carlo Pedretti's rediscovery (first published in 1973) among the Ashburnham manuscripts in the Biblioteca Laurenziana in Florence of four manuscript volumes of treatises by Zaccolini made it possible to assess for the first time, and in a way not accessible to students of Poussin earlier in this century, what Domenichino and Poussin (as well as others, including Pomerancio, the Cavaliere d'Arpino, and Gagliardi, who are all said to have been taught by Zaccolini) could have learned from him.[29] The Theatine painter dedicated the manuscript volume entitled "Prospettiva del colore" to the Governor General of his Order in Naples in 1622, and he died in Rome in 1630.[30] This makes it more than likely that Poussin met him, as Bellori says he did, and had access to his writings very soon after his arrival in Rome, and almost certainly during the period of intense study that he undertook in 1625–26, when Cardinal Barberini and Cassiano dal Pozzo were absent from the city. His admiration for the work of Domenichino, then painting in S. Andrea della Valle, would also have encouraged him to seek Zaccolini out.

On the basis of Dughet's report that he possessed the manuscripts on *lumi et ombre* which he had copied out for Poussin from Zaccolini's unpublished manuscript book in Cardinal Barberini's library, Pedretti believed that the Barberini copy of Zaccolini's writings had ended up in the Biblioteca Laurenziana in Florence (one volume of which bears this very title), and that it was, therefore, from these same volumes that Dughet had copied out sections for Poussin before they both went to Paris in 1640. Now that Janis Bell has indicated a firmer early provenance for the Laurenziana volumes, however (tracing them beyond Ashburnham, and beyond the infamous cataloguer and dealer Libri and the Albani family, back to the Vatican and thence to Carlo Antonio dal Pozzo, and so in turn to Cassiano dal Pozzo himself), this conclusion is no longer quite so clear.[31] The evidence, she suggests, points to the possibility that there were more copies of Zaccolini's writings than Pedretti had thought. To the version supposedly in the Barberini library and another, reputed to be written in reverse script, in the library of San Silvestro (both of which are presumed missing or lost), must now be added the four volumes in the Laurenziana, apparently commissioned by Cassiano dal Pozzo himself, and organized by him in readiness for the printer. On the other hand, before setting out in search of lost manuscripts, we should keep in mind that the relationship between Cassiano and Francesco Barberini was such that a manuscript consulted by Dughet in the Barberini library in the late 1630s could easily have ended up in the hands of Cassiano after the death of Urban VIII in 1644, especially given Cassiano's intent to see to its publication. Such copying, organizing with tables of contents, and preparation of books for publication was part of Cassiano's more general determination, based on his experience as a member of the Accademia dei Lincei, to disseminate knowledge, especially knowledge of the natural world, and in which he was supported by Cardinal Francesco Barberini.[32]

Another notable example of this practice, one that also engaged Poussin, was the publication of Leonardo's *Trattato della Pittura*. Like the plan to publish Zaccolini's treatises, this too was closely linked to Cassiano's work for Cardinal Barberini. It was Cassiano's purchase of a manuscript copy of Leonardo's treatise for the Barberini (Vat. Barb. lat. 4304) that led to his inquiries about other manuscripts in Milan, especially the Codex Pinellianus (which had been given to the Ambrosiana by its founder, Cardinal Federico Borromeo), as well as the original notebooks of Leonardo that Arconati gave to the Ambrosiana in 1636. The exchange of texts for detailed critical comparison between Cassiano and Arconati that followed came to an end with the death of the Barberini pope in 1644.[33] The plan to publish the Zaccolini treatises failed, but Cassiano's hopes for the publication of the *Trattato della Pittura* were fulfilled. Edited by Raphael Trichet Du Fresne, with whom Poussin was in close contact in Rome during the 1640s when Du Fresne was head of the Imprimerie royale before going on to become librarian to Queen Christina, the Italian version was printed in Paris by the royal printer Langlois in 1651, with a dedication to the Swedish Queen herself.[34] As Du Fresne recounts in the introductory letter to Pierre Bourdelot (then the Queen's doctor, and also a friend of Poussin), the published text was based on several manuscripts. Especially precious was the one that Cassiano dal Pozzo had given to Chantelou, because it included the figures drawn by Poussin that were then followed in the engravings illustrating the text.[35] A French translation by Fréart de Chambray, also based on a copy of Cassiano's illustrated manuscript, bearing a dedication to Poussin, was printed by Langlois in the same year.[36]

A sense of just how closely knit all these projects and personalities—that is to say the plans to publish Leonardo's *Trattato della pittura* and Zaccolini's various *Trattati*, the Barberini, Cassiano dal Pozzo, Zaccolini, and Poussin—really were is glimpsed most vividly in a few jotted notes on the title page of the manuscript known as Ambrosiana MS H 227inf. This copy of various of Leonardo's writings had been sent to Cardinal Barberini in Rome by Arconati in Milan so that Cassiano dal Pozzo could arrange for a copy to be made.[37] One note is a reminder that Cassiano had lent Zaccolini's volume on linear perspective to Monsignor Albrizzi (Luigi Albrizzi, the famous preacher), who was staying in the Chigi palace on the Lungara.[38] A second note on this page states, "Monsu Poussino deve rest.re uno dell'ombre e lumi. con figure appartate." Pedretti has suggested that this refers to another of the Zaccolini volumes—that on the perspective of colors (that is to say Ashburnham 1212²)—because some of the figures in this volume are gathered on two folios at the end.[39] This does not really justify the phrase "con figure appartate," however, and, given that this note is in graphite whereas the note referring to Albrizzi and Zaccolini is in ink, the connection with Zaccolini's manuscript is not so obvious here. Fortunately a simpler solution is at hand. *Ombre e lumi* is in fact the title of the first group of notes (fols. 1–54) in Ambrosiana MS H 227 inf. itself. These notes, based on material by Leonardo, are followed by separate illustrations of various optical problems on fols. 1–82.[40] It seems likely, therefore, that the

note records Cassiano's loan to Poussin of this very volume, and that it served to remind the borrower rather than the lender that he must return it. It is such a volume, we should recall, the title of which is also echoed in the chapter of Accolti's book *Lo inganno degl' occhi* entitled "De lumi et ombre," cited above, that Poussin holds in the version of the *Self-Portrait* designed as the frontispiece to Bellori's Life.

The Uffizi drawing substantiates Dughet's report that Poussin had access to a copy of Zaccolini's writings, even if in this case Cassiano's note does not. Regardless of whether that copy was the printer-ready version now in the Laurenziana or an earlier, even autograph, manuscript, it establishes that Poussin must have seen illustrations very like those in the volumes now in the Biblioteca Laurenziana.[41] And it also helps us to see why Poussin would have found at least one of these treatises, that entitled "Della descrittione dell'ombre prodotte da corpi opachi rettilinei" (Ashburnham MS 1212[4]), so important that he wanted to have a copy of parts of it to take with him to Paris.[42]

The illustrations in this Ashburnham volume are so remarkable that Pedretti believes Zaccolini must have had access to a lost volume on light and shade by Leonardo himself. The relationship between Poussin's drawing of a studio and the contents of the manuscript is most readily established by looking at some of these drawings in detail.[43] On fol. 12v (fig. 89) Zaccolini illustrates, first through a geometrical construction and then, in the lower section, in a rendered drawing, how to describe the shadow cast by a rectilinear solid on a plane that is partially horizontal and partially inclined (as is the platform in Poussin's drawing).[44] A more complicated example appears on fol. 13v (fig. 90). Here the platform on which the solid rests is surrounded by vertical surfaces, like Poussin's folding screen, that turn towards and away from the light. Another example of the use of the folding vertical screen appears in the drawing on fol. 8v (fig. 91), which shows how to draw the shadow of a cube cast by a single light against a vertical surface that bends in an angle behind it. The first two examples (figs. 89 and 90) make clear how the platform on which Poussin has arranged the solids in his drawing, on the sloping side of which the student rests his foot, is intended to be used. Poussin has shaded the screen where it is turned away from the light as in the drawing on fol. 13v (fig. 90), and the shadow of the sphere is projected along the platform, and then vertically onto the screen, like the shadow of the cube on Zaccolini's fol. 8v (fig. 91). Poussin's student could vary the problems he set himself by folding the screen in different ways in relation to the light, and also by moving the lights in relation to the platform.

In several of Zaccolini's illustrations geometrical solids are suspended from the same kind of gibbet construction from which the cylinder hangs in Poussin's drawing. On fol. 36r (fig. 92), for example, a rhomboid cube is attached directly to the gibbet, while in the upper drawing on fol. 80r (fig. 93) a sphere is suspended by means of a chain, like the one also employed by Poussin.[45] Such a device, as Blunt noted, also appears in the engraving of an artist's academy by Cornelis Cort after Stradanus, and it may well have been a familiar studio item (fig. 94). In Stradanus' Academy, however,

89. Biblioteca Laurenziana, Florence,
Ashb. 1212⁴, fol. 12 verso, drawing

90. Biblioteca Laurenziana, Florence,
Ashb. 1212⁴, fol. 13 verso, drawing

91. Biblioteca Laurenziana, Florence,
Ashb. 1212⁴, fol. 8 verso, drawing

92. Biblioteca Laurenziana, Florence,
Ashb. 1212⁴, fol. 36 recto, drawing

93. Biblioteca Laurenziana, Florence,
Ashb. 1212⁴, fol. 80 recto, drawing

the gibbet supports a corpse upon which an anatomy is being performed.[46] Poussin and Zaccolini, on the other hand, were concerned with the anatomy of chiaroscuro, to which Stradanus makes no reference in his highly linear, or glyptic, conception of the arts. In assigning the pose of the hanging corpse to the statuette on the table at the right, Poussin makes the displacement of one anatomy by another all the more conspicuous.

Zaccolini's choice of a variety of geometrical solids was certainly not new in the history of the study of shadow projection. For example, Guidobaldo del Monte, the brother of Caravaggio's patron, also used them in his demonstrations of shadow projection (fig. 95).[47] And Zaccolini's method for plotting shadows, like Del Monte's, was broadly inspired by Dürer's application of the rules of linear perspective to shadows.[48] In his *Perspectivae libri sex*, for example, Guidobaldo del Monte also analyzed the problem of the shadow cast at the angle of a vertical plane, which functions like Poussin's and Zaccolini's screens, as well as the projection of shadows by solid gemetrical bodies

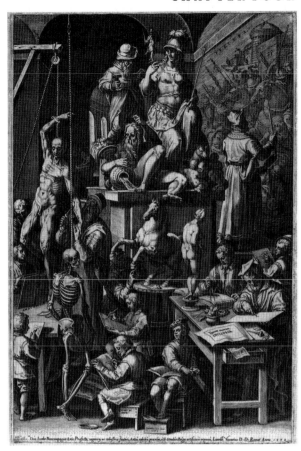

94. Cornelis Cort after Johannes
Stradanus, *The Academy of Fine Arts,*
engraving, Boston Museum of Fine
Arts, Boston

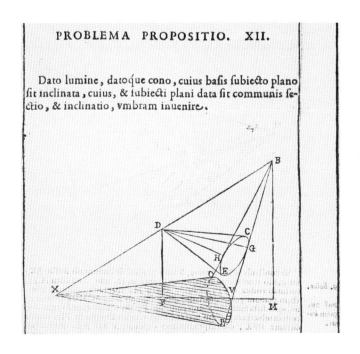

PROBLEMA PROPOSITIO. XII.

Dato lumine, datoque cono, cuius baſis ſubiecto plano
ſit inclinata, cuius, & ſubiecti plani data ſit communis ſe-
ctio, & inclinatio, vmbram inuenire.

95. Engraving from
Guidobaldo del Monte,
Perspective libri sex, Pesaro,
1600

LIBER QVINTVS. 251

altitudo supra subiectum planum ; oportreatque vmbram inuenire. Ducatur MDK, in planoque HF ducatur KL ipsi EF perpendicularis ; erit vtique KL in plano per MDK DG, & MB ducto. cùm sint BM GD LK subiecto plano erectæ ; lineaque MK dicti plani, ac subiecti plani sectio communis. Itaque iungatur BGL, quæ secet KL in L: nimirum vmbra puncti G erit in L. vnde patet, iuncta HL, vmbram lineæ GH esse in HL, vmbramque ipsius GD esse in LK KD ; ita vt ducta BK, quæ ipsam GD secet in I, vmbra LK sit portionis GI, KD verò sit portionis ID. Itaque plani HF pars HEKL erit in vmbra, planumque DH totum vmbrosum erit ; subiecti verò plani pars DEK in vmbra similiter existet.

PRAXIS.

Sit in subiecto plano basis CDEF, plana verò erecta supra CD DE EF (facilitatis gratia) eandem altitudinem habeant DG ; lumen verò in subiectum planum perpendiculariter cadat in M, cuius altitudo sit BM Ducatur MDK, cui ad rectos angulos à punctis MDK exponantur lineæ MB DG, & KL. ducaturque BGL, quæ lineam KL secet in L ; erit sanè KL vmbræ terminus erectæ lineæ supra K, & EDK in subiecto plano vmbram quoque ostendet ; & propter lineam DK dignoscitur, erectum planum supra DE totum vmbrosum esse. quod facere oportebat.

Ex iis, quæ diximus in præcedenti, constat, quomodo duobus

Ii 2 *modis*

Ex 19. & 38. vndecimi

96. Engraving from Guidobaldo del Monte, *Perspectivae libri sex,* Pesaro, 1600

inclined to the plane or placed upon it (fig. 96).[49] Several aspects of Zaccolini's treatise are so unusual, however, that the similarities between Poussin's drawing and Zaccolini's illustrations can only be accounted for by Poussin's direct and specific knowledge of them.

First of all, though Zaccolini follows writers like Dürer and Guidobaldo del Monte in concentrating on the effects of light thrown by a torch rather than by daylight, he goes beyond their examples by multiplying the variables through introducing more than one source of light, and even occasionally considering the different effects of firelight and sunlight.[50] On fol. 63r (fig. 97), for example, a cube is illuminated by two torches, which create two overlapping shadows of the cube, and short shadows at their own bases.[51] On fol. 65r (fig. 98) the number of torches is increased to three. In Poussin's studio complex shadows are also created by various sources of light. Each bar of the gibbet, for example, casts two different and distinct shadows on the screen, while the cone casts two different-sized shadows on the two sides of the angle of the screen.

The second significant variable that Zaccolini introduces is the juxtaposition of different geometrical solids. This means, for example, that one can study the way in which the shadow of a rectilinear body falls on the curved surface of another body, and affects its shadow. On fol. 47r (fig. 99) he shows how the shadow of a rectangular solid falls upon a cylinder, part of which emerges into the light. Even more closely related to Poussin's drawing is the study on fol. 30r (fig. 100), in which a rectangular solid and a cone are juxtaposed and illuminated by a torch set rather low on the corner of the plane solid. Zaccolini describes the elliptical conic section in defining the line of shadow on the surface of the cone, and this detail was taken up by Poussin, who shows two different sections on the surface of his cone indicating the boundaries of shadows of different intensity.

The third, remarkable, aspect of Zaccolini's treatise is his manner of descriptive presentation itself; that is, his juxtaposition of geometrical constructions with studies in pen and wash. Zaccolini explains several times why he does this, as Pedretti pointed out. He wanted to show natural appearances, and to encourage and invigorate the student at the same time.[52] Zaccolini addresses his reader as a "scientifico Pittore," and often justifies his procedures by appealing to his reader's ultimate purposes as a painter. In the case of a drawing of a cube, for example, rendered without geometrical contruc-tion, he says this should help the "tired and new practitioner" ("il stanco e Novello operatore") to gain strength in a single step, without exhausting himself in an "intri-cate labyrinth of lines," and that this kind of drawing will help keep his eye on the perfection of his practice.[53]

The rendered drawings are not only easier to understand. They also require that the student think about the density of shadows, especially at their edges, and not just their projection, breaking down any distinction between chiaroscuro and solid geome-try.[54] This is evident on fol. 63 (fig. 97), for example, where Zaccolini has added

97. Biblioteca Laurenziana, Florence, Ashb. 1212⁴, fol. 63 recto, drawing

98. Biblioteca Laurenziana, Florence, Ashb. 1212⁴, fol. 65 recto, drawing

99. Biblioteca Laurenziana, Florence, Ashb.
1212⁴, fol. 47 recto, drawing

100. Biblioteca Laurenziana, Florence, Ashb.
1212⁴, fol. 30 recto, drawing

feathery touches of gray wash towards the limits of the area of shadow otherwise described geometrically; and on fol. 47r (fig. 99), where he had to graduate the shadow on the cylinder cast by the corner of the rectangular solid where it meets the light, and where he also shaded the right side of the cylinder without benefit of geometrical proof.

Such concern for the inseparability of *sfumato* from the geometry of shadow projection, as Pedretti noticed, is also to be found in the work of another important contemporary student and popularizer of Leonardo's ideas. This is Pietro Accolti, whose *Lo inganno degl' occhi* has already been mentioned.[55] In the section of his book entitled "De lumi et ombre," Accolti begins by dismissing the Venetian Daniele Barbaro's *La pratica della perspettiva*, as well as Guidobaldo del Monte's *Perspectivae libri sex*, for having nothing to offer the painter.[56] Their observations are worthless, he claims, because they are based on torchlight, or lamplight, the rays of which, as we have seen, spread out pyramidally. Because a true painter is concerned to imitate natural appearances, he must learn to deal with natural light from the sun, the rays of which fall in more nearly parallel lines because of the sun's great distance and magnitude. Accolti determines no ideal light for painting, but encourages artists to recognize the differences in chiaroscuro caused by different sources of light. The sun also moves through the heavens, and he seeks to help the painter to analyze the changes in chiaroscuro that result.

Accolti is especially interested in the way in which *chiaro* and *scuro* intersect, in "what painters call *unione* and *sfumamento*."[57] In this context, he attacks those painters who shade colors infinitely, in what he calls an equal, circular union, because this undermines relief. Accolti insists upon the delights of color, and cautions young students at the Florentine Academy not to fall into the common trap of losing color "in great highlights and intense shadows."[58] Though his illustrations do not always reveal it, Zaccolini shared this position, and he too insisted upon the importance of the tempering qualities of reflected light, without which shadows would merely resemble the darkness of night, and give no pleasure to the eye.[59] However, whereas Zaccolini's remarks probably signal his opposition to the sharp contrasts of chiaroscuro, or that "crude cutting manner that contributes nothing to the delight of looking," which characterized the paintings of Caravaggio and his followers in Rome, Accolti's observations seem to reflect his criticism of the continuous quality of Leonardo's *sfumato*, in the application of which color is habitually sacrificed to shadow, and whereby relief melts away into an infinity of reflections.[60]

This criticism of Leonardo's practice, and notably its influence in Florence, is particularly interesting given that so much of Accolti's book is based on Leonardo's writings.[61] It may also seem surprising that this kind of advice was still being given in 1625, even in Florence. We should remember, however, that the particular reform of color and chiaroscuro effected by the Carracci had not produced a single, definitive solution.[62] Rather, their discoveries opened the way to a new series of speculations about color and light, not least by helping painters to learn once again the fundamental

lesson of Leonardo's investigations, which was that both color and light could be manipulated in systematic ways. The Carracci also made it imperative for succeeding generations, which included Zaccolini and Poussin, to return to the direct study of natural phenomena.

Zaccolini and Accolti both adopted another aspect of Leonardo's teaching, one to which the Carracci themselves had given new emphasis, and which would be of primary importance to Poussin: the importance, that is, of establishing a balance between experience and theory, mediated by judgment. Both Zaccolini and Accolti sought to show how theoretical and practical optics could be made accessible to the painter who wanted to achieve illusions scientifically—to "ingannare gli occhi"—but who did not share Leonardo's obsessiveness. It is, of course, extremely important that both Accolti and Zaccolini wrote in Italian, following in the tradition of Leonardo, whereas Augilon and Guidobaldo del Monte still wrote in Latin. Accolti introduces material from familiar sources on optics, such as Augilon and Witelo, but he also refers frequently to artistic practice. For example, when discussing how to arrange figures in perspective he first gives a geometrical method, but he then recommends the more practical manner he had seen used by such artists as Cigoli, Allori, and Passignano, who employed wax models, a widely adopted practice we know Poussin also followed.[63] Although Poussin's friend, Pietro Testa, grappled with Daniele Barbaro's account of the Analemma of Ptolemy, Accolti acknowledged that the theory of sundials was beyond the comprehension of most artists. Nevertheless, such theory was very necessary for the study and portrayal of the effects of the moving sun, and Accolti therefore proposed a simple method for drawing a sundial on any wall.[64]

Like Zaccolini, Accolti sought to simplify, but only to make his book useful to a special audience, and not yet to provide rules of thumb that substituted for independent inquiry. His explanation of how a student should learn the principles of *sfumato*, gradually making himself independent of the need for geometrical demonstration, also provides the best explanation of how both Zaccolini and Poussin expected the student to learn, progressing from the geometrical solids seen in the drawings under discussion to the more irregular models of nature. Accolti writes as follows:

> We do not mean to say that the painter must effect the *unione* and *sfumamento* of every shadow and *sbattimento* (which many try to represent) by means of a plan and profile, and all this with compasses in hand, for this would be much too laborious; but we mean in this, as in the things discussed above and below, so to open the eyes of contemplation, and so to empower the mind and the intellect that, imbued with these demonstrations and having established himself really firmly in them, he will not fear to execute freely with the brush that which we have represented geometrically with mathematical demonstrations for the purposes of teaching.[65]

In Poussin's drawing we see the same progression from the study of illuminated regular solids to the more complicated task of working with such irregular figures as the statuette.[66] After using geometry as a way of learning how to analyze chiaroscuro rationally, the students in his ideal studio then learn to work freehand, although their instruments and books are constantly to hand on the table. In the end they will paint "con franchezza" without such tools, and the presence of the painter at his easel in Poussin's drawing serves as a reminder that such exercises were not ends in themselves. To understand what Poussin himself learned from Zaccolini about shadow projection, we must look at his paintings. Poussin had Dughet copy sections of the manuscript before leaving for Paris in 1640. Poussin's illustrations for Cassiano's manuscript of Leonardo's *Trattato della pittura* were made in the mid-1630s. Blunt has suggested a date for the Uffizi drawing in the 1640s. It is not, therefore, surprising that the best example of Poussin putting his study of Zaccolini's treatise on shadow projection into practice, and in an overtly deliberate way, is the *Eucharist* from the series of *Sacraments* that he painted between 1636 and 1642 for Cassiano dal Pozzo, the greatest patron of Leonardo studies in Rome, and the custodian of the Zaccolini and Leonardo manuscripts (pl. III).[67]

In this painting Poussin was able to demonstrate his own mastery of shadow projection through the careful arrangement of a candle and a double-wicked lamp, without breaking the rules of decorum, or denying the demands of verisimilitude. The effects he created were singled out for special notice by Bellori, who writes:

> There are in this work three sources of artificial light; two come from a lamp hanging up high with two wicks that illuminate all the figures from the front; the third light comes from a candle placed low upon a stool, and this means that there is a doubling and tripling of the rays of light and shadows, which are spliced together at larger and smaller angles, and more or less clearly depending on the distances; this can be seen in the bench itself and in the feet of the bed where the Apostles rest facing the light.[68]

Bellori's further notice of the gradation of the shadow cast by the overhead lamp itself upon the floor, the faintly overlapping shadows of the low stool to the right—twin to the one on which the student sits in the studio drawing—created by the two flames of the lamp, and of the torchlight effect caused by the brilliance of the light streaming through the partially open door, is remarkably accurate. These comments reflect his consistent critical interest in chiaroscuro and color in the *Lives*. When Bellori singles out the shadows cast by the bench to the left and by the leg of the triclinium, however, he identifies the very passages that owe the most to Poussin's study of Zaccolini. Like Zaccolini's torches, the candle set on the corner of the bench casts its own shadow at its base. To the right this is juxtaposed to a pool of light, which falls on the horizontal surface of the bench, with the result that a soft elongated shadow is projected by the edge of the table along the floor. To the left, a much darker and shorter shadow is cast

on the floor by the overhanging edge of the bench along its short side and part of the longer side parallel to the picture plane. The lamp in the center of the room also casts a shadow on these two sides, much fainter and more distorted by perspective. There is a similar distinction between the shadow cast by the candle and that cast by the overhead light on the leg of the triclinium closest to the candle; the one is darker and broader, the other paler and narrower. These are exactly the kinds of problems that Zaccolini's example of the cube illuminated by two or three torches (figs. 97 and 98) would have helped Poussin to resolve. And it was because Cassiano had made available such drawings for him to study that Poussin chose to organize his painting in this way.

The *Eucharist* for Cassiano dal Pozzo, which presented Poussin with the opportunity to construct an interior, artificially illuminated space that resembled the controlled circumstances of studio experiment, provides the most deliberate demonstration among the paintings of the late 1630s and 1640s of Poussin's study of Zaccolini's analysis of the specific problem of shadow projection. But it is not the only work from that period to declare its structure in terms of a logical ordering of chiaroscuro based on the principles of optics in the tradition of Leonardo, and following Zaccolini's study of the projection of shadows and the perspective of color. Félibien singled out the *Rebecca and Eliezer at the Well*, painted in 1648, as a work especially indebted to Leonardo's ideas (pl. VI).[69] He writes that for this painting Poussin selected a late afternoon light, rather than bright sunlight, because this would have produced little shadow or relief. From the point of view of illumination, the *Rebecca and Eliezer* provides the perfect complement to the *Eucharist*, the first a scene set in natural light, the second in candlelight, both systems of lighting arranged for the same end of achieving the optical illusion of both relief and space, if under very different circumstances.

In the *Rebecca and Eliezer at the Well* the perfect sphere placed on a rectangular pedestal is a reminder of the kind of studio exercise and analysis upon which the whole work depends. In fact, partially shaded and partially lit, with all harshness at the boundary of *chiaro* and *scuro* removed, the sphere functions virtually as a sundial, locating the story in time through recording the exact angle of the sun's rays, even as the carefully researched hairstyles and costumes locate it in place. Between this perfect sphere and the figures of the individual women the various forms of the vases mediate. Each vase is modeled in chiaroscuro according to its position, the angle of the sun, the texture of its surface, and the consequent effect of reflected light. In every case, however, an area of highlight is juxtaposed to a dark shadow to produce relief on the surface of the vase. In the far middleground the contrast is not so profound, even though the architecture is constructed in planes of color entirely by means of light and shade, and without intervention of visible contour. In the open countryside, towards the horizon, there is hardly any contrast of the values of light and shade at all.[70]

Poussin's ordering of the lights and darks in relation to the values of color in this work is quite different from the *sfumato* of Leonardo's practice, which had ultimately led to the loss of hue. It stands much closer to Accolti's principle of the degradation of

chiaroscuro according to a proportional system, whether achieved by calculation or through the arrangement of models in wax or clay. At the same time, however, such analysis of the effects of light, so clearly based on general principles derived from observation, is inconceivable without the example of the experiments of Leonardo. It was, we should remember, their direct knowledge of Leonardo's manuscripts that prompted both Accolti and Zaccolini to present their own versions of the theory and practice of shadow projection and the perspective of color and light, and according to which many effects of Leonardo's own practice were countermanded.

Félibien understood that the *Rebecca and Eliezer* also demonstrated that Poussin's excellence in the diminution of color according to aerial perspective was not inferior to his mastery of the degradation of light and shadow and linear perspective.[71] Although he states that in this work Poussin took nature and Raphael for his guide, Félibien is in this case opposing Raphael as a master of aerial perspective and the degradation of hue (*la diminution des teintes*), not to Leonardo, but to the Venetian painters, whose broad masses of light and shade he criticizes as unnatural in this instance (just as Zaccolini and Accolti criticized painters who forced the juxtaposition of large areas of highlight and darkness), and which he also felt were often employed to conceal weaknesses in drawing.[72] Like Cérisier's inquiry about Poussin's book on *lumi et ombre, colori et misure*, Félibien's awareness that Poussin's study of the diminution of hues and aerial perspective was equal to his study of the diminution of forms and linear perspective points once again to Poussin's study of Zaccolini's treatises.

Zaccolini himself had held up Raphael as an example for having made his colors in the foreground more lively and those in the background weaker.[73] He also insisted on the union of theory and practice in the painter's observation of his experience of color, and on the need to learn from nature rather than from texts such as his own.[74] At the same time, however, he also provided the most rigorous system to date for the diminution, or degradation of colors by assigning numbered values on a series of scales for individual colors and the order of their transmutation to blue at the horizon (fig. 101).[75] This system, which Zaccolini insisted was based in its detail on observation, also involved the differentiation of illuminated and shadowed areas and took into consideration such variables as size, and draperies of changing colors.[76]

So far as Poussin is concerned, it is of singular importance to recognize that these scales were expressly understood by Zaccolini to relate to the scales and harmonies of music, and consequently to its emotional effects (fig. 102).[77] This systematic attempt to give actual values to colors on a series of scales, and to organize them into chords, a modern revision of the ancient theories of affinities between harmonies of music and color, surely helped to inspire Zaccolini's student Domenichino to attempt when he was in Naples to build various instruments capable of playing the ancient *genera*.[78] And, now that the contents of these manuscripts are better known, it seems reasonable to think that Poussin would have found in Zaccolini's musical scales for the diminution of colors and their effects the clearest modern explanation for the ancient theory of the

101. Biblioteca Laurenziana, Florence,
Ashb. 1212², fol. 41 verso

102. Biblioteca Laurenziana, Florence,
Ashb. 1212¹, fol. 255 recto

Greek musical modes and its direct application to painting. When Poussin wrote to Chantelou in 1647 about the modes by which the Greeks produced "marvellous effects," he may have been quoting passages from the musical theorist Zarlino, but he was also surely thinking about Zaccolini's analysis of the effects of different chords of color in terms of the *conformità* they had with different musical chords, and their power to move the soul of the beholder.

The study of Poussin's debt to Leonardo (and conversely of Leonardo's legacy in the seventeenth century) has been hindered to some extent by Bosse's report that after the publication of the *Trattato della pittura* Poussin told him that everything of value in Leonardo's treatise could be written in large letters on a single page.[79] This report has been so misunderstood that it has been found necessary to discredit it.[80] Not so easily recognized, perhaps, is that Poussin, dedicated as he was to gaining knowledge of the principles of the natural world by theorizing from experience, could not have approved of any book as an authority in itself, which the *Trattato* was quickly to become in France. His caustic comment, which inadvertently served Bosse's purpose to discredit the volume, also sheds light on the pressures we have noted among French critics to find some kind of canonical text on painting by Poussin himself. To have produced a book of rules would have been contrary to the teachings of Leonardo himself, as well as to the requirement of the union of theory and practice through judgment that he had championed, and which became the guiding principle of the Accademia dei Lincei under the aegis of Federico Cesi and Cassiano dal Pozzo.[81] Poussin planned to write his own observations, according to Bellori, but in the manner of Leonardo.

When the Florentine painter Matteo Rosselli was asked about Leonardo's writings, he responded that he understood those things that he knew how to do, but not those things that he could not do, because not being able to do something one understood was the same as not understanding it. Even before the publication of Leonardo's *Trattato*, in the introduction to the *Dialogo sopra i due massimi sistemi del mondo* (1632), the Florentine Galileo borrowed from his colleague Viviani the example of theory without experience of those people who knew all of Leonardo's precepts but could not themselves paint a stool.[82] Poussin (not to mention Leonardo) would have agreed, in accordance with his own study of Leonardo and with what he in turn had learned from Galileo and his Roman contemporaries. Among these are to be included those such as Zaccolini and Accolti, who set out to interpret Leonardo's optical theories for painters, as well as members of the Accademia dei Lincei, including Cassiano dal Pozzo, for whom natural philosophy and painting were of equal importance and interest.[83]

The Uffizi drawing confirms and illuminates Poussin's study of Zaccolini's illustrated treatises. Paintings such as the *Eucharist* and the *Rebecca and Eliezer at the Well* reveal how these writings affected his practice, and why it was Poussin's mastery of optics that Bellori especially praised. As Félibien reports of Poussin, "il s'est contenté d'avoir montré par ses propres Peintures ce qu'il avoit appris du Père Zaccolini, & même des livres d'Alhazen & de Vitellion."[84] That Poussin arrived in Paris with pas-

sages copied out from Zaccolini and Witelo was not forgotten. After the foundation of the Académie Royale in 1648, followed by the publication in 1651 of Leonardo's *Trattato*, the bitterest arguments in the new academy concerned the importance, character, and teaching of perspective. These centered around the claims of Abraham Bosse, whose ambition to give official status to his own views on the fundamental importance of strict, geometrical, linear perspective was to be thwarted by Le Brun, who preferred a more logical approach to composition as a whole. Bosse was expelled from the Académie in 1661.

No wonder, then, that the memory of Poussin's "Traité des Lumières et des Ombres," his putative book "dealing with lights and shadows, colors and measures," led to the belief and even the determination that the volume in Poussin's hands in the Pointel portrait, whether written by Poussin himself or, if that could not be, by Padre Zaccolini, or even by Leonardo (whose published *Trattato* it resembles in format), should be entitled *De lumine et colore*.

There is also every reason to believe, moreover, even if we can no longer be so certain of its title, that Poussin intended to refer to his interest in just these subjects by including a book in the *Self-Portrait* for Pointel. We can only speculate about why Bellori's frontispiece emphasized light and shadow, whereas Pesne's version of the Pointel portrait gave full recognition to the equal importance of color, but there can be no doubt that both contemporary French and Italian critics understood Poussin to have based much of his art on what he learned about color and light from the Theatine father. In the end it seems most likely that the volume Poussin holds in the Pointel portrait is the book of notes on light and shadow, colors and measures that he treasured so greatly. The book, presumably also including illustrations such as those in the Laurenziana volumes, represents his commitment to the preservation of the knowledge recorded by both Leonardo and Zaccolini, a commitment that he shared with Cassiano dal Pozzo. That Cérisier should have become embroiled in defense of Poussin against the Rubénistes is just one reminder of how high the stakes over drawing and color, linear perspective and the perspective of color, and over the relationship of theory to practice were to become in the Académie.[85]

Poussin's association with Zaccolini and Dal Pozzo, and, through them, with the tradition of natural philosophy that derived its interest for painters from Leonardo and culminated more recently in the investigations of Galileo, makes it easier to understand how Poussin's own practice as a painter participated in an experimental world of *esperienza* that was quite different from that of the official Académie Royale, which was seeking to appropriate that practice in France, and where his name would be placed at the center of controversies over the teaching of perspective and color. Such experiment on the part of Zaccolini and Poussin in particular was founded on a fresh observation of nature, no matter how much it also depended on artistic traditions or cultural and historical conventions. Without acknowledging this, as Janis Bell has also argued, we run the risk of missing the originality of their contribution.[86]

At the same time, we should not confuse the *esperienze* of Poussin and his contemporaries with modern experiment, nor the social context in which it took place with the objectivized world of the modern laboratory. Zaccolini's means of exposition, making frequent addresses directly to his reader, do not simply reflect the fact that he hoped to influence studio practice. They were characteristic of the conventions of the conversational rhetoric by which such experience was presented, defended, and discussed in the seventeenth-century academy. As well as practicing the same habits of inquiry into experiential nature, painters and natural philosophers, especially those associated with Cassiano dal Pozzo and the Accademia dei Lincei, shared in the practice of civil conversation and *discorso* about what they saw in nature.[87] When painting itself as practiced by Poussin recorded a series of *esperienze* of nature subjected to rational analysis and organized rhetorically in the representation of the idea, it carried with it the complementary possibility, and even requirement, that the same process of experience, analysis, and conversation be brought to the viewing of the work.

For that reason each of the works of Poussin's mature years should be seen and understood as proposing a kind of thesis about seeing the world and looking at painting that demands the beholder's attention and response. However much the arguments over principles of instruction in the Académie may have betrayed Poussin's views on experience in the end, the debates of the Académie, as recorded in its published *Conférences*, are noteworthy for preserving this kind of conversation, and for sponsoring a new way of talking about painting that in the end did respect Poussin's hopes and expectations for the reception of his work. This is what classicist and formalist criticism has ignored. In a handful of paintings produced around 1650 Poussin made the explicit articulation of such a thesis concerning the critical response to his work his express purpose in painting them. The *Self-Portrait* for Chantelou and the *Healing of the Blind* for the Lyonnais silk-merchant Reynon, both completed in 1650, are such works, and they will be discussed in the next chapter.

III

MONTAIGNE

PAINTING AND POSSESSION: POUSSIN'S *SELF-PORTRAIT* FOR CHANTELOU AND THE *ESSAIS* OF MONTAIGNE

THE LACK OF POSSESSIONS, or goods, was often seen as an obstacle to the virtuous conduct of the Renaissance artist, and a familiar emblematic figure shown with one winged hand flying up toward heaven, and the other weighed down by a stone expressed this predicament.[1] Ultimately derived from the tradition of Vitruvian commentary, the figure appears ubiquitously, and for its standard meaning we may refer to Ripa's *Iconologia*, where it appears with the title, *Povertà in uno ch'habbia bell'ingegno*.[2] In Jean-Jacques Boissard's late sixteenth-century version (1593) of the figure, the image is adapted to that of a military genius whose winged hand flying toward virtue is opposed to a shackled leg, but the bitter moral is appropriate for all virtuous artists (fig. 103). Though Virtue's splendor derives from her own light (signified by Boissard as a diamond, as in several other of his images), under a poor roof she languishes—*nemo bonus est nisi qui bonis abundat*—for riches are now the key to heaven.[3]

Poverty, according to the ancient proverb, prompted the invention of those practical arts whose perfection would defeat her.[4] Painting's origin, on the other hand, lay in a different kind of lack. Not material necessity but the desire to possess an image of one's beautiful beloved called painting into being, whether in Narcissus' embrace of his own image as Alberti had it, or in the ancient potter's daughter's outlining of her lover's shadow as described by Pliny.[5] Alberti's preferred myth of origin required that Narcissus' perfect likeness be painted by love, in a process that destroys both the subject and the beholder-creator, both the beautiful beloved and the lover (even as the reverse success of a Pygmalion destroys the work of art).

This problematic of formal beauty is overtly thematized in a special category of painting in the Italian Renaissance, a kind of painting that is linked to the traditions of lyric poetry, rather than to epic, history, or the narrative imagery upon which most

Othoni Comiti Ringravio.

OYT APETH ATEP OΛBOY ΕΠΙCTA .

ΤΩΝ ΠΕΝΗΤΩΝ ΕΙ
CΙΝ ΟΙ ΛΟΓΟΙ ΚΕΝ-
ΟΙ· ΠΕΝΙΑ Δ᾽ΑΤΙΜ-
ΟΝ Κ᾽ΑΝΤΟΝ ΕΥΓ-
ΕΝΗ ΠΟΙΕΙ .

H Aud facile emergunt qui paupertate premuntur:
 Quos retinet, tanquam compede, tetra fames.
Immodicis opibus virtus non gaudet: at illa
 Degeneri fordet fubruta pauperie.
 E 3 HISTO-

103. *Military Genius,* engraving from J. J. Boissard, *Emblematum liber,*
Frankfurt, 1593

studies of relationships between painting and poetry in the period have focused. The
power to enchant, and to charm, which, according to Vasari, was the special force of the
painting of the *terza età,* was also the power to represent completely deceptive beauty.
As the figure of beauty itself came to be more and more perfectly realized, the increas-
ingly autonomous, mute image of it was replicated ever more rapidly.[6] At this point, it
would seem, painting arrived at the possibility for achieving an eroticism not of subject
only, but of the pleasurable looking at purely formal beauty that the ancient myths of
origin, of Narcissus and Pygmalion, had promised.[7]

Petrarch's sonnets on Simone Martini's portrait of Laura provided an especially
important justification for the charms of painting by acknowledging the ability of a
painter to see the divine image of beauty uniquely inscribed on his heart, that of the
poet-lover. At the same time, however, they reasserted the incapacity of paintings to
reply in ways that could reveal the soul of his beloved.[8] Consequently, in the Renais-
sance *paragone* of painting with poetry the portrayal of a beloved and beautiful woman

104. Leonardo da Vinci, *Mona Lisa,*
Musée du Louvre, Paris

became the primary figure for the problem of the complete and truthful perfection of represented beauty as such, calling into question not only the limits of painting, but also the very possibility of a beautiful painting itself.[9] In painting a beautiful woman the painter desired to possess and to display his possession of the art of painting, even as the poet, following the example of Petrarch, desired and embraced his own laurels.

Such embodiments of Petrarchan desire as Leonardo da Vinci's *Mona Lisa* (fig. 104) empowered a belief in illusionistic presence, even as the originary myths of painting—like those of poetry—entailed the absence of, and inability to possess forever, the beloved subject. In this context Petrarch's restatement in lyric poetry of the ancient rhetorical commonplace of the impossibility of completely representing the beloved was often reformulated. Castiglione translated the *paragone* back into prose in *The Book of the Courtier* in a version of the story of Apelles and Campaspe, in which the Emperor Alexander's judgment is elevated above all else, and in which, as in Primaticcio's invention reproduced by Léon Daven, a beautiful painting is exchanged for a woman (fig. 105).[10] On seeing Apelles' portrayal of his mistress Campaspe, says Cast-

105. Leon Daven after
Primaticcio, *Apelles and Campaspe,*
etching

iglione's Count, Alexander decided to give her to Apelles because the love inspired by
beauty gives greater pleasure to the one who discerns it best. To Cesare Gonzaga's
objection that he sees more beauty in the woman *he* loves than could Apelles, the Count
replies that Apelles and Alexander were inflamed only by Campaspe's physical or ex-
trinsic beauty, whereas Cesare's love is based on mutual affection and on his knowledge
of his beloved's character. This observation reflects on the painter's inability, which the
ancient rhetorician Lucian had also indicated in his fundamental text *Essays in Portrai-
ture* (and which Petrarch had restated), to represent qualities of character only disclosed
over time. Castiglione's retelling of the story provided a most fertile paradox to
sixteenth-century painters seeking to portray beautiful women, and by extension to
embody beauty in paint for possession by the desiring eye. Even as the portrayal of
woman provided a figure for the beauty of painting, the very possibility of representing
beauty itself was denied, given that writers from Lucian to Petrarch, Bembo and Cast-
iglione had claimed that the intrinsic beauty of character could never be communicated

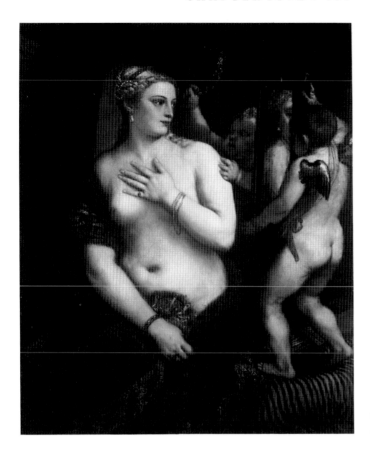

106. Titian, *Venus with a Mirror,* National Gallery of Art, Washington, D.C.

in the single beautiful moment of painting.[11] Beautiful paintings ran the risk of representing only a superficial allure, like an enslaved woman passed between two men, patron and painter.

Despite such insistence upon the inadequacy of the painter's image of the beloved, the possibility for true representation, its authority still founded in Petrarch's sonnets, remained a paradoxical ideal. In Renaissance painting the representation of a beloved and naturalism, or the representation of nature as vitally alive as a human being, became inseparable. Represented beauty signified the filling of a loss of remembered love, and through projection and remembrance, the desire to recover beauty could give meaning to the experience of nature: between the naturalism of style and the natural subject portrayed there was the most intimate connection. This was especially the case in Venice in the sixteenth century. Titian, for example, in his *Venus at the Mirror*—or more accurately *Venus Mirrored*—(fig. 106), acknowledges the metonymic character of his image of beauty by including the framed mirror image of her perfect beauty presented by love, even as he presents his embodiment of beauty in its frame directly to our eyes as if it were a reflection.[12] A century after Titian, and notwithstanding his

deep admiration for Titian's work, Nicolas Poussin set about severing from the theory of representation this complex conjunction of natural illusion, presence, and the delight of the loving, possessive gaze in the apparent beauty of painting that this paradox empowered. This he sought to do by refusing to allow his own works to be seen as enchanting, beautiful, potentially deceptive or superficial objects of desire.

Writing of Poussin's *Self-Portrait* for Chantelou (pl. IV), Bellori records that the figure of the woman in the partially concealed painting to the left represents *Pittura*, and the hands that reach out to embrace her express "l'amore di essa pittura e l'amicizia," to which the painting is dedicated.[13] The subject of the portrait is then both the love of painting and friendship. Friendship, not romantic love for an unobtainable or undescribable woman, was, as we shall see, Poussin's chosen metaphor for the affect of painting. In consequence the lyric poem was no longer the appropriate literary double for his image, nor for the relationship of both painter and beholder to painting. Not the impress of his beloved but the seal of *Confidentia*, of Stoic friendship, was the personal device Poussin had chosen for himself.[14] Cicero and Montaigne replaced Petrarch and his followers in his defense and definition of painting.

Poussin found the *paragone* of painting and friendship in the writings of Montaigne, and especially in the essay *De l'amitié*, as both Louis Marin and Oskar Bätschmann have observed.[15] Here Montaigne set out to fashion a picture of his dead friend Etienne de la Boëtie, who had been snatched from him prematurely by death at the age of thirty three. Montaigne likens himself to a painter, choosing for his essay the best spot in the center of a wall, surrounding this with fantastic grotesques—that is to say, with his own fragmented texts. But unlike the painter Montaigne cannot complete the image they frame, and he proposes instead to substitute his friend's own treatise *De la servitude volontaire*. Montaigne's point of departure is La Boëtie's statement that a tyrant is incapable of friendship, and can neither love nor be loved, because friendship results from a good life, good nature, faith, and constancy. In Montaigne's own essay he celebrates true friendship, which, he claims, is impossible in the dutiful ties of father to son, in the bonds of satiable desire between husband and wife, or in the ill-matched love of an older man for a youth. He celebrates true friendship, in which he and La Boëtie had embraced even before they met. Afterwards their wills became one.[16]

How important was Montaigne's essay to Poussin? Anthony Blunt noticed the artist's general knowledge of Montaigne's views and he pointed especially to those letters in which Poussin described himself as a spectator of the *theatrum mundi*. For Blunt, however, Montaigne was only one among a group of modern French writers, including Du Vair and Charron, that he saw as important to an understanding of Poussin's philosophy, and in particular the artist's interpretation of Senecan Neo-Stoicism.[17] Bätschmann, in support of his association of Poussin's portrait with *De l'amitié*, cites Poussin's painting of the *Testament of Eudamidas*, now in Copenhagen, the subject of which Montaigne also retells in the essay on friendship. He also recognizes that Poussin could have read the story elsewhere, notably in Charron or in Lucian

directly.[18] It is in fact very reasonable to suppose that Poussin read more than one telling of the story, but, the specific example of the *Testament of Eudamidas* apart, we should also be open to the consideration that Poussin was an habitual *reader* of Montaigne. Poussin surely lived with the *Essais* constantly to hand, and Montaigne's body of writing was much more than a source for individual themes for Poussin, as we shall see in this and the following chapter.

Poussin's most direct reference to Montaigne appears in a letter to Jean Fréart de Chantelou of 19 December 1648. After three years of delay, Poussin had at last sent Chantelou the Elder a tiny painting on cypress of the *Baptism of Christ* he had promised him.[19] Acknowledging Chantelou's letter of thanks, he describes it as a copy in words, painted more perfectly than the original. But then Poussin reminds Chantelou the Elder of what he had written earlier about the painting, "that I only dedicated it to you in the manner of Michel de Montagne [sic], not as something good, but as the best I could do." The best I could: this is the proverbial *ut potui, non sicut volui*, or *Als ich kan*, as Jan Van Eyck had inscribed it on the frame of his *Man with a Red Turban* (fig. 107).[20] In the letter, however, Poussin associates it specifically with Montaigne's *Selon qu'on peut*, or, as Montaigne inscribed it in a slightly different, more ironic form on several volumes in his library, *Mentre si puo*.[21]

Montaigne indicates his own source for the saying in the essay *De trois commerces*: "Selon qu'on peut, c'était le refrain et le mot favori de Socrate, mot de grande substance."[22] Socrates' statement, according to Xenophon who records it, was in turn a quotation from Hesiod. Its tone is quite different from the mixture of modesty and pride usually associated with Jan Van Eyck's famous but remarkably little discussed motto, but which it may in turn serve to illuminate: "According to your power render sacrifice to the immortal gods," said Socrates, adding that "in our treatment of friends and strangers and in all our behaviour, it is a noble principle to *render according to our power*."[23]

Selon qu'on peut: so important was this maxim to Montaigne that, although Poussin was certainly thinking of *De trois commerces* when he cited it in his letter to Chantelou the Elder, to identify a single source is misleading. Montaigne's own repetitive emphasis on the phrase renders each appearance of it in the *Essais* more significant. This in turn helps to account for Poussin's association of the idea with Montaigne specifically. In the *Apologie de Raimond Sebond*, for example, Montaigne describes how Timaeus, having to teach Socrates about the gods, the world, and men, "proposes to speak of them as man to man, for the exact reasons are not in his hand, or in any mortal hand." He then cites Cicero's imitation of this in the *Tusculan Disputations*: "As well as I can, I will explain; however, I shall not declare certain and fixed things, like Pythian Apollo, but shall speak like a puny man, pursuing probabilities by conjecture." Cicero's translation from the *Timaeus* follows immediately: "If by chance, discoursing on the nature of the gods and the origin of the world, we do not attain the goal we have in mind, no wonder. You should rightly remember that both I who shall be discoursing

107. Jan van Eyck,
Man in a Red Turban,
National Gallery,
London

and you who will be judging are men; so that if probabilities are stated you will ask for nothing more."[24]

The seemingly endless intertextual referentiality of these sentiments reinforces the probabilism they express, in which what is possible is opposed to the notion of absolute truth, human knowledge is opposed to divine revelation, and, in the end, becoming is opposed to being.[25] Poussin in this case, of course, contrasts what he has done not so much to the notion that it is true as to the idea that it is good. This too is consistent with Montaigne's self-presentation. Writing of his textual borrowings to Madame Diane de Foix in the dedication of *De l'institution des enfans*, for example, he says:

> whatever these absurdities may be, I have had no intention of concealing them,
> any more than I would a bald and graying portrait of myself, in which the painter

had drawn not a perfect face, but mine. For likewise these are my humors and opinions; I offer them as what I believe, not what is to be believed. I aim here only at revealing myself, who will perhaps be different tomorrow, if I learn something new which changes me. I have no authority to be believed, nor do I want it, feeling myself too ill-instructed to instruct others.[26]

Following Georg Kauffmann's observation that there are no whole things in Poussin's portrait, Bätschmann proposed that the bust of the artist and of the figure of Painting might be related to the conclusion of *De l'amitié*, in which Montaigne laments that where once he had a double, now he is halved.[27] This rather literal reading does not, however, draw out the full implication of the close association of Poussin's image with Montaigne's essay. In light of this association, the whole enterprise of the portrait should, in fact, be understood to have been conceived as a species of essay, provisional and probable. Even as each of Montaigne's *Essais* represents a deliberate attempt at self-portrayal, so does each of Poussin's mature works. Essays in becoming, not being, they are concerned with knowing, not with the presentation, or representation of ideally beautiful form.

The story of the genesis of the portrait, aptly described by Louis Marin as a classic tragedy in five acts that took three years to reach its dénouement, is important here.[28] Poussin's reluctance to send a portrait of himself to his friend in Paris is well known. His reservation was first expressed in a letter of 7 April 1647, in which Poussin claimed that there were no good portraitists in Rome.[29] In August of the following year he was still complaining at the thought of having to pay even a small sum for a portrait "de la façon du Sieur Mignard."[30] Further promises were sent to Chantelou in January and May of 1649.[31] But then, in a letter of 20 June 1649, he staged, as Marin called it, a "petit coup de théâtre" by revealing that he has completed a self-portrait but is going to paint another. He will send the most "successful" to Chantelou.[32]

It is through Poussin's letters that the circumstances of the portrait may be reconstructed. The letters themselves are also an essential part of the story, however, small chapters, so to speak, in an evolving communication to Chantelou of which the *Self-Portrait* is also a part. After Poussin had first taken his leave from Chantelou in Paris on 21 September 1642, not in person but in a letter, Chantelou followed his friend to Rome for the winter. Upon Chantelou's return to Paris in June of 1643, their friendship became entirely an epistolary one.[33] Only a little more than half a year later Poussin had cause to reflect in a letter to his friend that "the distance between places is the reason why often things that one writes according to time and circumstance seem quite the opposite when they arrive."[34] Through letters such as this, in which ambiguities and potential misunderstandings were heightened by distance and the passage of time, Poussin set out to teach the far-away Chantelou about friendship, servitude, judgment, and jealousy over possession. These were all themes that Montaigne had examined. Poussin's carefully constructed relationship with his absent friend was without doubt not the same as that perfect identity celebrated by the older writer in his

reminiscence of his friendship with the dead La Boëtie. Nevertheless, Poussin's ideal for it is inseparable from his understanding of the model provided for friendship by Montaigne: an embrace not of passion but of will, a relationship free of the servitude of tyranny. Like the letters, the portrait was sent from Rome to Paris; it belongs to the same discourse on friendship and freedom.

Poussin insisted to Chantelou that, while paintings must be produced with love and diligence and are also objects of desire, the bond between the painter and the possessor of paintings, as between friends, is not one of servitude but is freely willed. In a postscript to his letter to Chantelou of 5 November 1643, for example, he reports that the little *Ecstasy of Saint Paul* he has been working on (to serve as a pendant for Chantelou's *Vision of Ezekiel*, then attributed to Raphael) requires "enquore deux jours de caresses."[35] By contrast to this sentiment, expressed in the language of love, for Poussin it was the evident lack of devotion that made the work of the professional copyists so disappointing and unsatisfactory. However, even as he lamented, in a letter of 12 January 1644, the way in which bad copies may serve to damage an artist's reputation, Poussin also recognized the need for such copies in order to satisfy those who desire beautiful things they cannot otherwise possess. It was for such reasons of affection, of course, that Poussin decided in the end not to commission copies of Cassiano dal Pozzo's *Seven Sacraments* for Chantelou, but resolved instead to remake the series himself, "d'une autre disposition."[36] This took time, and in May of the same year Poussin confirmed to his friend how well he knew "that having to wait for what one desires to possess is one of the greatest pains one can suffer." His hope was that Chantelou would show the same moderation in waiting for his pictures as he did in everything else.[37]

In his famous letter on the Greek musical modes of 1647, written, as we have seen, in response to Chantelou's charge that Poussin had shown more love for Pointel in painting the *Finding of Moses* (fig. 82) than for himself in the *Sacrament of Ordination* (fig. 79), Poussin asserted to Chantelou that his devotion is true and freely willed. He wrote, "I will always continue to serve you with my whole heart. I am not a light man, nor do I change affection once I have given it."[38] Later, in November of 1648, concerning the *Self-Portrait* and the *Virgin* he has promised Chantelou, Poussin prayed that his capacity will match his *bonne volonté*.[39] His prayer that he might not only do his best, but also fulfil his own best wishes, was not to be answered. Later he was obliged to report that his *bonne volonté* and impossibility have been at war.[40] In May of 1650 Poussin described the completed *Self-Portrait* as a "sign of the servitude" he had vowed to Chantelou, for whom he has done more than for any other living person.[41] In the next month, and quite consistently, he wrote that the man who tries to please the world is a fool, but that trying to please one's friends sits well with an *honnête homme*.[42] Then, when Chantelou rewarded him for the work, Poussin protested that his friend had exerted a kind of tyranny over him, placing him too much in his debt:

I promised myself that you would receive the little present with a favorable eye, but I expected nothing more, and did not claim that it placed you under any obligation to me. I was content enough to have a place in paint in your cabinet without filling my purse with money. It is a kind of Tyranny for you to render me so much your debtor that I can never pay off my debt.[43]

Poussin emphasized the importance of freedom from obligation between friends in this passage, but he also referred to Chantelou's "favorable eye." This is, of course, the eye of judgment, to which Poussin often refers in the letters. As we shall see, it is also the judging eye that denotes perspective, or prospect, in the crown of the female personification of Painting in the *Self-Portrait*.[44] Poussin saw in the equality of friendship an equality of judgment, and the very friendship that justified his own desire to please therefore made Chantelou an honest judge untainted by adulation.[45] Perfect things must be judged with the same means by which they were made.[46] Seen in the context of these statements (which is also how Chantelou saw it), the *Self-Portrait* itself became a locus for the trial of Chantelou's judgment and for the representation of Poussin's own. Like Montaigne's *Essais*, the two self-portraits—and by extension Poussin's self-representation in his other works—are trials of the artist's judgment.[47]

Should such a reading of Poussin's letters in the light of Montaigne's repeated reflections on the theme of friendship that is freely given appear to make Poussin seem either presumptuous or improbably purposeful, to mistake the conventions of rhetoric for intended significance, then it ought to be enough to recall the way in which Poussin chides his noble friend for his jealousy. Jealousy over possession of the best of Poussin's paintings was implicated in the project from the beginning, for the *Self-Portrait* was conceived at the very moment Chantelou expressed his jealousy of the *Finding of Moses* painted for Pointel (fig. 82). In the letter on the modes, Poussin protested Chantelou's suspicion that he loved him less because his friend was more enamored of Pointel's picture than the *Sacrament of Ordination* Poussin had made for him. Chantelou desired Pointel's *Finding of Moses* only because its subject demanded "une autre manière," Poussin wrote, and in this matter lay the whole art of painting.[48]

In arguing in this way Poussin sought to sever the ties of desire that had made painting the object of passions rather than judgment. His freely pledged servitude could not be bought, and Chantelou must learn to judge with his reason not his appetite.[49] Poussin later reported, on 22 December 1647, that he was searching for an invention that would prevent the cruel jealousy that makes his friend seem—here echoing Lucian and Erasmus—like a fly as big as an elephant.[50] On 20 June 1649, announcing that he has completed a *Self-Portrait* but is now painting another and will send Chantelou the most successful, he begged his friend not to mention this "pour ne point causer de jalousie."[51] His concern was not idle, for the second *Self-Portrait* (pl. V), as Chantelou well knew, was destined for none other than Pointel. But, even as he

promised Chantelou the more successful of the two, and even as he later repeated that Chantelou would have no cause to be jealous because he would receive the best work and the best resemblance (and Bernini would later reassure Chantelou that he did indeed own the better portrait), by so determining to replicate his own image, not as a copy but as another attempt at a likeness, Poussin both rendered the issue of resemblance itself problematic (could he fail to represent himself successfully?) *and* simultaneously deprived Chantelou of unique possession of the painter and his painting.[52]

The *Self-Portrait* (pl. IV) Poussin eventually sent to Chantelou is only an effigy, but the painter begs Chantelou to accept it "tel qu'il est," assuring his friend that the original is as much his as the copy.[53] But which original and which copy? With typical wit, Poussin here confuses the question of the natural original (that is, himself), and the painted copy (the original paintings for Chantelou *and* for Pointel). He tantalizes Chantelou further by saying that delivery of the portrait will be delayed even longer, because one of his "bons amis" has ardently requested a copy and he has been unable to deny him.[54] Poussin's friendship is not such, then, that the portrait of friendship cannot be reproduced. Moreover, Pointel will soon receive his, the other "original," and will take care of Chantelou's if the latter is out of town. In this way Poussin sets the stage for Chantelou to be himself the judge of each essay in portraiture, for he will see both images side by side, and in the absence of the true original.

Unlike Montaigne, mourning the friend he had embraced before they met, Poussin had to seek out inventions that would teach Chantelou to be a true friend, and about jealousy, possession, and the love of painting. In the first of the two self-portraits (that eventually destined for Pointel) the painter's laurels are not those of the desire for beauty and immortality—of Apollo's desire for Daphne or Petrarch's for Laura—but the signs of death and silence decorating the painter's own tomb (pl. V). On the one hand, by including this painted tomb Poussin establishes the ability of painting to render the qualities of sculpture, both through the avoidance of harsh contour and attention to the softness and tenderness of living flesh, and through the manipulation of chiaroscuro in the service of relief. On the other hand, given that the sculptured tomb, as has often been noted, is designed in the form of a work by Poussin's dead friend Duquesnoy (derived in turn from the conventions of Roman cippi) with whom he had studied just those qualities of sculpture, its inclusion raises even more pointedly the question of the difference between the tactile experience of sculptural relief and the visual illusion of painting. Before the tomb Poussin stands alive, holding the chalkholder and the book that together signify the theory and practice of representation. If for Alberti painting could make the absent present and bring life to the dead, Poussin seems to insist instead here that in painting, and especially self-portraiture, no matter how much it may triumph over sculpture, the living voice is silent, and absence is commemorated as in a kind of tomb.[55]

In the *Self-Portrait* for Chantelou (pl. IV) the argument of painting as absence, as only the illusion of presence, is established in a different way. Behind the artist's self-

representation is a canvas inscribed in Latin: "The Effigy of Nicolas Poussin, the Painter from Les Andelys, in the Jubilee Year 1650." Across this inscription on an otherwise empty canvas falls the fictive shadow (itself a sign of friendship) of the painter's effigy.[56] In place of the book and chalks, a portfolio of drawings and a refracting diamond in the square golden setting of a ring now signify the chiaroscuro and the colors that create illusions of presence—those paintings stacked behind the image of Poussin in their golden frames, of which the *Self-Portrait* itself is yet another. Through the emphatic placement of himself at the central axis of the image—the horizontal line across his brown eyes deliberately continued in the thin stripe of blue sky to either side on the picture behind him, and the vertical down the center of his face marked through powerful chiaroscuro—Poussin conspicuously articulates order and proportion. Remarkably, this very structure was recommended by Abraham Bosse in his *Sentiments sur la distinction des diverses manières de peinture, dessin et gravure, et des originaux d'avec leur copies*, published in 1649, the year Poussin was working on this portrait.[57] At this point Bosse's views were still close to Poussin's own; he insists, for example, that for "portraiture," or "peinture," the two most necessary qualities were "l'oeil bon" and "la main libre."[58] In his advice for the copying of a head, illustrated by an engraving after the bust of an ancient sculpture (fig. 108), Bosse recommends drawing horizontal and vertical axes on the surface first, before placing the original, or *patron* (which means *both* model and patron), where it can be seen all at once.[59] The parts of the face, in this case, should then be marked off along these horizontal and vertical lines. The point of doing it this way, rather than with a grid, or any of the other mechanical means that Vincenzo Giustiniani had recorded, was that it allowed the student to copy the idea of the whole rather than every single part so that eventually he would be able to work from memory or invention. Such a way of copying the model would always succeed, providing the position of the eye or point of view did not change ("en sorte qu'on ne change point la position de l'oeil ou de la vue").[60]

Bosse's advice may reflect a standard studio practice, but the similarity between his engraving and the structure of Poussin's copy of himself takes on special significance in relation to the prominence Poussin gave to perspective, Bosse's primary interest, in the portrait for Chantelou. Behind a table, or *tavola*, at the left-hand edge of the picture, partially obscured by the painting, or *tavola*, bearing the inscription, and by the frame of the very painting that we look upon, like the painter confronting his own image in the mirror, there appears part of yet another painting, which shows the personification of *Pittura* reaching out to a male figure in a mutual embrace. Whereas painters working within the lyric tradition of courtly love troped the beautiful work of art as the embodiment of a woman, Poussin made of painting a figure, *La Pittura*, for expressing the embrace of two sympathetic wills across the frame of his canvas. The perfect judgment of the art of painting is reciprocated and embraced by the perfect judgment of comprehending looking that does not mistake signification for presence. The figure of Painting derives, like the majestic woman to the right of the *Arcadian*

108. Engraving from A. Bosse, *Sentiments sur la distinction des diverses manières*, Paris, 1649

Shepherds (pl. VIII), and like the figure of Thermutis in Pointel's *Finding of Moses* that Chantelou admired so much (fig. 82), from the Cesi Juno (fig. 7), a version of which was owned by Vincenzo Giustiniani and engraved by Matham for the *Galleria Giustiniana*.[61] The eye in her crown signifies, to use Poussin's term, the Prospect, or perspective viewing based on the principles of rationalized vision learnt from the study of optics, and which Poussin opposed to simple vision, called the Aspect.[62] Both Thermutis in the *Finding of Moses* and, as we shall see, the woman in *The Arcadian Shepherds* stand for this kind of understanding in perspective, an understanding and a perspective that implies not just space but also time. Moreover, Painting's further close resemblance to the image of the woman wearing the eyed crown, also adapted from the Cesi

Juno, that would appear in the following year in the illustration Poussin had earlier designed for the first edition of Leonardo's *Trattato della pittura* as an introduction to the chapter entitled "Delle pieghe de' panni in scorcio" (fig. 109), indicates even more securely that she does not represent merely the alluring appearance of illusion, but instead is directed toward Chantelou's understanding. As the figure of Perspective, she reaches out across the edge of the painting at that very point where the principles of perspective projection posit a second, imaginary picture plane, purely conceptual and in a mathematically determined relationship set at right angles to the actual picture plane, on the basis of which the proportional relationships of objects in space are established (fig. 110).[63]

Poussin and Chantelou live miles apart, in different countries, and the true picture plane, the medium through which Chantelou beholds the face of his absent friend, reveals only the effigy, or copy, of Poussin, and underscores his absence. However, sympathetic intellects, bound by friendship and the love of art, can embrace across the virtual plane of painting, especially a painting that is so conceptually ordered. The good judgment of Poussin's friend will understand the painter's perspective *tel qu'il est*, the point of view from which he portrayed himself, and embrace it.

In both ancient and Renaissance commonplaces for the concept of painting-as-the-portrait-of-beauty, the subject of the artist's image of beauty is a female figure who can almost be grasped, and the work of art is the embodiment of a woman placed between men.[64] The terms of Poussin's portrayal of the love of painting (and only in *this* sense is it truly a self-portrait) are quite new, for instead of placing painting as a female figure between men, in the manner of Titian, he personifies the qualities of painting in an emblematic figure, and represents himself. Chantelou's desire may not have been for the absent beauty of a displaced beloved, but it was nonetheless a desire to possess that could, as Poussin's letters reveal, turn quickly to jealousy. Poussin's will, on the other hand, was to represent a discourse on a theme that was the very opposite of that desire for possession which had long been perceived as expressing the relationship between spectator and object. This meant he had to insist on changing the status of the work. No longer an object of lyric desire that seemed to replace the beloved in its natural presence, the image of painting was placed in parity with the continuing discourse of letters, exchanges that constituted the friendship of painter and patron, and which could overcome the silence of the painting-as-tomb.

In a limited sense, this is not in itself a new condition for portraits that passed between friends.[65] Extraordinary in the story of Poussin's *Self-Portrait*, however, is his deliberate articulation of the problematic of painting and possession to Chantelou, and his enforcement of a discursive status for his work comparable to that of a letter that seeks a reply, or as representing the open text of an essay in constant revision, as a trial of judgment *à la* Montaigne.

This analysis of the character of Poussin's *Self-Portrait* for Chantelou as a species of

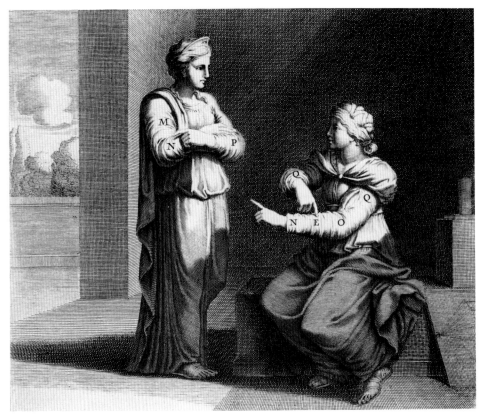

109. Charles Errard, engraving from Leonardo da Vinci, *Trattato della pittura,* Paris, 1651

110. Engraving from L. B. Alberti, *I tre libri della pittura,* in Leonardo da Vinci, *Trattato della pittura,* Paris 1651

essay is not an iconographical interpretation. However, in discussing the importance of Montaigne's essays in providing grounds for a fundamental reassessment of the status of Poussin's painting, we should take note that a reading of Montaigne also contributes to a more precise interpretation of at least one particular image within the work. This is the figure in the painting within the painting that is cut off by the frame delineating the field of discourse. Only the naked male arms identified by Bellori as signifying the love of painting, and friendship, appear.

In his intimate address to the reader in the 1580 edition of the *Essais*, Montaigne professes his own good faith, for, in words that Poussin would echo, he has not written to please the world. He wants to be seen in his book in his simple way, "natural and ordinary without effort and artifice," because, in his famous words, "c'est moy que je peins."[66] So far as his faults are concerned, had he been able to, had he lived in one of those nations said to live still in the sweet liberty of the laws of nature, Montaigne assures his reader that he would have painted himself completely nude. Poussin's image of the truncated figure is nude, male, and as anonymous as possible. This naked figure embracing the *figura* of Painting across the limits of the frame, the figure that is drawn into the picture *by* Painting, yet simultaneously draws the rhetorically figured image out, *is* the painter.[67] He is not only the maker of the work, whose free hand is the equal of his good eye, but also the true, naked, whole self who must try to represent himself as naturally, as openly, and as completely as possible, not through the illusion of presence, but through the perspective of painting.[68]

This figure is also Chantelou, as we have indicated, for in true friendship each becomes other; the painter and the absent friend, or the friend and the absent painter are one. Though Poussin regards Chantelou, and Chantelou returns the gaze, both friends know that the pool of Narcissus is a field neither for painting nor for friendship. Given that the naked self cannot be portrayed, only the arm's-length perspective of painting is possible. And, Poussin would suggest, both understand that the scene of their encounter is not the specular mirror in which beauty is simply reflected in a *coup d'oeil*, but the constantly revised text, the dialogue over time. What is represented is the discourse of judgment itself.[69] The nature of this dialogue may be framed in the words of Cicero's translation of the *Timaeus*, quoted by Montaigne in the *Apologie*, and already cited above: "If by chance, discoursing on the nature of the gods and the origin of the world, we do not attain the goal we have in mind, no wonder. You should rightly remember that both I who shall be discoursing and you who will be judging are men; so that if probabilities are stated, you will ask for nothing more."

In his *Essais*, written and rewritten as the *grotesqueries* to frame his absent alter ego, Montaigne offers the probable and provisional as the true. The sincerity of the moment, however, is always guaranteed by the indelible seal of the presence of the author, by the identity of the man and the work, the author who offers his opinions as the measure of his sight, not as the measure of things.[70] In the same way Poussin, by doubling his own self-image, and by including a stack of framed paintings, complete and incomplete,

like a pack of cards from among which the present *Self-Portrait* is turned uppermost in its matching golden frame, deliberately denies his portrait, however well ordered, the finality of closure, and offers his perspective as a changing one.[71] His insistence on his own ability to change his tune (reinforced by his understanding of the ancient musical modes, as well as his second *Self-Portrait* for Pointel) was not without its risks, further-more, and constitutes a claim that goes well beyond an antiquarian treatment of genre. Replying to Chantelou's criticism of the *Ordination*, Poussin had to admit that no man is equally successful in everything he sets out to do.[72] A painter may fail, even in painting his own portrait. The guarantee of *his* portrait of the love of painting was his friendship, his identity with his work, in which the structure of vertical and horizontal lines is fixed to mark the consistency of this particular copy, lovingly produced as the best he could. Poussin's own seal of confidence marked the case in which it was sent across time and space to his friend.[73]

Poussin knew it had been otherwise. In an earlier work, the *Cephalus and Aurora* (fig. 111), he acknowledged the power attributed to painting in an older tradition.[74] Cephalus gazes upon a portrait of Procris, his true love, as he resists the appeals of Aurora. This profile image of the beloved woman could have been apostrophized by Petrarch or Bembo, but by the 1620s it belonged securely to the past of Pollaiuolo and Baldovinetti. The figure of the little love holding up the image adds to this historical perspective the sense that the portrait of Cephalus' beloved is effective only as metaphor.[75]

In Castiglione's story of Apelles and Campaspe, beauty is first possessed by the painter, but once captive it is seized again by the lover of beauty, who leaves the painter only the body of the enslaved woman. An essay on friendship and the love of painting, Poussin's portrait is also about the emptying out of such desire for the possession of Painting and painter, and the deflection (or destruction) of myths about painting as enchantment. The metaphor of romantic love, of Apollo's unconsummated passion, is displaced by that of Stoic love, defined according to Cicero, and as quoted by Mon-taigne in *De l'amitié*, as the striving to form a friendship inspired by the appearance of beauty.[76] *Le bien juger*, the embrace of the love of understanding was what Poussin asked of his friend in this portrait of the love of painting, and friendship. The golden frame that sets lines and colours apart from the world of appetite is no longer the encircling bank of the pool of Narcissus. When a painting could partake of a conversa-tion between absent friends, voice and intellect were no longer lacking.

Boissard's image of virtue in poverty with which this chapter began (fig. 103) may also serve to introduce one more conclusion to our discussion of the self-portrait for Chantelou, for it prompts a reframing of the problem of Poussin's portrait of Painting in terms of the conditions of its production. In the portrait, light from Chantelou's side of the painting illuminates one side of the artist's face and the golden frames behind him: the same light brings luster to the diamond of his ring, indicating through yet

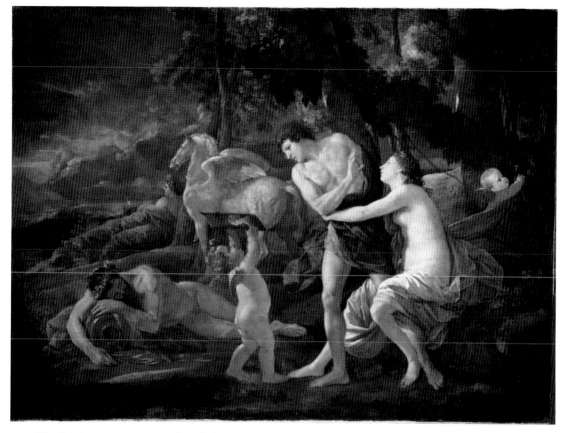

111. Nicolas Poussin, *Aurora and Cephalus,* National Gallery, London

another denial of the surface of the image as a mirror, that the gem of virtue, as in Boissard's image, cannot shine by inner light alone.[77] However, Poussin deliberately refuted that collapsing of goodness into goods lamented by Boissard. Though he kept careful account of the money he spent on Chantelou's behalf, and was proud of the number of figures in each of the *Seven Sacraments*, he was notoriously evasive on the price of a Poussin.[78] He had the confidence derived from possession of goods, and never did less than he could. He neither put a price on his work nor risked it in the marketplace.[79]

Such a collapsing of the distinctions between the good and worldly goods has recently been attributed to Rembrandt in a context that concerns Poussin.[80] Svetlana Alpers has identified Rembrandt's conjunction of the good and goods, or of "freedom, art, and money," as a kind of self-definition in the marketplace peculiar to him. Only Rembrandt, she claims, through the aggressively autographic touch of the late self-portraits, succeeds in establishing the self-possession of "I paint, therefore I am." Other

contemporary artists' self-portraits in Holland she has described as conforming to the type in which the painter, in presenting himself to a patron, accommodates himself to a "certain social order and a certain notion of art." Even Poussin's self-portraits for Chantelou and Pointel, Alpers concludes, "entertained the ambition to offer a definition of Art and of the status of the artist. On this point iconographical studies are correct."[81]

In the case of Poussin this characterization, as we have seen, cannot be sustained.[82] Poussin presented his works as the best he could, as a succession of essays presented to the judging eye of friends. He too worked for a living, but his success was precisely matched by conscious resistance to the commodification of his work, or of himself. For the definition of painting as possession (even as self-possession), Poussin succeeded in substituting the question: *Que sçay je?*

NOTWITHSTANDING the fundamental importance of Montaigne's writings that we have traced (and which extends indirectly to a broader range of views shared by Poussin and his contemporaries concerning, for example, the relationship between knowledge and experience, or between being and becoming), this change in the status of the work of art also necessarily engaged questions more specific to the art of painting than anything found in Montaigne. In this regard the lessons Poussin learned from both Montaigne and Zaccolini about the discourse of theory and practice, and about learning from experience come together.

In the *Healing of the Blind*, painted in 1650, the same year as the Chantelou portrait (pl. VII), Poussin succeeded in thematizing more generally those arguments, inspired by Montaigne, about the correct way to view the world and his work that he had just worked out in the highly personal exchange with Chantelou in the process of painting the *Self-Portrait*. In this *tableau* Poussin also refined his ability to express what he had learned from Zaccolini (again as opposed to simply putting it into practice), going beyond a demonstration of shadow projection and the optical illusion of relief, such as we have examined in the cases of the *Eucharist* and *Rebecca and Eliezer at the Well*, to take the association of light and color itself as his theme, and, we shall argue, to play upon the relationship between seeing and touching, or between opticality and tactility in painting. In the *Healing of the Blind*, in other words, Poussin thematized a theory and criticism of vision that applied to both painters and beholders, to looking at nature as well as at art, and in a way that did not rely on the extraordinary conditions of the dialogue with Chantelou.

That Poussin was engaged in the representation of a discourse on and of the theme of painting itself was, like the argument for the importance of Montaigne's essay *De l'amitié* for Poussin, first proposed by Louis Marin. Before looking at the *Healing of the Blind*, therefore, it will be helpful to review at some length his complex, and little understood, reading of the second version of the *Arcadian Shepherds* (pl. VIII), in which

he laid out this argument most fully. It is important to keep in mind that Marin did not propose an iconographical reading of the subject of Poussin's painting so much as he did one that turns upon its broader theme (in this regard taking Panofsky's classic study as his point of departure), which then led him to a consideration of the *Arcadian Shepherds* as an expression of the very thematics of painting itself. According to his reading three of the shepherds are to be understood as standing for the emission and reception of a message whose referent is what the fourth figure is doing.[83]

One of Marin's insights concerned the character of the standing woman, whom he interprets as signifying Memory, as the discovery of endless interpretation, and as providing the necessary grounds for existence. She is not literally the allegorical personification of Mnemosyne. Rather, because of her authority and calmness, and because she is the figure towards whom the others turn for an explanation of the meaning of the inscription on the tomb, she is presented as the possessor of the knowledge they seek, the sign for Memory. And she is silent:

> On the right side, the "shepherdess" (the interlocutor of the shepherd whom she taps gently with her hand but whose silent question she seems to ignore; the woman who contemplates the kneeling man with a peaceful aloofness) makes the beholder-reader dream of a figure of Mnemosyne who remembers an enigmatic meaning, the meaning of the epitaph by an ineffable anamnesis. Her monumental stature, her presentation in profile, the position of her left arm and hand on her hip, her statuelike eye without vision, all these traits evoke a Cartesian admiration, the originary passion for knowledge without any bodily effects, the memory of an originary loss. Is not the sense of the question silently asked by her companion: "What is the name of the written *ego* in the inscription that the reader tries to decipher?" And the sense of her answer: "You, reader, are condemned to decipher, and nevertheless, you will not know anything. You remember only one thing: that you have always already forgotten everything." A silent dialogue without any anxiety: decipherment, the fate of an endless interpretation, is in its very indecidability the way in which living people neutralize the anxiety of an originary loss and liberate themselves from death.[84]

Marin chose to discuss the *Arcadian Shepherds* to exemplify the tension between individual description and methodological generalization, but his reading also follows upon the simple observation made by Klein in 1937 that in the classic order of this painting two who do not know are balanced by two who already know the significance of the inscription at the center, a balance that tips towards the woman at the right who constitutes a second center.[85] In Marin's view the kneeling figure who looks at the inscription, pointing to it, and reading it, functions as a sort of alter-ego for the beholder: as he reads so do we, as he sees so do we, and what for him is the mystery of the tomb is for us the mystery of the picture—another kind of tomb, which in its represen-

tation of loss and death has the potential, like the figure signifying Memory, to exorcise our anxiety.[86]

Marin also called attention to the way in which the pointing finger seems to trace the outline of the kneeling shepherd's own shadow, thus mimicking the production of painting in its earliest origins, which Quintilian had described as the tracing of a line round a cast shadow; and he also saw that the shadow itself is configured as a scythe, the death-dealing weapon of Chronos, or Saturn, ruler of the golden age that Arcadia invokes.[87] He also suggested that the rough-hewn rock on which the questioning figure places his foot is not simply a naturalistic element, but also a sign that links the two figures on the right to images of Clio, the Muse of history as designed by Raphael (fig. 112) and as defined by Ripa in his *Iconologia* (fig. 113). The rock, as in Marcantonio's print after Raphael, stands for the firmness of history.[88] In his *Inspiration of the Epic Poet* Poussin placed Apollo's foot on a similar rock in order to signify such firmness, suggesting that the poetry he dictates is founded in history. And according to Ripa, History is the light of Memory, who looks backward because she is "the memory of past things born for posterity."[89] Marin stressed the importance of that backward look toward the standing figure in Poussin's painting, establishing a movement "from history to its decipherment," that is, from the question about meaning toward Memory.[90]

Just about everything that was new and persuasive in Marin's interpretation on the figurative level—the shadow, the pictorial signs suggesting an appeal to history and authority, the loss of innocence in the act of reading, and the idea that this painting "is not only a means for representing something else but also the object of representation," was taken up in Oskar Bätschmann's discussion, published some ten years later.[91] In support of Marin, he placed in evidence Poussin's design for Mellan's engraving of the frontispiece to the 1642 Paris Bible, in which Raphael's figure of Clio is again adapted (fig. 114).[92] And he made the additional proposal that Poussin's reference to the origin of painting in the drawing of a shadow is extended, and indeed completed in the red, yellow, and blue triad of the primary colors of painting manifest in the draperies of the figures at the right. Mourning and shadow replace the unknowing present of innocent happiness, but then turn to reflection and memory, which is perfected in the colors of painting.[93] Referring to the story of the invention of drawing by Butades as she traces the outline of her departing lover's shadow on the wall, Jacques Derrida has observed that "it is as if seeing were forbidden in order to draw," and, writing of drawing as the memories of the blind, he added that from the outset perception belongs to recollection, to nostalgia.[94] If this be so, then one argument of the *Arcadian Shepherds* would be that it is the colors of painting, and the painting of history in particular, that can bring back memories, even if they cannot recover a lost presence.

Marin's reading, no hint of which is found in Panofsky's study, is not complete, nor has its true value been recognized as a proposal for coming to terms with Poussin's

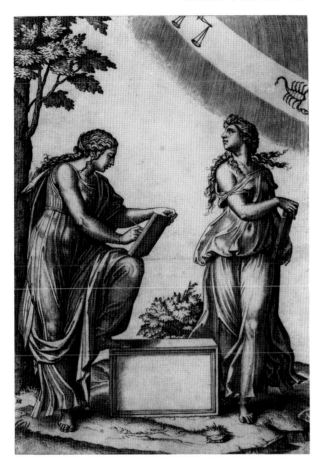

112. Marcantonio Raimondi after
Raphael, *Clio and Urania,*
engraving, National Gallery of
Art, Washington, D.C.

113. *Historia,* woodcut from
C. Ripa, *Iconologia,* Padua, 1618

BIBLIA SACRA.
PARISIIS MDCXLII
E TYPOGRAPHIA REGIA.

N. Poßin in. Mellan f.

114. Claude Mellan, engraving after
Nicolas Poussin, frontispiece to the
Biblia Sacra, Paris, 1642

own deliberate representation of a critical discourse in his work (which is not the same as the contribution to a semiotic theory of reading also proposed by Marin). One or two refinements to Marin's exposition may be offered. In adapting the engraving of Clio to represent the divine truth of Christian history in the Bible frontispiece (fig. 114), Poussin gave her the upward and backward-looking gaze of Urania, her companion in Marcantonio's engraving. It is striking that the figure for Memory in the *Arcadian Shepherds* looks down, emphasizing by contrast that she stands for human memory, or the memory of human life. Her hand rests gently on the shoulder of the reader, who appeals backwards to Memory, even as he stands firm in his historical search for the true interpretation of the text.

Ripa, furthermore, had explained that History is shown writing because written histories are the memorials of spirits and the statues of the body.[95] In support of this he cited a sonnet by Petrarch addressed to Pandolfo Malatesta, Lord of Rimini, in which the poet records his desire to write on paper something to increase Pandolfo's fame, "for

nowhere can sculpture be solid enough to give a person life through marble."[96] In the lines cited by Ripa Petrarch concludes: "Pandolfo mio, those works are frail in the long run, but *our* study is the one that makes men immortal through fame."[97] The same quotation, which contrasts the permanence of writing on paper to that of sculptured memorials, was adopted as a kind of motto in two inventions by Poussin's friend Pietro Testa. In the first, developed in two drawings from the early 1640s, the sister arts of *Disegno* are welcomed by Fame, seated on the celestial globe of immortality, at the base of which appear Time and Envy.[98] The second is also a drawing, this time preparatory for an etching, *The Triumph of the Young Artist on Parnassus*, datable to 1644–1646.[99] The artist-hero, guided by Wisdom, arrives on Parnassus, where he is greeted by the Muses gathered around the nymph of the Castalian stream. At the lower right the personified human affections are vanquished; Petrarch's lines are inscribed on the rock at the lower right, upon which chained Time rests. First among the Muses to greet the ideal painter is Clio, identified by the trumpet in her hand. Whatever Petrarch may have said about the inability of sculpture to bring a person alive, Painting, we are to understand from Testa's inventions, must be included among the arts that *do* make men immortal, and is therefore especially close to History. Ripa's definition of History moreover provides an equally suitable definition for the increasingly rhetorical conventions of history painting: it is the art by which are expressed significant human actions, the divisions of times, natures, past and present accidents of persons and things, and for which three principles are required, truth, order, and decorum.

To associate Poussin's pastoral scene with the allegorical constructions of Ripa and Testa is not to say that the *Arcadian Shepherds*, which Bellori accurately characterized as a *concetto morale*, functions straightforwardly according to the conventions of seventeenth-century allegory. However, we should not hesitate to follow Marin's sense of a kind of meta-allegorical structure at work here, which he indicated by calling it not literal, but dreamlike. In insisting on that instinctive allegorical semiotic structure, he pointed to two other paintings associated with the *Arcadian Shepherds*, both of which share more explicit connections with the allegorical conventions deployed by Testa.[100] In his biography of his close friend Nicolas Poussin, Giovanni Pietro Bellori tells how the artist painted not just ancient fables but also modern ones by Tasso, and then went on to describe the three *concetti morali* (translated by Félibien as *pensées morales*) that Poussin painted for Giulio Rospigliosi.[101] These are the *Ballo della vita umana*, now in the Wallace Collection, *Truth Discovered by Time*, of which the original is lost, and finally *La felicità soggetta alla morte*, the painting we have been considering, which is better known as the *Arcadian Shepherds*.[102] It was Marin, once again, who first called attention to the fact that the scythe of Time appears in all three.

To press Marin's interpretation a little further, we will return to his statement that the question silently but clearly asked by the companion turning to the figure of Memory is "What is the name of the written *ego* in the inscription that the reader tries to decipher?"[103] The desire for historical knowledge, that is, asks the custodian of

memory to tell him the name of the person buried in the tomb. The dead person, that speaking self who so famously does not identify himself as anything other than an *ego*, has been provided a sculptured memorial, but one that, as Petrarch had predicted, proves inadequate over time: History now seeks to remedy this through appeal to Memory.

Before going further, we should also take note of Marin's obvious uncertainty about the act of reading as shown in Poussin's painting. He describes the kneeling shepherd as *trying* to decipher the inscription; elsewhere he writes that the figure is *looking at* the writing; and at one point he suggests that the shepherd gives the sense of *spelling out* the signs of the inscription.[104] Such uncertainty about this figure's ability to read is well founded, precisely because Poussin places so much emphasis upon his touching the traces of the inscription with his finger, as opposed to seeing or comprehending it with his eyes and mind. The shepherd to the right, on the other hand, has surely read and no longer touches, but asks for meaning—and not just for the name of the *ego*—as a result.

That Poussin wanted to emphasize the initial step of having to learn to decipher through touch, as well as the superiority of memory's comprehending gaze to the simple reading of a text, can be established more clearly through comparison of the *Arcadian Shepherds* with a closely related painting by Castiglione now in the J. Paul Getty Museum (fig. 115).[105] Castiglione's figures are not the ideal shepherds of Poussin's painting, but coarse and uncivilized savages. In this case the inscription— *Temporalis Aeternitas*—presents the viewer with a paradox, for it signifies that eternity itself is temporal, made up of an infinite sequence of timebound moments.[106] Whereas Poussin's Arcadians find that others have also enjoyed their happiness, which discovery ensures the end of happiness for them (even as it promises happiness—and loss—for others in the future), Castiglione's shepherds discover instead only the folly of their predecessors, which now encompasses and overwhelms them. Those who had sought to achieve immortality through their monuments and sculptures had deluded themselves: the earth reclaims their works, and the carved stones crumble under the irresistable strength of living plants.[107] Only the vegetative forces of endlessly generative and devouring nature are eternal. In contrast to Poussin's elegiac sense that a recovery of past beauty was eternally available, Castiglione satirizes the very idea of Arcadia and the pretensions of the classicists by returning to the familiar theme of all-devouring time. But Castiglione's invention shares an important feature with its model. If his uncouth wanderers, or "natural men" are themselves until this moment unaware of time, having none of the civilized qualities that characterize Poussin's shepherds (though we should take note that Poussin's pointing "reader," unlike his companions, is bearded and does not wear a circlet around his shaggy locks), their discovery of the inscription on the tomb precipitates a similar Fall into history. Even if they cannot read, but must perceive the meaning of this inscription through the sense of touch, simply recognizing the artificial signs as invented by man, these primitive men are

115. Giovanni Benedetto Castiglione, *Temporalis Aeternitas,* Collection of the J. Paul Getty Museum, Malibu, California

falling into history nonetheless. Being bound by time, monuments in stone ineluctably destroy the timeless eternity of the unconscious. Castiglione's paradoxical statement is that only through a concept of history does eternity come into being, and even that is governed by nature.[108] Reading the epitaphs both in Arcadia and among the ruins of empire, we are to understand, produces the loss of innocent happiness and a subjection to history. However, reading is not a "natural" ability, and the meaning hidden in writing is enigmatic and requires interpretation. In Plato's words, which Poussin's friend Testa again singled out for record in his notes, a trust in writing, which is produced by external and arbitrary characters, discourages the use of memory, and

produces (as in the ancient superstition about the reading of epitaphs) only forgetful-ness.[109] The invention of letters could provide only an *aide-memoire*, substituting re-minding for knowledge.

If in Poussin's *Arcadian Shepherds*, as in Castiglione's *Temporalis Aeternitas*, writing creates the sense of loss and at the same time fails to provide understanding; and if drawing, produced by the same touch, is identified with that selfsame loss and with the inability to understand more than simple absence and the passage of time, then how are we to interpret the completion of Poussin's enigma in the figure on the right? For Marin, we recall, she is an oneiric figure of Memory; for Bätschmann she and her companion taken together, wearing the primary colors of painting, are a paraphrase of History, whereby the shepherd reveals the testimony of the past and the woman signi-fies reflection upon it. As we have seen in chapter one, the famous Cesi *Juno* was Poussin's and Duquesnoy's ideal model for the draped and regally mature female figure, and this statue was specifically the model for the shepherdess in the *Arcadian Shepherds*. The formal relation in this case, especially so far as the pose of the left arm and the drapery is concerned, is very precise. Generally speaking, Poussin employed his canon of ideal perfections to communicate particular expressive qualities and characters, and not as an iconographical lexicon, but this figure of Juno seems to have held especial importance for Poussin beyond her formal beauty.

One of the titles of the ancient goddess Juno was *Moneta*, probably deriving from *monere*, or to warn. Consequently, this title was occasionally, as in Stephanus' *Glossaria* of 1573, translated as Mnemosyne.[110] If Poussin knew this, then his choice of a figure of Juno has meaning beyond her regal beauty alone. Juno, daughter of Saturn, would stand quite specifically for the memory to which history appeals in its search for the meaning of the human past, and as memory she provides a gentle warning to the reader of the text. If we follow Bätschmann's argument, this figure also stands for Painting. Specifically, given the distinction in the actions of the two figures on the right, between the figure who asks for enlightenment and the other who possesses the answer, she stands for Painting as Memory, a reflective, visual capacity that transcends history and the written.

That this particular figure of Juno indeed stood for painting in Poussin's vocabu-lary, and more precisely for the perspective of painting, is born out by her appearance in a closely knit group of images, as we have already seen. To summarize, Poussin adapted the Cesi *Juno* for his illustration of Leonardo's observations on the depiction of drapery folds in foreshortening; the standing figure in this illustration, now with arms crossed, is identified as Juno by her crown (fig. 109). In that crown is the eye of *Prospettiva*, as is confirmed by the schematic eye on the tablet in the bottom right corner. This latter eye is placed at the very left edge of the tablet, at the point of a pyramid of rays embracing the profile of an entablature. Both the entablature and Juno's ideally beautiful draperies are thus seen in perspective. The same figure, with the eye in her crown, as Posner pointed out, appears in the *Self-Portrait* for Chantelou (pl. IV), and in support of Pos-ner's reading Winner cited Rubens' frontispiece to Augilon's *Optics*, published in 1613,

in which Juno has a refracting diamond in her crown, is accompanied by the peacock whose feathers are made up of all the colors of the spectrum, and holds a scepter bearing the eye of perspective. Her other hand touches the point of a pyramid—the pyramid of vision. In both the *Self-Portrait* for Chantelou and the *Arcadian Shepherds* the figure of Juno as *Pittura* is turned at right angles to the picture plane. In the illustration to Leonardo's *Trattato* the head of Juno is similarly placed. Its conspicuous turning signifies the theory and practice of the perspective of painting, which in two of these examples is also represented by the eye in the crown. In both, the perfect judgment of the art of painting in perspective is reciprocated by the perfect judgment of comprehending looking.

To take stock for a moment. We have added to Marin's crucial observation about the relationship between history and memory, and about the discourse of painting in the *Arcadian Shepherds*, some further observations about the distinctions drawn between understanding gained through touching and through seeing, between the shadows of drawing and the colors of painting, and between the carving of memorials and the painting of memories, as well as their relative claims to immortality. Painting, in line with this interpretation, reflects on the meaning of history, whereas reading itself has to be learned and (in agreement with Montaigne) does not produce knowledge. But if the text once read fails to explain itself transparently, to disclose the identity of its *ego*, so too must painting be concerned with the ordering of perspective, remembering and judging with reason, rather than simply being the conveyor of seductive or deceptive illusions. In the end, in reply to Petrarch on the greater immortality provided by writers as opposed to sculptors, Poussin decides in favor of Painting, but specifically Painting as the repository of Memory, reflecting on history seen in perspective, and guided by truth, order, and decorum—and not Painting as the reflection, or shadow, of life.

THE DISTINCTION, or relationship, between seeing and touching—which also involves a distinction between painting and sculpture, or between color and chiaroscuro—in the recovery of memories was taken up quite specifically by Poussin in the two self-portraits of 1649 and 1650 (pls. IV and V). In the portrait for Pointel, Bätschmann has seen in the juxtaposition of the painter with a tomb sculptured in the style of Poussin's friend Duquesnoy "the contrast between the transience of paintings and the permanence of sculptures."[111] Instead, it would seem that Poussin was arguing that while his painted portrait may not provide a presence, or even an illusion, it is not, like sculpture, twice dead. The sculptured tomb appeals to the touch, but it is the perspective of painting, whose theory and practice are emblematized in the crossed hands—like those in the Leonardo illustration—holding the chalkholder and the book, that can bring the past alive: the gentle caresses of painting supply the figure of the *ego* in the tomb.

The distinction between sight and touch is more explicit in the Chantelou por-

trait, in which the figure of painting in perspective represents the new kind of under-
standing that Painting both provides and demands. In so doing she stands in contrast
to the shadowy record of the writer on the Arcadian tomb, whether understood as a
reference to the origin of painting, to the difference between written memorials and
drawn ones, or as an indication of the passage of time. We are to understand that the
eye of perspectival painting can arrange events in space and time proportionally and
correctly, even as memory does, and more perfectly than the written text of history
itself.

Such an arrangement, more complete and more perfect than a written text, was
provided by Poussin in the *Healing of the Blind* (pl. VII). The painting is best known,
perhaps, as the subject of a *conférence* led by Sebastien Bourdon at the Académie Royale
in Paris on 3 December 1667.[112] As recorded by Félibien, this *conférence*, and the other
six published together with it, need to be understood as official, institutionalized suc-
cessors to the conversations about visual experience we have discussed in relation to
Poussin's Uffizi drawing of the studio in chapter four, and, in turn, to the discussions in
the Accademia dei Lincei.[113] The *conférences* also represent an extension of the sort of
civil conversation engaged in by Vincenzo Giustiniani and his friends. They are at-
tempts to understand what artists had *tried*, or essayed to do, to judge in the manner of
Montaigne. What distinguishes the *conférences*, however, in addition to their setting, is
that they focus on developing a set of critical terms for discussing particular works of
art. For such a focus there were, of course, also precedents, and here Ludovico Dolce's
dialogue *L'Aretino* immediately comes to mind.[114] In the case of the *conférences* on
Poussin's *Fall of Manna* and *Healing of the Blind*, however, the situation was even more
extraordinary. From his correspondence, especially the exchanges with Chantelou over
the *Self-Portrait*, we know that Poussin actually produced his work in the expectation
that it would be received with such critical debate, even if not anticipating such an
institutional context for it.

The *conférence* of 1667 led by the painter Sebastien Bourdon provides a sharply
focused point of entry into a reading of the work. After identifying the colors of the
draperies, especially all the prominent primaries—the red, yellow, and blue of the
Apostles, the yellowish white of Christ, and the blues and yellows of the figures to
the left—Bourdon moves to consider the effects of light, "given that light," he says, in
a statement echoing Poussin's own rehearsal of Witelo, "reveals everything."[115] Morn-
ing, he continues, is the most beautiful time, when objects seem most graceful. Poussin
therefore showed the eyes of the blind being opened then so that the men could enjoy
the greatest possible pleasure from recovering their sight. This pleasure is exactly what
Poussin does *not* show, and at this point Bourdon slips into describing *our* pleasure in
having our eyes touched, just as those of the blind will be opened by Christ's healing
touch (which moves counter to the natural light). He describes the contrasts of light
that result from the different ways in which the parallel rays of the morning light fall
upon the mountains, trees, and palaces, and from the sweet color that spreads in the

shade of the trees, tenderly uniting the whole.[116] Even shadow functions here, according to Bourdon, as a kind of veil that prevents our sight being distracted away from the significant objects of attention.[117]

After Bourdon has identified the proportions of various figures with those of ancient sculptures, among them the *Farnese Gladiator*, the *Apollo Belvedere*, and the *Medici Venus* (as he had in the debate on the *Fall of Manna*, to which we have referred in chapter one), the discussion is opened to the floor. Objections are raised to the fact that Poussin has interpreted his subject to include only a few figures, whereas the story in Matt. 20: 30–34 records that Christ was accompanied by a crowd when he healed the blind in Jericho; one figure, the woman to the left, even appears indifferent to an event that should arouse her admiration and surprise. Another speaker makes several stabs at a solution: the figure in the center in red stands for the surprise of the whole Jewish people, and the figure who stares closely at the eyes of the blind stands for the desire of the Jews to witness miracles. In other words, single figures epitomize whole groups. At the same time, according to this speaker, the multitude from which Christ has stepped aside is merely concealed by the buildings, and by this means Poussin has made it possible for us to see Christ and the blind more clearly. In yet another identification of the image within the painting with the act of beholding it, he concludes that it was especially important to Poussin to show the figures around Christ full of attention so that those who look at the painting will be so also.[118]

Another speaker questions—and with good reason—the subject of Reynon's picture, which was by then in the royal collection.[119] He argues on the basis of his reading of the texts that Poussin has represented Christ's miracle at Capernaum in Matt. 9: 27–31, rather than the miracle at Jericho, and this discussion leads to more general comments on the special requirements for representing sacred history with accuracy.[120] What follows is an exemplary debate about invention, the implications of which have never truly been assimilated.

Bourdon first rejects the Capernaum hypothesis, saying that the landscape surely represents Jericho, and that there were no witnesses to this first miracle at Capernaum, which took place secretly inside Jesus' house, not in the street. His opponent rejoins with a grammatical analysis of the notion of *chez luy*, or the difference between *domum* and *in domum* in the Vulgate.[121] To this he adds a geographical account of the difference between Jericho and Capernaum, referring to Josephus and the Gospels.[122] Jericho was known as the City of Palm Trees, and had Poussin wanted to signify Jericho he would have included at least one palm, and some of the city's balsam groves. Given that Poussin, so careful to depict pyramids and obelisks to signify Egypt in other paintings, had paid such attention to architecture in this work, how would he have forgotten the amphitheater and the hippodrome for which Jericho was famous? Capernaum on the other hand was the main city in upper Galilee, a large town with many beautiful palaces. It was at the most fertile spot where the Jordan empties into the Sea of Galilee, close to the mountain where Jesus had preached the Beatitudes and performed the

miracle of the loaves and fishes. On the land side this mountain was said to rise up on gentle, cultivated hills covered in trees, above the fountain of the same name as the city. The final argument concerns the number of apostles present: the speaker reminds his audience that Christ was accompanied by just three Apostles—Peter, James, and John—at the miracle at Capernaum, whereas all twelve were said to have been present in Jericho.

Much of this is correct and all of it is important for understanding Poussin's invention. In particular, the presence of just three apostles establishes that the event is indeed the healing of the two blind men as described in Matt. 9, which took place in Galilee, not in Jericho. The geography of the holy places was a matter of renewed scholarly debate in Poussin's day, in keeping with the interest in the documentation of early Christianity that we have discussed in connection with Cassiano dal Pozzo and the *Sacraments* Poussin painted for him.[123] Even Claude Lorraine, whose landscapes are normally more poetic than documentary, attempted to locate the Sermon on the Mount accurately in his painting of c. 1653, now in the Frick Collection.[124] On a preparatory drawing for this work notes in another hand give distances to Jerusalem and Nazareth, and identify Nazareth and the city of Tiberias.[125]

In Poussin's case, as Bourdon understood, geographical accuracy was more to be expected. But Poussin himself overtly signifies a metaphorical aspect of his architecture here by including a version of Palladio's unexecuted design for the Villa Garzadore at the left.[126] In the center, beneath the rocky mountain, and behind Christ, appears a complex of buildings comprising a basilica with a wide portico and with an oculus in the upper facade, a campanile to the left, an assortment of palaces or basilicas to the right and behind, including one to the right with an open loggia. The basilica, tower, and palace signify in general terms, but nonetheless unambiguously, the early Christian churches of Rome with their medieval towers (such as Poussin's own parish church of S. Lorenzo in Lucina, or S. Giorgio in Velabro). Given the specific configuration of buildings and their position beneath the rocky mountain, they represent more precisely both the ancient, medieval, and modern appearance and the symbolic origins of St. Peter's and the Vatican palace (fig. 116).[127] Such was the historical perspective of painting that it could place memories in the spatial order of a constructed argument, not in the temporal lines of chronicle.[128]

In the fifth century Christian basilicas were built in both Capernaum and the nearby city of Tiberias, and both were dedicated to Peter in commemoration of the Apostle's residence on the shores of Galilee at Capernaum. At Tabgha, a few miles from Tiberias, was the primacy chapel of Peter, commemorating the place where he was entrusted with his pastoral duties by Christ.[129] Whether Poussin intended his cityscape to depict Capernaum or the grander city of Tiberias nearby, there can be no doubt that the general location is Galilee, the site of Christ's ministry and the home of Peter. In Galilee Peter walked upon the waters and found the tribute money in the fish's mouth, was chosen by Christ to be present at the raising of Jairus' daughter (which we

116. Marten van Heemskerck, *The Vatican and St. Peter's,* drawing, Albertina, Vienna

are to understand has just taken place), as well as at this scene of the healing of the two blind men. He was also chosen to be present on Mount Tabor when Christ was transfigured, when "his face did shine as the sun and his raiment was white as the light."[130] This scene of the healing of the blind, in which Christ is the light, and at which just Peter, James, and John were present, is a sort of prefiguring of that transfiguration. The Parisian *conférence* conspicuously ignored all of these Roman and Petrine arguments.

After praising the sweetness and vivacity of the colors, the speaker who has re-identified the miracle turns to the question of expression.[131] He points to Poussin's remarkable skill in suggesting that the second blind man is straining to listen, using the heightened sense of hearing that the blind acquire. The bearded man in the center has all his muscles and spirit concentrated in his eyes and forehead, and he expresses defiant curiosity. The standing man in red, on the other hand, expresses both astonishment and admiration and meditates on Christ's power. The two other onlookers are less thoughtful: the one strives to see rather than to understand, and the other, leading the second blind man, is simply a rustic, with no *esprit*. The Apostles, however, each express a different emotion at what they see: James, joy; John, a mixture of compassion and scorn; and Peter some indignation. Finally, turning to the harmony and economy of colors, this critic claims that the beholder's own eyes are neither dazzled by confusion nor blinded by brightness or the dark.[132]

Ultimately enjoined neither to look so closely that, like the old man in the painting who strains to see the working of the miracle, he fails to see its cause, nor so full of admiration for its cause that he misses its effects, the ideal beholder posited by the *conférence* will come to discover the beauty of Poussin's representation of morning light touching the eye as an analogue for making us see correctly.[133] And to do this, we infer from the debate itself, neither a silent desiring gaze is called for, nor yet the confusion

of public opinion, but a kind of private viewing among a small group—such indeed as that formed by the Apostles in the painting.

Within the terms of the debate, it is understood that Poussin anticipates that the beholder will, among other things, bring a knowledge of texts to bear on his reading of the painting. This kind of looking distinguished the *homme d'esprit* from others who, like the bearded, defiantly curious man at the center of the painting, can only stare and hope for miracles, or like the figure behind him who, according to the speaker, can only look without understanding. To repeat the words of the speaker who argued in defense of the proposition that Poussin's subject was in fact the miracle at Jericho, the artist chose to show only a few figures, "so that the figures he painted around Christ looking at him attentively might contribute in some way to making those who look at this painting do so also, without finding themselves distracted by other movements or expressions."[134]

This distinction between simply seeing and looking with attention is again the distinction between Aspect and Prospect between "voyant simplement" and "considérant avec attention," that Poussin had expressed in his letter of 1642 to Sublet de Noyers, the cousin of Chantelou and Chambray who was responsible for Poussin's commission to paint the Grand Gallery of the Louvre. In the 1640s the theme of making the distinction between looking and seeing that we have associated with the figure of *Pittura* in the *Self-Portrait* for Chantelou, and with the figure of the shepherdess in the *Arcadian Shepherds*, makes its appearance as part of a narrative more than once.[135] The contrast between, for example, jealous watching and astonished distraction among the observing women in the *Rebecca and Eliezer at the Well* (pl. VI) comes immediately to mind.[136] But the discussion of the *Healing of the Blind*, which took place only a year after Poussin's death, provides an especially forceful demonstration of Poussin's contemporaries' understanding of how he had thematized within a painting itself the question of the beholder's proper reading of a picture.

In the case of the *Healing of the Blind* Poussin expressed more than this question of reading as such (raising attendant questions of what Marin characterized as the ultimate indecidability of interpretation).[137] He also focused, appropriately enough, on the nature of vision, or sight itself. Marc Fumaroli has placed this question in the context of post-Tridentine oratory, seeing a sort of identification between the touch of the painter and the gentle touch of Christ, a sort of *Deus Pictor* who opens the eyes of the blind to the spectacle of creation.[138] But though based on Christian history, Poussin's *tableau* was for a secular patron, and the balance of the argument has shifted towards analysis of his own ability to make the natural world visible—that is legible— with his loving touch.[139] We have already proposed that the kneeling rustic in the *Arcadian Shepherds*—as much in this second version as in the first—sees only by touching (pl. VIII). The pole that he carries, as do the other three rustic figures, reinforces one's sense of the blindness of his comprehension. The meditative figure to the right reflects on what she sees with understanding, reassuring a second shepherd who points,

and who looks to her for an explanation. Poussin insists on different ways of viewing in this painting: from the figure to the left who looks down and so sees no message, but only his companion; to the pointing shepherd he looks down upon, and who touches the inscription; to the pointing figure who no longer touches, but turns towards understanding; and to the contemplative figure, who understands.[140] The contrast between the kneeling shepherd who touches and the standing contemplative woman subsumes the opposition of shadow and color, suggesting that Poussin is exploring a yet more complicated question concerning the relationship between touch and sight in vision, or tactile and optical responses to things seen, and not just stating the sequential relationship between chiaroscuro and color in painting. His way of thinking about it, furthermore, helps to define Poussin more precisely as an optical painter of light and color, which is how he was defined in Pesne's print after the Pointel *Self-Portrait*.

That we tend to think of Poussin as belonging to the camp of *disegno* rather than *colore* has, as we have already suggested, greatly to do with the later interpretation of his work in the Académie, and with the fact that *colore* came there to be associated with a looser brushwork and painterly technique based on the practice of Rubens and the Venetians.[141] But this should not be allowed to obscure the fact that Poussin's own concern at this point in the middle of his career, as Badt understood especially well, was with the optical effects of color and light taken together, and not with the representation of linear contour or purely sculptural relief for their own sake. Such, as we have seen, was the manifesto of the *Self-Portrait* for Pointel.

In the *Healing of the Blind*, the stick by which one blind man "sees" through touching has been left abandoned in the shadows of the door of the house on the left, where its colors and those of its ambient are invisible. The blind men reach out to touch Christ, but they do not succeed in actually seeing him until he, the Light (*Lumen*) itself, touches their eyes, opening these to the natural light (*Lux*) and color of the morning.

In his *Dioptrique*, one of the essays in the *Méthode* published in French in 1637, Descartes compared the impression made on the eyes by rays of light to the instant experience conveyed by a stick either to a blind man or to a seeing man in the dark.[142] The eye, writes Descartes, sees by being touched by light, in the same way that a blind man sees by touching; rays of light, then, are like the sticks of the sighted (fig. 117).[143] Through these rays of light we see all sorts of colors, which we distinguish immediately in the same way that the blind man tells the difference between trees, stones, and water through his instrument of touch (and it is obviously important that the stick is the medium for this, not merely the hand).

In his analysis of the image on the optic nerve, Descartes always refers to it as a *peinture*. The painting on the optic nerve, like the painter's image, results from a kind of touching, the touching of the eye by light; but this is in effect quite different from the blind man's touching, for color is always already part of this instantaneous vision (notwithstanding the effects of distance treated as aerial perspective).[144]

136 OEuvres de Descartes. 57-58.

nonobſtant que la peinture, qu'ils impriment dans

l'œil, en ait vne toute contraire : ainſi que noſtre aueugle peut ſentir en meſme temps l'obiet B, qui eſt a droite, par l'entremiſe de ſa main gauche; & D, qui eſt a gauche, par 5 l'entremiſe de ſa main droite. Et comme cet aueugle ne iuge point qu'vn cors ſoit double, encore qu'il le touche de ſes deux mains, ainſi, lors que nos yeux ſont tous deux diſpoſés en la 10

117. Illustration to René Descartes, *La Dioptrique: Discours VI,* from *Discours de la méthode,* Leiden, 1637

What Descartes is implying, and what a painter would have understood him to be implying (though this is not his central argument), is that there is a significant difference between the opticality of color and light and the tactility of relief, however much they may be compared to each other, and that vision results from the arrival of colored light, not color and light, in the eye, which then passes the image on to the soul. Poussin, well aware from his reading of Zaccolini of the inseparability of color and shadow, and their equal, proportional, and combined degradation as they move from different distances to the eye, understood his task to be the representation both of the effects of colored light on the eye, and of the understanding by the soul of the visual image painted there.

To understand a bit better the implications of Descartes' useful comparison of seeing to touching on the one hand, and his distinction between these two kinds of touch on the other—especially insofar as its implication for painting is concerned—we

can gain some clarification from Roger de Piles. This critic's radical subordination of linear contour to color deeply affected the manner in which earlier paintings, especially including those by Poussin, were understood.[145] In his *Cours de peinture par principes*, published in 1709, De Piles insists that chiaroscuro is a subordinate part of coloring.[146] Rejecting the arguments of those who insist that the contours and proportions of figures are primarily known through light and shadow, he states that these things can be learned entirely through touch. The drawing of contour lines and proportions (not to be confused with drawing as *idea* or as *étude*) can be accomplished without light; it is only painting in colors that demands light.[147]

In support of his assertion that colors and light are the objects of sight, whereas drawing in the sense of contour or outline relates to touch, De Piles refers to a story he had been told about the blind sculptor from Gambassi—i.e., Giovanni Gonnelli— whom a colleague had met in the Palazzo Giustiniani, where Gonnelli was copying the famous *Minerva*.[148] The sculptor had explained to De Piles' informant that he touched all the dimensions and surfaces of a head, and then stored all this knowledge in his memory before reproducing the form in wax. Gonnelli's story is repeated in more detail by Baldinucci, whose reports on Gonnelli's work for the Giustiniani, and of the various tests of the sculptor's blindness were likely De Piles' source.[149]

Among these is the story of Cardinal Pallotta's commission to Gonnelli to make a portrait of a woman in Gambassi, whom the sculptor had loved as a youth before losing his sight. This he did, and the Cardinal meanwhile commissioned a painter to make a portrait of the same woman. So alike were the two representations that the astonished Cardinal gave Gonnelli's statue pride of place in his gallery, attaching an inscription to it that inverts the well-known Petrarchan metaphor of the sighted painter attempting to represent the image that love has carved on his heart. It reads, "Giovanni, who is blind, and who loved Elisabetta, sculptured her according to the Idea formed by love."[150] As De Piles commented, if he had been a painter he would have been denied this consolation. And in this way, his argument about contour not being related to light is also proven.

Such a consolation was not limited to this unique artist, but could also distinguish one beholder from another. In a drawing now in the Louvre, attributed to an artist close to Guercino and which bears the inscription *Della scoltura si, della pittura non* (fig. 118), a blind beggar with a cane touches the bust of a woman, but cannot see the painting propped up beneath it.[151] Conventionally, the drawing has been situated within the context of sixteenth-century debates on the paragone of painting and sculpture. Responding, for example, to Tribolo's defense of sculpture on the grounds that a blind man had said he could enjoy it, Vincenzo Borghini had defended the sense of sight over that of touch by reporting the comment of another blind man who regretted that he could not admire a painting of the exploits of Alexander the Great, whose statue he had just touched.[152] The drawing certainly relates to this tradition, but, as we might expect from the caricatural genre adopted, something rather more satirical

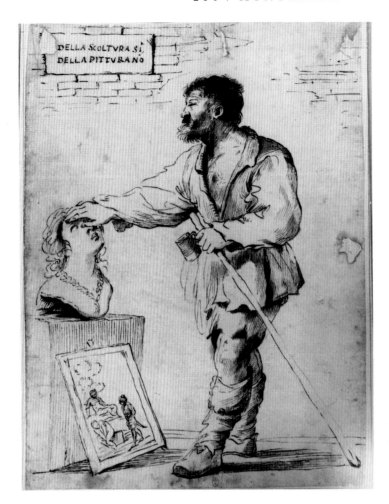

118. School of Guercino, *Della scoltura sì, della pittura non,* drawing, Département des arts graphiques, Musée du Louvre, Paris

was intended. The ragged, hairy pauper touches, not a statue of Alexander the Great, but a sweetly imploring female beauty. The painting at his feet, which he cannot see, shows a very different male figure, well dressed and with a sword instead of a blindman's stick, who gazes at a naked, bathing woman; the presence of a second naked figure, seated slightly higher and in front of a tree, suggests an idyllic scene. The social distinction drawn between the two men might argue that the sense of touch is less noble than that of sight, but the sighted gentleman does not use his vision to look at the inspiring deeds of ancient heroes. He gazes on naked female beauty, in a humorous reference to the special quality of painting—the missing noun in the inscription is surely *Bellezza,* referring to the traditional identification of the beautiful work of art with female beauty that we have discussed in connection with Poussin's figure of *Pittura* embraced by the judging eye of the connoisseur of painting in the *Self-Portrait.*

The change in the status of his paintings into essays in knowing that Poussin

sought to effect involved a refusal to allow his works to be seen merely as desirable objects, enchanting illusions that made the absent seem present. In painterly terms that refusal engaged the important distinction between tactility (the desiring touch of the shepherd in the *Arcadian Shepherds*) and opticality (the understanding of the standing woman in the same painting, or the figure of *Pittura* in the *Self-Portrait*). The former quality was established in Renaissance painting through chiaroscuro modeling, which, as Berenson recognised, gave the illusion of presence and the sense that the desirable beauty represented might truly be touched and grasped, or possessed. The new opticality in painting required a cognitive visual and perspectival reading, in which all the discursive practices outlined here, whether about vision, friendship, interpretation, or understanding, could be experienced and expressed. Poussin determined to make it impossible to separate the beauty of a work of art from the understanding of it. That is why De Piles had to insist on just this distinction, and separate the senses of touch and sight once again, if in a new way, now privileging the gentleman's vision of alluring color over the blind beggar's touch.

CHAPTER SIX

MAVORS ARMIPOTENS:
THE POETICS OF
SELF-REPRESENTATION IN
POUSSIN'S *MARS AND VENUS*

POUSSIN'S *Self-Portrait* for Chantelou is not the only work that may be elucidated critically by a close parallel reading of Montaigne's *Essais*. As we suggested in the preceding chapter, it seems clear that Poussin was a careful and attentive reader of Montaigne and deeply sympathetic to his views. Indeed, he derived intellectual and spiritual sustenance from Montaigne's writings throughout his life, and was not merely a scavenger of Montaigne's works for the odd iconographical theme or motif.

In this chapter we shall turn to a much earlier work by Poussin, the *Mars and Venus* now in the Boston Museum of Fine Arts (pl. IX). The subject and expressive content of this painting derive from two famous and related passages in ancient literature, in Lucretius and Virgil, which Montaigne had made the focal point of his essay *Sur des vers de Virgile*. The subject of Montaigne's essay, however, despite its title, is the sexual act; and beyond that it is the expressive energies of poetic language in reproducing, and sublimating through art, the actual effects of desire. These are also the themes taken up by Poussin, whose understanding and reading of Lucretius and Virgil will be seen to follow in Montaigne's footsteps, and not least in his adaptation of the fictions of ancient fable as the pretext for a sustained essay in the representation of self.

Let us begin by drawing attention to an aspect of Poussin's *Mars and Venus* that apparently no one has ever mentioned, but which no doubt everyone has noticed: namely, the impotence of Mars.[1] The fact of his impotence is made unmistakeably manifest, not because Mars gives no visible sign of arousal (which would be surprising, though not absolutely unheard of, given the conventions of the time), but because he is literally unsexed. The absence of the male member is not owing to interference or damage in the fabric of the painting, which is in excellent condition, including the area in question. It is intentional, and requires explanation.

Poussin's explicit theme is the disarming of Mars by Venus, and the goddess, in a

reversal of the conventional sexual roles, accordingly assumes the dominant and active position, with Mars playing the passive partner. She sits in an upright and command-ing posture and gently but insistently pulls the enervated and powerless—indeed quite helpless and incapable of resisting—Mars backwards into the fold of her embrace. His sword lies on the ground at his feet, and two torches appear on either side of the drapery thrown carelessly upon the earth. One shines with the brilliant gold of the morning star—the *lampada Veneris* which, as in Guido Reni's *Aurora* or in Poussin's own *Diana and Endymion*, indicates Venus' planetary identity—while the other glows with the angry fire of the red planet Mars. At Venus' back an *eros*, arrow in hand, pulls back the curtain to prepare the lovers' bed, while five of his companions disrobe, or rather disarm Mars. Two of them remove the shield from his unresisting arm, and a third raises up the helmet from his head. A final pair of loves, in the lower left-hand corner, together embody an especially elegant conceit, which is moreover an entirely original invention on Poussin's part. One *eros* empties the arrows from Mars' quiver, depriving him of his murderous weapons. However, his companion does not break or otherwise destroy them, as we might expect. Instead, paradoxically, he sharpens them, and in so doing converts the death-dealing arrows of Mars into their opposite, arrows that inflict the perpetually living wounds of love.

The double-edged metaphor of weapons that inflict the wounds of death and life is a famous and often repeated one in classical literature and its vernacular derivations, and it is indeed one of the most familiar conventions of sexually explicit and obscene prose and poetry. Apuleius' graphic account of the athletic and specifically military sexual grapplings of Lucius and Fotis in the *Metamorphosis*, familiarly known as the *Golden Ass*, is merely an especially well-known example, which we may further illus-trate with two robustly vulgar seventeenth-century engravings (figs. 119 and 120) reproducing two pendant paintings of *Mars* and *Venus* by Jan Bijlert. The engravings were published with Latin hexameters in Crispin de Passe II's instructional drawing book, entitled *Della luce del dipingere et disegnare*, first issued in Amsterdam in 1643.[2] Beneath the image of Mars the following question is posed, again invoking the ancient simile likening lovemaking to a passage of arms:

> Mars pater Aeneadum natae coniuncte [D]iones,
> Cur ferri oblitus contraria suscipis arma?

(Mars, father of the Romans, when uniting with Venus why, forgetful of the sword, do you take up arms of an opposite nature?)

To which Venus, her nourishing breast tweaked provocatively by an *eros*, replies:

> Continua mortale genus ne caede periret,
> Arma dedi dulci [t]in[c]ta liquore Venus.

(Lest mankind perish in continual slaughter, I Venus have given weapons dipped in sweet fluid.)

119. Crispin de Passe after Jan Bijlert, *Mars,*
engraving, Rijksmuseum-Stichting, Amsterdam

120. Crispin de Passe after Jan Bijlert, *Venus,*
engraving, Rijksmuseum-Stichting, Amsterdam

The sentiment of these inscriptions, if not the *farouche* carnality of Bijlert's paintings, ultimately derives from (even as it vulgarizes) Lucretius' famous prologue to the *De rerum natura*, which is the *locus classicus* describing and giving full meaning to the myth of Mars' subjugation by Venus. The same is true for Poussin's *Mars and Venus*, in which the artist's new *concetto* of the arrow-sharpening loves is directly motivated by a more profound meditation on Lucretius' characterization of Mars in the same prologue. There the poet requests nourishing Venus, who alone possesses the power to bestow peace, to subdue *Mavors armipotens*, Mars powerful in arms, to vanquish him by inflicting the eternally living wound of love (*aeterno devictus vulnere amoris*). Thus Lucretius expresses the very paradox developed by Poussin in his painting. For peace to prevail over war it is necessary for fertile Venus to defeat and disarm Mars *armipotens*, for the power of love to render the war god powerless and feeble, *impotens*, and to afflict the giver of deadly wounds with a wound that brings life. This paradox also accounts for the actions of the loves who take away the god's armor in Poussin's painting, as well as the *concetto* of the *erotes* who sharpen his deadly arrows for the purpose of inflicting the new wounds of love. Needless to say, it is also this paradox that motivates Mars' literal impotency.

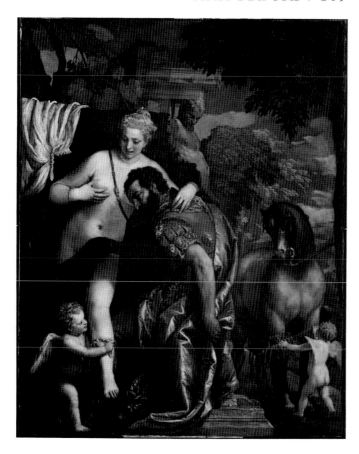

121. Paolo Veronese, *Mars and Venus*, The Metropolitan Museum of Art, New York

There is no need to document once again the importance to the Renaissance imagination of Lucretius' famous opening hymn to Venus Genetrix, of which it has been written that "après 1547 [with the appearance of the *Oeuvres poétiques* of Jacques Peletier du Mans] il n'est pas un poète en France qui n'utilise quelque réminiscence du prologue du Lucrèce."[3] The first part of the invocation is more than any other classical text fundamental for Renaissance conceptualizations of Venus in poetry and in painting (including Poussin's *Triumph of Venus* in the Philadelphia Museum of Art).[4] The second half may fairly be called the primary ancient text defining Venus as the nourishing spirit of peace and fertility, who disarms Mars and the savage works of war. We need only recall Veronese's *Mars and Venus* in The Metropolitan Museum in New York (fig. 121), in which the milk spurting from Venus' breast denotes her as the *alma Venus* invoked by Lucretius. Here Love literally binds the two gods together, while a second *eros* pushes back Mars' warhorse with the god's own sword that he has taken from him.[5] Venus again assumes the dominant role, and, although the theme of Mars' impotency plays no part in Veronese's conception, in a second treatment of the theme in the Galleria Sabauda in Turin (fig. 122) he depicted the strenuously athletic engagement of

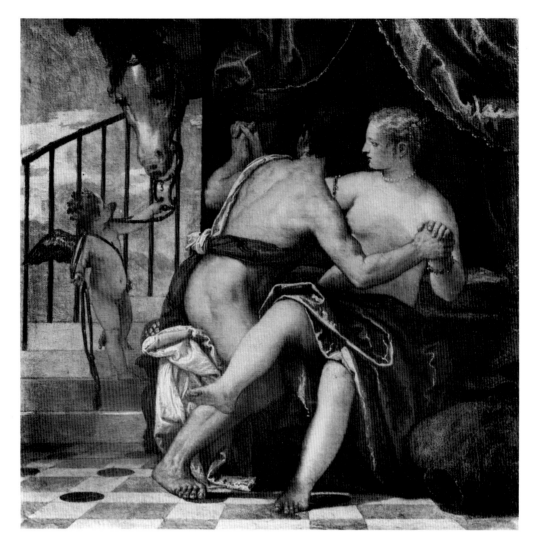

122. Paolo Veronese, *Mars and Venus,* oil on canvas, Galleria Sabauda, Turin

the two gods stopped at the critical moment—*coitus interruptus* in the spirit of *opera buffa*—by an *eros* leading Mars' dewy-eyed warhorse into the lovers' chamber.[6]

With regard to the specific imagery of Poussin's painting, on the other hand, the painter not only responded to the poet's theme of Mars' impotence in confrontation with the power and fertility of Venus, but also followed remarkably closely the letter as well as the spirit of Lucretius' description of their encounter:

> . . . belli fera moenera Mavors
> armipotens regit, in gremium qui saepe tuum se
> reicit aeterno devictus vulnere amoris,

atque ita suspiciens tereti cervice reposta
pascit amore avidos inhians in te, dea, visus,
eque tuo pendet resupini spiritus ore.
hunc tu, diva, tuo recubantem corpore sancto
circumfusa super, suavis ex ore loquellas
funde petens placidam Romanis, incluta, pacem.[7]

(Mars, potent in arms, rules the savage works of war, yet often casts himself back into your lap vanquished by the ever-living wound of love, and thus hanging with shapely neck bent back and open mouth he feeds his eager eyes with love, and as he lies back his breath hangs upon your lips. There, as he reclines, goddess, upon your sacred body, bend down around him from above and pour from your lips sweet coaxings, and for your Romans, illustrious one, seek quiet peace.)

In the *De rerum natura* Lucretius invokes Venus as a planet (*alma Venus, caeli subter labentia signa*) and as the goddess of spring, the nourishing spirit of life in nature. But he also invokes her as the mother of Aeneas and hence the Romans (*Aeneadum genetrix*). The father of the Romans is Mars, who sired Romulus and Remus, and Lucretius' plea for Venus to subjugate Mars is made with reference to the civil wars, when half the Roman peoples were divided from the other half. Since Mars *armipotens* rules the savagery of war, Lucretius asks Venus as the goddess of peace to inflict him with the eternally living wound of love so that he may cast himself backwards (*se reicit*) into her lap, and, there suspended with shapely neck thrown back (*ita suspiciens tereti cervice reposta*), gape upwards into her face, his breath hanging upon her lips. Poussin responded directly to the erotic power of Lucretius' description, both in imagining Mars' attitude and in rendering the poet's beautiful characterization of the dominant Venus, *circumfusa super*, in the particular action of pulling Mars into her embrace, while he falls helplessly back so that he may be received into her lap.

Every pictorial response to poetry entails the artist's own, particular interpretation of that poetry. And so it is important also to stress that, just as Poussin invented his own *concetto* of the arrow-sharpening *eros* in order to express as a species of painted *sententia* Lucretius' paradox of the weapons that inflict the wounds of life, so too did he part company from Lucretius in several important ways. With regard to complete literal fidelity to Lucretius' text, for example, he was not concerned merely to illustrate the descriptive accidents of the poem, and so he did not depict Mars lying on his back in Venus' lap in the position indicated by Lucretius, which might well be imagined in the form of a pagan, and highly erotic *Pietà*. The completed action that is implied in Lucretius' invocation corresponds perfectly with the postures of Venus and Adonis, though with the male and female roles reversed, in the painting of that subject in the Kimbell Museum by the putative Master of the Clumsy Children, to which we have alluded in the first chapter. In the *Mars and Venus* Poussin rather was concerned to express the erotic potency of Venus, so impressively evoked in Lucretius' language, in

active deployment—in the very action of dominating Mars, disarming him and pulling him backward down into her embrace. In so doing, imagining the engagement of the gods in the midst of their encounter rather than in its final positioning, his attention was concentrated in particular upon the accumulated, erotically descriptive and suggestive energies of Lucretius' diction. His own imagery evokes directly, and newly expresses in paint, the extraordinary potency and natural vividness of that diction—*se reicit, tereti cervice reposta, inhians, pascit,* and *circumfusa super.* The last of these, *circumfusa super,* Poussin beautifully recast into the image of dominant Venus, who actively and commandingly turns and pulls Mars' backwardly falling figure gently downwards into her lap.

The impressive naturalness and force of Lucretius' poetic diction was remarked upon by Montaigne in his famous essay *Sur des vers de Virgile* when he compared Lucretius' description of Venus' seduction of Mars to Virgil's verses in the *Aeneid* devoted to Venus' parallel seduction of her husband, Vulcan. "When I reflect," Montaigne wrote (artfully mingling Lucretius' words with Virgil's), "upon this *reicit, pascit, inhians, molli, fovet, medullas, labefacta, pendet, percurrit,* and this noble *circumfusa,* mother of the gentle *infusus,* I am filled with disdain for those petty distinctions and verbal allusions that have afterward appeared."[8] Montaigne is here alluding by simultaneous quotation to Virgil's celebrated borrowing from Lucretius' description of Mars, *aeterno devictus vulnere amoris,* in order to characterize Vulcan, *aeterno fatur devinctus amore.*[9] In the *Aeneid* Venus' seduction is calculated to make her husband forge armor for Aeneas, but even so Montaigne remarks that "what I find worth considering here is that [Virgil] paints her as a little too passionate for a marital Venus, for in this sober contract the appetites are not so wanton, but rather dull and more blunted."[10] Montaigne was not wrong about the powerful eroticism of Virgil's poetry:

> Dixerat, et niveis hinc atque hinc diva lacertis
> cunctantem amplexu molli fovet. Ille repente
> accepit solitam flammam, notusque medullas
> intravit calor et labefacta per ossa cucurrit,
> non secus atque olim tonitru cum rupta corusco
> ignea rima micans percurrit lumine nimbos.
> Sensit laeta dolis et formae conscia coniunx.
> tum pater aeterno fatur devinctus amore[11]

(She ceased speaking, and gathers her hesitating lord in her snowy arms and caresses him in a soft embrace. He at once felt the familiar flame, and the well-known heat entered into his marrow and raced through his melting bones, even as betimes a flashing streak of lightning, bursting with a crack of thunder, races through the storm clouds with dazzling light. His consort, conscious of her beauty, knew it, and rejoiced in her wiles. Then spoke her lord, chained by immortal love)

The two passages from Virgil and Lucretius are the pivotal cruces of Montaigne's essay, and without doubt Poussin's image of Venus' snowy-armed embrace of Mars, provoking the melting fire coursing through his loins, also occurred with Virgil's, no less than Lucretius' poetry in mind. His understanding of Lucretius, in other words, and hence his interpretation of his poetry, was in some part informed by Virgil directly, as well as by Montaigne's reflections on the verses of both poets. For it is in fact certain that Poussin had Virgil's account of Venus and the forging of Aeneas' armor before him when he painted the *Mars and Venus*. This can be determined by comparing Lucretius' verse characterizing the backwardly reclining Mars, gazing upwards into Venus' face with shapely neck thrown back—*tereti cervice reposta*—to Virgil's equally famous imitation in the passage immediately following Vulcan's seduction by Venus. There he describes the shield that Vulcan fashioned for Aeneas at Venus' request, upon which was represented the green grotto of Mars, within which the mother-wolf with shapely neck bent back—*tereti cervice reflexa*—licks the infants Romulus and Remus as they suckle at her teats:

> fecerat et viridi fetam Mavoris in antro
> procubuisse lupam, geminos huic ubera circum
> ludere pendentis pueros et lambere matrem
> impavidos, illam tereti cervice reflexa
> mulcere alternos et corpora fingere lingua.[12]

(He also made the mother-wolf stretched out in the green grotto of Mars, with the twin boys hanging round her teats playing and mouthing the mother without fear. She, with shapely neck bent back, fondled them in turn and shaped their bodies with her tongue.)

Venus' gift of the armor to Aeneas was later painted twice by Poussin (and his friend Pietro Testa also made an etching of the subject), but it is still remarkable—and wonderful—to find that in a preparatory drawing now in the Louvre for the *Mars and Venus* (fig. 123), which was the basis for an etching of Poussin's invention by Fabrizio Chiari in 1635 (fig. 124), Poussin directly incorporated Virgil's borrowing from Lucretius into his own interpretation of the theme of Mars' subjugation.[13] In the drawing we see the initial *concetto* he conceived for the left-hand foreground of his composition, which he later changed into the arrow-sharpening *erotes* in the finished painting. Poussin's first conceit instead took the form of the she-wolf that is equally the attribute of Mars and the Roman people. Instead of giving suck to the infants Romulus and Remus, however, she is shown subdued by an infant *eros*, who mounts her back and toward whom she turns, *tereti cervice reflexa*, in a movement that precisely rhymes with that of the subdued Mars, who turns toward Venus, *tereti cervice reposta*. In this way Poussin can be seen initially to have intended to preserve Lucretius' political allegory through reference to the Roman wolf tamed by love, even as simultaneously the war god submits to the power of Venus.

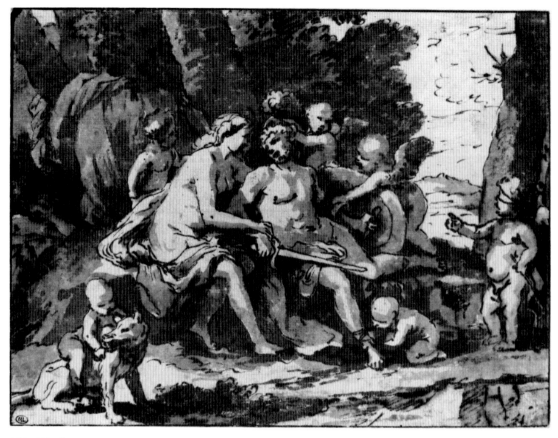

123. Nicolas Poussin, *Mars and Venus*, drawing, Département des arts graphiques, Musée du Louvre, Paris

The political allegory that inheres in the prologue to the *De rerum natura* was also central to Rubens' paintings of *War and Peace*—which in their very different, allegorical mode are also interpretations of Lucretius, and equally valid readings of his poetry—with the reference transferred from ancient Rome to the Europe of the Thirty Years War (fig. 125). In the version in the Pitti Palace, for example, we see Europe despairing while Venus tries to restrain Mars from following in the Fury Alecto's path and trampling underfoot emblems of poetry, painting, and the various arts (for Lucretius had summoned Venus to ask for peace so that he might write his poem and the arts flourish). In Rosso Fiorentino's famous drawing of *Mars and Venus* (fig. 126), on the other hand, there is no overtly political content. The erotic context of Rosso's interpretation is instead developed through reference to the actions of the *erotes* playing with the hero's armor in Raphael's even more famous drawing of *The Marriage of Alexander and Roxana*, well known through engraved variations (fig. 127).[14] The expressive force of Rosso's invention takes the erotic content of Lucretius' poetry as its point of departure, which the artist then developed with reference to the explicitly Lucianic ribaldry

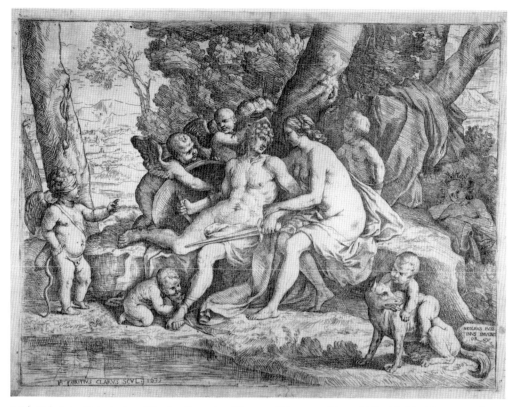

124. Fabrizio Chiari after Nicolas Poussin, *Mars and Venus,* etching, Philadelphia Museum of Art, Philadelphia

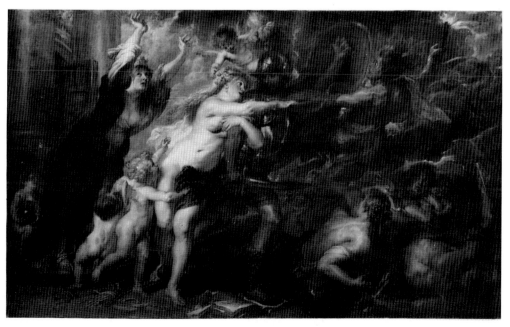

125. Peter Paul Rubens, *War and Peace,* Galleria Palatina, Palazzo Pitti, Florence

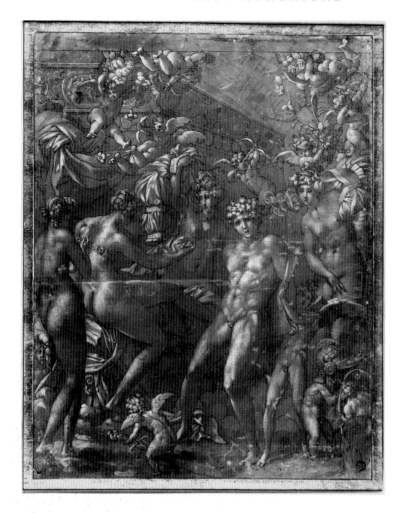

126. Rosso Fiorentino, *Mars and Venus,* drawing, Département des arts graphiques, Musée du Louvre, Paris

that informs his Raphaelesque model, and by the witty contrast of Mars' hang-dog advance to the nuptial couch with the manly attitude of the proud Alexander. The eroticism, and the wit, of Rosso's drawing is moreover magnified by the artist's conspicuous mockery of the manifest inadequacy of Mars' miniscule member for the task at hand, a *concetto* that of course expresses the same Lucretian paradox of the vanquished *Mavors armipotens* which also attracted the attention of Poussin.[15]

Moreover, in Poussin's preparatory drawing for the *Mars and Venus* we can see that the eroticism of Lucian's description and its subsequent history in art (especially including Annibale Carracci's variation in the *Venus and Anchises* in the Farnese Gallery fig. 128) also played an initial part in his thought.[16] While a blindfolded *eros* mocks the lovers, one of his companions unlaces Mars' sandal in an action that precisely mirrors that of the *eros* who prepares Roxana for the nuptial bed, an action that even more explicitly states Mars' identity with the female role, whether as Roxana, as in Raphael's drawing, or as Venus herself, as in Annibale's fresco. In the finished painting,

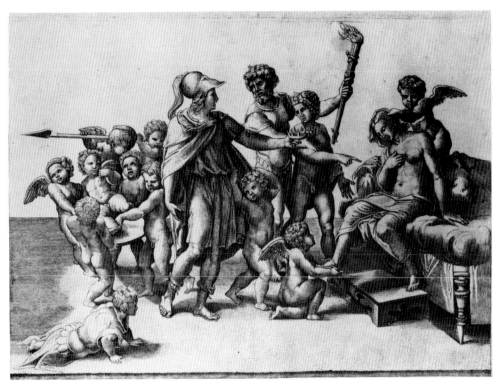

127. Gian Jacopo Caraglio, engraving after Raphael, *Alexander and Roxana*

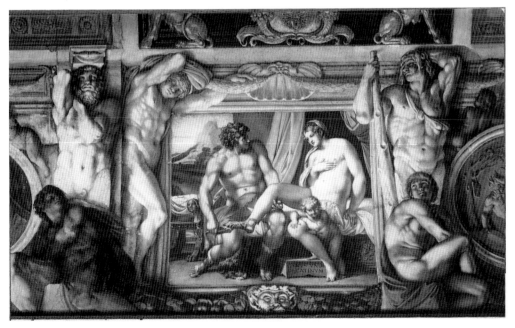

128. Annibale Carracci, *Venus and Anchises,* the Farnese Gallery, Palazzo Farnese, Rome

however, in contrast to Rosso's witty interpretation of the theme, Poussin abandoned the motif of the sandal-removing *eros*, as well as that of his mocking brother. His final, more serious interpretation arises from his intense concentration on the specifically sexual (as distinguished from the merely erotic) content of Lucretius' poetry, on its linguistic energies together with its more purely psychological qualities. It was this particular focus that also led him in the final painting to abandon the political *concetto* of the wolf in favor of the poetic *scherzo* of the loves adapting Mars' armor for their own, new use.

Indeed, already in the Louvre drawing we can see that the paradox of *Mavors armipotens et impotens* which forms the dark undercurrent of Lucretius' poetry, and which was parodied by Rosso, and moreover the theme of castration that is explicit in Poussin's finished painting, are both central to his theme. In the drawing (fig. 123) the god's manhood is discreetly veiled, but the sword that in the painting is cast to the ground here lies menacingly across Mars' lap, its handle in his inert and powerless hand. Venus grasps Mars' wrist in order to pull him back into her embrace. As she pulls his unresisting arm, it is as if to cause him unwittingly to pull the sword across his lap, cutting through the area covered by the drapery. Thus will *Mavors armipotens* himself be vanquished by the eternal wound of love, *aeterno devictus vulnere amoris*. Thus wounded do we see him in the final painting.

It would not be difficult to discover an Oedipal fantasy acted out in Poussin's *Mars and Venus*, expressed through the castration and feminizing of Mars, together with his absorption and loss of self within the embracing and all-powerful mother. Instead of reaching for such a Freudian reading at the level of the subconscious, however, we have sought to elucidate the expression of Poussin's own quite conscious and deliberate meditation, assisted by his close reading of Lucretius and Virgil, upon the theme of the terrible, and permanent wound inflicted by love. For what is the Venereal wound with which the beautiful, pacific, and abundantly fertile goddess afflicts those who follow in her path? Though the exact date of the *Mars and Venus* is not known, scholarly opinion is virtually unanimous in placing it to about the year 1629–30, when Poussin was suffering the agonies of the *morbus gallicus* and its even more anguishing cure. A trenchant drawing in red chalk showing the effigy of the artist during the period of his affliction still survives in the British Museum (fig. 129).[17] An inscription appended to the portrait identifies it as "an excellent likeness of Nicolas Poussin made before the mirror by his own hand around the year 1630 during his convalescence from his serious illness, and [later] given by him to Cardinal Massimi." Passeri writes movingly of Poussin's long illness:

> [H]e was painfully tormented by the *mal di Francia*, which for several years afflicted him very grievously, so that he lived in great mortification and pain. By good luck he had contracted a friendship with one of his countrymen in Rome, a Parisian named Jacques Dughet, a very good man who cared for him with much love and assiduousness during his great affliction. He brought doctors and sur-

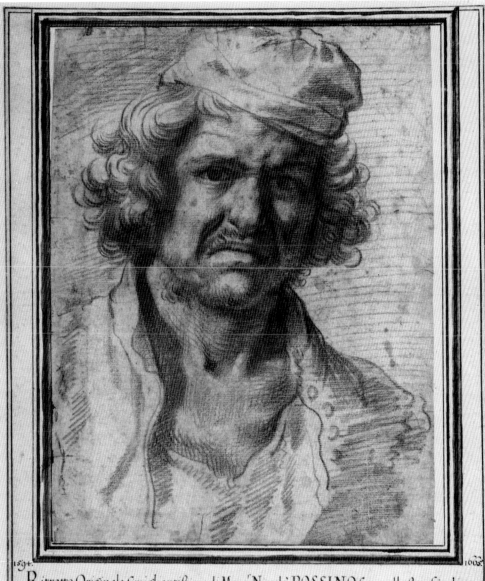

1594.　　　　　　　　　　　　　　　　　　　　　　　　　1665.

Ritratto Originale simigliantissimo di Mons.ʳ Niccolò POSSINO fatto nello specchio di propria mano circa l'anno 1630. nella convalescenza della sua grave malattia, e lo donò al Cardinale de Massimi allora che andava da lui ad imparare il Disegno. Notisi che và in stampa nella sua vita il Ritratto ch'ei dipinse per il Sig. Chatelou l'anno 1650. quando non aveva che anni 56. Fù buon Geometra, e prospettivo, e studioso d'Istorie. A Niccolò Possino è obbligata l'Italia, e massime la Scuola Romana d'avere fatto vedere praticato lo stile di Raffaello, e nell'antico da lui compreso nel suo fondo sostanziale imbevuto ne i suoi primi anni, poiche nacque nobile nel Contado di Soison di Piccardia in Andelò l'anno 1594. Andò à Parigi, dove dal Matematico Regio gl'erano imprestate le stampe di Raffaello, e di Giulio Romano, sulle quali indefessamente, e di tutto suo genio s'affaticò su quello stile di disegnare ad imitazione, e di colorire à proprio talento. Fu trattenuto à Parigi per alcuni quadri ordinatili l'anno 1628. per la Canonizazione di S. Ignazio, e S. Francesco Xaverio. Nell'Ospedale studio d'Anatomia in Roma venuto quà nel 1624. per il Naturale all'Accademia del Disegno.

129. Nicolas Poussin, *Self-Portrait,* drawing, British Museum, London

geons to cure him, and never failed in giving him diligent care or help of any kind. What is more, he ordered his own wife to assist him continually with his needs, as much in the kitchen as in trying to keep him clean and provided with bedlinen, which she did with great diligence and love. The loving care of Jacques and his wife were of great comfort to Nicolas, and God knows how he would have pulled through without this help, and he confessed that he owed them a debt far beyond the ordinary.[18]

After Poussin's health improved (though he never fully recovered from his terrible illness) he repaid his debt to Jacques Dughet and his wife by marrying their daughter, Anne Marie, on the first of September in 1630. The marriage ended thirty-four years later when Anne Marie Dughet died on the sixteenth of October in 1664. They never had any children.

POUSSIN'S MARRIAGE was contracted on the basis of the deep gratitude and friendship he felt for Jacques Dughet and his wife, and there is no reason to think that the marriage itself was not nourished by the same spirit of mutual friendship and constancy. It was, in other words, undertaken in a spirit consistent with the sentiment expressed by Montaigne when he wrote in the essay *Sur des vers de Virgile* that ardor is an insufficiently solid and stable foundation for marriage, and that he found "no marriages that sooner are troubled and fail than those that progress by means of beauty and amorous desires":

> Therefore I like this fashion of arranging it rather by a third hand than by our own, and by the sense of others rather than by our own. How opposite is all this to the conventions of love! . . . A good marriage, if such there be, rejects the company and conditions of love. It tries to reproduce those of friendship.[19]

Montaigne here refers to "love" within its narrower identity as *eros*, and in the context of an argument that within the state of marriage sexual desire should be tempered. But marriage is not the theme of his essay. It is what he calls its opposite, the conditions of erotic love, and specifically his subject is the sexual act.[20] The essay was written in what he calls "this calamity of old age," some half-dozen years before his death in 1592, when he was suffering from the stone and other ailments, so that "from an excess of gaiety I have fallen into an excess of severity, which is more disagreeable."[21]

Sur des vers de Virgile is an attempt to find an antidote to the author's diminished sexual powers and his encroaching impotence by examining openly the nature of erotic desire: "But am I not right to consider that these precepts [of philosophy], which by the way are in my opinion still a bit rigorous, concern a body that performs its function, and that for a run-down body, as for a broken-down stomach, it is excusable to warm it up and support it by art, and by the mediation of fancy to restore appetite and blitheness to it, since by itself it has lost them?"[22] Of Virgil's and Lucretius' verses on

the lovemaking of Venus, Montaigne writes that "the verses of these two poets, treating of lasciviousness as reservedly and discreetly as they do, seem to me to reveal it and illuminate it more closely."[23] Moreover, the simultaneous sublimation and arousal of desire by means of their art—and through Montaigne's writing about it—has the special power to minister to the wounds with which disease and onwardly creeping age afflict the body:

> I have not been so long cashiered from the roll and retinue of this god [Eros] as not to have a memory informed of his powers and merits: *Agnosco veteris vestigia flammae*—I know the traces of the ancient flame [Virgil]. There is still some remnant of heat and emotion after the fever: *Nec mihi deficiat calor hic, hyemantibus annis*—In wintry years, let me not lack this heat [Joannes Secundus]. Dried out and weighed down as I am, I still feel some tepid remains of that past ardor. . . . But from what I understand of it the powers and worth of this god are more alive and animated in the painting of poetry than in their own reality: *Et versus digitos habet*—And verses have their fingers to excite [Juvenal]. Poetry reproduces an indefinable mood that is more amorous than love itself. Venus is not so beautiful all naked, alive, and panting, as she is here in Virgil.[24]

The sublimation of *eros* in art, and the consequent healing and recreation of desire in the experience of painting (or what Montaigne calls "the painting of poetry"), is equally Poussin's theme. This appears first of all in the narrowly iconographical sense, as may be seen by considering the *Mars and Venus* together with a second painting, entitled *Mercury and Venus*. The latter has been virtually destroyed, although fragments exist at Dulwich and in the Louvre (figs. 131 and 130).[25] The picture has not been discussed in relation to the *Mars and Venus*, partly because the mutilated state of the fragments makes it appear a smaller picture, and partly because its abraded condition produces an adventitious clumsiness in the figures that has prompted scholars to date it slightly earlier. However, the full composition is preserved in a drawing, also in the Louvre, which shows that the figures were originally placed in a large and spacious landscape that perfectly reciprocates the scheme of the *Mars and Venus*, of which the painting originally was a complementary reversal (fig. 132).[26]

What is more, Fabrizio Chiari also made an etching after this drawing, which he dated in 1636 and issued as a pendant to his etching after the drawing for the *Mars and Venus* that he dated in 1635 (fig. 133).[27] The reason for the pairing of the two etchings (the only ones Chiari ever made after Poussin) is furthermore obvious from the identity of Mars' pose in the one print with that of Venus in the other. The two gods are mirror reflections of one another, so that the feminizing of Mars in the *Mars and Venus*, his loss of power and the submersion of his sexual identity within the dominant female potency of Venus, is underscored by the literal identity of his attitude and character (down to the absent part) with that of Venus in the *Mercury and Venus*. And finally, the pairing of Poussin's two inventions is thematically stated. Whereas the *Mars and Venus* revolves

Eros.
Anteros.

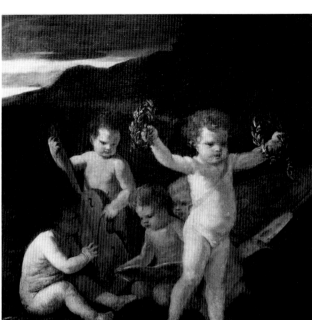

130. Nicolas Poussin, *Venus and Mercury* (fragment), Musée du Louvre, Paris

around the *concetto* of Venus' power to disarm the god of war, the *Mercury and Venus* takes as its subject the sequel to the story of Mars' conquest by love, and puts forward the solution to the problem set by his encounter with Venus. For the union of the two gods was not barren. It resulted in the birth of a child called Anteros: and Poussin's *Mercury and Venus* is centered on the well-known *concetto* of Anteros vanquishing sexual love, represented in the form of a swarthy, goat-legged *satyriscus*.[28] As the various instruments of the arts scattered at Mercury's feet testify, we here see desire redirected and triumphantly reemergent in that love which is embodied in art.

The principle embodied in Anteros is a familiar one, and one often represented in sixteenth- and seventeenth-century art, and since it has been fully explicated in several exemplary studies only a brief outline of it need be given here.[29] As Eros was the child of Venus and Vulcan, so Anteros was born of the union of Mars and Venus. Strictly speaking, Anteros means reciprocated love, and in antiquity a statue was erected in the gymnasium at Elis representing Eros wrestling with Anteros for the victor's palm. This configuration and its meaning, referring entirely to the domain of earthly passion, was well known in the Renaissance, and was famously employed by Annibale Carracci in the Farnese Gallery as the foundation for his *concetto* of the universal power of love. It was also adopted by his brother Agostino in an engraving (one of the so-called *lascivie*)

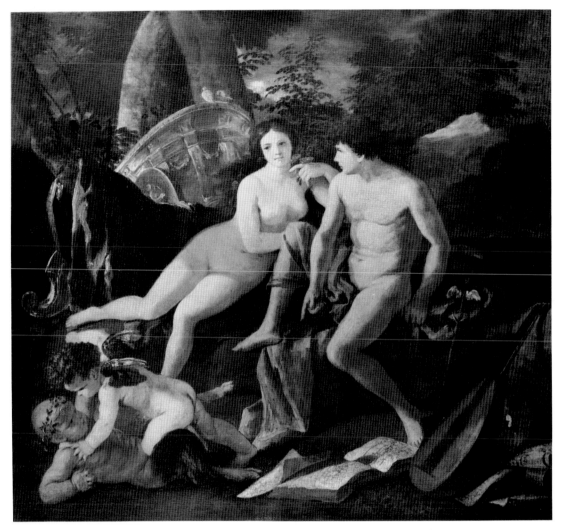

131. Nicolas Poussin, *Venus and Mercury* (fragment), Dulwich Picture Gallery, London

entitled *Reciproco Amore*.[30] Because victory in love, whether by the originator or the returner of it, is by definition self-defeating, the two infants are always shown as equals in the fight, with no clear winner indicated.

Eros

At the same time, however, a second interpretation also existed in the Renaissance whereby Anteros, by a false etymology with Anti-Eros, signified the opposite of purely terrestrial passion, and instead emblematized virtuous, or celestial, love embattled with, and conquering, profane *eros*. This meaning was given wide currency through two famous emblems published by Alciati, the one entitled *Anteros id est Amor virtutis* and the other *Anteros, Amor virtutis alium Cupidinis superans*.[31] It forms the governing *concetto*

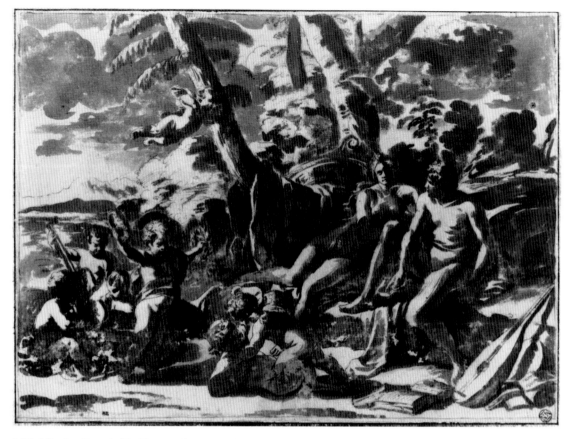

132. Nicolas Poussin(?), *Venus and Mercury,* drawing, Département des arts graphiques, Musée du Louvre, Paris

for many works of art, among them Annibale Carracci's *Amor virtutis* in Dresden, inventions by Agostino Carracci and Guido Reni, as well as Pietro da Cortona's segment of the Barberini Ceiling showing the triumph of Chastity over profane Venus.[32]

In all such cases, in the words of the commentary to Alciati, Anteros stands for a love that is honorable ("alter [Anteros] honestas cupiditates animis ingerit"), while Eros represents profane desire ("alter [Eros] affectus voluptuosos & terrestres inculcat"). Equally, in all such cases the virtuous Love is shown triumphing over his profane counterpart (*Amor virtutis alium Cupidinis superans*). Furthermore, as Verheyen has shown in his study of Correggio's *Education of Cupid* in London (fig. 134), the conceit represented by Anteros was elaborated by the humanists in a way that identified the *amor virtutis* he personifies specifically with the arts.[33] In this elaboration Anteros was made the pupil of Mercury, who ever since antiquity was known as the inventor of the alphabet, and hence rhetoric and all the arts. In Correggio's painting (as in Poussin's)

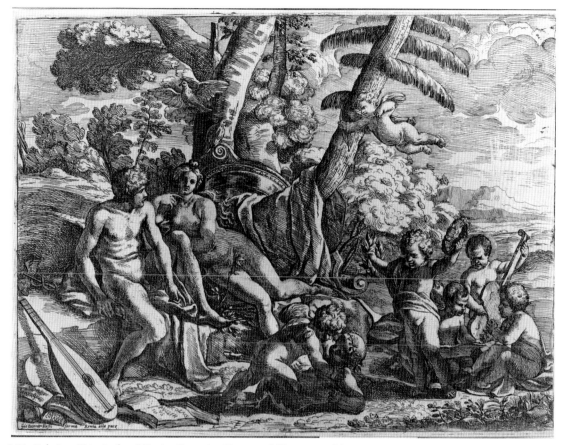

133. Fabrizio Chiari after Nicolas Poussin, *Venus and Mercury,* etching

Venus looks on while Mercury instructs the child, and in this way the idea is elegantly expressed that Virtue grows when attended by Beauty and commended by Eloquence.

In Poussin's *Mercury and Venus* the victory of Anteros over carnal passion is made explicit by the artist's *concetto* of substituting a *satyriscus* for the conventional but less explicitly vicious *eros*. The conquering and sublimation of fleshly desire by redirecting and recreating desire in art is made equally plain by the attributes of the arts (including the painter's palette) cast about on the ground. Put in more familiar terms, the pairing of the *Mercury and Venus* with the *Mars and Venus* expresses the well-known Neoplatonic opposition of Honorable to Profane Love, with the victory of Honorable Love conceived as a virtuous dedication to the arts.[34] For this reason, in the *Mercury and Venus* Mercury points firmly with his finger to the books with musical scores at his feet. In the *Mars and Venus*, by contrast, the war god points with his feebly raised right finger to Venus' torch on the ground at his feet, thereby elegantly translating Virgil's *accepit solitam flammam*. In this way the profane context of his situation is unmistakably opposed to

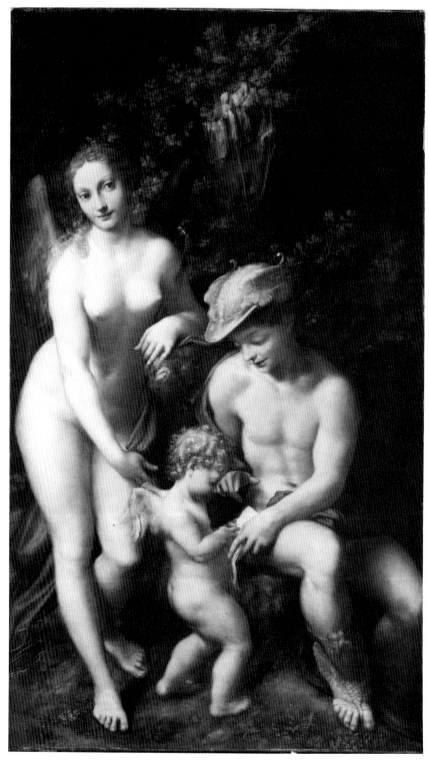

134. Antonio Correggio, *Education of Cupid,* National Gallery, London

the more elevated idea of love expressed in the *Mercury and Venus*.[35] And this is suffi-
cient to grasp the iconographic structure of Poussin's *concetto*, or what we might call the
public meaning of his poetic idea.

IT SHOULD BE CLEAR from what has already emerged that Poussin's conception for
the *Mars and Venus* was shaped not only by Lucretius' and Virgil's poetic descriptions of
the lovemaking of Venus, but also by Montaigne's meditations on the expressive con-
tent of precisely the same passages in relation to his own sexual life and his writing. *Sur
des vers de Virgile* contains Montaigne's most extended treatment of sex, and until sur-
prisingly recent times has scandalized many readers, who have also been puzzled to find
that the essay simultaneously contains some of his most considered and penetrating
reflections on the apparently quite unrelated subjects of language and style in litera-
ture. Barbara Bowen was the first to point out that there are important precedents for
the parallel juxtaposition of style and sex, the oldest and most enduringly influential of
which was Plato's *Phaedrus*.[36] She also made the fundamental observation that Mon-
taigne's essay is really a kind of anti-*Phaedrus* that, by claiming that it is perfectly
proper to write about sex, looks very much like a reply to Cicero's claim that it is
indecent to discuss the subject (*De officiis*, I. xxxv). Thus, Montaigne's disavowal of the
Neoplatonic love treatises that were so popular in the Renaissance, expressed in pas-
sages such as the following, must be regarded as more than a little disingenuous. And
indeed the authors he mentions (as well as the contents of his library) give ample
testimony of how widely he had read in that tradition:

> Learning treats of things too subtly, in a mode too artificial and different from the
> common and natural one. My page makes love and understands it. Read Leon
> Hebreo and Ficino to [Eros]: they talk about him, his thoughts and his actions,
> and yet he does not understand a thing in it. I do not recognize in Aristotle most
> of my ordinary actions; they have been covered and dressed up in another robe for
> the use of the school. God grant these men may be doing the right thing! I would
> naturalize art as much as they artify nature. Let us leave Bembo and Equicola
> alone.[37]

By the same token the explicitly Neoplatonic structure given the argument of
Poussin's *Mars and Venus* by pairing it with the *Mercury and Venus* is also less than
candid. The iconographical pretext for the imagery of the *Mercury and Venus*, and the
way in which it responds to that of the *Mars and Venus*, can indeed be understood by
turning to Alciati's emblems and their commentaries explaining Eros and Anteros with
reference to Plato's *Symposium* and such Italian authors on the philosophy of love as
Agostino Nifo, Celio Calcagnini, and Mario Equicola. But this no more arrives at the
heart of Poussin's theme than does the merely descriptive parallel that exists between
the poses of the gods in the *Mars and Venus* and their description in Lucretius' poetry.

His theme is expressive potency, making of the painting itself, like the passage from the *De rerum natura* that is its point of departure, an instance of *enargeia*—the rhetoric of actual presence (hypotyposis)—arousing in the spectator a fusion of sensations that derive from a mingling of aesthetic, or what Terence Cave has called contextural stylistic and fictive structure, with actual response to the subject represented and its significance or meaning.[38]

Poussin had certainly thought about and understood Montaigne's remarks about *enargeia* and the potency of language (as he was to appreciate Mascardi's in *Dell'arte historica*), and its powers to recreate in the reader the particular psychological responses and conditions (or what Poussin called *dispositions*) it describes. "Virgil," he wrote to Chantelou in the later letter on the Greek modes, "accommodates the actual sound of the verses with such skill that *with the sound of his words he seems to set before our eyes* the things he is describing [italics added]"; and, he continues, "so when he is speaking of love, he has cleverly chosen words that are sweet, pleasing, and highly gracious to the ear, [while] when he sings of a feat of arms or describes a naval battle or accident at sea, he has chosen words that are hard, sharp, and unpleasing, so that on pronouncing them they arouse fear."[39] The nature of the subject—whether lovemaking or warfare—requires variations in diction, or poetic coloring, in order to establish a particular psychological disposition, or state of mind—whether the actual effects of desire or of terror—in the reader: "Voyés vous pas bien que c'est la nature du subiec qui est cause de cet effet, et vostre disposition."[40] With regard to the elocution latent not only in the energies of words but also in the tonalities and colors of music and painting, Poussin goes on to write of "those fine old Greeks, who invented everything that is beautiful, [who] found several Modes by which they produced these marvelous effects."[41]

It is not our intent here to try to resolve the vexed question of the particular pictorial means by which Poussin sought to establish modality in painting, but rather to indicate that his conception of mode was keyed to the broader powers of *enargeia*, disposing the beholder to respond to the work of art as he or she would respond to the actual events depicted. Timotheos had been able to move Alexander alternately to tears and to laughter by a change of mode, and in the letter to Chantelou Poussin characterizes various effects produced by the deployment of different modes, whether of sadness, or that fierce frenzy that seizes Bacchantes in the grip of the god or soldiers marching into battle (producible in each case, one might imagine, by the wild skirling of bagpipes).[42]

When Poussin wrote of the actual fear that could be inspired by the harsh diction of Virgil's description of a calamity at sea he was paying the same tribute to the poet's *enargeia* that Vasari accorded to Leonardo da Vinci's *Medusa* when he wrote of the actual terror the painting evoked in a contemporary viewer, who believed himself to be looking upon a real severed head when he looked into a dimly lit room in which Leonardo had artfully positioned the picture.[43] Poussin's first Italian friend and patron, the poet Marino, in turn made of Medusa the very emblem of the seicento aesthetic of the

Marvelous, commingling irresistable sensual beauty with sensations of real horror, an aesthetic he especially elaborated, as we shall see, in the *Strage degli Innocenti*. The same tribute to *enargeia* is paid when it is written of a painting of a dreadful battle or tortured martyrdom that it has the power to provoke actual fear in the beholder.[44] Actual fear may be inspired by the poet when describing at length the agonies of slaughter, the shrieks and moans of the victims, the horrible wounds inflicted, and the terrifying clash of arms, all intensified by the energies of a harsh and turbulent diction that seems to present to the overpowered senses actual sensations of the event itself. When Lessing wrote of the statue of *Laocoon* (as we have already indicated, in Renaissance aesthetics the *exemplum doloris par excellence*) that it had the capacity to arouse responses of horror and pain in the viewer (hypotyposis), he went on to praise the ancient sculptor for a restraint that permitted the beholder also to respond to the heroic struggle of the Trojan priest; and he warned against the exaggerated energies (hyperbole) of a statue that might faithfully reproduce the visible effects of a man actually being crushed to death.[45] Such a work could only produce sensations of nausea and disgust in the viewer.

Lessing's point is easily exemplified by contrasting the sublime and heroic resistance to torture represented in Rubens' painting of *Prometheus Bound* in Philadelphia (Euanthes' ancient painting of Prometheus being also a famous *exemplum doloris*) to Salvator Rosa's extraordinary, and disgusting, painting of the same subject in the Corsini Gallery in Rome (figs. 135 and 136).[46] Because both Rubens and Rosa adopt for their subjects a familiar classical *topos* for representing the particular passion of *dolor*, or pain, they also both explicitly thematize poetic *enargeia* in their respective paintings. So too (in the hyperbolic sense of Rosa's version) does Marino in the *Strage degli Innocenti*, to be discussed in the next chapter, as well as Luca Giordano in his horrific painting of *Ulysses Slaughtering Phineas and the Suitors of Penelope* in the National Gallery in London (fig. 137). The operatic light and coloring of the latter, combined with morbid details depicting not only the violently spurting blood of the victims but also gore, mucous, and pools of vomit (in the spirit of the ghastly descriptions in Marino's *Strage*), may be compared to the more restrained, and hence heroic and ennobling energies of Annibale Carracci's fresco of the same theme in the Palazzo Farnese (fig. 138). To judge from the many recorded responses to Poussin's own *Martyrdom of St. Erasmus* (fig. 139), this painting skirts a very fine line between producing the actual effects of terror that inspire pity and admiration on the one hand, or those hyperbolic effects that merely inspire disgust and revulsion on the other.[47]

Yet it is with sexual themes, and not just themes of extreme violence (which make up the chief argument of Lessing's *Laokoon*), that the tension between aesthetic and actual response is most sharply drawn. As Montaigne had written of Lucretius and Virgil, "the powers and worth of this god [Eros] are more alive and animated in the painting of poetry than in their own reality"; and "Venus is not so beautiful, *all naked, alive and panting*, as she is here in Virgil" (italics added).[48] The forthrightly sexual

135. Peter Paul Rubens,
Prometheus, Philadelphia Museum
of Art, Philadelphia

expressive content of Poussin's *Mars and Venus* cannot be better invoked than by quoting Montaigne's praise for Lucretius' "noble *circumfusa*, mother of the pretty *infusus*."[49] The two terms in combination with one another beautifully characterize the interaction of the two gods. At the same time they explain why Poussin did not follow the letter of the poet's description of Mars in the lap of Venus. Moreover, as Cave has gone on to observe, the vocabulary employed by Montaigne when writing about Lucretius' poetry is itself explicitly sexual in nature: "According to a sustained metaphor of rhetorical potency, the Lucretian text is as well filled as Gargantua's *braguette*: the swelling or inflation attributed to imagination is authentic."[50] Thus:

> These good people needed no sharp and subtle play on words; their language is all full and copious with a natural and constant vigour . . . *Contextus totus virilis est; non sunt circa flosculos occupati* [Seneca: "The whole contexture is manly; they are not concerned with pretty little flowers"]. This is not a soft and merely inoffensive eloquence; it is sinewy [*nerveux*, translated by Cotgrave as "strong, stiffe"] and solid, and does not so much please as fill and ravish; and it ravishes the strongest minds most. When I see these brave forms of expression, so alive, so profound, I do not say "This is well said," I say "This is well thought." It is the sprightly vigour of the imagination that elevates and swells the words.[51]

136. Salvator Rosa, *Prometheus,*
Galleria Corsini, Rome

The parallel between the language of sexuality and that of style in Montaigne's essay has often been remarked upon—in making works of art, for example, the artist is "both father and mother of his child," his language is "virile," and "copiously full," and "ravishes" the mind of his reader. "My page makes love and understands it," he wrote in a passage already quoted, and in an earlier essay he makes the astonishing claim (long before Freud noticed that writing entailed "making a liquid flow out of a tube on to a piece of white paper") that his penis is an author ("this member, author of the sole immortal works of mortals").[52] Although the penis is the author of children, Montaigne immediately extends the metaphor by claiming that the production of books is more commendable than the production of children, being "produced by a more noble part of the body," and elsewhere he concludes that "I do not know whether I would not like better to have produced one perfectly formed child by intercourse with the Muses than by intercourse with my wife."[53]

We have here it seems the answer to what has happened to Mars' conspicuously absent member in Poussin's *Mars and Venus*, an answer that the artist in fact made inescapably explicit in the pairing of it with the *Mercury and Venus*. For the latter openly asserts the superior potency of the painter's brush to the suppressed instrument of sex by recourse to the *sententia* expressed in the conceit of Anteros vanquishing the

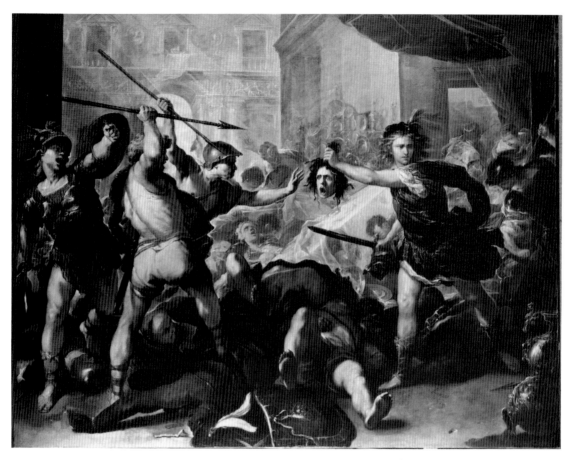

137. Luca Giordano, *Ulysses Slaughtering Phineas and the Suitors of Penelope,* National Gallery, London

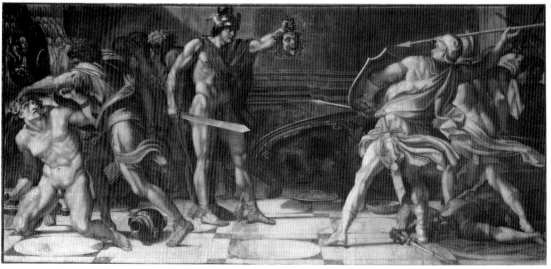

138. Annibale Carracci, *Ulysses Slaughtering Phineas and the Suitors of Penelope,* the Farnese Gallery, Palazzo Farnese, Rome

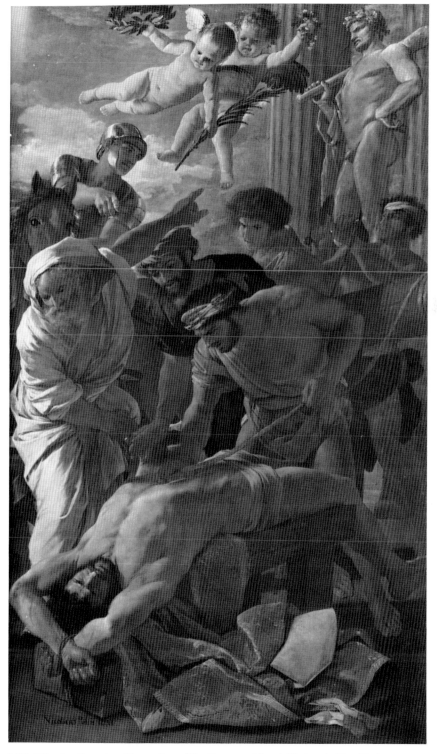

139. Nicolas Poussin, *Martyrdom of St. Erasmus*, Musei Vaticani, The Vatican

sensual *satyriscus*, while, in contrast to Mars' drooping finger indicating Venus' torch—*accepit solitam flammam*—Mercury points vigorously to the instruments of the arts. As Montaigne wrote of what he more than once called "the painting of poetry," such painting as this represents an indefinable mood more amorous than love itself ("quel air plus amoureux que l'amour mesme").[54] Sexual and aesthetic arousal, desire and its expression, subject and effect, have become so intertwined that it is no longer possible nor even necessary to attempt a separation. Poussin paints Lucretius, and Montaigne quotes him (in Cave's words), "not because he provides a convenient illustration of the sexual theme, but because his verses embody textual mastery: the scene they describe becomes the emblem of their own energies."[55]

The suggestion that Poussin might have been motivated by the psychological role of the phallus/paintbrush in the creation of the *Mars and Venus* and its pair, the *Mercury and Venus*, either on the subconscious level, or on the conscious—stimulated by an active meditation on the poetic and expressive content of Virgil and Lucretius as mediated by Montaigne—may seem disconcerting at first. However, the linguistic association of the brush (*pennello*) with the male member is at least as old as Cicero (*Ad familiares*, IX. xxii. 2: "*Caudam* antiqui *penem* vocabant: ex quo est propter similitudinem *penicillus*. At hodie *penis* est in obscenis"). The analogy was not lost on that old pornographer Pietro Aretino in his *Ragionamento della Nanna e della Antonia* of 1534, in which he describes the act of love: "che posta il suo pennello nello scudellino del colore, umiliatolo prima con lo sputo, lo facea torcere nella guisa che si torceno le donne per le doglie del parto o per il mal della madre."[56] Poussin was no pornographer, however, and on a more serious level he worked, like his first Italian supporter Marino, within an inherited Petrarchan aesthetic tradition which, as we have seen in the preceding chapter, is partly defined by a poetics of desire. In this tradition, which conceived expression and response in terms of an idea vested in the poet's particular beloved, the parallel drawn between artistic creation and the act of love is scarcely an unfamiliar one. As we have already noted, creative desire, for which the ancient tale of Apelles and Campaspe and the modern achievement of Raphael's *Fornarina* may stand as the emblems, is vested with an intensity of emotion that fuses art and nature.

Such intensity is underscored by the habitual appeals in Renaissance accounts to the familiar ancient *topoi* of Pygmalion and Praxiteles' statue of Venus, so lifelike in its allure that Pliny tells the story of the youth "who left his stain upon it."[57] Interconfusion of the effects of art and nature in the response of the beholder (the very definition of *enargeia*) is also the theme of a poem by the painter Agnolo Bronzino, which explicitly and scurrilously takes the phallus/paintbrush as its theme, no doubt on the model of Aretino, but which ends on an unexpectedly serious note making this very point:

> Io vidi a questi giorni un buon ritratto
> d'un uomo e d'una donna: erano ignudi,
> dipinti insieme in un piacevol atto.
>
>

Io non saprei contarne de' mille uno
de' diversi atti e modi stravaganti;
sapete che il variar piace ad ognuno.
 Basta, che a fargli o dirietro o davanti,
a traverso, in iscorcio o in prospettiva
s'adopera il pennello a tutti quanti.
 E non è fra' cristiani arte più viva
di quella in che si mescola il pennello,
ovunque l'arte alla natura arriva.[58]

(I lately saw a good portrayal of a man and a woman: they were naked, painted together in a pleasurable act. . . . I wouldn't know how to choose one from the thousand such diverse acts and extravagant postures; you know that variety is pleasing to everyone. It is enough, that in making them either from the rear or the front, transversely, in foreshortening or in perspective, the brush adapts itself to any position. Among Christians there is no art more alive than that in which the brush is mingled, and in this way art attains equality with nature.)

Poussin painted in the *Mars and Venus* a number of clearly phallic implements that in terms of the argument we have been developing require some comment—the two quivers and the arrows which are sharpened by the foreground *erotes*, for example, or the arrow held by another *eros* which seems about to be plunged into Venus' back, or yet again the sword and the flaming torches of Venus and Mars tossed carelessly onto the ground. In the same vein, Mars' feebly raised finger pointed at Venus's torch (the only indication given of any rapidly ebbing strength remaining in him), especially in its juxtaposition to his absent member, as well as its opposition to Mercury's more energetically gesturing finger in the *Venus and Mercury* (also strategically placed, this time between the god's spread legs), specifically invites phallic metaphorizing.

This is especially true insofar, as we have noted, as all these elements are *already* iconographically and literarily determined as sexual metaphors. The double-edged paradox of the weapons of death and life we have seen to be one of the most familiar cliches of ancient literature. (Thus, Ovid tells the familiar tale in the *Metamorphoses* [I. 456ff.] of the inception of Apollo's passionate love for Daphne, and of how the god, exulting over his killing of the Python with his arrows, taunts Cupid: "What have you, wanton boy, to do with serious weapons? You contentedly do—I don't know what— with *that* [your torch] to ignite lovers' fires—don't lay claim to my honors!" Cupid merely shoots him, retorting: "Your shaft may strike all, Phoebus, but mine strikes *you*.")[59] Mars' finger pointing at Venus' torch, as we have also seen, is again explicitly phallic, and directly motivated by Poussin's meditation upon the description by Virgil of the flame of passion suddenly rising in Vulcan's loins. The weapons removed by the loves from the impotent *Mavors armipotens* also carry explicitly phallic meaning, as keyed by the *concetto* of the two *erotes* who hone Mars' arrows for the games of love.

Poussin's theme, cued by Montaigne, is the displacement of desire and its recreation in art. In portraying the active lovemaking of Mars and Venus the painter and his brush are also implicated as participants in that act (which is repeated and reciprocated by the virtual identity of the male Mars with the female Venus in the *Mercury and Venus*), both in the sense of active creating and that of passive beholding and response. Poussin's relationship to his subject in fact remarkably reproduces a phenomenon (though in a different context and with different variables) which has recently been discussed by Michael Fried under the rubric "Courbet's 'Femininity,'" in which he explored the thematics of the phallus/paintbrush in Courbet's art:

> Recent feminist writing about the gender coding of visual images in the Western tradition, much of it centered on film and almost all of it informed by psychoanalysis, has stressed the extent to which the representation of women has been governed by a series of systematic oppositions: between man as the *bearer* and woman as the *object* of the look or gaze; between *having* the image (at a commanding distance from it, so to speak) and *being* the image (or at least lacking such distance); between *activity*, including the activity of looking, and *passivity*, as exemplified in merely being seen; and, perhaps most important, between man as *possessing* and woman as *lacking* (or, in Lacanian terms, *being*) the phallus. In all these pairings, and they are by no means exhaustive, the first term historically has been privileged, the second subordinate.[60]

Fried goes on to suggest that such oppositions might carry more critical depth if conceived in complex and appropriately textured interaction, rather than as absolute polarities, and that with respect to Courbet's paintings of women, notwithstanding the artist's unabashedly "masculist" conception of their appeal, masculine and feminine attributes and points of view may be seen to mingle disconcertingly. Such interactions he discerns in Courbet's simultaneous casting of himself as painter (active) and beholder (passive), as distant from the image and at the same time being himself the image, at least in part, as the representer and possessor of his subject but also as self-represented and possessed by it, all in the very act of painting. Moreover, even regarding the psychological role of the phallus/paintbrush (expressive desire, or representation), this too Fried has suggested is not so unambiguous in its meaning as might be supposed. It is also, at least in the case of Courbet, capable of being feminized, becoming part of a more embracing metaphorics of gender which "resituates sexual difference 'within' the painter-beholder rather than between him and the object of his representations."[61]

In the case of Poussin, precisely such metaphoric complexity and ambiguity of gender representation and response is openly stated by the fact that in the *Mars and Venus* it is not Venus, but the male figure of Mars who is presented to the active gaze of the beholder (and painter) as the passive object of desire, as the object of the possessing look. Mars is, at the same time, sexually ambivalent, literally neutered, open and yielding in the act of lovemaking. He is distinctly non-phallic, and he *is possessed by*

Venus (who *is* the phallus, in the Lacanian terms invoked by Fried). Moreover, his identity with Venus as the passive object of desire is explicitly underscored by the fact that he is shown in the persona of Venus, who appears as his mirrored twin in the *Mercury and Venus*.

Venus is by definition the embodiment of love and that perfect beauty (*venustas*) which wills love, whether, as Montaigne argued, this be expressed on the one hand through the active desire to create children, or on the other hand through the active desire to create art. By recasting Mars in Venus' role Poussin posited the same ambiguity of gendering within himself, as the representer of his theme and as self-represented in it, as subject and object, that we also saw him exploring in the *Self-Portrait* for Chantelou, painted in a later time and in a different moment, when ideas about talking about the image were more developed, and when Titian and Petrarch were no longer his models. There the extended personification of *Pittura* is cast in a doubled and reflexive role, as *Amicizia*, and as *L'Amore di essa Pittura*. She is both the perfected idea of painting that is expressed in the female "Poussin" desired and embraced by Chantelou, of which the *Self-Portrait* itself is only a contingent expression. And she is also the perfected understanding of art which Poussin in turn desires in Chantelou, and to which he in turn offers his love and masculine embrace.

In painting Mars, on the other hand, Poussin painted his own sublimated desires, and, following Montaigne in *Sur des vers de Virgile*, he did so knowingly, thematizing desire and expressive *enargeia*, making of them the true subject of his painting and recreating them in art. In painting Mars as woman (and as Venus) he adopted the position both of maker and beholder, as both the author of the image and as himself being the image, as bearer and as object of the gaze, as possessing the phallus and lacking it, as the representer and as himself self-represented. As Fried wrote of Courbet, sexual difference is resituated in Poussin's *Mars and Venus* within a single painter-beholder rather than between him and the objects he represents. Montaigne put it another way: in the calamity of disease and diminished desire, the powers of *eros* are more animated in the painting of poetry than ever they were in life. Venus is not so beautiful all naked, alive, and panting, as she is when sublimated and recreated in art.

METAPHORS of sexuality also appear in Poussin's references to his own painting. "Le petit St. Paul veut enquore deux jours de caresses,"[62] as we have seen him writing to Chantelou some fifteen years after painting the *Mars and Venus*, and in the *Self-Portrait* he conceived as the emblem for Painting the figure of a woman—the painter's own poetic *donna*, or Muse—being drawn into the naked embrace of a male suitor.[63] The personification of Poetry or Painting as the artist's mistress is of course deeply embedded in tradition (as in Petrarch's Laura or Raphael's *Fornarina*), and so too is the sublimation of erotic and sexual passion within the guise of ancient fable.[64] Montaigne, for all that he claims unreserved and uninhibited self-portrayal, himself keeps his most

explicit sexual references hidden in the fictions of similar ancient stories and quotations in Latin, and the very title of *Sur des vers de Virgile* masks its contents under the veil of an apparent textual commentary. This is partly done (as Cave again has pointed out) in order to make a point about the fullness and force of the Latin language, in comparison to which his native French seemed flaccid and impotent. It is also done as a way of assimilating the fragmented and recombined segments of ancient culture within the present and one's own experience, as a therapeutic for impotence in language and for the individual case-history of one's own illnesses, aging, and decline.[65]

The self-reflexiveness of Montaigne's essays, that they make up an extended project of self-portraiture, ending only with the cessation of life itself, has always been recognized as the great unifying theme of the *Essais*.[66] "Don't I represent myself to the life?" he writes in *Sur des vers de Virgile*, "Enough then, I have done what I wanted. Everyone recognizes me in my book, and my book in me."[67] The same introspectiveness also informs the content and expression of Poussin's paintings, which thereby come cumulatively to represent the momentary and time-bound traces of a particular sensibility, self-representations that develop and are altered across the span of a single lifetime.

Walter Friedlaender's acute observation that Poussin is one of the very few artists in whose works it is possible to trace the slow development of a sustained meditation on the great themes of life is especially telling here.[68] We have tried to give greater precision to this observation by exploring in two case-histories the conceptual relationship Poussin's paintings bear to the unending, sequentially developing reflections of the *Essais*, each of which is an unfinished fragment contributing to a life-long, and in its nature also incomplete, project of self-representation—to quote again Montaigne's words, "I aim here only at revealing myself, who will perhaps be different tomorrow if I learn something new which changes me."

Even before Friedlaender Panofsky recognized, in his noble essay on the *Arcadian Shepherds* (pl. VIII), the deeply poetic introspection of all Poussin's mythological paintings, each of them infused with an unmistakable elegiac sentiment that derives from a bittersweet reflection on the enduring theme of youthful love, the painful certainty of its transience and loss, and its enduring sweetness in the memory.[69] The tomb in Arcadia, as we shall see in the final chapter, is the monument to that love, a love that is revived and re-embodied in the painting of it with a heightened desire, a sharper poignancy than ever it possessed in actuality.

As we saw in the first chapter, when Poussin was a young man in Rome, in the decade that ended with the painting of the *Mars and Venus*, he devoted himself to intensive study and critical analysis of the ancient statues in the great collections and sculpture gardens of the city. His constant companion in these studies was the Flemish sculptor François Duquesnoy, and together they defined a new concept of stylistic *expression* in art, based upon "Greek" models which they distinguished from the inferior productions of the Romans. Central to their notion of Greek style was a concept of

surface and contour which carried in themselves an expressive content productive of involuntary psychological responses akin to those ideally producible by linguistic qualities of diction and elocution. In this concept lay the foundation for a French idea of *expression*, which was psychologically founded and distinguishable from the earlier Italian doctrine of the *affetti*, which are merely descriptive, or theatrical imitations of the passions.[70] *Expression* predisposes and conditions the beholder's responses to a story, even before this is recognized, while the latter embellishes a narration that is already known. Through such means, in Poussin's terminology, the *disposition* of the beholder might be conditioned and altered in the very act of contemplating the work of art.

If for Montaigne the touchstone for vigor and potency of expression was to be found in the Latin language, for Poussin and Duquesnoy it was in the perfected forms of Greek statuary, and on this basis they began to form a new and expanded canon of exemplars for the perfected states of differing human conditions: blossoming youth in the Belvedere *Antinous*, as we have seen, or desiccated old age in the Borghese (Pseudo-) *Seneca*.[71] Such physical states in the fullness of their varying perfections literally embodied different expressive qualities capable of affecting the beholder's disposition (in both an aesthetic and moral sense) through the physical presentation, or actual manifestation of absolute qualities of tenderness, delicacy, youthful or maternal beauty, mature or waning virility, and weakness and decline.

We may here end where we began, with Poussin's *Mars and Venus*, wherein Venus is conceived with the perfected contours and proportions of the Medici *Venus*, the canon for mature womanly beauty. Mars, on the other hand, is not presented as her equally mature counterpart, but is instead conceived on the more youthful (and hence more vulnerable) proportions of the Belvedere *Antinous*, a statue the proportions of which Poussin had carefully measured and which Orfeo Boselli named the canon for beautiful youth. Venus' dominance, *circumfusa super*, is accordingly communicated automatically to the response of the spectator (determining his *disposition*) by the very fact of her greater maturity, which is indeed reinforced by the ravishing, buddingly youthful nymph who looks on from the right. Mars, *aeterno devictus vulnere amoris*, falls back into her lap, *infusus*, as the young son received into the body of the mother, his pose irresistably evocative of Niobe's dying son, or some mortally wounded Gaul, expressing a pathos akin to that he had achieved in the *Death of Germanicus* for Cardinal Barberini, in which the youthful hero sinks inexorably down into the embrace of death. Through such means did Poussin find his own eloquence, an "air plus amoureux que l'amour mesme," the antidote to disease and to the inexorable assaults of time.

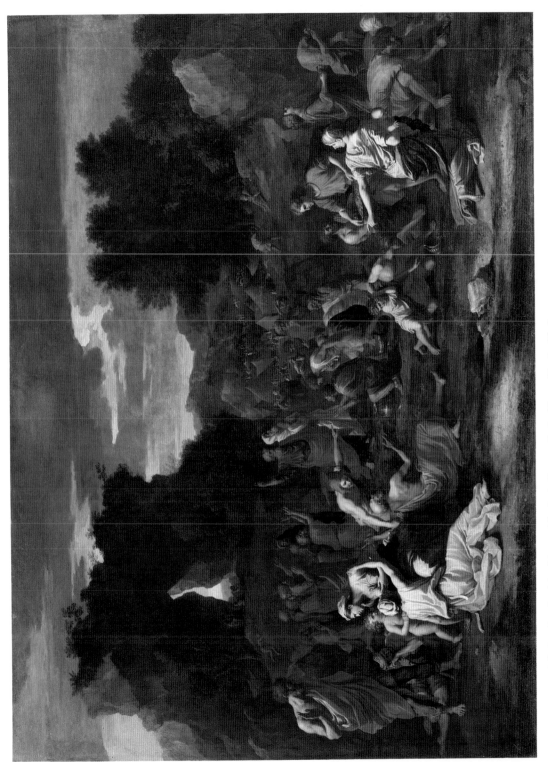

I. Nicolas Poussin, *The Israelites Receiving Manna*, Musée du Louvre, Paris. Photo: Musées Nationaux.

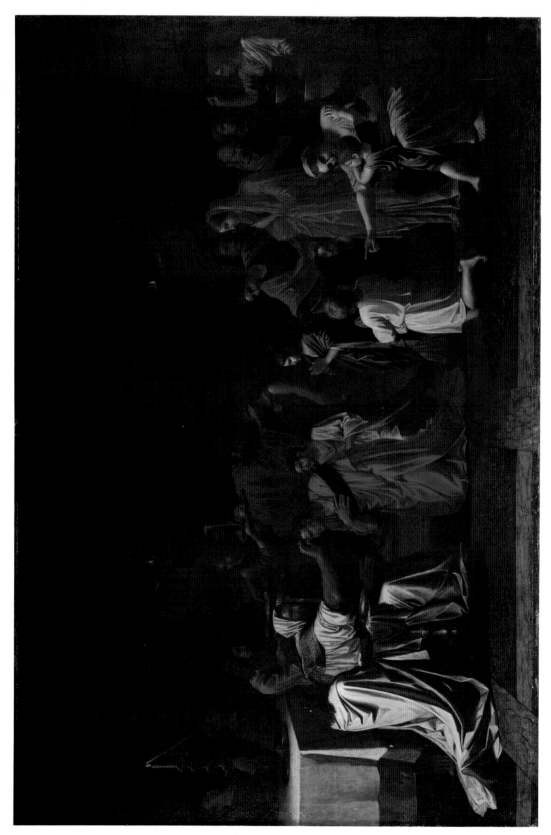

II. Nicolas Poussin, *The Sacrament of Confirmation*, Collection Duke of Sutherland, on loan to The National Gallery of Scotland, Edinburgh. Photo: Antonia Reeve.

III. Nicolas Poussin, *The Sacrament of the Eucharist*, The Duke of Rutland, Belvoir Castle.

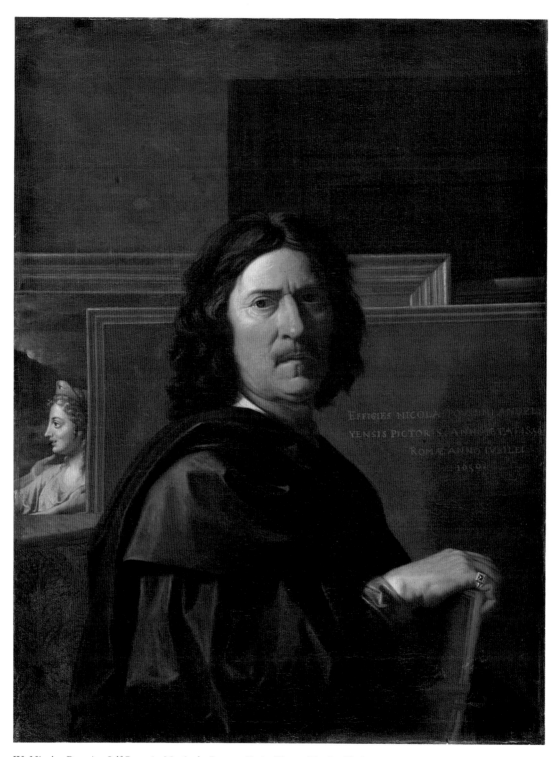

IV. Nicolas Poussin, *Self-Portrait,* Musée du Louvre, Paris. Photo: Musées Nationaux.

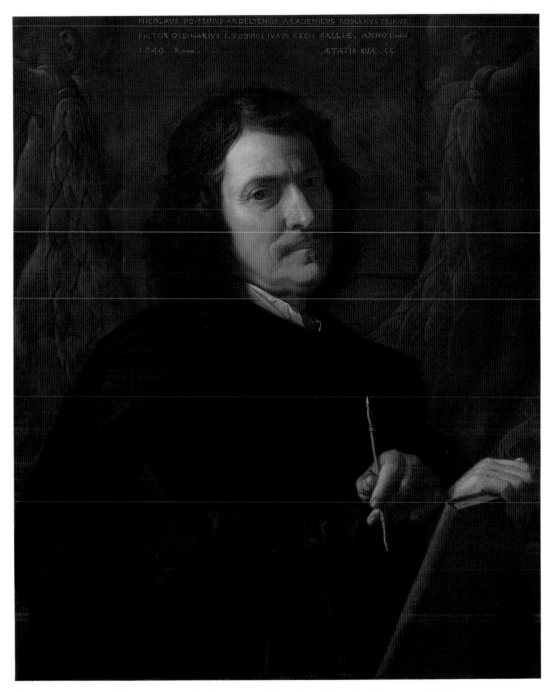

V. Nicolas Poussin, *Self-Portrait*, Staatliche Museen zu Berlin, Gemäldegalerie. Photo: Jörg P. Anders.

VI. Nicolas Poussin, *Rebecca and Eliezer at the Well*, Musée du Louvre, Paris. Photo: Musées Nationaux.

VII. Nicolas Poussin, *The Healing of the Blind Men at Capernaum*, Musée du Louvre, Paris. Photo: Musées Nationaux.

VIII. Nicolas Poussin, *The Arcadian Shepherds*, Musée du Louvre, Paris. Photo: Musées Nationaux.

IX. Nicolas Poussin, *Mars and Venus*, Boston Museum of Fine Arts, Boston. Photo: Boston Museum of Fine Arts.

X. Nicolas Poussin, *The Consignment of Bacchus to Dirce and the Nymphs*, The Fogg Museum of Art, Cambridge, Massachusetts, Gift of Mrs. Samuel Sachs in Memory of Her Husband, Mr. Samuel Sachs. Photo: The Harvard University Art Museums.

XI. Nicolas Poussin, *Apollo and Daphne*, Musée du Louvre, Paris. Photo: Musées Nationaux.

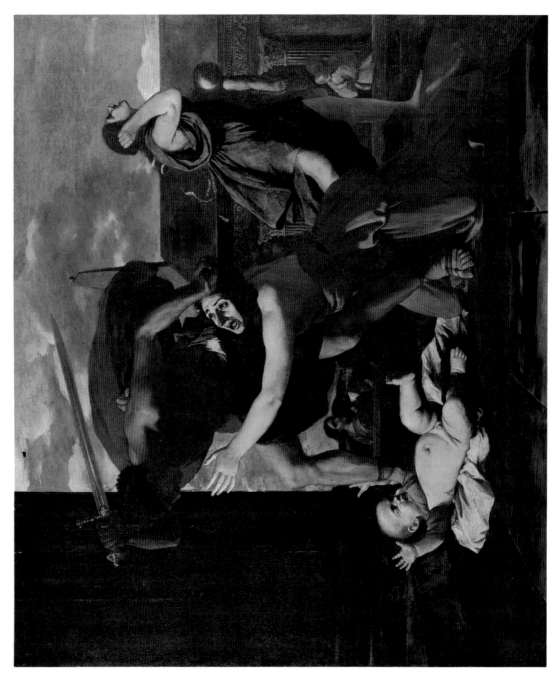

XII. Nicolas Poussin, *The Massacre of the Innocents*, Musée Condé, Chantilly. Photo: Giraudon/Art Resource, New York.

IV

THE POETS

CHAPTER SEVEN

MARINO'S *LA STRAGE DEGLI INNOCENTI*, POUSSIN, RUBENS, AND GUIDO RENI

IN THE FIRST EDITION of the catalogue of the Poussin exhibition of 1960 Charles Sterling argued that the date of Poussin's *Massacre of the Innocents*, now in the Musée Condé in Chantilly (pl. XII), could be deduced from a combination of textual sources and stylistic analysis. The painting had to have been made at some moment between 1631 and 1637, the former date (in fact a typographical error for 1632) marking the publication of Giovanni Battista Marino's *La Strage degli Innocenti*, and the latter the date of the death of Vincenzo Giustiniani, when an inventory was drawn up in which the canvas is listed.[1] That Marino's poem was the source of Poussin's imagery had been claimed many years before in 1914 by Otto Grautoff, but the case had been made even more strongly by Andrea Moschetti in 1922. Moschetti believed that the central image of a mother struggling to defend her child from a soldier who tramples the baby underfoot had no precedent in painting. This could, therefore, only have derived from Poussin's knowledge of *La Strage*.[2] Sterling concluded that for stylistic reasons the painting must have been completed very early within the *termini* of 1631 and 1637, that is in 1632.

Inevitably this conclusion was disputed. The most bitterly fought arguments in modern Poussin scholarship have been over chronology, and the dating of the Chantilly *Massacre of the Innocents* is no exception. Most recently, for example, Konrad Oberhuber, arguing on anthroposophical grounds, has proposed to see in the *Massacre* the culmination of Poussin's first "seven-year cycle" in Rome, and the remote harbinger of the emotional intensity and classical restraint of the *Judgment of Solomon*, dated to 1649.[3] The impasse scholarship has reached over the relative chronology of this work—and of the presumably earlier painting of the same subject attributed to Poussin, formerly in the Altieri collection and now in the Petit Palais in Paris—epitomizes the results of the sort of formal determinism that has tended to prevail in discussion of individual works by Poussin. Too often dogmatic claims have been made which are based upon myopically focused forms of argumentation that are often engaged in without reference

to any wider historical context (with Oberhuber's work entailing even mystical and astrologically determined elements).

As a counterfoil, we suggest that the dating and appearance of the Chantilly *Massacre* may be reinterpreted in light of the evidence that the painting was one of a series of four overdoors painted by Poussin and three other foreign artists in the Palazzo Giustiniani in Rome. The series was almost certainly painted between 1632 and 1635.[4] It was comprised of four scenes of death brought about by despotic or governmental tyranny: Poussin's *Massacre of the Innocents*; the *Death of Seneca* by Joachim von Sandrart, dated 1635 (fig. 140); the *Death of Cicero* by François Perrier (fig. 141); and the *Death of Socrates* by a certain "Giusto Fiammingo" (fig. 142).[5] The thematic relationship among the four is original, but nonetheless clear. All four stories concern the virtuous death of innocents. Within the set of four there are also distinct pairings. The two suicides, setting a Stoic tone, take place in darkened interiors. In each the hero, flanked by a frieze of mourners, is turned out impassively towards the spectator. Cicero's death was also Stoical, for after attempting to escape from Octavian's vengeance he returned to Rome to await death in his villa (the Giustiniani inventory accurately

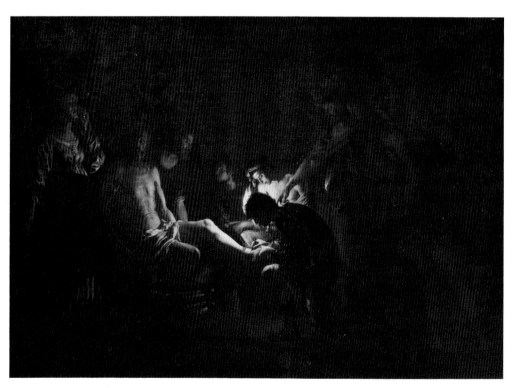

140. Joachim von Sandrart, *Death of Seneca,* destroyed, formerly in the Kaiser Friedrich Museum in Berlin, Städtische Kunstsammlung, Augsburg

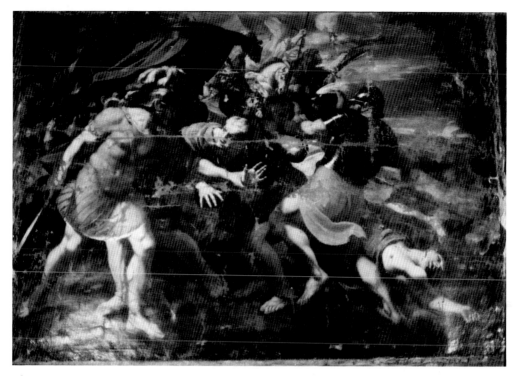

141. François Perrier, *Death of Cicero*, Staatliche Schlösser und Gärten, Bad Homburg

describes the event as taking place in a landscape). Perrier's work, a dramatically move-mented scene of murder taking place outdoors, a pyramid in the distance, would have complemented Poussin's violent *Massacre*, with its backdrop of obelisk and temple, beside which the great basin of the Nile in the land that protected the Holy Family may be glimpsed. But Poussin's image also stands as commentary upon its companions: although the Innocents were, like Socrates, Cicero, and Seneca, the victims of pagan tyranny, they were the first to die for Christ, and their deaths were a sign of the end of the power of that tyranny. The four inventions are also linked, even beyond their thematic consistency, by a common acknowledgment of the ancient rhetorical conven-tions for describing war and violent death that, as we shall see, had long provided a traditional stockpile of embellishments for narratives of the story of the Massacre of the Innocents in Christian literature and art.

That all four works were described specifically as overdoors in 1638, and that they share similar, large dimensions, argues in favor of the hypothesis that they were con-ceived as a group, even though all four may not have been completed simultaneously. Several unusual qualities of Poussin's *Massacre* change in significance if this is acknowl-edged. The masterful perspective construction of the shallow architectural stage, and

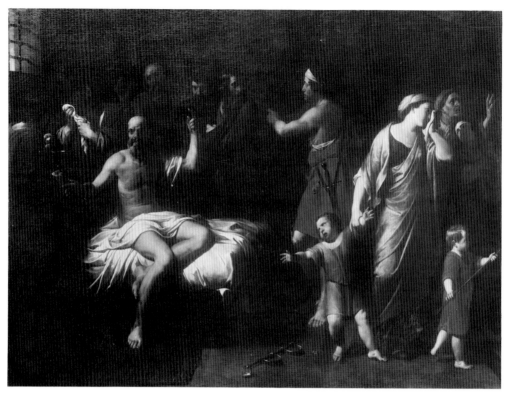

142. "Giusto Fiammingo," *Death of Socrates,* destroyed, formerly Kaiser Friedrich Museum, Berlin

the manner in which (as Oberhuber recognized) the low viewpoint leads us into the painting at the level of the floor in order to focus on the baby lying on the ground, take on a different aspect if we accept that Poussin conceived the painting as a *sopraporta*, designed to be seen from below.[6] The similarly pyramidal arrangement of foreshortened figures in Perrier's canvas appears to complement Poussin's in this respect (though without the severe linear perspective provided by architecture), arguing in favor of both artists' certain knowledge of the destination intended for their works. The size of Poussin's canvas, the large scale of its figures, their reduced number, and the summary handling of paint are all explicable and dateable only with difficulty according to traditional formal analysis.[7] They are, however, all consistent with the requirements of the particular setting of the picture in Palazzo Giustiniani. Circumstantial, contextual evidence, then, makes it likely that Poussin's *Massacre of the Innocents* was completed after 1632, when Joachim von Sandrart became a member of the Giustiniani household.[8] Such a new *terminus post* would help to account for Poussin's mastery not only of perspective, but also of the painting of architecture and the historical understanding of it that he gained from reading Serlio and Palladio.

Because the imagery of Poussin's painting has been linked so directly to the poetry of his friend Marino, the narrow question of its chronology is also inseparable from the broader question of interpreting Poussin's invention. Interpretation, rather than the technical matter of the date, is what truly concerns us here. Sterling's proposal that the publication of Marino's *Strage degli Innocenti* in 1632 provided a *terminus post* for the Chantilly picture found little support at the time he made it. Only Denis Mahon, however, took the trouble to state his objections clearly, claiming that the resemblances between the painting and Marino's poem seemed more factitious than actual: "There turns out to be absolutely no real resemblance between Poussin's picture and the blood-curdling incident so luridly portrayed in Marino's vivid description, apart from the fact that the murderer's foot plays a part (though not the same one) in both."[9] Furthermore, for Mahon the treading of the baby underfoot was inextricably linked in Marino's poem to the immediately preceding moment (also cited by Grautoff and Moschetti), when Marino describes a soldier who swings the infant around his head and then hurls it against a wall three times, causing blood to gush from its mouth and nose. The result is a death for which no sword is necessary. Moreover, observed Mahon, the motif in question had already appeared in the version in the Petit Palais, "which surely must have been painted very appreciably before the publication of [Marino's] poem."[10]

Mahon restated his view in 1962, now chiding Erwin Panofsky for accepting a connection between poem and painting in his essay on Poussin's so-called *Bacchus-Apollo* in Stockholm (1960). Mahon went so far as to suggest that Panofsky had not read Marino's *Strage degli Innocenti* himself, because his citation of it repeated a misprint in Grautoff's monograph of 1914, in which the connection had first been advanced![11] In fact Panofsky had acknowledged Grautoff's finding concerning the relationship between Marino's verses and Poussin's painting only reluctantly, saying that the gruesome detail of the soldier putting his foot on the body of an infant was *apparently* not found in earlier representations of the scene, and would seem therefore to have derived from Marino.[12] In his view, however, given the close relationship between painter and poet in Paris in the early 1620s (when, as we have seen from Bellori's report, Poussin and Marino used to read poetry together), the actual date of publication of the *Strage* provided no secure *terminus post quem*; poets, as he noted, often read their poetry to friends before publishing it. Panofsky's real purpose in considering the matter at all in an essay on the *Bacchus-Apollo* was to consider what the *Massacre* revealed about Poussin's interest in Guido Reni, specifically his famous picture of *Bacchus and Erigone* in Bologna, which took as its subject a rare mythological theme earlier thought (and probably correctly) to be the same as that adopted by Poussin for the Stockholm picture.

Closer analysis of Marino's *Strage* reveals, indeed, that the pregnantly horrible image of the soldier crushing the child underfoot, like almost every other image in Marino's poem, was not original. The principal source for the third and fourth books of the *Strage*, in which the scenes of the massacre are so vividly evoked, is, as had already been established by Scopa in 1905, Pietro Aretino's *Umanità di Cristo*, first published in

Venice in 1535.[13] Although Marino rewrote Aretino's prose very thoroughly, almost every invention in the *Strage* is to be found in this source, including the crushing of the infant underfoot by a muscular and fierce warrior. Aretino's text in fact matches Poussin's image more literally than Marino's, for in it the soldier treads on the child's chest without any preliminary torture, and kills him outright with two blows of his sword.[14] However, it does not follow that Marino's text held no importance for Poussin.

As Panofsky recognized, arguments over publication dates of texts and their relation to pictures in this period often reflect an artificial and very literal-minded sense of chronology. The publication of a text does not demand an immediate visual response; nor does a less than literal reaction to the text by the painter imply that it was insignificant for his own inventive interpretation of a common theme. When, as in the case of Poussin and Marino, both picture and text arise from one of the most famous rhetorical *topoi* in the history of literature and art, the establishment of a true relationship is especially problematic.

The story of the Massacre, a minor episode in Matthew's gospel, challenged orators and artists from the earliest days of Christianity to explore its potential for the violent combination of beauty and pathos. As a theme calling for the most vivid effects of *enargeia*, commingling the actual effects of utmost horror with emotions of rarefied and purely aesthetic delight (the very definition of the marvelous as conceived by Marino, who took the *Strage* as a vehicle for testing both effects at their absolute limits), the Massacre early became a Christian equivalent for the vivid and highly conventionalized descriptions of war in pagan oratory. Virtually all the elements of Marino's *poemetto sacro*, as well as of his own immediate sources, were already present in the *ekphrases* of early Christian orators, both Greek and Latin.

In his study of Byzantine art and rhetoric, Henry Maguire traces descriptions of the Massacre of the Innocents back to a highly influential fifth-century sermon by Basil of Seleucia.[15] As late as the twelfth and thirteenth centuries Basil's sermon was still listed in standardized collections as the reading for the feast day of the Innocents in the Byzantine church. Moreover, by the twelfth century, when the south Italian preacher Philagathus included in a sermon of his own not only a detailed description, or *ekphrasis*, of the massacre itself, but also a second *ekphrasis* of a painted representation of it, most of the elements of the rhetorical tradition, for which Basil's sermon may stand as the prime example, had entered the repertory of painters.[16] By the sixteenth century, the conventions of the eastern orators had become thoroughly assimilated into the traditions of western art. In what was to become the canonical pictorial representation of the story in the Italian Renaissance—Marcantonio's engraving after an invention by Raphael—children are shown slaughtered by swords and daggers, which their mothers ward off with bare hands even as they seek to hold fast to their children's limbs (fig. 143). All these ornamental episodes ultimately derive from the traditions of Byzantine *ekphrasis*.[17]

Raphael's invention was equally indebted, of course, to an already highly devel-

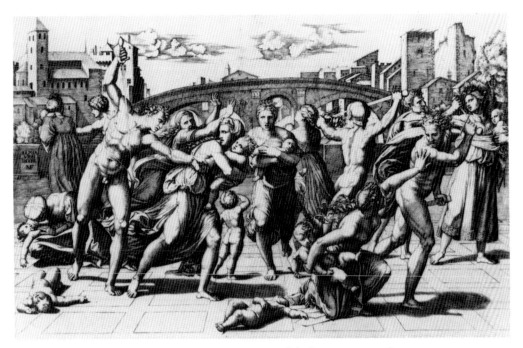

143. Marcantonio Raimondi after Raphael, *Massacre of the Innocents,* engraving

oped tradition of modern representation in Italy.[18] His *Massacre of the Innocents*, there-fore, is not notable for the originality of its particular motifs. Rather, what is extraordinary is Raphael's successful creation and deployment of a manner, or style, for representing the energies and ornamental inventions which had progressively been developed in the long tradition of actual rhetorical descriptions of the Massacre, con-ventions grounded in the diction and embellishments of ancient rhetoric itself. Like the orators, ancient and modern, Raphael understood how the story might be amplified by associating it with ancient images of the capture of a city, for example, or by combining images of war taken from pagan antiquity with the particulars of the story as told in the Gospel. His executioners, accordingly, are heroic nude warriors, fit for epic battle, and the whole violent scene is conceived as a noble exposition of the sort that contemporaries believed best revealed the full possibilities of painting.[19]

That Raphael was working from a particular textual source, however, a *descriptio* whether in poetry or in prose, also seems more than likely. The woman who rushes forward in the center of his invention, the fulcrum of the whole composition, does not hold an infant in her arms, as at first appears, but instead the broken pieces of her child that she has gathered up. This image too is highly conventional, but the centrality of her position, addressing the spectator—her mouth open in speech—corresponds in a striking way to the centrality of the same woman in Basil of Seleucia's archetypal

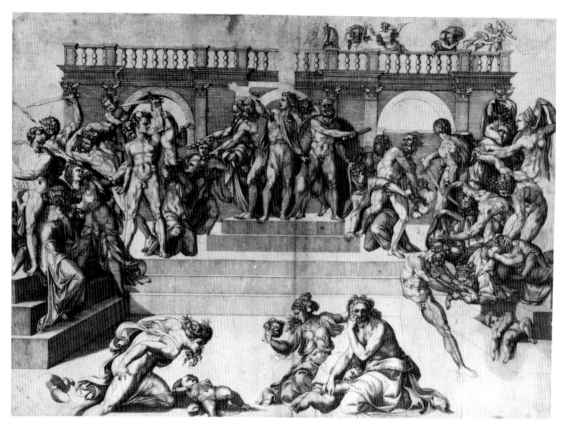

144. Marco Dente after Baccio Bandinelli, *Massacre of the Innocents,* engraving

sermon. In Basil's text, as in Raphael's invention, the mother of the dismembered child is the only one to be given direct speech. After collecting up and kissing the pathetic pieces of her son's body, and after searching for those still missing, she concludes with a lament addressed to her dead and pitifully mutilated child: "How will I put your limbs back together again that he so mercilessly has cut up with his sword: what womb will serve me to put your body together again? or with what hands will I pile up the earth needed to bury you? how will I tear myself from your image?"[20]

This famous example illustrates the difficulty of establishing a relationship between text and picture when the subject in question has become a major *topos* for ekphrastic invention. But it also suggests how we might hypothesize a direct relationship between a text and an image otherwise conventional in its details. In Bandinelli's version of the *Massacre of the Innocents* from the 1520s (fig. 144), to name but one other sixteenth-century example, different rhetorical embellishments are called upon: an association with the theme of the Judgment of Solomon, the importance of Herod's majestic columned palace, the combination of smashing and spearing, the violent re-

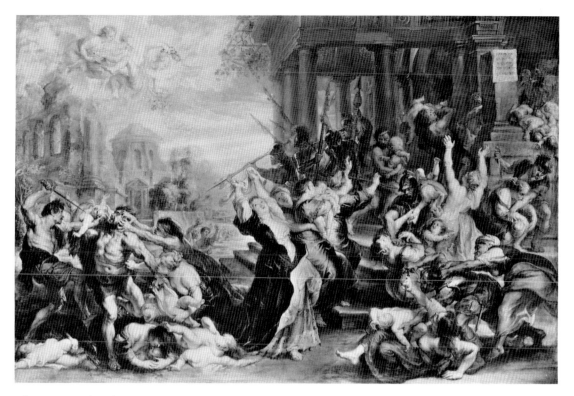

145. Peter Paul Rubens, *Massacre of the Innocents,* Bayerische Staatsgemäldesammlungen, Alte Pinakothek, Munich

sponse of the biting, struggling mothers, and, finally, the central image of the mother holding out the bodiless head of her child, an image that would influence many later interpretations.[21]

If the images contained in Marino's *Strage* were commonplace by the beginning of the seicento, both through printed images and through Aretino's published text, was the publication of Marino's poem in 1632 of any importance for painters? The answer must certainly be yes. Surprisingly, the theme was not popular as a subject for painters in Rome in the early seventeenth century, even among the followers of Caravaggio. After 1632, on the other hand, many artists explored it. Rubens' version of the theme, now in Munich, is one of the most copious of these new inventions (fig. 145).[22] He embellishes the scene with every kind of murder and resistance, including the smashing, piercing, and slitting of the helpless infants, the desperate biting and grasping of the executioners' swords by the mothers, and, finally, the mothers' last, tender embrace of the severed body parts of the children. As he invented this image Rubens surely had before him the print after Bandinelli's drawing, with all its tragic-heroic *enargeia.* However, he also conveyed in his painting, through the isolated lament of the beautiful

woman at the center, that same pathos and contrast of *bellezza* with *orrore* that is the truly distinguishing mark of Marino's poetics.

Poussin's friend Pietro Testa had also mastered the earlier Renaissance tradition, in one drawing of the theme considering in his fancy an infant derived from a Judgment of Solomon, and in others creating images of smashing, spearing, biting, as well as the tragedy of severed heads (fig. 146).[23] Testa would have known Poussin's canvases, but Rubens could not have, and it was surely the publication of Marino's *Strage* that stimulated him (and other artists, such as Massimo Stanzione and Valerio Castello) to reinvestigate the theme.[24] What led Rubens and other artists to such a renewed investigation—not merely to illustrate a Biblical tale which was in itself well known—was the force and wit of Marino's poetry, which presented a spur to the imagination and a challenge to them to rival in paint the poet's copiousness of invention and expressive energy, to capture in another medium the excitement and sparkle of his poetry. Their response was to Marino's *poetry*, and to the objection that Aretino's rather than Marino's "text" was their true literary "source," it might be replied that this very possibility is also attributable to the publication of Marino's poem. Given the extent to which Marino had pillaged this long out-of-print and little-known text by a

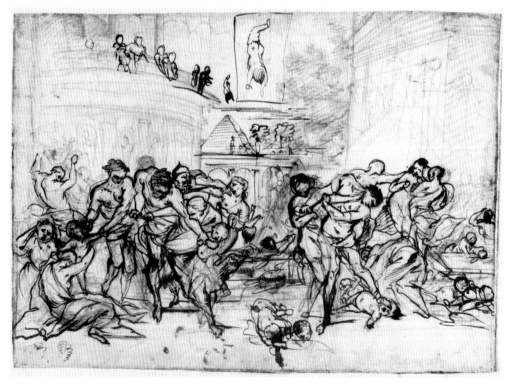

146. Pietro Testa, *Massacre of the Innocents,* drawing, National Gallery of Scotland, Edinburgh

discredited author, it is significant that only one year after the Neapolitan edition of the *Strage* appeared, and in the same year as the Venetian and Roman editions, Aretino's *Umanità di Cristo* was republished in Venice. Giovanni Pozzi has suggested that Marino himself had probably studied Aretino's works only as a very young man in Naples, where they were more accessible than in northern Italy. After 1558, when Aretino was censored by the Church, his writings were almost completely out of circulation in Rome.[25]

It is also easy to argue, as Panofsky did, that Poussin must have known the *Strage* before Marino departed for Naples in 1624. In a famous letter to the painter Bernardo Castello, written from Rome in April of 1605, Marino already describes *La Strage degli Innocenti* as being among the poems that he hopes will soon see print.[26] Pozzi in fact has concluded that the text of the poem (itself thoroughly pillaged in turn by Marino himself in favor of the *Adone*, its secular double) was essentially fixed by about 1610.[27] Marino certainly had the poem with him in France in 1622 when he befriended Poussin, for in 1619 he had written to Lorenzo Scoto that he was planning to publish the poem in Turin. The trip to Turin never took place, however, and Marino's deep dissatisfaction with the Venetian edition of the *Galeria* made him decide instead to publish both the *Adone* and the *Strage* in France.[28] Only the *Adone* appeared, but on his return to Rome in May of 1623, Marino was asked by the Roman *conservatori* to read "un canto della *Strage degli Innocenti*" at a dinner on the Capitoline.[29] The circumstances were auspicious for a public laureation, and this reading was surely accompanied by others in the Crescenzi household, where Marino held court.[30] Gregory XV died in July of that year, however, and with him presumably Marino's hopes.

In 1624, probably soon after Poussin's arrival in Rome, Marino wrote to Scoto, "La *Strage de' fanciulli innocenti* dorme." He had intended to dedicate it to the pope (this only the last of many proposals), but now did not know what to do.[31] By May of that year he was in Naples, and from this moment on Marino's Roman friends may not have had many opportunities to hear the poem. On 8 October 1624 he promised to send Antonio Bruni "alcuni canti" of the *Strage*, to which he claimed to be adding the final touches, but there is no evidence that he did so before his death on 26 March 1625.[32]

Various aspects of Poussin's two versions of the theme of the Massacre of the Innocents make it impossible to believe that he did not know Marino's poem, and improbable that he had only a general recollection of it derived from a reading, public or private. The text itself (and not Aretino's or another more "original" one) seems to have been as important and accessible to him as the engravings after Raphael and Bandinelli. Here we will focus exclusively on the Chantilly painting, the attribution of which has never been doubted, and in relation to which the case for a truly intertextual relationship with Marino's poem is stronger. Mahon, it will be recalled, found the connection between Poussin's invention and the single incident at the climax of Marino's description of the massacre (identified by Moschetti as Poussin's source) too weak to justify an association with *La Strage degli Innocenti*. But the more important connec-

tions, which reveal Poussin's reflective understanding of the poem, are less literally based in narrative action. They are instead to be found on the level of poetic invention. Thus, after describing the puncturing of a child so tiny that the sword could hardly find a place to wound him ("minore e del colpo il corpo angusto"), Marino adds:

> La madre il prende e se l'accoglie al petto,
> Peso che già le piacque ed or l'aggrava,
> E i freddi spirti e 'l volto pallidetto
> Con lacrime di cor riscalda e lava.
> Ella sí nel sembiante e ne l'aspetto
> A l'estinto fanciullo egual sembrava,
> Che distinguer da lui mal si potea,
> Se non forse però ch'ella piangea.[33]

(The mother took him and clasped him to her breast, a weight that once pleased her and is now a burden, and she warms up and washes his cold spirits and pallid little face with tears from the heart. She so resembled her dead child in her countenance and in her appearance that she could hardly be distinguished from him, except for the fact that she was weeping.)

This is the mother who walks, lifeless as the statue of tearful Niobe, with her child clasped by her womb at the right of the Chantilly painting.[34] In the next cantos Marino continues:

> Una ve n'ha, che del bel fianco ignudo,
> Misera! e del bel petto e del bel volto,
> Come può meglio, al caro suo fa scudo,
> Né soffrir sa, che le sia morto o tolto.
> Ma le sta sovra uom minaccioso e crudo,
> Che l'aureo crin s'ha intorno al braccio avolto,
> E del crespo e fin or le bionde pompe
> A scossa a scossa le divelle e rompe.
>
> Ella, sí come tronco edera cinge,
> Al dolce pegno abbarbicata stassi,
> Ma lui nel piè, lei ne la chioma stringe
> Sí forte il fier, ch'alfin convien che lassi;
> Poi con robusta man lo scaglia e spinge
> Contro il muro vicin fra duri sassi;
> Pria però che l'aventi e che 'l percota,
> Tre volte e quattro intorno intorno il rota.[35]

(There was one who on her beautiful naked side mourned! And as best she could she made a shield for her dear one with her beautiful breast and beautiful face,

not knowing whether to suffer him killed or torn from her. But over her stood a threatening and cruel man who had wrapped her golden hair around his arm, and jerk by jerk he uprooted and broke the curling and fine gold of her blonde splendor. She, just as the ivy clings to a trunk, stayed rooted to her sweet charge, but the beast on foot squeezed her hair so hard that in the end she had to let go. Then with a robust hand he hurled the child, and threw him against the nearby wall among the hard rocks. Before he hurled him, however, and before he struck him, he swung him around three or four times.)

In the Chantilly picture the assassin keeps the woman from shielding her child by pulling her hair, and by treading on the baby (an action quite different from the more traditional motif Guido Reni took from Raphael [figs. 147 and 143], in which the mother's long tresses are grabbed from behind to arrest her flight).[36] The horrific incident of the child being smashed and spun around, however, is indeed absent from Poussin's invention, and this is what convinced Mahon of the irrelevance of Marino's poem. Although the mere inclusion of this incident would not in itself necessarily point to a source in Marino, we need, perhaps, in arguing conversely that Poussin was interpreting Marino's poem, to suggest why he might have suppressed this horrific episode.

Poussin and his contemporaries would not have been attracted to Marino's *Strage degli Innocenti* because of the details of its violent narrative, most of which responded to a well-known visual tradition. More fascinating to them was the poetic quality of the work—its unique combination of lyric beauty with tragic horror. Poussin also understood, however, the constant risk in representing such a combination of qualities. As we have seen in the last chapter, critics had warned from antiquity down to Poussin's own time that if the rules of decorum were ignored in poetic representation the limits of horror might be transgressed, producing only effects of disgust in the audience.[37] Marino's verse describing the body of the infant after his death by being smashed (and indeed many others of his images) skirts daringly close to the limits:

> Al fin, rotto le membra, infranto l'ossa,
> Steso al suol tutto pesto e tutto trito,
> Per le labra e le nari in copia grande
> Con la bianca midolla il sangue spande.[38]

(In the end, his limbs broken and bones snapped, the child lay stretched out on the ground all mashed and all chopped, and through his lips and nostrils there flowed white marrow in great quantity, mixed with blood.)

Benedetto Croce's harsh, and influential view that Marino produced only vulgar poetry, and a false *gentilezza*, did not acknowledge the extraordinary tension maintained in such lines between horrific images and beautiful verse.[39] Such tension relies heavily on Marino's consistently artful use of conspicuous devices such as chiasmus, and on his employment of a Petrarchan vocabulary, all of which work to subvert the realism of the

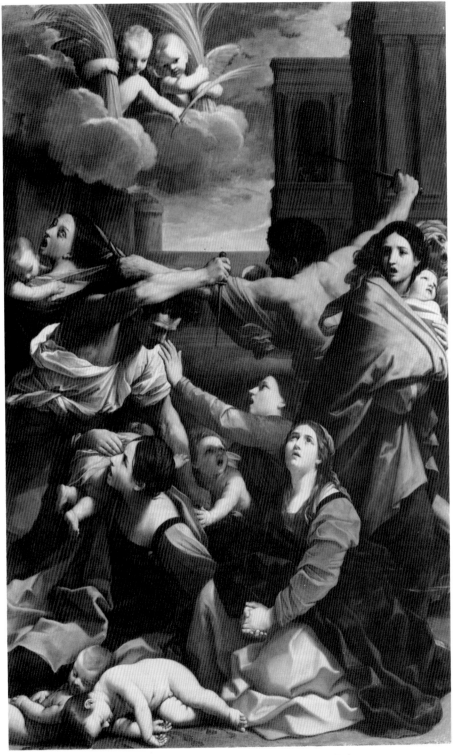

147. Guido Reni, *Massacre of the Innocents,* Pinacoteca Nazionale, Bologna

action, even as they summon up horrific visual effects. Only in a limited sense were these, or similar devices available to painters.

Rubens' painting of the *Massacre of the Innocents* in Munich (fig. 145) again provides the best comparison here, for, as we have suggested above, it represents various narrative episodes visualized in Marino's poem most completely. Although other painters, among them Testa, followed Marino's inventory of the ferocious effects of hand-to-hand fighting between soldiers and mothers, only Rubens dared to come to terms with the ideas of animal butchery summoned up by Marino's comparison of the murderers to wild boar, as well as the process of the breaking of limbs and cracking of bones, all made the more shocking through Marino's choice of the culinary "pesto" and "trito" in the verses cited above. To the left of Rubens' picture, as one woman clutches her dead child to her breast on the ground, and others claw at an almost naked wild executioner who stands over her, a hunting dog paws its way over a dead infant to lap up the pool of bloody marrow on the ground. Rubens, in other words, dared to represent the massacre as an image of the bestiality of war. However, as in his *Allegory of War and Peace* in the Palazzo Pitti in Florence (fig. 125), Rubens also opposed horror to beauty, placing at the very center of his canvas not a scene of combat, but the single figure of a woman, all ivory and vermilion, her bare breasts full of milk, who raises to heaven a scrap of bloodied cloth, a single tear running down her cheek.[40]

Pietro Testa also came close to the threshold of disgust in his *Massacre of the Innocents*, now in the Palazzo Spada in Rome (fig. 148), by showing a decapitated baby at his mother's milky breast, evoking yet another of the more appalling images in Marino's poem.[41] Among the hideous acts performed by the executioner Malacche at the beginning of Book IV of the *Strage degli Innocenti* (a section of the poem Pozzi closely connected with Prudentius' description of the massacre in his *Cathemerinon*) is the decapitation of a child at his mother's breast; the child spits up his food and his soul swims out in a mixture of blood and milk. Testa places the infant's head at his mother's breast at the center of his invention, but he elides many gruesome details in favor of the simple, tender opposition of blood and milk, a realization in paint of Marino's constant opposition of Petrarchan *vermiglio* and *biancho*, or *candido*, that runs throughout the metaphors of the poem.[42]

Vasari's famous verbal embellishment of Ghirlandaio's fresco of the *Massacre of the Innocents* in the Tornabuoni Chapel in Santa Maria Novella—adding to his description of it this selfsame image of the mortally wounded child at his mother's breast sucking in his own blood with her milk—comes immediately to mind.[43] That Vasari introduced such rhetorical *topoi* into his descriptions as a way of lending them a greater degree of liveliness is a commonplace.[44] But the reverse possibility, even more important for the art of painting itself, must also be acknowledged. Painters might have to suppress certain familiar episodes which they inherited from rhetorical tradition because these were not appropriate for visual representation. Their excessive *enargeia*, actualizing the hideous effects of slaughter, produced disgust rather than pleasure and

148. Pietro Testa, *Massacre of the Innocents,* Galleria Spada, Rome

caused the beholder to look away, something the second-hand verbal accounts of poetry or history did not.

Pliny's description of a painting by Aristeides provides an important model for the problematic conjunction of breast, baby, blood, and milk.[45] The Theban artist, who was famous for his representation of moral character, depicted a scene of images of battle that is very different from those we have encountered so far; a mother dying from her wounds makes evident her fear that her child, creeping towards her breast, will suck blood. Pliny's description probably has very little, if anything, to do with Vasari's image of the wounded child, which relies more directly on the rhetorical tradition for describing the Massacre.[46] On the other hand, Pliny's record of this famous ancient painting may help to account for the prominence of the dead mother and the living child creeping up to her breast in both Poussin's *Plague at Ashdod* (fig. 55), which we have discussed in chapter two, and in the so-called *Morbetto* (fig. 149), Marcantonio's famous engraving after Raphael, which Bellori identified as Poussin's principal

model.[47] Certainly Fuseli, writing in 1801, saw it that way, and disapproved. He observed that whereas Aristeides, in portraying the mother's extraordinary affection for her child, touched the "ambiguous line of a squeamish sense," Raphael in the *Morbetto* (where the mother is dead) had simply gone too far in imitating the ancient artist. He turned the mother from an object of noble apathy into one merely of disgust, especially by showing a man who, holding his hand to his nostrils to evoke the stench of death, bends over her to remove the child from her breast. According to Fuseli, Poussin, imitating Raphael, forgot, "in his eagerness to render the idea of contagion still more intuitive, that he was averting our feelings with ideas of disgust."[48] Such appeals to taste and to smell had no place in painting, he added, for the very reason that their extremes were closer to disgust or to "loathsome or risible ideas," than they were to a true, purgative, and ennobling terror.[49]

149. Marcantonio Raimondi after Raphael, *Il Morbetto,* engraving, National Gallery of Art, Washington, D.C.

Poussin constantly tested the limits of expression in his work, revealing a keen awareness of their potential, though not yet constrained, as was Fuseli, by the exact critical delineation of those limits by Lessing in particular. In the *Plague at Ashdod* he went even beyond Raphael, by placing the decaying mother's naked breasts at the center of his composition, and by moving the child even closer. Yet at the same time, Poussin's adaptation of Serlio's architectural design for the setting of a tragic stage endowed the whole scene with a sense of dramatic grandeur not found in his model.[50] Equally important in tempering the potential for arousing horror or disgust in his painting is the heroic attitude conceived by Poussin for the dead mother and her two little children. Though her hair flows down to the edge of the picture, and though her breasts are full, she is not posed as weak and suffering, as we saw in chapter two. Her upraised right arm and lowered, clenched left, the spread of her legs, with right knee raised and the left more fully stretched out and down, as well as her complement of two sons, all identify her as a female Laocoon who has just lost her struggle with the serpents of plague. Equally significant, as we have also suggested, is her resemblance to the *Dead Amazon* (fig. 56), an ancient statue which was then in the Farnese collection. In this suffering figure Poussin found the model for the bare, full breasts, the extended right arm, the left arm bent behind her, and the right leg bent but relaxed in the agony of death.[51]

Once recognized, this formal derivation for the dead mother, endowing her with an expressive pathos on the analogy of that of the dead Amazon, overcomes the potential for "squeamish sense" in the child at her breast; indeed, the affective simplicity of the child's expression, already noticed by Bellori, only enhances the heroic effect of the mother's struggle with death. Through his translation of the *exemplum doloris* of the *Laocoon*, together with the *Dead Amazon*, in order to express the pathos of the relationship between mother and child, Poussin displayed his mastery of the ultimate representation of character which Pliny had called Aristeides' greatest strength—that is to say, he succeeded in portraying the moral character even of the dead, and in the immobility of a corpse.

These three examples of paintings which treat of the theme of maternal loss, from Rubens' daring acceptance of the risks of representing bestiality within the framework of an interpretation of the Massacre of the Innocents as an image of war, to Testa's rather literal (and also limited) concentration on the poetic juxtaposition of blood and milk, to Poussin's discovery and adaptation of a visual metaphor as a way of preserving moral sense in the *Plague at Ashdod*, represent a narrow sampling of the devices through which painters in the seventeenth century tried in their own art to come to terms with the poet Marino's problematic combination of *orrore* and *diletto*. Although Vasari (like all humanist painters) had been aware of this problematic, and even exploited it in his writing, it was with the invention and popularizing of new lyric forms for new subjects by Marino and his contemporaries that the modern task of working through the implications of linking visual pleasure with tragic horror became truly urgent for painters.

One of the most important means by which Marino had tempered the imagistic horror of his poem was, paradoxically, through employing the distancing effect of references to works of art in a reversal, or inversion, of the rhetorical power of *ekphrasis* to create greater vividness. Even as painful descriptions of the awful brutality of the executioners (especially in Book IV) are repeatedly elaborated, so the lovely women and their little sons are periodically taken out of the action, suspended in time so to speak, as if they were distinct and ideally beautiful works of art. Marino's invocation to the Cavaliere d'Arpino at the beginning of the massacre in Book III sets the stage. By adding the painter's colors to his ink, the poet hopes that his paper will emulate the Cavaliere's linen support for his paintings.[52] Later in the poem he introduces Arpino's name once again, in an especially important context. In his description of the Massacre of the Innocents in *L'Umanità di Cristo*, Aretino had compared a group of a mother and three children to a sculpture of Charity; after the slaughter the mother resembles a marble stained with vermilion.[53] Marino, in his highly elaborated imitation of this passage, gives the beautiful mother five children, and he divides the simile between painting and sculpture, the one being transformed into the other. He first compares the beauty of the mother-as-Charity with her delightful children to a painting of *Charity* by Arpino. Then Marino takes up Aretino's sculptural metaphor in an extended comparison of the scene with the Niobid sculptures, then in the garden of the Villa Medici. Comparing the executioner's heart to *macigno* (hard white marble), he also describes the mother as a sculptured, white marble image stained by her children's blood: "Di bianco marmo, se non quanto i figli/ Fatto i candidi membri avean vermigli."[54]

Marino and the Cavaliere d'Arpino were close friends—indeed the elegant painter, with his noble title, his palace, and his collection of pictures, probably provided the poet with a model for his own ambitions. Nowhere in Arpino's work, however, which Mancini so aptly characterized as lacking in naturalism but yet possessing "that loveliness which ravishes and delights the eye in a trice," do we find the unnerving combination of horror and delight of Marino's *Strage*.[55] Much closer in spirit than any painting by the Cavaliere is the *Massacre of the Innocents* by his Roman protegé, Guido Reni (fig. 147). This painting was itself to become a canonical version of the theme, comparable to Raphael's. Guido and Poussin probably never met, which may have contributed to Poussin's fascination with Reni's work.[56] Between the two painters, as between Poussin and his other polar opposite, Caravaggio, stood Poussin's patron Marino. Well before Poussin met him Marino had celebrated several of Guido's paintings, including his *Massacre of the Innocents*, in *La Galeria*, his anthology of poems about works of art, first published in 1619.[57] Guido's *Massacre* bears a quite different relationship to Marino's from Poussin's, adding a further complication to the story of the relationship between text and images.

The date of Guido's painting for the chapel of the Conte Bero in San Domenico, Bologna, is not certain, though the artist received a down-payment in 1610 and Domenichino probably saw the final work in Bologna in 1612.[58] The Bolognese critic

Malvasia wrote that in this picture Guido undertook to silence critics who claimed that he could not compose many figures together.[59] In his description of the work, Malvasia especially singles out the antithesis between the explosive movements of figures who threaten to spill out of the small space of the picture and the contrasting calm pose of the woman in the foreground weeping over her children. Guido executed the whole, he writes, with an unparalleled mixture of force and tenderness.[60]

Guido's devices for accomplishing these effects are very complex. Most conspicuous among them is the extraordinary formal contrapposto of the composition (especially the arrangement of figures about to disappear across the edges of the canvas), which is held together only by the crossed arms of the executioners. They are almost balanced, as Cavalli put it, on the dagger, whose bloody point is the emblematic heart of the picture, at its otherwise empty center.[61] Cavalli characterized the figures as *impietriti*, turned to stone, each caught in a suspended gesture and occupying its own space. And the marbles into which they are turned, as has often been noted, are the *Niobe*, the *Laocoon*, Hellenistic putti, and the now-petrified figures of Marcantonio's print after Raphael.[62] These stones are, however, also given life, the women through their open-mouthed silent screams, like that of the boy who flies out of the *Martyrdom of Saint Matthew* by Caravaggio, whose style is also evoked in the executioners. They are enlivened through the intense hues of the fabrics of the costumes (fanning out from the red, yellow, and blue of the kneeling supplicant), and through the delicacy of ivory and vermilion in the women's flesh. The promise of the two little angels on dark clouds with their golden palms is reflected in the golden light of dawn breaking on the horizon, which miraculously also bathes the faces of the women.

Color, more usually an embellishment of space in painting, is deployed by Guido in this frozen moment as a metaphor for time. The little boy at the center of the composition, who shrieks at the sight of the bloody dagger as he emerges from his mother's skirts, is rosy cheeked, his flesh soft and tender. To the right the baby carried away in his mother's arms already looks heavenwards, his head juxtaposed to her waxen beauty and to the old woman's leathery, teary face. The swaddling he wears is red, in sharp contrast to the white bands that tie it, and also to his already pallid face: this red stain is to be understood as his blood—whether as metaphor or reality is left open—gone from his flesh. Finally, in the foreground the twinned little corpses have passed beyond mere resemblance to sculpture, and have become white ivory veined with vermilion, inexpressibly precious objects whose material opulence is again a metaphor for the preciousness of childhood, and of their martyred condition. In a double metaphor for the limbo in which they now exist, Guido turns them into sleeping cupids, both little loves who resemble sculpture as they sleep, and sculptures of little loves who seem to be alive, but sleeping.[63]

In Guido's painting the infusion of painted blood into fictive marble and its ebbing away again around the bloody dagger interrupts the horror of the action, distancing it in such a way as to make it beautiful—as Marino would say in his madrigal in praise of the picture, "O in cruelty yet merciful, gentle artificer, well you know that

a tragic event is also a precious object, and that often horror goes with delight."[64] In order to create the image of that beauty in his own poem, as we have seen, Marino had first to summon up a painted *Carità* by Arpino and then transform its living colors into a Niobid group stained with blood. Having lamented that his pen is no match for the sword, he claims to need to learn from a painter how to bring canvases (that is to say pictures) alive.

Guido's is not, however, a "nuova strage," bringing to life the scene as if it were happening before us, in the manner of an *ekphrasis* full of *enargeia*. It is instead a literal realization of Marino's metaphors as such, posing the same question later offered by the poet: "Contro furor, che val bellezza?"[65] Whereas Raphael had represented the rhetorical tradition for the description of the massacre as a scene of war, Guido here paints that same problematic of the representation of horror combined with delight, of violence joined with beauty, which so fascinated Marino. Rubens, for his part, we should recall, attempted to combine both arguments.

Guido was not illustrating Marino's poem. Some details seem to tie the two works together directly. But in this case painter and poet were working out of the very same culture, both poetic and pictorial.[66] The more important issue at stake is what the relationship between painting and poem tells us about artists' common interest in the problematic relationship between dramatic lyricism and narrative—that is, in genre of style as a medium of expression—and of the paradoxical allure of beauty in horror.

Malvasia's report that Guido had been accused of inability to put figures together in a way that told a story is not contradicted by the evidence of his paintings. The only truly narrative subjects he had attempted before painting the *Massacre of the Innocents* were, indeed, the famous fresco of *St. Andrew Led to His Martyrdom* in San Gregorio Magno in Rome, and the now-destroyed fresco of *Farmers Presenting Gifts to Saint Benedict* in the cloister of San Michele in Bosco in Bologna. The contrast of the former with the lively narrative by Domenichino of the *Flagellation of St. Andrew* opposite it was such that it immediately gave rise to a critical debate that continues to reverberate.[67] Engraved copies after the fresco in Bologna not only reveal the lack of narrative unity in Reni's composition, but also help to confirm Malvasia's observations about what Guido was really interested in here—the adoption of various manners, or *gusti*, in order to portray the different characters of the peasants who bring their gifts (fig. 150). We may not agree with all of Malvasia's stylistic parallels, but the distinction between the loveliness of the Raphaelesque and Correggesque women, as well as the muscular, Michelangelesque contrapposto of the almost naked man pulling the mule in the foreground is unmistakable.[68]

For further confirmation of Guido's practice we might consider his *Martyrdom of Saint Catherine* in Conscente, Liguria (c. 1606–7, fig. 151), a work not discussed by Malvasia in this regard.[69] It is not the action of the saint's beheading that is presented here, but the vision of her coronation by angels, the sort of invention that harks back to the *maniera devota* practiced by Perugino and the artists of the papal states at the very outset of the sixteenth century, and which specifically invokes Reni's admiration for

150. G. Giovanni after Guido Reni, *Farmers Presenting Gifts to St. Benedict,* engraving, Boston Museum of Fine Arts, Boston

151. Guido Reni, *Martyrdom of St. Catherine,* Conscente, Liguria

earlier Bolognese painters like Francia.[70] Equally important, however, and reinforcing the iconicity of the work, is the fact that Guido painted Saint Catherine on the model of Raphael's Saint Cecilia, and her executioner in the manner of Caravaggio's realistic figures in the Cerasi Chapel. Such choices, like those in his fresco in San Michele in Bosco, were made according to the artist's understanding of stylistic epitomes. Caravaggio is a painter of reality, and Guido's executioner, his sword drawn back in a gesture as paradoxically *impietrito* as those portrayed in the *Massacre of the Innocents*, stands within and for a reality outside the miraculous event; Raphael's Saint Cecilia, on the other hand, set the standard for heavenly rapture.

Guido's ability to manipulate the affective power of styles and gestures was one of many qualities that would have attracted Poussin to him. Guido's particular study, for example, of the head of Seneca in his possession (whose wrinkled neck might appear on Saint Peter or on Joseph to denote their age) provides an important precedent for the kind of analysis of ancient sculptures undertaken by Duquesnoy and Poussin.[71] It was only later in Poussin's career, however, when he painted the *Rebecca and Eliezer at the Well* (pl. VI) in direct rivalry with Guido, that he would refer overtly to Guido's technique of combining references to individual modern styles. In this painted criticism of Reni's *Sewing Madonna* (which, as we shall see in the last chapter, the *Rebecca and Eliezer* was commissioned to rival), Poussin succeeded in combining the different love-linesses of women painted according to a variety of artistic ideals with narrative clarity of expression, unified in time and space.[72]

Time and space are exactly what is suppressed by Reni, and also by Poussin's other nemesis, Caravaggio, who was similarly criticized for being unable to tell a story. But Marino's form of story-telling, in which time is also made to stand still so that the reader may admire the horror, helps us to see that such suppression had a purpose. In the midst of the slaughter in *La Strage degli Innocenti*, Marino describes the murder of a single child born to the beautiful mother:

> Tacque la bella donna e non disciolse
> Voce, pianto o sospir: tacque e sofferse,
> Ma sí pietosa in atto il figlio tolse
> E voluntaria al mascalzon l'offerse,
> Che, se non ch'egli altrove i lumi volse,
> Se non ch'ella d'un velo i suoi coverse,
> Vincealo il dolce sguardo, e 'l ferro acuto
> Fora di mano al feritor caduto.[73]

(The beautiful woman falls silent, and lets out no voice, cry, or sigh: she suffers in silence, but she takes up her son and freely offers him to the rogue in an action so piteous that, had he not turned his eyes elsewhere, and had she not covered hers with a veil, her sweet glance would have conquered him, and the sharp blade fallen from the striker's hand.)

It is at this moment that Marino exclaims his inquiry about the value of beauty against fury: "Ma che? Contro furor, che val bellezza?" Perfect beauty had failed to soften the heart, to disarm murderous intent without words or force; what failed, that is, was the very effect of silent painting to conquer without discourse, to persuade in a single glance. Marino had first lamented that his words (both his "tongue," or "lingua," and his "stile," meaning *both* pen and style) could neither sting like a sword nor imprint wounds of pity in every gentle heart, this sentiment itself an inversion of the conventional expectation of the effects of love. Neither able to kill nor move to pity with words written in ink, he seeks to borrow the colors of the painter. But in his poem, filled with the colors of metaphor and with appealing images of works of art, beauty fails to stop the progress of events, even as the poet's pen succeeds in conquering the effects of horror and beauty, delineating frozen tableaux of the effects of both assassin's sword and mother's love.

Marino's thematizing of his pen as both sword and brush is everywhere apparent in the *Strage*, and in this light his famous madrigal on Guido's *Massacre* becomes yet more complex. Not the writer's own ink, but the painter's brush is here celebrated as the instrument that offers both life and death. First it brings the infants alive, and then it kills them anew. The work of the brush is bloody, enlivening forms with a vermilion hue that then flows out of the little bodies into daubs upon the ground. In Guido's assemblage of living, dying, and dead forms, in contrast to other representations of the massacre considered so far, no child is actually being murdered. The true psychological center of the painting, close to the true, empty center where the diagonals meet (its tip actually on one transverse), is the short dagger, dipped in blood, held up by the bearded executioner who so thoughtfully goes about his work, even as the startled little boy cries out silently at the sight of it, and his mother seeks to stay the blow.

That blow is stayed forever, not by the deflection of a sword, but by the determination of the brush. That Guido thematized his brush as the sword, portraying its power to bring alive and to kill through carmine tints, is fully substantiated by the invention of the *Massacre of the Innocents*, in which he provided an answer to the question of what beauty could do in the face of horror. Unlike the executioners who do not stop to look, we gaze upon the work and in doing so are arrested by its beauty; and, like the painter/executioner, we turn the *tragico caso* into a *caro oggetto*, and back again, in an eternal *glissement*.[74] That Guido also rivalled the pen of the poet, in a *paragone* that was unavoidable within the poetic tradition in which he worked, is a further corollary to which those seven beautiful figures with silent open mouths direct us. The golden palms held out by the little angels in the sky, promises of eternity, take on distinct meaning here; the dagger stands for the painter's brush, but so does the palm. In his invocation of painting, and through complex wordplay, Marino questions the relative power of epic and lyric poetry. In the end (if ironically from Marino's point of view) Reni shows that it is indeed the painter's lyrical hand that knows how to give life to shades, and to animate canvases. The palm of immortality, the symbol of the achievement of heavenly perfection, is its divine equivalent. One brings eternal life on earth,

the other truly knows how to give life to shades eternally. In both Marino's poem and Reni's altarpiece, the work of salvation comes perilously close to being an artistic enterprise.

Poussin understood as well as Reni how Marino elevated simple artistic metaphors, like those in Aretino's text, to an even more vivid level through references to actual works of art, known at least by reputation to his readers. He made such references himself. In the *Plague at Ashdod*, as we have seen, he adapted the figure of the dead mother and child from the Farnese *Amazon*, adding to this pathetic image the heroic grandeur of the *Laocoon*. In the Chantilly *Massacre of the Innocents* he again reshaped the figure of Niobe for the woman carrying the dead body of her child.[75] But in neither of Poussin's versions of the *Massacre* do the metaphors of beauty, or the association with works of art, dominate the narrative, as they do in Reni's picture. We have seen how Poussin reduced the potential for disgust in an image of murder that is horrific nonetheless. In keeping with this restraint, Poussin presents quite a different notion of *bellezza* from the seductively lyrical companion of *orrore* thematized in both Marino's poem and Reni's altarpiece. The colors of the Chantilly picture are limited to the primaries of red, yellow, and blue, with no hint of Petrarchan ivory and vermilion; the figures are like stone, and indeed the mother at the center wears a tragic mask, petrified by grief.[76] A sense of pathos is conveyed through the single figure of the running Niobe, and by the involuntary gesture of surrender of the child. Although the structure of the whole is highly sophisticated in its antitheses, the painter does not paint the antithetical lines of Marino's poem, but instead requires his spectator to summon them up. Furthermore, the space of Poussin's perspective, whether shallow, as in the Altieri picture, or deep, as in the canvas at Chantilly, is that of a stage for history or for tragedy, closer both in genre and detail to the *Plague at Ashdod* or his two versions of the *Rape of the Sabine Women*. Deeply affected by Marino's scenes of horror, and undoubtedly fascinated by Reni's work, Poussin nevertheless shows no interest in distancing the image, nor, in this work, in thematizing his own act of painting. Despite his knowledge of the *Strage* (or rather in response to it), his interpretation of the scene was governed by his own understanding of the story as an ancient tragedy enacted in a more traditional style in the manner of a civil war.

In 1931 Giuseppe Zamboni, more sympathetic to Marino than was Croce, characterized the *Strage* in the following way:

> The inspiration of the poem is fundamentally theatrical, not to say dramatic, and it responds in certain of its qualities that are not secondary to the demands of the theory of tragedy in the seicento, which, as is well known, confounds the horrid with the tragic. Rather than a heroic episode, Marino's poem is a horrid, bloody event, and Herod is more the type of the conventional tyrant from tragedies of a Senecan stamp than he is the hero of an epic.[77]

Poussin interpreted Marino's poem as just such a Senecan tragedy.

It would not be an exaggeration to say that no treatment of the theme of the Massacre of the Innocents from the first half of the seicento, whether in poetry or in painting, could ignore the poetry of Marino, in which the long tradition of the relationship of pictorial and poetic values was so thoroughly problematized. Poussin's *Massacre of the Innocents* in Chantilly reflects a deep understanding, not only of Marino's remarkable poetics, but also of the poetry of *La Strage degli Innocenti* quite specifically. The generic differences in invention, disposition, and coloristic embellishment that pertain between his work and Reni's *Massacre*, as well as others by Rubens or Testa, point this up in a way that comparisons of a strictly narrative kind cannot. Does this then mean that Sterling's proposal, with which our discussion began, was correct? In denying any relationship between a printed text of the *Strage degli Innocenti* and the Chantilly painting, Mahon also suggested that the dispute over custody of Marino's manuscripts, which occurred between the poet's death in March of 1625 and the publication of the *Strage* in 1632, would have made even these unavailable.[78] Only one manuscript of the *Strage* (presumably destroyed in an eruption of Vesuvius) is documented, and we must respect Mahon's claim that it would have been difficult for Poussin to have had direct access to a text of the poem after Marino's departure from Rome in 1624. Poussin surely remembered very well the noble poet's recitations from the poem in Paris and Rome during the short duration of their friendship, as Panofsky suggested. But it was much easier for him, as it was for Testa and for Rubens, to read the text upon its publication.

We have already suggested above, on the evidence of the Giustiniani inventory, and on the basis of Joachim von Sandrart's entry into Vincenzo's household after 1632, that the Chantilly canvas should be dated closer to 1632. If Poussin had the text of the *Strage* to hand, then his faithfulness to certain aspects of it and his ability to think critically about it in relation to an artistic tradition, are easier to account for. If he did not, then his memory of the poem is all the more remarkable. Most important, however, is the argument provided by his painting that he surely knew the poem. Rather than focusing narrowly on the question of publication date as a way of denying that Marino could possibly have provided a textual "source" for Poussin's invention, as Mahon wanted to do, we should marvel instead at the difference between Poussin's and Reni's ways of independently interpreting a series of models, both textual and visual, among which Marino's *Strage* is the most important. Such interpretation and independent expression, as it was for Marino himself, was very likely the impetus behind their choice of the theme. Both Poussin and Reni criticized Marino's poetry and the lengthy rhetorical and poetic traditions in which it was nourished according to the evolving critical and aesthetic principles of their own visual art. There can be no doubt that it was Marino's challenging and complicated poetics, and not the conventional and predictable details of his narrative, that engaged them.

CHAPTER EIGHT

DEATH IN ARCADIA

AS WE HAVE SEEN from the preceding chapters, the particular subjects indicated by the titles of such paintings by Poussin as the *Mars and Venus*, taken from ancient fable, the *Massacre of the Innocents*, derived from Biblical history, or the *Self-Portrait* of 1650, an effigy of the artist copied after life, even though they are accurate and sufficient for the purposes of a museum label or for the cataloguer, are no more than points of departure for the expression of broader, and highly abstract themes. In the first example Poussin's argument emerges as an extended reflection on the interrelationship of sexual and artistic arousal, in the second as a Marinesque expression of the pathos of beauty enhanced by horror, and in the third as an essay on friendship as opposed to possessive desire. This distinction between subject and theme also appears, as we have already suggested, from Félibien's eyewitness account of the circumstances leading to the commission given Poussin for his painting of *Rebecca and Eliezer* (pl. VI), completed in 1648:

> [W]hen Poussin made his painting of Rebecca, I pray you what was his design? I was still in Rome when the thought came to him. The Abbé Gavot had sent a painting by Guido Reni to Cardinal Mazarin, in which the Virgin is seated in the midst of several young women occupied with different tasks. This painting is estimable for the diversity of airs in the noble and gracious heads, and for its agreeable costumes, painted in that beautiful manner that Guido possessed. Le Sieur Pointel having seen it, he wrote to Poussin and told him he would be greatly obliged if he wished to make him a painting filled, like this one, with several young women, among whom one could distinguish different beauties.[1]

The theme of Poussin's *Rebecca and Eliezer* then is beauty, for which the beauty of woman stands as the synecdoche (notably so in the tradition of Petrarchan vernacular lyric), and with it a comparison of different and competing standards of beauty.[2] The subject chosen by Poussin to exemplify this theme is that of Rebecca and her various companion maidens who have come to draw water from the well. Poussin's theme also entails the power of beauty to provoke love, and with it a desire to possess the most perfect idea of beauty, exemplified by Eliezer's choice of the most beautiful maiden to be the bride of Isaac. Further—as in the case of Poussin's *Self-Portrait* for Chantelou, which was conceived in the context of a rivalry with Pointel to possess the finest

expression of Poussin's love and esteem (each wishing to have the most beautiful "Poussin")—Poussin's theme of beauty and its possession is cast by the terms of Pointel's commission as a rivalry between patrons to possess the most beautiful painting, and beyond this to possess an expression of the most perfect idea of Painting itself. Poussin's commission arose from Pointel's explicit desire for him to emulate, not only the *Sewing Madonna* by Guido, possessed by Mazarin, but also another concept of beauty and its possession—"cette belle manière que le Guide possedoit." It was this "beautiful manner" itself for which Guido was especially famous and his work coveted, and Pointel desired Poussin to rival Guido with another manner and idea of beauty, one possessed by Poussin. In other words, Pointel wished to possess a sample of Poussin's idea of beauty, conceived both in general rivalry with Guido and in particular rivalry with the painting by Guido owned by Cardinal Mazarin. He left the choice of subject by which the theme he proposed would be realized up to the judgment of the artist.

Poussin, in responding to Pointel's additional challenge to paint not one but several different female beauties (themselves standing for differing ideals of beauty, or manners in painting), developed the theme proposed to him by appealing initially to the familiar Petrarchan metaphors for defining normative beauty in women. This in turn was mediated by his additional assimilation of Agnolo Firenzuola's comparison in the *Dialogo delle bellezze delle donne* of the swelling proportions of different women to various forms of vases (and vases also play an important part in the story of Rebecca and Eliezer, which is one reason why Poussin undoubtedly was attracted to this subject, and which once again allowed him to link the subject to his theme and its expression). Poussin responded to the particular artistic challenge given him by Pointel through further reference to the different ideal norms of beauty that had been established in the manners possessed, not only by Guido, but also by other famous painters—among them Raphael for the woman stooping to pick up a vase at the left-hand side of the painting; Rubens for her counterpart at the right, a nearly double-chinned blonde woman wearing a vivid red underdress; and Guido himself for the imposing woman standing before the pier, leaning on a vase, and looking indignantly at the jewels given by Eliezer to Rachel, who wins the prize and of course represents Poussin's own idea of perfected beauty.[3]

None of this means, however, that the subject Poussin chose to express his theme of beauty is unimportant, especially for a painter who had written that it was necessary to *read* the story and the painting together ("Lisez l'histoire et le tableau, afin de connaître si chaque chose est appropriée au sujet"); and who also had said, "In speaking of painting, just as the twenty-four letters of the alphabet serve to form our words and express our thoughts, so do the lineaments of the human body express the diverse passions of the soul, in order to make apparent on the outside that which is contained in the spirit."[4] For example, it is significant that in accepting Pointel's challenge Poussin did not choose from among the obvious, and even hackneyed subjects for realizing his theme, such as the ancient *topoi* of Apelles painting Diana from various models, or

of Zeuxis painting Helen's perfect beauty by combining the individual parts of five or six Crotonian maidens. He instead turned to the Old Testament story of the eldest servant of Abraham, sworn to go abroad from Canaan and choose a wife for Isaac. In his famous contrast, much praised by Bellori, of Rebecca's quiet dignity with the reactions of her companions, some of them distracted by the jewelry offered to her by Eliezer, some jealous or inattentive, Poussin indicated that beauty consisted not only in simple comeliness and ornament, but also in character. None of this was lost on Félibien, who, in praising the beauty of Rebecca, himself automatically summoned forth the *topos* of Apelles, the painter of perfected female beauty whose example Poussin had rejected: "One can not say of Poussin what Apelles remarked to one of his disciples, that being unable to paint Helen beautiful, he had represented her rich."[5] Poussin had instead shown beauty shining forth more brightly than all her ornaments, which in the *Rebecca and Eliezer* are spare and simple, "convenables au sujet."

IN THIS CHAPTER we shall turn to an investigation of the broader thematics of Poussin's landscape paintings, concentrating in particular on two late works, the *Birth of Bacchus and Death of Narcissus* in the Fogg Art Museum, and the *Apollo and Daphne* in the Louvre. By way of introduction, however, it is necessary to recall that Poussin, although he had experimented sporadically with landscape painting earlier in his career, became at two distinct moments the master of two highly developed and distinct landscape styles. The first has been named the Heroic Style, although, for reasons that shall presently become clear, it would perhaps be preferable to call this the Historical, or better yet a literarily reconstructed Archaeological Style. It is comprised of a group of paintings produced from about the year 1648, that is to say, from just at the moment that Poussin completed the second series of *Seven Sacraments* for Chantelou. As we have seen, in this series Poussin displayed his antiquarian interests in their most impressive deployment and at their most intense, and in each of its individual paintings he almost obsessively attempted to recreate the historical Roman world of early Christianity exactly as it must have appeared.

Poussin's first landscape style continues in a different genre his concern for historical reconstruction, and is devoted to the representation of fictive ancient landscapes. The viewer of these paintings immediately has the inescapable sense of looking directly into the world of a long-vanished past, one not defined by a generic overlay of abstractly antique architectural forms such as gives Annibale Carracci's or Domenichino's geometrically structured landscapes their timeless—that is, not specifically time-bound—quality of narrative appropriateness. Nor is it a world in which classical structures and ancient ruins are intermingled with a poetically idealized, eternally unchanging idea of the life of the land, of the sort that gives Claude Lorraine's landscapes, illumined by the golden light of the forever contemporary Roman *campagna*, their own satisfying feel of timelessness, and the sense that it really doesn't matter whether we are witness to a

152. Nicolas Poussin, *Burial of Phocion*, Collection Earl of Plymouth, on loan to the National Museum of Wales, Cardiff

153. Nicolas Poussin, *Recovery of Phocion's Ashes*, Walker Art Gallery, Liverpool

dance of the Satyrs and Nymphs or to a rural wedding celebration. On the contrary, Poussin's landscapes in his first style are profoundly time-specific and not eternal, and are informed by an intense antiquarian, and even archaeologically motivated desire to place before the viewer's eyes the historical appearance of ancient places. Moreover, the historically actual landscapes of the first style meticulously avoid any reference whatsoever to the fictional beings—mythological spirits such as River Gods, Nymphs, Satyrs, or even Olympian gods—who populate and animate the ancient countryside in classical literature and religion. By contrast, Poussin's second landscape style, dating from around the year 1658, is characterized by the reintroduction of mythological figures into the landscape, by a corresponding rise in interest in the spirits that endow ancient sites with their particular aura, and in what may be called the special spirit or divinity of place.[6]

Exemplary of the first style are the paired landscapes of the *Burial of Phocion* (fig. 152) and the *Recovery of Phocion's Ashes* (fig. 153), the former showing Athens from which Phocion was exiled in death, the latter depicting Megara where he was buried and his ashes secretly retrieved by his wife and daughter.[7] In the second, aside from observing the impressive ancient cityscape in which the scene is set, it is sufficient to take note only of the exquisitely antiquarian detail of the philosopher strolling through the late afternoon shadows, reading from a papyrus roll. In the first we see Mount Hymettus set against the morning sky, the tomb of Hippolytus in the center, to the left the round *tholos* where the Athenian senate met, and to the right a temple set behind a fortification wall, which undoubtedly is intended to represent the Parthenon. The whole may be compared to a later engraved view of Athens (fig. 154), illustrating Nicolas Gerbel's *Graeciae descriptio* and imagined entirely on the basis of ancient literary descriptions (for until Spon's and Wheeler's voyage in 1680 no living western scholar had seen Athens at first hand). Although not identical to Poussin's painting, the principal topographical features of the city are remarkably close in conception and their relationship to one another—Mount Hymettus in the distance, the *tholos* to the left, and the Acropolis set before an indeterminate body of water, perhaps intended to be the Piraeus.[8] The incorrect rendering of the Acropolis in both the engraving and in Poussin's painting derives from the fact that the Acropolis was known to be the fortress of Athens, and hence was translated as the *arx*, *castello*, or *château* of the city; and that both Gerbel's engraver and Poussin worked from some common visual prototype is indicated by the huge tower in the *Burial of Phocion*, which clearly was adapted from a view incorporating the minaret the Turks had built within the walls of the Parthenon itself.[9]

As a second example of Poussin's first landscape style, it is useful to turn briefly to the paired landscapes of the *Greek Road* (fig. 155) and the *Roman Road* (fig. 156), the very titles of which indicate Poussin's unprecedented distinction between Greek and Roman civilizations and styles, which we considered in the first chapter.[10] The *Roman Road* depicts a vision of a formerly wild nature that has been conquered and improved by the building of a great Roman military highway (which there are good reasons for

ATHENAE. *pag.65.*

154. *Athens,* engraving from N. Gerbel, *Graeciae descriptio,* in J. J. Gronovius, *Thesaurus antiquitatum graecarum,* Leiden, 1697–1702, volume four

thinking may be the via Domitiana running along the coast of Campania with its groves of lush oranges), running straight as a string to the horizon, lined with impressive tombs and monuments, and fitted with level bridges, mounting posts, milestones, and cisterns filled with water for the refreshment of thirsty and dust-covered travelers.[11] While Statius had praised in his *sylva* on the via Domitiana the building of the road as a reclamation of the land from unruly nature, lauding Roman engineering genius for its ability to tame and to civilize the land and rivers, Poussin in the *Greek Road,* on the other hand, contrasts the *Roman Road* to a different ideal, a road carved by spontaneous nature with no need for human improvement or intervention, and which itself is a civilizing agent. There is no distinction in value drawn between the two landscapes, each of which represents an ideal of natural perfection and fertility, but at the same time there is a clear contrast drawn between Greek and Roman civilizations and their relation to nature. In the *Greek Road* Poussin's landscape is surely meant as the vale of Tempe in Thessaly, here illustrated again in a later engraving from Gerbel's *Graeciae descriptio* (fig. 157), made on the basis of Aelian's celebrated description in the *Varia historia* of the perfect amenities of the natural road meandering through Tempe,

155. Nicolas Poussin, *The Greek Road (The Vale of Tempe)*, National Gallery, London

156. Nicolas Poussin, *The Roman Road (via Domitiana)*, Dulwich Picture Gallery, London

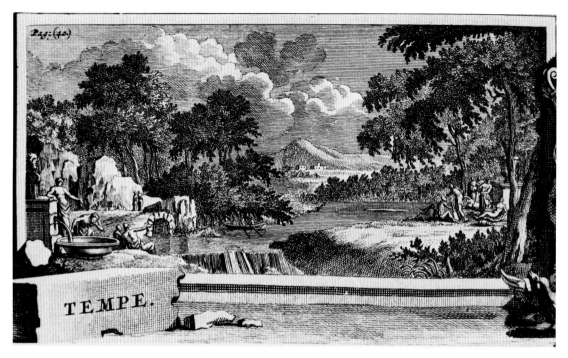

157. *Tempe,* engraving from N. Gerbel, *Graeciae descriptio,* in J. J. Gronovius, *Thesaurus antiquitatum graecarum,* Leiden, 1697–1702, volume four

which was lined by cool shade trees for the traveler's rest and abundant fountains for drinking and washing, and which was a holy place with multiple shrines affixed to trees for the worshipping of the local gods. Gerbel's illustrator is in this instance so close to Poussin's conception that it is impossible to think that he did not know the *Greek Road* directly or from an engraved copy, but in any event we give here Aelian's description as translated from Blaise de Vigenère's French edition of Philostratus, which Poussin is known to have consulted on several occasions:

> Let us now represent Thessalian Tempe in speech: for it is very widely known that, if oration has the grace and power to explain things clearly, it cannot put before our eyes the things it wishes to have understood less artfully than do the most excellent masters of the art of painting. There is, then, a certain place situated between Olympus and Ossa, two mountains of a marvelous height, separated one from the other as though by the work of a god, between which there is a region the length of which extends about forty stades; and the width of which in some places is about a plethron, and in others even a little greater. Through this region and vale passes a river they call the Peneus, into the fullness of which many other streams flow together and empty their waters, thus enlarging it. There are also little places for rest and refreshment of all sorts there, though not always made by human hand, but appearing rather as the proper attributes of

spontaneous nature, which in first bringing the valley into being endowed it with a marvelous beauty. Ivies are there in abundance everywhere, well decked in branches and leaves, and in the manner of a copious vine they climb the length of the tree trunks, around which, springing from the base, they intertwine themselves. There is convolvulus in plenty, which clings to the cliffs and carpets them, so that the stone remains completely hidden and one can see nothing but the verdure alone. In the valley there are infinite glades, shaded completely by the leaves of the trees, which in the summer offer pleasant refuges for travelers, where they can take recreation and refreshment with great pleasure and comfort. There are numerous springs and fountains running with cool water, delicious, and very agreeable to drink. They say, moreover, that these waters are highly suitable for bathing, and beneficial to the health. There are little birds scattered from one side to the other, from their sweet and harmonious breasts filling the ears of those who travel along the road with song, accompanying them and sending them on their way with such pleasure that they are made to forget all their labor. On the two banks of the river are leafy bowers and retreats which, as I have already said, are all expressly for repose. And so the gentle Peneus flows lazily through this delightful Tempe, tranquil, smooth, and silent, as if it were oil, most abundantly covered with shadows cast by the branches and boughs of the trees thickly planted on either side. For the greater part of the day the heat of the sun is thus warded off, and the course of the water is kept from becoming heated, affording in this way a cooling refreshment to those who sail beneath. All the neighboring inhabitants come together here, making their sacrifices and feasting together.[12]

The two paintings of the *Greek Road* and the *Roman Road* are especially remarkable, as we have suggested, for being the very earliest examples of an attempt to distinguish and contrast the appearances of Greek and Roman civilizations. Such an interest in the forms of ancient cultures derives generically from the kind of antiquarian scholarship we have seen was promoted by Cardinal Francesco Barberini under the direction of Cassiano dal Pozzo, and in particular it was without doubt furthered by the Barberini (and later Vatican) librarian, the great geographer Lucas Holstenius, who was, in Thomas Ashby's opinion, "the first topographer of the [Roman] Campagna who really counts."[13] His most important and lasting work included the tracing of the ancient Roman aqueducts, highways and their minor tributaries in his invaluable commentary to Philip Clüver's *Italia antiqua* of 1624 (the first systematic study of the topography of ancient Italy), together with a close commentary to Stephanus Byzantinus on the cities of Greece, which is still included in the standard modern edition.[14]

Not all the ancient views painted by Poussin in his first, Historical landscape style, however, seem to be specifically identifiable. One of his first essays in landscape, for example, the *Landscape with a Snake* in the National Gallery in London (fig. 158), has so far resisted exact localization, whether in the world of antiquity or in Poussin's

158. Nicolas Poussin, *Landscape with a Snake*, National Gallery, London

contemporary Italy.[15] But a contemporary scene it is not, as a cursory examination of the architecture of the beautiful town nestled between the hills beyond the lake suffi-ciently indicates. Moreover, the central narrative episode depicted by Poussin—a woman seated by the road reacting with alarm at the sight of a youth suddenly frozen in horror at seeing a gigantic snake which enfolds the corpse of a dead man in a spring of water—certainly derives from an ancient source. This is a relief sculpture that ap-pears in identical form on two funerary urns, or cippi, one of Egnatius Nicephorus (fig. 159) and the other of Herbasia Clymenes (fig. 160), which in Poussin's lifetime were both in the Barberini collection.

The subject of the relief shown on the two cippi, which shows a man and a woman fleeing in terror from the sight of a third figure caught in the coils of a huge serpent, has long been known to be the story of Archemorus, the infant son of Lycurgus, who was killed by a snake when left alone by his nurse Hypsipile while she guided Adrastus to a spring of water, and whose death was subsequently commemorated by the estab-lishment of the Nemean Games.[16] However, although the urns were extremely well known in the sixteenth and seventeenth centuries, having often been copied in an-tiquarian sketchbooks and often published, among others by Jean Jacques Boissard in the *Romanae urbis topographia* of 1597–1602 (fig. 160), Janus Gruter in the *Corpus inscriptionum* of 1603, and Sandrart in the *Teutsche Academie* of 1675, their subject re-mained a mystery, no doubt owing to the fact that the figure crushed by the snake appears of adult size, in fact identical in size to the man and woman who flee from him.[17] The earliest correct identification of the subject was made in 1726 by Adam van Nideck, who in a footnote in his *Antiquitates sacrae et civiles Romanorum explicatae* sug-gested that "it nevertheless could be that this is Archemorus, the son of Lycurgus, king of Thrace." However, van Nideck favored another interpretation, which was in his time the standard one, and which was specifically inspired by the funerary context of the reliefs:

> I suppose therefore that this infant suffocated by a serpent which wraps itself around his body, these rabbits torn apart by eagles, this cock pulled to pieces by a bear, are so many emblems of the sad condition of men, for whom death, hidden in a thousand different guises, everywhere lays ambush from within its unavoid-able traps.[18]

In this interpretation van Nideck was following the opinion of the indefatigable Ber-nard de Montfaucon, who had written of the Egnatius Nicephorus relief in his *L'An-tiquité expliquée* of 1719:

> Two winged women occupy the corners, and they each have at their feet an eagle which holds a hare in its claws. These women hold a large festoon which falls below and encircles the inscription. Above the festoon one sees a completely mysterious thing: a young man, wrapped round by a serpent, falls on his head and drops an urn, which is overturned. Another youth and a young woman look

159. Funerary urn of Egnatius
Nicephorus, The Detroit Institute of
Arts, Detroit

160. Funerary urn of Herbasia
Clymenes, engraving from J. J.
Boissard, *Romanae urbis topographia,*
1597–1602

upon his fall with fright, and seem to wish to take flight. We have seen in the first volume, when we spoke of Mithras, that the man wrapped round by a snake signifies the sun and its circuit through the Zodiac; and this fall of a man encircled by a serpent apparently signifies that when a man is dead the sun falls for him, and that he will no longer sport beneath its course nor under its influences.[19]

The emphasis in both interpretations is on the suddenness and unexpectedness of death, from the grim encounter with which the young woman and youth flee in terror. And such too is the emphasis of Poussin's *Landscape with a Snake*, in which horror radiates outward from the grim aspect of the dead man and snake like the rings from a stone cast in a still pool, affecting first the young man poised for flight by the bank of the stream, then the young woman seated by the side of the road, who responds to his terror, and finally faintly stirring the awareness of a youth idling with his friends by the side of the lake, whose attention has been caught by the woman's sudden gesture. The skill with which Poussin represented the stages of fear was remarked upon by Félibien in two famous passages, even though he was ignorant of the point of departure for Poussin's invention in the two ancient funerary altars; and it is for this reason that the painting was for a long time known as "Les effets de la Peur," the title first bestowed upon it by François Fénelon in one of his *Dialogues sur la peinture*, in an imaginary conversation between Poussin and Leonardo da Vinci (whose theories of the passions Poussin took as a point of departure for expressing the theme of the *Landscape with a Snake*).[20] Although certainly in error as to Poussin's subject, confusing the subject with the means for expressing it, Fénelon's dialogue, following upon a careful reading of Félibien's descriptions of the passions depicted in the *Landscape with a Snake*, nevertheless sheds sharp light on Poussin's conception. The author of the *Télémaque* and the *Lettre à l'Académie française* (containing his "réflexions sur la grammaire, la rhétorique, la poésie, etc.") could not have failed to recall when contemplating Poussin's painting a similar famous, and highly influential "exercise in the passions" in Homer (*Iliad*, III, 33ff.): "As a man who has come upon a snake in the mountain valley steps back, and the shivers come over his body, and he draws back and away, cheeks filled with a green pallor; so in terror of Atreus' son godlike Alexandros lost himself in the hosts of the haughty Trojans." The simile was often imitated in ancient literature, most notably by Virgil (*Aeneid*, II, 378), and Macrobius pointed out the connection in his comparison of Homer and Virgil (*Saturnalia*, V, 11–12), thus ensuring its long life as a rhetorical and poetic *topos*. So well does the action of the terrified youth in Poussin's painting fit the spirit and the letter of Homer's simile, right down to his "green pallor," that it is reasonable to suppose that he too had it in mind. This is especially likely, not only in the light of his mature and long-standing conversance with contemporary and ancient poetry and poetics in general, which we have been tracing throughout this book, but also in light of his particular remarks on Virgil's diction in the letter on the Modes, which we adduced in chapter six in relation to the *Mars and Venus*.

However, in the absence of knowledge of Poussin's source and hence his subject, Félibien and Fénelon could only respond to the effects of his painting. And though it is possible that Poussin had a theory of his own, which we can never know, regarding the subject shown on the two Barberini cippi, one at variance with Montfaucon's and van Nideck's interpretations, nevertheless we can surely recognize his theme to be the unexpected encounter with death in an ancient landscape, in a natural and otherwise idyllic setting of perfected serenity and bliss. His theme, in other words, is that which is summarized in the literary concept of Arcadia.

Arcadia itself is not the literal setting for Poussin's painting of course, which is rather a reconceptualization in terms of ancient landscape of related themes that for a long time had preoccupied him, and which he had earlier expressed, not in pure landscapes, but rather in terms of mythological metaphors for the landscape and for natural existence, metaphors that he had especially learnt from Ovid's *Metamorphoses*. One need only call to mind paintings such as the blindingly bright *Realm of Flora* in Dresden or the darker and more somber *Triumph of Flora* in the Louvre, in which the tragic deaths of youthful lovers are redeemed in the immortally regenerative flowers of spring; or to recall the *Phaeton Requesting the Chariot of the Sun from Apollo* in Berlin, the dramatic *Diana and Endymion* in Detroit, the tender *Aurora and Cephalus* in London, the Boston *Mars and Venus*, or even the overtly allegorical *Dance to the Music of Time* in the Wallace Collection, in order to be reminded of what Panofsky felicitously characterized as Poussin's "elegiac absorption" in the great poetic theme of transience and mortality, a theme of the intensity of youthful love and blighted bliss enacted beneath the implacable movement of Apollo through the great band of the Zodiac, and of an immortality that is promised by love, not by an escape from Nature's wheel, but paradoxically by an absorption within Nature, its ineluctable processes, and its eternal transformations and renewals.

The great, indeed canonical expression of this theme by Poussin appears in the *Arcadian Shepherds* in the Louvre, a painting that, like the *Landscape with a Snake* (in which we see the triumphant sun rising over the tranquilly beautiful landscape from behind the hills beyond the dead youth's corpse), avoids recourse to the fictional characters of ancient fable, but which, unlike the *Landscape with a Snake* and despite its title, does not express its theme in terms of the landscape of antiquity or even Arcadia as such. In Poussin's second landscape style, on the other hand, there may be discerned a renewed concern with particular ancient places and their mystery and particular aura, this time expressed through a return to the gods of place that define the special and unique spirit of each—the twin Nymphs of the water reclining by their Sabine spring in the *Landscape with Two Nymphs* in Chantilly, for example; the peasants of Sicily with the Nymphs and Satyrs, and Polyphemus brooding on Mount Etna (and as Mount Etna) in the *Landscape with Polyphemus*; and the cave of Cacus on the prehistoric Aventine in the *Hercules and Cacus*. We shall now turn to a special consideration of two of these late landscapes, the *Birth of Bacchus* and the *Apollo and Daphne*.

POUSSIN'S PAINTING of the *Birth of Bacchus* (pl. X), more precisely entitled by Dora Panofsky the *Consignment of the Infant Bacchus to the Nymphs*, is best described in the words of Bellori, Poussin's close friend. Bellori's even more appropriate title for the painting—more appropriate because it indicates the interpretive problem set by Poussin's subject—was the *Birth of Bacchus and the Death of Narcissus*, and he described the picture in a manner explicitly reminiscent of Philostratus. Indeed it had been Poussin himself (whom both Dora and Erwin Panofsky showed was intimately familiar with the *Imagines* through the translated, copiously commented and luxuriously illustrated French edition of Blaise de Vigenère) who had advised Bellori to adopt Philostratus' manner of paraphrase when citing important paintings in his own *Lives of the Painters*, so that he might give some satisfaction, "not only to the general invention [of each picture], but also to the conceit and movement of each individual figure, and to the actions that accompany the affections."[21] Here is Bellori's description of Poussin's *Birth of Bacchus and Death of Narcissus*:

> The baby whom Mercury presents to that Nymph is the newly-born Bacchus. The Nymph is Dirce, daughter of the river Achelous, who receives him joyfully and admires the divinely born child. She is embraced about the shoulder by another Nymph, who points out the infant to the accompanying Naiads, who, seated in the water, turn in curiosity and gaze admiringly at him. Behold Jupiter in the clouds above, reclining in the bed where he gave birth to the child, and with him Hebe ministering ambrosia to him as a restorative. But it is the cave by the river that is wholly prodigious, for it is clothed in new vine leaves and new grapes interlaced with ivy, born at the birth of Bacchus. The god Pan sits on the hill above, joyfully blowing upon the sonorous reeds of his pipes, and the same image was also painted by Philostratus. The other figures in the corner of the painting are not part of this fable, because the painter, following the description and sequence of Ovid's *Metamorphoses*, continued with another fable, that of Narcissus, who through love of himself ended in death, and the painting shows him dead next to the water in which he used to mirror himself. He lies crowned with the flowers into which he was changed, and Echo sits nearby him, miserably enamored, who, leaning on her upper arm, by her harsh pallor perfectly appears transformed to stone.[22]

Bellori here states the problem of the painting simply, and it is one that has plagued scholars to this day. Why did Poussin bring together the apparently unrelated myths of Bacchus and Narcissus in one picture? He also supplies the key to an answer by telling us that Poussin followed the sequence of fables narrated by Ovid; by adding that he also followed Philostratus for the image of Pan piping on the hill above the grotto of the Nymphs (for, although Pan is part of the myth of Echo, he is not part of Ovid's telling of her story); and by inferring that he must surely have followed Euripides in conceiving the chief Nymph of this grotto as "Dirce, daughter of the river

Achelous"—for Euripides in the *Bacchae* is unique among all ancient authors in naming Dirce as the nurse of the infant Bacchus.[23]

The stories shown by Poussin are told in the third book of Ovid's *Metamorphoses*, which is devoted entirely to Boeotian myths. The book begins with the tale of Europa's brother Cadmus, his discovery of a mysterious spring of water arising from a dark cave inhabited by the dragon of Mars, his slaying of the dragon and sowing of its teeth, and his founding of the accursed city of Thebes. It continues with the myth of Cadmus' grandson Actaeon, and how he was pulled to pieces by his hunting dogs as punishment for gazing upon Diana bathing naked with her Nymphs in a cooling spring of water. This story is followed in order by the three myths to which Poussin refers in his painting: that of Cadmus' daughter Semele, incinerated in her bedchamber in Cadmus' palace when she looked upon the splendor of her lover Jupiter; the story of the twin births of their son Bacchus and his consignment to the Nymphs of the spring; and the tale of Echo and Narcissus, she who was turned to stone, and he who perished when gazing upon his own reflection in a spring of water. The book then ends with the terrible story of the impious Pentheus and his dismemberment by his own mother and Bacchus' Maenads when spying upon their rites on Mount Cithaeron. Although, as Bellori realized, Ovid's poetry cannot account by itself for any thematic unity of conception in Poussin's painting, nevertheless Poussin's theme does take as its point of departure a theory about the origins of Ovid's stories, which is that each of the Boeotian myths he tells is connected with one and the same place, a site permeated with primal terror, ancient mystery, and a magical poetry. That place is the sacred Theban fountain of Dirce, rising in the cave of Achelous and the Nymphs at the foot of Mount Cithaeron.

In Ovid's telling of the story of Bacchus' birth, the god was attended for a while by Semele's sister Ino, after which he was given over to the care of the nymphs of Nysa, who hid him in their cave and nurtured him with milk. Many ancient cities had laid claim to being the site of Nysa (at least ten according to Stephanus Byzantinus, as quoted by Blaise de Vigenère in his commentary to Philostratus), and they were located everywhere from India and Africa to the mainland of Greece.[24] When Bellori identified the Nymph who receives Bacchus in Poussin's painting as Dirce, however, and furthermore drew attention to the "cave that is wholly prodigious," he gave notice that the landscape is to be understood as set in the territory of ancient Thebes, one of the most sacred sites, which Nonnus called in the *Dionysiaca* the spring of "dragon-breeding Dirce, where Cadmus had slain the dragon of Mars."[25] As we have seen, Euripides, whose *Bacchae* is one of the most precious ancient testimonia describing the rites of Bacchus, is the unique authority claiming that the infant Bacchus was nursed at the fount of Dirce; and accordingly the Renaissance mythographer Natale Conti (whose *Mythologiae* Poussin is known to have consulted, perhaps in the Latin edition and certainly in the French translation of Jean de Montlyard, published in 1597 and republished by Jean Baudoin in 1627) tells of Dirce and the infant Bacchus by quoting Euripides directly in Latin translation:

> Acheloi filia
> Verenda pura virgo Dirce
> Tu enim tuis fontibus
> Iovis cepisti infantulum
> Cum femori igni ex immortali Iupiter
> Patiens arripuit eum,
> Ista ita locutus est:
> Veni, ò Dithyrambe, meum
> Masculum hunc in uterum, veni.[26]

(Daughter of Achelous, pure and reverend virgin Dirce, thou who once within thy springs received Jove's infant son, at the time when childbearing Jupiter snatched him into his thigh from the undying fire with this cry, "Come, O Dithyrambus, pass into this male womb of mine.")

Bellori, as we have also seen, went on to claim that Poussin had conceived his painting in the same manner that the image had been "painted" by Philostratus in the *Imagines*. His reference is to Philostratus' description of a painting of Semele, wherein he found the motivation for several elements in Poussin's painting, especially what Bellori calls the "prodigious cave" crowned with new vine leaves and ivy, as well as the appearance of Pan on the hill above. The description, here given in translation from Blaise de Vigenère's French translation of Philostratus, clearly derives from the Theban version of the story of Bacchus' impending nourishment by Dirce and her Nymphs next to Mount Cithaeron:

> But Dionysus, having rent his mother's womb, throws himself out of it, and, shining more brightly than a star, he makes the flame [that consumes her] look dark and gloomy by his radiance. The flame, for its part, dividing, fashions for him a cave more agreeable than the appearance of any I know in Assyria or Lydia; for ivy, with its beautiful clusters of berries, luxuriates all around it, and the grape vines there, together with thyrsus stalks, spring up so willingly from the earth that there are some which grow out of the fire itself. For this reason one must not be astonished if, in honor of Dionysus, the earth crowns the flames, since the two together must wildly revel with him in Bacchic fury; and make it possible to ladle out wine by the bucketful from the springs, and likewise to draw out milk from lumps of earth or from pebbles as though from two breasts. Listen to Pan, how he warbles to Dionysus on the crest of Mount Cithaeron; leaping and dancing, the word Evian in his mouth. But Cithaeron in human form will soon enough lament the woeful accidents which are destined there; for this occasion he is crowned with an ivy wreath, which he wears carelessly on his head, ready to cast it aside, for it is much against his wishes to see himself thus being prepared for the rites of Dionysus. And behold the furious Megaera, who plants a fir tree beside him and causes a fountain of living water to spring up, on account of the blood of Actaeon and Pentheus which must be shed there.[27]

Philostratus here marvelously accounts for Poussin's depiction of the prodigious cave entirely covered with vine, together with the ivy that sprouts spontaneously around the infant Bacchus' head and overgrows the rock upon which the grieving Echo leans, into which, as Bellori noted, by her pallor she seems to merge and be transformed. Within the arch of the cave appears an altar-like table laden with vessels for the miraculous new wine and milk. In a subtler way Philostratus also accounts for the brightness of the fiery sun hidden behind the damp and mysteriously dark mouth of the cave, a fertile conjunction of the forces of fire and wet earth that Poussin made even more explicit in his well-known preparatory drawing for the painting, also in the Fogg Museum, in which Apollo is literally shown rising within the flaming ball of the sun (fig. 161). More important still, Philostratus describes the cave set aside for the infant Bacchus as placed by a spring next to Cithaeron—a place that for Poussin could only be the pool of Dirce, for it was she whom Euripides named as the nurse of Bacchus. And Philostratus adds that this spring betokens the blood of Actaeon and Pentheus, in allusion to the fact, confirmed by Euripides in the *Bacchae* and by Nonnus in the *Dionysiaca*, that Actaeon and Pentheus were later to meet their deaths in the same place, by this same spring.[28]

161. Nicolas Poussin, *Consignment of the Infant Bacchus to Dirce and the Nymphs,* drawing, The Fogg Art Museum, Cambridge, Massachusetts

Moreover, as Dora Panofsky recognized, Philostratus, in his description of another painting showing the story of Narcissus, seems to identify the pool into which Narcissus gazed and where he died as also being the same spring where Bacchus was received by the Nymphs. Although Pausanias locates the pool of Narcissus as situated in Boeotia, though not in Thebes, Philostratus does specifically identify this spring as set in the cave of Achelous and the Nymphs, and he describes it in terms virtually identical to those he had used in describing the cave prepared for Bacchus in the painting of Semele. He furthermore adds that the cave was connected with the Bacchic rites of Dionysus, because it was inhabited by the Nymphs of the wine-press, or *lenai*, which Blaise de Vigenère translated as the *ministresses* of Bacchus:

> The pool truly represents Narcissus beautifully, but it is the painting that makes the pool visible, and everything that has to do with the story of Narcissus. The youth, having just left the hunt, has taken his stand on the bank, deriving I know not what satisfaction from the water, and he is enraptured by his own beauty; for, as you can also see, sparks dart like lightning from his glances. There is here in addition the cave of Achelous and the Nymphs, and it is all painted as it should be. . . . Nevertheless the pool is not unadorned with what pertains to the rites of Bacchus, since it is that which he produced for the benefit of his ministering Nymphs. It too is embroidered all around with vines and ivy, having most beautiful branches and buds, and also from one side to the other with grapes and thyrsi.[29]

Philostratus writes of Pan's birdlike warbling of the name of Evian at the advent of Bacchus on the slopes of Cithaeron, and Blaise de Vigenère glosses this reference to the Bacchic cry by quoting Persius, *Evion ingeminat: reparabilis adsonat Echo*—"The shout Evian redoubles, and resounding Echo answers."[30] Pan in Poussin's painting sits on the hill above the cave of Dirce and the Nymphs, not leaping and dancing as Philostratus had described him, but turned toward Echo and thoughtfully blowing a muted riff on pipes his lips barely touch. In myth Pan had been rejected by Echo, even as she in turn was spurned by Narcissus, but Poussin here plumbs more deeply into the particular mystery of this place, in which at the first appearance of Bacchus one senses rather than actually hears the first wild thrill of Pan's pipe, and the echoes resounding softly from the rocks and cave. In Pan and Echo Poussin expressed the hallucinatory and panicky, possessive powers that invest Cithaeron and the sacred spring of Dirce, powers soon to fill the Maenads and cause them to tear calves to shreds, that afterwards overwhelmed the dogs of Actaeon and the mother of Pentheus.

Pan is universally famous as Arcadia's god, but there were caves and grottoes sacred to Pan and the Nymphs everywhere in Greece, as attested by numerous ancient testimonia and a great many works of art.[31] One of these caves was on Mount Cithaeron, as, not surprisingly, Euripides also testifies in the *Bacchae*, and such caves sacred to Pan were places associated with strange phenomena, lending themselves to the kind

of hallucinatory and panic possession that overtook Pentheus' mother and aunts when they tore him limb from limb in an insane fury.[32] Perhaps the most famous of such caves was that dedicated to Achelous and the Nymphs in Athens, a place sacred to Pan, where Socrates in the *Phaedrus* is described as threatened by panic delirium.[33] There are many Attic relief sculptures of Achelous and the Nymphs, and indeed there has been recently excavated in the Athenian agora a relief sculpture showing Mercury consigning Bacchus to the Nymphs in the cave of Achelous, who appears together with Pan, Jupiter, and other deities.[34] The inclusion of Pan with the Nymphs in ancient representations of the infancy of Bacchus is in fact extremely common, an especially famous example being the Roman sarcophagus in the Walters Art Gallery showing the triumph of Bacchus and, on its lid, three episodes from the god's childhood: his first birth at the death of Semele, his second birth from Jupiter's thigh, and finally his consignment to the Nymphs by Mercury in a grotto presided over by Pan (fig. 162). A second sarcophagus with the infancy of Bacchus in the Walters also shows Pan prominently.[35]

Although none of these particular examples could have been known to Poussin, it is nevertheless certain that, in conceiving his painting of the Theban cave of Dirce, the cave was understood by him as being equally sacred to Pan, who was well known to be the leader of the Nymphs. This can be established on the basis of an etching of the *Consignment of Bacchus to the Nymphs* by the Roman artist Andrea Procaccini (fig. 163), reproducing a lost composition by his master, Carlo Maratta. Several of Maratta's preparatory drawings for the whole composition survive, however, among them one in the Frits Lugt collection in Paris (fig. 164), and another in the Kupferstichkabinett in Berlin, and they are sufficient to establish that the artist must certainly have known and was following Poussin's unusual invention closely.[36] In both drawings Mercury appears on the left with several Nymphs, to one of whom he tenders the infant Bacchus. Cadmus' palace is in flames behind, and Jupiter reclines in the heavens above. Pan is at the right, reclining in the mouth of a cave, looking upward in astonishment at the rich growth of foliage sprouting from the top of his grotto. Near him in both drawings, seated in shadow behind Mercury, a Nymph who is separated from her sisters sits alone on a rock, so that we may suppose her to be Echo, who was for love of Narcissus "in sasso trasformata"; and this conjecture is supported by the flowers displayed prominently in the center of the foreground in front of her, which, despite the breadth of Maratta's rendering, appear very like narcissi. Although Nymph and flowers are both absent in Maratta's final composition as it is recorded in Procaccini's etching, his initial scheme therefore followed Poussin closely in its assembly of mythical characters, if not in its poetic depth of feeling. Moreover, the dedicatory inscription on Procaccini's print, as well as Pan's position at the mouth of the flourishing cave, clearly identifies the cave of the Nymphs as also sacred to Pan:

> It was a fiction of the Greeks that Bacchus, having been extracted from the flames of his maternal home, was at the command of Jupiter carried by Mercury to the Nymphs of the fountains, so that they might raise him; to the stupefaction of

162. *Scenes from the Infancy of Bacchus*, Roman sarcophagus lid, Walters Art Gallery, Baltimore

163. Andrea Procaccini after Carlo Maratta, *Consignment of Bacchus to the Nymphs*, etching, Philadelphia Museum of Art, Philadelphia

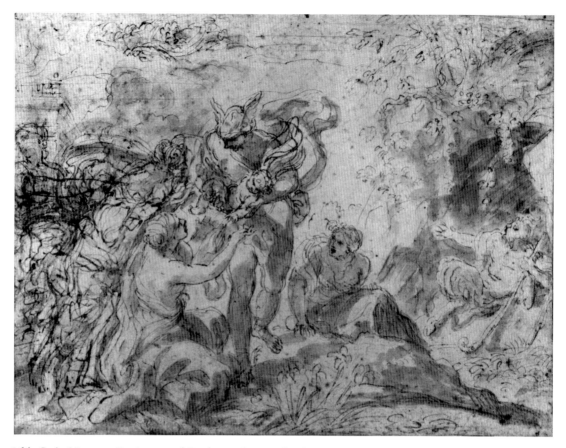

164. Carlo Maratta, *Consignment of Bacchus to the Nymphs,* drawing, Collection Frits Lugt, Institut Néerlandais, Paris

Pan, who, at the arrival of the infant boy, sees his cave spontaneously adorned with flourishing vines and clusters of white berries. This fable, so happily explicated in drawing by the most virtuous Cavaliere Maratta.[37]

The theme of Poussin's painting, the subject of which we might indicate by yet again retitling it, no doubt cumbersomely, as *The Fount of Dirce and the Cave of Pan and the Nymphs at Mount Cithaeron: the Birth and Consignment of Bacchus to Dirce, and the Death of Narcissus at Dirce's Fount,* is comprised of an extended poetic meditation upon the primal magic of a particular ancient, and very sacred place. At the advent of Bacchus, heavenly fire, in Philostratus' formulation, revels with the earth to produce the ivy and vines spontaneously springing up around the cave of the Nymphs, to which Poussin gave instinctive equivalent in the contrast of the hot brightness of the sun with the cool darkness of the cave and its pool.

WE MAY NOW TURN to Poussin's last painting, the unfinished *Apollo and Daphne* in the Louvre (pl. XI), a deeply absorbing conception that, as Bellori wrote, "lacks the final brushstrokes because of weakness and trembling in the artist's hand, and it was dedicated by Nicolas not long before his death to Cardinal Camillo Massimi in the knowledge that he would be unable to bring it to final completion, although in what he did paint it is most perfect."[38] The principal episode depicted by Poussin is indeed the story of Apollo and Daphne, but the picture is famous for the density and complexity of its additional mythological references, which seem to possess no relation to Poussin's primary subject, nor any narrative or conceptual unity save perhaps for comprising a generic assembly of stories related to Apollo. Apollo appears in red drapery at the left of the painting, tending a herd of cattle, shown in the center by the side of a lake with a mountain rising in the distance beyond. He is seated beneath an oak tree, and with his left hand grasps the top of his inverted lyre, which he holds firmly cradled against his side. Two Dryads accompany him. One, who clasps a branch of the tree, is dressed in blue and crowned with an oak wreath. The second, dressed in yellow, sits in the tree, her feet resting on the same branch held by her companion, and Apollo's python is coiled round the branch at her feet. Mercury has crept up behind the god, and deftly steals an arrow from his quiver. Cupid stands at Apollo's feet, aiming his lead-tipped arrow at Daphne, who appears seated at the far right-hand side of the painting. She is dressed, most unusually, as a huntress, wearing a short, belted tunic with a quiver cinched at her waist, and she embraces her river-god father. No fewer than six Nymphs are gathered around, again unusually, some of them standing and some reclining in the cool water in which they have evidently been bathing—as is indicated especially by the action of the maiden in the center foreground, who wrings the water from her hair. Finally, and most mysteriously, there appears a dead youth in the right middleground, just above and behind two Nymphs who recline at the feet of the river god. The youth is mourned by a shepherd leaning on his staff. A young girl kneels beside the shepherd, her attention absorbed by a heap of earth piled up near the head of the dead youth, towards which she gestures. The corpse has been identified by some interpreters as Narcissus, by others as Hyacinth, but both identifications have been challenged for good reasons, especially on the grounds that no flower may be seen in the young man's vicinity.[39]

It would be reasonable to suppose that the place shown by Poussin is the vale of Tempe in Thessaly, an actual *locus amoenus* that held a place in the Greek imagination similar to that later held by Arcadia in the Roman, and which by metonymic transfer was to become, as in Virgil's *frigida Tempe*, synonymous with any land of perfected natural beauty and terrestrial bliss. Thessalian Tempe is the site of Daphne's transformation in Ovid's canonical telling of her story in the *Metamorphoses*. The river Peneus, named by Ovid as Daphne's father, flows through Tempe, and the laurel-filled valley was a sanctuary sacred to Apollo.[40] It was in Thessaly that Apollo did penance for the

slaying of the Python by guarding the herds of King Admetus, in some accounts by the river Peneus, and in others by the river Amphrysus. Thus Servius, for example, comments on Virgil's characterization of the god as the "pastor ab Amphryso" (*Georgics*, III. 2), that "Amphrysus is a river in Thessaly, near which Apollo, despoiled of his divinity for the killing of the Cyclops, is said to have tended the flocks of King Admetus; hence he is now invoked by the name of Nomius, either from 'apo tes nomes,' that is, from shepherding, or 'apo ton nomon,' that is, from the law of musical chords."[41] And it was in Tempe that Apollo fell in love with Daphne, gave chase to her, and her metamorphosis into the laurel tree occurred. One detail of Poussin's painting in particular, however, interferes with the Thessalian hypothesis, and this is the mysterious appearance of the dead youth. If one accepts the identification of him as Hyacinth, whose story, like the others, is a part of the larger history of Apollo, then the place can not be in Thessaly, for Hyacinth was a Spartan, and it was in Lacedaemonia that his death occurred. If, on the other hand, one accepts his identification as Narcissus, whose story is entirely unconnected with the fable of Apollo, then this also is problematic because the story of Narcissus, as we have seen, is a Boeotian myth.

In the face of this interpretive knot, however, a wonderful happenstance occurs. There is a far older version of the myth of Apollo and Daphne than the one made famous by Ovid, and moreover one that tells how the god's giving chase to Daphne was preceded by his jealousy for a noble Arcadian youth named Leucippus, who loved her and who won her affections. Apollo caused the young man to be killed by Daphne's maiden companions when they wished to go swimming in the river Ladon in Arcadia, and they left his body lying by the river's edge. The story is told in abbreviated form by Natale Conti, whose *Mythologiae* we know that Poussin had quite certainly consulted when designing the series of paintings devoted to the story of Hercules for the Grand Gallery in the Louvre, using the French translation of Jean de Montlyard, first published in 1597 and republished by Jean Baudouin in 1627:[42]

> [T]he laurel was also dedicated to Apollo, since the Nymph Daphne, whom Apollo loved, was changed into this tree when she fled from him because she loved Leucippus more greatly, a beautiful, beardless youth of great valor. They say that Leucippus, at the instigation of Apollo who envied him for being loved by Daphne, being dressed as a woman and finding himself in the company of the other maidens, was invited by the young women to bathe with him in the river Ladon. This he refused to do, excusing himself as best he could, but in the end they carried him off and despoiled him of his clothing. In this way the companions of Daphne discovered that he was disguised, and they killed him with blows from their lances and daggers.[43]

The dominant myth of Apollo and Daphne depicted by Poussin in his painting is in fact extremely ancient, and it survives in more than one form. Like all such myths, it underwent changes and adaptations as it spread and was adopted in different centers for

the cult of Apollo which grew up throughout the Greek world; and it too produced the same variations in genealogies and narratives that are reflected in the multiple and contradictory stories of all the ancient gods which are recorded by both the ancient and Renaissance mythographers. The Thessalian fable immortalized by Ovid, which is the most familiar and widely diffused version of the myth, and which also has enjoyed the greatest post-antique literary and artistic fortune, is in fact a relative latecomer. The origins of the myth are either Arcadian or Elean, from whence it was diffused into Laconia, Thessaly, and finally as far as Syria.[44] As Lucian reports, "In Arcadia mythological tales are very numerous, such as the flight of Daphne, or the metamorphosis of Callisto into a wild animal."[45] The most ancient story of Daphne, like that of Callisto, arises from among a clearly defined group of Arcadian legends, including those of Atalanta and Arethusa, which concern wild, and fiercely misogamous young huntresses.[46]

In remotest antiquity Daphne was the daughter of the river Ladon in Arcadia (*Ladonis filia*, as Servius calls her), and she was a virgin Nymph pledged to Diana and the hunt.[47] The Ladon, fabled as the most beautiful river in the whole of Greece, had its source near Lake Pheneus (hence the confusion with the river Peneus, which flows through Thessalian Tempe), which lay at the foot of Mount Cyllene. It was there that Apollo tended his cattle, and for this reason was known to the Arcadians as Apollo Nomius—the *deus pastoralis* or shepherd god—as both Cicero ("[Apollo] in Arcadia, quem Arcades Nomionem appellant") and Clement of Alexandria ("the Arcadian [Apollo], called Nomius among the Arcadians") testify.[48] The cult of Apollo Nomius then spread from Arcadia (as we have seen occurred with that of Daphne, to which it is related) to other Greek centers, among them Thessaly, Epirus, Epidaurus, and Patrae.[49] It was on the slopes of Mount Cyllene that Mercury, one of whose most familiar epithets is Cyllenius, was born, and there that he stole the arrows and the cattle of Apollo. And it was in Arcadia that Daphne, before being chased and transformed by Apollo, was first loved by another, the noble youth named Leucippus, who disguised himself in woman's clothes in order to win her affections. When his deception was discovered by Daphne's maiden companions while bathing one hot day in the Ladon, the heat of the sun having been increased by Apollo in his jealousy, they killed him and left his body lying by the river's edge. Here is Daphne's story as told by Pausanias in his description of Arcadia (*Graeciae descriptio*, VIII. 20):

> Advancing about fifty stades from Lycuria, you will come to the source of the Ladon. I heard that the water making a lake in the territory of Pheneüs, descending into the chasms in the mountains, rises here and is the source of the Ladon, but I cannot say for certain whether this is true or not. The Ladon is the most lovely river in Greece, and is also famous for the legend of Daphne that the poets tell. I pass over the story current among the Syrians who live on the river Orontes, and give the account of the Arcadians and Eleans. Oenomaüs, prince of Pisa,

had a son Leucippus. Leucippus fell in love with Daphne, but despaired of winning her to be his wife by an open courtship, as she avoided all the male sex. The following trick occurred to him by which to get her. Leucippus was growing his hair long for the river Alpheus. Braiding his hair as though he were a maiden, and putting on woman's clothes, he came to Daphne and said that he was a daughter of Oenomaüs, and would like to share in her hunting. As he was thought to be a maiden, surpassed the other maidens in nobility of birth and skill in hunting, and was besides most assiduous in his attentions, he drew Daphne into a deep friendship. The poets who sing of Apollo's love for Daphne make an addition to the tale; that Apollo became jealous of Leucippus because of his success in his love. Forthwith Daphne and the other maidens conceived a longing to swim in the Ladon, and stripped Leucippus in spite of his reluctance. Then, seeing that he was no maid, they killed him with their javelins and daggers.[50]

A number of the descriptive details and episodes shown in Poussin's painting, a few of which have long seemed problematic, and many of which have not been noticed as problems at all, now find coherent explanation. The mountain in the distance, for example, and the lake by which Apollo's cattle are gathered, are topographically motivated, and can be recognized as Mount Cyllene in Arcadia, with Lake Pheneus below, near which is the source of the river Ladon, whom Poussin personified at the right-hand edge of the painting. Apollo Nomius, the Arcadian shepherd-god, sits in the midst of the nymphs, and Cyllenian Mercury steals an arrow from his quiver. He looks toward Daphne, depicted as a huntress wearing a short, belted tunic, a quiver at her side. A Nymph who has lately been bathing in the Ladon wrings the river's water from her hair. A dead youth lies by the river bank, his dress pulled down to his waist—for it is certainly no man's garment he wears, but a woman's gown that covers his body all the way down to his feet. He too finds motivation in the remotely ancient myths of the Arcadians, a people old beyond time, and in their stories of the shepherd Apollo and his love for Daphne, the huntress daughter of the river Ladon.

Poussin's last painting thus presents us with his final meditation on the great theme of Arcadia. It is well known that it was Virgil who was responsible for making one change in the tradition of Greek pastoral that was of great and permanent consequence for the later European tradition, and that was his substitution of the Greek Arcadia for Theocritus' Sicily as the geographical pretense for the purely literary *locus amoenus* which is the landscape of pastoral. In part this seems to have been inspired by the ancient tradition that Pan is the patron divinity of the shepherd's *locus amoenus*, and Pan, of course, was well known as Arcady's god. There is indeed an old tradition that pastoral was invented in Arcadia as the first strain of poetry to arise, after the end of the Golden Age, when shepherds and cowherds watching their flocks in the rough mountainsides sang songs in order to pass the time, and Pan as the deity of the woods and flocks naturally became associated with these songs.[51] This tradition is reflected in one

of Pan's epithets, which also is Nomius, translated, as we have seen, as the *deus pastoralis*, or god of the flocks; and it makes its appearance at the very beginning of the Renaissance revival of the forms of pastoral, in Sannazaro's tenth *Eclogue*, where the story is told that the genre was first introduced by Pan and then transmitted by Theocritus and Virgil to the herdsmen of the Italian Arcadia.[52] It is this tradition to which Poussin's painting is partly comment. For the mythographers of the sixteenth century, notably Giraldi and Conti, also report that the name the Arcadians gave Apollo was Nomius, the shepherd god, or *Apollo pastoralis* (as Poussin has shown him), a title that derives from the fact that he tended his herds by the Ladon.[53] Conti further attests that it was when Apollo kept the herds of King Admetus that he invented the harp, and that he was the first to set verses to music, an assertion that repeats in different form Servius' more explicit statement in the proem to his commentary on Virgil's *Eclogues*. Servius writes that there are those who maintain that Apollo Nomius was the inventor of bucolic poetry itself: "Alii non Dianae sed Apollini Nomio consecratum carmen hoc [Boukolikon] volunt, quod tempore Admeti regis pavit armenta."[54] According to this tradition it is Apollo, not Pan, who is the original bucolic, or herder of cattle, and it was he who first sang pastoral poetry to his herds in Arcadia.[55]

The spirit of the Arcadian Apollo makes divine Poussin's landscape, but it is not so much Apollo's role as the originator of pastoral poetry that is the subject of Poussin's meditation as it is the originating theme of poetry itself, that is to say the eternal theme of love and death in Arcady. Daphne's transformation into the poet's laurel has yet to occur, though it is incipient, and Apollo sits with his lyre in a landscape of oaks, not yet the singer but instead the principal actor in a story of doubly unrequited love. Cupid aims his leaden shaft at Daphne, beloved of Leucippus who lies dead by the Ladon; and beloved too of Apollo, whose love she is fated not to return. Even in its origins the sentiment of tragedy and loss invades the beauty of the place. Apollo's love is frustrated and Leucippus lies dead, the first to die for love in Arcady. His body is contemplated in mournful reflection by two figures, a shepherd who leans upon his staff, and a shepherdess who kneels down and seems to trace something on the tumulus of earth by which he lies. What is it that she traces? Do we not have here Poussin's final answer to the question of who lies buried in the most famous Arcadian tomb of all?

IT IS NOT NECESSARY here to recapitulate Panofsky's argument in his famous essays on Poussin's *Arcadian Shepherds* (pl. VIII), beyond recalling several basic observations. First of all, the inscription on the tomb—*Et in Arcadia ego*—was not invented by Poussin for the painting now in the Louvre but had been used first by Guercino in a painting of around 1618, and then again by Poussin about a decade later in an earlier version of the theme of the Arcadian shepherds, now at Chatsworth. In both works, as Panofsky deftly demonstrated, the meaning of the inscription is to be understood as a kind of *memento mori*, and in both a death's head placed upon the tomb is to be under-

stood as the speaker: "Even in Arcadia there am I."[56] The effect of the inscription, despite its Latinate invocation of an ideal classical landscape of literary sentiment, is to provoke a meditation on death in a Christian world. Indeed, although the origin of the phrase "Et in Arcadia ego" has not proven to be traceable earlier than its use by Guercino, a remarkable discovery by Judith Bernstock suggests that his painting (in which the shepherds contemplating the inscription are more modern than ancient in appearance and costume) was inspired by Franciscan, or even specifically Capuchin devotion. She deciphered an even earlier inscription, of 1585, appearing beneath a death's head in Annibale Carracci's *St. Francis Adoring a Crucifix*, now in the Accademia in Venice, which reads "Io imago della morte in mezzo dal paesaggio," and was quick to realize that the landscape of Franciscan devotion here invoked was very similar to that progressively idealized from Guercino to Poussin into the literarily perfected antique landscape of Arcadia.[57] In Poussin's later, and canonical treatment of the subject, however, the death's head is absent, and gone with it, as Panofsky argued, is any lingering trace of moralizing intent. In its place there appears a profoundly Virgilian meditation on the idea of Arcadia itself, an idea that is embedded in the meaning of the tomb and its occupant.

For it had been Virgil who created the idea of Arcadia as a territory of the imagination, a realm of perfect bliss that existed, never in the present and not so much as a Utopian dream of the future, but as a recreation of a golden past forever alive in memory and in sentiment. The particular sentiment of Arcadia is built upon lost youth, whether of the individual or the world, and it is poised upon the two most fundamental tragedies of life, frustrated love and death. It had been Virgil who, accordingly, raised the first tomb in Arcadia—the tomb of Daphnis, which he transplanted from its original home in Theocritus' Sicily and made, in a most un-Theocritean way, the poetic focus of that tension between the imperishable perfection of human bliss that defines the idea of Arcadian youth and love, together with the poignancy of its inevitable closure and death. The elegiac sentiment represented by Arcadia, and for which it stands, finds its most intensely poignant expression in the tomb of Daphnis, and in the inscription on it:

> Spargite humum foliis, inducite fontibus umbras,
> pastores (mandat fieri sibi talia Daphnis)
> et tumulum facite et tumulo superaddite carmen:
> 'Daphnis ego in sylvis, hinc usque ad sidera notus,
> formosi pecoris custos, formosior ipse.'[58]

(Spread the ground with leaves, ye shepherds, and form a shade over the fountains: Daphnis commands such things be done for him. Raise also a tumulus, and add a verse to the tumulus: 'I Daphnis was celebrated from these woods even to the skies: the shepherd of a beautiful flock, but more beautiful myself.')

165. *Daphnis Ego in Sylvis,* woodcut from *Publii Virgilii Maronis opera,* ed. S. Brandt, Strasbourg, 1502

The tomb of Daphnis was made the subject for an illustration to the fifth eclogue, from which the above quotation comes, in Sebastian Brandt's magnificent edition of Virgil's works, first published in Strasbourg in 1502 (fig. 165).[59] The tomb is, as the poet specifies, shown scattered with flowers in sign of mourning, and across its front appears the first phrase of Daphnis' epitaph: "Daphnis ego in sylvis." It is this phrase, as Panofsky realized (though he did not dwell on the point), that is the point of departure for the variant "Et in Arcadia ego," and that is also the foundation for Poussin's rethinking of the meaning of the inscription he inherited from Guercino (and his own earlier painting) in a way that renaturalized it in Virgilian sentiment. Daphnis' song was written on his tumulus as an epitaph, and Virgil in repeating the inscription means to refer to the extremely ancient custom of writing verses on burial mounds—"tumulus" being a word that originally meant a simple mound of earth raised as a monument.[60] It is just such a tumulus of earth that Poussin showed raised next to the

body of Leucippus in the *Apollo and Daphne*. Also significant is the fact that both "Daphnis ego in sylvis" and "Et in Arcadia ego" are themselves poetic verses. Virgil himself underscores the point by urging the shepherds at Daphnis' grave to raise a tumulus to his memory and to inscribe it with verses—"et tumulo superaddite carmen." That it was the custom to inscribe tumuli with verses is accordingly duly noted in commentaries from Servius and Donatus onwards.[61] In other words, the foundation to pastoral song, its fundamental and originating sentiment, is enshrined in the epitaph itself. The origin of the elegiac pastoral mode is the inscription on the tomb. Before the existence of the tomb in Arcadia there was no poetry there, for the place itself lacked its own defining, distinctive poetic aura.

And finally, we encounter the question of the inhabitant of that first tomb in Arcadia. This is not an easy question, and it was not one directly faced by Panofsky when he showed how the meaning of the inscription, "Et in Arcadia ego," which lacks both a name and a verb, was clearly altered from its original meaning in Guercino's and in Poussin's first treatment of the theme. In both earlier paintings it appears as a grim warning spoken by the skull, Death itself: "I too am in Arcadia." The understood verb is *sum*, in the present tense. In Poussin's second version, however, the Death's head is absent. The only possible speaker is thus the inhabitant of the tomb, who should speak in the past tense, "I too lived in Arcadia," and on this hypothesis Panofsky built his interpretation, even though he was fully aware that it was founded on a solecism: "Et in Arcadia ego fui." The solecism also appears from comparison of Poussin's inscription with that on Daphnis' tomb—"Daphnis ego in sylvis, hinc usque ad sidera notus"—in which the verb *notus* is again completed by *sum*, making a past tense: "I, Daphnis in the woods, was known from here even to the stars."

As we have seen in chapter five, one of the most important of Louis Marin's contributions to interpretation of the Louvre version of the *Arcadian Shepherds* was his reopening the issue of the inscription on the tomb, turning explicitly to the question, who is the *ego* that speaks? Marin wrote as a theorist, and his approach followed upon Benveniste's semiological work, as well as Merleau-Ponty's *Phénoménologie de la perception*, but at the same time he insisted that the methods of analysis he employed also had a historical dimension, especially as founded in the Logic of Port Royale, on which he was an authority.[62] Marin's analysis, which supported even as it extended and challenged Panofsky's reading, followed in part upon the Logic of Port Royale, according to which every declarative statement can ultimately be reduced to the pronoun *ego* and the verb *sum*; and in part upon the well-known conventions of that class of Roman funerary inscriptions that begin with an injunction to the traveler to pause—*Siste viator*—so that a message may be addressed to him from the tomb. Such messages are addressed from the past to the present (*fui*), but they are at the same time composed in the present (*sum*) for direct address to an indefinite future, creating the fiction that the deceased is in direct communication with the living. In a certain sense, to insist that the dead *can* only speak in the past tense is to fall into a schoolmasterish quibble, for

the very function (and the poignancy) of such inscriptions is to make the dead present, affirming their existence by allowing immediate utterance by the past in the present, permitting history to speak *now*, and without mediation to the living, just as a letter does. In fact tomb inscriptions written in the first person of the present tense do exist, but the important point is that to negate the *sum*, whether actual or implied, in such inscriptions is also to deny their particular poignancy, no less than the deeper poetry informing the *Arcadian Shepherds* and the many similar meditations ultimately descended from Poussin's *pensée*, among them Shelley's lines about the inscription carved on the pedestal of the monument to Ozymandias:

> "My name is Ozymandias, king of kings:
> Look on my works, ye mighty, and despair!"
> Nothing beside remains. Round the decay
> Of that colossal wreck, boundless and bare
> The lone and level sands stretch far away.

With equal pomp (and emptiness), and with much less poetry, the astonishing *sum* in the inscription on Sigismondo Malatesta's tomb in Rimini proclaims the willful force of a personality unable even to contemplate its own extinction:[63]

SVM. SIGISMVNDVS. MALATESTE. E. SANGVINE. GENTIS.
PANDVLPHVS. GENITOR. PATRIA. FLAMINIA. EST.

In Panofsky's interpretation, the grammatically correct translation of the inscription ET IN ARCADIA EGO, "Even in Arcadia there am I," became in Poussin's meditation an expression of the sentiment "I too was in Arcadia." This formulation, like Virgil's "Daphnis ego in sylvis," correctly acknowledges that the speaker must be understood as the occupant of the tomb, and it also is remarkably close to the true spirit of Virgil's poetry. Accordingly, as Panofsky went on to argue, Poussin reinvested his theme of Arcadian love and loss with the characteristic note of Virgilian bittersweet melancholy and recollection, turning his thoughts to a reminder of death which is softened by the added reminder that the intensity of youthful love and happiness, the principle of Arcadia itself, is eternal. For Panofsky the tomb was sufficient to sound this note, and he did not pursue the further point that, if the speaker is the occupant of the tomb, this implies, as for the tomb of Daphnis, that the inhabitant has a name.

Nevertheless, in the end the meaning of the inscription on the tomb remains indeterminate, with neither name nor verb. It refers to no person or action, and it was Marin's great merit to have recognized that its very indeterminacy is in fact at the core of Poussin's meaning. The viewer—*ego*—joins the small band of shepherds gathered round the tomb, and shares in their perplexity. As they contemplate the tomb *I* too contemplate the tomb, but also the painting of it, in which *I* read the mysterious inscription. And so the circle of referents widens: *Et in Arcadia ego*—is it the tomb that speaks, or its inhabitant?—is it the painting that speaks, or is it the painter?—is it the

reading spectator that speaks, or is it *I*? And in stressing this very indeterminacy Marin made his most important contribution, uncovering a subtle but unmistakable generic shift from the painting of history—recording the former existence of one who had lived in Arcadia—to that of allegorical fable—which mythologizes the past in the present and in future experience by means of Poussin's *pensée* freely playing upon the theme of love and loss presented by the subject he has chosen, Arcadia.

The allegorical fable that is unfolded in the *Apollo and Daphne* presents Poussin's final return to the great theme of Arcadia; and in the small group of the meditative shepherd and the kneeling girl who traces words on the tumulus next to the dead Leucippus we see the artist's explicitly self-referential return to the imaginative construction of the *Arcadian Shepherds*. We do not know the name of the person buried in the tomb in that earlier painting, and it would be clumsy to suggest that he must be Leucippus, retrospectively identifying him on the basis of the later group. Rather, in the mythological landscape of the *Apollo and Daphne* history and fable are joined together in Poussin's imagination to produce a new *pensée* on the theme of Arcadia. The historical Arcadia, a place the Greeks thought older than the moon, is populated with the ancient mythological beings that define its aura. In this landscape a tumulus is raised—not to the poet-shepherd Daphnis, who died in Sicily and was its first bucolic singer—but to Leucippus, who was the first to die for love in Arcadia, and whose death was followed by Apollo's pursuit of Daphne and her metamorphosis into the poet's bay.[64] There are no laurel trees in this Arcadia, for Apollo has not yet sung. Poussin's theme is not yet the poet but his subject, the theme of tragic love and death that is forever identified with the place Arcadia. It is the theme that initiated the genre of pastoral, the sentiment preceding the poem and willing its existence. It is the theme first sung by Apollo Nomius, the shepherd god, when he mourned the loss of Daphne to his cattle as they grazed.

NOTES

INTRODUCTION

1. For this and what follows, see the Preface to Blunt, 1967.

2. Blunt, 1953, p. 195.

3. Mahon, 1947.

4. Blunt, 1967, p. 6. The statement goes back to an assertion made by Friedlaender, 1957, p. 53.

5. Cited from Shiff, 1984, p. 136, quoting from Denis, "De Gauguin, de Whistler, et de l'excès des théories."

6. Shiff, 1984, p. 135, quoting from Denis' review of the Salon d'automne of 1905.

7. Shiff, 1984, p. 180.

8. As quoted by Shiff, 1984, p. 175.

9. As quoted by Shiff, 1984, pp. 181–182.

10. Blunt, 1953, p. 195.

11. Fumaroli, 1992, p. 11.

12. Friedlaender, [1966], p. 11.

13. Montaigne, 1965, p. 504 (II: 18, "Of Giving the Lie").

14. Montaigne, 1965, p. 2 ("To the Reader").

15. Montaigne, 1965, p. 611 (III: 2, "Of Repentance").

16. Montaigne, 1965, p. 612 (III: 2, "Of Repentance").

17. Montaigne, 1988, p. 806 (III: 2, "Du repentir"). Translated in Montaigne, 1965, p. 612.

18. Montaigne, 1965, p. 834 (III: 13, "On Experience").

CHAPTER ONE

1. Passeri, 1934, p. 182. See further Cropper, 1984, pp. 11–18.

2. Sandrart, 1925, pp. 288–289.

3. Blunt, 1967, pp. 54–57.

4. Cropper, 1984, p. 13. See also Solinas and Nicolò, 1988.

5. See the standard account in Wittkower, 1973, esp. pp. 261–278.

6. Wölfflin, 1915.

7. See Kurz, 1960; and also Martin, 1977, pp. 11, 297, and 306–307.

8. Wellek, 1965.

9. Harris, 1977, pp. 26–30, is representative of the various scholars who have chafed against the generic opposition of classic-baroque for being too general and imprecise to apply in the close study of a particular artist, even one so closely identified with seventeenth-century "classicism" as Andrea Sacchi.

10. Brendel, 1962. See also the *Encyclopedia of World Art*, s.v. "classicism."

11. Winckelmann, 1764 (recte late 1763). For useful brief summaries of Winckelmann's achievement, see Honour, 1968, pp. 57–60; and Haskell and Penny, 1982, pp. 99–107. See further Justi, 1898; Hatfield, 1943; Leppmann, 1970; and Potts, 1978 and 1994.

12. As an indication of how powerful this idea remains, see E. H. Gombrich's statement that, "Such a morphology of styles as we have we owe to the stability and identifiability of the classic solution. . . . We know what we mean when we call Raphael's Madonnas more beautiful than Rembrandt's, even though we may like Rembrandt's better" (Gombrich, 1966, pp. 95–96). See also Cropper, 1994.

13. It is significant, of course, as has often been pointed out (see Honour, 1968, pp. 31–32), that Mengs' *Parnassus*, painted for the main room in the Villa Albani in Rome, with its famous collection of ancient sculptures, seeks to recreate an idea of classical perfection with reference not only to antiquity but also to the paintings of Raphael and Domenichino.

14. Affò, 1794, p. 41.

15. Cropper, 1984, p. 13.

16. Passeri, 1934, p. 112.

17. Blunt, 1967, pp. 232–233.

18. Nava Cellini, 1982, p. 77.

19. Bellori, 1976, p. 435. For the painting see Blunt, 1966, pp. 19–20, no. 22.

20. Dempsey, 1963.

21. Blunt, 1967, pp. 233–235; and, for the drawing, p. 181, fig. 149.

22. The principal figure in the painting in

the Prado, known only as a *Landscape with Buildings*, also wears the *duplex pannum* and carries the *baculum*. He too is clearly meant to represent Diogenes (whom he physiognomically resembles), and the painting, as we shall see in chapter three, may be more satisfactorily entitled *Diogenes Departing Sparta for Athens*.

23. See also Blunt, 1967, pp. 192–193.

24. For the *Minerva Giustiniana*, see Haskell and Penny, 1982, p. 270, fig. 140; and for the *Liceo della Pittura*, Cropper, 1988, pp. 76–82, no. 41.

25. See Cropper, 1984, pp. 65–95, for a thorough discussion of the imagery of *Il Liceo della Pittura*. The bust of Minerva in *Altro diletto ch'imparar non trovo* (Cropper, 1988, pp. 220–224, no. 101), incidentally, is also copied from the *Minerva Giustiniana*.

26. See Haskell and Penny, 1982, p. 265, fig. 137.

27. Bottari and Ticozzi, 1822–1825, VI, pp. 135–136.

28. Huse, 1970, observes correctly that the *Sta. Susanna* also clearly evinces Duquesnoy's close study of the Cesi *Juno*.

29. Bellori, 1976, pp. 289 and 426. See also Kauffmann, 1960a, for drawings by Poussin after the *Antinous*, the *Laocoon*, and the Belvedere *Apollo*.

30. Conférence of 5 November 1667, in *Conférences*, 1883, pp. 48–65; see also Félibien, 1725, IV, pp. 120–122 (*Entretien* VIII, in Pace, 1981, p. 139).

31. Haskell and Penny, 1982, p. 275, fig. 143.

32. Haskell and Penny, 1982, p. 338, fig. 179.

33. Haskell and Penny, 1982, p. 197, fig. 102.

34. Haskell and Penny, 1982, p. 149, fig. 77 for the *Apollo*; and p. 327, fig. 173 for the *Venus*.

35. Haskell and Penny, 1982, p. 188, fig. 97.

36. See Perrier's *Segmenta nobilium signorum et statuarii quae temporis dentem invidium evasere*, Rome and Paris, 1638; and his *Icones et segmenta illustrium e marmore tabularum quae Romae adhuc extant*, Rome and Paris, 1645.

37. For the Farnese *Hercules*, see Haskell and Penny, 1982, p. 231, fig. 118.

38. *Conférences*, 1883, p. 113.

39. *Conférences*, 1883, p. 174.

40. See the text of Agucchi's *Trattato* published by Mahon, 1947, pp. 241–258.

41. *Conférences*, 1883, pp. 91–92. See also Fried, 1986. For Rubens' idea that men in antiquity may have been more perfectly formed than in later ages, see Muller, 1982, esp. pp. 231–233.

42. Boselli, 1978, folio 11 verso.

43. Besides Le Brun's lecture on *The Israelites Gathering Manna*, see also Sébastien Bourdon's lecture on Poussin's *Christ Healing the Blind*, now in the Louvre (Blunt, 1966, pp. 52–53, no. 74). There he observes that the artist based one of the men on the Farnese *Wounded Gladiator*, another on the *Apollo Antique*, and one of the women on the Medici *Venus* (*Conférences*, 1883, p. 72).

44. Boselli, 1978, folio 11 verso.

45. Haskell and Penny, 1982, p. 273, fig. 142.

46. Haskell and Penny, 1982, p. 310, fig. 164.

47. Haskell and Penny, 1982, p. 166, fig. 85.

48. Haskell and Penny, 1982, p. 228, fig. 117.

49. Haskell and Penny, 1982, p. 217, fig. 113.

50. The ancient and modern canons for representing infants are analyzed by Colantuono, 1986; and see also Colantuono, 1989.

51. Boselli, 1978, folio 3 recto and verso. For the equestrian *Marcus Aurelius*, see Haskell and Penny, 1982, p. 253, fig. 129. See the same for the Borghese *Gladiator* (Louvre), p. 223, fig. 115; for the *Fauns* (Museo delle Terme, Museo Nazionale Romano), p. 287, fig. 151; for the *Orestes and Pylades* (Prado), p. 175, fig. 90; for the *Pasquino* (Piazza del Pasquino, Rome), p. 292, fig. 153. For *The Deification of Homer* (British Museum, London), see Bieber, 1955, fig. 497.

52. The Medici *Venus*, Borghese *Gladiator*, Farnese *Hercules*, and Belvedere *Torso*, for example, are all signed in Greek, while the *Laocoon* and Farnese *Bull* correspond to statues attributed to Greek sculptors by Pliny. Statues like the *Antinous* and the equestrian *Marcus Aurelius* were thought to be by Greek sculptors, and Bellori indeed reports in a letter to Carlo Dati that the latter was by an Athenian who signi-

fied his origin by figuring the foretop of the horse's mane in the shape of an owl.

53. Boselli, 1978, folio 10 verso.

54. Boselli, 1978, folios 9 verso and 10 recto.

55. Boselli, 1978, folio 11 recto.

56. For a discussion, see Honour, 1968, p. 31.

57. It is undoubtedly here, even as Poussin and Duquesnoy were forming an idea of Greek form and expression, that we find the origins of the reaction against Michelangelo's style (as opposed to sixteenth-century Counter-Reformatory attacks on his handling of the subject of *The Last Judgment* in the Sistine Chapel). The revision downward of Michelangelo's relative standing within the artistic canon is notoriously a phenomenon of French academic criticism, and indeed provides an important touchstone for distinguishing the values of this criticism, which is firmly based in the thought and achievement of Poussin, from those of the Italians. See in particular Roland Fréart de Chambray's *Idée de la perfection de la peinture*, first published in Le Mans in 1662 (not only for its attack on Michelangelo but also for its praise of the proportions and *taille* of the figures in Raphael's design of *The Massacre of the Innocents*); see also Thuillier, 1957.

58. See Dempsey, 1977.

59. Félibien, 1707, pp. 20–21.

60. Quoted by Boselli, 1978, folio 10.

61. For Bernini as a restorer of ancient statues, see, for example, his celebrated and extensive additions to the Ludovisi *Mars*, excavated at some moment around 1623 during the building of the Villa Ludovisi (for which, see Palma, 1983).

62. Bellori, 1976, p. 556.

63. See Poussin's letter of 24 November 1647 to Chantelou, in *Correspondance*, 1911, pp. 370–375; and see chapter six below.

64. De Piles, 1990, p. 94. For De Piles see also Puttfarken, 1985.

65. De Piles, 1990, p. 94.

66. See Fried, 1980.

67. Cropper, 1988, pp. 235–239, no. 110.

68. Passeri, 1934, p. 183.

69. Bellori, 1976, pp. 289–290 and 299–300.

70. Colantuono, 1986, pp. 37–40.

71. Bellori, 1976, p. 299.

72. Bellori, 1976, p. 299.

73. Blunt, 1962; and Blunt, 1966, p. 177, no. R107. There have been numerous attempts to rehabilitate the Fort Worth picture as by Poussin, as well as other problematic "early" paintings rejected by Blunt, by assigning them, often on the basis of hopeful readings of the inventories of Cassiano dal Pozzo's descendants, to the years immediately following Poussin's arrival in Rome (see Standring, 1988). Suffice it here to cite only Oberhuber, 1988, published in conjunction with an exhibition held at the Kimbell Art Museum, as representative of the state of the question. For a contrary view, see the authors' reviews of this exhibition (Cropper, 1988b) and of Mérot, 1990 (Dempsey, 1991).

74. For a detailed study of the imagery of the four *Seasons* by Testa (Cropper, 1988, pp. 160–179, nos. 74–83), see Cropper, 1974.

75. For a detailed discussion of the print, see Cropper, 1984, pp. 45–46, 54. And for the *Laocoon* as an *exemplum doloris*, see Ettlinger, 1961. Although the *Laocoon* had been taken as the *exemplum doloris par excellence* ever since its discovery early in the sixteenth century, there is a significant difference in interpretive positions regarding the way in which it exemplifies pain: on the one hand through the representation of the *affetti* in Laocoon's anguished face and muscles straining against the serpent's coils; and on the other through an empathetic response conditioned by the proportions and contours of the body. The latter of course corresponds to the position developed by Poussin and Duquesnoy. See further the discussion of the rhetorical concept of *enargeia* in chapter six.

76. See Dempsey, 1977, pp. 65–71. Poussin's analysis of the various types of female beauty in his *Eliezer and Rebecca*, together with Testa's notes on female beauty in the Düsseldorf Notebook, have been discussed in Cropper, 1976; and see further chapter eight.

77. Thuillier, 1957, pp. 353–354.

78. Haskell and Penny, 1982, p. 42.

79. Quoted in Haskell and Penny, 1982, p. 73.

80. Quoted in Haskell and Penny, 1982, p. 30; the Barberini *Faun* (Glyptothek, Munich) and *The Dying Gladiator* (Musei Capitolini, Rome) are reproduced, respectively, on p. 203, fig. 105, and p. 225, fig. 116.

81. Haskell and Penny, 1982, p. 102. The quotations are from W. Pater, *Studies in the History of the Renaissance*, London, 1873, p. 164; and from J. A. Galiffe, *Italy and its Inhabitants: An Account of a Tour in That Country in 1816 and 1817*, 2 vols., London, 1820, I, p. 247.

82. See Raggio, 1985 (from which the quotation from Johann Adam von Liechtenstein is taken), pp. 63–65 and nos. 49 and 50. The latter catalogue entries are for two exquisite bronzes, respectively a *Mercury* and *Apollo*, both based on the proportions and contour of the *Antinous*. The former may be the bronze commissioned by Vincenzo Giustiniani as a pendant to an ancient bronze of *Hercules* in his collection (now in the Villa Albani in Rome). Both the ancient statue and Duquesnoy's bronze were reproduced in the *Galleria Giustiniana*. See chapter two below.

83. Bellori, 1976, p. 291.

84. Wittkower, 1973, p. 275. As Wittkower, p. 274, remarks, Bellori's regarding of the *Sta. Susanna* as establishing a modern canon "was perfectly justified, since there is hardly any other work in the history of sculpture, not excluding Bernini's most important statues, that had an effect as lasting as Duquesnoy's *Susanna*."

85. Bellori, 1976, p. 294.

86. See Consagra, 1988.

87. Le Brun, 1698.

88. See Wellek, 1965; and for Testa's later influence Cropper, 1988a.

89. See Wiebenson, 1964; and also Cropper, 1988a.

CHAPTER TWO

1. Ruggieri drew twelve plates for Volume I of the *Galleria Giustiniana*. Podestà contributed one to each volume. Mellan engraved twenty-four in all. Vaiani drew three. The *Mercury* Duquesnoy made for Giustiniani appears in Volume I, as plate 84, engraved by Mellan (fig. 50). For Duquesnoy's career, see most recently Nava Cellini, 1982, pp. 72–81, 84–85.

2. Salerno, 1960. On the Palazzo Giustiniani, see Toesca, 1957; and *I Palazzi del Senato. Palazzo Cenci, Palazzo Giustiniani*, Rome, 1984 (often unreliable).

3. Haskell, 1963, pp. 98–119.

4. See the comment in *Naudaeana et Pati-*

niana, Amsterdam, 1703, cited by Haskell, 1963, p. 99, n. 5, that Cassiano "a six mil livres de rente." Joachim von Sandrart, by contrast, boasted of Giustiniani's annual income of 80,000–90,000 crowns; Sandrart, 1925, p. 277.

5. For the letter of 12 April 1653, see Cropper, 1988a, pp. xxxiii–xxxiv, n. 15.

6. For the letter of 14 September 1624 from Girolamo Aleandro to Nicolas Fabri de Peiresc, see Cropper, 1988a, p. xxxiv, n. 15. For Peiresc's letter, in which he refers to the *Galleria* as unfinished, comparing it to Bosio's *Roma sotterranea* (1632), see Solinas and Nicolò, 1988, p. lxxix.

7. Freedberg, 1989. On the engravings, see Ficacci, 1989, pp. 324–327, no. 108.

8. Ficacci, 1989, p. 259, no. 66, for Mellan's portrait drawing of Anna Maria Vaiani, wife of Jacques Courtois. See also the brief notice in Albricci, 1973.

9. The inventories published by Salerno show that Giustiniani owned several works by an assortment of artists from the younger generation, including Claude, Artemisia Gentileschi, Lanfranco, Lemaire, Perrier, Van Laer, Poussin, Ranieri, Ruggieri, Spierincks, Swanevelt, Testa, and Vignon. See also Haskell, 1963, pp. 10, 29–30, 94–95, and 135. Haskell believes that Vincenzo was out of sympathy with "the Baroque masters of the new generation" (p.95), but his interest in Lanfranco (by whom he owned four paintings) suggests otherwise.

10. For the history of the collection, see Gasparri, 1980. See also the important articles by Guerrini, 1986, and by Guerrini and Carinci, 1987.

11. Guerrini, 1971, pp. 36–38. In 1766 R. Venusti described statues and oriental stones "of great value" in the collection; and in 1780, praising the Uffizi's incomparable collection of busts of emperors, Luigi Lanzi wrote that no Roman family "not even the Giustiniani" so rich in marbles had anything like it; see Barocchi, 1982, pp. 1470–1471.

12. Haskell and Penny, 1982, p. 26; on the *Marble Faun* and the *Minerva*, see further pp. 209–210 (no. 36), and 269–271 (no. 63). See also Baccheschi, 1989.

13. See, for example, Guerrini and Carinci, 1987, p. 177, for the suggestion that the *Galleria* was a "monumento pensato e dedicato a sé stesso."

14. See, for example, Haskell and Penny,

1982, p. 26, for the description of the *Galleria* as an illustrated catalogue, "the first of its kind ever to appear," and of Sandrart's attention to it as "disproportionate," his illustrations as "fanciful." This is not an isolated view. Mistrust of Sandrart's account of his role in the production often underlies it; see, for example, Mariette's sceptical comments in the *Abecedario*, as cited by Ficacci, 1989, p. 39. See further, Guerrini, 1971, p. 37.

15. Guerrini, 1986, p. 70, proposes that most of Cassiano's drawings of pieces then in the Giustiniani collection were made before Vincenzo acquired them in support of her view that the Marchese bought many of his pieces from collections in dispersal around 1600. Only one Giustiniani acquisition has been documented, but the *Museo Cartaceo* contains several more modern drawings after other sculptures in the Giustiniani collection. The inventory numbers cited by Gasparri are not always reliable, however, and an exhaustive comparison of the Giustiniani collection with the dal Pozzo drawings has yet to be undertaken.

16. The recent discovery in Genoa of most of the copper plates for the *Galleria* has prompted renewed interest. See, in particular, Algeri, 1985, as well as the notices by Ottria, 1989; see further Ficacci, 1989, pp. 288–292.

17. Algeri, 1985, pp. 71–72, 88, n. 11, points out that the importance of Rubens' comment was recognized long ago by Kutter, 1907, p. 60, n. 51, but practically ignored ever since. For the letter of 4 September 1636, see Rubens, 1987, pp. 485–486. The editor's note in this edition, stating that the *Galleria* appeared in 1640, follows the standard view. 1640 was, however, the year in which Rubens succeeded in getting his copy bound, for which see now D. Jaffé, 1989, p. 134.

18. D. Jaffé, 1989, pp. 134 and 141–142.

19. See n. 6 above. For Sandrart's departure from Rome, see Klemm, 1986, pp. 338, 352, nn. 29 and 37.

20. The inscription reads: *Vincentius Iustinianus Josephii F. Claud. Mellan Gall. del. et sculp. Romae 1631 sup. pm.* This print, reused for the frontispiece to Volume II (with the inscription *Parte Seconda* added), is the only one for which a permission was granted. Possibly Vincenzo or Mellan intended to give it wider circulation and wanted protection of copyright.

Ficacci, 1989, pp. 294–295, publishes the preparatory drawing, now in the Albertina, on which has been written "*Incidatur.*" On such permissions in Rome in the seventeenth century, see Consagra, 1988, pp. lxxxviii–lxxxix.

21. Klemm, 1986, pp. 337, 352, n. 29.

22. For Peiresc's letter to Barberini, see Biblioteca Apostolica Vaticana, Barb. Lat. MS. 6503, f. 179; for Peiresc's letter to Cassiano, see Bibliothèque de l'Ecole de Médecine: Bibliothèque Interuniversitaire, Montpellier, MS. 271, II, f. 14. Both these references we owe to David Jaffé.

23. Ficacci, 1989, p. 292, argues that the project was complete when Vincenzo deposited this request. The text of the note is published by M. Giustiniani, 1669, pp. 63–64; see also Bottari and Ticozzi, 1822–25, VI, pp. 145–147; and Algeri, 1985, pp. 86–87, n. 5. The provision of the will was known to Pier Leone Ghezzi, who describes Alfonso Giustiniani's discovery on a visit to Genoa of the plates covered in verdigris in a credenza. Ghezzi, who owned several loose prints, reports that foreigners paid up to 160 scudi for the two volumes. See Guerrini, 1971, pp. 37–38.

24. In his letter of 17 May 1636 (Aix-en-Provence, Bibl. Mejanes MS. 210, p. 210), to Peiresc about Rubens' description of the ancient *ninfeo*, cited by D. Jaffé, 1989, p. 141. For Rubens' letter to Peiresc of 16 March 1636, see Rubens, 1987, pp. 481–484.

25. Algeri, 1985, p. 84; see also p. 90, n. 41, for clarification of Hoogewerff's proposed date of 1636. Klemm, 1986, pp. 337 and 352, n. 34, proposes this date, following Sandrart's account, even though the *Stati delle anime* record the presence of only four engravers in 1635, the year of Sandrart's departure.

26. See Algeri, 1985, pp. 84 and 90, n. 39. For Perrier, see Schleier, 1968, and Schleier, 1972. See also Rosenberg, 1982, pp. 299–300; and Thuillier, 1993. On Perrier as a printmaker, see A. Clarke's monographic article, forthcoming.

27. These were plates 98, 99, 139, 142, all engraved by Bloemaert. Perrier would contribute four more drawings to Volume II.

28. Olga Raggio proposed the attribution to Duquesnoy of this "restored" piece, now in The Metropolitan Museum, in a lecture at the Bibliotheca Hertziana, Rome, in 1983. Her proposed date of c. 1629 for the restoration seems,

however, to follow the traditional dating of the *Galleria*, according to which 1631 was a *terminus ante quem*. The possibility remains, of course, that the restoration was executed before the sculptor met his patron, but this seems unlikely. On Duquesnoy and Giustiniani, see Nava Cellini, 1966, esp. p. 46. See also Faldi, 1959.

29. Birke, 1987, pp. 22, 92; and Ficacci, 1989, p. 291.

30. Ficacci, 1989, p. 65.

31. Sandrart, 1925, p. 382, n. 36. After mentioning the 270 ancient pieces of sculpture he bought for Vincenzo, and the 500 in the *Antiquario*, Sandrart states that he drew 160 of the most famous *in folio*, and had them engraved. Elsewhere, he describes Vincenzo's plan for "ein grosses Buch von allen seinen Antichen Statuen" (p. 30), adding that the other engravers were brought to Rome because Vincenzo wanted to see the project finished. Sandrart also states, however, that the *Galleria* contained prints of "der bästen Antichen Statuen in folio 150, der Bassa rilieven aber, das ist halb-runden, 50" (p. 247). Possibly this last figure represents the number of plates after bas-reliefs completed when Sandrart left Rome. Many plates in Volume II are unsigned.

32. Salerno, 1960, pp. 25-26, citing the *Testamento dell'Ill.mo Sig. Vincenzo Giustiniani*, Rome, Ludovico Grignani, ASR, Archivio Giustiniani, Busta 16. Vincenzo's inheritance passed to Andrea di Cassano Giustiniani, who married Maria Pamphili, niece of the future Innocent X.

33. Those who have described the *Galleria* as a catalogue have not associated it with the *fideicommissum*. Bloemaert's eight engravings after paintings in the collection, sometimes appended to Volume II (the first edition at the Library of Congress includes them, whereas the second edition in the Marquand Library, Princeton University, does not) suggest that the project to reproduce the collection was originally even grander. See Algeri, 1985, p. 88, n. 17.

34. On the illustrated catalogue, see Borea, 1979, esp. pp. 389-396. Borea cites David Teniers' *Theatrum Pictorium* (Antwerp, 1658) as the first monumental example of an illustrated catalogue (of Archduke Leopold Wilhelm's collection). Her statement that Italian collectors

were slow to take up this medium on account of cost is not wrong, but her claim that Urban VIII was the first to have his collection engraved (H. Tetius, *Aedes Barberinae ad Quirinalem descriptae*, Rome, 1642), should be amended to take into consideration the *Galleria Giustiniana*, as Haskell and Penny have also suggested.

35. Lugli, 1983, pp. 93-94. Lugli's observation that the published catalogue (as opposed to the private inventory) represents a golden moment when the collector/author creates an ideal portrait of a completed collection in need of protection from dispersal, is highly suggestive here. See also Lugli, 1986. Almost all early catalogues, she notes (citing Walter Benjamin's reference to the pride of appearing together with one's collection), open with the portrait of the author.

36. Sandrart, 1925, p. 382, n. 36. For the tradition of public access to gardens, see Coffin, 1982.

37. Sandrart, 1925, p. 382, n.36.

38. Prinz, 1970; but see also Nencioni, 1982. V. Scamozzi, *Dell'idea della architettura universale*, Venice, 1615 (cited by Prinz, pp. 10-11) associates the gallery with Lucullan grandeur, and attempts a derivation from *Gallia*, or France, where *gallerie* were first introduced. Giustiniani saw the galleries at the Louvre on his journey to northern Europe in 1606.

39. Nencioni, 1982, p. 1527.

40. Pieces seem to have been arranged according to type and theme in the palace and villas (perhaps by Sandrart himself), but a full reconstruction of the history of the display remains to be attempted. In 1793 Pacetti describes the Gallery as containing "le statue più classiche," for which see Gasparri, 1980, p. 98. Gasparri adds that by that later date, in addition to the Minerva and the Hestia, and pairs of Venuses, Fauns, Herculeses, and other famous types, the gallery also included pieces relating to unusual themes or cults, such as the Harpocrates paired with Diana of Ephesus, an ancient sheep paired with a famous goat restored by Algardi; there was also a *kore*, identified by Visconti as "di antichissimo greco stile e di sommo merito" (p. 60).

41. See again the letter of 5 June 1636, cited in n. 22 above. Peiresc's comment that the va-

riety of figures representing the same subject could illuminate subjects only touched upon by ancient authors reflects the sense, shared by Vincenzo, that some things were better described in images than in words.

42. See Guerrini and Carinci, 1987, pp. 166 and 178, for the identification of fig. 46 as the Peschiera of the villa outside the Porta al Popolo; and of *Galleria Giustiniana*, vol. 2, plate 158 as the Casino Nobile in the garden at the Lateran.

43. See Prinz, 1970, pp. 53–56, for the galleries created for Vincenzo Gonzaga between 1604 and 1611–1612 and for Carlo Emmanuele I of Savoy in 1606–1607.

44. For this bust, now in the Villa Albani, see Bieber, 1955, pp. 86–87, figs. 311–313.

45. Marino, 1979, I, p. 3. See also Fumaroli, 1988 (reprinted in Fumaroli, 1994).

46. For Vincenzo's extraordinary statement on the *paragone*, to be discussed below, see the letter to Ameyden on sculpture, in V. Giustiniani, 1981, pp. 67–75.

47. Voss, 1924, p. 109.

48. Salerno, 1960, p. 97, no. 101.

49. See especially his poems in *La Galeria* on Lanfranco's *Perseus Killing Medusa* and Caravaggio's *Medusa*, in Marino, 1979, I, pp. 31–32; see also his sonnet on Villamena's print of Rome, p. 261, and for the Medusa see further p. 272. The general *topos* of Love, Desire, or Venus, as the animating force of the collection of an amateur is a familiar one; see, for example, Pomian, 1987, pp. 69–71.

50. Gasparri, 1980, p. 198, no. 288, confuses the Praxitelean sculpture of the Eros stringing his bow (of which there are several versions in the *Galleria*) with the sculpture described in the 1638 inventory as no. 110 (p. 77). Occasionally pieces are described as "moderno" or "ristaurato" and this is not; but it is not called "antico" and the implication is that the piece was new.

51. See the reference by Nencioni, 1982, p. 1529, to M. Buonarotti the Younger's *Fiera* of 1619, in which, after pointing to the broken noses and half-ears that populate the *Terme*, the secretary of the Podestà of Pandora (Florence) mocks the restored sculptures in the *galleria*, "la testa d'un Apollo / sopra 'l busto d'un Bacco . . . una Minerva / ridotta in una Venere: un Mercurio / 'n un Ganimede." For comparison

with the Ludovisi collection, see Palma, 1983. On the history of restoration see Rossi Pinelli, 1986.

52. For this passage from his letter to Ameyden, see V. Giustiniani, 1981, p. 70, and chapter one above.

53. DeGrazia, 1984, pp. 29–35, 45–46, and 60–68; Limouze, 1988, and Limouze, 1989. See also Melion, 1990.

54. Sandrart, 1925, p. 241.

55. DeGrazia, 1984, p. 66, states that after 1600 there were two main reproductive engraving styles in Europe—the swelling line of Goltzius, and the more rational manner of Agostino. On Villamena, see now the important contribution of Anna Grelle, in Ficacci, 1989, pp. 128–142; and Camiz, 1994.

56. There they had worked together on the reproduction of a series of drawings by Diepenbeck, the *Tableaux du Temple des Muses* from the collection of Monsieur Favereau.

57. See Sandrart, 1925, pp. 247–248.

58. Muller, 1982, esp. pp. 235–236. Rubens' views should be related to the famous criticism by the Carracci of the *maniera statuina* practiced by those who imitated ancient models too closely. The engravers of the *Galleria* brought to the reproduction of ancient statues the coloristic qualities that had been developed in the later sixteenth century for the reproduction of paintings. Other series, such as Giovanni Battista de' Cavalieri's *Urbis Romae aedificiorum illustrium quae supersunt reliquiae* (Rome, 1569), and François Perrier's own *Segmenta nobilium signorum et statuarum quae temporis dentem invidium evase* (Rome and Paris, 1638), aimed at liveliness through such superficial features as open eyes, but they did not convey the sense of living flesh.

59. Sandrart, 1925, pp. 242 and 249, called both Phoenixes among artists.

60. On this stylistic plurality, see further Ottria, 1989, pp. 10–12.

61. See also the reviews of Birke, 1987, by Bohn, 1988 (for several new attributions to Valesio, including a drawing of the arms of Cardinal Giustiniani), and by Turner, 1988.

62. Préaud, in Ficacci, 1989, pp. 62–73, esp. pp. 71–72, discusses the importance of Mellan's study of Villamena, Sadeler, and Cort.

63. Van Gelder, 1963, esp. pp. 56–57.

64. Blunt, 1966, pp. 24–25, no. 32.

[handwritten marginalia: Which goes back to Titian.]

65. Now in the Museo Nazionale, Naples. See Bieber, 1955, fig. 109–110, fig. 435.

66. For the Dead Amazon, see Royal Library, Windsor Castle, *Bassi Rilievi* I, vol. 155, fol. 68; for the Dead Persian, fol. 66; for the Dead Giant, VIII, vol. 162, f. 31; and for the Dying Gaul, IX, vol. 163, f. 31. Bieber, 1955, p. 110, n. 28, cites the views of Michaelis, Petersen, and Reinach concerning the child at the Amazon's breast. Michaelis follows earlier suggestions that the group should be associated with Pliny's description of Epigonos' sculpture of an infant piteously caressing his dead mother (Pliny, *Natural History* II, 88), itself perhaps an emulation of Aristeides' pair. He also proposes that the child would account for the Amazon's swelling breast. Whether or not Poussin knew this tradition, the group in the *Plague* is closer to Pliny's description of the work by Epigonos than of that by Aristeides. See further Bober and Rubinstein, 1986, pp. 179–180, no. 143.

67. Blunt, 1966, pp. 47–48, no. 67.

68. For the complicated history of this sarcophagus, see Robert, 1890, II, pp. 96–99. See also Bober and Rubinstein, 1986, pp. 142–143, no. 142. For the *Agenda* and the note "pilo dell'Amazzoni," see Solinas and Nicolò, 1987; and Solinas and Nicolò, 1988.

69. See Salerno, 1960, pp. 101–102, nos. 153, 156, 157, 158. Ficacci, 1989, p. 289, refers to the proposal that "Giusto Fiammingo" was Josse de Pape (died Rome, 1646), who also worked on the *Galleria*.

70. Gasparri, 1980, p. 78, no. 128.

71. Bizoni, 1944, p. 101.

72. Haskell, 1963, p. 30.

73. For the fragments of mosaic from St. Peter's, given to Benedetto Giustiniani, see Tomei, 1989. Salerno, 1960, pp. 137–138, proposed that the Francia *Virgin and Child with Saints Francis and Jerome* in the Giustiniani inventory might be identical with that in the J. E. Taylor Collection, now in The Metropolitan Museum, New York. The identification of it as the Giustiniani picture has been disputed on the grounds that the painting was in the Sciarra collection in 1834. See Zeri and Gardner, 1986, pp. 20–21. The possibility remains open, however.

74. Haskell, 1963, pp. 29–30.

75. Salerno, 1960, p. 25. A more detailed analysis of the collection, which Elizabeth Cropper is undertaking, will also have to take into consideration the availability of works on the market.

76. Torquato Tasso defines inclinations versus habits as follows: "Ma l'inclinazioni precedono gli abiti, e l'inclinazioni sono naturali e gli abiti sono morali"; for which see Tasso, 1958, II, 2, p. 775.

77. The personification of *Inclinazione* entered Cesare Ripa's *Iconologia* in the Pietro Paolo Tozzi edition (Ripa, 1986, II, p. 277). Ripa's *Inclinazione* (according to the will in intellectual Nature; according to sensitive appetite in sensitive nature; and according to the order of nature in nature that has no understanding—as with stones that fall and flames that rise) is potentially both good and bad, and so the figure is accompanied by two stars, Jupiter and Saturn. In Artemisia Gentileschi's figure of *Inclinazione* for the Galleria Buonarroti, painted in 1615, the force of the direction of natural inclination is represented by a compass, and the rightness of Michelangelo's inclination insisted upon through the inclusion of only a single, good star.

78. Roskill, 1968, esp. pp. 12–25. For later developments of Castiglione's ideas in relation to painting, see Sohm, 1991.

79. Klein, 1975.

80. See Patrizi, 1990, and especially the introduction by A. Quondam to Guazzo, 1993.

81. Magendie, 1925, remains the fundamental study of the French tradition. See esp. pp. 305–385 for the Italian and French sources, and on Montaigne. On Faret's treatise, published in Paris in 1630, see Faret, 1925.

82. It should be stressed that in seventeenth-century French discussions of the concept, *honnêteté* was appled to bourgeois, worldly, intellectual, or other groups, and not just to the courtier, as Magendie indicates at length.

83. See Moriarty, 1988, esp. the conclusion, pp. 189–193.

84. See, for example, Connors, 1992.

85. Recently, the subject of civil conversation in seventeenth-century Europe has attracted wider attention, although without much reference to the Italian tradition. Fumaroli, 1992, provides the most concise discussion. For Italy, in addition to Quondam's masterful treatment of Guazzo's text, see Tribby, 1992; and, with regard to northern European painting, see also Goodman, 1992, and Vidal, 1992.

86. V. Giustiniani, 1981, pp. 125–158.

87. The letters on architecture, painting, and sculpture were also published by Bottari and Ticozzi, 1822–1825, VI, pp. 99–145. All citations here are to A. Banti's edition (V. Giustiniani, 1981).

88. Castiglione, 1959, pp. 97–104.

89. See Quondam's comments in Guazzo, 1993, I, pp. 18–19 (for the text), and II, pp. 35–37 (for a commentary on the ethical economy at work here). See also Magendie, 1925, pp. 323–329.

90. Montaigne, 1965, p. 116 (I. 16, "Of the education of children"), and p. 744 (III. 9, "Of vanity").

91. Bizoni, 1944, pp. 114–115.

92. Bizoni, 1944, pp. 117 and 120–121.

93. For the *Istruzione*, see V. Giustiniani, 1981, pp. 99–120; for the diary, see again Bizoni, 1944.

94. V. Giustiniani, 1981, p. 104.

95. On the frontispiece, see Massar, 1971, p. 74.

96. V. Giustiniani, 1981, p. 107.

97. V. Giustiniani, 1981, p. 112. And in Venice Vincenzo had indeed preferred to stay at the Albergo della Sirena Ostriota, rather than with the papal Nuncio, with the Strozzi, or with Francesco Franceschi, his own old domestic accountant, for which see Bizoni, 1944, p. 47.

98. V. Giustiniani, 1981, pp. 109–110. See also Bizoni, 1944, e.g., pp. 88–93, 105–107, 184–186.

99. V. Giustiniani, 1981, p. 108.

100. V. Giustiniani, 1981, p. 114.

101. V. Giustiniani, 1981, pp. 119–120.

102. For the "Discorso sopra la caccia," see V. Giustiniani, 1981, pp. 81–98.

103. V. Giustiniani, 1981, pp. 81–82.

104. V. Giustiniani, 1981, p. 83.

105. For Callot's print of 1619–20, see Choné, 1992, p. 305, no. 400; and see Reed and Wallace, 1989, pp. 227–229, no. 115.

106. For the "Discorso sopra la musica," see V. Giustiniani, 1981, pp. 13–36.

107. V. Giustiniani, 1981, p. 18: "che se ne prendevano diletto e gusto per inclinazione naturale."

108. V. Giustiniani, 1981, pp. 20–26. For the identification of the music in the *Luteplayer*, see Christiansen, 1990, esp. pp. 42–44.

109. V. Giustiniani, 1981, p. 25.

110. V. Giustiniani, 1981, p. 26.

111. V. Giustiniani, 1981, pp. 27–28.

112. V. Giustiniani, 1981, p. 29.

113. V. Giustiniani, 1981, pp. 30–31.

114. V. Giustiniani, 1981, p. 36.

115. For the *Discorso sopra l'architettura: Istruzione necessaria per fabbricare*, see V. Giustiniani, 1981, pp. 47–62. Giustiniani begins this letter with an apology: he is constantly interrupted by people with specific things on their mind, and who refuse just to talk about topics of general interest—that is to engage in conversation.

116. Bizoni, 1944, pp. 143–144.

117. V. Giustiniani, 1981, p. 61. See McBurney, 1992, and *Paper Museum*, 1993, pp. 178–179, no. 107, for discussion of the *Uccelliera*.

118. V. Giustiniani, 1981, pp. 58–59. See Bizoni, 1944, pp. 118–120, for details of the visit.

119. V. Giustiniani, 1981, pp. 60–61.

120. For the *Discorso sopra la scultura*, see V. Giustiniani, 1981, pp. 63–75; and for the *Discorso sopra la pittura*, pp. 37–45. A translated extract of the latter appears in Enggass and Brown, 1970, pp. 16–20.

121. V. Giustiniani, 1981, p. 67.

122. V. Giustiniani, 1981, p. 73.

123. V. Giustiniani, 1981, pp. 73–74. This comment may help to date the letter. Bernini was made a knight of the Order of Christ by Pope Gregory XV (1621–23).

124. V. Giustiniani, 1981, pp. 74–75.

125. V. Giustiniani, 1981, p. 75.

126. For a modern edition, see Fracastoro, 1924. The Latin text from the Venetian edition of 1555 is reproduced in facsimile, followed by the translation.

127. Salerno, 1960, p. 138, no. 73.

128. Fracastoro, 1924, pp. 165 (Latin) and 74.

129. Others had paved the way for Fracastoro's adaptation of rhetorical texts, especially Cicero's *De Oratore*, to express his ideas on elocution. Speroni, for example, had interpreted Cicero to be recommending demonstrative oratory above all others because it is the most capable of ornament, and because it aims chiefly at delight. Though he claimed to disagree with Pontano's definition of the real goal of the poet as the arousal of *admiratio* through invention and elocution, Fracastoro's own is closely related. See Fracastoro, 1924, pp. 157–

158 (Latin) and 58–60, as well as the introduction, pp. 17–22.

130. Fracastoro, 1924, p. 158: "verum ideam sibi aliam faciens liberam & in universum pulchram, dicendi omnes ornatus, omnes pulchritudines quaeret, quae illi rei attribui possunt." For the translation, see p. 60.

131. Fracastoro, 1924, pp. 162 (Latin) and 68–69.

132. Fracastoro, 1924, pp. 160 (Latin) and 64–65.

133. For the *Discorso sopra la pittura*, see V. Giustiniani, 1981, pp. 37–45.

134. V. Giustiniani, 1981, pp. 41–42.

135. For the copy, see Christiansen, 1990, esp. pp. 32–39. On such copying techniques, see Beal, 1984, pp. 198–202.

136. V. Giustiniani, 1981, p. 42.

137. This was an overdoor with fruit and flowers by Pietro Paolo Bonzi, known as the "Gobbo dei Carracci," which hung in a small room with other assorted paintings; for which, see Salerno, 1960, p. 96, no. 66.

138. The two landscapes by Annibale Carracci listed in the inventory, for which see Salerno, 1960, p. 141, nos. 102–103, are no longer considered autograph.

139. On the frescoes at Bassano di Sutri, see Brugnoli, 1957a.

140. V. Giustiniani, 1981, p. 43.

141. Salerno, 1960, p. 103, nos. 208–209. Tempesta received payments in 1603 for his work in the courtyard, for which see Brugnoli, 1957, esp. pp. 241–242 and 254.

142. See Marabottini, 1969.

143. Vincenzo owned only a small head of an Angel, attributed to Barocci, for which see Salerno, 1960, p. 143, no. 163. By Pomerancio, or Roncalli, the artist who had accompanied him to England, he owned a Holy Family; see p. 103, no. 182. He had a *Christ at the Column* and a *St. Francis Praying in a Landscape* attributed to Passignano, for which see p. 103, no. 183, and p. 145, no. 207. By the Cavaliere d'Arpino, whose frescoes in the Capitoline he especially admired, Vincenzo owned a head of the resurrected Christ; p. 97, no. 103.

144. V. Giustiniani, 1981, p. 44. For Vincenzo's Riberas, see Salerno, 1960, p. 96, nos. 46 and 76, p. 101, nos. 141–148 (including a series of Doctors of the Church), p. 102, no. 174, and p. 103, nos. 199 and 200 (two philos-ophers); for Honthorst, p. 96, no. 70, pp. 98, 101, no. 125 (the *Christ before Caiaphas* in the National Gallery, London), and p. 146, no. 244; for Enrico d'Anversa, p. 101, nos. 150 and 151; and for Baburen, pp. 95–96, no. 45.

145. On the the critical association of these three around 1600, see Dempsey, 1993.

146. V. Giustiniani, 1981, p. 44. He also points to the new fashion for decorating palaces with many paintings instead of rich hangings as an important way for artists to gain advancement.

147. Barocchi, 1982, pp. 1421–1430.

148. Barocchi, 1982, pp. 1427–1428.

149. Montaigne, 1965, p. 355 (II. 12, "Apology for Raymond Sebond").

150. For the "Cupido del Caravaggio," as described in the inventory, and for Sandrart's recommendation, see Cinotti, 1983, pp. 409–411, no. 1.

151. Ripa, 1986, I, pp. 258–260.

152. On conversation, see further Goldsmith, 1988, and Stanton, 1980.

CHAPTER THREE

1. Bellori, 1976, p. 424; and for the most comprehensive modern biography of Poussin, see Thuillier, 1988.

2. Thuillier, 1988, pp. 89–90; and Blunt, 1967, pp. 52–53.

3. Thuillier, 1988, p. 102.

4. Bellori, 1976, p. 431.

5. The bibliography on Cassiano dal Pozzo is vast, and in recent years has seen a rapid growth in connection with the ambitious, and laudable project to catalogue and publish the volumes of drawings surviving at Windsor Castle. Especially useful recent publications include: *Cassiano dal Pozzo: Atti del Seminario Internazionale di Studi*, ed. F. Solinas, Rome, 1989; and the four volumes published to date by Olivetti, entitled *Quaderni Puteani*. A useful and up-to-date bibliography appears in *The Paper Museum of Cassiano dal Pozzo*, a publication of the Cassiano dal Pozzo Project, the Royal Library, Windsor, the British Museum, and Olivetti (*Quaderni Puteani* 4), cataloguing an exhibition held at the British Museum in 1993. The following is especially indebted to F. Haskell's succinct and thoroughly informed

introduction to that volume, pp. 1–10. See also Sparti, 1992 (with bibliography).

6. For the lost painting of *The Capture of Jerusalem by Titus*, see Blunt, 1966, pp. 158–159, no. L9; and Bousquet, 1960, pp. 3–4.

7. Bellori, 1976, pp. 426–427; and Thuillier, 1988, pp. 121–122.

8. See the exemplary catalogue by Rosenberg and Butor, 1973.

9. For Cassiano's collection, see, among others: Haskell and Rinehart, 1960; Brejon de Lavergnée, 1973; Standring, 1985 and 1988; and Sparti 1989 and 1992. The inventories in question pertain to the descendants of Cassiano, whose collection is known to have contained both originals and copies of Poussin's paintings. The distinction is not always clear, and in consequence certain paintings with the distinguished Dal Pozzo provenance have been given attributions more distinguished than their quality merits. See chapter one above, note 72.

10. For Cassiano's house, see Sparti, 1989 (cf. her fig. 7 for a hypothetical reconstruction of the "Stanza de'Sagramenti"); and see further Sparti, 1992, figs. 53–57. For Chantelou's house, see his own description in Chantelou, 1885, pp. 65–70.

11. Bellori, 1976, p. 431.

12. Bellori, 1976, pp. 431–434. See also Blunt, 1938–1939; and for the history of study of the triclinium in the context of Cassiano dal Pozzo and the *Museo Cartaceo*, see Vagenheim, 1992.

13. See Bätschmann, 1982, esp. p. 31.

14. Bellori, 1976, p. 432.

15. Bellori, 1976, pp. 431–432: "Nel Battesimo espresse un bellissimo concetto, mentre San Giovanni, versando l'acqua sopra il capo di Cristo nella sponda del Giordano, all'udirsi in alto la voce del Padre Eterno verso il suo figliuolo diletto, volgonsi alcuni a quel suono che scende dalle nubbi, ed uno di loro addita il cielo, l'altro accenna Cristo, riconoscendolo per figliuolo di Dio."

16. Bellori, 1976, p. 432: "Risplende sopra il suo capo lo Spirito Santo in forma di colomba, e piegando egli le mani al petto umilmente vien servito da gli angeli che gli reggono il manto." See also Poussin's letter of 27 March 1642 to Cassiano dal Pozzo, in *Correspondance*, 1911, p. 124: "L'incomodità del tempo passato, come già scrissi a V. S. è stata causa che non l'ho fino adesso potuto intieramente compire. Rimane il Cristo con due Angiolini, ma spero la settimana prossima darli l'ultimo mano." For the motif of the angels miraculously covering Christ's nakedness during the Baptism, profoundly Counter-Reformatory in nature, see Mâle, 1932, pp. 261–262.

17. See Poussin's well-known drawing in the Hermitage, showing a banqueting table drawn after a painting in the catacombs, which the artist identified as a "lunar triclinium called sigma." The inscription reads: "Convito funerale. Col triclinio lunare detto Sigma" (see Blunt, 1967, p. 200, fig. 166). On the drawings of the triclinium in the *Museo Cartaceo*, see further Vagenheim, 1992, and *Paper Museum*, 1993, p. 70, no. 27.

18. Poussin has apparently confused the phylactery, which is in actuality a small box, with the tallith, or prayer scarf. The imagery (and the confusion) is not uncommon, and can be found, for example, in the Pharisee shown to the left in Dürer's *Christ among the Doctors* of 1506, painted while he was in Venice (see Panofsky, 1955a, pp. 114–116 and fig. 156); and in Mantegna's *Ecce Homo* of c. 1500 (see *Mantegna*, 1992, pp. 245–247, no. 61). See also Panofsky, 1956. We are grateful to Professor Herbert Kessler for help on this point, as well as to Keith Christiansen, who is presently undertaking a study of the painting by Mantegna.

19. We are grateful to Professor Samuel Lachs of the Department of Religion at Bryn Mawr College for translating and discussing Poussin's inscription with us many years ago.

20. Blunt, 1967, pp. 176 and 187. For complete information and biography concerning both series, see also Blunt, 1966, pp. 73–79, nos. 105–118. For the most recent expression of a similar position regarding Poussin's orthodoxy, see Henneberg, 1987.

21. See, most recently, Haskell, 1993, pp. 102–111 and 122–127. See also Jones, 1993.

22. Blunt, 1938–1939.

23. Mâle, 1932, pp. 122–145. The view of Poussin's *Sacraments* presented here is aligned with that expressed by Powell, 1985; and by Santucci, 1990. For a more summary discussion, see also Santucci, 1985, pp. 36–43.

24. See Herklotz, 1992.

25. Suarez, 1655. For recent bibliography, see *Paper Museum*, 1993, pp. 115–118, nos. 70–72.

26. See the citations of Suarez in Bosio, 1650. The first edition was published in 1632. We have also used the Latin edition (Bosio, 1659). For Suarez on the practice of the sacraments in the early Church, see I. xxi. 12.

27. See Morey, 1915, p. 37. See also Bosio, 1650, *passim*.

28. Herklotz, 1992, pp. 38–45.

29. Herklotz, 1992, pp. 32–38.

30. Blunt, 1967, pp. 192–193.

31. Blunt, 1967, pp. 192–193.

32. Blunt, 1967, p. 193, n. 58.

33. Rubenius, 1655 (reprinted in Graevius, 1694–1699, VI, cols. 913–1030).

34. Ferrarius, 1657 (reprinted in Graevius, 1694–1699, VI, cols. 604–912).

35. Quoted from Addison, 1850, 3, p. 276.

36. Sterne, 1978, 2, p. 529.

37. The summary of the debate given here and in the following paragraphs follows Rubenius and Ferrarius.

38. Sandys, 1921, II, p. 193.

39. "Una statua di marmo grande come un huomo ordinario e non molto di più, si dice sia statua d'un filosofo." We are grateful to Francesco Solinas for this reference, which is to a manuscript in Montpellier (Mont. H267, 50r.).

40. Our thanks again to Francesco Solinas for this reference in the *Carteggio Puteano*, XI (ex-Albani 1974, Aosta 9), fol. 22r, v: "Ricevi dal Signor Pozzo [Francesco of Verona] il pacchetto de' disegni trasmessi dalla singolare benignità di V.S. Ill.ma e gliene rendo di novo humilissime et affettuosissime gratie. . . . Li disegni mi sono tanto più grati quanto che fanno mirabilmente al mio proposito. Nella prima la figura di mezzo che stimo Traiano ha la penula che così mezzo levata si portava. Le altre ḥanno la chlamide poco differente della penula ma pur differente. Con la 2a del soldato è con la penula. Mi fa ben stupire la penula di Mercurio che è poco differente dalla toga, è cosa rara, se pure è antica. Sopra tutte m'è carissima la statua del cinico che tale è la quarta col Tiberio e portatura cinica per risparmiare la tonaca, perchè conforma la mia opinione contra il Salmasio che crede portassero almeno la subercola o sia camisciole."

41. Blunt, 1966, pp. 108–109, no. 150.

42. Blunt, 1966, p. 147, no. 216.

43. Diogenes Laertius, *Lives of the Eminent Philosophers*, VI, 59.

44. Blunt, 1966, p. 79, no. 116.

45. Bosio, 1659, II, p. 299 (Lib. VI, cap. xxiii).

46. Blunt, 1967, p. 191.

47. See also Blunt, 1938–1939.

48. Bosio, 1650, pp. 527–528.

49. Bosio, 1659, II, p. 175 (cap. xxiii).

50. Bosio, 1659, II, p. 175: "ubi Romanis primum Christi Evangelium, Petro annunciante, innotuit: 'Caeterum (inquit Baronius, t. I, ann. 44, n. 61) ubi Petrus Evangelium praedicans Gentibus innotuit, non amplius apud Iudaeos permissus est agere, sed a Pudente Senatore, qui Christo credidit, in domum suam exceptus est Pastoris titulo nuncupatus.'"

51. Bosio, 1659, II, p. 178.

52. Bellori, 1976, p. 431.

53. See Morey, 1915, pp. 40–41.

54. Morey, 1915, pp. 40–48. The frescoes were originally published by Wilpert, 1916, and the drawings after them republished by Waetzoldt, 1964, pp. 73–74, and figs. 506–514.

55. Morey, 1915, p. 43.

56. Kessler, 1987.

57. For the text, see note 50 above.

58. Blunt, 1966, p. 79, no. 117; and see further Blunt's discussion of the painting in Blunt, 1967, pp. 195–199.

59. Blunt, 1967, p. 196.

60. Herklotz, 1992, pp. 35–36 and fig. 3.

61. Bosio, 1659, I, p. 135 (Lib. II, cap. iii: *De Triumphali Porta, Vaticano colle, & iis, quae antiquitus eisdem in locis suspiciebantur*).

62. Bosio, 1659, I, p. 138: "Hanc vero Pyramidem [Scipionis] nonnulli ipsammet fuisse asserunt, quae non multis ab hinc annis haud longe ab Hadriani Mole erecta conspiciebatur."

63. Blunt, 1967, pp. 201–203.

64. Bosio, 1659, I, p. 135.

65. *Correspondance*, 1911, pp. 370–375.

66. Chantelou, 1885, p. 67.

CHAPTER FOUR

1. Blunt, 1966, p. 7, no. 1.

2. Wildenstein, 1957, pp. 19–20, no. 1.

3. The cleaning was carried out by Mario

Modestini in New York in the spring of 1993 at the request of Eric Schleier for the Berlin museum. The inscription on the book has been painted over, while that at the top remains visible; the autograph status of this inscription was already qustioned by Dempsey, 1963a.

4. On the copy sometime with Gimpel fils, London, once thought by Friedlaender to be the original, see Blunt, 1966, p. 7, no. 1, and Wildenstein, 1957, pp. 19–20, no. 1 (reporting Meyer Schapiro's observation on the absence of the inscription on the Gimpel version).

5. Kauffmann, 1960, p. 87, fig. 69; Winner, 1987, pp. 378 and 396, fig. 8.

6. On Alberti's text, see Schlosser Magnino, 1967, pp. 390–391.

7. For the claim that Mariette's date is simply mistaken, see Thuillier and Mignot, 1978, p. 48, no. 4.

8. A copy by Natalis (who had worked on the *Galleria Giustiniana*) of Pesne's engraving after the *Ecstasy of St. Paul* was dedicated by the editor Jean Valdor to Louis Hesselin, who died in 1662, according to Wildenstein, 1957, p. 129, no. 80. Pesne also engraved the *Self-Portrait* for Chantelou.

9. For Félibien's publication of the letter, see Pace, 1981, pp. 128–129. The text is also published in *Correspondance*, 1911, pp. 483–486. For Poussin's knowledge of texts by Witelo and Alhazen, first discussed by Alfassa, see Blunt, 1967, pp. 224–225 and 372.

10. *Correspondance*, 1911, pp. 453–454 (4 February 1663).

11. *Correspondance*, 1911, pp. 461–464. On Fréart de Chambray's appropriation of Junius, see Junius, 1992, I, pp. lxvi–lxvii.

12. *Correspondance*, 1911, pp. 418–419.

13. Bellori, 1976, pp. 472–481.

14. To the sources identified by Blunt others have been added, for which see Borea's notes in Bellori, 1976, pp. 478–481; and see Cropper, 1984, pp. 118 (n. 107), 127, and 142–143.

15. On these frontispieces, see Previtali's introduction to Bellori, 1976, pp. xliv–xlv, n. 3. Thuillier, 1978, pp. 164–165, attributes them to Charles Errard, pointing to the artist's close connections with Bellori in Rome immediately after Poussin's death. The connection between Zaccolini's manuscripts and Bellori's frontispiece reinforces the argument that the design was made under Bellori's guidance, and not simply invented by Errard (who had produced the offending landscape backgrounds to Poussin's figures for the illustrations in the *Trattato*) in order to support his own arguments about the relationship between Poussin and Leonardo.

16. Bellori, 1976, p. 427.

17. Galleria degli Uffizi, Gabinetto Disegni e Stampe, 6121F. This autograph drawing was published by Blunt in Friedlaender and Blunt, 1939–1974, V, as no. 369, pl. 280, together with the copy, Hermitage 5078 (as no. A. 157). See further Blunt, 1967, p. 241, n. 66, pointing to the existence of the original in the Uffizi, but reproducing the more legible copy as fig. 197.

18. For a more recent discussion of the Uffizi drawing, see Bätschmann, 1990, pp. 16–29. Bätschmann's claim that the superimposed figure at the easel demonstrates that "painting suspends the laws of optics, and with it the theory of colour," is part of a larger hypothesis that is not supported by the drawing itself. His comment that the figures are not merely pupils follows the original publication of Cropper's argument in which it is stated that Poussin is representing a kind of ideal practice, involving knowledge and judgment.

19. Blunt, 1967, pp. 240–242; see also Weil-Garris, 1981, esp. pp. 235–236 and 246–247, n. 39, for the second print of the studio, with references to Cellini's and Leonardo's statements on such study of chiaroscuro modelling.

20. In the Codex Huygens, fol. 90r, a painter does draw around the enlarged shadow of a statuette cast by a candle. For this, and for references to the legend that painting was invented in this way, see Panofsky, 1940, p. 61, n. 4, and fig. 51.

21. Richter, 1949, pp. 105–106; and see also Leonardo, 1882, I, pp. 92–94, para. 42.

22. Accolti, 1625, p. 95. For Galileo's proposal, see Panofsky, 1964, pp. 8–9, and fig. 4.

23. The connection of this particular drawing with Cézanne is made by Blunt, 1967, p. 242, who sees Poussin's composition as primarily dominated by mathematical elements. Bätschmann, 1990, p. 16, makes a similar assumption when he asserts that "the pupil in Poussin's drawing is not studying light and shade. He constructs a figure with a pair of compasses and is therefore dealing with geometry." The separation of geometry from optics

is exactly what Zaccolini, and Poussin, wanted to avoid.

24. Reff, 1960, pp. 169–170, and Reff, 1977, pp. 47–48. Reff's point is that Cézanne's statement must be understood as having to do with perspective and the painting of chiaroscuro and color to achieve it.

25. For a similar situation in Cézanne studies, see Shiff, 1984, esp. pp. 175 and 180–183. These ideas are also taken up by R. Verdi in the catalogue of the exhibition *Cézanne and Poussin: The Classical Vision of Landscape* in Edinburgh (Verdi, 1990), even though this exhibition, as its very title suggests, upheld the classical, formalist view of both artists.

26. Badt, 1969, I, esp. pp. 263–379.

27. Badt, 1969, I, esp. pp. 306–310. See Cropper, 1984, pp. 137–146, for a development of this argument. Recently Bätschmann, 1990, pp. 30–61, has attempted an interpretation of Poussin's theory of the Modes based on an analysis of a specific group of chiaroscuro drawings and their transformation into paintings. On the modes in general, see Montagu, 1992.

28. Badt, 1969, I, p. 264.

29. See Pedretti, 1977, I, pp. 36–47. For a more detailed study of the history of the manuscripts, see now Bell, 1988 and 1993.

30. For the dedication of Ashburnham 1212², "Prospettiva del colore," see Pedretti, 1977, I, p. 45.

31. See Bell, 1988.

32. On Francesco Barberini's publishing projects, see Petrucci Nardelli, 1987. See also the brief discussion in Solinas, 1992.

33. Bell, 1988, pp. 116–117.

34. Leonardo, 1651.

35. The history of Poussin's illustrations for the *Trattato* and the evidence for the relationship between these illustrations and Poussin's paintings are summarized in Friedlaender and Blunt, 1939–1974, IV, pp. 26–30.

36. Leonardo, 1651a.

37. The note is reproduced in its entirety by Pedretti, 1962, as fig. 1, p. 62. For the history of this manuscript, see Steinitz, 1958, pp. 99–105 (but see also Pedretti's comments in the article cited above).

38. For Albrizzi, see Pirri, 1960. Another note later in the volume records that Albrizzi has the notes on painting, while Camillo Massimi had others; for which see Bell, 1988, p. 115.

39. Pedretti, 1977, I, pp. 41–42.

40. Bell, 1988, p. 115, follows this proposal.

41. The term "un libro originale" used by Jean Dughet to identify the volume in the Barberini Library from which Poussin had him copy out sections surely indicates an unpublished manuscript, but it may not signify an autograph copy.

42. For Goldstein's objection that Poussin's interest in the Zaccolini manuscripts must have focused on *quadratura* painting (which is not treated in the manuscripts, despite Zaccolini's own proficiency in this field) and Cropper's reply, see Goldstein, 1981, and Cropper, 1981. Bell, 1988, p. 123, n. 68, misconstrues Cropper's original statement, first published in 1980, concerning Poussin's knowledge of the manuscripts. Rather than stating, as Bell quotes Cropper, that Dughet "is undoubtedly referring [only] to . . . *Della descrittione dell'ombre*," Cropper was arguing that Poussin's knowledge of that specific volume could be so firmly established that Dughet's reference to copying out material on light and shadow surely pointed to it. It was not the intention of the author to exclude the topics of color and measurement, and Bell's insertion of "[only]" in this statement distorts its meaning.

43. Pedretti, 1977, I, p. 47, suggests that Zaccolini knew the lost *Libro W*. Further on Zaccolini's knowledge of Leonardo's manuscripts, see now Bell, 1991.

44. All references to the manuscript are to the modern numeration in pencil, which occasionally conflicts with the original numbers in ink.

45. The pair of drawings reproduced as fig. 93 are rather unusual because no geometrical construction is supplied, and because Zaccolini shows the light source as a luminous sphere rather than as a torch. These drawings relate to the problems set on fol. 78r. Zaccolini does provide a geometrical construction on fol. 79r, writing (79v) that he intends to illustrate the problem naturalistically so that the student painter will be inspired to work "più coraggiosamente invigorito." The upper drawing illustrates the given problem, the lower shows what the effect would be if the sphere were not suspended.

46. Blunt, 1967, pp. 241–242.

47. On the Del Monte, see Spezzaferro, 1971.

48. Kaufmann, 1975. For the study of shadow projection and perspective of all kinds, see also the bibliography in Vagnetti, 1979.

49. Del Monte, 1600, pp. 251, 255, 271.

50. See Kaufmann, 1975, pp. 279–287, for the criticism of shadow projection on the basis of a point source, beginning with Augilon in 1613. Kaufmann reprints Pietro Accolti's specific criticism of Barbaro, Guidobaldo, and Sirigatti for having treated torchlight and lamplight rather than natural light. Zaccolini was also aware of this inconsistency, and on fol. 66v he writes that he has used points of light only as a convenience to make the rules easier to understand. Even though he provides some examples of illumination by different sources of light, e.g. folio 65r (fig. 98), he had in fact no alternative system for solar shadow projection. According to Kaufmann, this was the contribution of Desargues. See now Bell, 1993, esp. p. 91, n. 10, for mention of unpublished evidence that Abraham Bosse's publication of Desargues' theories of aerial perspective was inspired directly by Bosse's having seen Poussin's copy of passages from Zaccolini's treatises.

51. The edges of the shadow in this drawing are softened with a white wash.

52. Pedretti, 1977, I, p. 47.

53. MS Ashb. 1212⁴, fol. 72v.

54. Again, this goes against Bätschmann's attempt to separate light and shade from geometry (Bätschmann, 1990, p. 16).

55. Pedretti, 1977, I, pp. 35 and 47. For Accolti and *sfumato*, see Kaufmann, 1975, pp. 281–283; and Accolti's own statements in Accolti, 1625, pp. 108–109.

56. Accolti, 1625, pp. 95–96; see also p. 136.

57. Accolti, 1625, p. 138; see also p. 108.

58. The attack on even *sfumato*, "come li più fanno, con una eguale circolare unione, onde non appariscono poi, nè i piani sfuggire, nè i corpi rilievarsi," occurs in chap. 27 of Accolti, 1625, pp. 136–138. Two alternative methods are given in the following chapters. In his address to the young students at the Florentine Academy, Accolti urges each: "dilettisi sopr'ogni cosa della copia, & varietà de colori, fugga il repricargli, nè gli smarrisca mai ne i

gran lumi loro, & nelle intense ombre, come molti fanno" (p. 150).

59. For example, on fol. 64v Zaccolini writes that the artist must consider reflected light, "perche altrimenti senza il temperamento del lume reflesso il detto spatio ombroso non sarebbe ombra, ma di notte tempo, il che non essendo buona imitatione, farebbe maniera cruda tagliente, e inutile alla vaghezza dello sguardo, essendo questa quella parte, che deve dal Pittore essere abborrita." Zaccolini deals with this problem more extensively in MS Ashb. 1212², "Prospettiva del colore," which is also important for an understanding of Poussin's use of color. Zaccolini shared Poussin's belief in the consonance between colors and musical sounds, and he develops this even more fully in Ashb. 1212¹, "De colori, Trattato 11º," devising scales of color for the specific purpose of curing victims of tarantula bites. Poussin's theory of the Modes should be considered in relation to such equations between the effects of harmonies of sound and harmonies of color, which, as we know, also fascinated Domenichino.

60. See, for example, Zaccolini's criticism on MS Ashb. 1212⁴, fol. 64v, of the "maniera cruda tagliente, e inutile alla vaghezza dello sguardo" that results when reflected light is ignored.

61. Shearman, 1962, remains the most concise treatment of the impact of Leonardo on Florentine color and chiaroscuro.

62. For this reform see Dempsey, 1977, esp. pp. 7–36.

63. Accolti, 1625, p. 21, points to the use of wax models by these artists and others.

64. For Testa's study of Daniele Barbaro's discussion of the Analemma, see Cropper, 1984, p. 204. Accolti, 1625, pp. 125–128, provides instructions for the construction of a sundial, which remains, however, only relatively simple.

65. Accolti, 1625, p. 108.

66. The student working from the statuette serves as a further reminder of Poussin's use of wax models, mentioned above, as a means of studying chiaroscuro in perspective. He employed such models, despite the fact that Armenini had described the method as laborious, for which see Blunt, 1967, pp. 242–244.

67. Blunt, 1966, pp. 73–76, nos. 105–111, esp. p. 75, no. 107. Blunt, 1967, p. 155, also connected this work with Poussin's study of

Leonardo, though without knowledge of the Zaccolini manuscripts.

68. Bellori, 1976, p. 432.

69. See Félibien, 1725, IV, pp. 107–108 (*Entretien* VIII), reprinted in Pace, 1981, p. 136, for the reference to the comparison of Poussin to Leonardo in terms of his arrangement of groups of figures, not only according to age and disposition, etc., but also according to the effects of light and shade. See also Blunt, 1966, pp. 10–11, no. 8.

70. See Félibien, 1725, IV, pp. 111–112 (*Entretien* VIII), in Pace, 1981, p. 137.

71. Félibien, 1725, IV, pp. 112–113 (*Entretien* VIII), in Pace, 1981, p. 137: "Et quand il a representé des personnes en campagne & en plein air, il les a peintes telles qu'elles doivent paroître du lieu où on les voit. Il a observé la diminution des teintes, de même que celle de la forme & des grandeurs, & a été aussi excellent observateur de la perspective Aërienne que de la perspective linéale. Comme il connoissoit que c'est une perfection de la Peinture, & un des plus difficiles secrets de l'art, de bien marquer la quantité d'air qui s'interpose entre l'oeil & les objets, il avoit tellement étudié cette partie, & l'a si bien mise en practique, qu'on peut dire, avec verité, que c'est en cela qu'il a excellé."

72. Félibien, 1725, IV, p. 114, in Pace, 1981, p. 137; see also Félibien, 1725, IV, p. 111, for comments on the "doux accorde" and "harmonie admirable."

73. MS Ashb. 1212^2, fol. 69.

74. MS Ashb. 1212^2, fol. 44.

75. MS Ashb. 1212^2, fols. 41v and 42.

76. Bell, 1993.

77. See, for example, MS Ashb. 1212^1, p. 255, for fig. 102, in which a diagram shows colors from white to black assigned numbers from 1 to 9, and is accompanied by a text that begins "Per maggior intelligenza della conformità che hanno insieme il colore e il suono."

78. See Spear, 1982, I, pp. 40–46, for a summary of what is known about Domenichino's musical interests.

79. For a general discussion of the question of the relationship of Poussin to Leonardo, see Bialostocki, 1960; see also the same author's more specific discussion of one aspect of the problem in Bialostocki, 1954.

80. The letter is published in *Correspondance*, 1911, pp. 419–421, from Bosse's *Traité des practiques géometrales et perspectives*, Paris, 1665, but the original is lost. For a summary of the arguments about its authenticity, see Bialostocki, 1960, pp. 135–137. The attack is based on the argument that it was adapted to serve Bosse's own purposes in his battle with Le Brun; the connections between Poussin and Bosse with respect to this debate are discussed in detail by Kauffmann, 1960, pp. 16–25. See also Teyssèdre, 1957, pp. 129–133, for the argument between Bosse and Le Brun with special reference to Félibien's mention of Zaccolini.

81. See, for example, Leonardo's comment, "Though I may not, like them, be able to quote other authors, I shall rely on that which is greater and more worthy—on experience, the mistress of their Masters. They go about puffed up and pompous, dressed and decorated with [the fruits], not of their own labours, but of those of others"; translation from Leonardo, 1883, I, p. 15, para. 11. Such skepticism was shared by Poussin's friend Pietro Testa, who recognized Socrates' warning in the *Phaedrus* about the dangers of writing: for which see Cropper, 1984, pp. 98 and 236–238. These comments, it should be emphasized, do not reflect opposition to theoretical knowledge itself, for, as Leonardo insisted, "Sempre la pratica deve essere edificata sopra la buona teorica, della quale la prospettiva è guida e porta" (Leonardo, 1883, I, p. 18, para. 19).

82. Baldinucci, 1846, IV, pp. 172–173. Baldinucci, pointing to the passage in Galileo, concludes rightly that Rosselli meant to say, "che poco, o nulla vale quella teorica, che non mai giunge alla pratica: concetto veramente ingegnoso, che mi fa ricordare d'un nobil detto del nostro dottissimo Galileo nella giornata prima de' due sistemi, portato dal celebre matematico Vincenzio Viviani nel quinto libro degli Elementi d'Euclide . . . ove disse . . . ci sono molti, che sanno per lo senno a mente tutta la poesia, e son poi infelici nel compor quattro versi solamente: altri posseggono tutti i precetti del Vinci, e non saprebbero poi dipignere uno sgabello." See also Pedretti, 1977, I, p. 15.

83. Witness, for example, Claude Mellan's engraving of the phases of the moon for Peiresc, for which see Préaud and B. Brejon, 1988, pp. 115–118, nos. 145–148.

84. Félibien, 1725, IV, p. 16 (*Entretien* VIII),

in Pace, 1981, p. 113; the passage concludes "Il avait aussi beaucoup d'estime pour les livres d'Albert Dure, & pour le Traité de la Peinture de Leon Baptiste Albert." Returning now to Cézanne's statement, it also becomes clearer that the advice given in popular nineteenth-century manuals (such as those by Thénot and Valenciennes) to work from illuminated geometrical solids, needs to be placed in the context of a continuous tradition, going back to Leonardo, of studying chiaroscuro and shadow projection in this way. For these manuals, see Reff, 1977, p. 47.

85. For the reference to Cérisier in the *Banquet des Curieux* (1675), see most recently Thuillier and Mignot, 1978, p. 43, n. 3.

86. See Bell, 1993, pp. 109–111.

87. On this subject, with bibliography, see Tribby, 1992, as well as the discussions of civil conversation cited in chapter two above.

CHAPTER FIVE

1. See Volkmann, 1923, pp. 43–47, 97–98, and 122. The image, which was closely associated with Vitruvius, was also taken up by painters, including Elsheimer, in the Renaissance. For Pietro Testa's use of it in a sort of rebus, see Cropper, 1984, pp. 87–88 and 217–218, fig. XIV.

2. Ripa, 1986, II, pp. 123–124.

3. Boissard, 1593, pp. 20–21.

4. As in the famous maxim *Paupertas omnes artes perdocet*; for sources, see, for example, Plautus, *Stichus*, I, 3, 178; Apuleius, *De Magia*, 18; Theocritus, *Idylls*, 21, 1–2. See also Otto, 1890, pp. 668–669.

5. Alberti, 1972, pp. 60–63 (*On Painting*, Book 2, 25–26); Pliny, *Natural History*, 35. 151. For a definition of the problems *already* implicit in the early Renaissance model of painting-as-the-portrait-of-beauty, see Cropper, 1986.

6. On the notion that Beauty does not describe itself but can only assert itself in the form of a citation, its only predicates being tautologies or similes, see Barthes, 1974, pp. 33–34; see also pp. 113–115.

7. That Vasari found narrative in paintings where there was none should not come as a surprise in this context. The alternative would have been to submit to the dumbfounding

effect of the vision of the beautiful Medusa and her endless metaphorical replications. See Cropper, 1995.

8. Petrarch, 1976, pp. 176–179, nos. 77 and 78. See also Cropper, 1986, pp. 182–183.

9. It goes without saying that paintings in the lyrical and narrative traditions stood in very different relationships to the spectator, for which see Cropper, 1995.

10. Zerner, 1969, pp. 21–25, and pl. L.D. 51.

11. Cropper, 1986, pp. 175–176 and 181–182.

12. For the painting, now in the National Gallery of Art, Washington, D. C., see Wethey, 1969–1975, III, pp. 68–70 and 200–201, no. 51, plates 127–129. Many paintings of this type have been accorded narrative or descriptive titles that mask the problem of the reflective image and the desiring eye.

13. Bellori, 1976, p. 455. For earlier literature, see Blunt, 1966, p. 8, no. 2. See also Kauffmann, 1960, pp. 82–98. Among recent publications the most important for what follows are: Bätschmann, 1990; Marin, 1983; Winner, 1983; and Winner, 1987. See further Bätschmann, 1992; Kemp, 1992; and Carrier, 1993, pp. 2–46.

14. For the source of Poussin's emblem in Ripa's *Iconologia*, see Blunt, 1967, p. 174.

15. Bätschmann, 1990, pp. 49–52.

16. See Montaigne, 1988, pp. 183–195 (I. 28). All references to the *Essais* in this chapter are to this standard edition. For a modern edition of La Boëtie's treatise, see E. de la Boëtie, *De la servitude voluntaire ou Contr'un*, ed. M. Smith, Geneva, 1987. In the end, of course, Montaigne decided to substitute his friend's sonnets of desire, only to suppress this body of lyric poetry in turn.

17. Blunt, 1967, pp. 157–176. On Charron, see further S. McTighe, 1989.

18. Bätschmann, 1990, p. 51. See also Blunt, 1967, p. 166. On Montaigne, see further Weller, 1978.

19. *Correspondance*, 1911, p. 393. For the painting, last published as with Wildenstein in New York, see Blunt, 1966, p. 51, no. 71; and Blunt, 1967, pl. 171.

20. See Otto, p. 285, for a quotation from Plato (*Hippias maior* 301C) that comes close to the proverbial saying. For Jan Van Eyck's motto, which appears on three other works, see

Scheller, 1968, esp. p. 136; Vos, 1983, and Dhanens, n.d., pp. 179–180. For further discussion, see Koerner, 1993, pp. 106–107.

21. For Montaigne's inscription, see Frame's note in Montaigne, 1965, p. 622, n. 1. According to Villey, in Montaigne, 1988, III, p. 820, n. 10, it appears (not surprisingly, given the argument presented in chapter six below) in Montaigne's copies of Petrarch and Leone Ebreo.

22. Montaigne, 1988, p. 820 (III. 3). *Correspondance*, 1911, p. 393, n. 2, cites inaccurately II. 10, "Des livres," as Poussin's source.

23. Xenophon, *Memorabilia*, I, 3, 3, cited from *Memorabilia and Oeconomicus*, trans. E. C. Marchant (Loeb Classical Library), London and New York, 1923, pp. 45–46. This follows Xenophon's report of Socrates' statements concerning the relative importance in sacrifices to the gods of the magnificence of the gift and the piety of the giver, in which he concludes that "the greater the piety of the giver, the greater (he thought) was the delight of the gods in the gift." For the text from Hesiod, *Works and Days*, 318–336, see *The Homeric Hymns and the Homerica*, trans. H. G. Evelyn-White (Loeb Classical Library), Cambridge and London, 1977, pp. 26–29: "An evil shame is the needy man's companion, shame which both greatly harms and prospers men: shame is with poverty, but confidence with wealth. Wealth should not be seized: god-given wealth is much better; for if a man take great wealth violently and perforce, or if he steal it through his tongue, as often happens when gain deceives men's sense, and dishonour tramples down honour, the gods soon blot him out and make that man's house low, and wealth attends him only for a little time. . . . But do you turn your foolish heart altogether away from these things, and, *as far as you are able*, sacrifice to the deathless gods purely and cleanly, and burn rich meats also" (italics added). All of the subjects included here, from gifts to friendship, from the shame of poverty to the confidence of wealth, from the dishonor of deceptive oratory to the virtue of constancy and honesty, may be related to the morality of Poussin's self-image.

24. Montaigne, 1988, p. 507 (II. 12); for a translation, see Montaigne, 1965, pp. 375–376. For Cicero's statement, see *Tusculan Disputations*, 1.9.17: "quae vis, ut potero, expli-

cabo, nec tamen quasi Pythius Apollo, certa ut sint et fixa quae dixero, sed ut homunculus unus e multis, probabilia coniectura sequens."

25. See Cottrell, 1981, esp. pp. 80–93.

26. Montaigne, 1988, p. 148 (I. 26); for the translation, see Montaigne, 1965, pp. 108–109. The dedicatory formulation here suggests that Poussin may also have had this passage in mind as he dedicated his painting to Jean Fréart "in the manner of Michel de Montagne."

27. Kauffmann, 1960, p. 185; and Bätschmann, 1990, pp. 51–52.

28. Marin, 1983, pp. 87–88.

29. *Correspondance*, 1911, p. 355.

30. *Correspondance*, 1911, pp. 386–387.

31. *Correspondance*, 1911, pp. 394 and 399.

32. *Correspondance*, 1911, p. 402.

33. For Poussin's leavetaking from Paris, see *Correspondance*, 1911, p. 182. And for the epistolary character of the portrait, see also Fumaroli, 1989, pp. 94–96 (reproduced in Fumaroli, 1994, pp. 53–147, esp. pp. 143–147).

34. *Correspondance*, 1911, p. 239: "La distanse des lieux est cause que souvent les choses que l'on escrit à temps et à propos (se semble) à leur arivée paresse tout au contraire." He adds, "O que le temps amène de variété en peu de jours."

35. *Correspondance*, 1911, p. 228. See further, for example, Poussin's statements to Chantelou (30 October 1644), that as he grows older he is consumed by the desire to do well, especially for him (p. 289); and that he has always worked for Chantelou "avec le plus de soin et amour qu'il m'a esté possible" (p. 376, from a letter of 22 December 1647). Two images reproduced by Winner (Winner, 1983, p. 438, fig. 23, and p. 441, fig. 25) deserve attention. In Guercino's *Drawing and Painting* in Dresden, it is an image of a sleeping Cupid, or Love that Painting produces according to Drawing's design. More extraordinary is the drawing after Reni reproduced by Winner, in which Painting is presented as *Maria lactans* embraced by a young man, or Drawing. Winner's explanation of the latter in relation to Zuccaro's notions of the incarnation of the Logos (*Disegno*=*segno di Dio*) is surely correct, even if the iconographical connection to Poussin's *Self-Portrait* remains uncertain.

36. *Correspondance*, 1911, pp. 244–245.

37. *Correspondance*, 1911, p. 268.

38. *Correspondance*, 1911, p. 372.

39. *Correspondance*, 1911, pp. 390–391.

40. *Correspondance*, 1911, p. 405.

41. *Correspondance*, 1911, p. 415.

42. *Correspondance*, 1911, pp. 415–416 (letter of 19 June 1650): "Ce seroit une grande sotise à celui qui voudroit entreprendre de contenter tout le monde; mais de tâcher à satisfaire à ses amis c'est une chose qui sied bien à un honnête homme." The reference to himself as an *honnête homme* is highly significant. For this concept, discussed in chapter two above, see Magendie, 1925; and, more recently, Dens, 1981.

43. *Correspondance*, 1911, p. 418. A letter from Poussin's friend Pietro Testa to his friend and supporter Simonelli concerning friendship, tyranny, and money, to which Testa added a drawing of the story of the Feast of Midas, provides an interesting parallel; see Cropper, 1988, pp. 216–220, nos. 99, 100.

44. On the need to view "de bon oeil," see further, for example, *Correspondance*, 1911, pp. 354, 380, and 405; on the "bon oeil" of the king, see p. 239. On the eye in the crown in Poussin's painting, see Posner, 1967.

45. See, for example, the letter of 3 June 1647, in which Poussin requests that after Chantelou has thought about the *Penitence* he is sending, "vous m'en escrirés sil vous plaist vostre sentiment sans adulation" (*Correspondance*, 1911, p. 357); and the letter of 22 June 1648 (pp. 383–384) concerning the *Marriage*, in which Poussin states that "L'amitié qui vous a pleu me témoigner vous en rendra juge favorable."

46. See Poussin's letter of 20 March 1642, *Correspondance*, 1911, pp. 121–122: "Les choses esquelles il i a de la perfection ne se doivent pas voir àlla haste mais avec temp jugement et intelligense. Il faut user des mesme moiens à les bien juger comme à les bien faire."

47. On the *Essais* as such trials of judgment, see Frame, 1955, pp. 78–85, esp. pp. 82–85. Montaigne himself expresses this idea most succinctly in "De Democritus et Heraclitus" (Montaigne, 1988, p. 301 [I. 50]). See further Gray, 1982.

48. *Correspondance*, 1911, p. 372.

49. *Correspondance*, 1911, p. 372: "pardonnés à ma liberté si je dis que vous vous estes mon- stré précipiteus dans le jugement que vous avés fet de mes ouvrages. Le bien juger est très-difficille si l'on n'a en cet art grande Théorie et pratique jointes ensemble. Nos apetis n'en doivent point juger sellement mais la raison."

50. *Correspondance*, 1911, p. 376.

51. *Correspondance*, 1911, p. 402.

52. *Correspondance*, 1911, pp. 414–415.

53. *Correspondance*, 1911, p. 416: "Je vous suplie, Monsieur, d'accepter de bon coeur ce mien portrait tel qu'il est, et vous prie de croire que l'original est autant votre, comme la copie."

54. *Correspondance*, 1911, p. 416.

55. See Cropper, 1984, p. 146; and Winner, 1987.

56. For the association of such a shadow with operating through affinity (or the image of *Amicus est alter idem*), see Ripa, 1986, II, pp. 281–282.

57. Included in Bosse, 1964, pp. 107–186.

58. Bosse, 1964, pp. 170, 173.

59. Bosse, 1964, pp. 182–184.

60. Bosse, 1964, p. 184.

61. See chapter one above for Poussin's employment of the Cesi Juno as a model for mature female beauty.

62. Posner, 1967, pp. 201–202. For the letter on Aspect and Prospect, see *Correspondance*, 1911, pp. 139–147. See also Winner, 1983, pp. 445–446, for the association of the figure in the *Self-Portrait* with the image of Juno in Rubens' frontispiece to Augilon's *Opticorum libri sex* (Antwerp, 1613).

63. No drawing by Poussin survives for this illustration (fig. 109), but we are not persuaded that it is by Errard. Everything points to Poussin's invention. See Posner, 1967, p. 202, on the *Trattato*. Fig. 110 is from the edition of Alberti's *Tre libri della pittura* included in the *Trattato della Pittura di Lionardo da Vinci*, Paris, 1651.

64. See Sedgwick, 1985, for an important discussion of a relationship that awaits analysis in the case of the visual arts.

65. Giovanni Pico della Mirandola's exhortation to his friend Paolo Cortesi may stand as an example here. After commenting that "It seems to me that between a portrait and a letter there is the following difference, that the former represents the body and the latter the mind. . . . The portrait, as is its office, emu-

lates the colors of the flesh and the form [*figura*]; the letter represents thoughts, advice, pains, pleasures, cares, and finally all the emotions, . . . and sends faithfully the secrets of the soul to the distant friend. In the end the letter is a living and efficient form, and the portrait is a silent and dead simulachrum." He urges that they exchange both kinds of portraits, so that the friends will be immune to the injuries of time and place. See Pico, 1601, I, p. 248. On the tradition of friendship portraiture, see Lankheit, 1952; Keller, 1967; and Roworth, 1988.

66. Montaigne, 1988, I, p. 3; translated in Montaigne, 1965, p. 2.

67. For a similar interpretation of this as the figure of the painter drawing Painting to him, see Marin, 1983, pp. 106–107.

68. In a letter of 5 November 1643 (*Correspondance*, 1911, p. 228), Poussin expresses a similar longing for the natural language of signs invented by certain nations "par la force desquelles il peuvent à autrui faire concepvoir ce quils ont en l'intellect." Fumaroli has argued that Poussin is reformulating Montaigne's statements in the "Apologie" here, for which see Fumaroli, 1982, esp. pp. 31 and 46, n. 20 (and see now Fumaroli, 1994, esp. pp. 154 and 479, n. 20).

69. On the way in which Montaigne sought to *represent* conversation, see Cottrell, 1981, p. 107. The similarity between Montaigne's and Poussin's cultivation of a sense of loss is striking. Poussin's cultivation of regular conversation in Rome is famous, but less commented upon is his creation of a situation in which he was regularly painting for an absent friend. On Montaigne, see further Defaux, 1985.

70. See, for example, Montaigne, 1988, p. 410 (II. 10, "Des Livres"): "Ce que j'en opine, c'est aussi pour declarer la mesure de ma veuë, non la mesure des choses." On the signs of authorship, see, for example, p. 805 (III. 2, "Du Repentir"): "Les autheurs se communiquent au peuple par quelque marque particuliere et estrangere; moy le premier par mon estre universel, comme Michel de Montaigne, non comme grammairien ou poëte ou jurisconsulte." In "Sur des vers de Virgile" (III. 5, p. 875) Montaigne combines the notion of do-

ing the best he can with fulfilling the desire to be himself: "Je l'eusse faict meilleur ailleurs, mais l'ouvrage eust esté moins mien; et sa fin principale et perfection, c'est d'estre exactement mien. . . . J'ay faict ce que j'ay voulu: tout le monde me reconnoit en mon livre, et mon livre en moy."

71. For this reason the frame should be considered part of the portrait, which should never be reproduced without one (though the present frame is not original). Poussin's approval of Chantelou's decision to cover the *Sacraments* so that each could be revealed in turn in order to avoid the debilitating assault of seeing them all in a single *coup d'oeil* also relates to this issue, for which see *Correspondance*, 1911, p. 384. On Poussin's view of the frame, see Marin, 1982, esp. pp. 13–23. See further on the frame the issue of *Revue de l'art* (no. 76, 1987), devoted to this subject; Lebensztejn, 1988; Marin, 1989; and Stoichita, 1992. Poussin's attention to the framing of his work was probably inspired by his understanding of Zaccolini's views (ultimately derived from Leonardo) on this matter. The kind of frame he preferred appears several times in the portrait, each time in proportion to the size of the work.

72. *Correspondance*, 1911, p. 356. In another letter, of 15 March 1658 (p. 447) Poussin is still promising Chantelou that he will do even better work if his hand will allow. He hopes to be able to say as Themistocles did on his deathbed that man departs the world when he is most competent, or just when he is ready to do well. Poussin's view of his work as a series of trials, always attempting a more perfect expression, could not be more clearly stated. The question of good faith must not be ignored, however. Poussin shared Montaigne's view of the relative importance of *manière* and *matière* (witness his views on novelty), but like Montaigne he expected to be understood. On Montaigne's purpose, see Defaux, 1983.

73. It should be recalled that most of Poussin's work arrived at its destination by mail. His seal, bearing the figure of Confidence, defined by Ripa as personifying both the knowledge of imminent danger and the firm belief in deliverance from it, had more than emblematic importance. First conceived, according to Bellori, after Poussin's uncertain journey to Paris,

it later permitted the identification of the cases containing his work, and was a guard against theft or substitution. Without it Chantelou could not know that he had received what Poussin had sent. Poussin's letters frequently refer to the identifying marks on packing cases, including this personal emblem. See, for example, the letter of 30 October 1644, *Correspondance*, 1911, p. 288: "La caisse sera scellée de mon cachet de la confiance."

74. Blunt, 1966, pp. 104–105, no. 144.

75. Wollheim, 1987, pp. 197–201, discusses the representation of the beloved within this work in terms of his argument about borrowed content. He understands the representation within the image as establishing Poussin's view that the conflict between reason and desire is fought out as "a battle between desire and desire," which reason wins. The power of Wollheim's observations derives from his recognition that Poussin's reason was dedicated to the expression of instinct.

76. Montaigne, 1988, p. 188 (I. 28). Montaigne's citation of the Stoic definition of love, as "Amorem conatum esse amicitiae faciendae ex pulchritudinis specie," is from Cicero, *Tusculan Disputations*, 4. 34.

77. On the ring, see Kauffmann, 1960, pp. 87–91.

78. On the matter of price, see, for example, the letter of 30 October 1644, concerning the *Extreme Unction* (*Correspondance*, 1911, p. 289): "Le payement dudit tableau est du tout remis à vostre volonté, car je scais bien que vous considérés le temps et la fatigue que j'y ay mise, néanmoins que ce soit ce qui y est moins de considérable." On the number of figures, see pp. 371–372. Poussin was not unprepared to ask for payment of debts; see, for example, the letter of 9 June 1643 (p. 198).

79. Nor did he enlist help in order to work more quickly, and the correspondence is full of comments concerning the waiting list for his work, which was often two years long. Poussin's determination to produce his own work as autographic essays according to his own inventions and at his own speed, made it impossible for him to work according to the wishes of the French court.

80. Alpers, 1988, pp. 88–122.

81. Alpers, 1988, pp. 115–116.

82. The argument is, furthermore, far too loosely contructed to be useful in the context of the Italian market. Guido Reni, famous for increasing the price of paintings in his day, deliberately problematized the value of his work by (among other devices) selling off unfinished commissioned works to the highest bidder. The lives of several seventeenth-century Italian artists, among whom Reni, Salvator Rosa, and Pietro Testa are only the most conspicuous, provide a rich hoard of information about the difficulties faced by artists claiming the proprietorship of their work in an economy in which patronage and the market coexisted in unpredictable ways.

83. See Marin, 1988; see also Marin, 1977 (with reference to earlier publications).

84. Marin, 1988, pp. 82–83.

85. J. Klein, 1937.

86. Marin, 1988, pp. 78–79.

87. Marin, 1988, p. 88. See also Steefel, 1975.

88. Marin, 1988, p. 84; see also Marin, 1977, p. 92, for the original, and more forceful statement that this rock is "un des signes de la Mémoire et de l'Histoire, de la Mémoire de l'Histoire."

89. Ripa, 1986, I, p. 204. Following Cicero, Ripa also defines History as "the mistress of life, and the witness to time."

90. Marin, 1988, p. 84.

91. Bätschmann, 1990, p. 61.

92. Bätschmann, 1990, pp. 58–59.

93. Bätschmann, 1990, p. 61.

94. Derrida, 1993, p. 49.

95. Ripa, 1986, I, pp. 202–204.

96. For the sonnet, see Petrarch, 1976, p. 207, no. 104.

97. Petrarch, 1976, p. 207; emphasis added.

98. The drawings are in the Louvre (Département des arts graphiques, Inv. no. 1912) and Stockholm (Nationalmuseum, Inv. no. 553/1863). For an illustration of the Louvre drawing, see Cropper, 1984, fig. 93; see also pp. 74–75.

99. Cropper, 1988, pp. 226–228, no. 103.

100. Marin, 1988, p. 87.

101. Bellori, 1976, pp. 463–464.

102. Blunt, 1966, pp. 80–84, nos. 120, 121, 123. See esp. pp. 80–81, no. 120, for dis-

cussion of the *Arcadian Shepherds*, which may not have belonged to Rospigliosi.

103. Marin, 1988, p. 79.

104. Marin, 1988, pp. 78 and 82.

105. See Percy, 1971, pp. 3–4, fig. 23, and p. 41.

106. Percy, 1971, pp. 140–141, for the etching with the same inscription, dated 1645, and p. 148 for the more closely related etching of 1655.

107. Castiglione's *Allegory of Vanity* (Percy, 1971, p. 30, fig. 16) belongs in this context. Everything that Percy and others have said about time, nature, and memory in connection with Castiglione's inventions needs to be understood in relation to his meditation on tradition (especially the classical tradition) in painting.

108. Castiglione's own obsessions with natural magic, his paintings of patriarchal journeys densely populated with animals, his rejection of classical models, and his presentation of his own genius as capricious and natural, all support a reading of this image too as a representation of artistic discourse, if along lines rather different from those proposed by Marin for Poussin.

109. For Testa's views, see Cropper, 1984, esp. pp. 237–238, para. 57B and 57C. See also Bätschmann, 1990, pp. 112–113.

110. Stephanus, 1573, col. 133. See also Cicero, *De Natura Deorum. Libri Secundus et Tertius*, ed. A. S. Pease, Cambridge, Mass., 1958, pp. 1072–1073, where Hyginus, *Fabulae*, praef. 27 ("ex Iove et Moneta Musae"), is also cited.

111. Bätschmann, 1990, p. 47.

112. Félibien, 1668, pp. 108–144. The discussion of *The Healing of the Blind* appears in the "Septième conférence."

113. On the role of the *conférences* in providing a shared language of artistic discourse, see also Crow, 1985, pp. 28–36.

114. See Pace, 1981, pp. 63–67, for a brief discussion of the importance of Dolce.

115. Félibien, 1668, pp. 111–112.

116. Félibien, 1668, p. 113.

117. Félibien, 1668, p. 114.

118. Félibien, 1668, p. 125.

119. For the history of the painting, see Blunt, 1966, pp. 52–53, no. 74.

120. Félibien, 1668, pp. 123–138, for dis-

cussion of the subject; for the argument that the treatment of sacred history must be especially faithful to what scripture requires us to believe, see pp. 128–129; and, on expression, see pp. 138–143.

121. Félibien, 1668, pp. 131–132.

122. For what follows, see Félibien, 1668, pp. 134–138.

123. See Ritter, 1832–1882, II, pp. 22–53, on travelers' accounts; and see pp. 226–318, on Galilee, Capernaum, and Tabor. Ritter points out that it is only since the time of Cyril and Jerome that Tabor, rather than the Mount of Olives near Jerusalem, was associated with the Transfiguration. See further Parthey and Pinder, 1848, and *Onomasticon*, 1631.

124. Roethlisberger, 1961, I, pp. 331–332; and II, fig. 230.

125. See Roethlisberger, 1961, I, p. 333, for this problematic drawing.

126. On the idea of metaphoricity and mode in Poussin's use of architecture, and for further examples of borrowing from Palladio, see Bätschmann, 1990, pp. 119–132. For the Villa Garzadore, see Blunt, 1967, p. 238, fig. 195, and p. 239; and for further on Poussin and Palladio, pp. 235–241.

127. Filippi, 1990, p. 25.

128. Wollheim, 1987, p. 224, discusses this sense "that the past survives within the present, or that the present is heavy with the future" in connection with *The Exposition of Moses* in words that could equally well apply to the *Arcadian Shepherds*.

129. See, for example, Ovadiah, 1990, pp. 56–60, 186–188, and Murphy O'Connor, 1980, pp. 233–237.

130. Matt., 17: 2.

131. Félibien, 1668, pp. 139–143.

132. Félibien, 1668, pp. 143–144, for the "agréable concert & une douceur charmante dont la veuë ne se lasse jamais."

133. For the pleasure of vision, see Félibien, 1668, pp. 112–113, on the comparison of the way in which the light strikes the different parts of the landscape—mountains, trees, and palaces—in different ways with the manner in which "les yeux sont d'autant plus agreablement touchez que ces échapées de lumiere font un contraste merveilleux avec les ombres & les demy teintes qui se rencontrent dans tous ces differens objets." Bourdon also comments on

the manner in which "on se laisse attirer les yeux par la douceur & la vivacité des couleurs" (p. 139).

134. Félibien, 1668, p. 125, "afin que ceux qu'il a peint autour de luy estans attentifs à le considerer, contribuassent en quelque sorte à faire que ceux qui verront cet Ouvrage le soient de mesme, sans se trouver distraits par d'autres mouvements & par d'autres expressions."

135. The source of the letter is discussed by Goldstein, 1966.

136. Blunt, 1966, pp. 10–11, no. 8. For Félibien's comments on the distinctions between jealousy, resentment, indifference, and curiosity in this work, see Pace, 1981, p. 136 (Félibien, 1725, *Entretien* VIII, pp. 108–110). As is often the case (and as in the *Healing of the Blind*), Poussin includes figures who are unaware of the events. Félibien is most interested in the attempt of one maiden to alert her companion who is filling the vase she holds that the water is overflowing: she seems to ask her "à quoi elle pense de ne pas regarder à ce qu'elle fait."

137. Marin, 1988, p. 83.

138. Fumaroli, 1982, pp. 43–44 (see now Fumaroli, 1994, p. 176).

139. Bätschmann, 1990, p. 44, understood of the *Healing of the Blind*, that "In this painting one can understand that perfect painting is not the representation of an historical event but its allegory, in so far as the depicted is understood through the depiction." The problem with this reading is the extent to which the balance between depicted and depiction shifts in Poussin's work, as Marin understood, a problem that is inseparable from the question of the phenomenon of the *tableau*. The painting for Reynon derives its story from scripture, but it may be that it is the depiction that is understood through the depicted, rather than the reverse.

140. The juxtaposition of touching and seeing is not observed by Marin or Bätschmann, who are more interested in the relationships of reading and seeing (or understanding) and writing and drawing.

141. See Teyssèdre, 1957. For a discussion of painterliness in Italy, see Sohm, 1991.

142. Descartes' title, of course, reflects the model of Montaigne, and his intention, as he explains it in the introduction to the *Discours de la Méthode*, was not to teach an authoritative method for everyone to follow, but only to show how he had developed his own reason. On Descartes and Poussin, with special reference to ideas of judgment, the passions, and aesthetic delight, see Rodis Lewis, 1993. For an important and perceptive analysis of Descartes' theories in a historical and visual context, see Jay, 1994, esp. pp. 1–82.

143. See especially *La Dioptrique*, Discours VI, "De la Vision," in Descartes, 1897–1957, VI, pp. 130–147; for fig. 117 see p. 136. On the blind man's stick and the origins of drawing, see also Derrida, 1993, and Marin, 1977, p. 75.

144. See, for example, Descartes, 1897–1957, VI, p. 134, on aerial perspective. For a discussion of Alpers' association of *pictura* as a retinal image with Kepler, and of Descartes' criticism of such a passive theory of representation, see Jay, 1994, pp. 60–63 and 75–82; see also Marin, 1992.

145. For recent studies, see Puttfarken, 1985, and Lichtenstein, 1989; see also Tessèydre, 1957.

146. For what follows, see De Piles, 1990, pp. 142–164, esp. pp. 152–154.

147. De Piles, 1990, p. 152.

148. De Piles, 1990, pp. 152–154.

149. Baldinucci, 1845–1847, IV, pp. 620–629.

150. Baldinucci, 1845–1847, IV, p. 625.

151. Département des arts graphiques, Anciens Fonds du Louvre, Inventaire 6952. See the discussion in Derrida, 1993, pp. 42–44 and 133; and fig. 17.

152. Derrida, 1993, p. 133, where the work's satirical quality is not, however, acknowledged.

CHAPTER SIX

1. See Blunt, 1966, p. 130, no. 183 (with bibliography up to 1966). The most extensive particular study of the *Mars and Venus* remains Friedlaender, 1942. The painting has most recently been discussed (from a chronological point of view) by Oberhuber, 1988, pp. 224 and 284, cat. 80. We are grateful to Peter C. Sutton, formerly Mrs. Russell W. Baker Curator of European Paintings at the Boston Mu-

seum of Fine Arts, and to Brigitte Smith of the Department of Conservation at the Boston Museum of Fine Arts, for sharing with us information about the condition of Poussin's *Mars and Venus* and for confirming observations we had made before the picture in Boston and in Fort Worth.

2. See Sutton, 1989.

3. Fraisse, 1962, p. 77.

4. For Poussin's *Triumph of Venus* and Lucretius, see Dempsey, 1966.

5. See Rearick, 1988, pp. 133–134, no. 68.

6. Rearick, 1988, pp. 82–83, no. 38.

7. Lucretius, *De rerum natura*, I. 32–40.

8. Montaigne, 1965, p. 664 (III. 5: "On Some Verses by Virgil"). All references in this chapter will be to the English translation by D. M. Frame, unless otherwise indicated. We have consulted the Frame translation together with the Villey-Saulnier edition (Montaigne, 1988).

9. See Lucretius, 1986, II, p. 600.

10. Montaigne, 1965, p. 645 (III. 5).

11. Virgil, *Aeneid*, VIII. 387–394.

12. Virgil, *Aeneid*, VIII. 630–634.

13. For the drawing, see Friedlaender and Blunt, 1939–1972, III, p. 30, no. 206. For the engraving, see Wildenstein, 1957, p. 186, no. 122.

14. For Rosso's drawing of *Mars and Venus*, see Carroll, 1987, pp. 170–175, no. 57; and for the engraving after it, pp. 176–179, no. 58. For Raphael's drawing of the *Marriage of Alexander and Roxana*, see *Raphael*, 1983, pp. 126–129, no. 42; and for the engravings after it, *Raphael*, 1985, pp. 160–161 and 650–653. For the theme, see the still fundamental article by Förster, 1894; and the useful remarks by A. Hayum, 1966.

15. Shearman, 1967, p. 68, has stressed the humorously mocking aspects of Rosso's invention, and Barolsky, 1978, pp. 113–115, aptly took note of the *eros* "with a phallus-like sword between his legs . . . who gazes up at Mars [and] seems to be endowed with the 'weapon' that Rosso's helpless Mars lacks."

16. For Annibale's *Venus and Anchises* in the Farnese Gallery, see Dempsey, 1981.

17. The attribution of this drawing to Poussin has recently been challenged by Pierre Rosenberg in his review of the exhibition of Poussin's drawings in British collections held at the Ashmolean Museum in 1990–1991 (Rosenberg, 1991). As Rosenberg writes, "To reject the famous self-portrait in the British Museum may seem sacrilegious," especially in light of the drawing's distinguished provenance and the early inscription accompanying it, but he is right to note that in certain respects it is unusual in Poussin's oeuvre. Whether unusual enough to merit rejection is another matter, and we tend to regard the jury as still out.

18. Passeri, 1934, pp. 324–325. For Poussin's illness, see, most recently, Thuillier, 1988, p. 105. The tremors that afflicted Poussin late in his life, incidentally, forcing him ultimately to cease painting altogether, are characteristic symptoms of the later stages of syphilis, for which information we are grateful to Professor Sigmund R. Suskind of the Department of Biology at The Johns Hopkins University.

19. Montaigne, 1965, p. 646 (III. 5).

20. Montaigne, 1965, p. 644 (III. 5): "But let us come to my theme. What has the sexual act, so natural, so necessary, and so just, done to mankind, for us not to dare talk about it without shame and for us to exclude it from serious and decent conversation?"

21. Montaigne, 1965, p. 638 (III. 5).

22. Montaigne, 1965, p. 681 (III. 5).

23. Montaigne, 1965, p. 671 (III. 5).

24. Montaigne, 1965, p. 645 (III. 5). See also Montaigne, 1988, pp. 848–849, for the Latin citations.

25. Blunt, 1966, p. 131, no. 184; and Oberhuber, 1988, pp. 133–138 and 266–267, nos. 28a and 28b. For Poussin's broader theme of *eros* and its sublimation in art, to which we shall shortly be turning, see Richard Wollheim's penetrating discussion (Wollheim, 1987, esp. p. 201): "Any conception of how reason relates to sexual desire—particularly a complex conception like Poussin's, which portrays reason mobilizing desire against desire—belongs inside a larger conception of instinct and of the place it occupies within human nature. Poussin, I believe, had such a larger conception." This is, incidentally, one of the first attempts to treat seriously the sexual thematics of Poussin's art, about which scholarship has been generally reticent.

26. Friedlaender and Blunt, 1939–1974, III, pp. 30–31, no. 208.

enargeia

27. Wildenstein, 1957, p. 185, no. 121. The two etchings by Chiari are much the earliest made after designs by Poussin.

28. For a discussion of Poussin's *Mercury and Venus* and the theme of Eros and Anteros, see Blunt, 1967, pp. 108–110.

29. See in particular Panofsky, 1933; Merrill, 1944; and Verheyen, 1965.

30. Dempsey, 1981; and DeGrazia, 1984, pp. 176–177, no. 191.

31. Alciati, 1621, pp. 457–459, no. 110, and pp. 461–463, no. 111.

32. For Annibale's *Amor virtutis*, see Posner, 1971, II, p. 22, no. 48 (and compare Alciati, 1621, pp. 457–459, no. 110). For Agostino's invention, see Pepper, 1971. For Reni's *Eros and Anteros,* see, most recently, *Reni*, 1988, pp. 236–237, no. 33. For Pietro da Cortona's triumph of Chastity over profane Venus in the Barberini Ceiling, see Briganti, 1962, pp. 196–203, and fig. 126; and Scott, 1991, p. 140, and fig. 82.

33. Verheyen, 1965, pp. 322–324.

34. Reni's *Eros and Anteros*, in which musical instruments are shown next to the two protagonists in order to indicate the triumph of art over physical desire, has an iconography precisely parallel to Poussin's *Mercury and Venus*, and when offered for sale in 1670 was accordingly described as an "amor divino [i.e., Anteros], che avendo legato amor profano [i.e., Eros], abbruggia gl'stromenti di vanità; oltre le due figure vi sono varij stromenti di musica e un paese" (see Pepper, 1984, p. 246, no. 88). For a further discussion of Poussin's *Mercury and Venus* in relation to other representations of the theme of Eros and Anteros, see the small catalogue of the exhibition devoted to the painting at the Dulwich Picture Gallery in 1986–1987 (Waterfield, 1986).

35. We are grateful to Matthias Winner for prompting us to think more carefully about the opposed gestures of Mercury and Mars in the two paintings, which precisely indicate the opposed meanings of Sacred versus Profane Love.

36. Bowen, 1975.

37. Montaigne, 1965, p. 666 (III. 5). In chapter five we have referred to Montaigne's motto, *mentre si puo*, which he wrote in his copy of Leone Ebreo (and other books), and which we have cited in connection with *selon qu'on*

peut. In the context of the passage quoted above, the phrase assumes a possible additional meaning.

38. For Montaigne's *Sur des vers de Virgile* and the rhetoric of *enargeia*, see Cave, 1979, pp. 271–302.

39. From a letter of 24 November 1647 to Chantelou; see *Correspondance*, 1911, pp. 370–375; and see the translation in Blunt, 1967, pp. 367–370.

40. *Correspondance*, 1911, p. 372; and see chapter one above.

41. *Correspondance*, 1911, pp. 372–373.

42. Blunt was perplexed by the apparent contradiction in Poussin's naming the effects of the Phrygian mode as being at one and the same time "joyous," and "vehement, furious, and highly severe." The contradiction vanishes, however, if we think on the one hand of the wild excitement, and even rapture of soldiers on the point of battle, and on the other of the panoleptic delusions seizing the Maenads in Euripides' *Bacchae*; and see Borgeaud, 1988.

43. Vasari, 1906, IV, pp. 23–24. For the critical *fortuna* of the *Medusa*, based upon the erroneous identification of the painting in Vasari's account with a Flemish picture in the Uffizi, see A. R. Turner, 1993, pp. 114–117.

44. See A. R. Turner, 1993, p. 116, quoting Luigi Lanzi's gallery guide to the Uffizi (1782), describing the "Leonardo" *Medusa* as: "a painting produced like this in which one saw fear and fled." For *enargeia*, see Lausberg, 1960, I, nos. 810–811; and Junius, 1992, I, pp. 375–380. The literature is vast, but for useful recent contributions (with bibliographies) see Galand-Hallyn, 1991; and Galand-Hallyn, 1990. See also LeCoat, 1975, for a comparative study of "Three Imitations of Anger," i.e., Marino's *Strage degli Innocenti*, Poussin's *Massacre of the Innocents* at Chantilly, and Monteverdi's *Combattimento di Tancredi e Clorinda*.

45. Lessing, 1968. Shearman, 1992, pp. 192–226, esp. pp. 208ff., discusses *enargeia* in relation to painted expression, but unfortunately conflates the term with *energeia*, leading him to identify its effects with extreme, or hyperbolic expression. The distinction is a well known crux of ancient and Renaissance philosophy and criticism (beyond the Renaissance sources cited by Shearman, see Junius, 1992, I, pp. 375–380, and Galand-Hallyn, 1991, p. 306). See

Blair, 1967; and for the philosophical sources of the concept of *enargeia* see Bundy, 1927.

46. Dempsey, 1967.

47. See Blunt, 1966, pp. 66–68, no. 97.

48. Montaigne, 1965, p. 645 (III. 5).

49. Montaigne, 1965, p. 664 (III. 5).

50. Cave, 1979, p. 285 (with references up to 1979). See further Cottrell, 1981, pp. 123–125, and Kritzman, 1983, pp. 75–89.

51. Cave's translation, p. 357; see also Montaigne, 1965, pp. 664–665 (III. 5).

52. Montaigne, 1965, p. 73 (I. 21: "Of the Power of the Imagination"); and see Cottrell, 1979, p. 130. The quotation from Freud is from *Inhibitions, Symptoms and Anxiety*, in Freud, 1959, 20:90.

53. Montaigne, 1965, p. 293 (II. 8: "Of the Affection of Fathers for their Children").

54. Montaigne, 1965, p. 645 (III. 5).

55. Cave, 1979, p. 287.

56. See Sohm, forthcoming in *Renaissance Quarterly*.

57. Pliny, *Naturalis historia*, XXXVI, 21. The story is often retold, most famously by Ludovico Dolce (Roskill, 1968, pp. 216–217). See also Goffen, 1987; and Cropper, 1995.

58. Bronzino, 1988, pp. 23–26. On these verses see also Gaston, 1991, esp. pp. 272–273.

59. Ovid, *Metamorphoses*, I. 454–464:

Delius hunc nuper, victo serpente
 superbus,
viderat adducto flectentem cornua nervo
"quid" que "tibi, lascive puer, cum
 fortibus armis?"
dixerat: "ista decent umeros gestamina
 nostros,
qui dare certa ferae, dare vulnera
 possumus hosti,
qui modo pestifero tot iugera ventre
 prementem
stravimus innumeris tumidum Pythona
 sagittis.
tu face nescio quos esto contentus
 amores
inritare tua, nec laudes adsere nostras!"
filius huic Veneris "figat tuus omnia,
 Phoebe,
te meus arcus" ait

(Delian Apollo, while still exulting over his conquest of the serpent, had seen him bending his bow with tight-drawn string, and had said: "What hast thou to do with the arms of men, wanton boy? That weapon befits my shoulders; for I have strength to give unerring wounds to the wild beasts, my foes, and have but now laid low the Python swollen with countless darts, covering whole acres with his plague-engendering form. Do thou be content with thy torch to light the hidden fires of love, and lay not claim to my honors." And to him Venus's son replied: "Thy dart may pierce all things else, Apollo, but mine shall pierce thee.")

60. Fried, 1990, p. 189.

61. Fried, 1990, pp. 197–198.

62. From a letter of 5 November 1643; in *Correspondance*, 1911, p. 228.

63. See above, p. 189; and Bellori, 1976, p. 455.

64. Cropper, 1986.

65. Cave, 1979, pp. 287–290.

66. Cave, 1979, pp. 272–275.

67. Montaigne, 1965, p. 667 (III. 5).

68. Friedlaender, 1966, p. 11.

69. Panofsky, 1936; and Panofsky, 1955.

70. In this distinction between a concept of *expression* inherent in forms themselves, and one of the *affetti*, or affections that are the objects of representation, appears an adumbration of, and also the indispensable critical foundation for the development in French criticism from about 1750 of the concepts of absorption and theatricality; for which see Fried, 1980.

71. See chapter one above.

CHAPTER SEVEN

1. *Exposition*, 1960, p. 227. For the inventory, see Salerno, 1960; the *Massacre* is listed on p. 101, no. 153.

2. Moschetti, 1922, esp. pp. 382–384; and Grautoff, 1914, I, pp. 352–353.

3. Oberhuber, 1988, pp. 236–241, and p. 285, no. 83. The most important earlier discussions are by Mahon, 1960, p. 291; Blunt, 1966, pp. 47–48, no. 67; Thuillier, 1974, p. 87, no. 25. See also Wild, 1980, II, no. 59.

4. 1632 marks Joachim von Sandrart's entry into the Giustiniani household. In 1635, when he left for Frankfurt, dating his own *Death of Seneca* that year, Sandrart already knew Pous-

sin's painting; for his drawing after it, see Peltzer, 1925, esp. p. 132, fig. 35.

5. Salerno, 1960, pp. 101–102, nos. 156, 157, 158. For Sandrart's *Death of Seneca*, see Klemm, 1986, pp. 63–67, cat. no. 11, fig. 11; for the *Death of Socrates*, see Nicolson, 1979, pp. 54–55, pl. 233. Despite the name in the inventory, Nicolson believes that the painter of this last work was probably a French Caravaggist.

6. Oberhuber, 1988, p. 236.

7. It was on account of all these features that, for example, Thuillier suggested that the work was undertaken as a kind of proof of Poussin's abilities to paint on a large scale upon his arrival in Rome. See Thuillier, 1961, esp. p. 340.

8. There, as supervisor of the great publishing project of the *Galleria Giustiniana*, he was in a position to help his friends from the North, as he helped Duquesnoy in 1633. See, in addition to Klemm, 1986, pp. 337–338, Faldi, 1959.

9. Mahon, 1960, p. 291.

10. Mahon, 1960, p. 291.

11. Mahon, 1962, pp. 3–4, n. 8.

12. Panofsky, 1960, p. 31. Mahon acknowledges that Panofsky, who accepted a date of c. 1627, had no intention of suggesting that the date provided a *terminus post quem*.

13. See Marino, 1960, esp. pp. 453–454, for a brief summary of the argument of G. Scopa's very rare book, *Le fonti della Strage degl'Innocenti di G. B. Marino*, Naples, 1905, of which we have been able to locate no copy. In this 1960 edition of Marino's *Strage*, the editor Giovanni Pozzi's citations of Aretino's *Umanità di Cristo* are to the edition published in Parma, 1536. We have followed Pozzi in the difficult matter of the division of the *Strage* into books, or *canti*.

14. See Marino, 1960, p. 548, n. 40 (*Strage*, III, 40) for the reference to Aretino's "calcatogli il ventre col piede, uccisolo con due ferite."

15. Maguire, 1981, pp. 22–34. See pp. 26–27 for the important elaboration and transformation of the sermon into a hymn for the feast of the Innocents in the sixth century by the poet Romano.

16. Maguire, 1981, pp. 26–28. His figs. 9–14 illustrate the early fourteenth-century mosaics of the Karije Djami, in which are to be found all the appropriate episodes (even including the image of the soldier treading a baby underfoot as he slays him). These scenes are also divided according to the traditional composition of the *ekphrasis*, showing the prelude, the action itself, and the aftermath, as Maguire has shown.

17. In the less influential Roman early Christian tradition infants are smashed to the ground rather than pierced by swords. See Kötzsche-Breitenbruch, 1968–1969.

18. He also had the same ancient Roman sources to draw upon as the Byzantine artist of the Karije Djami. See especially the figure of the woman in the background, seen from the rear and clasping a child to her breast, who also appears in the mosaics. Maguire, 1981, p. 32, relates this group to the scene of the taking of the Dacian captives on Trajan's column, but is uncertain if the relationship is one of reinvention rather than imitation.

19. Maguire, 1981, pp. 24–26, for the subject of battle as a suitable one for vivid description according to Hermogenes and Quintilian, and on the importance of this tradition for descriptions of the Massacre.

20. *Patrologiae Graecae*, LXXXV, cols. 395C-398A: "Quomodo tua rursum connectam membra, quae tam inclementer machaera dissecuit? cuiusmodi matrix ad te recorporandum mihi subserviet? aut quibus manibus necessariam tibi terram aggeram? quomodo me ab imagine tua semovebo?" It is very likely that Raphael knew this figure through some intermediary source, quite possibly a sermon too.

21. The image, which was famous throughout Europe according to Vasari, may even have contributed to Aretino's invention. Bandinelli's incomplete *modello* for the engraving by Marco Dente is in the Devonshire Collection; for illustrations of both, see M. Jaffé, 1987, pp. 36–37, figs. 8 and 8.1.

22. Bayerische Staatsgemäldesammlungen, Alte Pinakothek, Munich, Inv. no. 572.

23. Cropper, 1988, pp. 97–102, nos. 50–51.

24. For Castello's paintings, which are remarkably close in spirit to Testa's drawings, see Lamera, 1981–1982. For Stanzione's painting in Schloss Rohrau, see Schütze and Willette, 1992, pp. 203–204.

25. Marino, 1960, p. 454.

26. See Marino, 1966, p. 54, no. 34.

27. Marino, 1960, pp. 445–463.

28. Marino, 1966, pp. 214–215, no. 126; and pp. 257–259, no. 138.

29. Marino, 1966, p. 352, no. 189.

30. On the Crescenzi, see Grelle, 1961.

31. Marino, 1966, p. 381, no. 209.

32. Marino, 1966, pp. 418–419, no. 232.

33. Marino, 1960, p. 547 (*Strage*, III, 36).

34. Her counterpart in the background of the *Plague at Ashdod* is far less emotionally charged. The figure in the *Plague* might be a *ricordo* of the figure in the *Massacre*, but according to our dating it is more likely that Poussin instead took up this figure from the *Plague* and invested it with unique expressive power as he rethought the scene of the Massacre through the medium of Marino's poetry.

35. Marino, 1960, p. 547 (*Strage*, III, 37–38). The unequal struggle is rendered all the more bittersweet by Marino through the comparison of the woman clinging to the murderer to the image of ivy clinging to a tree trunk, a familiar metaphor of conjugal love.

36. In the Petit Palais version the assassin to the left has the mother by her hair, and forces her away from her infant, upon whom he is about to tread. The child raises his arms as if, in another of Marino's images, to embrace his father, his sweet tenderness enhancing the horror. The seizing of the woman's hair derives from the imagery of ancient Amazon sarcophagi; see, for example, Markham Telpaz, 1964.

37. See, for example, Horace's threat (*Ars poetica*, 185) that he would turn in disgust if Medea was shown butchering her children in the presence of the audience, and so on. See also chapter six above on this question, which was, of course, extensively defined by Lessing.

38. Marino, 1960, p. 548 (*Strage*, III, 39).

39. See, for example, Croce, 1935, I, pp. 106–118. Croce compares Marino to a tailor, or hairdresser, who merely fixes things up.

40. Rubens also conveys sweetness through the garlands of flowers strewn by angels; in the *Strage*, IV, 95 (Marino, 1960, p. 594), these are woven by the Innocents as they dance in a ring.

41. Cropper, 1988, pp. 102–104, no. 52.

42. Marino, 1960, p. 569 (*Strage*, IV, 13). Pozzi associates the image with Prudentius' image of drowning in a sea of blood. The awfulness of Marino's vision is compounded by that of the sword being driven into the breast: Marino's choice of *lingua* for sword is guaran-teed to shock, and Testa does not show this. See also Marino, 1960, p. 570 (*Strage*, IV, 16), for milk turning to blood, which stains the breast of the mother and the face of the child; and pp. 552–553 (*Strage*, IV, 55), for the horrific image of a sword slicing through the lips of a child at the breast so that the breast is made into a cup of blood.

43. Vasari, 1906, III, pp. 264–265. On this description see, for example, Alpers, 1960, pp. 202–203.

44. Alpers, 1960.

45. Pliny, *Natural History*, XXXV, 98–99.

46. Alpers, 1960, pp. 202–203, refers Vasari's *ekphrasis* of the fresco by Ghirlandaio to this source in Pliny, suggesting that Vasari changed the story to show the child rather than the mother dying. But Vasari's source lay more appropriately in descriptions of the Massacre.

47. As noted by Blunt, 1967, pp. 94–95, and fig. 88. Blunt also relates Aristeides' image to Ghirlandaio's fresco.

48. Knowles, 1982, II, p. 67.

49. Knowles, 1982, II, p. 66.

50. Blunt, 1967, pp. 94–95.

51. In the sixteenth century the Amazon was shown with a child beside her. Bieber, 1955, p. 110, cites a drawing of 1540 after this pair. For further discussion, see chapter two above.

52. Marino, 1960, pp. 535–536 (*Strage*, III, 1–2).

53. See Pozzi's comparison of the passages (in Marino, 1960, p. 554).

54. Marino, 1960, p. 558 (*Strage*, III, 70, lines 7–8): "Of white marble had not her sons/ Made her ivory limbs vermilion."

55. Mancini, 1956, I, p. 109.

56. See Panofsky's perspicacious comments (Panofsky, 1960, pp. 29–31).

57. See Marino, 1979, I, pp. xlvii–lii, for the publication history.

58. Pepper, 1984, pp. 225–226, no. 34. Pepper's proposal that the picture was painted in Rome, rather than in Bologna, matters less than the fact that he also seeks to undermine Malvasia's critical credentials. This is unfortunate, for in the case of the *Massacre* Malvasia's observations may indeed be corroborated by the evidence of the pictures themselves.

59. Malvasia, 1841, II, p. 17. Guido's failure to "istoriare," according to Malvasia, continued throughout his career.

60. Malvasia, 1841, II, p. 17. On the important critical notion of tenderness, see Colantuono, 1986.

61. Gnudi and Cavalli, 1955, p. 63.

62. Gnudi and Cavalli, 1955, p. 63.

63. For further discussion of the figure of the sleeping Cupid in the work of Marino, Caravaggio, and Reni, see Cropper, 1991. On sleep and death in the Massacre, see Marino, 1960, p. 569 (Strage, IV, 12): "E gl'insegna a saper come vicini/ Hanno il sonno e la morte i lor confini."

64. "O nella crudelitate anco pietoso/ Fabbro gentil, ben sai,/ Ch'ancor tragico caso è caro ogetto,/ E che spesso l'orror va col diletto." Quoted by Malvasia, 1841, II, p. 18. See also Marino, 1979, p. 56.

65. Marino, 1960, p. 551 (Strage, III). For an introduction to this question as one of the most powerful challenges to painters in the seventeenth century, beginning with Caravaggio, see Cropper, 1991, p. 199.

66. See, for example, the image of the beautiful twins, and of the little child who comes out from under his mother's skirts, as well as the play upon the golden light of dawn as marking both beginning and ending of the story. And Reni's own combination of the graceful style of the Cavaliere d'Arpino with that of ancient sculpture in the Greek style fits Marino's taste for beauty perfectly.

67. For a summary of the discussion, see Dempsey, 1988, esp. pp. 108–111.

68. For the engraving by G. Gandolfi, see Garboli and Baccheschi, 1971, pp. 88–89; for that by G. Giovanni, see Pepper, 1984, pl. 15 and pp. 214–215, no. 14. For the discussion of the various styles, see Malvasia, 1841, II, p. 12.

69. Pepper, 1984, p. 221, no. 25.

70. Dempsey, 1986; and Dempsey, 1988, pp. 117–118.

71. See Malvasia, 1841, II, p. 21, on Guido's assiduous study of the Seneca. For Poussin's and Duquesnoy's analysis of ancient sculpture, see chapter one above.

72. For which see Cropper, 1976.

73. Marino, 1960, p. 551 (Strage, III, 50).

74. See further Cropper, 1991, p. 199.

75. See also Wittkower, 1963, esp. p. 44, for the suggestion that Poussin's source was a Medea sarcophagus (though the Niobe is a more complete model). Wittkower's important point is that Poussin introduces antique

models as a vehicle of catharsis as he approaches his final version.

76. On the tragic mask, which also appears in the Plague at Ashdod, see Wittkower, 1963, pp. 43–44.

77. Zamboni, 1930–1931, p. 915.

78. Marino's intense sense of proprietorship would lend credence to this story.

CHAPTER EIGHT

1. Félibien, 1725, Entretien VIII, pp. 99–100, in Pace, 1981, p. 134:

[Q]uand le Poussin fit son tableau de Rebecca, quel fut, je vous prie, son dessein? J'étois encore à Rome lorsque la pensée lui en vint. L'Abbé Gavot avoit envoyé au Cardinal Mazarin un tableau de Guide, où la Vierge est assise au milieu de plusiers jeunes filles qui s'occupent à differens ouvrages. Ce tableau est considerable par la diversité des airs de tête nobles & gracieux, & par les vétemens agréables, peints de cette belle maniere que le Guide possedoit. Le Sieur Pointel l'ayant vû, écrivit au Poussin, & lui témoigna qu'il obligeroit s'il vouloit lui faire un tableau rempli comme celui-là, de plusiers filles, dans lesquelles on pût remarqeur differentes beautez.

2. Cropper, 1976.

3. For the material in the above paragraph, see Cropper, 1976.

4. "Lisés l'istoire et le tableau" is from a letter of 28 April 1639 to Chantelou; see Correspondance, 1911, pp. 20–22. The analogy of painting and the alphabet is reported by Félibien (for which see Blunt, 1967, p. 222), and the two passages have been most usefully analyzed by Marin, 1977, pp. 43–45 and passim. On the movements of the body, see Fumaroli, 1994, pp. 149–181 and 478–481.

5. Félibien, 1725, pp. 90–91; in Pace, 1981, pp. 131–132.

6. For Poussin's two landscape styles, see Blunt, 1944. The characterization of the second style as "Mythological" is owing to D. Panofsky, 1949, and this much more specific and useful term was followed by Friedlaender, 1966, and subsequent writers. The reintroduction of mythological figures into the landscape

is adumbrated at the end of Poussin's first style, notably in pictures like the *Orpheus and Eurydice* in the Louvre.

7. Blunt, 1966, pp. 124–125, nos. 173 and 174. The story derives from Plutarch, *Phocion*.

8. Gerbel (1st ed., Basel, 1545), in Gronovius, 1697–1702, IV. For a more detailed discussion, see Dempsey, 1963a, pp. 112–122.

9. Dempsey, 1963a, p. 117. For the Parthenon with the minaret, see also the illustrations in Spon, 1685; and in Delaborde, 1854.

10. Blunt, 1966, pp. 144–145, nos. 210 and 211.

11. See Dempsey, 1963a, pp.132–144, for a fuller discussion of the painting in relation to contemporary scholarship, notably the monumental study of Roman military highways written by N. Bergier (*Histoire des grands chemins de l'empire romain*, Paris, 1622). An argument that Poussin intended to represent the via Domitiana can be made on the basis of the seaside location of the road, the huge orange trees, and Statius' encomium of it (*Sylvae*, IV, 3); as well as on the basis of material gathered by one of Cassiano dal Pozzo's friends and correspondents, Camillo Pellegrini, for his *Discorsi della Campania felice*, published in Naples in 1651.

12. Blaise de Vigenère, 1614, pp. 395–396 (La Thessalie):

Venons maintenant à representer par ce discours les Tempé Thessaliques: car cela est assez notoire, que si l'oraison a la grace & la force de se bien nettement expliquer, elle ne pourra moins naïfuement nous remettre devant les yeux ce qu'elle vouàra entreprendre, que les plus excellens ouvriers en l'art de peinture. Il y a doncques un certain lieu situé entre le mont Olympe, & celuy d'Ossa, qui sont d'une marveilleusse hauteur, separez l'un de l'autre presque par un divin ouvrage; embrassant au milieu un espace dont la longueur s'estend à quarante stades; & en largeur par endroits à un Plethre contenant cent pieds de Roy (qui peuvent revenir à seize ou dix sept de nos toises) & en d'autres quelque peu plus. Par ce milieu & ouverture passe ce qu'on appelle Peneus, dedans lequel tout plein d'autres rivieres se viennent rendre, & luy communiquans leurs eaux, l'aggrandissent. Il y a aussi là force petits cabarets & hostelleries de toutes sortes:

non toutesfois faictes d'ouvrage de main, mais du propre motif de nature; qui y apporta une merveilleuse beauté lors que premierement cela vint en estre. Car il y a par tout des Lierres en abondance, bien revestus de branches & de feuilles: lesquels à guise d'une plantereuse vigne grimpent le long de la tige des arbres, & s'y entrelassent naissans à leur pied. Plus du Liset à foison, qui se placque contre les rochers, & les tapisse de sorte que toute la pierre en demeure cachée, sans qu'on y puisse rien appercevoir que se soit fors la seule verdure. En la plaine infinis iardinages, & des feuilles de tous costez, aggreables retraittes en temps d'Esté pour les passans, où ils se peuvent raffreschir avec beaucoup de recreation, volupté, & soulagement: & plusiers sources & fontenils courans d'une eau fresche, delicieuse, & tres-agreable à boire. L'on dit davantage qu'elle est fort propre à se baigner, & prouffitable à la santé. Là les petits oisillons espandus de costé & d'autre, de leurs douces et armonieuses gorges remplissans les oreilles de ceux qui passent ce chemin, les accompagnent & convoyent tout le long d'iciluy avec tant de plaisir, que cela leur en fait du tout oublier le travail. Et sur les deux bords de l'eau sont ces ramées & friscades que i'ay dit cy dessus, tout expressement pour se reposer. Ainsi au travers de ce delicieux Tempé coule le gentil Peneus, tranquille, quoy, & uny, comme s'il estoit d'huile; couvert tresabondamment d'ombrages provenans des branches & rameaux des arbres plantez li dru & menu; qui la plus grande partie du jour repoussent l'ardeur de Soleil, & empeschent que le cours de l'eau n'en soit rechauffé; apprestans par ce moyen un gracieux raffreschissement à ceux qui navigent dessus. Au surplus tous les habitans d'alentour vivent de compagnie, faisans par ensemble leurs sacrifices & banquets. Et pource que grand est le nombre de ceux qui font ces offrandes & vacquent continuellement au service divin; il s'en ensuit que ceux qui passent par ce quartier soit par terre ou par eau, participent a l'odeur de ces bons parfums & encensemens. De maniere que l'assiduel soing, & la diligence dont les Dieux sont là reverez

sans cesse, rendent le lieu merveilleusement saint et devot. Les Thessaliens dient qu'Apollon Pythien y fut purifié par le commandement de Iuppiter, apres qu'à coups de flesche il eut mis à mort le grand serpent Python qui occupoit encore Delphes, lors que ce territoire rendoit les oracles: mais que puis apres il fut couronné du Laurier de Tempé, dont prenant un rameau en sa main, il vint se saisir de Delphes; & y a mesme en cest endroit la un autel où il fut couronné, & d'où il emporta le rameau. Au moyen dequoy jusqu'a aujourd'huy, ceux de Delphes y envoyent de neuf en neuf ans les enfans de bonne maison avec un maistre de ceremonies, lì où ils font magnifiquement un service & anniversaire; & s'en retournent apres s'estre parez le chef de chappeaux de ce Laurier propre, dont le Dieu amoureux de Daphné fut couronne le premier.

13. Ashby, 1927, p. 5. For a biographical account of Holstenius, including his travels with Philip Clüver, the first topographer of ancient Italy, see Almagià, 1942; and Dempsey, 1963a, pp. 134–137.

14. Holstenius, 1666; Stephanus Byzantinus, 1825; and see Holstenius, 1817.

15. Blunt, 1966, pp. 143–144, no. 209. See also Blunt, 1967, pp. 286–291, for an argument that Poussin represented a recent incident that took place in Fondi, near Terracina. There is an old tradition in support of this suggestion, notably the inscription on Etienne Baudet's engraving of 1701 after the *Landscape with a Snake* ("L'on tient que le Poussin peignit ce tableau à l'occasion d'un accident semblable qui arriva de son temps aux environs de Rome"), and the entry under Lot 113 of the catalogue of the sale of the paintings of Robert Strange in March of 1773 ("a prospect of Terracina, in the kingdom of Naples. It was in the neighborhood of this city, in the morass of Pontius, that the catastrophe which gave rise to the subject of this picture happened in the year 1641"). Both suggestions clearly arise, however, as hypotheses put forward in the absence of any knowledge of Poussin's subject transmitted by the early sources, and Blunt's specific suggestion falls because Fondi was completely abandoned in the seventeenth century, and in consequence of its location in the

Pontine marshes was described as snake-infested, foul, and pestilential by contemporary witnesses, none of which fits with Poussin's idyllic setting. Blunt was also unaware that the episode shown derives from ancient sculpture.

16. For Archemorus, see Statius, *Thebaiad*, IV, and Apollodorus, *Bibliotheca*, III. 6. 4. For Archemorus as the subject of the reliefs, see *Corpus inscriptionum latinarum*, Berlin, 1863–1936, VI, part 3, nos. 17102 and 19296, with extensive earlier references; Matz and Duhn, 1882, p. 193, no. 3926; Altmann, 1905, p. 102, no. 84; Dempsey, 1963a, pp. 72–73; and Simon, 1971. The story of Archemorus has been tentatively proposed as the subject of Poussin's painting, but was rightly rejected by Blunt, 1967, p. 286, n. 11, because the victim would be an infant, not a youth.

17. For the many antiquarian drawings after the two cippi, which belonged to Cardinal Carpi before the Barberini acquired his land for their palace, see Rubinstein, 1989.

18. Van Nideck, 1726, pp. 173 and 281.

19. Montfaucon, 1719, V, part 1, p. 61, and plate XXX; see also pp. 86–87 and plate LXVII.

20. Fénelon, 1730. For Félibien's descriptions, see Félibien, 1725, *Entretien* VI, p. 204, p. 63, *Entretien* VIII, pp. 150–151. For the last two, see Pace, 1981, pp. 125 and 146–147. The passions are beautifully characterized by Félibien, although no indication is given of Poussin's subject:

The situation of the place shown there is marvelous, but in the foreground there are figures who express horror and fear. This dead corpse, extended along the side of a spring and wrapped round by a serpent; this man who takes flight with fear in his face; this seated woman, both astonished at seeing him run and terrified —these are passions that few other painters have known how to figure in as worthy a manner as he. . . . One discovers in the countenance of the man, and in the features of his face, not only the horror he feels at the sight of the dead corpse lying by the side of the fountain, but also the fear that has seized him at the encounter with that frightful serpent, which he regards with a similar treatment. For when fear of evil is joined to the aversion one

feels for a disagreeable object, it is certain that the expression of it is even stronger. For the eyebrows rise up, and the eyes and mouth open wider, as though to seek some asylum, and ask for help. The hairs rise on the head, the blood drains from the face, leaving it pale and distorted, and all the members become so powerless that one can scarcely speak or run; and this is what one sees perfectly represented in this painting.

21. Bellori, 1976, pp. 8–9. Aside from the fundamental study by Dora Panofsky, 1949, see Blunt, 1966, pp. 92–93, no. 132 (with full bibliography up to the date of publication); and Blunt, 1967, pp. 316–319.

22. Bellori, 1976, pp. 460–461.

23. See Euripides, *Bacchae*, ed. with introduction and commentary by E. R. Dodds, 2nd ed., Oxford, 1960, p. 143 (commentary to vv. 521f.).

24. See Blaise de Vigenère, 1614, pp. 112–113, for an exhaustive account of ancient testimonia regarding the location of Nysa, among them "Stephanus [Byzantinus], au livre des villes, en met dix de ce mesme nom," i.e., in Helicon, Thrace, Caria, Arabia, Egypt, the isle of Naxos, India, Mount Caucusus, Libya, and Negropontis.

25. Nonnus, *Dionysiaca*, IV, 356; and see Euripides, *Bacchae*, 1–63.

26. Conti, 1567, p. 213, translating Euripides, *Bacchae*, 519ff.

27. Philostratus, *Imagines*, I. 14, as translated from Blaise de Vigenère, p. 110:

Mais Dionysus ayant faussé la ventre de sa mere, s'en iette dehors, & plus clair luisant qu'une estoille, rend par sa splendeur le feu tenebreux, & sombre. La flamme, au reste, se separant, luy façonne ie ne sçay quelle apparence de grotte plus agreable que celle d'Assyrie, ne de Lydie: Car les lyerres, avec leurs belles grappes sont parcreux à l'entour: & les vignes desia, ensemble les arbres du Thyrse, sortent si volontairement de la terre, qu'il y en a quelques unes mesmes emmy le feu: dont il ne se faut pas esbahir, si en faveur de Dionysus elle coronne les flammes, comme celle qui doibt d'oresnavant rager avec luy; & laissera puiser le vin à pleins seaux dedans les fontaines: traire pareille-

ment le laict, tant des mottes, que des cailloux, tout ainsi que de deux mammelles. Escoutez Pan, comme il gringotte Dionysus sur la cime du mont Citheron; sautant, ballant, ce mot d'Evion en la bouche. Mais Citheron en forme humaine lamentera bien tost les doloreux accidens qui y doivent advenir; coronné pour cette heure d'un chapeau de lyerre, qui luy penche nonchallammant sur la teste, tout prest à cheoir; Car c'est bien fort contre son cueur de se veoir ainsi paré pour l'amour de Dionysus. Et voila l'enragée Megere qui plante un sapin pres de luy, & fait sourdre une fontaine d'eau-vive, à cause du sang d'Acteon, & de Pentheus qui s'y doit respandre.

The importance of Blaise de Vigenère's edition of Philostratus for Poussin has been discussed at length by D. Panofsky, 1949, and by Panofsky, 1950. For ancient representations of the birth of Bacchus and his nurture by Dirce and the Nymphs, some of which Poussin certainly knew, see Thompson, 1977 (esp. n. 12 for further bibliography).

28. Euripides, *Bacchae*, 338ff. and 1291, and Nonnus, *Dionysiaca*, V, 269ff., esp. 355 and 428. The fir tree planted by Megaera is that in which Pentheus hid himself from the Bacchantes, and from which he was pulled down and torn to pieces.

29. *Imagines*, I. 23, as translated from Blaise de Vigenère, p. 193:

La fontaine de vray represente fort bien Narcisse; mais la peinture faict voir la fontaine, & tout ce qui depend de Narcisse. Le Iouvenceau ayant n'agueres quitté la chasse s'est venu planter sur le bord, puisant ie ne sçay quel contentement de l'eau, & est espris de sa beauté propre: Car il y darde (ainsi que vous voyez) des oeillades estincellantes à maniere d'esclairs. C'est au surplus ici la Grotte d'Acheloüs & des Nymphes; le tout peint comme il faut. . . . La source neantmoins n'est pas desgarnie de quelque Bacchanalerie, comme celle que Bacchus a produite en faveur de ses ministresses: aussi est elle tapissée à l'entour de vigne & de lyerre, avecques de fort-beaux

pampres & bourgeons: des grappes aussi,
& des Thyrses de costé & d'autre.

Dora Panofsky realized that the pool of Dirce
and the cave of Achelous were common to both
the myths of Bacchus and Narcissus, and her
perception is duly noted in the later literature,
notably by Friedlaender, who writes that nev-
ertheless the two myths have nothing to do
with each other. But they have everything to
do with the pool of Dirce, and the difficulty
that appears in the earlier art-historical litera-
ture in grasping the significance of this fact
stems from the prevalent misconception that
even artists as sophisticated as Poussin primar-
ily "illustrated" myths, rather than using the
materials of fable as a foundation for poetic
reasoning (*mythos*), an imaginative means for
expressing their own poetic themes and inven-
tions. In the case of the *Birth of Bacchus* Pous-
sin's theme is neither Bacchus nor Narcissus
directly, but rather the spirit of the ancient
landscape, in this case the pool of Dirce in all
its wonder and its terror.

30. Blaise de Vigenère, and Persius, *Sat.* I.
102. The complete passage reads as follows:

Torva Mimalloneis implerunt cornua
 bombis,
Et raptum vitulo caput ablatura superbo
Bassaris, et lyncem Maenas flexura
 corymbis
Evion ingeminat: reparabilis adsonat
 Echo.

Poussin also referred to the Bacchic cry in his
painting of the *Triumph of Bacchus* in Kansas
City, in which one of the celebrants carries aloft
a garlanded plaque inscribed *Evoe*, in reference
to *Euios*, the name of Bacchus (*Euhius* in Latin).

31. See Borgeaud, 1988, esp. pp. 47–50;
Philippart, 1930; Hanfmann, 1939; and
Thompson, 1977.

32. Borgeaud, 1988, p. 59; and Euripides,
Bacchae, 951f., in which Dionysus addresses
Pentheus, who is in a state of hallucination,
saying "Now nay, the shrines of Nymphs de-
stroy not thou, and haunts of Pan that with his
piping ring."

33. Plato, *Phaedrus*, 258c-d; and see Bor-
geaud, 1988, pp. 104–105.

34. Thompson, 1977.

35. Lehmann-Hartleben, 1942.

36. Byam Shaw, 1983, I, pp. 169–170, no.
167; and Dreyer, 1969, pp. 57–58, no. 114.

37. "Finsero i Greci, che Bacco sottratto a
gl'incendi della casa materna, fosse per co-
mando di Giove portato da Mercurio alle Ninfe
de'fonti per educarlo; con istupore di Pan, che
all'arrivo del fanciullo vide la sua spelonca di
verdeggianti viti, e di biondi grappoli improv-
isamente adornarsi. Questa favola si felice-
mente spiegata in disegno dal virtuosissimo
Cavaliere Maratti [etc.]."

38. Bellori, 1976, p. 459. See also Panofsky,
1950; Blunt, 1966, p. 92, no. 131; and Blunt,
1967, pp. 336–353. The painting has been
discussed in a fine article by Vetter, 1971.

39. See in particular Vetter, 1971.

40. The *locus classicus* for a description of
Tempe is in Aelian, *Varia historia*, 24, which
we have quoted above from Blaise de Vige-
nère's translation (see above, note 12).

41. Servius, *Ad Verg. Georg.*, III, 2.

42. Poussin's reading of Conti has been es-
tablished beyond any doubt, not only by
Gombrich (in Gombrich, 1972), but specifi-
cally by scholars of his project for the Long
Gallery in the Louvre, for which Conti pro-
vided Poussin his inventive foundation: see
Van Helsdingen, 1971; and Henderson and
Henderson, 1977.

43. Conti, 1627, p. 332. Conti's original
Latin reads as follows:

Juniperum spinosam arborem conse-
cratam fuisse, cui laurus praeterea dicata
putabatur quod nympham Daphnen ab
Apolline amatam in hanc ferunt muta-
tam, cum fugeret Apollinem: quia magis
Leucippo juvene imberbi ac praevalido
delectaretur. Ferunt Leucippum fuisse in-
vitatum cum caetero coetu virginum, ut
se laveret in fluvio Ladone, cum esset
indutus veste muliebri, idque impulsu
Apollinis invidentis ejus felicitati, quod
cum recusasset Leucippus, fuit denique
protractus ac deprehensus virginem emen-
titus a sociis Daphnes jaculis et pugionibus
confossus interiit.

44. Giraud, 1968, Part I, Chapter 2 ("Ori-
gine et évolution du mythe de Daphné").

45. Lucian, *The Dance*, 48.

46. Giraud, 1968, pp. 28–30.

47. Ancient references to Daphne as the
daughter of Ladon are very frequent; see Gir-
aud, 1968, pp. 27–39; and Pauly-Wissowa,

Real-Encyclopädie der class. Altertumswissenschaft, s.v. "Daphne."

48. Cicero, *De natura deorum,* III. 23, and Clement of Alexandria, *Protrepticon,* II. 24P. For Apollo *Nomios,* see also, for example, Theocritus, *Idyls,* XXV, 21, or Pindar's ninth Pythian Ode, 112ff., the latter of which is quoted by Conti, 1567, pp. 108–109 (Apollo "quem Arcades Nomionem appellant").

49. See Williams, 1978, p. 48, and Farnell, 1896–1909, IV, pp. 123–124.

50. Pausanias, *Description of Greece,* VIII. 20. Pisa is a city in Arcadia (besides Pausanias, see Ovid, *Metamorphoses,* V. v. 94: "Pisa, Arcadiae oppidum"). The only other version of the story is Parthenius, *Erotika pathemata,* 15:

> The following story is told about Daphne, the daughter of Amyclas. She never went to town at all, nor did she have much to do with other girls. She preferred to round up her hounds and hunt in Laconia, ranging at times into the farthest hills of the Peloponnese. Because of this she became a favorite of Artemis, and the goddess made her an excellent archer. Now once, while she was wandering through Elis, Leucippus, the son of Oenomaüs, fell in love with her. Despairing that he could succeed with her in any other way, he dressed himself in women's clothing, and disguised as a young girl joined her in the hunt. As luck would have it she found him altogether to her liking; continually embracing him and hanging upon him, so she would not let him leave her side. Apollo too burned with longing for the girl; he was gripped by anger and jealous of her companion Leucippus. So he put it in Daphne's mind to go off with the other girls to bathe in a spring. They arrived at the spot, and each began to remove her clothes. When they noticed that Leucippus was hesitating, they tore his clothing off. And when they realized how they had been deceived and how he had manipulated them, they all hurled their spears at him. Thus by the will of the gods he was obliterated. But Daphne, seeing Apollo advancing toward her, fled as quickly as she could. The god kept up the chase, until the girl begged Zeus to be released from humankind. And they say that she then became the tree named after her.

The translation is from Parthenius, *Erotika pathemata: The Love Stories of Parthenius,* translated with notes and an afterword by J. Stern, New York and London, 1992. Parthenius sets the story in Elis.

51. See Panofsky, 1936.

52. Sanazzaro, *Arcadia, Prosa decima.*

53. See, for example, Conti in the Montlyard-Baudoin edition (Conti, 1627), pp. 323 and 325.

54. Servius, *Ad Verg. Ecl.,* proem.

55. Donatus, for example, traces the origins of pastoral to various gods of husbandry, from Apollo *Nomios* to Artemis and Pan, because they are "id genus numinum principi, quibus placet rusticum carmen" (*Scholia in Theocritum vetera,* Leipzig, 1914, p. 18, 10–18), while Servius writes, "alii non Dianae, sed Apollini Nomio consecratum carmen hoc volunt" (*ibid.,* p. 21, 1–4). See Halperin, 1983.

56. Panofsky, 1936 and 1955. Much has been written about Poussin's *Arcadian Shepherds* since Panofsky, among which the following works by Louis Marin are especially useful: Marin, 1977; and Marin, 1988. See chapter five.

57. Bernstock, 1987.

58. Virgil, *Eclogues,* V. 40–44.

59. Virgil, 1502. The illustrations and the tradition of Virgilian commentary have been treated at length by Patterson, 1987.

60. See, for example, Virgil, 1749, commentary to Eclogue V. 42: "Tumulum: A heap of earth for a monument."

61. Virgil, 1749, commentary to Eclogue V. 42: "*Carmen:* An epigram or inscription which is thought to be best when contained in two lines."

62. See in particular Marin, 1977.

63. Ricci, 1974, p. 344.

64. We are grateful to Irving Lavin for reminding us that the pose of the shepherd leaning on his staff is a well-known figure for mourning derived by Poussin from ancient sarcophagi, where similar figures appear either as attendant mourners or as personifications of Sleep and Death leaning on their torches (for which, see Bartoli and Bellori, 1693, pl. 67).

BIBLIOGRAPHY OF WORKS CITED

ACCOLTI P. Accolti, *Lo inganno degl' occhi*, Florence, 1625.

ADDISON *The Works of Joseph Addison*, 3 vols., New York, 1850.

AFFÒ I. Affò, *Ragionamento . . . sopra una stanza dipinta dal celeberrimo Antonio Allegri da Correggio nel Monistero di S. Paolo in Parma*, Parma, 1794.

ALBERTI L. B. Alberti, *On Painting and On Sculpture*, ed. and trans. C. Grayson, London, 1972.

ALBRICCI G. Albricci, "Donne incisori nei secoli XVI e XVII," *I Quaderni del conoscitore di stampe* 19, 1973, pp. 20–25.

ALCIATI A. Alciati, *Emblemata cum commentariis Claudii Minois I.C. Francisci Sanctii Brocensis, & notis Laurentii Pignorii Patavini*, Padua, 1621.

ALGERI G. Algeri, "Le incisioni della 'Galleria Giustiniana'," *Xenia* 9, 1985, pp. 71–99.

ALMAGIÀ R. Almagià, *L'opera geografica di Luca Holstenio*, Vatican City, 1942.

ALPERS, 1960 S. Alpers, "'Ekphrasis' and Aesthetic Attitudes in Vasari's 'Lives,'" *Journal of the Warburg and Courtauld Institutes* 23, 1960, pp. 190–215.

ALPERS, 1988 S. Alpers, *Rembrandt's Enterprise: The Studio and the Market*, Chicago, 1988.

ALTMANN W. Altmann, *Die römischen Grabaltäre der Kaiserzeit*, Berlin, 1905.

ASHBY T. Ashby, *The Roman Campagna in Classical Times*, New York and London, 1927.

BACCHESCHI E. Baccheschi, "Vincenzo Giustiniani collezionista d'arte e la sua Galleria di stampe," in *La Galleria Giustiniana: sculture antiche e incisioni secentesche* (Quaderni del Museo Accademia Ligustica di Belle Arti 10), Genoa, 1989, pp. 3–5.

BADT K. Badt, *Die Kunst des Nicolas Poussin*, 2 vols., Cologne, 1969.

BÄTSCHMANN, 1982 O. Bätschmann, "Diskurs der Architektur im Bild: Architekturdarstellung im Werk von Poussin," in *Architektur und Sprache* (Gedenkschrift für Richard Zürcher), ed. C. Braegger, Munich, 1982, pp. 11–48.

BÄTSCHMANN, 1990 O. Bätschmann, *Nicolas Poussin: Dialectics of Painting*, London, 1990 (first published as *Dialektik der Malerei von Nicolas Poussin*, Zürich, 1982).

BÄTSCHMANN, 1992 O. Bätschmann, "*De lumine et colore*: Der Maler Nicolas Poussin in seinen Bildern," in *Der Künstler über sich in seinem Werk* (Internationales Symposium der Bibliotheca Hertziana, Rome, 1989), ed. M. Winner, Weinheim, 1992, pp. 463–483.

BALDINUCCI F. Baldinucci, *Notizie dei professori del disegno da Cimabue in qua*, ed. F. Ranalli, 5 vols., Florence, 1846.

BAROLSKY P. Barolsky, *Infinite Jest: Wit and Humor in Italian Renaissance Art*, Columbia and London, 1978.

BAROCCHI P. Barocchi, "La storia della Galleria degli Uffizi e la storiografia artistica," *Annali della Scuola Normale Superiore di Pisa* 3, 1982, pp. 1411–1523.

BARTHES R. Barthes, *S/Z*, trans. R. Miller, New York, 1974.

BARTOLI AND BELLORI P. S. Bartoli and G. P. Bellori, *Admiranda romanarum antiquitatum ac veteris sculpturae vestigia*, Rome, 1693.

BEAL M. Beal, *A Study of Richard Symonds: His Italian Notebooks and their Relevance to Seventeenth-Century Painting Techniques*, New York and London, 1984.

BELL, 1988 J. C. Bell, "Cassiano dal Pozzo's Copy of the Zaccolini Manuscripts," *Journal of the Warburg and Courtauld Institutes* 51, 1988, pp. 103–125.

BELL, 1991 J. C. Bell, "Zaccolini and Leonardo's MS A," in *Il collezionismo dei leonardeschi a Milano e la Madonna Litta*, ed. M. T. Florio and P. C. Marani, Milan, 1991, pp. 183–193.

BELL, 1993 "Zaccolini's Theory of Color Perspective," *Art Bulletin* 75, 1993, pp. 91–112.

BELLORI G. P. Bellori, *Le vite de' pittori, scul-*

tori, e architetti moderni, ed. E. Borea, Turin, 1976.

BERNSTOCK J. E. Bernstock, "Guercino's 'Et in Arcadia Ego' and 'Apollo Flaying Marsyas'," *Studies in Iconography* 11, 1987, pp. 137–183.

BIALOSTOCKI, 1954 J. Bialostocki, "Une idée de Léonard réalisée par Poussin," *Revue des Arts* 4, 1954, pp. 131–136.

BIALOSTOCKI, 1960 J. Bialostocki, "Poussin et le 'Traité de la Peinture' de Léonard: Notes sur l'état de la question," in *Nicolas Poussin* (C. N. R. S., Colloques internationaux, Sciences humaines), ed. A. Chastel, 2 vols., Paris, 1960, 1, pp. 133–140.

BIEBER M. Bieber, *The Sculpture of the Hellenistic Age*, New York, 1955.

BIRKE V. Birke, *Italian Masters of the Sixteenth and Seventeenth Centuries* (The Illustrated Bartsch 40), Commentary, Part I (formerly Vol. 18, Part 2), New York, 1987.

BIZONI *Europa Milleseicentosei: Diario di Viaggio di Bernardo Bizoni*, ed. A. Banti, Milan and Rome, 1944.

BLAIR A. Blair, "The Meaning of 'Energeia' and 'Entelecheia' in Aristotle," *International Philosophical Quarterly*, 7, 1967, pp. 101–117.

BLAISE DE VIGENÈRE Blaise de Vigenère, *Les images ou tableaux de platte peinture des deux Philostrates Sophistes grecs*, Paris, 1614 (repr. New York, 1976).

BLUNT, 1938–39 A. Blunt, "The Triclinium in Religious Art," *Journal of the Warburg and Courtauld Institutes* 2, 1938–1939, pp. 271–276.

BLUNT, 1944 A. Blunt, "The Heroic and the Ideal Landscape in the Work of Nicolas Poussin," *Journal of the Warburg and Courtauld Institutes* 7, 1944, pp. 154–168.

BLUNT, 1953 A. Blunt, *Art and Architecture in France 1500–1700*, Harmondsworth, 1953.

BLUNT, 1962 A. Blunt, "Poussin Studies XIII: Early Falsifications of Poussin," *The Burlington Magazine* 104, 1962, pp. 486–498.

BLUNT, 1966 A. Blunt, *The Paintings of Nicolas Poussin: A Critical Catalogue*, London, 1966.

BLUNT, 1967 A. Blunt, *Nicolas Poussin* (The A. W. Mellon Lectures in the Fine Arts), 2 vols., New York, 1967.

BOBER AND RUBINSTEIN P. Bober and R. Rubinstein, *Renaissance Artists and Antique Sculpture*, London, 1986.

BOHN B. Bohn, review of V. Birke in *Master Drawings* 26, 1988, pp. 369–381.

BOISSARD J. J. Boissard, *Emblematum liber*, Frankfurt, 1593.

BOREA E. Borea, "Stampa figurativa e pubblico," in *L'artista e il pubblico* (*Storia dell'arte italiana*, Part I, vol. 2), Turin, 1979, pp. 319–411.

BORGEAUD P. Borgeaud, *The Myth of Pan in Ancient Greece* (trans. by K. Atlass and J. Redfield from *Recherches sur le dieu Pan*, Rome, 1979), Chicago, 1988.

BOSELLI O. Boselli, *Osservazioni della scoltura antica dai manoscritti Corsini e Doria e altri scritti*, ed. P. D. Weil, Florence, 1978.

BOSIO, 1650 A. Bosio, *Roma sotterranea, opera postuma di Antonio Bosio romano . . . , compita, disposta, & accresciuta dal M. R. P. Giovanni Severani . . . , Sacerdote della Congregatione dell'Oratorio di Roma*, Rome, 1650.

BOSIO, 1659 A. Bosio, *Roma subterranea novissima . . .* , Rome, 1659.

BOSSE A. Bosse, *Le peintre converty aux règles de son art*, ed. R.-A. Weigert, Paris, 1964.

BOTTARI AND TICOZZI G. G. Bottari and S. Ticozzi, *Raccolta di lettere sulla pittura, scultura, ed architettura: scritte da' più celebri personaggi dei secoli XV, XVI e XVII*, 6 vols., Milan, 1822–1825.

BOUSQUET J. Bousquet, "Les relations de Poussin avec le milieu romain," in *Nicolas Poussin* (C. N. R. S., Colloques internationaux, Sciences humaines), ed. A. Chastel, 2 vols., Paris, 1960, 1, pp. 1–16.

BOWEN B. Bowen, "Montaigne's anti-*Phaedrus*: 'Sur des vers de Virgile' (*Essais*, III. 5)," *The Journal of Medieval and Renaissance Studies* 5, 1975, pp. 107–121.

BREJON A. Brejon de Lavergnée, "Tableaux de Poussin et d'autres artistes français dans la collection Dal Pozzo: deux inventaires inédits," *Revue de l'art* 19, 1973, pp. 78–96.

BRENDEL O. Brendel, "The Classical Style in Modern Art," in *From Sophocles to Picasso: The Present-Day Vitality of the Classical Tradition*, ed. W. Oates, Bloomington, 1962, pp. 71–118.

BRIGANTI G. Briganti, *Pietro da Cortona o della pittura barocca*, Florence, 1962.

BRIGSTOCKE H. Brigstocke, *Sotheby's Ashmolean Exhibition. A Loan Exhibition of drawings by Nicolas Poussin from British Collections*, London, 1990.

BRONZINO Agnolo Bronzino, *Rime in burla*, ed. F. Petrucci Nardelli, Rome, 1988.

BRUGNOLI, 1957 M. V. Brugnoli, "I primi affreschi nel Palazzo di Bassano di Sutri," *Bollettino d'arte* 42, 1957, pp. 241–254.

BRUGNOLI, 1957a M. V. Brugnoli, "Gli affreschi dell'Albani e del Domenichino nel Palazzo di Bassano di Sutri," *Bollettino d'Arte* 42, 1957, pp. 266–277.

BUNDY M. W. Bundy, *The Theory of Imagination in Classical and Mediaeval Thought* (University of Illinois Studies in Language and Literature 12, 2–3), Urbana, 1927.

BYAM SHAW J. Byam Shaw, *The Italian Drawings of the Frits Lugt Collection*, 3 vols., Paris (Institut Néerlandais), 1983.

CAMIZ F. Trinchieri Camiz, "The Roman 'studio' of Francesco Villamena," *The Burlington Magazine* 136, 1994, pp. 506–516.

CARRIER D. Carrier, *Poussin's Paintings: A Study in Art-Historical Methodology*, University Park, Pennsylvania, 1993.

CARROLL E. A. Carroll, *Rosso Fiorentino: Drawings, Prints, and Decorative Arts* (exh. cat., National Gallery of Art, Washington, D.C.), Washington, 1987.

CASSIANO DAL POZZO *Cassiano dal Pozzo: Atti del seminario internazionale di studi* (18–19 December, 1987, Naples), ed. F. Solinas, Rome, 1989.

CASTIGLIONE B. Castiglione, *The Book of the Courtier*, trans. C. S. Singleton, New York, 1959.

CAVE T. Cave, *The Cornucopian Text: Problems of Writing in the French Renaissance*, Oxford, 1979.

CHAMBRAY Roland Fréart de Chambray, *Idée de la perfection de la peinture*, Le Mans, 1662 (repr. Farnborough, 1968).

CHANTELOU *Journal du voyage du Cavalier Bernin en France*, ed. L. Lalanne, Paris, 1885 (first published in *Gazette des Beaux-Arts*, 1877–1884).

CHONÉ *Jacques Callot: 1592–1635* (exh. cat., Musée historique lorrain, Nancy), ed. P. Choné, Paris, 1992.

CHRISTIANSEN K. Christiansen, *A Cara-vaggio Rediscovered: The "Lute Player"*, New York, 1990.

CINOTTI M. Cinotti, *Michelangelo Merisi detto il Caravaggio: Tutte le opere* (I Pittori Bergamaschi, *Il Seicento*, 3 vols., 1), Bergamo, 1983.

CLARKE A. Clarke, "François Perrier," forthcoming in *Print Quarterly*.

COFFIN D. Coffin, "The 'Lex Hortorum' and Access to Gardens of Latium During the Renaissance," *Journal of Garden History* 2, 1982, pp. 201–232.

COLANTUONO, 1986 A. Colantuono, *The Tender Infant: "Invenzione" and "Figura" in the Art of Poussin*, Ph.D. diss., The Johns Hopkins University, 1986.

COLANTUONO, 1989 "Titian's Tender Infants: On the Imitation of Venetian Painting in Baroque Rome," *I Tatti Studies* 3, 1989, pp. 207–234.

CONFÉRENCES *Conférences de l'Académie Royale de Peinture et de Sculpture*, ed. H. Jouin, Paris, 1883.

CONNORS J. Connors, "Virtuoso Architecture in Cassiano's Rome," in *Cassiano dal Pozzo's Paper Museum*, 2 vols., Milan, 1992, 2 (Quaderni Puteani 3), pp. 23–40.

CONSAGRA F. Consagra, "The Marketing of Pietro Testa's 'Poetic Inventions,'" in E. Cropper, *Pietro Testa 1612–1650: Prints and Drawings* (exh. cat., Philadelphia Museum of Art), Philadelphia, 1988, pp. lxxxvii–civ.

CONTI, 1567 N. Conti, *Mythologiae*, Venice, 1567.

CONTI, 1627 N. Conti, *Mythologie ou explication des fables*, tr. Jean de Montlyard, ed. J. Baudoin, Paris, 1627.

CORRESPONDANCE *Correspondance de Nicolas Poussin publiée d'après les originaux*, ed. Ch. Jouanny, *Archives de l'art français*, n.p. 5, Paris, 1911.

COTTRELL R. D. Cottrell, *Sexuality/Textuality: A Study of the Fabric of Montaigne's "Essais"*, Columbus, Ohio, 1981.

CROCE B. Croce, "'La Strage degli Innocenti'," in *Varietà di storia letteraria e civile*, 1, 2 vols., Bari, 1935, 1, pp. 106–118.

CROPPER, 1974 E. Cropper, "Virtue's Wintry Reward: Pietro Testa's Etchings of the Seasons," *Journal of the Warburg and Courtauld Institutes* 37, 1974, pp. 249–279.

CROPPER, 1976 E. Cropper, "On Beautiful

Women, Parmigianino, 'Petrarchismo,' and the Vernacular Style," *Art Bulletin* 58, 1976, pp. 374–394.

CROPPER, 1981 E. Cropper, "Letter to the Editor," *Art Bulletin* 63, 1981, pp. 672–673.

CROPPER, 1984 E. Cropper, *The Ideal of Painting: Pietro Testa's Düsseldorf Notebook*, Princeton, N.J., 1984.

CROPPER, 1986 E. Cropper, "The Beauty of Woman: Problems in the Rhetoric of Renaissance Portraiture," in *Rewriting the Renaissance: The Discourses of Sexual Difference in Early Modern Europe*, ed. M. W. Ferguson, M. Quilligan, and N. J. Vickers, Chicago, 1986, pp. 175–190, 355–359.

CROPPER, 1988 E. Cropper, *Pietro Testa 1612–1650: Prints and Drawings* (exh. cat., Philadelphia Museum of Art), Philadelphia, 1988.

CROPPER, 1988a E. Cropper, "Pietro Testa 1612–1650: The Exquisite Draughtsman from Lucca," in E. Cropper, 1988, pp. xi–xxxvi.

CROPPER, 1988b E. Cropper, "Fort Worth Early Poussin," *The Burlington Magazine* 130, 1988, pp. 958–962.

CROPPER, 1991 E. Cropper, "The Petrifying Art: Marino's Poetry and Caravaggio," *Metropolitan Museum of Art Journal* 26, 1991, pp. 193–212.

CROPPER, 1995 E. Cropper, "The Place of Beauty in the High Renaissance and its Displacement in the History of Art," in *Place and Displacement in the Renaissance*, ed. A. Vos, Binghamton, N.Y., 1995, pp. 159–205.

CROW T. E. Crow, *Painters and Public Life in Eighteenth-Century Paris*, New Haven and London, 1985.

DEFAUX, 1983 G. Defaux, "Readings of Montaigne," in *Montaigne: Essays in Reading* (Yale French Studies 64), ed. G. Defaux, New Haven, 1983, pp. 73–92.

DEFAUX, 1985 G. Defaux, "Rhétorique et représentation dans les *Essais*: de la peinture de l'autre à la peinture du moi," *Actes Rhétorique de Montaigne*, Paris, 1985.

DEGRAZIA D. DeGrazia, *Le Stampe dei Carracci con i disegni, le incisioni, le copie, e i dipinti connessi: Catalogo critico*, ed. and trans. A. Boschetto, Bologna, 1984.

DELABORDE L. Delaborde, *Athènes aux*

XVe, XVIe, et XVIIe siècles, 2 vols., Paris, 1854.

DEL MONTE G. del Monte, *Perspectivae libri sex*, Pesaro, 1600 (repr. Rome, 1984).

DEMPSEY, 1963 C. Dempsey, "Poussin and Egypt," *Art Bulletin* 45, 1963, pp. 109–119.

DEMPSEY, 1963a C. Dempsey, *Nicolas Poussin and the Natural Order*, Ph.D. diss., Princeton Univ., 1963.

DEMPSEY, 1966 C. Dempsey, "The Textual Sources of Poussin's 'Marine Venus' in Philadelphia," *Journal of the Warburg and Courtauld Institutes* 29, 1966, pp. 438–442.

DEMPSEY, 1967 C. Dempsey, "'Euanthes redivivus': Rubens's 'Prometheus Bound'," *Journal of the Warburg and Courtauld Institutes* 30, 1967, pp. 420–425.

DEMPSEY, 1977 C. Dempsey, *Annibale Carracci and the Beginnings of Baroque Style* (Villa I Tatti Monographs, 3), Glückstadt, 1977.

DEMPSEY, 1981 C. Dempsey, "Annibal Carrache au Palais Farnèse," in *Le Palais Farnèse* (École française de Rome), ed. A. Chastel and G. Vallet, 2 vols. in 3, Rome, 1980–1981, 1,i, pp. 269–311.

DEMPSEY, 1986 C. Dempsey, "Malvasia and the Problem of the Early Raphael and Bologna," in *Studies in the History of Art* 17 (Center for Advanced Study in the Visual Arts Symposium Series 5), Washington, D.C., 1986, pp. 57–70.

DEMPSEY, 1988 C. Dempsey, "Guido Reni in the Eyes of his Contemporaries," in *Guido Reni 1575–1642* (exh. cat., Los Angeles County Museum), Los Angeles and Bologna, 1988, pp. 101–118.

DEMPSEY, 1991 C. Dempsey, review of A. Mérot, *Nicolas Poussin*, New York, 1990, in *Art in America*, October 1991, pp. 41–43.

DEMPSEY, 1993 C. Dempsey, "Idealism and Naturalism in Rome around 1600," in *Il Classicismo: Medioevo Rinascimento Barocco* (Atti del Colloquio Cesare Gnudi, 1986), ed. E. de Luca, Bologna, 1993, pp. 233–243.

DENS J.-P. Dens, *L'Honnête Homme et la critique du goût: esthétique et société au XVIIe siècle* (French Forum Monographs 29), Lexington, Kentucky, 1981).

DE PILES R. De Piles, *Cours de peinture par*

principes (with an introduction by T. Putt-farken), Nîmes, 1990.

DERRIDA J. Derrida, *Memories of the Blind: The Self-Portrait and Other Ruins*, trans. P.-A. Brault and M. Naas, Chicago and London, 1993 (originally published as *Mémoires d'aveugle: l'autoportrait et autres ruines*, Paris, 1990).

DESCARTES *Oeuvres de Descartes*, ed. Ch. Adam and P. Tannery, 13 vols., Paris, 1897–1957 (repr. Paris, 1965).

DHANENS E. Dhanens, *Hubert and Jan Van Eyck*, New York, n.d. [1980?].

DOCUMENTARY CULTURE *Documentary Culture: Florence and Rome from Grand-Duke Ferdinand I to Pope Alexander VII* (Villa Spelman Colloquium Series 3), Bologna, 1992.

DREYER P. Dreyer, *Römische Barockzeichnungen aus dem Berliner Kupferstichkabinett* (exh. cat.), Berlin, 1969.

ENCYCLOPEDIA OF WORLD ART *Encyclopedia of World Art*, 17 vols., New York, 1959–1987.

ENGGASS AND BROWN *Italy and Spain 1600–1750*, ed. R. Enggass and J. Brown (Sources and Documents in the History of Art 10), Englewood Cliffs, N.J., 1970.

ETTLINGER L. D. Ettlinger, "'Exemplum doloris': Reflections on the Laocoon Group," in *De artibus opuscula XL: Essays in Honor of Erwin Panofsky*, 2 vols., ed. M. Meiss, New York, 1961, pp. 121–126.

EURIPIDES Euripides, *Bacchae*, ed. with introduction and commentary by E. R. Dodds, 2nd ed., Oxford, 1960.

EXPOSITION *Exposition Nicolas Poussin* (exh. cat., Musée du Louvre), Paris, 1960.

FALDI I. Faldi, "Le 'Virtuose operationi' di Francesco Duquesnoy scultore incomparabile," *Arte antica e moderna* 5, 1959, pp. 52–62.

FARET *L'Honneste homme ou lart de plaire à la court par Nicolas Faret*, ed. M. Magendie, Paris, 1925.

FARNELL L. R. Farnell, *The Cults of the Greek States*, 5 vols., Oxford, 1907.

FÉLIBIEN, 1668 A. Félibien, *Conférences de l'Académie Royale de Peinture et de Sculpture pendant l'année 1667*, Paris, 1668 (repr. Geneva, 1973).

FÉLIBIEN, 1707 A. Félibien, *L'Idée du peintre parfait, pour servir de Règle aux jugemens que l'on doit porter sur les ouvrages des Peintres*, London, 1707.

FÉLIBIEN, 1725 A. Félibien, *Entretiens sur les vies et sur les ouvrages des plus excellens peintres anciens et modernes*, 6 vols. in 1, Trevoux, 1725 (repr. Farnborough, 1967).

FÉNELON F. Fénelon, *Dialogues sur la peinture*, first published in the Abbé de Monville, *La vie de Pierre Mignard . . . avec . . . deux Dialogues de M. de Fénelon Archevêque de Cambray sur la Peinture*, Paris, 1730.

FERRARIUS O. Ferrarius, *Analecta de re vestiaria*, Rome, 1657.

FICACCI L. Ficacci, *Claude Mellan, gli anni romani: un incisore tra Vouet e Bernini* (exh. cat., Istituto Nazionale per la Grafica), Rome, 1989.

FILIPPI E. Filippi, *Marten van Heemskerck. Inventio Urbis*, Milan, 1990.

FÖRSTER R. Förster, "Die Hochzeit des Alexander und der Roxane in der Renaissance," *Jahrbuch der Preussischen Kunstsammlungen* 15, 1894, pp. 182–207.

FRACASTORO G. Fracastoro, *Naugerius, sive de poetica dialogus*, with an English translation by R. Kelso and an introduction by M. W. Bundy, in *University of Illinois Studies in Language and Literature* 9, 1924, pp. 1–88.

FRAISSE S. Fraisse, *L'influence de Lucrèce en France au seizième siècle*, Paris, 1962.

FRAME D. M. Frame, *Montaigne's Discovery of Man: The Humanization of a Humanist*, New York, 1955.

FREEDBERG D. Freedberg, "From Hebrew and Gardens to Oranges and Lemons: Giovanni Battista Ferrari and Cassiano dal Pozzo," in *Cassiano dal Pozzo: Atti del seminario internazionale di studi*, ed. F. Solinas, Rome, 1989, pp. 36–72.

FREUD S. Freud, *Inhibitions, Symptoms and Anxiety*, trans. A. Strachey, London, 1959.

FRIED, 1980 M. Fried, *Absorption and Theatricality: Painting and Beholder in the Age of Diderot*, Berkeley, 1980.

FRIED, 1986 M. Fried, "Antiquity Now: Reading Winckelmann on Imitation," *October* 37, 1986, pp. 87–97.

FRIED, 1990 M. Fried, *Courbet's Realism*, Chicago and London, 1990.

FRIEDLAENDER, 1942 W. Friedlaender, "Iconographical Studies of Poussin's Works

in American Public Collections—I: The Northampton 'Venus and Adonis' and the Boston 'Venus and Mars'," *Gazette des Beaux-Arts* 22, 1942, pp. 17–26.

FRIEDLAENDER, 1957 W. Friedlaender, *Mannerism and Anti-Mannerism in Italian Painting*, New York, 1957.

FRIEDLAENDER, [1966] W. Friedlaender, *Nicolas Poussin: A New Approach*, New York, [1966].

FRIEDLAENDER-BLUNT *The Drawings of Nicolas Poussin. Catalogue Raisonné* (Studies of the Warburg Institute 5), ed. W. Friedlaender and A. Blunt, 5 vols., London 1939–1974.

FUMAROLI, 1982 M. Fumaroli, "'Muta Eloquentia': la représentation de l'éloquence dans l'oeuvre de Nicolas Poussin," *Bulletin de la Société de l'Histoire de l'Art français*, 1982, pp. 29–48.

FUMAROLI, 1988 M. Fumaroli, "La 'Galeria' de Marino et la Galerie Farnèse: Épigrammes et oeuvres d'art profanes vers 1600," in *Les Carrache et les Décors Profanes* (Actes du Colloque organisé par l'École française de Rome, 1986), Collection de l'École Française de Rome 106, Rome, 1988, pp. 163–182.

FUMAROLI, 1989 M. Fumaroli, "*L'Inspiration du poète*" de Poussin: essai sur l'allégorie du Parnasse (Les dossiers du département des peintures, Musée du Louvre 36), Paris, 1989.

FUMAROLI, 1992 M. Fumaroli, *Le genre des genres littéraires français: la conversation* (The Zaharoff Lecture for 1990–1991), Oxford, 1992.

FUMAROLI, 1994 M. Fumaroli, *L'École du Silence. Le Sentiment des images au XVIIe siècle*, Paris, 1994.

GALAND-HALLYN, 1990 P. Galand-Hallyn, "Le songe et la rhétorique de 'l'enargeia'," in *Le songe à la Renaissance* (Actes du Colloque International R. H. R. de Cannes, 29–31 May 1987), Université de Sainte-Etienne, 1990, pp. 125–136.

GALAND-HALLYN, 1991 P. Galand-Hallyn, "'Enargeia' maniériste, 'Enargeia' visionnaire, des prophéties du Tibre au songe d'Océan," *Bibliothèque d'Humanisme et Renaissance* 53, 1991, pp. 305–328.

GARBOLI AND BACCHESCHI C. Garboli and E. Baccheschi, *L'Opera completa di Guido Reni*, Milan, 1971.

GASPARRI C. Gasparri, "Materiali per servire allo studio di Museo Torlonia di scultura antica," *Atti dell'Accademia Nazionale dei Lincei, Memorie* (Classe di Scienze morali, storiche e filologiche), ser. 8, 24, fasc. 2, 1980, pp. 37–239.

GASTON R. W. Gaston, "Love's Sweet Poison: A New Reading of Bronzino's London 'Allegory'," *I Tatti Studies: Essays in the Renaissance* 4, 1991, pp. 249–288.

GERBEL N. Gerbel, *In Graeciae Sophiani descriptionem explicatio* (Basel, 1545), in J. J. Gronovius, *Thesaurus graecarum antiquitatum*, Leiden, 1697–1702, 12 vols. in 13, 4.

GIRAUD Y. F.-A. Giraud, *La fable de Daphné: Essai sur un type de métamorphose végétale dans la littérature et dans les arts jusqu'à la fin du XVIIe siècle*, Geneva, 1968.

GIUSTINIANI, M., 1669 M. Giustiniani, *Lettere memorabili*, Rome, 1669.

GIUSTINIANI, V., 1981 V. Giustiniani, *Discorsi sulle arti e sui mestieri*, ed. A. Banti, Florence, 1981.

GNUDI AND CAVALLI C. Gnudi and G. C. Cavalli, *Guido Reni*, Florence, 1955.

GOFFEN R. Goffen, "Renaissance Dreams," *Renaissance Quarterly* 40, 1987, pp. 682–706.

GOLDSMITH E. C. Goldsmith, *"Exclusive Conversations": The Art of Interaction in Seventeenth-Century France*, Philadelphia, 1988.

GOLDSTEIN, 1966 C. Goldstein, "The Meaning of Poussin's Letter to De Noyers," *The Burlington Magazine* 108, 1966, pp. 233–239.

GOLDSTEIN, 1981 C. Goldstein, "Letter to the Editor," *Art Bulletin* 63, 1981, pp. 671–672.

GOMBRICH, 1966 E. H. Gombrich, *Norm and Form: Studies in the Art of the Renaissance*, London, 1966.

GOMBRICH, 1972 E. H. Gombrich, "The Subject of Poussin's 'Orion'," in *Symbolic Images: Studies in the Art of the Renaissance*, London, 1972, pp. 119–122.

GOODMAN E. Goodman, *Rubens: The Garden of Love as "Conversatie à la mode"* (Oculi: Studies in the Arts of the Low Countries 4), Amsterdam and Philadelphia, 1992.

GRAEVIUS J. G. Graevius, *Thesaurus antiquitatum romanarum*, Leiden and Utrecht, 12 vols., 1694–1699.

GRAUTOFF O. Grautoff, *Nicolas Poussin:*

sein Werk und sein Leben, 2 vols., Munich and Leipzig, 1914.

GRAY F. Gray, *La Balance de Montaigne: Exagium/Essai*, Paris, 1982.

GRELLE A. Grelle, "I Crescenzi e l'Accademia di via S. Eustachio," *Commentari* 12, 1961, pp. 120–138.

GUAZZO S. Guazzo, *La civil conversazione*, ed. A. Quondam, 2 vols., Modena, 1993.

GUERRINI, 1971 L. Guerrini, *Marmi antichi nei disegni di Pier Leone Ghezzi* (Documenti e riproduzioni, 1), Vatican City, 1971.

GUERRINI, 1986 L. Guerrini, "'Indicazioni' Giustiniane, II. Di affreschi e stucchi ritrovati e perduti," *Xenia* 12, 1986, pp. 65–96.

GUERRINI AND CARINCI L. Guerrini and F. Carinci, "'Indicazioni' Giustiniane, I: Di rami e statue ritrovate e perdute," in *Bollettino di Numismatica*, 1987, supplement to no. 4, *Studi per Laura Breglia*, 3 (Archaeologia e Storia), pp. 165–188.

HALPERIN D. M. Halperin, *Before Pastoral: Theocritus and the Ancient Tradition of Bucolic Poetry*, New Haven and London, 1983.

HANFMANN G. Hanfmann, "Notes on the Mosaics from Antioch," *American Journal of Archaeology* 43, 1939, pp. 229–246.

HARRIS A. S. Harris, *Andrea Sacchi: A Complete Edition of the Paintings with a Critical Catalogue*, Princeton and Oxford, 1977.

HASKELL, 1963 F. Haskell, *Patrons and Painters: A Study in the Relations between Italian Art and Society in the Age of the Baroque*, London, 1963.

HASKELL, 1993 F. Haskell, *History and its Images: Art and the Interpretation of the Past*, New Haven and London, 1993.

HASKELL AND PENNY F. Haskell and N. Penny, *Taste and the Antique: The Lure of Classical Sculpture 1500–1900*, New Haven and London, 1982 (second corrected printing).

HASKELL AND RINEHART F. Haskell and S. Rinehart, "The Dal Pozzo Collection, Some New Evidence, Part I," *The Burlington Magazine* 102, 1960, pp. 318–326.

HATFIELD H. C. Hatfield, *Winckelmann and his German Critics, 1755–1781: A Prelude to the Classical Age*, New York, 1943.

HAYUM A. Hayum, "A New Dating for Sodoma's Frescoes in the Villa Farnesina," *Art Bulletin* 48, 1966, pp. 215–217.

HENDERSON N. and A. Henderson, "Nouvelles recherches sur la décoration de Poussin pour la Grande Galerie," *La Revue du Louvre et des musées de France* 27, 1977, pp. 225–234.

HENNEBERG J. von Henneberg, "Poussin's 'Penance': A New Reading," *Storia dell'Arte* 61, 1987, pp. 229–236.

HERKLOTZ I. Herklotz, "Cassiano and the Christian Tradition," in *Cassiano dal Pozzo's Paper Museum*, 2 vols., Milan, 1992, 1 (Quaderni Puteani 2), pp. 31–48.

HOLSTENIUS, 1666 L. Holstenius, *Annotationes in Geographiam sacram Caroli à S. Paolo; Italiam antiquam Cluverii; et Thesaurum geographicum Ortelii*, Rome, 1666.

HOLSTENIUS, 1817 Lucae Holstenii epistolae ad diversos, ed. J. F. Boissonade, Paris, 1817.

HONOUR H. Honour, *Neo-Classicism*, Harmondsworth, 1968.

HUSE N. Huse, "Zur 'S. Susanna' des Duquesnoy," in *Argo: Festschrift für Kurt Badt*, Cologne, 1970, pp. 324–335.

JAFFÉ, D. D. Jaffé, "The Barberini Circle: Some Exchanges between Peiresc, Rubens, and their Contemporaries," *Journal of the History of Collections* 1, 1989, pp. 119–147.

JAFFÉ, M. M. Jaffé, *Old Master Drawings from Chatsworth. A Loan Exhibition from the Devonshire Collection* (exh. cat.), Alexandria, Va., 1987.

JAY M. Jay, *Downcast Eyes: The Denigration of Vision in Twentieth-Century French Thought*, Berkeley, Los Angeles and London, 1994.

JONES P. Jones, *Federico Borromeo and the Ambrosiana: Art Patronage and Reform in Seventeeth-Century Milan*, Cambridge, 1993.

JUNIUS F. Junius, *The Literature of Classical Art I: The Painting of the Ancients (De Pictura Veterum)* (California Studies in the History of Art 22), ed. K. Aldrich, P. Fehl, and R. Fehl, 2 vols., Berkeley and Los Angeles, 1991.

JUSTI C. Justi, *Winckelmann und seine Zeitgenossen*, 3 vols., Leipzig, 1898.

KAUFFMANN, 1960 G. Kauffmann, *Poussin-Studien*, Berlin, 1960.

KAUFFMANN, 1960a G. Kauffmann, "La 'Sainte famille à l'escalier' et le problème des proportions dans l'oeuvre de Poussin," in *Nicolas Poussin* (C. N. R. S., Colloques internationaux, Sciences humaines), ed. A. Chastel, 2 vols., Paris, 1960, 1, pp. 141–150.

KAUFMANN T. da Costa Kaufmann, "The

Perspective of Shadows: The History of the Theory of Shadow Projection," *Journal of the Warburg and Courtauld Institutes* 38, 1975, pp. 258–287.

KELLER H. Keller, "Entstehung und Blute-zeit des Freundschaftsbildes," in *Essays in the History of Art Presented to Rudolf Wittkower*, ed. D. Fraser, H. Hibbard, and M. J. Lewine, London, 1967, pp. 161–173, pl. 22, figs. 1–6.

KEMP W. Kemp, "Teleologie der Malerei: Selbstporträt und Zukunftsreflexion bei Poussin und Velázquez," in *Der Künstler über sich in seinem Werk* (Internationales Symposium der Bibliotheca Hertziana, Rome, 1989), ed. M. Winner, Weinheim, 1992, pp. 407–433.

KESSLER H. Kessler, "The Meeting of Peter and Paul in Rome: An Emblematic Narrative of Spritual Brotherhood," *Dumbarton Oaks Papers* 41, 1987, pp. 265–275.

KLEIN, J. J. Klein, "An Analysis of Poussin's *Et in Arcadia Ego*," *Art Bulletin* 19, 1937, pp. 314–317.

KLEIN, R. R. Klein, "*Giudizio* e *gusto* nella teoria dell'arte nel Cinquecento," in *La forma e l'intelligibile: Scritti sul Rinascimento e l'arte moderna*, Turin, 1975, pp. 373–386.

KLEMM C. Klemm, *Joachim von Sandrart: Kunstwerke und Lebenslauf*, Berlin, 1986.

KNOWLES J. Knowles, *The Life and Writings of Henry Fuseli*, 3 vols., London, 1831 (repr. with an introduction by D. H. Weinglass, Millwood, London, and Nendeln, 1982).

KOERNER J. L. Koerner, *The Moment of Self-Portraiture in German Renaissance Art*, Chicago and London, 1993.

KÖTZSCHE-BREITENBRUCH L. Kötzsche-Breitenbruch, "Zur Ikonographie des Bethlehemitischen Kindermordes in der Frühchristlichen Kunst," *Jahrbuch für Antike und Christentum* 11/12, 1968–1969, pp. 104–115.

KRITZMAN L. D. Kritzman, "My Body, My Text: Montaigne and the Rhetoric of Sexuality," *The Journal of Medieval and Renaissance Studies* 13, no. 1, 1983, pp. 75–89.

KURZ O. Kurz, "Barocco: storia di una parola," *Lettere italiane* 12, 1960, pp. 414–444.

KUTTER P. Kutter, *Joachim von Sandrart— Eine Kunsthistorische Studie*, Strasbourg, 1907.

LAMERA F. Lamera, "La Strage degli Innocenti tra Cinque e Seicento: Elementi per una lettura iconografica e compositiva," *Studi di storia delle arti* 4 (Università di Genova, Istituto di storia dell'arte), 1981–1982, pp. 87–94, 311–316.

LANKHEIT K. Lankheit, *Das Freundschaftsbild der Romantik*, Heidelberg, 1952.

LAUSBERG H. Lausberg, *Handbuch der literarischen Rhetorik*, Munich, 1960.

LEBENSZTEJN J. C. Lebensztejn, "Framing Classical Space," *Art Journal* 47, 1988, pp. 37–41.

LEBRUN Charles Le Brun, *Méthode pour apprendre dessiner les Passions*, Paris, 1698.

LECOAT G. LeCoat, *The Rhetoric of the Arts, 1550–1650* (European University Papers, série 18, Comparative Literature), Frankfurt, 1975.

LEHMANN-HARTLEBEN K. Lehmann-Hartleben, *Dionysiac Sarcophagi in Baltimore*, Baltimore, 1942.

LEONARDO, 1651 *Trattato della Pittura di Lionardo da Vinci novamente dato in luce, con la vita dell'istesso autore, scritta da Rafaelle du Fresne*, Paris, 1651.

LEONARDO, 1651a *Traitté de la Peinture de Léonard de Vinci, donné au Public et traduit d'italien en françois par R.F.S.D.C.*, Paris, 1651.

LEONARDO, 1882 *Leonardo da Vinci. Das Buch von der Malerei nach dem Codex Vaticanus (Urbinas) 1270* (Quellenschriften für Kunstgeschichte und Kunsttechnik des Mittelalters und der Renaissance, XV–XVII), ed. H. Ludwig, 3 vols., Vienna, 1882 (repr. Osnabrück, 1970).

LEONARDO, 1883 *The Literary Works of Leonardo da Vinci*, ed. J. P. Richter, 2 vols., London, 1883.

LEPPMANN W. Leppmann, *Winckelmann*, New York, 1970.

LESSING G. E. Lessing, *Laocoon: An Essay upon the Limits of Painting and Poetry*, New York, 1968.

LICHTENSTEIN J. Lichtenstein, *La Couleur éloquente: rhétorique et peinture à l'âge classique*, Paris, 1989.

LIMOUZE, 1988 D. Limouze, "Aegidius Sadeler (1570–1629): Drawings, Prints, and the Development of an Art Theoretical Attitude," in *Prag um 1600: Beiträge zur Kunst und Kultur am Hofe Rudolfs II*, ed. E. Fučíková, Freren/Emsland, 1988, pp. 183–192.

LIMOUZE, 1989 D. Limouze, "Aegidius

Sadeler, Imperial Printmaker," *Philadelphia Museum of Art Bulletin* 85, 1989, pp. 3–24.

LUCRETIUS *Titi Lucretii Cari de rerum natura libri sex*, ed. & comm. C. Bailey, 2 vols., Oxford, 1986.

LUGLI, 1983 A. Lugli, *Naturalia et mirabilia. Il collezionismo enciclopedico nelle Wunderkammern d'Europa*, Milan, 1983.

LUGLI, 1986 "La ricerca come collezione," in *Enciclopedismo in Roma barocca. Athanasius Kircher e il Museo del Collegio Romano tra Wunderkammer e museo scientifico*, ed. M. Casciato, M. G. Ianniello, and M. Vitale, Venice, 1986, pp. 268–281.

MAGENDIE, 1925 M. Magendie, *La Politesse mondaine et les théories de l'honnêteté, en France, au XVIIe siècle, de 1600 à 1660*, Paris, 1925.

MAGUIRE H. Maguire, *Art and Eloquence in Byzantium*, Princeton, 1981.

MAHON, 1947 D. Mahon, *Studies in Seicento Art and Theory*, London, 1947.

MAHON, 1960 D. Mahon, "Poussin's Early Development: An Alternative Hypothesis," *The Burlington Magazine* 102, 1960, pp. 288–304.

MAHON, 1962 D. Mahon, *Poussiniana: Afterthoughts arising from the Exhibition*, Paris, New York, and London, 1962 (first published in *Gazette des Beaux-Arts*).

MÂLE E. Mâle, *L'art religieux après le Concile de Trent*, Paris, 1932.

MALVASIA C. C. Malvasia, *Felsina Pittrice: Vite dei Pittori Bolognesi*, ed. G. Zanotti, 2 vols., Bologna, 1841 (repr. Bologna, 1974).

MANCINI G. Mancini, *Considerazioni sulla pittura*, ed. L. Salerno, 2 vols., Rome, 1956.

MANTEGNA *Andrea Mantegna* (exh. cat., Royal Academy of Art), ed. J. Martineau, London and New York, 1992.

MARABOTTINI A. Marabottini, *Polidoro da Caravaggio*, 2 vols., Rome, 1969.

MARIN, 1977 L. Marin, *Détruire la peinture*, Paris, 1977.

MARIN, 1982 L. Marin, "Du Cadre au décor ou la question de l'ornement dans la peinture," *Rivista di Estetica* 22, 1982, pp. 16–35.

MARIN, 1983 L. Marin, "Variations sur un portrait absent: les autoportraits de Poussin 1649–50," *Corps écrit* 5, 1983, pp. 88–107.

MARIN, 1988 L. Marin, "Towards a Theory of Reading in the Visual Arts: Poussin's 'The Arcadian Shepherds'," in *Calligram: Essays in New Art History from France*, ed. N. Bryson, Cambridge, 1988, pp. 63–90 (first published in *The Reader in the Text: Essays on Audience and Interpretation*, ed. S. R. Suleiman and I. Crossman, Princeton, 1980).

MARIN, 1989 L. Marin, *Opacité de la peinture. Essais sur la représentation au Quattrocento*, Florence, 1989.

MARIN, 1992 L. Marin, "Mimésis et description: ou de la curiosité à la méthode de l'âge de Montaigne à celui de Descartes," in *Documentary Culture: Florence and Rome from Grand-Duke Ferdinand I to Pope Alexander VII* (Villa Spelman Colloquium Series 3), ed. E. Cropper, G. Perini, and F. Solinas, Bologna, 1992, pp. 23–47.

MARINO, 1960 G. B. Marino, *Dicerie sacre e La Strage de gl'innocenti*, ed. G. Pozzi, Turin, 1960.

MARINO, 1966 *Giambattista Marino: Lettere*, ed. M. Guglielminetti, Turin, 1966.

MARINO, 1979 G. B. Marino, *La Galeria*, ed. M. Pieri, 2 vols., Padua, 1979.

MARKHAM TELPAZ A. Markham Telpaz, "Some Antique Motifs in Trecento Art," *Art Bulletin* 46, 1964, pp. 372–376.

MARTIN J. R. Martin, *Baroque*, New York, 1977.

MASSAR P. D. Massar, *Stefano della Bella: Catalogue raisonné {by} Alexandre De Vesme*, intro. and additions by P. D. Massar, 2 vols., New York, 1971.

MATZ AND DUHN F. Matz and F. von Duhn, *Antike Bildwerke in Rom*, Leipzig, 1882.

MCBURNEY H. McBurney, "Cassiano dal Pozzo as Ornithologist," in *Cassiano dal Pozzo's Paper Museum*, 2 vols., Milan, 1992, 2 (*Quaderni Puteani* 3), pp. 3–22.

MCTIGHE S. McTighe, "Nicolas Poussin's Representations of Storms and *Libertinage* in the mid-Seventeenth Century," *Word and Image* 5, 1989, pp. 333–361.

MELION W. Melion, "Hendrik Goltzius's Project of Reproductive Engraving," *Art History* 13, 1990, pp. 458–487.

MÉROT A. Mérot, *Nicolas Poussin*, New York, 1990.

MERRILL R. V. Merrill, "Eros and Anteros," *Speculum* 19, 1944, pp. 265–284.

MONTAGU J. Montagu, "The Theory of the Musical Modes in the Académie Royale

de Peinture et de Sculpture," *Journal of the Warburg and Courtauld Institutes* 55, 1992, pp. 233–248.

MONTAIGNE, 1965 *The Complete Essays of Montaigne*, trans. D. M. Frame, Stanford, 1965.

MONTAIGNE, 1988 *Montaigne: Les essais*, ed. P. Villey with V. L. Saulnier, 3 vols., Paris, 1988.

MONTFAUCON B. de Montfaucon, *L'Antiquité expliquée et representé en figures*, 13 vols., Paris, 1719.

MOREY C. R. Morey, *Lost Mosaics and Frescoes of Rome of the Mediaeval Period: A Publication of Drawings contained in the Collection of Cassiano dal Pozzo, now in the Royal Library, Windsor Castle* (Princeton Monographs in Art and Archaeology 4), Princeton, 1915.

MORIARTY M. Moriarty, *Taste and Ideology in Seventeenth-Century France*, Cambridge, 1988.

MOSCHETTI A. Moschetti, "Dell'influsso del Marino sulla formazione artistica di Nicola Poussin," in *L'Italia e l'arte straniera* (Atti del X Congresso Internazionale di Storia dell' Arte in Roma), Rome, 1922, pp. 356–384 (repr. Nendeln/Lichtenstein, 1978).

MULLER J. Muller, "Rubens's Theory and Practice of the Imitation of Art," *Art Bulletin* 64, 1982, pp. 229–247.

MURPHY O'CONNOR J. Murphy O'Connor, *The Holy Land*, Oxford and New York, 1986.

NAVA CELLINI, 1966 A. Nava Cellini, "Duquesnoy e Poussin: Nuovi contributi," *Paragone* 195, 1966, pp. 30–59.

NAVA CELLINI, 1982 A. Nava Cellini, *La scultura del Seicento* (Storia dell'arte in Italia), Turin, 1982.

NENCIONI G. Nencioni, "La 'galleria' della lingua," *Annali della Scuola Normale Superiore di Pisa* 3, 1982, pp. 1525–1561.

NICOLAS POUSSIN *Nicolas Poussin* (C. N. R. S., Colloques internationaux, Sciences humaines), ed. A. Chastel, 2 vols., Paris, 1960.

NICOLSON B. Nicolson, *The International Caravaggesque Movement*, Oxford, 1979.

OBERHUBER K. Oberhuber, *Poussin, The Early Years in Rome: The Origins of French Classicism*, Hudson Hills, N.Y., 1988.

ONOMASTICON *Onomasticon Urbium et Locorum Sacrae Scripturae-1. Liber de Locis hebraicis*, ed. Bonfrère, Paris, 1631.

OTTO A. Otto, *Die Sprichwörter und Sprichwörtlichen Redensarten der Römer*, Leipzig, 1890.

OTTRIA N. Ottria, "Problemi dell'incisione: note sulle tavole della Galleria Giustiniana," "Dall'incisione al mito: una proposta di lettura," and "Immagini incise e fonti iconografiche cinquecentesche," in *La Galleria Giustiniana: sculture antiche e incisioni secentesche* (Quaderni del Museo Accademia Ligustica di Belle Arti Genoa 10), 1989, pp. 6–13, 14–15, and 16–30.

OVADIAH A. Ovadiah, *Corpus of Byzantine Churches in the Holy Land*, Bonn, 1970.

PACE C. Pace, *Félibien's Life of Poussin*, London, 1981.

PALAZZI *I Palazzi del Senato. Palazzo Cenci, Palazzo Giustiniani*, ed. F. Cossiga, Rome, 1984.

PALMA B. Palma, *I marmi Ludovisi: Storia della collezione*, in *Museo Nazionale Romano: Le sculture*, ed. A. Giuliano (I vol. in 9 parts), 4, Rome, 1983.

PANOFSKY, D. D. Panofsky, "Narcissus and Echo: Notes on Poussin's 'Birth of Bacchus' in the Fogg Museum of Art," *Art Bulletin* 31, 1949, pp. 112–120.

PANOFSKY, 1933 E. Panofsky, "Der gefesselte Eros," *Oud Holland* 50, 1933, pp. 193–217.

PANOFSKY, 1936 E. Panofsky, "Et in Arcadia ego: On the Conception of Transience in Poussin and Watteau," in *Philosophy and History: Essays Presented to Ernst Cassirer*, ed. R. Klibansky and H. J. Paton, Oxford, 1936, pp. 223–254.

PANOFSKY, 1940 E. Panofsky, *The Codex Huygens and Leonardo da Vinci's Art Theory* (Studies of the Warburg Institute, 13), London, 1940.

PANOFSKY, 1950 E. Panofsky, "Poussin's 'Apollo and Daphne' in the Louvre," *Bulletin de la Société Poussin* 3, 1950, pp. 27–41.

PANOFSKY, 1954 E. Panofsky, *Galileo as a Critic of the Arts*, The Hague, 1954.

PANOFSKY, 1955 E. Panofsky, "Et in Arcadia Ego: Poussin and the Elegiac Tradition," in *Meaning in the Visual Arts*, Garden City, N.Y., 1955, pp. 295–320.

PANOFSKY, 1955a E. Panofsky, *The Life and Art of Albrecht Dürer*, 4th ed., Princeton, 1955.

PANOFSKY, 1956 E. Panofsky, "Jean Hey's 'Ecce Homo': Speculations about its Author, its Donor and its Iconography," *Musées Royaux des Beaux-arts Bulletin* 5, 1956, pp. 95–138.

PANOFSKY, 1960 E. Panofsky, *A Mythological Painting by Poussin in the Nationalmuseum Stockholm* (Nationalmusei Skriftserie 5), Stockholm, 1960.

PAPER MUSEUM *The Paper Museum of Cassiano dal Pozzo* (exh. cat., British Museum, *Quaderni Puteani* 4), Milan, 1993.

eros

PARTHENIUS *Parthenius of Nicaea, Erotika pathemata: The Love Stories of Parthenius*, translated with notes and an afterword by J. Stern, New York and London, 1992.

PARTHEY AND PINDER G. Parthey and M. Pinder, *Itinerarium Antonini Augusti et Hierosolymitanum*, Berlin, 1848.

PASSERI *Die Künstlerbiographien von Giovanni Battista Passeri*, ed. J. Hess, Leipzig and Vienna, 1934.

PATRIZI G. Patrizi, *Stefano Guazzo e la civil conversazione* (Biblioteca del Cinquecento 46), Rome, 1990.

PATTERSON A. Patterson, *Pastoral and Ideology*, Berkeley, 1987.

PEDRETTI, 1962 C. Pedretti, "Copies of Leonardo's Lost Writings in the MS H 227 inf. of the Ambrosiana Library Milan," *Raccolta vinciana* 19, 1962, pp. 61–94.

PEDRETTI, 1977 C. Pedretti, *The Literary Works of Leonardo da Vinci: A Commentary to Jean Paul Richter's Edition*, 2 vols., Oxford, 1977.

PELTZER R. A. Peltzer, "Sandrart-Studien," *Münchner Jahrbuch der bildenden Kunst*, N.F. 2, 1925, pp. 103–165.

PEPPER, 1971 D. S. Pepper, "Augustin Carrache, maître et dessinateur," *Revue de l'art* 14, 1971, pp. 39–44.

PEPPER, 1984 D. S. Pepper, *Guido Reni: A Complete Catalogue of his Works with an Introductory Text*, Oxford, 1984.

PERCY A. Percy, *Giovanni Benedetto Castiglione: Master Draughtsman of the Italian Baroque* (exh. cat., Philadelphia Museum of Art), Philadelphia, 1971.

PETRARCH *Petrarch's Lyric Poems: The "Rime sparse" and Other Lyrics*, trans. and ed. R. M. Durling, Cambridge, Mass., and London, 1976.

PETRUCCI NARDELLI F. Petrucci Nardelli, "Il Cardinale Francesco Barberini Senior e la Stampa a Roma," *Archivio della Società Romana di Storia Patria*, 1987, pp. 1–66.

PHILIPPART H. Philippart, "Iconographie des 'Bacchantes' d'Euripede," *Revue belge de philologie et d'histoire* 9, 1930, pp. 5–72.

PICO G. Pico della Mirandola, *Opera Omnia*, 2 vols., Basle, 1601.

PIRRI P. Pirri, s.v. "Albrizzi," in *Dizionario biografico degli italiani* 2, Rome, 1960, pp. 59–60.

POMIAN K. Pomian, *Collectionneurs, Amateurs et Curieux. Paris, Venise: XVIe-XVIIIe siècle*, Paris, 1987.

POSNER, 1967 D. Posner, "The Picture of Painting in Poussin's 'Self-Portrait'," in *Essays in the History of Art Presented to Rudolf Wittkower*, ed. D. Fraser, H. Hibbard, and M. J. Lewine, London, 1967, pp. 200–203.

POSNER, 1971 D. Posner, *Annibale Carracci: A Study in the Reform of Italian Painting around 1590* (National Gallery of Art: Kress Foundation Studies in the History of European Art), 2 vols., London and New York, 1971.

POTTS, 1978 A. Potts, "Winckelmann's Interpretation of the History of Ancient Art in its Eighteenth-Century Context," Ph.D. diss., The Warburg Institute, Univ. of London, 1978.

POTTS, 1994 A. Potts, *Flesh and the Ideal: Winckelmann and the Origins of Art History*, New Haven and London, 1994.

POWELL V. G. Powell, "Les *Annales* de Baronius et l'iconographie réligieuse du XVIIe siècle," in *Baronio e l'arte* (Fonti e Studi Baroniani 2: Atti del convegno internazionale di studi, Sora 10–13 Ottobre 1984), ed. R. de Maio, A. Borromeo, et al., Sora, 1985, pp. 475–487.

PRÉAUD AND B. BREJON M. Préaud with B. Brejon de Lavergnée, *L'Oeil d'or. Claude Mellan 1598–1688* (exh. cat., Bibliothèque Nationale), Paris, 1988.

PRINZ W. Prinz, *Die Entstehung der Galerie in Frankreich und Italien*, Berlin, 1970.

PUTTFARKEN T. Puttfarken, *Roger de Piles'*

Theory of Art, New Haven and London, 1985.

RAGGIO O. Raggio, "The Collection of Sculpture," in *Liechtenstein: The Princely Collections* (exh. cat., The Metropolitan Museum of Art), New York, 1985, pp. 63–114.

RAPHAEL, 1983 *Raphael in der Albertina* (exh. cat.), ed. E. Mitsch, Vienna, 1983.

RAPHAEL, 1985 *Raphael invenit: Stampe da Raffaello nelle collezioni dell'Istituto nazionale per la grafica*, ed. G. B. Pezzini et al., Rome, 1985.

REARICK W. R. Rearick, *The Art of Paolo Veronese: 1528–1588* (exh. cat., National Gallery of Art, Washington, D.C.), Cambridge, 1988.

REED AND WALLACE S. W. Reed and R. Wallace, *Italian Etchers of the Renaissance and Baroque* (exh. cat., Museum of Fine Arts, Boston), Boston, 1989.

REFF, 1960 T. Reff, "Cézanne and Poussin," *Journal of the Warburg and Courtauld Institutes* 23, 1960, pp. 150–174.

REFF, 1977 T. Reff, "Painting and Theory in the Final Decade," in *Cézanne: The Late Work*, ed. W. Rubin, New York, 1977, pp. 13–53.

RENI *Guido Reni 1575–1642* (exh. cat., Los Angeles County Museum of Art), Bologna, 1988.

RICCI C. Ricci, *Il Tempio Malatestiano*, Rimini, 1924 (repr. with an appendix by P. G. Pasini, Rimini, 1974).

RICHTER I. Richter, *Paragone: A Comparison of the Arts by Leonardo da Vinci*, London, 1949.

RIPA C. Ripa, *Nova Iconologia* (repr. from the edition of Padua, 1618), ed. P. Buscaroli, 2 vols., Turin, 1986.

RITTER C. Ritter, *The Comparative Geography of Palestine and the Sinaitic Peninsula*, trans. W. L. Gage, 4 vols., New York, 1832–1882.

ROBERT C. Robert, *Mythologische Cyklen, Die Antiken Sarkophag-reliefs*, vol. 2, Berlin, 1890 (repr. Rome, 1968).

RODIS LEWIS G. Rodis Lewis, "Descartes et Poussin," in *Regards sur l'art*, Paris, 1993, pp. 85–113.

ROETHLISBERGER M. Roethlisberger, *Claude Lorraine: The Paintings*, 2 vols., New Haven, 1961.

ROSENBERG, 1982 P. Rosenberg, *France in the Golden Age: Seventeenth-century French Paintings in American Collections* (exh. cat., The Metropolitan Museum of Art), New York, 1982.

ROSENBERG, 1991 Review of H. Brigstocke, *Sotheby's Ashmolean Exhibition. A Loan Exhibition of drawings by Nicolas Poussin from British Collections*, in *The Burlington Magazine* 133, 1991, pp. 210–212.

ROSENBERG AND BUTOR P. Rosenberg and N. Butor, *La "Mort de Germanicus" de Poussin du Musée de Minneapolis* (Editions des Musées Nationaux; Les dossiers du département des peintures), Paris, 1973.

ROSKILL M. Roskill, *Dolce's "Aretino" and Venetian Art Theory of the Cinquecento*, New York, 1968.

ROSSI PINELLI O. Rossi Pinelli, "Chirurgia della memoria: scultura antica e restauri storici," in *Memoria dell'antico nell'arte italiana*, ed. S. Settis, 3 (Biblioteca di storia dell'arte), Turin, 1986, pp. 183–250.

ROWORTH W. Roworth, "The Consolations of Friendship: Salvator Rosa's Self-Portrait for Giovanni Battista Ricciardi," *The Metropolitan Museum Journal* 23, 1988, pp. 103–124.

RUBENIUS A. Rubenius, *De re vestiaria veterum, praecipue de lato clavo*, Antwerp, 1655.

RUBENS P. P. Rubens, *Lettere italiane*, ed. I. Cotta, Rome, 1987.

RUBINSTEIN R. Rubinstein, "A Codex from Dosio's Circle (BNCF NA 1159) in its mid-Sixteenth-Century Context," in *Antikenzeichnung und Antikenstudium in Renaissance und Frühbarock: Akten des Internationalen Symposions 8–10 September 1986 in Coburg*, ed. R. Harprath and H. Wrede, Mainz am Rhein, 1989, pp. 201–214.

SALERNO L. Salerno, "The Picture Gallery of Vincenzo Giustiniani," *The Burlington Magazine* 102, 1960, pp. 21–27, 93–104, 135–148.

SANDRART J. von Sandrart, *Academie der Bau- Bild- und Mahlerey-Kunste von 1675. Leben der beruhmten Maler, Bildhauer und Baumeister*, ed. A. R. Peltzer, Munich, 1925.

SANDYS J. E. Sandys, *A History of Classical Scholarship*, 3 vols., Cambridge, 1921 (3rd ed.).

SANTUCCI, 1985 P. Santucci, *Poussin: Tra-*

dizione ermetica e classicismo Gesuita, Salerno, 1985.

SANTUCCI, 1990 P. Santucci, "Nuove considerazioni sull''Eucarestia' di Poussin nel dibattito religioso e filosofico del tempo," *Prospettiva* 57–60, April 1989–October 1990 (Scritti in ricordo di Giovanni Previtali 2), pp. 222–228.

SCHELLER R. W. Scheller, "Als Ich Can," *Oud Holland* 83, 1968, pp. 135–139.

SCHLEIER, 1968 E. Schleier, "Affreschi di François Perrier à Roma," *Paragone* 217, 1968, pp. 42–54.

SCHLEIER, 1972 E. Schleier, "Quelques tableaux inconnus de François Perrier à Rome," *Revue de l'art* 18, 1972, pp. 39–46.

SCHLOSSER MAGNINO J. von Schlosser Magnino, *La letteratura artistica. Manuale delle fonti della storia dell'arte moderna* (repr. of 3rd ed., 1964), trans. F. Rossi, with notes by O. Kurz, Vienna, 1967.

SCHÜTZE AND WILLETTE S. Schütze and T. Willette, *Massimo Stanzione: L'opera completa*, Naples, 1992.

SCOTT J. B. Scott, *Images of Nepotism: The Painted Ceilings of Palazzo Barberini*, Princeton, 1991.

SEDGWICK E. K. Sedgwick, *Between Men: English Literature and Male Homosocial Desire*, New York, 1985.

SHEARMAN, 1962 J. Shearman, "Leonardo's Colour and Chiaroscuro," *Zeitschrift für Kunstgeschichte* 25, 1962, 13–47.

SHEARMAN, 1967 J. Shearman, *Mannerism*, Harmondsworth, 1967.

SHEARMAN, 1992 J. Shearman, *Only Connect . . . Art and the Spectator in the Italian Renaissance* (The A. W. Mellon Lectures in the Fine Arts), Princeton, 1992.

SHIFF R. Shiff, *Cézanne and the End of Impressionism*, Chicago and London, 1984.

SIMON E. Simon, "Archemoros," *Archäologischer Anzeiger* 84, 1971, pp. 31–45.

SMYTH C. H. Smyth, *Mannerism and Maniera*, 2nd ed., with an Introduction by E. Cropper, Vienna, 1992.

SOHM, 1991 P. Sohm, *Pittoresco: Marco Boschini, his Critics, and their Critiques of Painterly Brushwork in Seventeenth- and Eighteenth-Century Italy*, Cambridge, 1991.

SOHM, forthcoming P. Sohm, "Gendered Style in Italian Art Criticism from Michel-angelo to Malvezzi," forthcoming in *Renaissance Quarterly*.

SOLINAS, 1989 F. Solinas, "Percorsi puteani: note naturalistiche ed inediti appunti antiquari," in *Cassiano dal Pozzo: Atti del seminario internazionale di studi*, ed. F. Solinas, Rome, 1989, pp. 36–72.

SOLINAS, 1992 F. Solinas, "'Portare Roma a Parigi': Mecenati, artisti, ed eruditi nella migrazione culturale," in *Documentary Culture: Florence and Rome from Grand-Duke Ferdinand I to Pope Alexander VII* (Villa Spelman Colloquium Series 3), ed. E. Cropper, G. Perini, and F. Solinas, Bologna, 1992, pp. 227–261.

SOLINAS AND NICOLÒ, 1987 F. Solinas and A. Nicolò, "Cassiano dal Pozzo: appunti per una cronologia di documenti e disegni (1612–1630)," *Nouvelles de la République des Lettres* 2, 1987, pp. 59–110.

SOLINAS AND NICOLÒ, 1988 F. Solinas and A. Nicolò, "Cassiano dal Pozzo and Pietro Testa: New Documents Concerning the *Museo cartaceo*," in E. Cropper, *Pietro Testa 1612–1650: Prints and Drawings* (exh. cat., Philadelphia Museum of Art), Philadelphia, 1988, pp. lxvi–lxxxvi.

SPARTI, 1989 D. L. Sparti, "Criteri museografici nella collezione dal Pozzo alla luce di documentazione inedita," in *Cassiano dal Pozzo: Atti del seminario internazionale di studi*, ed. F. Solinas, Rome, 1989, pp. 221–240.

SPARTI, 1992 D. L. Sparti, *Le collezioni dal Pozzo. Storia di una famiglia e del suo museo nella Roma seicentesca*, Modena, 1992.

SPEAR R. Spear, *Domenichino*, 2 vols., New Haven and London, 1982.

SPEZZAFERRO L. Spezzaferro, "La cultura del Cardinal Del Monte e il primo tempo del Caravaggio," *Storia dell'Arte* 9, 1971, pp. 57–92.

SPON J. Spon, *Miscellanea eruditae antiquitatis*, Lyons, 1685.

STANDRING, 1985 T. J. Standring, "A Lost Poussin Work on Copper: The 'Agony in the Garden'," *The Burlington Magazine* 127, 1985, pp. 614–617.

STANDRING, 1988 T. J. Standring, "Some Pictures by Poussin in the dal Pozzo collection: Three new Inventories," *The Burlington Magazine* 130, 1988, pp. 608–626.

STANTON D. Stanton, *The Aristocrat as*

Art: A Study of the "Honnête Homme" and the "Dandy" in Seventeenth- and Nineteenth-Century French Literature, New York, 1980.

STEEFEL L. D. Steefel Jr., "A Neglected Shadow in Poussin's 'Et in Arcadia Ego'," *Art Bulletin* 57, 1975, pp. 99–101.

STEINITZ K. Trauman Steinitz, *Leonardo da Vinci's 'Trattato della Pittura': A Bibliography of The Printed Editions 1651–1956* (Library Research Monographs 5, University Library, Copenhagen, Scientific and Medical Department), Copenhagen, 1958.

STEPHANUS H. Stephanus, *Glossaria duo e situ vetustatis eruta: ad utriusque linguae cognitionem & locupletationem per utilia*, Geneva, 1573.

STEPHANUS BYZANTINUS *Stephanus Byzantinus cum annotationibus L. Holstenii, A. Berkelii, et Th. de Pinedo, cum Guilielmi Dindorfii praefatione*, Lipsiae, 1825.

STERNE L. Sterne, *The Life and Opinions of Tristram Shandy, Gentleman* (The Florida Edition of the Works of Laurence Sterne), 3 vols., Gainesville, 1978.

STOICHITA V. I. Stoichita, "Nomi in cornice," in *Der Künstler über sich in seinem Werk* (Internationales Symposium der Bibliotheca Hertziana, Rome, 1989), ed. M. Winner, Weinheim, 1992, pp. 293–315.

SUAREZ J. M. Suarez, *Praenestes antiquae*, Rome, 1655.

SUTTON P. Sutton, "A Pair by Van Bilaert," *Hoogsteder-Naumann Mercury* 8, 1989, pp. 4–16.

TASSO T. Tasso, *Dialoghi. Edizione critica*, ed. E. Raimondi, 3 vols. in 4, Florence, 1958.

TEYSSÈDRE B. Teyssèdre, *Roger de Piles et les débats sur le coloris au siècle de Louis XIV*, Paris, 1957.

THOMPSON H. A. Thompson, "Dionysus among the Nymphs in Athens and in Rome," in *Essays in Honor of Dorothy Kent Hill* (*Journal of the Walters Art Gallery* 36, 1977), pp. 73–84.

THUILLIER, 1957 J. Thuillier, "Polémiques autour de Michel-Ange au XVIIe siècle," *Bulletin de la Société d'Etude du XVIIe siècle* 36–37, 1957, pp. 351–391.

THUILLIER, 1961 J. Thuillier, "L'Année Poussin," *Art de France* 1, 1961, pp. 336–348.

THUILLIER, 1974 J. Thuillier, *L'Opera completa di Nicolas Poussin* (Classici dell'Arte 72), Milan, 1974.

THUILLIER, 1978 J. Thuillier, "Propositions pour: I, Charles Errard, peintre," *Revue de l'art* 40–41, 1978, pp. 151–172.

THUILLIER, 1988 J. Thuillier, *Nicolas Poussin*, Paris, 1988.

THUILLIER, 1993 J. Thuillier, "Les dernières années de François Perrier (1646–1649)," *Revue de l'art* 99, 1993, pp. 9–28.

THUILLIER AND MIGNOT J. Thuillier and C. Mignot, "Collectionneur et Peintre au XVIIe siècle: Pointel et Poussin," *Revue de l'Art* 39, 1978, pp. 39–58.

TOESCA I. Toesca, "Note sulla storia del Palazzo Giustiniani a San Luigi dei Francesi," *Bollettino d'Arte* 42, 1957, pp. 296–308.

TOMEI A. Tomei, "Le immagini di Pietro e Paolo dal ciclo apostolico del portico vaticano," in *Fragmenta picta: affreschi e mosaici staccati del Medioevo romano* (exh. cat., Museo Nazionale di Castel Sant'Angelo, Rome), ed. M. Andeloro et al., Àrgos, 1989, pp. 141–146.

TRIBBY J. Tribby, "Of Conversational Dispositions and the *Saggi's* Proem," in *Documentary Culture: Florence and Rome from Grand-Duke Ferdinand I to Pope Alexander VII*, ed. E. Cropper, G. Perini, F. Solinas (Villa Spelman Colloquium Series 3), Bologna, 1992, pp. 379–390.

TURNER, A. R. A. R. Turner, *Inventing Leonardo*, New York, 1993.

TURNER, N. N. Turner, review of V. Birke in *Print Quarterly* 5, 1988, pp. 182–187.

VAGENHEIM G. Vagenheim, "Des inscriptions Ligoriennes dans le Museo cartaceo pour une étude de la tradition des dessins d'après l'antique," in *Cassiano dal Pozzo's Paper Museum*, 2 vols., Milan, 1992, 1 (*Quaderni puteani* 2), pp. 79–104.

VAGNETTI L. Vagnetti, *De Naturali et Artificiali Perspectiva* (Studi e documenti di Architettura, 9-10), Florence, 1979.

VAN GELDER J. G. Van Gelder, "Jan de Bisschop's Drawings after Antique Sculpture," in *Studies in Western Art* (Acts of The Twentieth International Congress of the History of Art), 4 vols., Princeton, N.J., 1963, 3, pp. 51–58.

VAN HELSDINGEN H. W. van Helsdingen, "Notes on Two Sheets of Sketches by Nicolas Poussin for the Long Gallery of the Louvre," *Simiolus* 5, 1971, pp. 172–184.

VAN NIDECK A. Van Nideck, *Antiquitates sacrae et civiles Romanorum explicatae*, The Hague, 1726.

VASARI G. Vasari, *Le vite de' più eccellenti pittori, scultori ed architetti moderni*, ed. G. Milanesi, 9 vols., Florence, 1906.

VERDI R. Verdi, *Cézanne and Poussin: The Classical Vision of Landscape* (exh. cat., National Galleries of Scotland), Edinburgh, 1990.

VERHEYEN E. Verheyen, "Eros and Anteros: 'L'Education de Cupidon' et la prétendu 'Antiope' du Corrège," *Gazette des Beaux-Arts* 65, 1965, pp. 321–340.

VETTER E. M. Vetter, "Nicolas Poussins letztes Bild," *Pantheon* 29, 1971, pp. 210–225.

VIDAL M. Vidal, *Watteau's Painted Conversations*, New Haven and London, 1992.

VIRGIL, 1502 *Publii Virgilii Maronis opera cum quinque vulgatis commentariis: expolitissimisque figuris atque imaginibus nuper per Sebastianum Brant superadditus*, Strasbourg (J. Grüninger), 1502.

VIRGIL, 1749 *Publii Virgilii Maronis bucolicorum eclogae decem*, London, 1749.

VOLKMANN L. Volkmann, *Bilderschriften der Renaissance: Hieroglyphik und Emblematik in ihren Beziehungen und Fortwirkungen*, Leipzig, 1923 (repr. Nieuwkoop, 1962).

VOS D. de Vos, "Nogmaals ALS ICH CAN," *Oud Holland* 97, 1983, pp. 1–4.

VOSS H. Voss, *Die Malerei des barock in Rom*, Berlin, n.d. [1924?].

WAETZOLDT S. Waetzoldt, *Die Kopie des 17. Jahrhunderts nach Mosaiken und Wandmelereien in Rom*, Vienna, 1964.

WATERFIELD G. Waterfield, *Paintings and their Context, Vol. I: Nicolas Poussin, Venus and Mercury* (exh. cat., Dulwich Picture Gallery), with essays by R. Verdi, K. Scott, and H. Glanville, Dulwich, 1986.

WEIL-GARRIS K. Weil-Garris, "Bandinelli and Michelangelo: A Problem of Artistic Identity," in *Art the Ape of Nature: Studies in Honor of H. W. Janson*, ed. M. Barasch and L. Freeman Sandler, New York, 1981, pp. 223–251.

WELLEK R. Wellek, "The Term and Concept of Classicism in Literary History," in *Aspects of the Eighteenth Century*, ed. E. R. Wasserman, Baltimore, 1965, pp. 105–128.

WELLER B. Weller, "The Rhetoric of Friendship in Montaigne's *Essais*," *New Literary History* 9, 1978, pp. 503–523.

WETHEY H. E. Wethey, *The Paintings of Titian*, 3 vols., London, 1969–1975.

WIEBENSON D. Wiebenson, "Subjects from Homer's *Iliad* in Neoclassical Art," *Art Bulletin* 46, 1964, pp. 23–37.

WILD D. Wild, *Nicolas Poussin: Leben, Werk, Exkurse*, 2 vols., Zurich, 1980.

WILDENSTEIN G. Wildenstein, *Les graveurs de Poussin au XVIIe siècle*, Paris, 1957 (first published in *Gazette des Beaux-Arts*, 1955).

WILLIAMS F. Williams, *Callimachus, Hymn to Apollo: A Commentary*, Oxford, 1978.

WILPERT J. Wilpert, *Die römischen Mosaiken und Malereien der kirchlichen Bauten vom IV. bis XIII. Jahrhunderts*, Freiberg, 1916.

WINCKELMANN J. J. Winckelmann, *Geschichte der Kunst des Alterthums*, Dresden, 1764 (recte late 1763).

WINNER, 1983 M. Winner, "Poussins Selbstbildnis im Louvre als Kunsttheoretische Allegorie," *Römisches Jahrbuch für Kunstgeschichte* 20, 1983, pp. 417–449.

WINNER, 1987 M. Winner, "Poussins Selbstbildniss von 1649," in *Il se rendit en Italie: Études offertes à André Chastel*, Rome and Paris, 1987, pp. 371–401.

WITTKOWER, 1963 R. Wittkower, "The Role of Classical Models in Bernini's and Poussin's Preparatory Work," in *Studies in Western Art* (Acts of the Twentieth International Congress of the History of Art), Princeton, 1963, 3, pp. 41–50.

WITTKOWER, 1973 R. Wittkower, *Art and Architecture in Italy, 1600 to 1750*, 3rd rev. ed., Harmondsworth, 1973.

WÖLFFLIN H. Wölfflin, *Kunstgeschichtliche Grundbegriffe: Das Problem der Stilentwickelung in der neueren Kunst*, Munich, 1915.

WOLLHEIM R. Wollheim, *Painting as an Art* (The A. W. Mellon Lectures in the Fine Arts), Princeton, 1987.

ZAMBONI G. Zamboni, "Barthold Hein-

rich Brockes," in *Atti del Reale Istituto Veneto di Scienze, Lettere ed Arti* 90, pt. 2, 1930–1931, pp. 879–953.

ZERI AND GARDNER F. Zeri and E. E. Gardner, *Italian Paintings: A Catalogue of the Collection of The Metropolitan Museum of Art. North Italian School*, New York, 1986.

ZERNER H. Zerner, *The School of Fontainebleau: Etchings and Engravings*, New York, 1969.

INDEX